Book Two

UNDERSTANDING AND CREATING ART

Teacher's Annotated Edition and Resource Book

Second Edition

Ernest Goldstein
Theodore H. Katz
Jo D. Kowalchuk
Robert J. Saunders

West Publishing Company

St. Paul New York Los Angeles San Francisco

ABOUT THE AUTHORS

Ernest Goldstein is an art critic, educator, and author of books on art, literature, and film. He is the creator of the *Let's Get Lost in a Painting* series and author of four of the books in the series: *The Gulf Stream, The Peaceable Kingdom, Washington Crossing the Delaware,* and *American Gothic.*

Theodore H. Katz, Ed.D. is an artist, teacher and administrator. Formerly Chief of the Division of Education of the Philadelphia Museum of Art, he has created model programs in art education throughout the United States for the Ford Foundation, Carnegie Corporation, National Endowment for the Arts and Humanities and the Smithsonian Institution. He is the author of *Museums and Schools: Partners in Teaching.*

Jo D. Kowalchuk has recently retired from the position of Program Specialist in Arts Curriculum for the Palm Beach County Schools in Florida. She has taught art in Alabama, Georgia, and Florida. She has served as Vice President of the National Art Education Association and has served on the Editorial Advisory Board of *School Arts* magazine. She is an active member of Delta Kappa Gamma International.

Robert J. Saunders, Ed.D. is Art Consultant for the Connecticut Department of Education and has taught art in California, New York, and New Jersey. He is the author of several books in art education including *Teaching Through Art* and *Relating Art and Humanities to the Classroom.* With Ernest Goldstein he co-authored *The Brooklyn Bridge* in the *Let's Get Lost in a Painting* series. He is a frequent contributor to art education journals.

Editorial Development and Supervision
Charles W. Pepper

CONTRIBUTORS

Several Activities, Annotations:
Elizabeth L. Katz and Janice Plank
Whitehall City Schools
Whitehall, Ohio

Photography Activities:
Constance J. Rudy
Palm Beach County Schools
Palm Beach, Florida

Printmaking Activities:
Elizabeth Kowalchuk
Palm Beach County Schools
Palm Beach Florida

Computer Activities:
Dr. Linda L. Naimi
Consultant, Computer Technology
State Department of Education
Hartford, Connecticut

Craft Activities:
Maryanne Corwin
Palm Beach County Schools
Palm Beach, Florida

Watercolor Activities:
Susan Carey
Eau Claire City Schools
Eau Claire, Wisconsin

The Artist and the West:
Sheilah T. Ramsay
Author and Illustrator

Student Art Work from:
Joanna Brown & Paul Krepps
Art Specialists
Palm Beach County Schools
Palm Beach, Florida

Nellie Lynch
Art Supervisor, Duval County
Jacksonville, Florida

Fran Phelps
Art Specialist, Jacksonville Museum
Jacksonville, Florida

Janice Rice
Art Supervisor
Alachua County
Gainesville, Florida

Cover: Detail from Frederick Remington, *The Buffalo Runners, Big Horn Basin.* 1909. Oil on canvas. 30 1/8" × 51 1/8". Courtesy Sid Richardson Collection of Western Art, Fort Worth. *Page iii:* Detail from Gilbert Stuart, *Portrait of Washington* (The Athenaeum Portrait). 1796. Oil on canvas. 48 × 37". Jointly owned by The Museum of Fine Arts, Boston and the National Portrait Gallery, Smithsonian Institution, Washington, D.C. *Page iv:* George Catlin, *Mint, a Pretty Girl.* 1832. Oil on canvas. 29" × 24". National Museum of American Art, Smithsonian Institution, Washington, D.C. Gift of Mrs. Joseph Harrison, Jr. *Page v:* Joseph Stella, *The Bridge.* The fifth panel of *Voice of the City of New York Interpreted.* 1920–1922. Oil and tempera on canvas. 88 1/2" × 54". Collection of the Newark Museum. Purchase 1937, Felix Fald Bequest Fund. Photograph © The Newark Museum.

CONTENTS

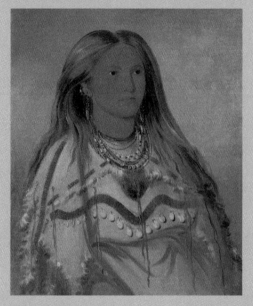

PART III
THE ARTIST IN THE INDUSTRIAL WORLD 247

UNIT 7
LET'S GET LOST IN A PAINTING: THE BRIDGE 249

Review, The Visual Elements of Art and Compositional Principles of Design 288

UNIT 8
FORMS OF EXPRESSION 291

UNIT 9
SPECIAL PROJECTS 365

PART IV
ART APPLICATIONS 373

UNIT 10
GRAPHIC DESIGN AND ADVERTISING ART 375

UNIT 11

FASHION, INTERIOR, AND LANDSCAPE DESIGN 381

UNIT 12

INDUSTRIAL AND TRANSPORTATION DESIGN 391

TEACHER'S ANNOTATED EDITION AND RESOURCE BOOK T-1

UNDERSTANDING AND CREATING ART

Second Edition

1992

In 1986 UNDERSTANDING AND CREATING ART became the first instructional material program developed to meet the major goals of NAEA with a balance of **creative expression, art appreciation, art history,** and **art criticism.**

West Educational Publishing proudly presents a major revision, greatly refined and expanded for 1992, based on teachers' experiences in the classroom.

Components of the Program

- **Student Texts** for each level.

- **TEST PACKAGE** provided in black-line master form for easy duplication.

- **Teacher's Annotated Edition and Resource Book** for each level.
 Contains all of the material in the STUDENT TEXT in FULL SIZE and color plus:
 - **Annotations** for the teacher that provide helpful teaching suggestions for the specific page *and* direct the teacher to the use of all components of the program.
 - **Lesson Plans** are the most complete, detailed plans ever included in a teacher package.
 - **Key to all Tests** (Correct answers marked on the reproduction of each test.)
 - **Scheduling** suggestions for a full-year course, a semester, or less.
 - **Materials** used, **Artists' Biographies, Bibliography,** and many other teacher helps.

- **Large Classroom Reproduction Package—**
 Twenty high quality, durable reproductions LAMINATED for each level.

The **Teacher's Annotated Editions,** the **Test Package,** and the **Classroom Reproduction Package of Artworks** are *all* integrated parts of the program and are furnished *gratis* by the publisher with classroom orders of the student textbooks.

USING THE PROGRAM

The TEACHER'S ANNOTATED EDITION AND RESOURCE BOOK (TAER) is the guide to the use of all components.

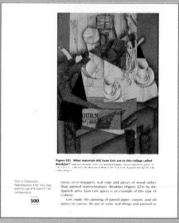

The **Annotations** on each page fulfill two purposes:
1. Annotations guide the teacher to the use of each component of the program at the appropriate times.
2. Annotations give specific teaching suggestions and reminders for the teacher's help *in class.*

The **Lesson Plans** are quite detailed and contain specific strategies and evaluation suggestions. The authors' method is to carefully word the studio activities in the STUDENT TEXT so that the teacher has wide latitude to utilize his or her talents and facilities, while providing specific instructions in the TAER to help eliminate unnecessary administrative detail and conserve the teacher's planning time outside of the classroom.

Scheduling Your Course

This section, beginning on page T59, will be of help in planning your course. The richness and diversity of material makes many options available, depending on your goals, and your district's requirements and facilities. The sequential order of the student material facilitates its use with students of widely varying abilities and previous experiences in art instruction.

A BRIEF OVERVIEW OF BOOK TWO

The text begins with an in-depth encounter with a major work of art . . .

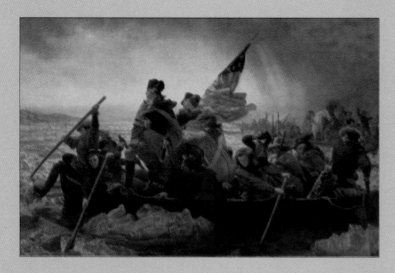

- **Emanuel Leutze's** *Washington Crossing the Delaware*. This unit has several purposes, among which is to give intuitive experiences in the visual elements and compositional principles as the work is analyzed.

- This introduction is immediately followed by the formal introduction of the **Elements and Principles.** If your class has previously used *Understanding and Creating Art, Book One,* or if you find the class members have a good working knowledge of the elements and principles, this section may be used as a review, or as a reteaching tool. The teacher may want to consider using the tests provided in the package of black-line masters as a pre-test to pre-determine the amount of time to devote to this section. From this point forward, all lesson plans are based on the elements and principles. Additionally, they are formally re-taught using Stella's *The Bridge* as the basis for instruction.

A BRIEF OVERVIEW OF BOOK TWO

(continued)

A four-step process of art criticism has been used by all students who have previously used *Understanding and Creating Art, Book One.* These students have had extensive practice in art criticism. The teacher may want to use the black-line masters on art criticism as a review, or as an introduction for those students who have little or no experience in this area of the art curriculum.

● The next section is **The Illusion of Space,** which is a formal introduction to perspective. Note the detailed teaching instructions to use if this is the class's first introduction to linear perspective.

● The **Forms of Expression** unit, which is the heart of the program, follows. A rich variety of examples from worldwide cultures is presented in the various forms of creative expression. These examples provide the basis for studio activities in each form of expression.

These studio activities are carefully sequenced (please see the special SCOPE AND SEQUENCE CHART FOR STUDIO ACTIVITIES) and the information for the students is carefully tied to the very detailed lesson plans for each activity.

A BRIEF OVERVIEW OF BOOK TWO

(continued)

UNIT

3

SPECIAL PROJECTS

The Artist and Heroes and Heroines

ART HISTORY

1. The Battle of Trenton was a landmark in the history of the United States. If you are currently taking a course in American history, read the section in your textbook that describes this battle. (If you are not taking American history at this time, check your school's Social Studies Department. It will have a copy of an American history text that you can use for this purpose.) Next, look at other accounts of this battle from encyclopedias and other sources in the library. Do you find that these sources do justice to the importance of this battle? Do they convey the suffering of the soldiers in the cold? Do they suggest the great boost the battle's outcome gave to American morale and recruitment of new soldiers?

Write your own account of the Battle of Trenton as if it were to be a part of a new history textbook. Select illustrations you would use, and create your own original artwork.

121

- The **Special Projects** unit completes the first part of the text. The projects are divided into two sections: *Art History* and *Appreciation* and *Aesthetic Growth*. These may be used as a wrap-up of the major part of the text, or they may be used during the course. Annotations will suggest where they may be used throughout the text if the teacher finds specific interests, and wishes to capitalize immediately on these interests with highly motivating material. One thing is common to the special projects—the student must extend his or her critical thinking skills.

PART

II

THE ARTIST AND THE WEST

PART

III

THE ARTIST IN THE INDUSTRIAL WORLD

- The second and third parts of the book are organized in the same sequence as the first part which is described above. Part II begins with an in-depth analysis of Frederic Remington's *The Buffalo Runners, Big Horn Basin,* and Part III with Joseph Stella's *The Bridge*. The careful sequencing of skills in each form of expression is continued throughout. The many steps in the movement from representational art to abstract art are carefully developed in Parts II and III.

PART

IV

ART APPLICATIONS

- The fourth part of the text is titled **Art Applications.** This part is devoted exclusively to applications of the visual arts as they relate to the students' daily lives. Experiences selected are particularly appropriate for this age level, and each includes accompanying creative activities.

A BRIEF OVERVIEW OF BOOK TWO

(continued)

Appendices . . .

A A BRIEF HISTORY OF ART

Art history is a major part of each unit of the text. This appendix provides an excellent supplemental aid for the teacher to use at her/his discretion. The section *is* brief, but the authors have taken great pains not to oversimplify it. A very strong feature is the emphasis placed upon the art of all world cultures, and the important information given about non-western art and artists. As much as possible, the works and artists selected are not covered extensively in other parts of the text. They *were* selected to illuminate a particular era or artistic tradition of a part of the world.

An interesting accompaniment to this section is the detailed **Timeline** which is included in the package of black-line masters so that each student may have a personal copy for future reference. As you would expect, the teacher annotations and the lesson plans suggest many appropriate places to extend the lessons by using this appendix.

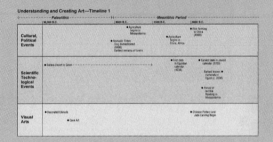

B A survey of CAREERS IN ART

The focus of this section is to give practical information about the opportunities for those with art skills and training. The students are introduced to the challenges and problems faced by practitioners in many fields.

The pages that immediately follow . . .

- The **Scope and Sequence Chart** for the program
- The **Scope and Sequence Chart** for the **Studio Activities**

The authors have considered preparing this series a labor of love. The series comes from the varied experiences of four dedicated art professionals, and is presented to you with the hope and expectation that it will provide you with an inspirational, as well as practical, teaching tool.

Scope and Sequence		I. Awareness and Sensitivity to Natural and Man-Made Environments		
		1.1 Examine a Variety of objects	**1.2 Explore Elements** (line value, texture, color, form and spaces)	**1.3 Apply Principles** (unity, emphasis, balance, variety, movement, and proportion)
UNDERSTANDING AND CREATING ART, BOOK ONE	Part One The Artist and Nature	• **The Gulf Stream** pp. 2–38 • **Forms of Expression:** Drawing pp. 70–78; Painting pp. 82–100; Sculpture pp. 111–120; Photography pp. 122–132; Architecture pp. 136–140; Crafts pp. 141–146. • **Special Projects** pp. 149–152	• **The Visual Elements of Art** pp. 39–48 • **The Illusion of Space** pp. 59–67 • **All Lesson Plans** for creative activities review and reteach the visual elements. See **Focus** for each activity. • **Special Projects** pp. 149–152	• **The Compositional Principles of Design** pp. 48–55 • **All Lesson Plans** for creative activities review and reteach the compositional principles. See **Focus** for each activity. • **Special Projects** pp. 149–152
	Part Two The Artist in the Community	• **American Gothic** pp. 155–192 • **Forms of Expression:** Drawing pp. 199–205; Painting pp. 210–234; Sculpture pp. 238–244; Photography pp. 248–256; Architecture pp. 259–268; Crafts pp. 269–275; Printmaking pp. 278–284. • **Special Projects** pp. 287–293	• **Review, The Visual Elements of Art** pp. 193–194 • **All Lesson Plans** for creative activities review and reteach the visual elements. See **Focus** for each activity. • **Special Projects** pp. 287–293	• Review, **The Compositional Principles of Design** pp. 194–196 • **All Lesson Plans** for creative activities review and reteach the compositional principles. See **Focus** for each activity. • **Special Projects** pp. 287–293
	Part Three Art Applications and Appendices	• **The Museum Experience** pp. 297–304 • **Computers and Art** pp. 305–312 • **Cartooning, Animation and Entertainment** pp. 312–321 • **A Brief History of Art** pp. A-1–A-30 • **Careers in Art** pp. B-1–B-7	• **Computers and Art** pp. 305–312	• **Computers and Art** pp. 305–312
UNDERSTANDING AND CREATING ART, BOOK TWO	Part One The Artist and Heroes and Heroines	• **Washington Crossing the Delaware** pp. 3–41 • **Forms of Expression:** Drawing pp. 72–76; Painting pp. 84–96; Sculpture pp. 97–104; Architecture pp. 105–110; Photography pp. 112–117. • **Special Projects** pp. 121–126 • **Epilogue** pp. 126–127	• **The Visual Elements of Art** pp. 42–54 • **The Illusion of Space** pp. 60–70 • **All Lesson Plans** for the above and creative activities continually review and reteach the visual elements. • **Special Projects** pp. 121–125 • **Epilogue** pp. 126–127	• **The Compositional Principles of Design** pp. 55–60 • **All Lesson Plans** for creative activities review and reteach the compositional principles. • **Special Projects** pp. 121–125
	Part Two The Artist and The West	• **The Buffalo Runners, Big Horn Basin** pp.131–166 • **Forms of Expression:** Drawing pp. 168–177; Painting pp. 181–197; Sculpture pp. 198–205; Architecture pp. 206–212; Photography pp. 213–216; Crafts pp.218–222; Printmaking pp. 225–229. • **Special Projects** pp. 235–240 • **Epilogue** pp. 240–246	• **All Lesson Plans** for creative activities review and reteach the visual elements. • **Special Projects** pp. 235–240 • **Epilogue** pp. 240–246	• **All Lesson Plans** for creative activities review and reteach the compositional principles. • **Special Projects** pp. 235–246 • **Epilogue** pp.240–246
	Part Three The Artist in the Industrial World	• **The Brooklyn Bridge** pp. 249–288 • **Forms of Expression:** Drawing pp. 292–295; Painting pp. 298–311; Sculpture pp. 314–330; Photography pp. 331–337; Architecture pp. 338–347; Crafts pp. 348–352; Printmaking pp. 355–357; Posters pp. 357–371. • **Special Projects** pp. 365–371	• Formal **Review, The Visual Elements of Art** pp.288–289 • **All Lesson Plans** for creative activities review and reteach the visual elements. • **Special Projects** pp. 365–371	• Formal review, **The Compositional Principles of Design** pp. 289–290 • **All Lesson Plans** for creative activities review and reteach the compositional principles. • **Special Projects** pp. 365–371
	Part Four Art Applications and Appendices	• **Graphic Design** pp. 375–377. • **Advertising Art** pp. 379–380. • **Fashion Design** pp. 381–387. • **Interior Design** pp. 387–389. • **Landscape Design** pp. 389–390. • **Industrial Design** pp. 391–392. • **A Brief History** pp. A-1–A-30 • **Careers in Art** pp. B-1–B-7	• **All Lesson Plans** emphasize the visual elements and compositional principles in each design field.	• **All Lesson Plans** emphasize the visual elements and compositional principles in each design field.

Scope and Sequence		II. Inventive and Imaginative Expression Through Art Materials and Tools	III Understanding and Appreciation of Self and Others Through Art, Culture, and Heritage
		2.1 Work with Design* (drawing, painting, printmaking, sculpture and crafts)	3.1 Appreciate Art 3.2 Art and Artists
UNDERSTANDING AND CREATING ART, BOOK ONE	Part One The Artist and Nature	• **Activities:** Pre-Drawing Activities: ATER; Drawing Activities pp. 78–82; Pre-Painting Activities: ATER; Painting Activities pp. 100–111; Sculpture Activities pp. 120–122; Photography Activities pp. 132–136; Architecture Activities p. 141; Crafts Activities pp. 146–148. • **Special Projects** pp. 149–152	• **The Gulf Stream** pp. 2–38 • **The Illusion of Space** pp. 59–67 • **Forms of Expression:** Drawing pp. 70–78; Painting pp. 82–100; Sculpture pp. 111–120; Photography pp.122–132; Architecture pp.136–140; Crafts pp.141–146. • **Special Projects** pp. 149–152
	Part Two The Artist in the Community	**Also see Special Scope and Sequence of Creative Expression Activities** • **Activities:** Drawing Activities pp. 205–210; Painting Activities pp. 234–238; Sculpture Activities pp. 244–248; Photography Activities pp. 256–259; Architecture Activities pp. 268–269; Crafts Activities pp. 275–278; Printmaking Activities pp. 284–286. • **Special Projects** pp. 287–293	• **American Gothic** pp. 155–192 • **Forms of Expression:** Drawing pp. 199–205; Painting pp. 210–234; Sculpture pp. 238–244; Photography pp. 248–256; Architecture pp. 259–268; Crafts pp. 269–275; Printmaking pp. 278–284. • **Special Projects** pp. 287–293
	Part Three Art Applications and Appendices	• **Computers and Art** pp. 305–312; black line masters for activities teaching elements and principles on a computer. • **Cartooning, Animation and Entertainment** pp.313–321	• **The Museum Experience** pp. 297–304 • **Computers and Art** pp. 305–312; and set of black line masters • **Cartooning, Animation, and Entertainment** pp. 313–321 • **A Brief History of Art** pp. A-1–A-30 • **Career in Art** pp. B-1–B-7
UNDERSTANDING AND CREATING ART, BOOK TWO	Part One The Artist and Heroes and Heroines	• **Activities:** Drawing Activities pp. 77–84; Painting Activities pp. 96–97; Sculpture Activities pp. 104–105; Architecture Activities p. 111; Photography Activities pp. 118–120. • **Special Projects** pp. 121–127	• **Washington Crossing the Delaware** pp.3–41 • **Forms of Expression:** Drawing pp. 72–76; Painting pp. 84–96; Sculpture pp. 97–104; Architecture pp. 105–110; Photography pp. 112–117. • **Special Projects** pp. 121–126 • **Epilogue** pp. 126–127
	Part Two The Artist and The West	• **Activities:** Drawing Activities pp. 177–180; Painting Activity p. 198; Sculpture Activities pp. 205–206; Architecture Activities pp.212–213; Photography Activities pp. 217–218; Crafts Activities pp. 223–224; Printmaking Activities pp. 229–233. • **Special Projects** pp. 121–127	• **The Buffalo Runners, Big Horn Basin** pp. 131–166 • **Forms of Expression:** Drawing pp 168–177; Painting pp. 181–197; Sculpture pp. 198–205; Architecture pp. 206–212; Photography pp. 213–216; Crafts pp. 218–222; Printmaking pp. 225–229. • **Special Projects** pp. 235–240 • **Epilogue** pp. 240–246
	Part Three The Artist in the Industrial World	• **Activities:** Drawing Activities pp. 296–297; Painting Activities pp. 312–314; Sculpture Activities pp. 330–331; Photography Activities p. 338; Architecture Activities pp. 347–348; Crafts Activity pp. 352–355; Printmaking (Poster) Activity pp. 363–364. • **Special Projects** pp. 365–371	• **The Brooklyn Bridge** pp. 249–288 • **Forms of Expression:** Drawing pp. 292–295; Painting pp. 298–311; Sculpture pp. 314–330; Photography pp. 331–337; Architecture pp. 338–347; Crafts pp. 348–352; Printmaking pp. 355–357; Posters pp. 357–371. • **Special Projects** pp. 365–371
	Part Four Art Applications and Appendices	• **Graphic Design Activities** pp. 377–379. • **Advertising Art Activity** pp. 380. • **Fashion Design Activity** pp. 387. • **Interior Design Activity** pp. 389. • **Landscape Design Activity** pp. 390. • **Industrial Design Activity** pp. 393.	• **Graphic Design** pp. 375–377. • **Advertising Art** pp. 379–380. • **Fashion Design** pp. 381–387. • **Interior Design** pp. 387–389. • **Landscape Design** pp. 389–390. • **Industrial Design** pp. 391–392. • **A Brief History** pp. A-1–A-30 • **Careers in Art** pp. B-1–B-7

*Note: Safety practices (2.2) are introduced and reinforced throughout all activities in both books.

IV. Aesthetic Growth Through Visual Discrimination and Judgment

4.1 Evaluate Artwork (of Students and Major Artists)	4.2 Explore Opportunities for Applying Aesthetic Judgments	Scope and Sequence	
• **The Gulf Stream** pp. 2–38 • **The Visual Elements of Art and The Compositional Principles of Design** using **The Gulf Stream** as a base for instruction pp. 39–55 • **The Illusion of Space** pp. 59–67 • **Forms of Expression,** pp. 69–148, for major artists works • See the **Evaluation** section of each lesson plan—strategies for evaluation of student artwork by the students as well as by the teacher. • **Special Projects** pp. 149–152	• **The Gulf Stream** (intuitive introduction) pp. 2–38 • **Introduction of Art Criticism** pp. 56–59 • Practice throughout the texts. For example, pp. 78, 110, 149, 152, T-12; evaluation section of each lesson plan.	Part One The Artist and Nature	UNDERSTANDING AND CREATING ART, BOOK ONE
• **American Gothic** pp. 155–192 • **Review, The Visual Elements of Art and The Compositional Principles of Design** using **American Gothic** as a base pp. 193–196 • **Forms of Expression,** pp.197–286, for major artists' works. • See the **Evaluation** section of each lesson plan—strategies for evaluation of student artwork by the students as well as by the teacher. • **Special Projects** pp. 287–293	• Practice throughout the text. For example, pp. 287, 292; evaluation section of each lesson plan.	Part Two The Artist in the Community	
		Part Three Art Applications and Appendices	
• **Washington Crossing the Delaware** pp. 3–41 • **The Visual Elements of Art and The Compositional Principles of Design** using **Washington Crossing the Delaware** as a base for instruction, pp. 42–70 • **Forms of Expression,** pp. 71–120, for major artists' works • See the **Evaluation** section of each lesson plan—strategies for evaluation of student and artwork by students as well as by the teacher. • **Special Projects and Epilogue** pp. 121–127	• If the class has not used **Understanding and Creating Art Book One**, see black line masters for **Introduction to Art Criticism.** • Practice throughout the text for example pp. 69, 96. • **Special Projects and Epilogue** pp. 121–127	Part One The Artist and Heroes and Heroines	UNDERSTANDING AND CREATING ART, BOOK TWO
• **The Buffalo Runners, Big Horn Basin** pp. 131–166 • **Forms of Expression,** pp. 167–234, for major artists works • See the **Evaluation** section of each lesson plan—strategies for evaluation of student artwork by students as well as by the teacher. • **Special Projects and Epilogue** pp. 235–246	• Practice suggested pp. 166, 187, 194. • Students are encouraged to practice criticism independently, and teacher to use any other images of choice for student practice of the process. • **Special Projects and Epilogue** pp. 235–245	Part Two The Artist and The West	
• **The Brooklyn Bridge** pp. 249–288 • Review of **The Visual Elements of Art and The Compositional Principles of Design** using **The Brooklyn Bridge** as a base for instruction, pp. 288–290. • **Forms of Expression,** pp. 291–363, for major artists' works • See the **Evaluation** section of each lesson plan—strategies for evaluation of student artwork by students as well as by the teacher. • **Special Projects** pp. 365–371	• Practice suggested pp. 290, 298, 307, 364. • Students are encouraged to practice criticism independently, and teacher to use any other images of choice for student practice of the process. • **Special Projects** pp. 365–371	Part Three The Artist in the Industrial World	
		Part Four Art Applications and Appendices	

P A R T

THE ARTIST AND HEROES AND HEROINES

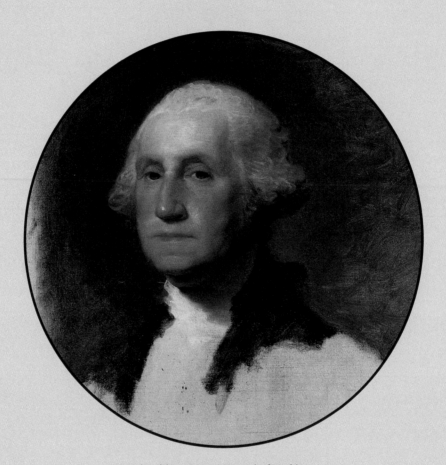

A detail from Stuart's *Portrait of Washington*.

UNIT

LET'S GET LOST IN A PAINTING

Washington Crossing the Delaware
by Emanuel Leutze

"It is doubtful whether so small a number of men in so short a space of time had greater results upon the history of the world."

A.G. Trevelyan

Figure 1. Emanuel Leutze, *Washington Crossing the Delaware.* **1855.**
Oil on canvas. 14' x 20'. The Metropolitan Museum of Art, New York. Gift of John S. Kennedy, 1897.

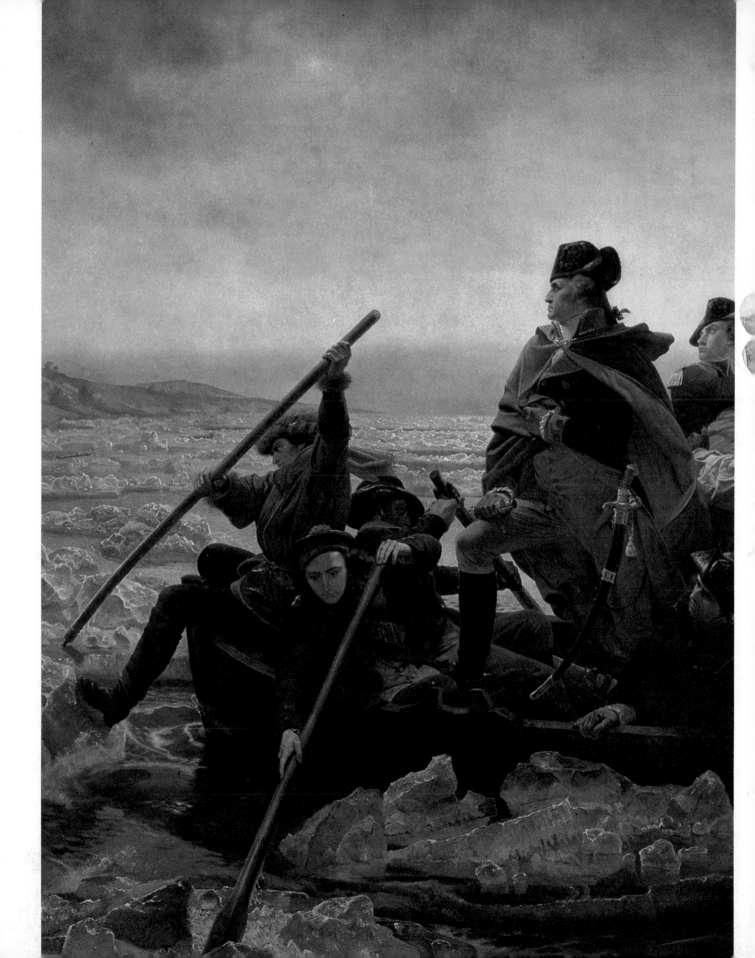

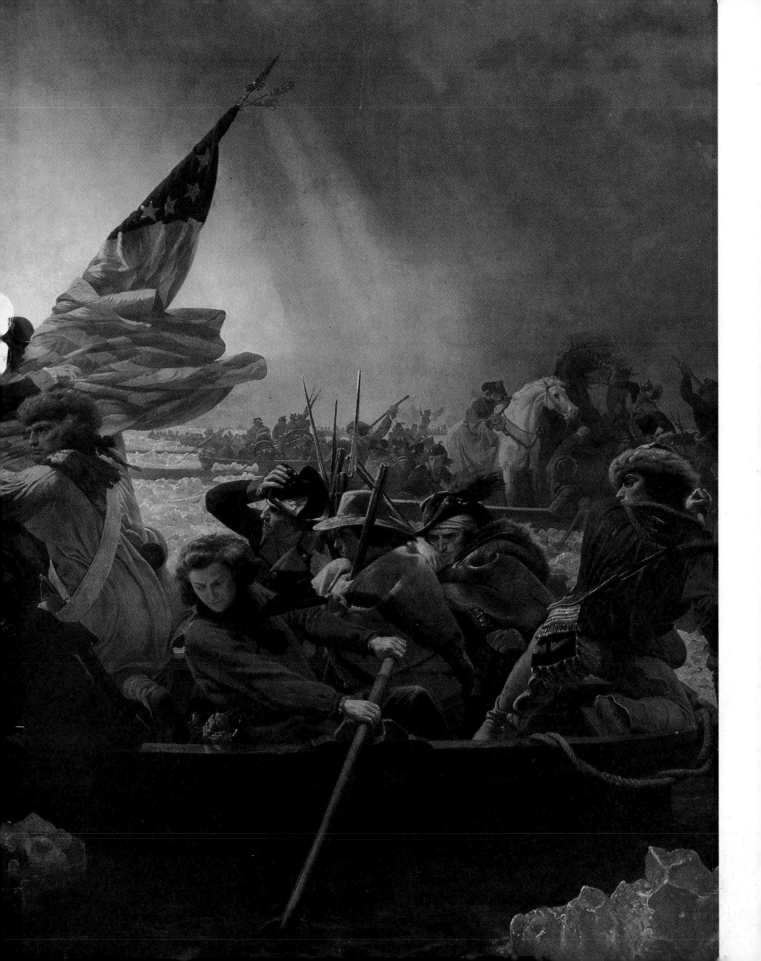

PART ONE:
THE ARTIST AND HEROES
AND HEROINES

1. See "Scheduling Your Course" section on page T-59 in this TAER.
2. Read *The Open-Ended Encounter*, page T-57.
3. See suggested Lesson Plans for *Washington Crossing the Delaware*, page T-4.
4. Use Classroom Reproduction # 1.

On the day before Christmas 1776, the Hessian commander in Trenton heard a startling rumor: George Washington was planning to cross the Delaware River and attack the British and Hessian troops. The commander, a certain Colonel Rall, roared with laughter. He is reported to have said, "If Washington and the Americans dare cross, I will personally chase them back in my stocking feet."

The colonel's statement tells much about the American army in the winter of 1776. The so-called army was a ragged group that had been defeated and driven from state to state and from river to river. The exhausted soldiers were suffering from lack of food, medical supplies, and protection from the cold. The winter had been especially severe—ice covered the Delaware River. Rall knew that crossing there was not only unthinkable, it was laughable.

On Christmas Eve, convinced that the rebellion would soon be over, Rall ordered his men to "lighten the guards and prepare for the holiday." This was Rall's last command. On the day after Christmas the American army had won the Battle of Trenton and the colonel was dead. He had made one fatal mistake. He and the entire British army had underestimated the character of a man and the power of an idea.

In 1851, seventy-five years later, an American artist living in Düsseldorf, Germany, finished painting his version of that fateful night. The public loved it immediately. To this day it remains America's most popular historical work, even though the artist is hardly known. The name of the painting is *Washington Crossing the Delaware;* the name of the almost forgotten artist, Emanuel Leutze (*loy-tse*).

You are about to take a journey into history through Leutze's painting. Since you have probably seen *Washington Crossing the Delaware,* stop before going on. Visualize the painting in your mind's eye. What do you remember most? Then go to the work. How much history can you read in it? What is the mood of the painting and of the men?

COMMANDING COMPOSITION

What people see and remember most is a sublime George Washington. He is dressed in yellow knee breeches, high boots, a dark coat lined with yellow, a gray military cloak lined with red, and a black cocked hat. His sword hangs at his side, and in his right hand he holds a spyglass. The confidence in his face and the quiet strength of his pose

reassure the soldiers and tell of the coming victory. But the power of his look goes beyond this one battle. He is the commander-in-chief who has measured the shoreline, and the statesman already planning the future of the young country.

A critic praised this picture because "unlike many good historical paintings which must be studied before being appreciated, Leutze's immediately strikes the eye." What you notice first is Washington. His stance and stature give a feeling of calm and control. But the artist has created an illusion. Once you go beyond the standing figure, the mood quickly changes to extreme danger. Wind, currents, and ice threaten the boat. The men battle the river, the cold, and their own fatigue. Hidden beneath Washington's gaze is turmoil, commotion, and great physical tension. Look at the arrangement of the men in the boat. What is each man doing? (See Figure 2.)

Ask students what effect the painting would have if Washington were seated or standing in the back of the boat. Students should see that this position, as it is, denotes leadership and confidence.

Figure 2. An outline drawing showing the men in the boat. The numbers indicate each one's activity.

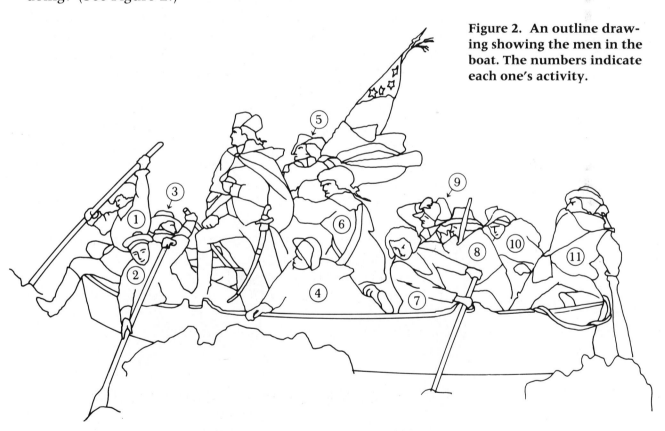

Figure 1	Pushing ice floes	Figure 7	Rowing
Figure 2	Pushing ice floes	Figure 8	Huntsman holding a gun
Figure 3	Rowing	Figure 9	Watching for danger
Figure 4	Watching for danger	Figure 10	Awaiting the battle
Figure 5	Flagbearer	Figure 11	Helmsman using an oar as a rudder
Figure 6	Flagbearer		

Discuss the expressions on the faces of the other men. Ask how the expressions affect the feeling in the painting.

This is especially true of the first six figures in the boat. Refer to the drawing on this page.

While the men appear to be in control, they are actually struggling. Study their various positions. Each body turns in a different direction. Each turn represents a human force against the force of the elements. Each twist of a body creates more tension and more activity. With such turmoil, why, asked one critic, is Washington standing? Before going on, look at the positions of the men again and try to answer this question.

Let's imagine Leutze's problem: how to dramatize the history of the country with a few men in a small boat. The men are not posing for a picture. Every action increases the feeling of danger outside the boat and the commotion within. In Figure 3 the figures have been turned into cube-like forms. Without the soft textures of their clothing, it is easier to follow the variety of ways Leutze positioned the bodies. The cubes allow you to feel the activity. In this presentation every action becomes an essential part of the design.

Notice how the angled bodies of the men create a circular motion around the fixed stance of Washington. He is the axis within the moving circle. As the men work together around him, his position stabilizes the boat.

Figure 3. The drawing shows the angled bodies of the men.

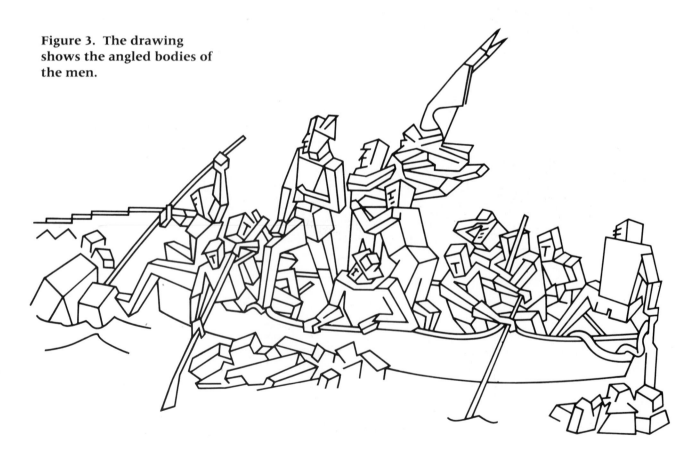

Inside the small area of a boat, Leutze made a compact design. He succeeded in creating tension and movement from eleven men working furiously, cramped and huddled together. The term for this technique in art is depth of motion. Leutze then calms the swirling motion with the standing figure. The arrangement of the men dramatizes danger, while Washington's fixed position makes order out of chaos.

DANGER ALL AROUND

The dangers outside the boat can be seen in the sea of ice. The artist designed the ice floes as heavy floating shapes—wandering aimlessly with the currents, banging against the boat. Figures 4 and 5 show the complex details of the two main ice floes.

Only a small portion of the ice floes shows above the water; as with icebergs, most is hidden below. It is hard to judge the floes' real size. Imagine they are above the water; then they would easily be as large as the boat. These giant floes are like mountains with jagged rocks jutting out in all directions. In the drawing, the threat of these pointed shapes can be felt. On the lower-right ice chunk, Leutze's name is splattered in blood. The two large ice floes in the foreground

Have students notice how close the ice floes are to the boat. This positioning increases the sense of danger and struggle.

Have students tilt the painting to see that the ice floe in the lower right resembles a profile of a human face.

Figure 4. Ice floes in the foreground.

Figure 5. Outline of jagged ice floes.

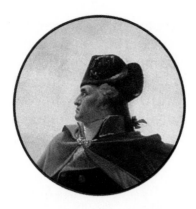

Figure 6. Detail showing the expression on Washington's face in *Washington Crossing the Delaware* by Emanuel Leutze (Figure 1).

Figure 7. Detail of ice floe that resembles a human face in *Washington Crossing the Delaware* (Figure 1).

What else in the painting suggests that the boat is rocking? Point out the ripples of water and the men struggling for balance.

take on the shapes of frozen masks of death floating in the water. The response to the threat is the calm look of Washington, repeated in the flagbearers, the huntsman, and in the helmsman at the rudder (compare Figures 6 and 7).

Nature's shapes are terrifying and destructive. Without Washington's presence the boat could end up like the large tree twisted into the ice (Figure 8).

Leutze resolves the conflict by the stability of the boat. Although it seems to be going smoothly ahead, this is another illusion. The boat is rocking, but the design hides the movement.

Figure 8. Tree branch embedded in the ice. (Detail from Figure 1.)

The drawing in Figure 9 shows the directions of the oars and the flag. Each oar slants in a different direction. By slanting them at various angles, Leutze shows the force of

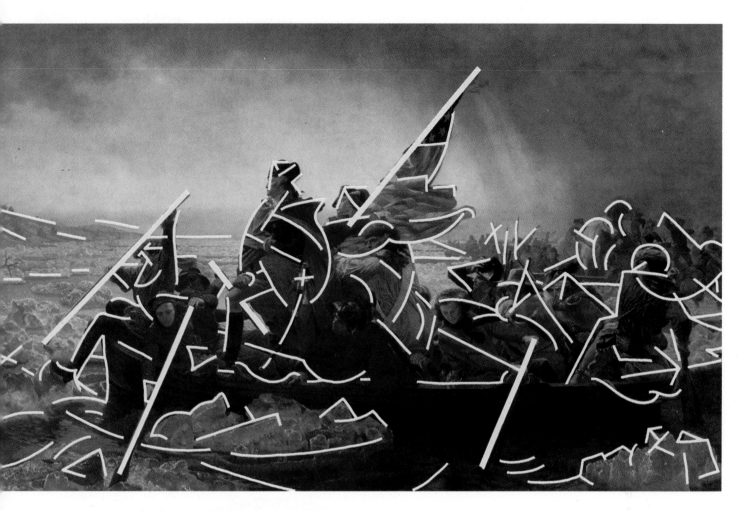

Figure 9. The lines indicate the visual movement in this detail of *Washington Crossing the Delaware* **(Figure 1).**

wind and currents. These diagonal lines break the circular motion and create another visual movement. The six major lines (the five oars and the flag), together with the soft curves and the other slanted lines in the drawing, give the impression of a rocking boat. The lines move to the rhythm of the currents in the water.

It may be difficult to visualize this rocking motion because the oars are arranged in triangular shapes. To Washington's right the two oars meet to form a triangle (Figure 10). To his left another triangle is made up of the huntsman's gun and the oar (Figure 11).

Notice the constant repetition of triangular shapes within the boat: the left leg of the first figure, Washington's left arm and right leg, the body position of the fourth figure. (Refer to Figure 9.) If you extend the angles of the front and

11

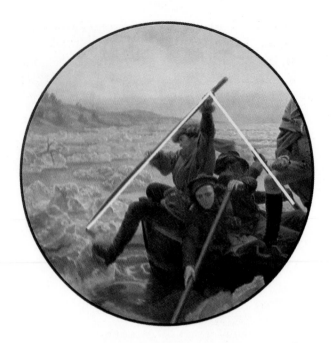

Figure 10. Detail of Figure 1 shows triangular shape of men in the bow.

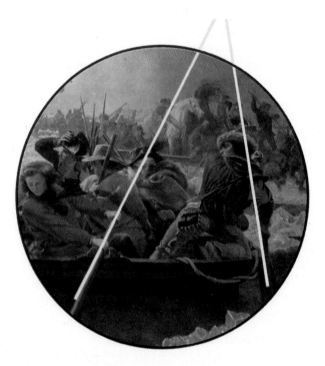

Figure 11. Detail of Figure 1 shows another triangular shape of the men.

rear oars, they meet to form a large pyramid at the top of the boat (Figure 12). The triangles and the large pyramid give a feeling of stability. The boat rests on the water in the same way a stepladder stands on the ground. The ladder balances when the two equal opposite forces meet to form the apex of a triangle. At the center of this large pyramid the artist braced his "ladder" with another triangle: a "V" made by the line of Washington's head and back against the flag (Figure 13.)

Figure 12. A pyramid shape is formed by extending the angles of the oars (detail, Figure 1).

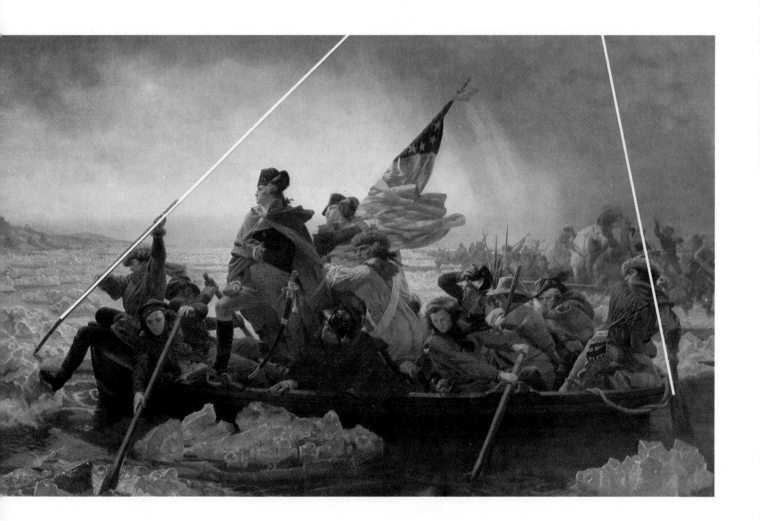

Figure 13. Comparison of solid "V" shapes (detail, Figure 1).

Ask students what effect knowing these details has on their reaction to the painting.

The "V" is the artist's final touch. It takes two men to hold the flag. As the wind whips against the flag it is met and balanced by the forceful figure of Washington. The final design gives the feeling and creates the illusion of balance, stability, and calm.

AN HEROIC STORY

The danger in the painting and the harshness of the elements accurately depict what Washington and his men faced during the winter of 1776—the most desperate moment of the American Revolution. Washington had planned to cross the river and attack in early evening. The Americans were to cross in three groups: the first under his command, the second under the command of General Cadwallader, and the third under General Ewing. But the crossing was so difficult that Cadwallader and Ewing had to turn back. It was not until four o'clock on the morning of the next day, December 26, that Washington's forces reached the New Jersey shore, ready for the nine-mile march to Trenton. Figure 14 shows Washington's advance for the surprise attack.

Only Washington's will got the men across. The men, already exhausted, were beginning to freeze. So pitiful was

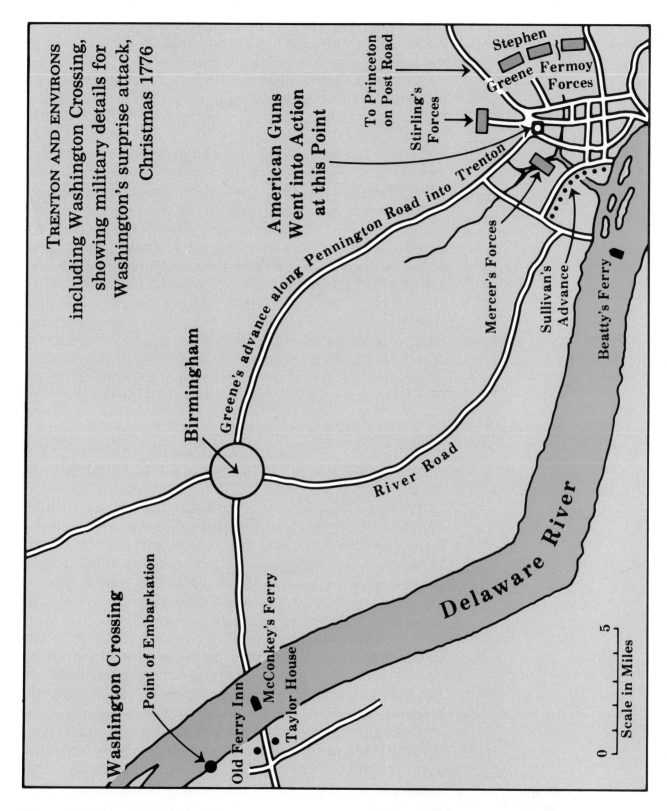

Figure 14. Map: Trenton and Environs, including Washington Crossing.

15

their condition that a messenger who followed them tracked their route easily "by the blood on the snow from the feet of the men who wore broken shoes."

One hour after daylight on December 26th, they arrived in Trenton. The Hessians, totally surprised, at first fought but then surrendered. After the battle, Washington reported the victory to Congress: approximately 80 Hessians killed, 900 others captured, along with a large store of supplies and ammunition. The Americans lost four men—two killed in the fighting, two others frozen to death during the crossing.

The victory at Trenton changed the course of the American Revolution. The inexperienced volunteers who had fled in terror from the Hessian bayonets had finally beaten their dreaded enemy. It was a victory not measured by the number of men captured or killed. It was the beginning of an army fighting for a cause that was not hopeless. Coming after a long series of defeats, it gave fresh courage to the cause of freedom. Years afterward the English writer A. G. Trevelyan described the importance of Trenton: "It is doubtful whether so small a number of men in so short a space of time had greater results upon the history of the world."

MANY PAINTERS, MANY PICTURES

Seventy-five years later, Emanuel Leutze put a small number of men in a boat and painted his version of *Washington Crossing the Delaware*. Leutze was born in Germany in 1816. When he was nine, his family came to America. The young Leutze grew up in Philadelphia and probably visited the place where Washington made the crossing. While still in his teens, he showed such artistic talent that he was sent back to Europe to complete his art studies. In 1849, in his studio in Düsseldorf, Germany, he began to work on *Washington Crossing the Delaware*. He finished the painting in 1851, and then came back to America where he remained until his death in 1868.

During the two years of painting the *Crossing* there were several interruptions, including a fire which partially destroyed the first canvas. Upon its completion, Leutze sent the painting to New York for exhibit, and the public loved it immediately. In time the work became popular around the world. Just a few years ago when representatives from

the People's Republic of China came to the Metropolitan Museum of Art in New York City, the one painting they knew and recognized was *Washington Crossing the Delaware.*

And yet, as popular as the work is, almost no one knows Leutze's name. In a strange way the popularity of the painting has worked against the artist; the work has been taken for granted. Historians look for errors, artists neglect it, and writers often omit the work from art books. Yet the painting continues to please new generations. It remains *the* popular image of the crossing. This, by itself, is interesting since Trenton had long stirred the imagination of artists. On the following pages you will look at versions of the crossing by three of America's foremost artists: John Trumbull, Thomas Sully, and George Caleb Bingham.

John Trumbull had been a soldier in the Continental Army. Around 1794 he painted *Capture of the Hessians at Trenton, December 26, 1776* (Figure 15). Under a large windswept sky the Hessians surrender to Washington. In the background an American flag rises in the breeze, while in the front the Hessian banner lies on the ground. The ceremony is formal; the battle is over. Trumbull was the "patriot painter" of the American Revolution. His work celebrates the men who fought. The key in Figure 16 (pages 18–19) identifies every major figure in his picture.

In 1819 Thomas Sully received a commission to paint *The Passage of the Delaware* (Figure 17) for the capitol building of North Carolina. But the painting (12 feet by 17 feet) was too large for the wall space and was rejected. This splendid work now hangs in the Museum of Fine Arts in Boston. Sully depicts Washington and his men preparing to cross the river. Mounted on a white horse atop a snow-covered hill, Washington is watching men in uniform at the left pushing a cannon while boatloads of troops cross the river below.

George Caleb Bingham's *Washington Crossing the Delaware* (Figure 18), completed in 1871, evokes a dramatic and beautiful mood. In front of a blue, dawn-lit sky, a thoughtful Washington is seated on a white horse. His gaze is directed toward the shore. The crossing has been made, and the boat is ready to land.

The works of Trumbull, Sully, and Bingham are important, and each can be studied and appreciated on its own terms. Sully's painting had been the most popular in America. Leutze's 1851 work not only replaced it but also made

Have students point out elements in Trumbull's painting that indicate its idealized character.

The faces of the common fighting men are not shown in Sully's work. What effect does this have on the painting? Have students compare Sully's work with Leutze's. Ask students to identify other elements missing from the Sully painting.

Have students compare Bingham's painting with Leutze's. How are the men in the boat different? What is the effect of the color in Bingham's work?

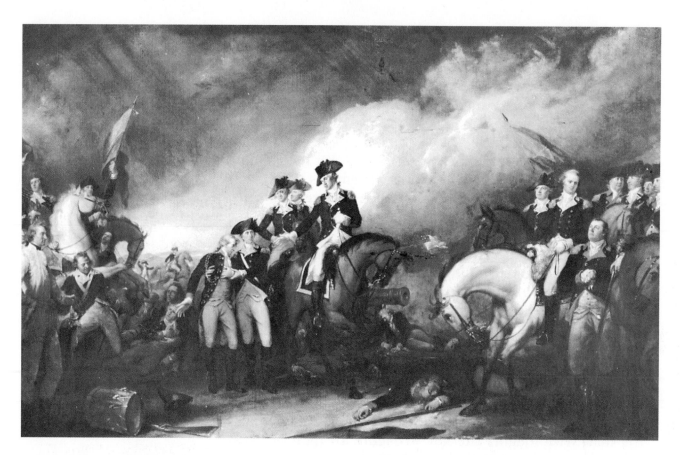

Figure 15. Trumbull's work celebrates and idealizes the men who fought in the American Revolution.

John Trumbull, *Capture of Hessians at Trenton, December 26, 1776.* c. 1786–1828. Oil on canvas. 21 1/4" x 31 1/8". © Yale University Art Gallery.

1. **Edward Wigglesworth** 1742–1826 Merchant and sea captain of Newburyport, Massachusetts; Revolutionary soldier; member of the Massachusetts General Court; Collector of the Customs at Newburyport.

2. **William Shepard** 1737–1817 Of Westfield, Massachusetts; Revolutionary soldier; member of Congress.

3. **Josiah Parker** 1751–1810 Of "Macclesfield," Isle of Wight County, Virginia; Revolutionary soldier; member of Congress.

4. **James Monroe** 1758–1831 Of "Oak Hill," Loudon County, Virginia; President of the United States; Revolutionary soldier, statesman.

5. **Johann Gottlieb Rall** 1720–1776 Colonel of Hessians serving with the British during the Revolution; killed at the Battle of Trenton (posthumous portrait).

6. **William Stephens Smith** 1755–1816 Lawyer of New York City and Lebanon, New York; Revolutionary soldier; Secretary of Legation, London; member of Congress.

7. **Robert Hanson Harrison** 1745–1790 Lawyer of Charles County, Maryland and Alexandria, Virginia; Revolutionary soldier; Chief Judge of the General Court of Maryland (from memory).

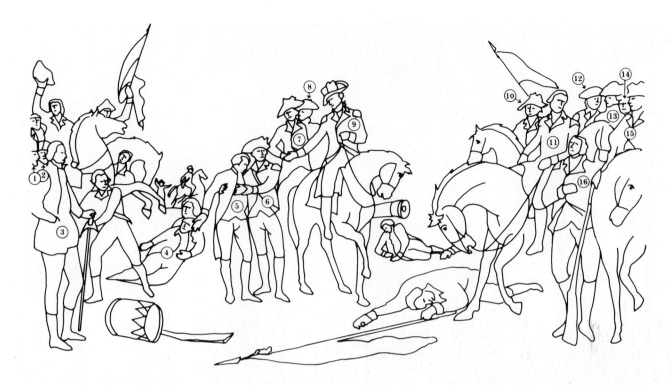

Figure 16. Match the numbered figures with the list to identify the people in the painting in Figure 15.

8. Tench Tilghman 1744–1786 Of Maryland and Pennsylvania; Revolutionary soldier; volunteer aide-de-camp and secretary to Washington by whom he was chosen to carry to the Continental Congress the news of the surrender of Lord Cornwallis.

9. George Washington 1732–1799 LL.D. 1781. Of "Mt. Vernon," Virginia; first President of the United States.

10. John Sullivan 1740–1795 Lawyer of Durham, New Hampshire; Revolutionary soldier; member of Congress; Governor of New Hampshire.

11. Nathanael Greene 1742–1786 Of Rhode Island and "Mulberry Grove," Savannah, Georgia; Revolutionary soldier; Quartermaster General.

12. Henry Knox 1750–1806 Of Boston, Massachusetts and "Montpelier," Thomaston, Maine; Revolutionary soldier; Secretary of War.

13. Philemon Dickinson 1739–1809 Lawyer of New Jersey and Pennsylvania; Revolutionary soldier; United States Senator.

14. John Glover 1732–1797 Of Marblehead, Massachusetts; Revolutionary soldier often in charge of transportation; secured boats for the crossing of the Delaware.

15. George Weedon *c.* 1730–1793 Innkeeper of Alexandria, Virginia; Revolutionary soldier.

16. William Washington 1752–1810 Planter of Virginia and "Sandy Hill," St. Paul's Parish, South Carolina; Revolutionary soldier, cousin of General Washington.

19

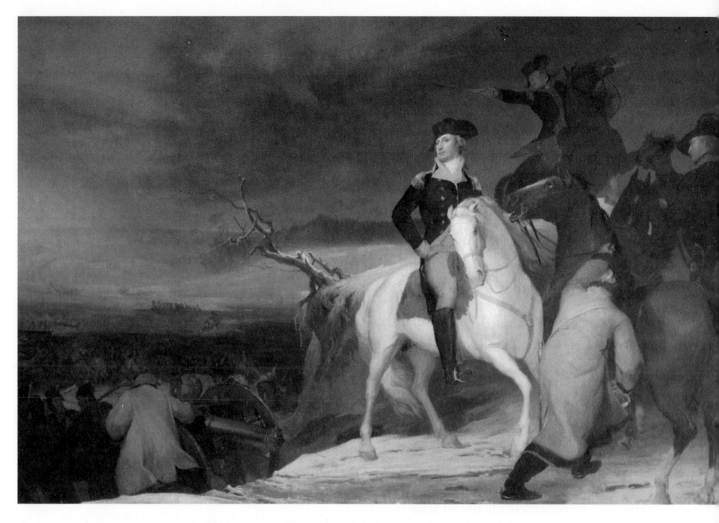

Figure 17. This painting was commissioned for the capitol building of North Carolina, but was too large (over 12′ x 17′) for the wall space. Thomas Sully, *The Passage of the Delaware*. 1819. Oil on canvas. 146 1/2″ x 207″. The Museum of Fine Arts, Boston.

Sully's *Passage* obscure. These three paintings are just as good as Leutze's. (In the opinion of many, they are better.) However, only Leutze's work is still seen everywhere—in schools, libraries, books and even in other paintings.

All of the artists took certain liberties with historical truth. The characters in Trumbull's work might or might not have been at Trenton. In Bingham's painting you will find to the left of Washington another famous American who was certainly not at Trenton, Andrew Jackson. Bingham, a midwestern artist who painted life on the Mississippi River, took other liberties in his painting. His Washington resem-

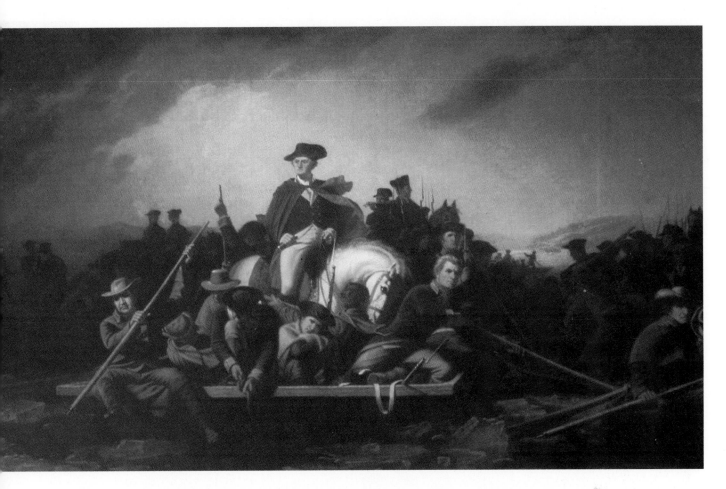

Figure 18. Bingham portrays a thoughtful Washington as the crossing is completed.
George Caleb Bingham, *Washington Crossing the Delaware*. 1856/1871. Oil on canvas. 36 5/8″ x 57 1/2″. The
Chrysler Museum, Norfolk, Virginia. Gift of Walter P. Chrysler, Jr., in honor of Walter P. Chrysler, Sr.

bles a riverboat man who appears in his other paintings,
and the boat is a Mississippi river raft.

The boats used in the crossing were Durhams. These
boats hauled cargo between New Jersey and Pennsylvania.
(Washington had the Durham boats available because he
had deliberately taken them during his initial retreat across
the Delaware.) They were long, low boats that held thirty to
forty people. Leutze did not have a model of the Durham
boat, nor would it have suited his purpose. His boat with
the twelve figures permits the viewer to see each individual
effort as part of the overall design.

Have students compare the
photograph with Leutze's
painting. Which do students
prefer? Have them give rea-
sons for their choices.

21

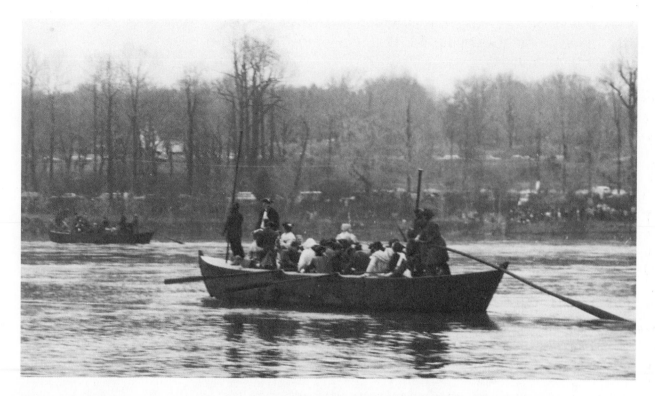

Figure 19. A modern re-creation of the crossing in a Durham boat, Washington Crossing, Pennsylvania. Courtesy of the Washington Crossing Foundation.

AN HISTORICAL PORTRAIT

Leutze's work does not have the sweep of a Trumbull sky, the beautiful harmony of color and movement of Sully's masterpiece, nor Bingham's quiet mood of dawn on the river. What it has is action and courage. The other paintings are quiet, almost subdued by beauty. Leutze's work is full of passion. It has drama! It portrays courage. It tells the story of that supreme moment when one man changed the course of history. It is the missing page of the book; a country's history in a small scene. In an action-packed, condensed area it tells everything about the conditions and the man.

All the works are historical paintings, but Leutze's has one important difference. Traditional historical paintings celebrate great events with large panoramas in which the eye wanders over the entire canvas. Go back and look at the other three works. The vast sweeps of land and sky require

time and study. They take our attention away from the central figure. In all of the paintings Washington is the center, but only in Leutze's work does all the action focus directly on him.

Although his *Crossing* is a history painting, its dramatic events make up an historical portrait. The tension, the battle against the elements, the fears of the men, and the future of the country are all resolved in this heroic portrait. It is the portrait of a man; it is also a portrayal of that moment when the fate of the country hung in the balance. Leutze shows that particular moment by depicting the condition of the army in the clothes of the men, the distance of the boat from the shore, and the time of day (or night). Look at the painting again. What does the dress of the men tell you? Who are they? Whom can you identify?

When the painting was first exhibited, Leutze wrote a short description for the catalogue: "The picture reproduces the moment when the great general is steering to the opposite shore in a small boat surrounded by eleven heroic figures—officers, farmers, soldiers, and boatmen." Leutze could not possibly have painted their actual clothes, but he had made a lifelong study of the Revolution. The clothes on Leutze's figures follow Washington's own descriptions of the Continental army before the crossing (Figure 20). They did not have uniforms because they were not yet an army. The soldiers were exhausted; their condition weak. The man with the bandage around his head recalls Washington's report of their condition: seven out of every ten men were sick, wounded, or unable to fight. *If Rall were watching he might have laughed!*

The only figures to be positively identified are the officer supporting the flag, young Colonel James Monroe (later President Monroe), and the black man at the oars to Washington's right who is Prince Whipple. Prince Whipple also appears in Sully's painting at the right of Washington (Figure 21).

Prince Whipple's place in the pictures at a time when slavery existed in America is an important statement. Whipple's personal story is also a fascinating piece of Americana. According to historical records he was born in Africa of fairly wealthy parents. At about the age of ten he was sent to America to be educated—"to enjoy the benefits of the New World." On the way, a treacherous ship captain brought him to Baltimore, where he was sold as a slave. The man who bought him was General Whipple of New Hampshire. Dur-

Artists did not have photographs to use in their research. Discuss the different sources they might have used for information, such as first-hand accounts, written reports, and books.

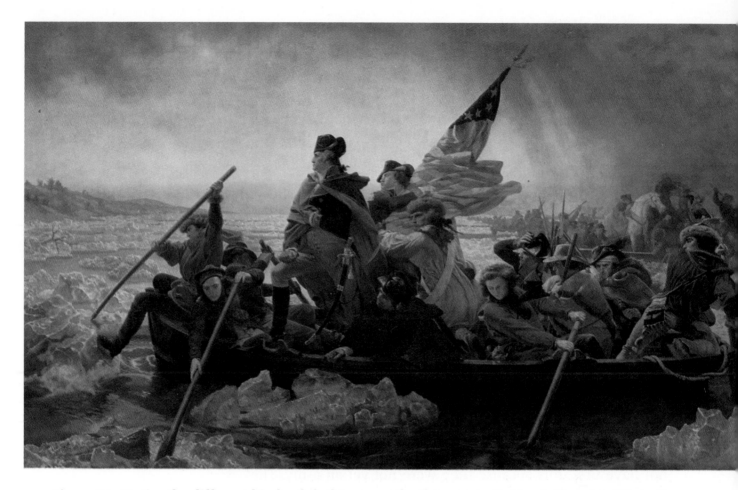

Figure 20. Notice the different kinds of clothing worn by the men in the boat. (See also Figure 1).

ing the Revolution he was given his freedom and served first under General Whipple and later under Washington. It is not clear whether Sully or Leutze knew the incredible story of blacks who chose to come to America, but Prince Whipple's place in their paintings tells much about both artists' vision of America.

The location of the boat in the water tells us the time (hour) of the picture. Can you determine how far the boat is from the shore? How long have the men been on the water? Look at the painting, then go to the diagram (Figure 22).

The diagram shows the boat without the men. You can get an idea of the boat's location by finding both shorelines at the back corners of the picture. On the left side is the New Jersey shore. If you follow the long line of boats behind Washington, you come to the other shoreline. When you extend the shorelines outside the picture frame, you realize that the boat is actually quite far from both shores,

Figure 21. The detail on the left shows Prince Whipple in Thomas Sully's painting, *The Passage of the Delaware* **(Figure 17). The detail on the right is from Emanuel Leutze's work,** *Washington Crossing the Delaware* **(Figure 1).**

Figure 22. This drawing shows the location of the boat on the river.

somewhere in the middle of the river. The shore looks close, but this is another illusion. Since the men embarked in the late afternoon on December 25 and did not arrive until the next morning, they had been struggling on the water for a number of hours.

THEATRICAL EFFECTS

From the artist's use of light, can you determine the time of day (or night)? Out of the dark night haze the line of boats leads up to the front. In the sky shines the last star of

Ask what Leutze's use of dark and light communicates. Students will probably offer that it reinforces the sense of hope in the painting.

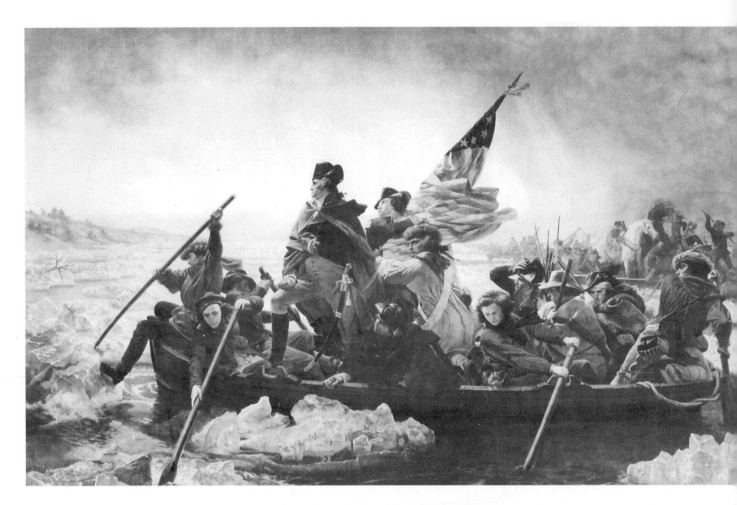

Figure 23. Notice how much light there is on the left side of the painting. (Black and white version of Figure 1.)

night—the morning star. The boat is moving toward the light of dawn. Washington is standing in the center of the light; the effect is theatrical—as if Leutze had thrown a spotlight on him. You can see his use of light in a black and white version of the painting (Figure 23).

In the black and white version you get the feeling of a drama. The dark haze above has the shape of a theater curtain. "On stage" the spotlight falls on the boat. Since the eye seeks and follows light, the white (or light) leads the eye from right to left. The light pushes the boat from the densely packed (dark) right into the open lighter area to the left. The boat moves in the same direction as the gaze of the standing figure in the center of the light.

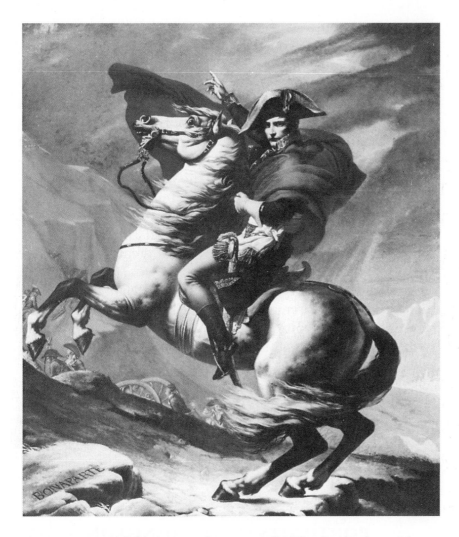

Figure 24. David depicts a calm, controlled leader in the midst of danger. Jacques-Louis David, *Napoleon Crossing the Alps.* 1800. Oil on canvas. 8′ 11 1/2″ x 7′ 7 1/2″. Versailles Palace. Courtesy, Cliché des Musées Nationaux, Paris.

Washington's placement at center stage has another theatrical effect. Leutze has raised him above the men. His position suggests a rider on a horse. He has mounted the boat and is riding out the storm.

The position recalls a dangerous crossing depicted in another world-famous painting: *Napoleon Bonaparte Crossing the Alps at the Great Saint Bernard Pass* by the French artist Jacques-Louis David (dah veed′) (Figure 24.) If you visit Versailles and see this work, you will note just how much one artist influences another. Washington's breeches are the same yellow as those of Napoleon.

David painted the work in 1804, four years after Napoleon had crossed the Alps during his second Italian

campaign. The crossing of the Alps was dramatic and dangerous. In the background, the army moves slowly over the ice. In the foreground, Napoleon is mounted on a spirited horse. As in Leutze's work, the action is violent but the picture is calm. The horse is rearing up and appears almost out of control. However, it is no match for the power and control of the rider. David carefully fixed Napoleon's leg on the horse and turned his calm and determined face to the viewer. Notice the triangular shape of the left leg firm in the stirrup and the left hand clenching the reins. The rider's position balances the wild movements of the animal. As the right arm points the way, you can read David's vision of Napoleon. The face of Napoleon carries greatness and calm and dominates the picture.

Although Washington is standing and Napoleon sitting, their positions are remarkably alike. Compare Washington's stance with Napoleon's position on his horse (Figure 25). In both pictures the exaggerated triangular shapes of legs and arms anchor the actions and keep the eye locked on the face.

David was a close friend of Napoleon, and his portraits are the result of their time together. Leutze worked many years after the death of Washington. Since photography had not been invented in Washington's time, Leutze had to work from portraits of other artists.

PORTRAITS OF WASHINGTON

There was no shortage of portraits. America, after the Revolution, was in the age of portrait painting. The heroes of the war were the subjects of the artists, and the man they celebrated most was George Washington. Artists came from all over America and Europe to paint his portrait. The quickest way to a fortune was a successful portrait of Washington. Once you have seen several of the portraits it is apparent that no two are alike. It would be impossible to study them and determine the exact likeness of the man.

Washington's family considered Charles Willson Peale's *George Washington at Princeton* to be the truest portrait (Figure 26).

The victory at Princeton came soon after Trenton. Peale had been a soldier with Washington and was a close friend of the family. The painting shows Washington at ease, resting an arm on a cannon. Peale painted this portrait in 1779

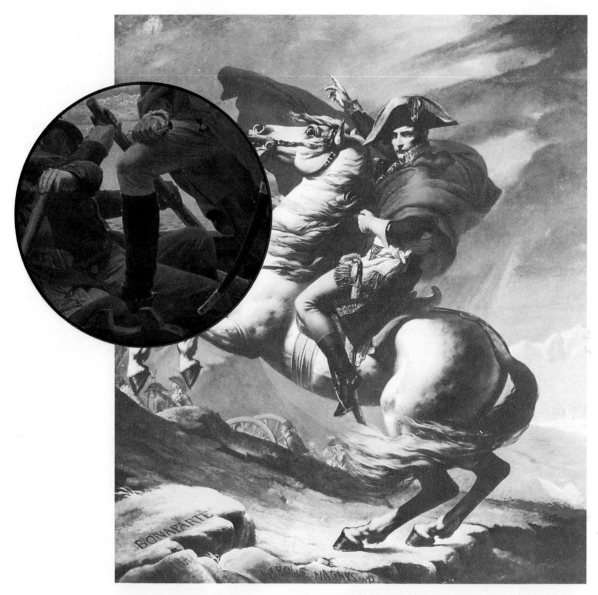

Figure 25. This detail (inset) from Leutze's painting, *Washington Crossing the Delaware* (Figure 1), shows the similarity of Washington's stance and Napoleon's position on his mount in the David painting (Figure 24).

at the request of the Supreme Executive Council of Pennsylvania. It was to be an official state portrait. Official portraits are usually formal and "stiff," but here you can feel the warmth of Washington in his relaxed pose. His face, full of pride and confidence, reflects the victories at Trenton and Princeton. In the left background, American soldiers are leading British prisoners to the buildings at Princeton College. To the right above Washington, an American flag with the thirteen stars of the colonies unfurls over the fallen Hessian banners.

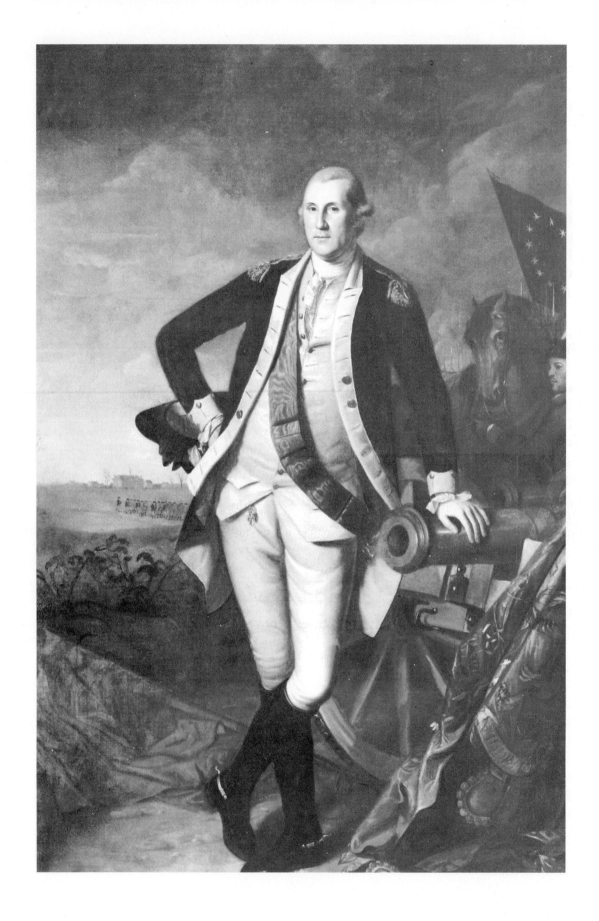

This picture had something special to tell Leutze. Historians critical of Leutze have noted that Congress had not yet approved the American flag at the time of Trenton. Peale had been at Trenton and is highly regarded for his accuracy. He had studied the exact military details of the battle. The American flag in his picture proves that a flag had been established at Trenton.

The enormous range in portraits of Washington reveals the different qualities of his greatness. Some artists painted him as a general, others as a statesman, and still others as a successful businessman. The two most important portraits, however, were inspired by Washington the horse trader. One is by Gilbert Stuart; the other by the French sculptor Jean-Antoine Houdon.

Gilbert Stuart is considered America's foremost portrait painter. Because of his reputation, Stuart was able to get Washington to sit three different times. The result was three different paintings. During the first two portraits, relations between artist and subject were formal and cold. Stuart was a brilliant talker and could excite people with his conversation. During the first sitting, as he chatted on subjects he thought important to the President, Washington remained silent. Stuart complained that the instant Washington started to sit he became totally distant, almost bored. The result is the first portrait—known today as the Vaughn portrait, (Figure 27).

When the portrait was first shown, it was highly praised, and many experts still consider it the best. But Stuart felt it was a failure—and Peale agreed. When Peale saw it he said, "If some day in the future Washington returned to life and should stand side by side with this portrait, he would be rejected as an impostor."

The sittings for the second portrait were even more difficult. By then Stuart was angry. He hated to dress his subjects in fancy lace or place them in elegant settings in full portrait—the very things he put into the second portrait, the Landsdowne portrait.

This full-length portrait shows Washington holding a sword, with his right arm extended in a theatrical pose. But Stuart noticed something else. Washington was having trouble with his newly made teeth. His lower plate fitted him so

Remind students that an artist's vision represents a composite of many different visions. This is an important element of art in general.

What other elements seem out of place or uncharacteristic of Washington and America in the Landsdowne portrait? Students may notice the background painting, the columns, and Washington's short body.

◄ **Figure 26. Peale's warm and informal portrait reflects the General's pride and confidence.** Charles Willson Peale, *George Washington at Princeton*. 1779. Oil on canvas. Courtesy the Pennsylvania Academy of Fine Arts, Philadelphia. Gift of Maria McKean Allen and Phebe Warren Downes through bequest of their mother, Elizabeth Wharton McKean.

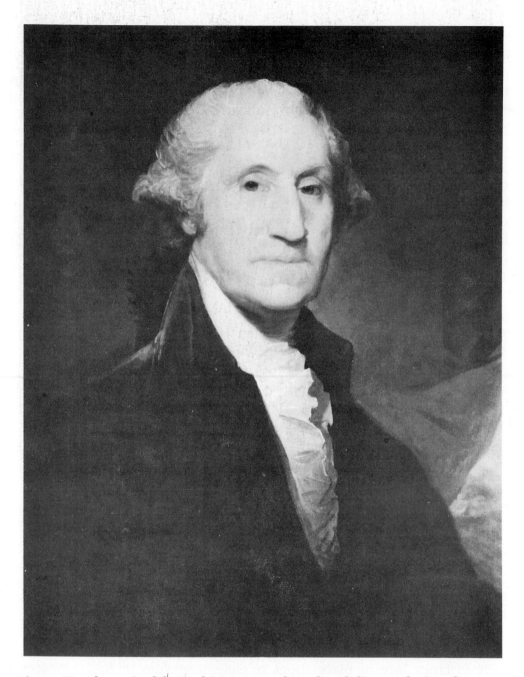

Figure 27. The artist felt Washington was bored and distant during the sittings. Gilbert Stuart, *Portrait of George Washington* (The Vaughn Portrait). The Metropolitan Museum of Art, New York. Rogers Fund, 1907.

badly that it pulled the lower part of his face out of shape. Look closely at the mouth in the Landsdowne portrait. The jaw takes away the heroic effect. Washington looks as though he is clenching his teeth, and his eyes, half closed, are distant.

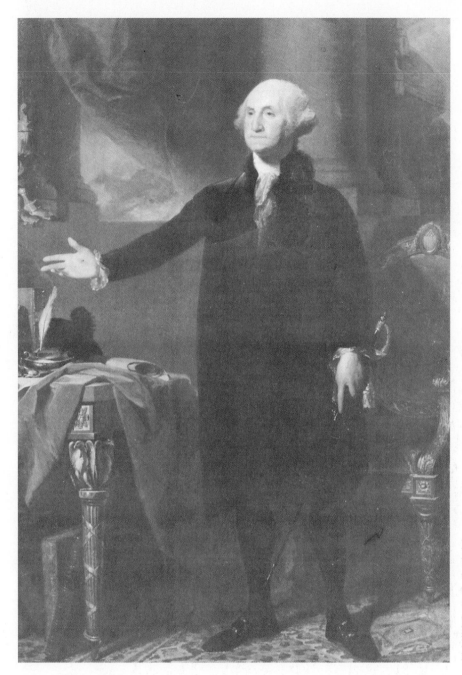

Figure 28. Stuart still felt unable to communicate with his subject.
Gilbert Stuart, *Portrait of Washington* (The Landsdowne Portrait). 1796. Oil on canvas. 96" x 60". Courtesy of the Pennsylvania Academy of Fine Arts, Philadelphia. Bequest of William Bingham.

By Stuart's time George Washington had become a legend all over the world. We can only guess what Stuart had in mind, but this is not the presentation of the legend. Perhaps it is Stuart's reaction to the Washington who took no pleasure in the artist's gossip and chatter. Stuart's second portrait is of a man who still remained distant and cold to him (Figure 28).

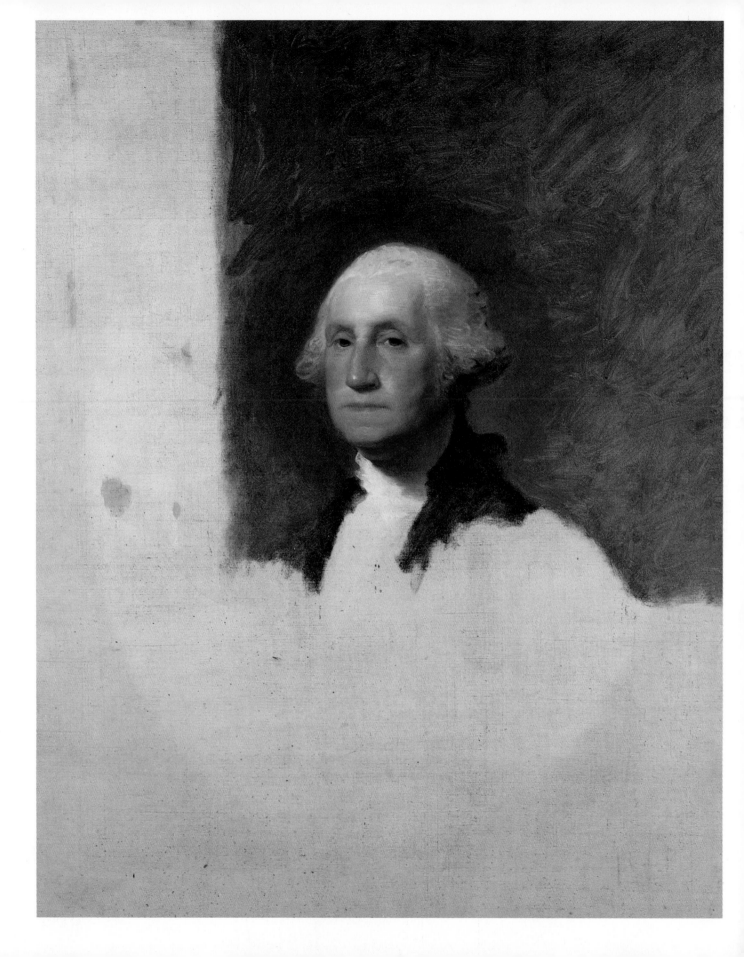

In 1796 Stuart did his third portrait of Washington at Mrs. Washington's request. Stuart's studio in Philadelphia was an old stone barn. When Washington first appeared, Stuart noted that his false teeth had been fixed. Stuart started to talk, and again Washington did not relax. Suddenly Stuart looked up and saw a gleam in his eye and a smile flash across his face. Stuart was amazed. Washington had seen a splendid horse gallop by the window and immediately the face became alive. Stuart started to talk about a local race horse. From horses the conversation went to farming; again Washington's face became alive and spirited. As Washington talked, Stuart worked. The result of that one moment is the sum of a lifetime, the Athenaeum portrait (Figure 29).

Everything about the man Washington is captured in this work. It is a picture of dignity, thought, and assurance. There are no props; the head stands out all by itself. Light falls on the face and reveals a strong jaw, thoughtful eyes, and a firm mouth. Many Americans know only this portrait of Washington because it appears on the dollar bill. Others think that to know this one is enough.

Leutze had been impressed by Stuart's Athenaeum portrait. In preparation for his own work he had made several studies of it. To this day there are copies of the Athenaeum portrait in museums signed "artist unknown." The unknown artist is Emanuel Leutze. But when it was time to select the model for his painting, Leutze went to the work of the French sculptor Jean-Antoine Houdon.

Houdon had left France for Mount Vernon in 1785 to make a bust for a statue of Washington. During the sitting Houdon was having a difficult time. Washington's face had the gloomy stare he saved for these occasions. Suddenly an unexpected arrival interrupted. A man, a horse trader, was brash enough to insult Washington's knowledge of horses. Washington's face lit up and the sculptor put his expression in the clay bust (Figure 30). By a stroke of luck, Houdon succeeded.

Since Washington was considered to be the greatest horseman of his time, both these stories could be true. It is certainly of interest to note that the best portraits of Washington were not inspired by war, politics, or business but by his love of horses and his knowledge of farming.

Discuss with students how this moment must have affected both the artist and Washington.

Point out that almost twenty years separate Peale's painting and Stuart's last portrait.

Point out that the portrait on the dollar bill is a copy of Stuart's painting. Have students note the differences between the two.

◄ **Figure 29. Stuart found that Washington loved to talk about horses, and this superior portrait emerged.** Gilbert Stuart, *Portrait of Washington* (The Athenaeum Portrait). 1796. Oil on canvas. 48" x 37". Jointly owned by the Museum of Fine Arts, Boston and the National Portrait Gallery, Smithsonian Institution, Washington, D.C.

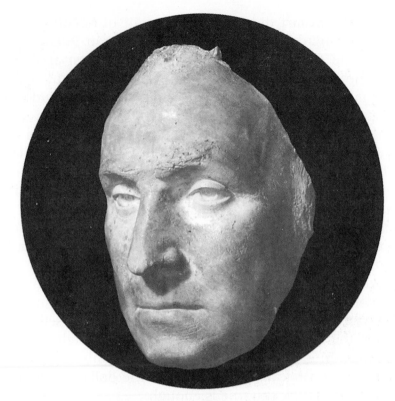

Figure 30. *The Mask of Washington,* **by Jean-Antoine Houdon (the Leutze-Stillwagen mask) is both noble and visionary.** Jean-Antoine Houdon, *Mask of Washington.* (The Leutze-Stillwagen Mask.) 18th century. Plaster. Life size. Courtesy of the Pierpont Morgan Library, New York.

This is yet another example of an artist being influenced by another artist's work.

The Athenaeum portrait and the Houdon bust are both important works, but the Houdon bust was Leutze's choice for his Washington. Leutze owned a rare copy of a mask made from the bust and is thought to have made a special trip to America to get it. Look at the Houdon mask. What does it tell about Leutze?

Houdon, the greatest sculptor of his age, had something special to tell about the universal quality of George Washington. The mask kept the faithful likeness of the man, but the noble face has a sublime expression. It is slightly uplifted and looks to the future. His gaze goes beyond time and space. That expression is the exact look Leutze wanted at the top of the pyramid of his storm-tossed boat (Figure 31).

WHAT THE ARTIST HAD IN MIND

Why would Leutze do such a painting seventy-five years after Trenton? And why this particular scene, already paint-

Figure 31. These two details show the similarity between Washington as depicted in the Leutze painting, *Washington Crossing the Delaware* **(Figure 1), and Houdon's mask (Figure 30).**

ed by so many other artists? Perhaps we will never know exactly why and how an artist chooses his subject, but the history of Leutze's life provides a clue.

In his catalogue description of the painting, Leutze said he hoped it "would have a special meaning for these troubled times." The year 1849, when Leutze began this work, was a period of turmoil in Europe. Germany was a confederation of small states governed by feudal lords and princes. In 1848 there had been a revolution that tried to unite the country and bring freedom to the people. It failed, and Germany went through a period of chaos and repression. The failure of that revolution was a devastating blow to Emanuel Leutze.

By then he had become a world-famous artist. Almost all of his paintings celebrated scenes of human liberty. A typical example of his earlier work is an 1843 painting depicting the founding of America, *Columbus Before the Queen* (Figure 32).

It is easy to see the difference between *Columbus* and *Washington Crossing the Delaware. Columbus* is a traditional historical painting with far less power, design, and intensity than *Crossing.* However times had changed. The year 1849 was a desperate moment in the life of the artist. His response to the failure of the 1848 revolution was a painting so huge that it takes up an entire wall of the Metropolitan Museum of Art. Fourteen feet high and twenty feet wide, it is a monument in painting. You approach it looking up in the same way you look up at a monument. It has the size, grandeur, and simplicity necessary for a monument (simplicity meaning the story immediately strikes the eye). The boat serves as the wide base of the monument. The arrange-

Discuss with students how the size contributes to the painting's impact.

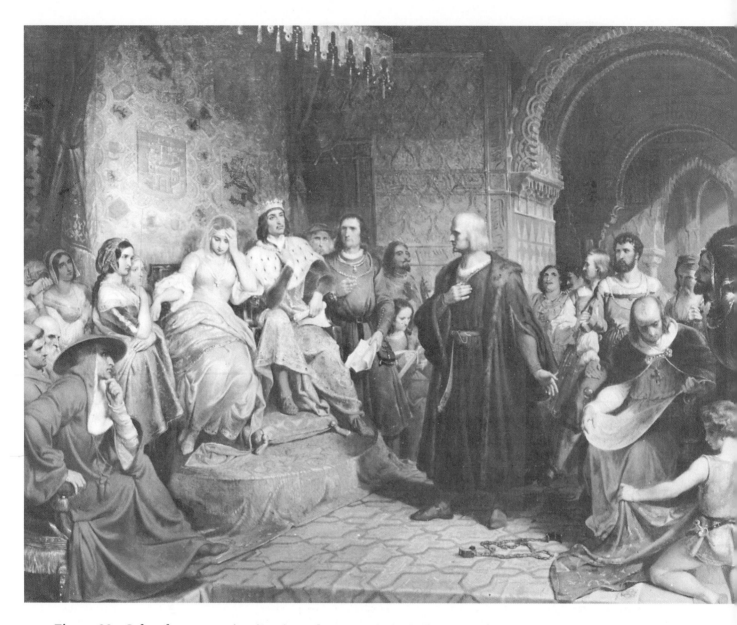

Figure 32. Columbus returning in triumph to Queen Isabella of Spain. Emanuel
Leutze, *Columbus Before the Queen*. 1843. Oil on canvas. 38 3/4" x 51 3/16". The Brooklyn Museum. Dick S.
Ramsay Fund and A. Augustus Healy Fund.

ment of men makes Washington larger than life. There he
is, as if seated on a horse, in public view.

The reason why Leutze chose a crossing for his most
important work has its roots far back in time. Traditionally
the crossing of a river has been one of the most powerful
images of meeting destiny. The Bible tells of Joshua's "one
more river to cross" when he tamed the mighty waters of
the Jordan and led his people to the Promised Land. The
Greeks had to cross the River Styx to their final destination.

Caesar faced his moment of truth when he crossed the Rubicon. In her book on Emanuel Leutze, *Portrait of Patriotism,* Ann Hutton wrote: "Every man as well as every nation makes just such a crossing once in a lifetime." The moment for Leutze's crossing was 1849. Through this one work, different from anything he had done, Leutze, in a monument to George Washington, made his commitment to freedom.

History explains why Leutze chose the Washington of Houdon instead of David's Napoleon. The American Revolution fired the shot heard round the world. It was Washington who sparked the later revolutions for freedom in Europe. Napoleon Bonaparte had brought war to Europe in the name of freedom, but after his victories he had proclaimed himself emperor. During the nineteenth century the image of Napoleon declined, while George Washington—the man who spurned a throne—became a universal symbol of human liberty, the very essence of the Houdon bust. That bust portrays grandeur. Washington's look goes beyond time and place to link this one artist's agony to a hope for mankind.

History provides still one more reason for the standing figure. Because Leutze worked seventy-five years after Trenton, the painting represents his view of Washington's place in America. The different positions around the central figure, pushing in all directions, could be the competing interests of the young country. After the Revolution, America was threatened by conflict among the states. Many historians claim that if Washington had not become President, the union might not have survived. From those early conflicts, Washington's vision of America emerged. A few years after the French Revolution, Britain and France were at war, and feelings in America ran high. Thomas Jefferson, mindful of the debt to France, wanted to help the French. Alexander Hamilton wanted to help the British. Between these two towered George Washington. He said it made no difference who won in Europe—the United States must be a haven of liberty for all. History proved him right.

A SYMBOL OF COURAGE AND LIBERTY

Washington was more than a general. In Leutze's vision he embodied all that was noblest and best in the American people. While some men made fortunes from war, he

Have students name other
individuals, such as Abraham
Lincoln and Dr. Martin Luther
King, Jr., who symbolize virtue
in our culture.

**Figure 33. The Marine
Memorial in Arlington, Virginia, resembles** *Washington Crossing the Delaware* **in its use of line and grouping.**
The Marine Memorial at Arlington (The Iwo Jima Memorial). Courtesy Wide World Photos, Inc.

refused his salary as general. With no thoughts of himself, he assumed every responsibility given to him and fulfilled it. But his image as the greatest horseman of his time, the inspiration of Stuart and Houdon, lingers on in *Washington Crossing the Delaware*. When Leutze stood him up and "mounted" him on a boat, he sent him on a journey through time with his message to the world: *Freedom is the only king.*

This message has spoken to generations ever since. Almost one hundred years later at Iwo Jima, in one of the bloodiest battles of World War II, American soldiers were struggling to plant the flag. That moment was captured by a photographer and later in a sculpture at the Marine Memorial in Arlington, Virginia (Figure 33). The diagonal line of

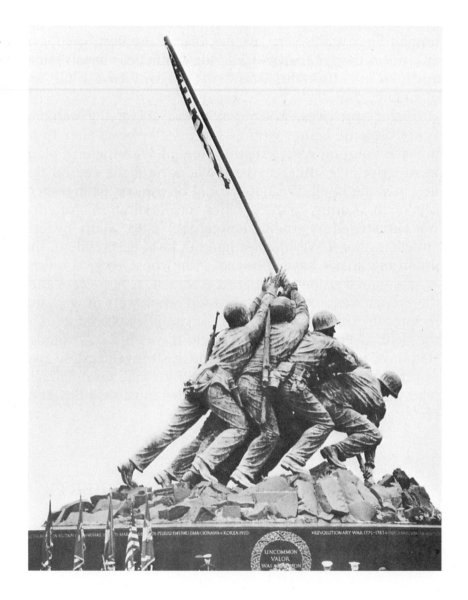

the flag and the grouping of the soldiers into the frozen drama come right out of *Washington Crossing the Delaware*.

There is still no answer to the question raised earlier: Which is the best painting—Leutze's, Sully's, Trumbull's, or Bingham's? The fact remains that this one work of the German immigrant has become the symbol for American courage and triumph. When Leutze packed the nation's history onto his canvas he put us all into the boat under the determined gaze of the standing figure. His look into the future is a country's bond with its past. Leutze's Washington is the heart and soul of America.

Since the business of art brings us closer to life, this painting brings us close to the best part of ourselves through the man who was the best of his time, perhaps of all time.

Have students decide which painting they prefer. Discuss the reasons for their choices.

Summary Questions

1. Why is Washington's stance critical to Leutze's painting?
2. Name two other artists who painted this same scene of Washington crossing the Delaware.
3. Why is Luetze's painting an historical portrait?
4. What theatrical effects does Leutze use?
5. How did David's painting of Napoleon influence Leutze?
6. Why was Houdon's mask of Washington important to Leutze?
7. What did Washington symbolize to Leutze?
8. What liberties did Leutze take with the facts of the historical event he painted?

You may use these questions either as a written assignment or as a take-off point for class discussion. Answers will vary, but students should be able to substantiate their responses from information in the text.

THE VISUAL ELEMENTS OF ART

Introduction

1. See schedule for this section on page T-59 of this TAER.
2. See overall teaching suggestions for this section on page T-7.

Look again at the painting of *Washington Crossing the Delaware.* Try to see it not as a painting of George Washington and his soldiers on a desperate journey, but as shapes and areas of dark and light colors, as images of solid forms, as lines and textures. These elements are the building blocks of art. Artists cannot produce works of art without using these **visual elements of art:** color, line, shape, form, space, and texture.

In using the visual elements of art, artists follow certain **compositional principles of design.** The principles are the *rules* by which artists organize their colors, lines, shapes, forms, space, and textures. The most common terms which apply to the principles of design in visual art are: repetition, variety (or contrast), emphasis, movement and rhythm, proportion, balance, and unity.

Artists use the elements and principles in their own way. One work may have more color than line, another more lines than shapes or forms. One painting may have continuous movement, as does *Buffalo Runners, Big Horn Basin* on pages 134–135. Another may have conflicting movement as in *The Brooklyn Bridge* on page 253. The use of various elements depends on the artist's goals. Different goals demand the use of different materials and methods. Thus, different works may be successful compositions in their own way. Let's turn first to a study of the visual elements of art.

Color

Light makes vision possible. During the last half of the seventeenth century, Sir Isaac Newton demonstrated that white sunlight is a combination of all colors. First, he passed a fine beam of sunlight through a triangular rod of glass. This rod of glass is called a **prism** and is illustrated in Figure 34. When a beam of white light passes through the prism, the prism bends and separates the sunlight into a

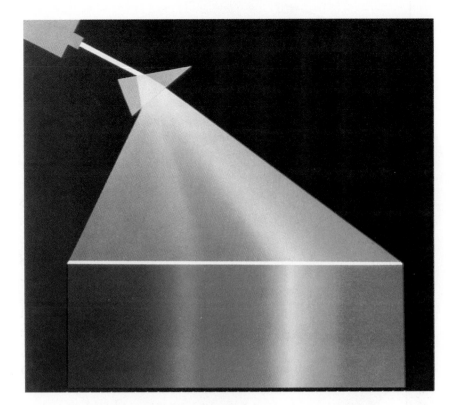

Figure 34. This prism breaks up the white light rays into a spectrum of color. Courtesy Harald Kuppers. From *Color: Origins, Systems, Uses.* New York: Van Nostrand Reinhold Company, 1972.

spectrum—that is, a display of all the colors that together make up the white light. The process of bending and separating the white light into its spectrum is called **refraction.** Refraction of sunlight through droplets of water causes a rainbow.

To offer further proof, Newton reversed the process by passing his refracted spectrum back through a second prism. All the colors of the spectrum recombined to form white light. Newton had then proved that white light is the *addition* of all colors of the spectrum. In this Newtonian system of light, black is the *absence* of all color, as none could be seen without light.

Each object that we see has physical characteristics which reflect some of the components of the spectrum; some are reflected more strongly than others. As our eyes receive this reflection, we perceive color. Thus a red object, such as a cherry, appears red in white light because it reflects the red components of the spectrum to our eyes.

Figure 35. Color wheel with intensities. Courtesy M. Grumbacher, Inc.

Newton's discoveries about color and light provide the basis for all subsequent scientific work on color.

Another important step in color theory proved to be of great practical value to the artist. This was the publishing of *Pigment Color Theory* in 1756 by J. C. LeBlon. LeBlon laid the foundation for the color wheel that you see in Figure 35, and also the foundation for mixing all colors that artists use. LeBlon was not concerned with white light. He was concerned with mixing pigments together. He demonstrated that black is the sum of mixing all colors together, and white is the absence of all color. This is easily proved in mixing paints. Black and white, as you will notice by looking at the color wheel, are not shown. They are called neutral colors. Gray, when mixed from black and white, is also called a neutral color.

It is important to have a working knowledge of these two color theories. You will be exposed to various color the-

ories in high school science courses, but for our purposes in paint mixing, we will be using the pigment theory and our color wheel. When two colors are mixed, new characteristics are created, and the mixture reflects light differently to our eyes. If we understand this basic concept about color, we have LeBlon and Newton to thank. Now, let's take a look at the properties of color.

Properties of Color. To understand the *properties* of color, we must become familiar with several terms. **Hue** is the name of a color, such as red, blue, or green. The term **value** refers to the degree of lightness or darkness of a hue. When we add white to a hue, the resulting color has a *higher* value. When we add black or another color that darkens our original hue, the result is a color of *lower* value. As we add more and more white to a hue we will approach pure white. If we continue to add black to a hue, pure black will be the end result. (See Figures 36 and 37.) As we work at either end of this scale, the lightness or the darkness (value) becomes more significant than the hue.

There are some colors which are, in themselves, high or low in value. For example, blue can be used to lower the value of another color. Yellow, on the other hand, has an inherent high value and can be used to heighten the value of another color.

Colors which are made lighter by adding white or a color of higher value to the hue are called **tints** of that hue. Colors that are made darker by the addition of black or a darker color are called **shades.**

Intensity refers to the strength and purity of a hue. Fully saturated hues are said to be more intense than other colors of the same hue. What does this mean? To understand we must look again at the *color wheel* in Figure 35.

Figure 36. Value: red and higher values of red.

Figure 37. Value: red and lower values of red.

Let's use red as our first example. Look at the red on the outer circle. The red you see on the outside is called the fully saturated or full intensity red. Follow the red part of the wheel inward toward the center. Notice that with each step nearer to the center the red is getting duller. What is happening here?

What color is directly opposite red on the color wheel? Do you see that in the case of red, its opposite color on the wheel is green? As we move toward the wheel's center, progressively larger and larger amounts of green are being added to the red. The more green that is added, the more neutralized the red becomes, the duller it looks, and the less intensity it has. Before we leave this illustration, look carefully at other examples of opposite colors on the color wheel and at the effect that the addition of its opposites has on each.

Now let's take an example of why intensity is important to an artist. You may have already observed this in nature. If you look, for example, at a grove of bright red maple trees in autumn, the trees closest to you appear *intensely* red. Those trees in the middle ground still appear red, but less *intensely* red. The trees farthest from you in the background appear dullest. The proper use of intensity helps the artist to simulate depth and emphasize contrasts (Figure 38).

All in the Family. The **primary colors** are red, blue, and yellow. These three, and these three alone, cannot be created from other hues on the color wheel.

Closely related to the primary colors are the **secondary colors:** green, a mixture of blue and yellow; orange, a mixture of red and yellow; and violet, a mixture of blue and red.

The intermediate colors can be thought of as cousins. **Intermediate colors** are achieved by mixing a primary color with its adjoining secondary color. They are therefore located on the color wheel between a primary and a secondary color. For example, yellow-orange is perched between yellow, a primary color, and orange, a secondary color. What is red-orange made of? Blue-violet?

Strangers in the Neighborhood. The complementary colors could be compared to strangers. **Complementary colors** are opposites in two ways. (1) They are directly opposite one another on the color wheel, and (2) they are least like one another. Remember that the color least like red

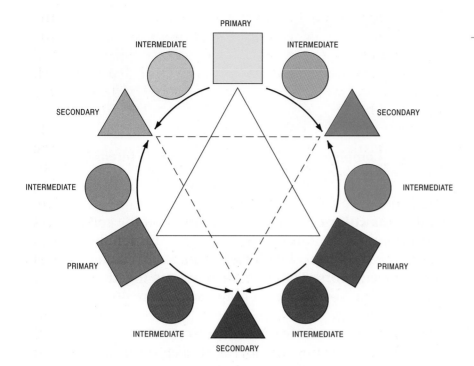

Figure 38. Primary colors An imaginary equilateral triangle (solid line in illustration), placed on a color circle so that one point of the triangle is at yellow, will locate the remaining two primary colors (red and blue) at the other two points.

Secondary colors Orange, violet and green are the secondary colors. Each is placed between the two primaries that are mixed to produce it. The secondaries may be located on the color wheel by an inverted triangle (dotted line) as illustrated.

Intermediate colors All the additional hues which fall between the primary and secondary colors around the color circle are known as intermediate colors and can be produced by the mixture of adjoining primary and secondary colors.

is green, which is directly opposite it on the color wheel. If you mix these complementary colors together, they will ultimately cancel each other out, forming a neutral-gray in this case. In some instances, the mixing of complementary colors will get you just plain mud. You can experiment in producing various gray tones in this way. By heightening one of these grays (adding white), you will find that you can produce harmonious grays without using black at all.

Another important feature of complementary colors is that when placed next to each other, they become highly intense as Figure 39 shows. This is important to remember for drama in design. To find a pair of complementary colors, just look on the opposite side of the wheel; you can't lose them.

Close Relations. Blue and blue-violet, violet and red-violet, red and red-orange are pairs called analogous colors. Can you see why?

Figure 39. Complementary colors become highly intense when placed next to each other.

Analogous colors are next to each other on the color wheel and so share close "family connections." This family extends around the color wheel with each color interrelating with its adjacent neighbors. They are harmonious together, and, if you mix them, you won't get gray. (See Figure 40.)

Adding to Your Color Vocabulary. Turn to Frederic Remington's haunting work, *The Outlier,* on page 147. We might say, in describing this painting, that its overall tonality is blue. There *are* other colors in this painting—the lustrous yellow of the moon, the deep skin tones of the sentinel, the blue-gray brown of the pony with a white face and forelegs. However, if you step back, you would probably say that the blue predominates. Blues are repeated in the colors of the central figure and his mount. The yellows, the yellowed whites, the shades and tints in orange and soft earth tones are themselves related, but contrast with the analogous blues and violets in harmony.

Our Feelings About Color. Different colors have different effects upon emotional states. In fact, we associate colors with definite moods. When we say we "saw red," we mean that we became angry. Red is associated with strong emotion and events that make emotions run high, such as warfare, blood and great anger. Blues of higher values can be very meditative and contemplative; lower values can be sad and depressive. In their mid-range, blues seem serene and relaxing. Yellow can be bright, cheerful, warm, or paled almost to coolness. Certain greens seem acidy.

All graphic artists, designers, and decorators concern themselves with these effects of color every day. An artist can create forms by contrasting warm and cool tones rather than merely using dark and light areas. In *The Outlier* did Remington create a "cool" statement? Why does even the

Figure 40. Analogous colors are harmonious together.

yellow moonlight seem cool? Did the artist use warm and cool colors to create forms, as well as light and dark contrasts?

Creating Art with One Color. If you use one hue in varying values, tints, and shades, you will create what is called a *monochromatic composition.* (**Monochrome** means one color.) In your first efforts, you may find that you need to depend more on line, form, and texture than on color to add interest to your work. In fact, for certain types of subject matter, monochromatic work can be an ideal mode of expression. Consider Arthur Dove's *Fog Horns* (Figure 41).

Color is an endlessly fascinating study in itself, but it is also great fun to experiment with color. As you get to know more and more about color, you will enjoy imposing your choices on your compositions. Look, for example, at what Henri Matisse has done with the portrait of his wife in Figure 42, popularly called *The Green Stripe.* This is a very unusual use of color. Madame Matisse's immediate reaction when she first saw the result is not recorded. However, since Matisse was a leader of the "Fauves" (a French name which means "Wild Beasts"), she may not have been surprised.

Keep your reliable friend the color wheel handy, and enjoy all of the many relationships it includes.

Use Classroom Reproduction #10.

Line

Let's look at the lines in *Washington Crossing the Delaware.* "What lines?" you might ask. Look closely. There are objects in the painting which are so long and thin that they work as lines in the design. For instance, the oars make long, major directional lines. The rifles, stacked toward the back of the boat, make short, clustered lines. There are also implied

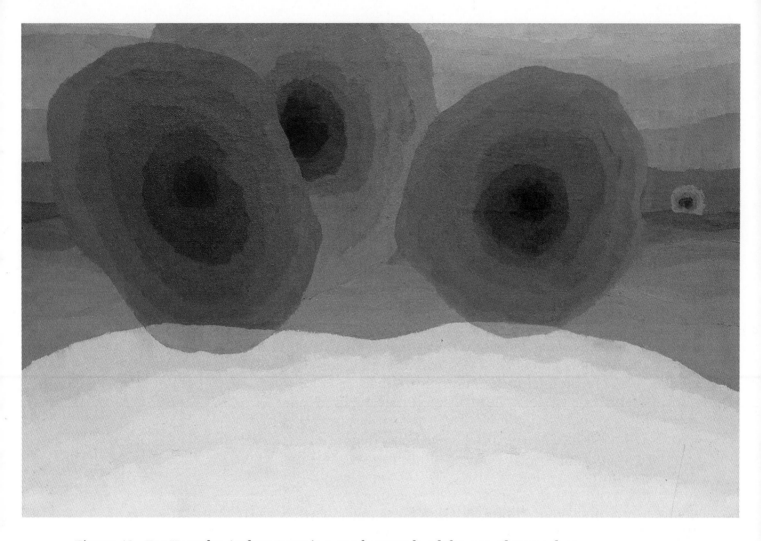

Figure 41. *Fog Horns* **by Arthur Dove is a good example of the use of monochromatic colors.** Arthur Dove, *Fog Horns.* 1929. Oil on canvas. 17 3/4″ x 25 1/2″. Colorado Springs Fine Arts Center. Anonymous Gift.

lines, such as the edges of the up-turned yellow lining of Washington's cape and the folds of the flag. The direction Washington is facing and looking makes an implied line. The light shining through the clouds creates a linear effect. Can you find other lines in the painting?

Now, look again at the white lines in Figure 9. Can you find the lines that indicate the oars, flag staff, and rope on the boat? Which white lines indicate the edges of shapes and the direction of movement?

Lines are one-dimensional, unlike shapes and forms, and are usually measured by length. Lines may be thick or thin, or change from thick to thin, but a line is not usually given

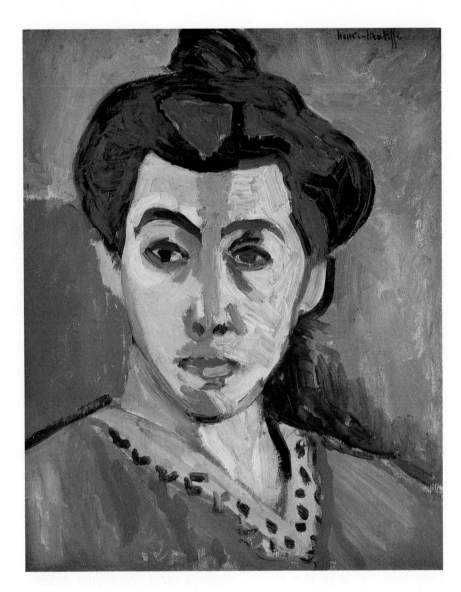

Figure 42. Henri Matisse, *Portrait of Madame Matisse.* Henri Matisse,
Portrait of Madame Matisse, 1905. Oil on canvas. 15 15/16″ x 12 13/16″. Statens Museum for
Kunst, Copenhagen. Rump Collection. Copyright © 1990 Succession H. Matisse/ARS, N.Y.

importance by a measurement of its thickness or thinness.
The quality and character of a line might be thought of as
thick, thin, light, heavy, bold, strong, or weak.

We encounter lines every day, everywhere. A line can
lend direction and suggest movement. Lines can go in any
direction—horizontally, vertically, diagonally—and may be
straight or curved. Curved lines can be arcs, waves, or spi-
rals, or any way you may wish to draw them.

There are two ways to draw and paint lines. One is free-
hand, the other is with a guide. A *guide* may be a straight

Be very careful with any pointed instrument such as a compass.

A series of computer activities which introduces the elements and principles of art is included in your black-line master package.

Pause to show students several examples of the credit lines which appear with the paintings in this text. Show them the order of dimensions (height x width).

edge, such as a ruler, yard stick, T-square, or even a smooth piece of wood or cardboard. A triangle can serve as a guide for straight lines; a compass, for curved or circular ones. Devices with geometrically shaped holes in them are called templets, or *templates* and are also used as guides.

Using guides takes practice. You must hold the guide firmly with one hand while guiding your pencil along or around it with the other hand. A ruler should be held in the middle, with your fingers spread wide. A compass should be held lightly between the thumb and index finger as you twist the handle with your thumb. Keep pressure on the point in the paper, and let the pencil move as your thumb moves. Be very careful with guides. They are necessary tools but can be dangerous if used carelessly. Also, be sure your pencil has a good point when you use guides.

Each type of line has its own quality and style. When you use guided lines in the same picture with freehand lines, you are mixing styles. Take care in mixing them so that your picture, design, or composition will have unity of style.

Lines and Computer Graphics. You may have the opportunity to use a computer in this art course. The lines on a computer monitor are made by points of light called *pixels.* In computer graphics, lines are measured by the number and size of the pixels which make up their length. Low-resolution graphics have larger and fewer pixels per square inch on the monitor. High-resolution graphics have more and smaller pixels per square inch. The size of the pixels is most noticeable in the curves. Curves on a computer monitor often look like a set of stair steps. Figure 43A shows lines created with low-resolution graphics. Figure 43B is an example of lines made with high-resolution graphics.

Shape and Form

When you take a line in some direction and bring it back to its beginning, you have created a **shape.** Remember that line has only one dimension, length. Shape has *two* dimensions and encloses space. The two dimensions of shape are height and width. In all cases, when the sizes of paintings are listed, the height is given first.

A **form** is three-dimensional; its third dimension is *depth.* In visual art there are two kinds of forms: (1) real forms

Figure 43A. Monitor with low resolution graphics. Courtesy of Scholastic, Inc.

Figure 43B. Monitor with high resolution graphics. Courtesy of CGL, Inc.

which you can see and touch and (2) illusions or representations of forms.

Real forms may be natural, such as trees, mountains, and human beings, or created forms such as sculptural or architectural ones. The *illusion of form* is found in photographs, prints, drawings, and paintings in which three-dimensional objects are pictured. The dimensions of pieces of sculpture (and photographic images of them such as you see in this book) are measured by height, width, and depth. These measurements are always listed in that order. Pablo Picasso's *She-Goat* (on page 325) is 46 3/8 by 56 3/8 by 28 1/8 inches. Each of these measurements is taken at the highest, widest, and deepest place on the piece of sculpture. Look at *She-Goat* and determine where on the goat each of these measurements was taken.

Can you see how the artist can give the illusion of depth on a two-dimensional ground support? Let's look at how shapes can be given the illusion of depth. (Refer to Figure 44.)

Light strikes three-dimensional objects in varying degrees. The artist who is working on a two-dimensional ground support represents these degrees of light. Areas receiving the least light have the darkest shades. Lighter or grayer areas have more light and are rendered in a lighter value. The small, brightest area of a painting or drawing is called a *highlight,* and is usually pure white. This technique used to create the illusion of form is called **shading.** Within a composition, forms can be made to come forward

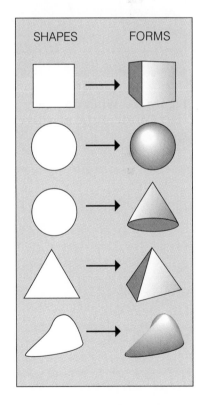

Figure 44. How have these shapes been given the illusion of form?

53

Ask what art has spaces within? (Architecture.)

Figure 45. What do you see? Consider the negative space.

(toward the viewer's eye) or recede by varying the values of the shades.

Space

The very word *space* implies an empty area, yet space can give an object its meaning—for example, a doughnut or Swiss cheese. The space in a cup determines the volume of liquid it will hold, as in an eight-ounce measuring cup. However, space is not always measurable. We think of outer space in terms of galactic travel. We think of inner space as a private place within ourselves. Although you cannot feel space, you know it is there.

In art, **space** is the area around, between, and within objects. It defines shape and form. The form or shape itself is the **positive space.** The space around, within, and between forms or shapes is **negative space.** Psychologists who study visual perception use the term *figure-ground* in describing positive and negative space. The figure shown as Figure 45 is often used to explain the figure-ground phenomenon.

If you saw the vase first, adjust your focus until you see the two profiles. If you saw the faces first, adjust until you can see the vase. When you focus on the vase, the faces are negative space (ground) and the vase is the figure (positive space). When you focus on the faces, the opposite is true.

Texture

Texture is the visual element that conveys the sense of touch. There are two types of textures: natural (or real) textures and visual textures. Natural textures feel to the touch as they look to the eye. They may be smooth, silky, rough, grainy, hard and gritty, or soft and mushy. Visual textures in drawings, paintings, or photographs, appear to have these same qualities, but they lack the feeling of the textures they represent. In acrylic or oil paintings, surfaces may be built up or treated to represent the textures of natural features, but if you touch them you feel the painted surfaces instead. In some instances, you may just feel the paper on which the image is reproduced. Notice the visual textures in *Washington Crossing the Delaware.* Leutze has placed rough, furry textures against smooth surfaces, and hard surfaces of ice and wood against the soft surfaces of water and fabrics. Yet we know that this is only paint on a canvas, or ink on a page.

THE COMPOSITIONAL PRINCIPLES OF DESIGN

Introduction

Now that you have studied the visual elements of art, it is time to organize them by using the compositional principles of design. In all of the arts, there are structural principles. Consider the structure and discipline of the performing arts as well as those of the written and spoken arts. Performers of music, dance, and drama, and creators of poetry, short stories, plays, novels, and screenplays, all work within a framework of rules and guidelines.

In the visual arts we call these structural principles the compositional principles of design. Artists who practice in all of the areas of art often try to stretch the structural principles of their discipline to see how far they can take them to new and exciting horizons. Sometimes the results are brilliant; sometimes the structural principles may get stretched too far, and the attempt is unsuccessful. Regardless, there is the excitement and joy of innovation.

The compositional principles of design in the visual arts are: repetition, variety (or contrast), emphasis, movement, and rhythm, proportion, balance, and unity. Although artists used these principles intuitively as long ago as the first cave paintings, they were not formally established until the Italian Renaissance in the fifteenth and sixteenth centuries. The great masters of the Renaissance recognized that when the principles were used well, the work of art was satisfying.

Repetition

Repetition is the process of using the same color, shape, line, or object more than once in the same visual composition. How did Emanuel Leutze use repetition? Let's look at a few examples in *Washington Crossing the Delaware*. The soldiers are almost all facing the far shore so we see them in left profile. The oars, guns, and flag staff repeat the same oblique angle to the right, or back, of the boat. How many

times did Leutze repeat the color red? The floating chunks of ice are repeated on the viewer's side of the boat and overlap as they recede in the distance. The artist also repeated the large triangular structure of the central figures in the two smaller triangular groups of soldiers on either side.

Repetition is important in *Washington Crossing the Delaware* because it gives a sense of stability. You will learn to use repetition judiciously. However, too much repetition can become monotonous. Its effect may be balanced by variety in an artwork.

Variety (or Contrast)

Leutze painted the Delaware River full of ice chunks. They are in a variety of shapes which gradually become smaller as the eye moves back into the painting. Notice that each of the soldiers is wearing a different type of hat and coat. If they had all been wearing the same uniform, this would have been a very different composition. Look at the sharp contrast of light and dark colors in the central section of the painting. This keeps us looking at the main figures. The sky is grayest at the upper left, lightest behind Washington, and darkest at the far right.

Variety, or contrast, is the combining of the visual elements in diverse ways to give works of art greater visual interest and hold the viewer's attention. Variety may be created by slight sequential changes or sharp differences in colors, shapes, forms, sizes, textures, and lines. As with repetition, too much variety will not work. It will create disorder and even chaos in an artwork. A proper balance of repetition and variety is an artist's goal.

Emphasis

Emphasis means giving certain figures or objects more importance than other similar features. The area which is emphasized is often called the **center of interest.** It usually dominates the composition and carries the main idea that the artist wishes to communicate to the viewer. The standing Washington and the flag dominate this painting by their larger size, but there is more to it than just that. The men in the stern (back) of the boat are all shown in muted softer values and darker colors. We see much more detail in the soldiers in the boat nearest our viewing point, and more detail in the ice on our side of the boat. Notice the hands of the oarsmen.

They are of light color, which adds importance to what they are doing. Compare the hand of the soldier which is placed on the gunwale (side of the boat). It is darkened to make it less important than those hands that are on the oars.

Movement and Rhythm

The artist's attempt to control the movement of the viewer's eye and keep it within the work is the compositional principle called **movement**. How does the artist use movement in *Washington Crossing the Delaware?* One way is in the direction in which George Washington and the soldiers are looking. Find those figures that are looking straight ahead to the left. Notice that even the two oarsmen who are facing the stern have their heads turned to face us and are looking diagonally forward. This arrangement leads the viewer's eye left across the painting.

The horses, flag, and oars point toward the opposite direction and create a counter-movement to the right of the painting. By curving the row of boats in the background from the right toward the center of the river, Leutze moves your eye back into the distance. On the left, he added a tapering strip of land to move your eye back again into the painting—another aspect of the counter-movement.

These are some of Leutze's uses of visual movement to control the direction he wanted your eye to move when looking at this painting.

Rhythm is a form of movement in which the artist repeats the same visual element to hold the viewer's attention and focus it as the artist wishes. In *Washington Crossing the Delaware,* notice the rhythm of the white lines in Figure 9 which indicate visual movement of the boat to the rhythm of the currents in the water.

The ice in the background appears to be laid out in long, rhythmic wave-like patterns. These rhythmic patterns have more definition and take up more of the width of the picture's surface as they get closer to the boat nearest the viewer. This helps direct the eye of the viewer back toward the central character, George Washington.

Proportion

Proportion is used to establish relationships among various features, elements of art, or principles of design. There are three types of proportions:

1. *Representational* proportions depict the size of objects in what appears to be the correct relation to each other, and also depict the distance an object is from the viewer in relation to other objects.

2. *Emotive,* or expressive, proportions are used when an artist wants to convey an emotion about a subject which is of more importance to the artist than the rest of the work. This may mean that the artist does not keep absolute proportions realistic.

3. *Design* proportions refer to the relationships within an art work. For example, the relative sizes of the elements of art need to be combined in a design that is pleasing.

These types of proportion are easier to understand if we study a specific artwork such as *Washington Crossing the Delaware.*

Representational Proportions. The ice nearest the viewer gives us a mental image of the size of the chunks of ice in relation to the size of the boat and the men. When we compare this with the ice we see in the background (becoming progressively smaller and smaller to show distance), we are better able to mentally estimate the depth of the painting. The brain automatically does this for us, and it does it easily if the representational proportion "feels" right to our eye.

Emotive Proportions. By having Washington stand, Leutze has given him a dominant position, but is he too large for the boat and the rest of the men? If he is, does this make him larger than life and more heroic? And, if so, is that all right with you, the viewer? This painting has, over the past 130 years, been occasionally criticized for the size of the boat compared to the number and size of the men who are in it.

Here are some questions about representational and emotive proportion to consider when looking at this painting:

■ Do you think the relationship between the men and the boat is representational? Emotive? Which, in your opinion, is more important in this particular painting?

■ Is Washington standing, like a subway rider at rush hour, because there is no place to sit? Why do you think Leutze depicted him standing?

■ What if all of the men stood up at once?

Design (Aesthetic) Proportions. Is the proportion of light sky to darkness appropriate to the mood of the painting? We know that the soldiers arrived on the far shore at early morning. Does the use of dark and light convey that to us? Do the soldiers seem to be riding out of darkness? Are the number of light colored hands appropriate to dark ones or other items in the boats? These types of questions about the elements and principles are called aesthetic questions because they deal with the viewer's aesthetic response to the visual, literal and expressive qualities of the painting.

Balance

It is the balanced relationships among the different elements of art and principles of design that make an artwork hold together. There are three types of balance:

1. In **symmetrical,** or formal, **balance,** each part of a design is relatively equal to the other parts. The left side of a painting has the same visual weight or "eye weight" to its spaces, shapes, and colors as the right side does.
2. In a work with **asymmetrical balance,** the amount of shape, space, and color on each side may be unequal, but the distribution makes them seem equal and satisfying.
3. **Radial balance** results when the most important part of the composition is placed in the center and the other parts of the composition radiate around it.

There are elements of each of the three types of balance in *Washington Crossing the Delaware.* Look for each and discuss them with your teacher and classmates. There are good arguments for each type.

Unity

Unity in a work of art is a result of all the elements of art and the principles of design working together. They work together to express the subject matter and to create a satisfying composition. Some questions to consider when looking for unity are: Does the work communicate a single message or contradictory messages? Is the style consistent throughout? Is the way it is rendered appropriate for the context and the message? Is everything there essential? Can changes

be made, something added or removed, without a loss of unity?

Compare *Washington Crossing the Delaware* with the photograph of the Marine Memorial in Arlington, Virginia (page 40). The painting is less compact or *focused* on the task than the sculpture. The message of the monument is the heroic planting of the American flag on the island of Iwo Jima by four marines under fire. The message of the painting is the carrying of the flag into battle in enemy territory by a bigger-than-life general and his bedraggled troups. The monument is based on a photograph of the actual historic event. The painting is the imaginative description of an historic event which was painted seventy-five years after the event occurred. There are more elements in the painting than in the sculpture and more opportunities to lose focus and unity. Which do you think is the more unified work?

THE ILLUSION OF SPACE IN ART

Prepare a bulletin board with examples of the three types of perspective (linear, continuous, aerial).

While out riding in a car, have you ever watched the street from the rear window of the car? Have you seen it grow narrower and narrower, and everything on each side get smaller and smaller? Finally, the point from which you started will be no bigger than a dot. Look at the five pictures of the arch (Figures 46A–E). Each picture is taken at a different distance from the arch. What happens?

Beyond the front arch, in the first picture, is another arch. It is the same size, but it looks smaller because it is farther away. Can you see where the street and the curbs almost disappear? The point at which they seem to disappear is called the **vanishing point.** Notice how the vanishing point remains in the same place as you get farther away in the rest of the photographs.

As you look at the pictures, everything remains the same but looks smaller. There is also a loss of detail. For instance, look at the carving over the arch in the first picture. Now

Figure 46A. Five photos of an arch which show linear perspective.

Figure 46B.

look at the second and third pictures. You see the shadows and forms, but can you tell what they are?

Now try this. Concentrate on the arch in the third picture for a few moments. Then look quickly at the fourth picture. What happens? It is like a zoom lens drawing back. Suddenly you are even farther away.

Figure 46C.

Figure 46D.

Look at the sides of the picture instead of the center. You see more trees, more street, the bridge, and lamp posts. You have just changed your way of seeing the same picture.

In the same way, there are two ways of looking out of the rear window of a car. One is to focus your attention on the vanishing point. The other is to give your attention to

what is happening out of the sides of your eyes—your peripheral vision.

European artists since the early Renaissance focused on the vanishing point in their artworks. This way of looking at space in which everything closes in and converges to a center spot, is called **linear perspective.**

LINEAR PERSPECTIVE

To have **perspective** is to have a point of view—to look at something from a certain angle. When you change your position, you then look at the same thing from a different perspective. However, in order to draw linear perspective, it is important *not* to change your position. You should even avoid moving your head. At least that is what the Renaissance artists thought, and many since then have agreed. Artists even invented devices for holding their heads in one position while looking at their subject matter and drawing. German artist Albrecht Dürer (1471–1528) shows an artist using such a contraption in a woodcut print (Figure 47).

In linear perspective, perspective is depicted through lines drawn so that they meet at a single point, called the vanishing point. The vanishing point is always located on an extension of the line from your eye to the object at which you are

Southern California tower and arch are examples of plateresque architecture, a seventeenth-century style of Spanish baroque, popular in Mexico. It featured highly ornate and exuberant carving around doors and façades, but the rest of the walls were plain and unadorned.

Linear and continuous perspective have characteristics similar to those found in convergent (linear) and divergent (continuous) thinking. Modes of perspective may reflect modes of thought, or cultural orientations to spatial perception.

Have students bring in magazine or other photographs and pictures demonstrating linear perspective (one or more vanishing points) and analyze them with a diagram. Use a ruler and draw converging lines from each side. Where they meet will be the vanishing point and establish the eye-level line.

Figure 47. Woodcut by Albrecht Dürer of an artist using a sight vane to maintain eye level while drawing a seated man on a pane of glass. Albrecht Dürer, woodcut from Dürer's *Underweysung der Messung* (On the Art of Measurement). Nürnberg, 1525. The Granger Collection, New York.

looking. This imaginary line is called the eye-level line. The object at which you are looking may be above or below you or at your eye level. The following rules for linear perspective in Western art were established five hundred years ago.

1. All lines that represent parallel surfaces converge at the same point on the eye-level line (or horizon line). This is the vanishing point (VP).

2. The eye-level line and the horizon line are the same. You can make the eye level change by raising or lowering the level of your head, or changing the angle at which you choose to look at your subject. But, once you decide and start drawing, you should not change the eye level again.

3. Objects near the artist are larger and have sharper color contrast and details. They block out objects farther away,

Figure 48. Diagram of Figure 46A showing the arch at eye level.

even if the more distant objects are larger (as is the example of the tower in Figures 46B and 46C). Objects farther from the artist get smaller as they recede, even if they are actually larger than some close objects.

4. There may be more than one vanishing point in a picture. For example, the pickup truck on the right sidewalk in the first photograph is not exactly parallel with the line of the curb, but pointed a bit to the right, creating its own vanishing point. Study the diagram of the first photo in Figure 48 to see how these rules work.

In this diagram the eye level is slightly above the end of the street. Follow the lines from the top edge of the tunnel, and the two sides of the arch. Notice that they meet at a single dot on the eye-level line.

Now follow the lines from the curbs, the dividing line in the street, and the low wall on the right behind the pickup truck. They also converge on the same dot. However, these lines go upward because they are below your eye level. The surface of the wall is almost right at your eye level. Crossing

65

over the eye-level line are the cars, the man walking, and the bases of the columns on each side of the arch. Notice how the pickup truck on the right and the tree on the left block out the walls behind them.

These rules of perspective also work when you are not standing directly in the middle of a scene, but to one side. Look at the painting called *The Gallery of Cardinal Valenti Gonzaga* by the Italian artist Giovanni Pannini (Figure 49). This painting shows the famous art collection of Cardinal Valenti Gonzaga.

Look at the diagram of Pannini's painting (Figure 50). Notice how the main figure, the Cardinal, is not in the center but to the right. Sunlight from a hidden window on the

Figure 49. *The Gallery of Cardinal Valenti Gonzaga* **by Pannini illustrates off-center linear perspective.** Giovanni Paolo Panini (Pannini). *The Gallery of Cardinal Valenti Gonzaga,* 1749. Oil on canvas. 78" x 105 1/2". The Wadsworth Atheneum, Hartford. The Ella Gallup Sumner and Mary Catlin Sumner Collection.

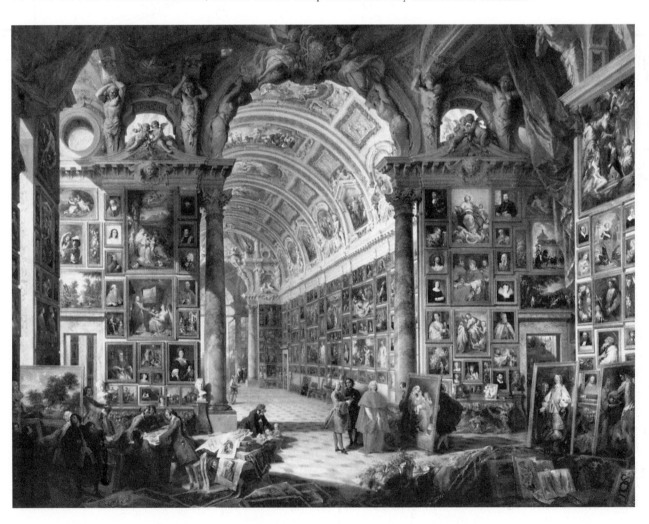

left casts a sharp line of light and shadow pointing directly to the Cardinal. The vanishing point is hidden behind the wall directly in front of you. As the diagram indicates, the viewer is left of center. If you follow the converging lines of the many rows of paintings and architectural features, you find they extend down the gallery tunnel and out the open doors into the garden beyond. However, this is blocked from view by the wall. On the left, a few paintings and the trim on a portion of wall give the beginning lines of convergence for the left side of the painting. Notice how you are looking down on the scene. Pannini has located himself slightly above, as if he were seated on a balcony. The size of the figures in the foreground emphasizes the grandeur of the gallery.

Figure 50. Diagram of the Pannini painting (Figure 49) showing perspective.

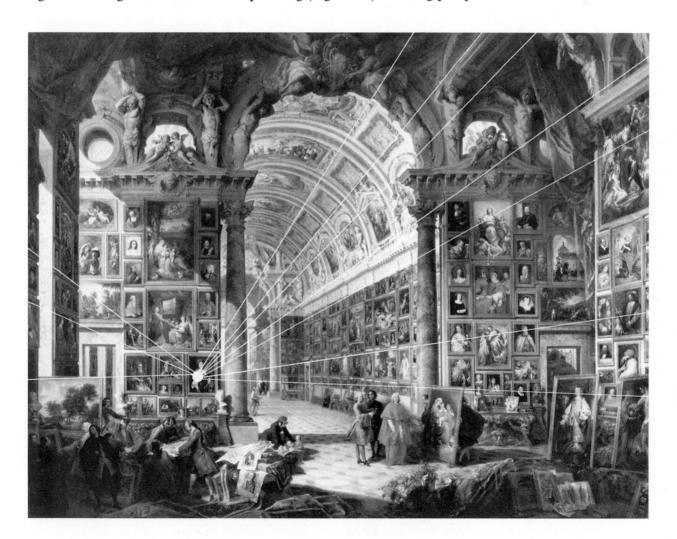

CONTINUOUS PERSPECTIVE

Continuous perspective is similar to *isometric* perspective, taught in mechanical and architectural drawing, but is not so geometrically precise. Both types of perspective can be taught along with linear perspective to broaden the students' drawing vocabulary of perspective styles.

While linear perspective was being developed in European countries, Oriental artists were using an approach to space and distance which was the reverse of linear perspective. Instead of closing space down into a point, they opened it up.

This Japanese screen from the seventeenth century (Figure 51) shows an entire village as if seen from above—a bird's-eye view. What do you notice about the horizontal lines that repeat the bottom and the top lines of the picture? These lines are parallel and regularly spaced as they recede. They do not get closer as they would in linear perspective. Now look at the sides of the buildings as they extend back. The angles of all the buildings are similar—about 45° or 60°.

To give a feeling of distance, clouds float over the entire scene. You get the feeling that if the top edge of the screen were not there, this village scene would extend continuous-

Figure 51. This Japanese screen from the Kano school, c. 1700, illustrates continuous perspective.
Screen. Kano school. Japan, c. 1700. The Granger Collection, New York.

ly to land's end. There is no vanishing point as there is in linear perspective.

AERIAL PERSPECTIVE

European artists also used *aerial perspective*. The rules of aerial perspective contain some of the rules of linear perspective.

1. Objects nearest the observer are larger and located at the bottom of the picture. They show sharp contrast in colors and details.
2. Objects farther from the observer get smaller as they recede and are placed higher on the picture. They have less color contrast and detail and are in cool colors or grays.

The Flemish artist Pieter Brueghel, the Elder, painted *The Fall of Icarus* about 1555 (Figure 52). Brueghel was a master

Air travel and space exploration have added new dimensions to concepts about aerial perspective and bird's-eye views. Have students analyze air and satellite photographs of the earth, and determine a set of conventions for this in class.

Figure 52. *The Fall of Icarus* **by Brueghel illustrates aerial perspective.** Pieter Brueghel, the Elder, *The Fall of Icarus.* (c. 1555.) Oil on board. 29″ x 44″. Courtesy of Musées Royaux des Beaux-Arts de Belgique, Brussels.

See page T-10 in the TAER concerning introducing black-line masters for reteaching the four steps of art criticism. If your students have used *Understanding and Creating Art, Book One*, the masters may be used as a quick review (and reference); if not, the masters give you a solid introduction.

of aerial perspective. Notice how the plowman in the foreground creates an entrance to the painting. The furrows of the plowed land lead the viewer's eye into the painting. On the next level down, a shepherd tending his sheep gives a middle distance that reinforces the scale of the painting.

FORMS OF EXPRESSION

The Artist and Heroes and Heroines

Artists have long portrayed stories and events that bring the past to life. The visual arts are a universal language and offer many clues to understanding experiences and ideals shared by people throughout the ages. Paintings, drawings, prints, photographs, sculpture, and architecture can provide visual records of the way things were—our heroes and heroines of the past. By studying and thinking about the way things once were, you can learn to understand better the way things are now and what they might be like in the future. As artists who are working today, we can contribute to this record.

1. See schedule for this unit on page T-60 of this TAER.
2. See Lesson Plans for this Unit beginning on page T-11.

DRAWING

Heroes and Heroines Larger than Life

Discuss body language and have students observe the importance of hands and other gestures to communication in artworks and in life.

The Preacher by Charles White is a two-dimensional drawing, yet it has a three-dimensional appearance. White has modeled the figure by building up the lines, using carefully placed white highlights, and dramatic foreshortening of the hands and forearms.

The hands are particularly important in White's drawing. One is pointing and one is restraining. What do you think each hand means? One might be saying, "Wait a minute.

Figure 53. *The Preacher* by Charles White uses lines and highlights effectively.
Charles White, *The Preacher*. 1952. Ink on cardboard. 21 3/8" x 29 3/8". Collection of the Whitney Museum of American Art. (Purchase)

I've heard that argument before. Don't interrupt me." This preacher has a healing message, and he means to be heard.

In *The Gross Clinic* (Figure 54), a drawing with India ink wash, you see another kind of healer as hero. The surgeon,

How would an artist of today portray an operating room scene? Why would it be different?

Figure 54. *The Gross Clinic* **by Thomas Eakins celebrates the healer as hero.** Thomas Eakins, *The Gross Clinic*. India ink wash on cardboard. 23 1/2" x 19". The Metropolitan Museum of Art, Rogers Fund, 1923.

Show the painting of the Gross Clinic and compare the two works.

Places for surgical demonstrations are often referred to as "theaters" now.

Discuss each of the meanings of the word "cradle" in relation to Biggers's drawing.

1. Use Classroom Reproduction #9.
2. Have the students look at other examples of cave art in the library, or bring some examples into the classroom. Ask the students to suggest other possible reasons for cave art.

Dr. Gross, is a hero of medicine. This drawing by the American artist Thomas Eakins is a copy of a famous painting he did on the same subject. Notice how the face and hair of Dr. Gross appear to glow. Perhaps his forehead, shining in the center of the drawing, suggests wisdom or intelligence. What other areas of the drawing are bathed in light? One is the operating table, which is the scene of battle, and the other is the table behind Dr. Gross. There, an assistant records what is happening in order that others may learn from the operation.

Note the many people present in the clinic. Some are students observing Dr. Gross; others are those assisting in the operation. Of particular interest is the woman sitting in the left foreground of the drawing, close to the operating table. She has drawn back from the operation, lifting her hands to cover her face. Who might she be? Perhaps she is related to the patient. In any event, it is unlikely that Dr. Gross will let her down.

Another larger-than-life character is portrayed in the forceful carbon drawing by John Biggers titled *The Cradle* (Figure 55). The drawing evokes the role of an African-American mother with deep feeling. Her children bury their faces in her, clinging dependently to her. She faces the world for all of them. Although she appears weary, there is strength and power in her attitude. In this composition her elongated arms and her head form a pyramid as she protectively encloses her three children. The forms assume heroic proportions as if to reinforce the task the mother has ahead of her. So monumental is the form of this family that it suggests a mountain.

Why do you think John Biggers titled his drawing *The Cradle*? "Cradle" has several meanings: a bed for a baby, the earliest period of life, a place where something began to develop, a framework or container, a supporting foundation, a resting place. How does each one of these definitions relate to the drawing?

Heroes from the Distant Past

We have seen that there are many ways to portray heroes, heroines, or heroic acts. Frequently the hero or heroine is presented in a direct manner, facing the viewer. This allows us to immediately identify and admire him or her.

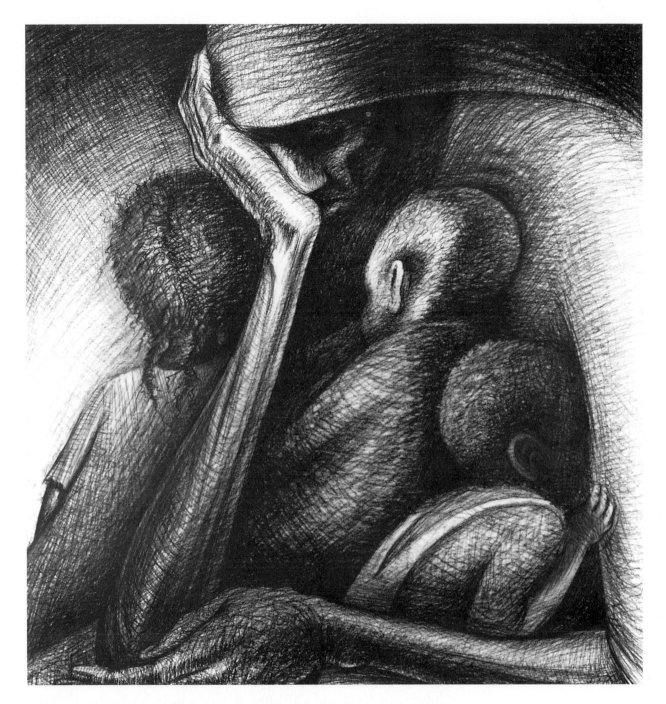

Figure 55. Find the cradle in the drawing, *The Cradle*. John Thomas Biggers (American, b. 1924), *The Cradle*. c. 1950. Charcoal on paper. 22 3/8″ x 21 1/2″. The Museum of Fine Arts, Houston. 25th Annual Houston Artists Exhibition, Museum Purchase prize, 1950.

By way of contrast, sometimes the identity of a hero or heroine is obscured, or merely suggested, in order to focus on the heroic deed itself. In some works of art, the hero or heroine is not even present in form but is strongly implied. *Young Mammoth* (Figure 56) is a drawing in the last category.

75

Figure 56. It is likely that drawings like this were part of the ritual and magic of the hunt. Cave drawing, *Young Mammoth*. Magdalenian period. 14,000–9500 B.C. Courtesy Grotte Préhistorique de Pech-Merle, Lot, France.

A heroic act is implied. A hunting party or hunter will be the heroes or hero of the day when the young mammoth is conquered. The mammoth in this drawing appears as a terrifying image. Its head and shoulders rise like a gathering storm from its pillar-like haunches.

Following the Ice Age, the great glaciers began to recede across the Northern Hemisphere. The first art that we know of was the art of cave people who depended on the herds of beasts for food and clothing. Many scholars who have closely studied cave art believe that this prehistoric art was intended to be magical rather than decorative in purpose. By making representations of the animals on the walls of caves, the hunters would be given power over them. Such drawings and paintings are generally found deep within caves where rituals probably took place to ensure the success of the hunt. It is because they were sheltered from the open air that many have survived.

DRAWING ACTIVITIES

1. A drawing can be produced from memory but only after intensive study of the subject. This is **reportage drawing,** or a drawing done from memory, reporting the characteristics of a particular subject. Take something from your pocket. Spend the next five minutes looking at the object so that you can draw it from memory.

Then put the object out of sight and draw it in pencil, using as much detail as you can recall. When your drawing is done, take out the object and compare it to your work. Have you represented the item well? Did you leave out any important details? Did you add any that weren't there? How accurate is your perception? How imaginative?

2. Drawing is the artist's basic way of expressing ideas and feelings. The quality of the work is in part the result of keen

Stage an interruption of your class by another teacher, or someone from outside the classroom. When this person leaves, ask the class to tell exactly what happened; to describe the person who just left, what he or she was wearing, and anything about the person that was unusual. (If it is a teacher that they know, have him or her wear three or four unusual things.) Discuss the different interpretations, and discuss descriptions of events by eyewitnesses in general.

You may want to use this activity without the text. Select any available resource which has variety and detail. Provide a time for observation and discussion. Remove the object, and have the students draw for five minutes.

Figure 57. Student art.

observation, skill development, and practice. A contour drawing is one in which the artist uses one continuous line to draw an object or figure while keeping his or her eyes on the subject. Contour drawings of a human figure express feelings and emotions by capturing the attitude of the subject. Using the technique of contour drawing, develop a series of full-figure drawings.

Figure 58. Student art.

3. In his portraits, Stuart strove to capture the inner strength and heroic greatness that set Washington apart from other men. The task tested his skills of observation. This activity examines the relationship between artist and subject and how the artist captures a person's "inner light" in a portrait.

Choose a partner and assume the roles of artist and subject. The subject can choose the identity of a historic character. The artist will need to know as much about the subject as possible. For the sitting, you might bring in clothing and props from the period the subject has chosen. When the portrait is completed, change places with your partner and assume the opposite role so that each of you has an opportunity to be both artist and subject.

Figure 59. Student art.

4. A drawing of an object can change dramatically depending on the lighting. Set up a simple still-life arrangement in the classroom. Pay special attention to the shadows caused by the existing light. With fluorescent light there are not many shadows. Turn off the overhead lights and turn on a spotlight held at a forty-five degree angle to the subject.

Lead the class in a discussion of how varying degrees of light, different angles of light, and different positions of the object change what the student sees.

Pose figures in a relaxed, comfortable position so they can hold the pose for a longer time.

As a second assignment, drape both figures in white sheets.

Have the students keep all of their sketches for review at a later time.

How has the lighting changed? Move the light to other locations. Combine the overhead lights with the spotlights. This gives you a softer image.

Choose three different lighting conditions and produce three drawings of the same subject. Then compare the drawings. How did the lighting conditions affect your picture? Which lighting did you like best? Think about ways you can control the light when you draw or paint.

5. This activity continues to address the problem of how different light sources affect the visual qualities of a work. For this assignment change the still life to a group of two figures. Select a position in the studio that gives you a clear view of an interesting composition. Consider drawing the two figures from a back view, from a very low angle, or from overhead looking down. Pay special attention to the overall positioning of the figures and how they relate to each other. Do three or four sketches. Choose the one that provides you with the most interesting composition.

6. It is very common for those just starting to draw figures to adopt all types of strategies to avoid drawing hands, heads, and feet. What really is needed is practice and more practice. This activity tackles the problem of drawing hands, heads, and feet in an orderly way.

Have you ever noticed that some people have special things they do with their hands, such as sitting with their

Figure 60. Student art.

chin propped on the palm of one of their hands? Others may intertwine fingers, squeeze their hands, or wave them about as they talk. Some people tilt their heads in one direction or another and some sit on one foot or wrap one leg around a table leg. Capturing such mannerisms helps the artist to capture the total image of the subject. These characteristics can be used to communicate personality.

First, practice drawing hands. Place your less dominant hand in a relaxed position on a table. Now, look closely at the overall shape of the hand. It's sort of a triangle, isn't it? Where is the highest point? Is it wider than it is tall? Can you see all of the fingers? Can you see one whole finger? Two? How do the fingers bend? What happens to the bottom line of the finger when it is bent? How far from the apex of the triangle does the index finger begin? What is the relative length of the joints of the index finger and the thumb? Continue this type of analysis and comparison as you sketch until you have an outline drawing of your hand. This may take several tries. Always remember you are drawing what you *see*, not what you know about a hand.

Next, do the same kind of analysis and comparison while looking at heads. Look at the overall shape of the head (not including the hair). Is it nearly a perfect circle or a perfect egg shape? It may be more rectangular or wider at the jaw line. Do the eyes seem relatively close together or far apart? Do the nose and mouth together make a triangle? Does the space above the eyes seem shorter or longer than that below the eyes? Compare the width of the eyes to the length of the nose.

Feet may be more difficult for you to observe. To get a really good model, you may have to get someone to remove his or her shoes while they are, perhaps, watching television. Once you have a model to observe and sketch, use the same process of relating shapes, sizes, and lines as you did above with hands and heads.

7. Now that you have developed some skill in drawing heads, hands, and feet, it is time to use these skills to add feeling and interest to figure drawings and to portraits. These features can convey mood and character, and can intensify the image.

Choose as a subject a person whom you have frequent opportunities to observe unnoticed. Detect any characteristic use of hands, general positioning of the head, or use of the facial features. Does the person smile a lot? Frown a

Have the students repeat this activity until they have developed fairly good skills in drawing heads, hands, and feet. Save three or four examples from each student for later use.

Reinforce the point that they should draw what they SEE, rather than what they know, about hands.

Figure 61. Student art.

Discuss the characteristics the students value in a hero or heroine. Why have they chosen these characteristics? Will these heroes and heroines be different in the future from the leaders, movie stars, athletes, and others of today?

lot? Chew on a pencil? Twist his or her hair? Select the characteristics that you think are most important and typical, and do a figure drawing of the subject.

8. For this activity, think into the future ten to fifty years. Who will our heroes and heroines be then? Create one with the characteristics you value in a hero or heroine. To begin, do several rough sketches. In addition to the person, who and what will be in the picture? A setting of some kind? On Earth or another planet? Other people? As you sketch, decide on the basic principles that will be used to build the composition, such as balance, rhythm, and unity. Plan what images will be in the foreground, middle areas, and background. Use pen and ink or black markers to draw your pictures. Then fill in with color.

9. Before the printing press came into general use, books were hand-lettered. The artists who accomplished this process were called scribes. Scribes not only arranged the text of the book in an orderly manner, they also decorated the pages of their books in wonderful and colorful ways (see Figure 62A).

Using line to produce visual symbols (letters and numbers) and arranging these symbols in imaginative and inven-

**Figure 62A. Early monks
filled blank spaces in a
manuscript with little
drawings, which in later
centuries developed into
miniature paintings.**
David and Goliath. Illumination from
the Peterborough Psalter. English, c.
1220. The Granger Collection, New
York.

tive ways is called **calligraphy.** The scribes who produced
these illuminated manuscripts produced the most beautiful
books ever made.

In this activity you will experiment with basic calligra-
phy. Take your name or initials and place the letters on a
sheet of paper. The placement should begin on one side of
the sheet, reach to the opposite side, and also touch (at least
in part) the top and bottom of the sheet. Make the letters as
thick or thin as you wish but, however you do it, they must
cover the entire page. Turn the paper upside down and look

Be sure to consider the exten-
sions in calligraphy in the les-
son plan beginning on
page T-16.

Figure 62B. Student art.

at the design in terms of how the shapes and spaces are arranged. Would the composition have better balance if you made one letter thinner, or, perhaps, thicker? Could the balance be improved by adding a strong color to a smaller space? Add the color to the design if you think it would improve it.

PAINTING

War Heroes

What are some of the characteristics you would expect of a hero or heroine? Courage? Trustworthiness? Unusual ability in some area? Attractiveness? Wisdom? Compassion? Strength? Imagination? What qualities would a hero or heroine need to rise from a humble beginning, conquer difficult times and situations, and rise to prominence? What heroes and heroines can you name from literature? Movies? Television? Describe them. What makes them great?

You have already looked at *Washington Crossing the Delaware* by Emanuel Leutze and discovered how much information a work of art can yield. *Washington at Princeton* is an oil painting by M. M. Sanford from the early nineteenth

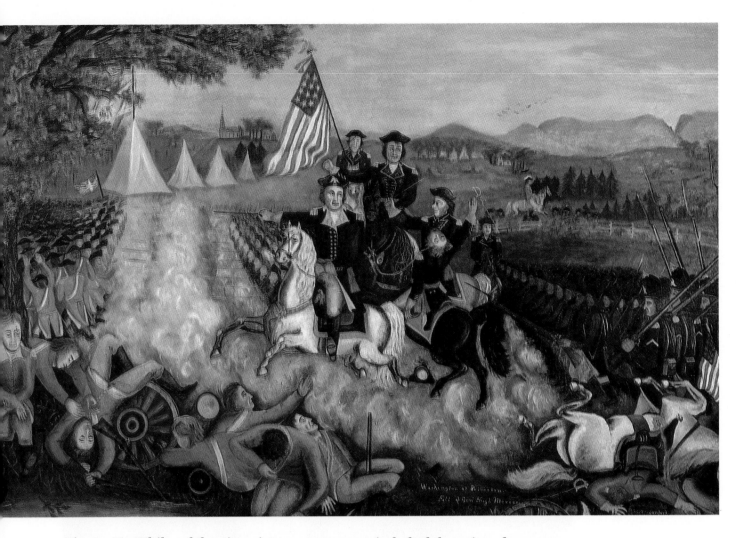

Figure 63. While celebrating victory, we are reminded of the price of war. M.M. Sanford, *Washington at Princeton*. c. 1850. Oil. 35" x 54". New York State Historical Association, Cooperstown.

century (Figure 63). Like *Washington Crossing the Delaware*, it reminds the viewer that independence from England was not easily won. This picture shows that death and sacrifice accompany war and that the price of victory is often high.

Washington at Princeton depicts one of the battles that saved America. The picture is filled with guns firing and men fighting. On closer study you can see that the painting represents still more. Perhaps it is a statement about conflict. In the background are gentle hills, farmhouses, a church, birds flying, and planted fields—images of peace and contentment. In the middle of the picture, lines of soldiers face one another and shoot. These opposing armies fight to the death over the issue of control. England wants to control the

85

Ask the students to observe
the way the artist has pictured
Washington's horse's gallop.
Does this look lifelike?

A bulletin board display of how
artists have depicted wars
might be assembled.

American colonies; the colonies want to control themselves. In the center of the painting is General Washington, astride his white horse. Sanford's Washington is so sure of victory that he charges without even looking at the enemy. Perhaps Washington's conviction that he represents what is right gives him his courage. The American flag, large and dominant, waves over the general. Where, in contrast, is the British flag? What else do you see in the painting? Look at the foreground. The images of death and destruction are Sanford's reminder that the price of war is terrible. The artist presents a strong vision filled with symbols. What symbols can you identify in *Washington at Princeton*? What does this historical painting remind you of?

The *End of War, Starting Home, 1918* (Figure 64) is an oil painting by Horace Pippin. Who is the hero, and what is going on in this explosive work? The painting's title gives you some clues. The hero is the simple soldier, the doughboy of World War I (1914–1918), who thinks not about

Figure 64. Deep somber colors reflect the horrors of World War I. Horace Pippin, *End of War, Starting Home, 1918*. Philadelphia Museum of Art. Given by Robert Carlen.

medals and promotion or being a hero, but about returning home. Fighting a war in a foreign country is a dangerous, lonely experience. Perhaps these soldiers were thinking as much about going home as winning the war. The German soldiers are fleeing or surrendering. German planes fall, burning, from the sky. Blasts of weapons and billowing smoke line the horizon. So great is the destruction and chaos that the artist has allowed weapons, tanks, and helmets to fly right out of the picture onto the frame itself. The canvas is bursting with violence. It is enough. The German near the middle of the painting holds up his hands to signify that the war is over.

Pippin was an American artist who taught himself how to paint. He was not concerned about what he should or should not do when making a painting. He had strong ideas about what he wanted to say and invented interesting ways to present them. What do you discover about the past in this historical painting? How does it differ from the picture *Washington at Princeton*?

You have seen how several artists have portrayed George Washington as a hero. You have also seen how an unnamed doughboy was a symbolic hero in Pippin's painting. The visual arts are filled with many other portrayals of heroes and heroines.

Heroes and heroines generally win admiration because they overcome many of the obstacles everyone encounters. Often, heroes and heroines stretch public belief of what is possible by demonstrating in their lives what can be accomplished. They represent models of what might be possible through great belief, great effort, and perhaps a bit of luck. In some instances heroes and heroines struggle with, and overcome, the forces of evil. In many of the old myths and legends, heroes are betrayed by someone they trust or must make a "heroic" sacrifice that results in death. Often a hero is thought of as "a knight in shining armor" who will overcome evil.

Try to collect works of Pippin and other "naive" artists (e.g. Grandma Moses). Discuss naive art.

Students will find research on Pippin's life quite fascinating. He was badly wounded in the First World War; his paintings reflect the influences of his African-American heritage and that of the Pennsylvania Dutch country in which he lived. Pippin himself is a good example of what is said in the last paragraph here.

St. George and the Dragon

In this fifteenth-century Italian painting (Figure 65), St. George slays a dragon to free the maiden. Like George Washington in *Washington at Princeton,* St. George sits astride a white horse. Could the white color of the horse symbolize

Have students research the story of St. George and the dragon.

Figure 65. Uccello was obsessed by the arrangement of solid geometric forms in space and became a hero of the twentieth century Cubists. Paolo Uccello. *St. George and the Dragon.* c. 1460. Oil on canvas. The Granger Collection, New York.

light and goodness, which triumph over the evil monster drawn from its dark cave?

Notice the elements of pictorial design which reinforce the concept of good over evil. St. George rises on his horse and, with the physical advantage achieved from that height, drives a lance through the eye of the dragon. The dragon, even with powerful wings to carry it to great heights, is driven to the ground. Thus, good overcomes evil.

Compare the painting we have just looked at to another *St. George and the Dragon* (Figure 66) by the fifteenth and sixteenth century Italian artist Raphael. The composition of Raphael's painting is developed around a big X. Can you outline the X? To the left of the X fall the dragon, cave,

Students may enjoy painting or drawing their own versions of dragons. Could a dragon be a symbol for something unpleasant?

**Figure 66. How has Raphael used color to
help him depict opposing forces?** Raphael
Sanzio. *St. George and the Dragon.* 1504–1506. Oil on wood.
The Granger Collection, New York.

darkness, and death; to the right, the maiden, hills, vegeta-
tion, light, and life. St. George, the knight in the middle,
appears to have power over life and death, light and dark-
ness, good and evil. He sits astride a bright white horse, but
he is wearing black armor, and a black cape rises from his
back. Notice that there are halos around the heads of both
St. George and the maiden. What meaning might that detail
contribute to this painting? Notice also the almost human
expression of the face of the horse, as it looks out of the pic-
ture at the viewer. What meaning do you see in the horse's
expression?

Heroes In Science and Engineering

Not all heroes are knights in shining armor. In this next
picture, you will see a hero of science. *Benjamin Franklin
Drawing Electricity from the Sky* (Figure 67) is an oil painting
on paper by the American artist Benjamin West. Did you list
imagination as one of the characteristics of a hero?
Benjamin West certainly did. He has shown the imaginative
Franklin as a superhuman, almost godlike person.

Figure 67. The artist illuminates a moment of discovery. Benjamin West, *Benjamin Franklin Drawing Electricity from the Sky.* 1805. The Philadelphia Museum of Art. Mr. & Mrs. Wharton Sinkler Collection.

In the painting, Franklin is drawing electricity from the sky. How did the artist dramatize the moment to make it more heroic? The storm swirls about Franklin, blowing his cloak and hair. Cherubs surround him as well, assisting in this historic act.

Benjamin Franklin discovered the key to defeating darkness by introducing electricity to the world. Many pictorial elements in the painting lead the viewer to the light in the upper left hand corner. Notice the cherub's arm and hand holding the kite string, Franklin holding his hand to the key, his eyes, and his blowing cape. It is as if the artist illuminated the painting to signify the moment of discovery.

Heroines of Their People

Another moment of truth is portrayed in the oil painting, *Joan of Arc* (Figure 68). This picture was done in 1879

You may want to point out the fact that Joan of Arc was only a teenager when she led the French army. Does this portrait capture her youth?

Figure 68. Bastien-LePage captures this famous heroine at the moment which changed her life. Jules Bastien-LePage. *Joan of Arc* (1879). Oil on canvas. 100″ x 110″. The Metropolitan Museum of Art. Gift of Erwin Davis, 1889.

by the French artist Jules Bastien-LePage. However, the moment it portrays took place in the early 1400s. Joan of Arc was a peasant girl born in France in 1412. At that time France was fighting what was known as the Hundred Years' War with England. So far the English had won every battle in their attempt to capture the French throne.

Joan was uneducated but wise in the ways of gentleness and charity. She was very devout. While in her teens she began to have visions. Voices of saints told her that she was chosen to lead the French against the English. At the age of seventeen she convinced the King of France, Charles VII, that she should lead the French army to victory.

In 1429 Joan freed the city of Orléans from the English. She then defeated them in four other battles. Although Joan wished to return home, the French King would not let her go. Instead, she led an attack to free Paris and was captured. At the age of nineteen, Joan of Arc was tried as a witch because of her visions, and burned at the stake in the city of Rouen.

Centuries later the Maid of Orléans was declared a saint by the Roman Catholic Church. Many books, plays, and poems have been written about her. Paintings and statues honor her memory throughout France. The painting you see here hangs in the Metropolitan Museum of Art in New York City.

Look closely at the painting. Joan appears to be in a trance. Her eyes are wide open, but what she is seeing is behind, not in front of her. This is perhaps a clue that she is experiencing something supernatural. What do you see behind her? Look very carefully, because it is not meant to be quickly or easily seen.

Although Joan's left arm is held outright before her, it seems to point to the light on the wall behind her. There, ghostlike and floating, are the spirits of the Saints Catherine, Michael, and Margaret. Although the saints are so light and filmy that they can barely be seen, their presence can also be felt through the impact they have on Joan of Arc. Her face, throat, and arms seem to be almost lit up by her vision. Her arm shoots forward, reaching, as if compelled by some electrifying jolt. The artist has shown this most famous of heroines at the moment which will change her life.

The painting is filled with clues that suggest what is yet to come. How many can you find? What is the saint directly behind Joan wearing?

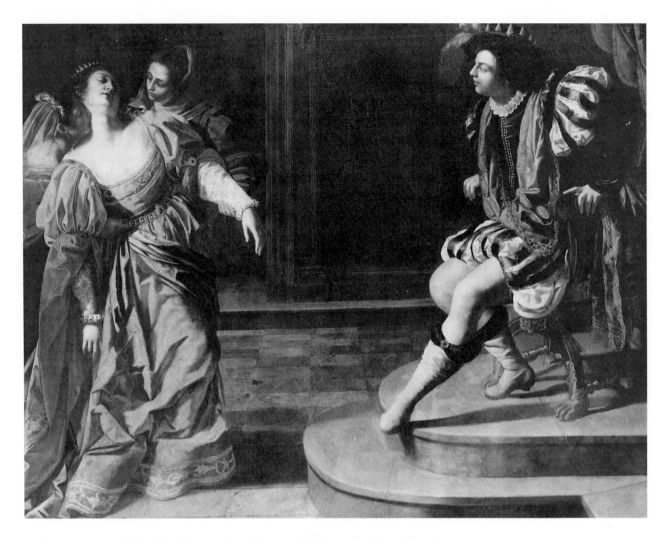

Figure 69. Gentileschi often painted women of strength and courage. Artemisia Gentileschi, *Esther Before Ahasuerus*. Oil on canvas. 82" x 102 3/4". The Metropolitan Museum of Art. Gift of Elinor Dorrance Ingersoll, 1969.

Another heroine who, like Joan of Arc, acted on behalf of her people was Esther. Look at the painting, *Esther Before Ahasuerus* (Figure 69), by the seventeenth-century Italian painter Artemisia Gentileschi (gen til-ess´ key). Notice the posture of both Esther and her husband, King Ahasuerus. How reluctant she is to approach him! How tense he is! The artist has captured the human suffering in this heroine's story most vividly.

The story of Esther is from the Old Testament. She was a beautiful girl of Jewish birth who was reared by her cousin Mordecai. When King Ahasuerus of Persia chose Esther to be his queen, he did not know she was Jewish. One day a man named Haman got angry at Mordecai because

Gentileschi was influenced by her father, the painter Orazio Gentileschi.

The painting depicts the precise moment when Esther risks her life. Note the *tension* the artist has achieved in the attitude of the two characters.

Have students name some contemporary women they consider heroic. Perhaps they would like to sketch their heroines.

Mordecai would not bow down to him. To punish Mordecai, Haman got the king to decree that all Jews should be killed.

On hearing this, Esther risked her life and told the king that she was Jewish. Moved by her suffering, Ahasuerus had Haman hanged instead. This tale of unselfish love and courage is still celebrated by Jewish people in the Feast of Purim.

Artemisia Gentileschi was a great painter of her period. She was known for her dramatic intensity and strong power of expression. Many of Gentileschi's works included strong heroines. She painted, among others, Susanna, Bathsheba, and Mary Magdalene. Gentileschi's work, built up with lively brushwork, is realistic and forceful. Look, for example, at the precise way in which the clothing of Esther and Ahasuerus is painted. Imagine that you can touch the clothing. What kinds of materials can you identify? How is the surface of each kind of material painted so that you can recognize it?

Think about the stories of Joan of Arc and Esther. The artists who painted them chose to portray crucial moments in these stories.

Another Kind of Hero

Joseph Mallord William Turner is considered by many critics to be the greatest of English painters. In this famous painting (Figure 70), we see the British sailing battleship Téméraire (tem-eh-rair´) being towed by a small steamer to the port of Deptford in England to be broken up. Turner witnessed this sight first-hand as the two ships passed Margate where he was staying.

The Téméraire was the symbol of naval heroism for the English. She was the second ship of the line at the momentous battle off Cape Trafalgar in 1805. The battle was considered the greatest of naval battles and the outcome made England the ruler of the seas for the next century.

William Makepeace Thackeray penned the thoughts of many succeeding generations of his countrymen:

> The little demon of a steamer is belching out a volume . . . of foul, lurid, red-hot malignant smoke . . . while behind it (a cold grey moon looking down on it), slow, sad and majestic follows the brave old ship with death, as it were, written on her.

Figure 70. Can you identify the heroine of this painting? *The "Fighting Téméraire" Tugged to Her Last Berth to be Broken Up*, by Joseph Mallord William Turner. Oil on canvas. 35 3/4" x 48". The National Gallery, London.

You may wish to speculate about Turner's own feelings. When he recorded this scene at sunset, he was deeply moved. The ships symbolized the end of one era and the beginning of another. His emphasis is on the tug; the Téméraire already appears a gallant ghost of the past.

PAINTING ACTIVITIES

You may want to refer the class back to Drawing Activity 6 on pages 80-81.

1. The artists who painted Washington all saw him with slightly different visions, but the character and greatness of the man are apparent in all the portraits. In Stuart's portrait it is Washington's "inner light" that shines through his "strong jaw, thoughtful eyes, and firm mouth."

In this activity, you will refer to Stuart's portrait on page 34. Use color to strengthen and heighten your own perceptions of Washington's heroic qualities.

Figure 71. Student art.

2. The subject matter of works of art can be analyzed and grouped according to content. Works of art which include many figures are grouped under the category called *figurative works*. There are subdivisions of figurative works which are even more specific. Look at the categories listed below. When you have discussed these categories, look for examples of each category in your book. When you have found at least one example of each category, discuss each category again, using the examples found.

a. Action figures: presents active, moving people.

b. Figures in repose.

c. Genre: shows everyday life, local or street scenes such as watching a parade, or attending a ballgame.

d. Mythological or allegorical figures.

3. You have found in your studies that historical events can shape the subject matter of a work of art. A work of art can also shape the way a historical event is remembered. Select an event in history that is of particular interest to you. Using one of the categories of figurative works, sketch and re-sketch the subject matter until you are communicating the event as clearly and as powerfully as you can. Ask a classmate to look at your sketches and tell you about the event as he or she sees it portrayed in your work. You may want to make some alterations based on this discussion. When you are ready, paint your event.

Allow time to brainstorm historical events. Make lists on the board. Allow time for research and consultation with social studies teachers. If possible, have the students write descriptively about the event to accompany their painting.

4. Look at Morris Graves's singing bird in Figure 72. This bird is clearly making sounds. You do not ordinarily see sounds, but Graves's vision shows us what this bird's song looks like to him. What do you think he may be telling the moon? Is it a heroic song? Choose a creature (another type of bird or any other creature) and paint a picture showing your creature *and* a sound it makes. Try to show the pictorial relationship between the animal and the sound. Try painting other sounds. Can you show visually the sound of a clock ticking or striking? How about a typewriter? Rain? How would you translate the sound of a car crash in a painting?

You may want to extend this activity by playing music and discussing the imagery each piece evokes. Point out that painting does not have to be representative. The music department will have some excellent examples that will evoke strong imagery.

SCULPTURE

For over two thousand years, sculpture has been used to portray heroes and heroines. Do you recall the historical monument *The Marine Memorial* (page 40)? Another well-

Figure 72. White lines help the artist depict the quality of sound. Morris Graves. *Bird Singing in the Moonlight*. 1938–39. Tempera and watercolor on mulberry paper. 26 3/4" x 30 1/8". Collection of the Museum of Modern Art, New York. (Purchase)

Have students speculate on the problems that Borglum encountered in carving *The Presidents.* Have them research his life and work.

Alfred Hitchcock used these enormous heads in *North by Northwest.* This film is generally available in libraries for rental. It gives a dramatic picture of the monument's size. You might mention that the mole on Lincoln's face is four feet wide.

known monument to American history is in South Dakota. It is the Mount Rushmore Memorial, *The Presidents* (Figure 73.) This amazing monument is carved in granite on the side of Mount Rushmore. The carving took from 1927 until 1941, and involved the use of dynamite and power tools. American sculptor Gutzon Borglum planned and directed the project.

The Presidents includes four of America's important leaders: Presidents George Washington, Thomas Jefferson, Abraham Lincoln, and Theodore Roosevelt. The heads are so huge that they can be seen from as far away as sixty miles. Why should an artist carve such an enormous sculpture? What might such giant heads symbolize? Perhaps the artist wants to show that these four men were giant influ-

Figure 73. The sculptured relief heads of Washington, Jefferson, Lincoln, and Theodore Roosevelt are each about 60 feet high. Gutzon Borglum. Mount Rushmore Memorial, *The Presidents*. 1927–1941.

ences in the history of their country. Gutzon Borglum is paying tribute to these leaders. He has done so in such an original and engaging way that you cannot help but take notice and perhaps pay tribute as well.

Conquerors on Horseback

A hero of state is often represented as a conqueror on horseback. Equestrian statues are seen in parks and city squares, particularly in the Western world. The *Equestrian Monument to Bartolommeo Colleoni* (Figure 74) is made of bronze and is thirteen feet high. It was completed by the Italian artist, Andrea del Verrocchio (vurr-oh'-key-oh), in 1488.

During the Renaissance, Italian professional soldiers of fortune could be hired for a price to serve those in pursuit of power. The *Equestrian Monument to Bartolommeo Colleoni* is an equestrian statue glorifying these soldiers of fortune. Notice the smug image of power. Both the man and the horse have expressions of toughness and arrogance. The *Equestrian*

The statue stands in Venice. Have students locate Venice on a map.

99

Figure 74. The sculptor was able to imply movement, a shift of weight, in the pose of the commander, Colleoni. Andrea del Verrocchio. *Equestrian Monument to Bartolommeo Colleoni.* Bronze. Height 13′. The Granger Collection, New York.

Monument to Bartolommeo Colleoni portrays brute power, not the power of mind, wisdom, or imagination. Nor does it show the devotion of an Esther or the fervor of a Joan of Arc. This man and his horse seem as one. The horse is strong and thickly muscled. The man is wrapped in heavy armor. The pair look almost like an advertisement which assures that whoever buys their services will indeed see an enemy crushed.

Look closely at the man's face. What do you see? The mouth is turned down in a snarl. The eyes look out from under the helmet in a fierce and penetrating way. Here you have an image of superhuman power and physical strength. This is the warrior hero. What other visual elements contribute to the portrayal of fierceness, physical strength, and power in the *Equestrian Monument to Bartolommeo Colleoni*?

Bronco Buster (Figure 75) is a bronze sculpture of a man and horse which represents the popular hero of the American West, the cowboy. This sculpture was modeled by the American artist, Frederic Remington.

Figure 75. Remington was unsurpassed in the depiction of the horse in action. Frederic Remington, *Bronco Buster*. 1901. Bronze. Casting No. 67 by Roman Bronze Works, New York. Height 22 1/4". The Thomas Gilcrease Institute of American History and Art, Tulsa, Oklahoma.

Remington worked as a magazine illustrator during the late nineteenth and early twentieth centuries. His paintings, drawings, etchings, and sculptures helped to popularize the West by recreating its vivid frontier spirit with directness and emotional appeal.

Compare Remington's sculpture to the one by Andrea del Verrocchio. Both statues suggest conquerors. Remington shows the strong qualities of his hero through a twisting, wild energy. The rider is in full action, intent on besting the horse. Verrocchio's hero, on the other hand, is impressive because of his powerful posture which suggests the cruelties and might of which he is capable.

The cowboy was, for many, a hero who helped to extend the geographical horizons of the United States to the West. He worked on untamed land in all kinds of weather. Wild animals, poachers, and rustlers often made his job tougher. *Bronco Buster* symbolizes the spirit of determination that enabled these cowhands to combat the mighty forces of nature.

Remington's sculpture is symbolic of another kind of taming in the American past, too—the conquest of new territory.

The Athlete as Hero

Still another kind of hero is the athlete. Look at these sculptures by two American artists—*Groggy* by Mahonri M. Young (Figure 76) and *Jack Johnson* by William Edmondson (Figure 77). The first is made of bronze, the second of limestone. How do these two statues of boxers portray power and strength?

Groggy depicts a boxer who is staggering but has not lost his footing. The fighter leans back, perhaps to regain his breath, yet his powerful legs continue to reach aggressively forward. The medium of bronze is well-chosen to portray the sinew and muscle under the skin of this strong athlete. The metallic surface lends a sheen that suggests sweat and adds to the presence of the figure. Despite the boxer's posture, *Groggy* communicates vitality and movement.

The William Edmondson statue, *Jack Johnson*, portrays the first African-American heavyweight champion. This fighter does not ripple and sway. He is planted firmly and squarely and appears to have the solidity of the side of a mountain. Here is an athlete who dares one to dislodge him or try to get beyond him. The medium of limestone adds considerably to this image.

William Edmondson's Unique Style

Look carefully at the forms and lines of *Jack Johnson*. With just a few cuts of the chisel, the artist has given the fighter a strong expression. What does it say? The forms of the legs are simply two columns. They look like the trunks of two great trees. The right arm ends in a blunt, smooth, rounded circle. It is pulled back, coiled like a spring into a massive chest. What does it say?

Starting with Greece and Rome there is a long history of representing athletes in sculpture.

A collection of artworks related to sports might be compiled as a bulletin board display. Greek and Roman examples should be included.

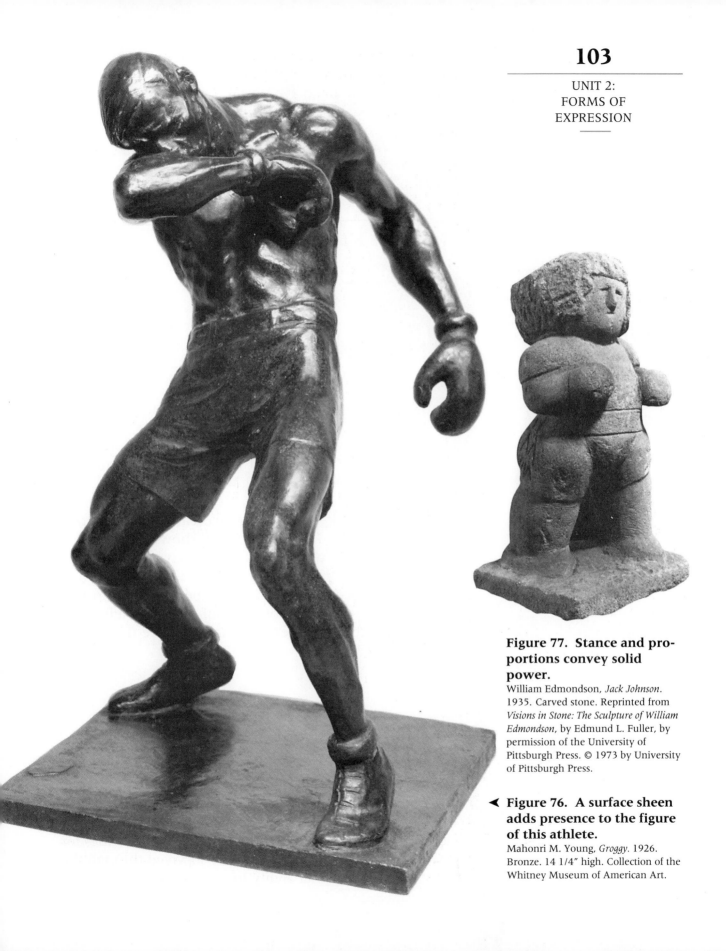

Figure 77. Stance and proportions convey solid power.
William Edmondson, *Jack Johnson*. 1935. Carved stone. Reprinted from *Visions in Stone: The Sculpture of William Edmondson*, by Edmund L. Fuller, by permission of the University of Pittsburgh Press. © 1973 by University of Pittsburgh Press.

◄ **Figure 76. A surface sheen adds presence to the figure of this athlete.**
Mahonri M. Young, *Groggy*. 1926. Bronze. 14 1/4″ high. Collection of the Whitney Museum of American Art.

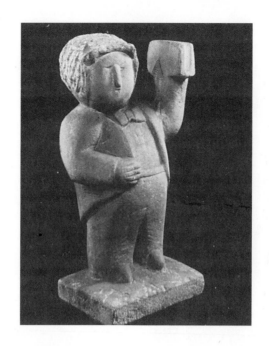

Figure 78. The sculptor communicates the steadfastness of faith.
William Edmondson, *The Preacher.* 1935. Carved stone. Reprinted from *Visions in Stone: The Sculpture of William Edmondson*, by Edmund L. Fuller, by permission of the University of Pittsburgh Press. © 1973 by University of Pittsburgh Press.

Sculptor William Edmondson was from Nashville, Tennessee. He did not begin sculpting until he was in his fifties. Most of his work is in limestone. Edmondson was a man of great faith and did not doubt, even though self-taught, that he was a professional.

Perhaps some of Edmondson's inspiration came from his local minister. Look at his sculpture called *The Preacher* (Figure 78). What kind of person does it show?

This is a preacher who speaks up and says what's on his mind. No doubt he offers encouragement and inspiration to the people in his community. Perhaps people came to him for guidance. How has Edmondson shown the solidity and steadfastness of this preacher? In what ways are these characteristics heroic?

SCULPTURE ACTIVITIES

1. Imagination and inventiveness are essential qualities for an artist. The artists whose works have survived through the years all have an unusual ability to see things from a differ-

ent point of view. You have been looking at some interesting examples of sculpture. You have seen how varied and expressive the forms can be, depending on the vision and execution of each individual artist.

We all know that a UFO is an unidentified flying object. Well, what would a UVO be? How about an unidentified visual object? That might be almost anything your artistic brain could imagine. Begin your UVO by making a series of small geometric forms—pyramids, cones, cubes, spheres. As you look at and modify these forms, make something unique.

2. One compositional principle used in works of art is balance. Balance is important to all works of art, but especially important to sculpture. There are two kinds of balance to consider: symmetrical and asymmetrical balance (Figure 79).

Discuss UFO sightings, and descriptions of their form and shape. An object that moves with speed should be streamlined. Categories for the students' UVOs might be futuristic transportation, housing, industrial plants and machines, and personal adornment.

Gather a large collection of materials for the students to select from to make their assemblages. This is a good time to review the section on balance in the Principles of Design section on pages 55–60.

Figure 79. Symmetrical and asymmetrical balance.

Make some sketches, showing your ideas for sculpture, that employ both kinds of balance. Discuss the best of them in class, along with the sketches of your classmates. It is important to consider the possibilities of each sketch as a successfully balanced piece, whether symmetrical or asymmetrical. After the discussion (and any revisions you feel necessary as a result of the discussion) make an assemblage of your best drawing.

ARCHITECTURE

Architects have provided monuments to the most important persons of history. Monument building began in the early civilizations that arose in Mesopotamia and Egypt.

The first architect to build a pyramid was Imhotep of Egypt. Imhotep built such an elaborate burial place for King

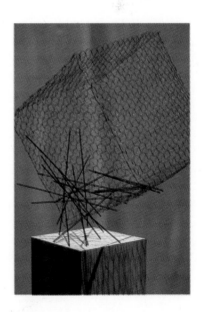

Figure 80. Student art— asymmetrical balance.

Zoser in 2800 B.C. that he himself became recognized as a hero of his era.

The history of architecture is that of great breakthroughs in methods and techniques. Those who led these advances are the heroes of architecture, acclaimed for their achievements, as are the heroes of medicine and science.

A Great Architect and a Hero of Science

The Salk Biological Institute honors a twentieth-century hero of science, Dr. Jonas Edward Salk, who gave us the polio vaccine. The institute was designed by the highly influential architect Louis I. Kahn (1901–1974), who was himself a hero to his many students and followers. Kahn was a quiet, thoughtful man who designed only about one hundred buildings during his lifetime, many of which were never built. Nonetheless, his work had an enormous impact on other architects.

Kahn claimed he depended more on inspiration than on knowledge. He sought to find out what each building *should* be rather than trying to impose a particular style, method, or technology on it. His forms are often very bold and composed of masses and voids, with the materials and the structure strongly expressed.

Look at the Salk Biological Institute (Figure 81). Located in La Jolla (lah-hoy'-yah), California, it was completed in 1967. The Institute's court is lined on either side by study towers. These provide offices for thirty-six research scientists who are in residence at the Institute. The towers are angled to face the ocean, and they serve as retreats. Here the scientists can reflect or plan. In the two huge blocks of laboratories behind the towers, they can put their ideas into action. The towers are separated from the laboratories by half-open passageways. When passing through, one encounters the play of sunshine and shadow, freedom and enclosure. The walk from the towers to the laboratory provides refreshment for the eye, the mind, and the spirit.

Kahn and Dr. Salk spent a good deal of time together talking about what the Institute might be. In placing the Salk Biological Institute by the sea, Salk and Kahn wanted the structure itself to give the researchers an unobstructed view. The boundless horizon would remind them that they might extend the boundaries of knowledge.

Compare the masses and voids in Kahn's architecture to positive and negative space in two-dimensional art.

The Egyptian pyramids honored kings who were thought to travel the rays of the sun to continued life beyond the earth. The Institute honors a "king of science" who provided a road to extended life through the conquest of disease. Encourage students to look for fresh relationships between the objects and events they are studying.

**Figure 81. A building, created by a hero of architecture, and
dedicated to a hero of science.** Louis I. Kahn, architect, the *Salk Institute for
Biological Studies*, La Jolla, California. 1967. Courtesy of the Salk Institute.

Memorials to Presidential Heroes

Look carefully at each of the celebrated monuments
illustrated in Figures 82 through 84. What is a monument?
It is a building or other structure erected to commemorate a
person or event, and some involve a natural geographical
feature or historical site. Monuments range in size from
simple grave markers to the gigantic carvings at Mount
Rushmore in the Black Hills of South Dakota.

The Jefferson Memorial (Figure 82) is a domed, circular,
colonnaded structure housing a bronze statue of Jefferson
by Rudolph Evans. Located in Washington, D.C., it was
designed by John Russell Pope (1874–1937) and his associ-
ates to reflect Jefferson's taste for classical architecture. The
exterior walls and the fifty-four columns are of Vermont
marble. The interior walls, of Georgia marble, are inscribed
with selections from Jefferson's most famous writings. The
domed ceiling is of Indiana limestone.

The Lincoln Memorial (Figure 83) is located across a
lagoon from the Jefferson Memorial. It was designed by
Henry Bacon (1866–1924). There are thirty-six marble
columns, which represent the number of states that had
been formed at the time of Lincoln's death. Forty-eight

Have the students research
Thomas Jefferson as an archi-
tect. Discuss the Palladian
style which Jefferson helped
introduce in the United States.

Figure 82. The Jefferson Memorial reflects the president's love of classical architecture. John Russell Pope, architect; Rudolph Evans, sculptor, *The Jefferson Memorial.* Washington, D.C., 1943. Courtesy the Library of Congress.

states were in the Union at the time the memorial was dedicated (1922). Their names are inscribed on the walls. There are two side chambers. One is inscribed with Lincoln's Gettysburg Address; the other with his second inaugural address. These are just off the main shrine, which houses the majestic statue of Lincoln, the great emancipator, by Daniel Chester French (1850–1931).

The Washington Monument (Figure 84) was designed by the architect Robert Mills (1781–1855). Mills's design was

Figure 83. The Lincoln Memorial houses the majestic statue of the Great Emancipator. Henry Bacon, architect; Daniel Chester French, sculptor. *The Lincoln Memorial.* Washington, D.C., 1922. Courtesy Uniphoto, Inc., Washington, D.C. Photograph, Regis Lefebvre.

Figure 84. One of the original plans for this monument included a statue of the first president clad in a Roman toga, driving a chariot. Robert Mills, architect, *The Washington Monument,* Washington, D.C., 1848–1885. Courtesy the Library of Congress.

Ask: "What do you think George Washington would have thought of being draped in a toga and driving a chariot?"

Students may sketch a version of the original base and obelisk that were intended for the Washington Monument. They may also design a new base, reflecting today's cherished values. Discuss whether they think any base is desirable.

Review the events of President Kennedy's assassination, and discuss the possible interpretations of the architect's statement about the monument being like a pair of magnets.

selected from the entries in a competition sponsored by the Washington National Monument Society. In the original plan the marble shaft was to rise from a dome, with Washington, clad in a Roman toga, driving a chariot above the entrance. Luckily there was a shortage of funds, and the dome with its chariot-driving Washington was eliminated before the shaft was finished in 1884.

The 555-foot, marble-sheathed obelisk is among the tallest masonry structures in the world. Work began in 1848 and continued for thirty-seven years. Major changes in the plan were responsible for the long period of work. These included a shift in site due to geological conditions and the abandonment of the classical temple base.

The John F. Kennedy Memorial (Figure 85) in Dallas, Texas, consists of two U-shapes forming an enclosure. The memorial is understated to the point of starkness and is strangely unsettling. The architect, Phillip Johnson (b. 1906–) described his monument to President Kennedy as a "pair of magnets about to clamp together." The memorial is situated a few hundred yards from the spot where the late president was assassinated. Construction is of simple precast concrete slabs slightly elevated above the ground on short supports. How does this architectural form suggest the inflexible and relentless turns of fate?

Figure 85. The stark simplicity of this memorial has a strong emotional impact.
Phillip Johnson, architect, *John F. Kennedy Memorial*, Dallas, Texas. Courtesy Uniphoto, Inc., Washington D.C. Photograph, Tim Ribar.

ARCHITECTURE ACTIVITIES

1. There are two kinds of environments: the natural one and those created by human beings. Both are affected by people. How many times have you seen trash left on the streets of our towns and cities or observed discarded rubbish along the highways, in parks, and rural areas? Of course, you have seen state highway signs reminding us of our responsibilities to refrain from littering, burning, or otherwise damaging our natural environment.

But what about the environments that we have created? New buildings, shopping centers, parks, and highways usually look nice when they are first completed. As time passes, however, people often forget (or ignore) their responsibilities, and these created environments suffer.

Look around your community and select three created environments that have a special meaning to people. Make a sketch of how they must have looked when they were first completed. What has happened to them? Are they as nice and well-kept as they were when they were new? Have people left trash around to detract from the original appearance? If there is what appears to be unnecessary wear, you should consider the possibility that they were, perhaps, poorly designed in the first place. For example, people may have made paths in the grass in a park because sidewalks were poorly placed.

2. Imagine that you are a city planner with an unlimited budget. Re-do your sketch from Activity 1, making changes to make that special environment easier to use, more fun to be in, and more beautiful. Plan so that your design will encourage people to take pride in their environment and to keep it in good shape. Do whatever you think will help; for example, you may change the placement of existing objects and facilities and add trees or recreational activities and equipment.

If you can possibly have a city planner visit with the class, discuss and prepare for the visit beforehand. The students should be asked to prepare technical questions. For example, how does the planner decide on such things as proposed walkways? How does he or she determine how many benches, water fountains, and restrooms are needed and where they should be placed for the number of people expected to use the park?

PHOTOGRAPHY

You have seen that heroes and heroines come from many walks of life. Throughout the ages artists have chosen ways to depict these unique personalities. Different media, postures, moments in time, and the vision and imagination of various artists all help to make the interpretations you have seen so wide-ranging.

Still another medium, photography, has been used to record the essence of heroes and heroines. Like other artists, a photographer uses imagination and vision to capture personality, meaningful moments, and a sense of greatness.

A photographer also uses certain technical processes to create a finished work. Yet, unlike other artists, a photographer must deal with the images seen through the camera's lens. You will now look at the heroes and heroines found through the camera's eye by different photographers.

Unusual War Heroes and Heroines

Look for photographs and stories that show everyday heroes and heroines in newspapers and magazines.

Dorothea Lange saw heroes and heroines where most people did not think to look for them—among the farmers and factory workers of America during the 1930s and 1940s. *End of Shift, Richmond, California* (Figure 86), shows the working men and women whose efforts contributed greatly to the country. These people were a key labor force during World War II (1939–1945). They were the "soldiers" who fought at home, often working long hours under pressure. What do you see in this photograph? The many people in the photograph appear to pull together. They seem unified as workers, moving toward a common goal. Look at the expressions on their faces. What do they tell you?

You have looked at other pictures and statues of soldiers in this unit. These are the people who are usually awarded the medals and honors. In *End of Shift, Richmond, California,* Lange reminds you that there was another army at home, fighting with energy and determination to win the war. For Lange, it was important to record the unsung heroes and heroines.

Mahatma Gandhi, Spinning (Figure 87) is a 1946 photograph by Margaret Bourke-White. Bourke-White was a photojournalist for *Life* magazine from 1936 until 1957. She

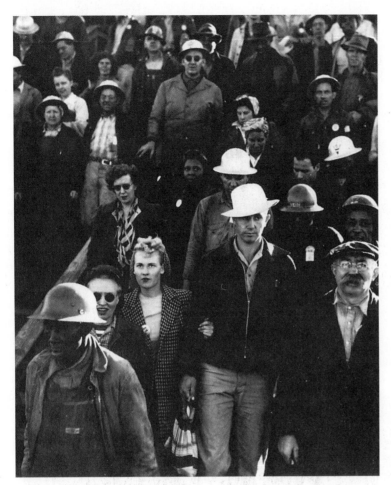

Figure 86. *End of Shift, Richmond, California,* **a photograph by Dorothea Lange, celebrates the unsung heroes and heroines of World War II.** Dorothea Lange, *End of Shift, Richmond, California.* 1942. Photograph Courtesy The Dorothea Lange Collection. © The City of Oakland. The Oakland Museum, 1990.

traveled widely, making pictorial reports in Europe, Asia, and America.

Mahatma Gandhi was an Indian leader, who taught his people to use nonviolent civil disobedience as a means of achieving independence from English rule. During his life Gandhi struggled with, and often overcame, great difficulties. He represented the dream of freedom to many of his people but died at the hands of assassins. Gandhi died in pursuit of his beliefs, and his death has been viewed as a heroic sacrifice.

Although Gandhi was a fighter in his own way, his weapons were not guns or tanks. Bourke-White's photo shows him quietly spinning fibers. Is this a form of war? In a way, for Gandhi, it was. Actual war leads to destruction. However, making fabrics to build industry was a way of battling the poverty which plagued India. Spinning, a peaceful and useful occupation, is symbolic of what Gandhi wanted for India.

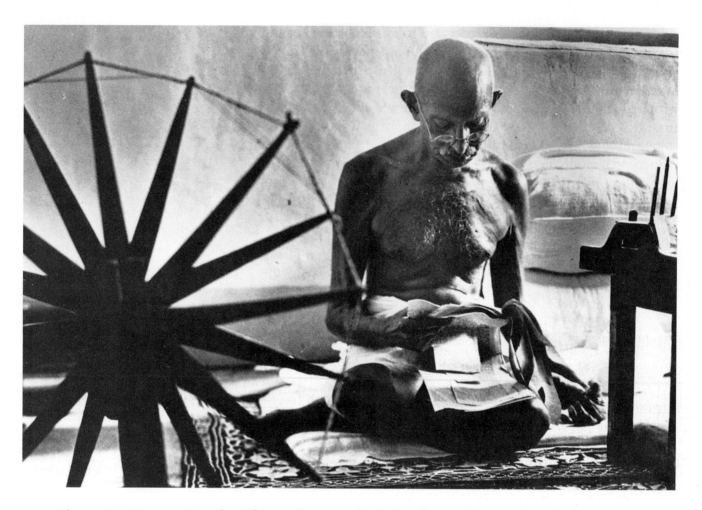

Figure 87. Margaret Bourke-White's photograph of Gandhi emphasizes the nonviolent, productive ideals of an international hero. Margaret Bourke-White, *Mahatma Gandhi, Spinning*. 1946. Silver gelatin print. 14 5/8" x 19 1/2". The Art Institute of Chicago. Gift of Photography Purchase Fund, 1957.

Analyze each of these examples of photography by using the compositional principles.

Discuss the career of a photojournalist. What kind of personality might be needed to photograph people?

114

Mahatma Gandhi, Spinning is an image of humility. How does Bourke-White accomplish this? Gandhi does not look out at the viewer, but down at the work he is doing. His figure appears small and somewhat frail. The spinning wheel is larger and more important visually in the photograph than the man. The man is only one of many objects in the picture. What other objects do you see? Mahatma Gandhi, in this sensitive photograph, is portrayed not as the center of things, as a typical hero might be, but rather as a part of the total picture.

In 1937 the world was shaken by the brutality and suffering of the Spanish civil war. The American photographer, W. Eugene Smith, went to Spain to report on the conditions of the people. Smith had his first job with a newspaper at

the age of fifteen and later became a photojournalist for several magazines, including *Life, Newsweek,* and *Harper's Bazaar.* During World War II, as a war correspondent, he was wounded.

A war hero is usually a monumental figure who has won a great battle; but Smith's figure is a simple Spanish woman weaving (Figure 88). Study the composition of lights and darks in this remarkable photograph. Notice how Smith uses light to catch the gifted hands and powerful neck muscles against the exquisite face. This extraordinary photograph so moved the world that one writer wrote, "Her image is as haunting and eternal as a drawing by Michelangelo of one of the three fates."

Smith had gone to Spain to report on the war's effect on the people. Instead, in a remote Spanish village untouched by the twentieth century, he captured the per-

Do you think the woman was aware of the presence of the photographer when this picture was taken?

Have students sketch some of the opposite attributes of a hero or heroine such as pride and humility. Sketch the same subject in defeat and in victory.

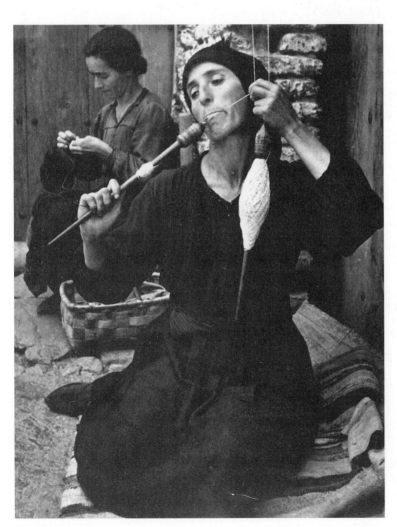

Figure 88. The faith of a nation is represented by this simple Spanish woman at work in Smith's photograph, *Spanish Woman Weaving.*
W. Eugene Smith, *Spanish Woman Weaving.* 1937. *Life* Magazine, © 1951, Time Inc.

sonality and the history of the Spanish people. In an age of destruction, Smith's heroic woman represented the faith of a nation.

Contrasts in Heroism

You have looked at photographs of two heroic persons in very humble settings. By comparison, look at *Primo Carnera* (Figure 89) by the American photographer Edward Steichen. Carnera was a heavyweight boxer in the 1930s. How proudly he stands with his feet spread and his arm raised! He is illuminated from behind, so his face and chest are in shadow. The light outlines the boxer's torso, giving him the appearance of a monumental statue. His figure is raised high above the viewer, and he looks down as a god would from a mountain top. How does Carnera's posture compare with that of the boxer in *Groggy* by Mahonri M. Young (page 103)?

Carnera appears to be enjoying the role of hero. He stands like an icon of power and strength, commanding

Figure 89. Compare the boxers in this photo and in *Groggy* (Figure 76).
Edward Steichen, *Primo Carnera*. 1933. Photograph. Reprinted with the permission of Joanna T. Steichen.

worship. Can you imagine Mahatma Gandhi posing like this for a portrait? How different the heroes of history are! Consider a true American hero, President Abraham Lincoln. There are many photographs of Lincoln. Photography was in its early stages during his life. Only a few photographs capture his warmth and humanity.

In the Gardner photograph of Lincoln (Figure 90), the President appears worn and tired. His necktie is askew and his hair is a bit ruffled. There were many grave issues facing Lincoln at the time, and his expression bears witness to their weight. Yet a smile plays across his face, and his warmth and humanity shine through.

This photograph was taken on April 10, 1865. By the time it was printed, Lincoln had been killed. Had he seen it, he might have found it to be, as he had said of other portraits of himself, "a good likeness, but not pretty."

Have the students research the issues that were concerning Lincoln at this time—four days before his assassination.

Figure 90. In this photograph of Lincoln by Alexander Gardner, the president's warmth and humanity shine through in spite of the burdens of his office. Alexander Gardner (1821–1882). *Abraham Lincoln, 1809–1865.* Sixteenth president of the United States. Photograph. Albumen-silver print. 17″ x 15 3/16″. 1865. National Portrait Gallery, Smithsonian Institution.

PHOTOGRAPHY ACTIVITIES

The best background to give students for this assignment is to discuss actual photographs of historical importance with them. If your local library has some of the books listed in the bibliography, they will be of great help. Also discuss those photos the students find in local newspapers and magazines—for interest as well as for composition.

1. Leutze tells a historic story in *Washington Crossing the Delaware*. Many great photographers have recorded moments in history with their cameras, on the very spot that history was being made. Have you ever imagined yourself as a great newspaper photographer? In this activity you will be acting like a photojournalist.

There are times when journalistic photography affects history and becomes a real part of the story itself. For example, a shot of a mother and child in a famine-plagued country may bring more relief than thousands of words written on the sad conditions. Look through newspapers and magazines and find several good examples of pictures that tell a story.

Think of a local problem or opportunity that could offer a good subject for photojournalism. Take several photographs that will explain the problem or opportunity in a dramatic way. Remember that it is not only the story which is important, but also the visual elements and compositional principles. News pictures can be very dramatic and moving. They can also be funny or mysterious.

Discuss photo montage, optical art, and the use of repetition to create rhythm and movement.

2. Collect prints which have interesting texture, movement, pattern, and repetition of elements. Choose two of these photographs which are visually related or look interesting together. Rule and mark off each of the two prints into vertical strips about three-fourths of an inch wide. Cut these carefully on the paper cutter, or with an X-Acto knife or scissors. Move the pieces up and down vertically to see if shifting the images is more effective. Glue, cement, or dry mount the strips in the most interesting composition you can arrange. What exciting visual effects can you achieve?

Be very careful as you cut.

CAUTION

Discuss various media and tools (brushes, colored pencils, swabs, cotton, food coloring photo-flo, bleach, watercolors, etc.). Discuss safety in the use of these. You may want to discuss possible effects students can work for—humorous, nostalgic, and so on.

3. Hand coloring is an interesting process which was particularly popular in the 1930s and 1940s. To do it, you apply color tints to black and white photographs. You do not have to have color photographic paper, nor do you need chemicals and filters. Instead you use oil- or water-based colors to tint a selected area of a carefully chosen print. What makes this so interesting is that you can get effects that can only be derived from this process. If you try to color the entire pho-

Figure 91. Student art (photo-montage).

Figure 92. Student art (hand coloring).

Tell the students to look close-
ly at this example of student
art. Remind them that, when in
doubt, *less* color is generally
more dramatic than more.

119

tograph, you may lose the effect of the contrast of the colored areas with those of black and white. Do you recall the dramatic effect when Dorothy and Toto landed in Oz and opened the door? The house inside was black and white; outside was Oz in full color, and the color was streaming in the door.

Have several extra copies of the photos you select so that you can practice before coloring the final print. Keep in mind that you are applying a *tint* and your color shouldn't be too strong or intense. For example, in a photo of a clown you might consider applying color only to the hands and face. In a landscape you might color just one flower or a few leaves. In an interior photo of a window you might color only the scene that is outside of the window. Notice the student artwork in Figure 92.

UNIT

SPECIAL PROJECTS

The Artist and Heroes and Heroines

ART HISTORY

1. The Battle of Trenton was a landmark in the history of the United States. If you are currently taking a course in American history, read the section in your textbook that describes this battle. (If you are *not* taking American history at this time, check your school's Social Studies Department. It will have a copy of an American history text that you can use for this purpose.) Next, look at other accounts of this battle from encyclopedias and other sources in the library. Do you find that these sources do justice to the importance of this battle? Do they convey the suffering of the soldiers in the cold? Do they suggest the great boost the battle's outcome gave to American morale and recruitment of new soldiers?

Write your own account of the Battle of Trenton as if it were to be a part of a new history textbook. Select illustrations you would use, and create your own original artwork

If scientific evidence can date when certain animals became extinct, this is a reasonably good way to get approximate dates for cave art.

to show key parts of the story. You might also include battle diagrams, maps, and graphic battle scenes. Which painting of the Delaware crossing would you select?

2. It would take a very brave hero or heroine indeed to face the young mammoth that is illustrated on page 76. To this day, the cave paintings are unsurpassed in vitality and gracefulness. Their importance goes beyond their artistic merit. They are also extremely useful for their depiction of ancient animals that are now extinct.

An interesting example of the usefulness of these works of art is the case of the woolly rhinoceros. Scientists knew of this extinct creature from the many bones of the animal they had found. They pieced together clues from these bones. In much the same way that police artists draw composite pictures of suspects from descriptions of witnesses, a picture of the woolly rhinoceros was constructed.

In 1907 an accidental discovery of a very well-preserved and almost complete woolly rhinoceros rocked the scientific community. The actual animal looked nothing like the composite picture that the scientists had constructed. It looked almost exactly like a picture of one on a cave wall in France.

Research and prepare a report on cave paintings. Cave art was common in many places around the earth. You can find several good reference works on cave art, particularly on the art of Africa and Europe. Your report should include several key points:

- How these works of art were discovered
- Initial speculation about just what the artworks were and who the artists were
- Various methods used in determining the age of these cave paintings
- Materials the artists used
- How the artists treated perspective
- The effects the artists achieved by the use of uneven wall shapes as their support surfaces

3. In this section on heroes and heroines, we have observed several examples of sculpture of two types: bronze casting and stone carving. Bronze is, of course, cast from a mold, and stone sculpture is cut from a block. On page 103 you saw two excellent contrasting examples of these two methods—the two boxers. Do you feel that William Edmondson could have achieved the effect he desired if his work was in bronze? The problems in the two methods are

quite different. Research stone carving to learn the difficulties an artist faces when working with a block of stone. Prepare a report on your findings. You might start your report with the classic statement of the greatest sculptor of all, Michelangelo: "The greatest talent has no conception which a single block of marble does not potentially contain within its mass, and only a hand obedient to the mind can penetrate to this image."

4. On pages 107 to 110 we looked at four significant memorials, each dedicated to a president of the United States. There is a great deal of difference among the four. Which do you think is the most appropriate as a memorial? Which do you believe best fits your image of the president it memorializes?

Select a hero or heroine whom you think deserves a memorial. List the attributes of this person that you believe should be preserved and revered. Draw a design for a memorial that reflects the person's character and helps perpetuate this person's fine qualities.

5. In Bastien-LePage's *Joan of Arc* (page 91) we see a moment in which Joan discovers her role in life. Select a person whom you consider to be a hero or heroine. It may be the same person you selected for Activity 4. Reflect upon a particular moment in the life of that person which might be considered comparable to the moment Bastien-LePage pictured in Joan's life. This moment may have decided an important course or action which changed this person's life.

Research the life of the person whom you have selected. Note specific details of the event you have chosen. Be sure to include the setting of this event (the architecture, clothing types and styles, types of transportation used at the time of the event, and other relevant details).

Plan a composition which includes the details you feel are most appropriate and draw or paint a scene depicting the event. Give your work a title which helps interpret the person and event.

6. The Statue of Liberty was given to the American people by the people of France in 1886. It is now, perhaps, the most famous landmark in the world. Many people are aware that the sculptor was Frédéric-Auguste Bartholdi. Comparatively few people are aware that the great French engineer and bridge builder Alexandre Gustave Eiffel designed the inner structure which supports this immense monument to freedom. Eiffel was one of the most talented persons of his time. Research and report on his life and his varied interests and

Eiffel's last project was the development of the first wind tunnel for testing airplanes.

achievements. Include information about the other great monument he designed, which bears his name and dominates the skyline of Paris. Report, too, on his spectacular bridges in the mountains and on the surprising project that he spent his last years studying and developing.

APPRECIATION AND AESTHETIC GROWTH

1. Your eyes give you a three-dimensional view of everything you see. As we know, when you render a drawing or painting of a subject, you are representing a three-dimensional object on a two-dimensional surface. This surface has height and width but not depth. You create the illusion of depth by the way you handle perspective. This can include varying the size of the near and far objects, varying the placement (high or low) on the surface, overlapping objects, and varying the intensity of color and definition.

Most of us have become so accustomed to looking at photographs that we have an intuitive sense of how three dimensions appear on a two-dimensional surface. Have you ever considered that a mirror accomplishes the same function? Experiment with a mirror. Look at a friend's image in a mirror. Why do you see a change? Mirrors played an important role in the history of perspective long before photography was invented. Can you see why a mirror image was helpful?

2. Bastien-LePage was proud that he was born in the same area of France as Joan of Arc. His painting of Joan (page 91) was done in 1879. He places Joan in a natural setting using his parents' garden as his model. At the time of this historical event, Joan was about fourteen years old. Bastien-LePage painted Joan in the clothing of *his* time (the late nineteenth century) rather than that of *her* time (the fifteenth century).

Look at your classroom reproduction of this painting. It began as a painting in a vertical format which was only one-half its current size (the right half). Joan was there, but no saints were. When Bastien-LePage decided to add the saints, he actually sewed the left half of the canvas on to the right side, and completed the painting as we see it.

Block out the left half of the painting. Describe what is still there (Bastien-LePage's original effort) as a composition, using the design principles. Now, look again at the

Remind students that they can see their own images only by looking in mirrors or other reflective surfaces, *not* as others see them.

complete painting. Discuss the artist's decision to add the left half in relation to the principles of design. What other things did he add besides the saints on the left side? Do these things make the moment more dramatic? How about balance? Is the re-done work balanced?

3. Arthur Dove's *Fog Horns* (page 50) has been described as almost monochromatic. In the painting Dove is depicting the *sounds* of the fog horns rather than the horns themselves. He suggests that these sounds move from the deep inner source to the lighter outer edge of the sounds by making concentric circles change from dark to light. Fog layers stretch across the lower half of the picture in light tints and deepen toward the center to violet grey in the upper half, as the fog spreads across the surface of the sand and sea. Dove often used abstractions of color such as this to express objects through the sounds they make. One critic rhymed:

> To paint the pigeons wouldn't do,
> And so he simply paints the coo.

Dove allows the viewer to find his or her own meaning in the colors and shapes he paints.

You and your classmates can enjoy working as Dove worked in several ways. Here are two things to try:

a. Select a small group to record natural and created sounds heard at school, in streets, at home, on sport fields, and so on. Listen to the tapes in class; describe the *quality* of each sound, and then identify the various sounds.

Each class member should select one of these sounds to interpret through visual symbols and colors. You may or may not want to do this monochromatically. Do not draw the object that *made* the sound. Consider the tone, volume, and rhythm of the sound in your interpretation. The title of each person's work is important. It should help interpret the sound and add to the meaning of the finished picture.

b. Listen to recordings of various musical instruments played solo (that is, without any other instrument). Consider the sound each instrument produces. Assign a color to each of the instruments you have heard. Discuss why the various colors you have selected seem appropriate for the individual instruments. Paint the colors the class has chosen for each instrument on square pieces of paper—a different color for each instrument, and one color per square.

At this point, your music teacher can be of great help. With his or her help, arrange these squares of color on a

This is a very rewarding activity. You will need the help of a music teacher. He or she may have Benjamin Britten's *Young People's Guide to the Orchestra*, or may be able to suggest other good examples for listening to solo instruments.

background, according to their placement in a real orchestra. Discuss with the music teacher why the class has selected the colors they did for each instrument.

The various instruments in a real orchestra are arranged on stage in precise ways for acoustical reasons. Your placement by color, which gives you the *impression* of the various instruments, may help you understand why they are arranged in the way they are in a symphony orchestra or band. *Acoustical* balance is as important to the composer, arranger, and musical director as *visual* balance is to the artist.

EPILOGUE TO PART I

Up to this point in the text, the drawings and paintings you have studied have been representational, meaning that the images are realistic. The artists discussed so far have rendered a true likeness of their subjects. We have noted that the artists of the Renaissance established rules concerning use of the visual elements of art. These rules are known as the compositional principles of design.

In the next part of the text we will begin to see the gradual changes that took place in the nineteenth century and continued in the twentieth century—changes in which many artists moved away from representational art to the many forms of non-representational art we refer to as "modern art" today.

Before we leave this section on heroes and heroines, let's consider the revolutionary work of Giotto (jot-toh) di Bordone (1266?–1337).

Giotto's name is not as well known as those of the great masters who followed in the Renaissance. His paintings may seem at first glance a bit dull to you; his figures may seem stiff and the poses unnatural. Yet when we consider that Giotto virtually reinvented representational art, his work seems truly miraculous.

For almost a thousand years before Giotto's time Europe had experienced what is generally known as the Middle Ages, or the Age of Faith. The Roman Empire had totally collapsed in the early part of the fifth century A.D. What was left of classical Greek and Roman thought lay dormant in abbeys and monasteries.

You may want to mention that the question mark that appears next to Giotto's birth date means it is not certain, and that the students may encounter this type of notation frequently.

Figure 93. Giotto's frescoes are great achievements. Giotto, *Saint Francis Cycle: Sermon to the Birds.* c. 1296–1300. Fresco. Life-size. Upper Church of St. Francis, Assisi. Scala/Art Resource, N.Y.

Giotto began his career working in mosaics, the dominant art form of the time. He soon turned to painting, and his achievements established this medium as a major art form. Giotto's paintings break out from the flat, uninspired techniques of his contemporaries. He had no examples to follow, no books on technique; Giotto invented his own methods in order to make his figures appear natural.

Much of the body of Giotto's work was centered around Saint Francis who had died at the time of Giotto's birth. His paintings of Saint Francis (one of which can be seen in Figure 93) emphasize the simple virtues and humanism of the leader of the Franciscans. He was particularly interested in making the paintings of Saint Francis realistic, since many of those who would view them had actually seen the saint in their lifetimes.

Saint Francis's humanism was a primary influence on the rebirth of the human spirit which was the Renaissance. Giotto's paintings provided the inspiration and direction for the great masters who followed.

A detail from *A Dash for the Timber*.

PART

THE ARTIST AND THE WEST

A detail from *The Buffalo Runners, Big Horn Basin.*

UNIT

LET'S GET LOST IN A PAINTING

The Buffalo Runners, Big Horn Basin

by Frederic Remington

"I want to know what you are doing on this road. You scare all the buffalo away. I want to hunt in this place. I want you to turn back from here. If you don't, I will fight you again. I want you to leave what you have got here, and turn back from here. I am your friend."

**Tatanka Yotanka
(Sitting Bull)**

PART TWO:
THE ARTIST AND
THE WEST

1. See "Scheduling Your Course" section on page T-60 in this TAER.
2. Review "The Open-Ended Encounter" on page T-57
3. See suggested Lesson Plans for *The Buffalo Runners, Big Horn Basin* on page T-25.
4. Use Classroom Reproduction #3.

Manifest Destiny: An expansion of a nation to the limits that are considered by its people to be "natural" and "inevitable". Ask students if they understand why expansion to the Pacific Coast seemed to be the "Manifest Destiny" of the United States at that time.

You may also ask the students to consider the placement of the riders as a component of the overall composition.

The Indians we see pounding up the sun-washed prairie hillside (Figure 94) are in great danger. They are not endangered by the buffalo they are pursuing. They are not in danger from any tribal enemy or from their environment. In fact, they are not fully aware of the danger or its nature.

The cause of their jeopardy lies almost two thousand miles to the east in the Capitol of the young Republic. As these riders course over the plains, the seed that will destroy their way of life is being sown in the halls of Congress and in the columns of the leading newspapers. It is the kernel of an idea which is already shaping the future of America and causing the focus of its people to turn westward. The name of this idea is Manifest Destiny.

When it took hold of the American imagination, the buffalo hunt would end. Both the hunters and the hunted would survive only in the painted image and on the printed page.

Tribal life, as these Native Americans had known it, would begin to die in the last half of the nineteenth century. Before the birth of the twentieth century, the nomadic ways of the Plains tribes, the buffalo hunt, and the great beasts themselves would be little more than an echo on the prairie hillsides.

New sounds rumbled across the Great Plains as endless wagon trains pushed west. On the horizon the dark clouds coughed up by the Iron Horse swallowed the fragile smoke signals of the wandering bands.

If you were to come upon this painting, entitled *The Buffalo Runners, Big Horn Basin*, in the Sid Richardson Collection in Fort Worth, Texas, you might feel you should take a quick step backward to let the horsemen hurtle by. The explosive force of the colors, the stunning prairie light, and the pounding momentum of the horses almost take your breath away.

Look at the leader. Here is a man doing just what he was born to do. You can see the intensity in his face, the purpose and confidence in his easy seat on the horse and his grip on the rifle. He and his horse are one, and what a horse! He seems to fly. The excitement of the chase exhilarates the horse as much as it does his master. Horse and rider have intensity, grace, and purpose and are in harmony with their world.

Look at the rider on the left. The leader has crested the hill, but this man isn't quite there yet and is not as intent on the chase. He's looking down at his horse or at the ground.

Has the animal stumbled or perhaps caught a hoof in a prairie dog hole? This man has the reins in his left hand, and we assume his weapon is down beside him in his other hand. Whatever has occurred, his attention has been taken away from the quarry for the moment.

The hunter, behind the leader, and his mount are laboring up the slope. You can almost feel the lathery sweat on the horse struggling up the steep incline.

How does the artist tell you that the man out in front is, in fact, the leader? How can we be sure that we are not just seeing a moment when this particular rider, perhaps on a faster or stronger horse, happens to be in front? Look at his face, neck, and shoulders. His head is up, his chin juts forward, his expression is intense. If he does not actually see the buffalo yet, he knows where they are. There is energy and resolve in his posture. He is the leader. Color also focuses our attention on this figure. His shirt is a rich, strong russet.

Here, the artist tells us, is a man who passionately loves the hunt. For him, it is not just an exciting pastime or a routine quest for food. The hunt provides him with his identity and defines his relationship to the world around him.

What else tells us he is the leader? What about his horse? Unlike the horses beside and behind him, this animal's head is up, his nostrils flaring. Look at his legs. He needs no encouragement from his rider, who is not even holding the reins.

AN AMERICAN MASTER

The Buffalo Runners, Big Horn Basin by Frederic Remington was exhibited in New York City in late November of 1909. By that time, Remington was a successful artist. He was widely admired as a sculptor as well as a painter.

Remington's first work came as a result of a trip he made to the West from his native state of New York almost thirty years before he painted *The Buffalo Runners, Big Horn Basin.* The young illustrator drew his impressions of the frontier and soon had a commission from *Harper's Weekly* magazine for more. The public's curiosity about the American frontier was unlimited. Its appetite for stories, and most particularly

Figure 94. Frederic Remington, *The Buffalo Runners, Big Horn* ➤
Basin. **1909.** Oil on canvas. 30 1/8" x 51 1/8". Courtesy Sid Richardson Collection of Western Art, Fort Worth. (See pages 134 and 135.)

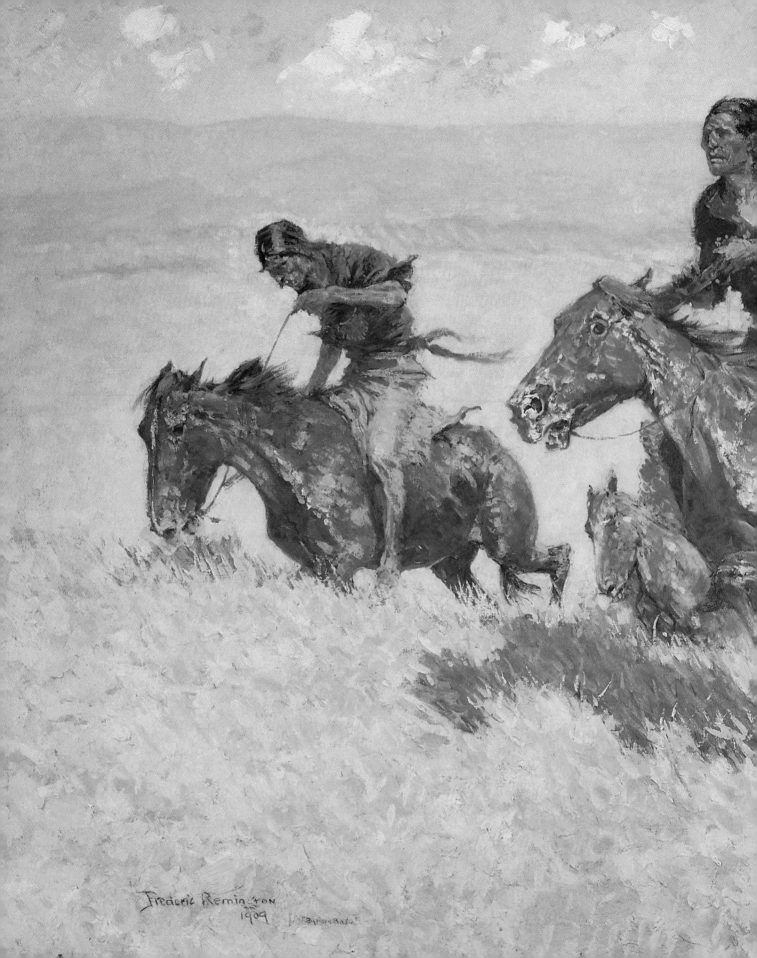

The theme of hard work and constant practice is emphasized in this unit.

illustrations, of this unknown landscape made Remington's name a household word in the 1880s.

Outside of his early college days at Yale, Remington had received his only formal training in art when he spent a few months in 1886 at the Art Students League in New York City. As his skills developed, so did his dedication to more artistic work and his love of the frontier. He was a very hard worker. We shall trace his progress as an artist, and, with it, the passing of his beloved West into oblivion.

The Galloping Horse

In the 1880s, a sequence of fast-shutter-speed photographs was published by the well-known photographer Eadweard Muybridge (Figure 95). They had a dramatic effect on the art world. In this sequence, Muybridge was able to show that for a brief instant all four hooves of a galloping horse were off the ground. It was also clear from the photographs that the running horse's legs were not spread out in "rocking horse" style as they had been depicted by all

Figure 95. Can you see why Muybridge's work changed the way artists depicted horses in motion? Eadweard Muybridge, *Frame 10 from Muybridge's Photograph Series, "Mohomet Running."* Department of Special Collections, Stanford University Libraries.

Figure 96. This is the way artists depicted galloping horses before the Muybridge photographs were published. Jean-Louis Ernest Meissonier (1818–1891), *Freidland, 1807*. c. 1875. Oil on canvas. 53 1/2″ x 95 1/2″. Metropolitan Museum of Art, New York. Gift of Henry Hilton, 1887.

artists up to that time. The legs were actually pulled up at one point under the horse's body.

These revelations caused great consternation among artists who had specialized in animals. It is said that the famous French painter of horses, Meissonier, lay awake all night when he first learned of the Muybridge discovery. He was tormented by the vision of a lifetime of his rocking-horse canvases marching into posterity bearing his name (Figure 96).

A number of artists took their direction from the Muybridge photographs, but it is Frederic Remington's interpretation of horses which has the greatest vitality. When *A Dash for the Timber* (Figure 97) was exhibited in 1889, it was a thundering success. Can you imagine the excitement the viewers felt? They were accustomed to paintings and drawings which were sedately elegant. Standard art of the time depicted rather formal scenes of

Look back to Sanford's *Washington at Princeton* (page 85) and Raphael's *St. George and the Dragon* (page 89).

Figure 97. This painting was done twenty years before *The Buffalo Runners, Big ➤ Horn Basin.* Frederic Remington, *A Dash for the Timber*. 1889. Oil on canvas. 48 1/4″ x 84 1/8″. Amon Carter Museum, Fort Worth. (See pages 138 and 139.)

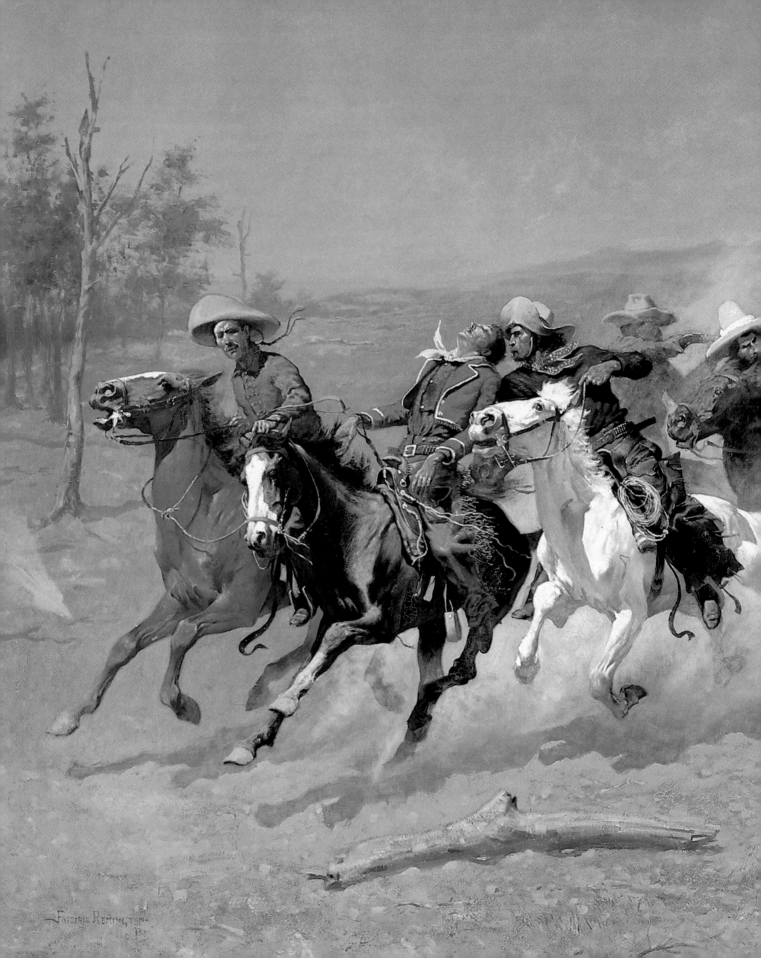

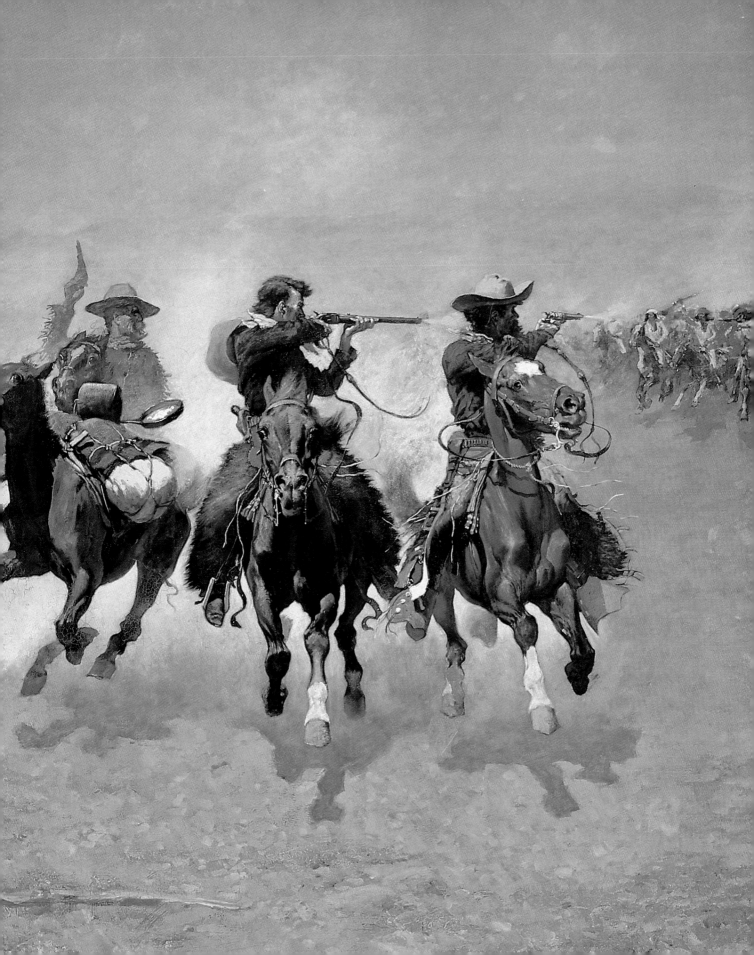

Use Classroom Repro-
duction #3.

Remind the students this era
had no TV or movies. This was
the visual entertainment of the
time as well as the art, and
reactions were strong.

battle—troops in a straight line firing at one another. If the troops were mounted on horses, the riders were handsome-ly dressed atop horses in rocking-horse poses. Remington took the Muybridge gallop, exaggerated it, and confronted the audience. His desperate riders were propelled over dusty, sunbaked plains on horses that seemed to fly. This was no polite drawing-room painting; the public loved it.

Remington, however, was not satisfied. In a letter to his friend Owen Wister, Remington said, "Why, why, why can't I get it?" The year was 1895. He continued, "I have to find out once and for all if I can paint. The thing [to] which I am going to devote two months is color . . . I have studied form so much that I have never had a chance to let go and find if I can see [color] *with the wide open eyes of a child.* What I know has been pounded into me—I *had* to know it—now I'm going to see. . . ."

It took longer than two months.

TWO LANDMARK PAINTINGS

We will begin our study of Remington's development as a painter by comparing some key aspects of two major Remington paintings: *A Dash for the Timber,* which was paint-ed in 1889, and *The Buffalo Runners, Big Horn Basin,* which was completed twenty years later in 1909. During the twen-ty years between these two paintings, Remington continu-ously worked on the mastery of color. As he came under the influence of the French Impressionist painters he began to soften the outlines of his works. He consciously moved from the hard, clearly defined outlines of shapes and forms that we see in *A Dash for the Timber* to the more softened outlines that are apparent in *The Buffalo Runners, Big Horn Basin.* He carefully studied the effect of light on color. He began to use looser brushstrokes and also to lay one color down beside another to let the viewer's eye blend them. He limited the range of color in his paintings. For a painter who already had succeeded by using sharp, clear realism in his art, these were hard adjustments. We will look carefully at these two paintings, and then at the influences that moved Remington in this direction.

Let's start with a close look at the *colors* in each painting. The sky in *A Dash for the Timber* is a somewhat cooler tone

than in *The Buffalo Runners, Big Horn Basin*. In the later painting, Remington gives us a warm, honeyed aqua and repeats these warm tones in his harmonious reds, ochres, and yellows. Can you see some of these tones repeated in the shadows? How do you think he did this?

Remington used a more **restricted palette** as time went on, which means that he used fewer colors than in his earlier work. The colors selected were increasingly more harmonious. In *Buffalo Runners*, the men, the horses, and the landscape appear blended and united.

Another major difference is the use of detail. What would you say about Remington's use of detail in each of these paintings? In *A Dash*, look at the various characters, their horses, and their clothing. Look at the just-wounded Mexican rider with his fine jacket and beautifully embellished saddle, and the different kinds of chaps worn by the various riders. What equipment do the riders carry? Now look at the riders and the horses in *Buffalo Runners*. How has Remington handled the details?

During the twenty-year period that passed between these two paintings, do you think that Remington's feelings about the West changed? The softened images certainly reflect a great deal of work and study on the part of the artist. They also make the Old West appear more remote—more a part of the lost era that was getting farther and farther away from him.

Let's look now at the horses in each painting: they are both in strong sunlight, but you can see the difference in the treatment of color outline. Look at the horse's coat in the detail from *Buffalo Runners*, (Figure 98). It catches and

For shadows, Remington used colors that were shades of his palette.

Make sure students understand the use of "palette" in this sense.

Discuss this question before continuing.

Figure 98. Detail from *The Buffalo Runners, Big Horn Basin* (Figure 94).

Figure 99. Detail from *A Dash for the Timber* **(Figure 97).**

reflects the light. It is also in harmony with other colors in the painting. Here, Remington used color to create movement, heightening the impression of speed.

In *A Dash* the artist has depended more on delineation of outlines and head-on perspective to give the illusion of movement (Figure 99). This realistic treatment makes us feel that the horses are about to run over us. He has masterfully foreshortened the horses as they approach the viewer. Can you tell what **foreshortening** means from looking at these horses?

See how the forelegs of the leader's horse in the *Buffalo Runners* seem to blend with the earth and the prairie grass (Figure 100). This softened outline makes them seem to be a part of the things around them. Men and horses in this painting blend with their surroundings. They are not imposed on the landscape but are in harmony with it. By contrast, in this detail from *A Dash* (Figure 101), we see a much harder, clearer outline. In this desperate flight, the men are imposed on the terrain. Conflict is conveyed to us, rather than harmony.

Both paintings, from different periods in his life, are representative of Remington's best. In the artist's later years,

Figure 100. Detail from *The Buffalo Runners, Big Horn Basin* **(Figure 94).**

Ask about foreshortening, and have the students discover its meaning, if this is their first time to encounter the concept. Its first introduction was with Charles White's *The Preacher* on page 72, which is a splendid example.

Figure 101. Detail from *A Dash for the Timber* **(Figure 97).**

Figure 102. Detail from *The Buffalo Runners, Big Horn Basin* **(Figure 94).**

we see that human beings, though still a vital part of the composition, no longer dominate. Rather they are a natural part of the scene.

In Figure 102, another detail from *The Buffalo Runners, Big Horn Basin,* note how the shadow under the leader's horse has been softened. You can see in this detail that the brushstrokes are quite loose and the artist has laid his colors beside each other. The shadows are not black but are made

143

Figure 103. Detail from *A Dash for the Timber* (Figure 97).

from colors used elsewhere in the painting. His use of white reflects light and adds movement. The vibrating energy the artist has created makes us feel that the shadow is really moving over the grass.

In Figure 103, a detail from *A Dash for the Timber,* the shadow is more clearly outlined. The color tones are more uniform and much cooler. The paint has been applied in a traditional, realistic manner. The sense of speed, movement, urgency, and drama comes more from the foreshortening than from the use of color.

Be sure students understand about "tells us less."

In *The Buffalo Runners, Big Horn Basin* Remington tells us less in the literal sense than he did in *A Dash for the Timber.* He allows our imagination free rein; the buffalo are just over the next ridge. In 1903 he said, "Big art is a process of elimination . . . cut down and out—do your hardest work outside the picture, and let your audience take away something to think about—to imagine . . ." Both of these paintings are a nostalgic look back to the Old West. Both have physical action, and both are dramatic. Between the 1889 and the 1909 work another element has changed. The element of conflict has gone. There is still the storytelling aspect, but, in *Buffalo Runners,* we see no buffalo, no closing for the kill, no detail of the hunt itself. In *A Dash,* conflict is right there,

clearly shown. All of the men have their weapons out and the battle rages.

In *Buffalo Runners,* the frontier seems to be fading, growing less distinct as the riders rush by. This is not the wild West of the lurid gunfighter legends, but the mythic West of light and landscape. The background and the atmosphere are a decorative surface on which the artist has placed his fabled hunters.

In 1908, Remington entered this in his diary: "I have always wanted to be able to paint running horses so that you could *feel* the details instead of seeing them . . ." The critic Royal Cortissoz, in his review of *The Buffalo Runners, Big Horn Basin,* said, ". . . they move as though on springs. Their heels play like lightning over the earth. You feel them hurtling themselves along. . . . It all makes an exhilarating spectacle . . . filled besides with the dry air and dazzling light. The joy of living gets into Mr. Remington's work." No one before or since has painted horses—the forward leap and full gallop, the desperate charge, the joyous chase—as Remington did in his bold and unsentimental treatment.

This is the confident brushwork and light-splashed color of a form of Impressionism which is quite American in character. The burnished red-brown of the lead horse, the leader's glowing shirt and the warm skin tones of the riders meld with the soft tan buckskins and the sunlit yellows of the prairie. The dusted blues of the other horses and hunters echo on the distant ridges and in the indigo shadows. In the summer of 1909, Remington wrote in his diary that he had finally "pulled *Buffalo Runners* into harmony." Critics then, as now, recognized it as a high point in his career. He had put his reputation as "only an illustrator" far behind him, and was winning his long struggle for recognition as an artist.

THE EFFECT OF IMPRESSIONISM

Impressionism is a style of painting which developed in the last half of the nineteenth century. To the public and critics of the time it was seen as revolutionary—a new way of seeing. It is characterized by bold brushstrokes of pure color plus white, placed side by side to represent the effects of light on objects. The term *Impressionist* came about in 1874 when a scoffing critic applied it to a Claude Monet oil sketch.

The introduction to Impressionism

Monet explained his work by saying he was trying to imagine what a blind person might see if he suddenly regained his eyesight. Pissarro, another Impressionist, urged artists to paint generously and without hesitation so they would not lose their "first impression."

Impressionist work is characterized by bold brushwork with loose, confident strokes, as in Figure 104. The viewer must stand back from the painting for the eye to blend these brushstrokes together into a recognizable composition. Colors are laid side by side in pure, bright tones. In many cases, a reduced palette is used. In some paintings, Remington limited himself to yellows, ochres, and warm tones of red. In other cases, such as in *The Outlier* (Figure 105), he used blues, gray-greens, and tones of brown lit with yellows to create a scene of quietness and harmony.

The Impressionists explored the effects of light on form. As a result, they produced softer shapes and less distinct outlines. They also discovered that when one color was

Figure 104. Monet often painted the same scene many times, to study the effects of light and atmosphere. Claude Monet (French, 1840–1926), *Japanese Bridge at Giverny.* 1900. Oil on canvas. Approx. 34 1/2″ x 38 7/8″. The Art Institute of Chicago. Mr. and Mrs. Lewis Larned Coburn Memorial Collection, 1933. Photograph © 1990, The Art Institute of Chicago. All Rights Reserved.

Figure 105. A quiet harmony of color adds a dreamlike sense of mystery and recollection. Frederic Remington (1861–1909), *The Outlier.* 1909. Oil on canvas. 40 1/8" x 27 1/4". The Brooklyn Museum. Bequest of Miss Charlotte B. Stillman.

placed directly beside another, the tonal qualities of each color were somewhat changed. The eye of the viewer tended to blend these two colors. With this technique they manipulated the effect of light on the eye of the viewer. The use of white was very important in creating such effects.

Remington became fascinated with the works of the Impressionists. He realized that the feel of movement and vibration that he so wanted in his own works could be achieved by the use of color. He would no longer need to rely on perspective alone as the traditional realist painters

Figure 106. An empty landscape on a bitter moonlit night shows us the hardships the Plains Indians faced in winter. Frederic Remington, *The Luckless Hunter*. 1909. Oil on canvas. 26 7/8″ x 28 7/8″. Courtesy Sid Richardson Collection of Western Art, Fort Worth.

did. In his struggle for color mastery, Remington had asked himself, "Why, why, why can't I get it?" The Impressionists had offered a solution. He had setbacks. On three occasions he burned many of his paintings in frustration, but he persevered and began to find the answers.

Remington kept a diary of color notes, which he called "CNs." One such CN reads, ". . . at times on certain ground the glare is beyond belief of the casual observer. Flake white would express it best but it would be a dangerous effect to attempt The shiny glitter of the sun on white ground . . . makes a reflected light on the belly of a horse" The more he studied color, the more he became equally fascinated with nocturnal scenes. Soon he was spending as much effort on the effects of moonlight and starlight as he had on his sunlit prairie scenes.

The Luckless Hunter (Figure 106) won considerable praise. A contemporary critic said, "I hardly know which is more moving in his picture of *The Luckless Hunter*, the stolidly

resigned rider huddling his blanket about him against the freezing night air, or the poor pony about which you could say there hung a hint of pathos" The man who had produced the unique action scenes, who told his tales of the wild dash in such clear detail, was becoming more reflective and thoughtful.

CAPTURING THE FOREVER

On his very first trip west in 1881 Frederic Remington realized that the scenes and the characters he saw were soon to disappear. "I knew the derby hat, the smoking chimneys, the cord-binders, and the thirty-day note were upon us in a restless surge. I knew the wild riders and the vacant land were about to vanish forever, and the more I considered the subject, the bigger the forever loomed." He resolved at that point to set down the saga of the frontier. It was well that he did, as his youthful prediction quickly came true. The West he had seen faded faster than anyone could have foretold. What Remington saw and recorded and left for us not only tells us what we have lost, but his observations are responsible in part for the way we and others view the heritage of the Old West today.

In order to fully appreciate and understand Remington's work, we need to look at the West as he saw it and at the influence his art has had on our perception of the West. We will start with the making of the "legend of the West." Then we will look at the real West of the Native Americans, the cavalrymen, the cowpunchers, and the sodbusters. It was this West that Remington recorded in *The Buffalo Runners, Big Horn Basin* and so many other images.

LARGER THAN LIFE: REMINGTON AND THE MAKING OF THE MYTH

"This is the West sir. When the legend becomes fact, print the legend."

Spoken by the editor of the Shinbone Star, *from the 1962 film* The Man Who Shot Liberty Valance, *directed by John Ford.*

Figure 107. This Remington canvas inspired the movie-makers.

Frederic Remington, *Downing the Nigh Leader*. 1907. Oil on canvas. 30" x 50". Museum of Western Art, Denver.

As you look at Remington's *Downing the Nigh Leader* (Figure 107), you may get the feeling that you've seen it somewhere before. You probably have—at the movies.

The "Western" movie began just after the First World War. Early Westerns starred actor Tom Mix, who possessed enough cowboy skills to do his own stunts, and the steely-eyed hero, William S. Hart, who actually had hobnobbed with gunslingers Wyatt Earp and Bat Masterson. The popularity of the Western gained momentum in the 1920s and the 1930s. Three generations have watched as the legend of the West has been played and replayed on miles of celluloid in countless movie houses.

What has all of this to do with Frederic Remington? Quite a lot. The most memorable creator of Western films was the director John Ford. In 1939 he introduced a film which many regard as the finest Western ever made, *Stagecoach*. This movie was the first of Ford's films to be made in Monument Valley, Utah. As you can see from the still photograph in Figure 108, this is the image most of us envision when we think of the West. Or rather, this is the image of the West that John Ford has given us. It is a stark, harsh landscape of brilliant mesas and dramatic buttes etched against a big sky. Monument Valley lives up to its name. It certainly *is* monumental. It was the perfect setting

150

Figure 108. John Ford, the director of *Stagecoach,* studied the works of Frederic Remington and Charles Russell. Still frame from the film *Stagecoach.* 1939. Courtesy the Museum of Modern Art, New York. Film Stills Archive.

for the no-holds-barred melodrama which was the subject of so many of Remington's paintings. "The men with the bark on," as he called them, continually faced danger and death and were caught up in the forces of Manifest Destiny. In *Stagecoach* Ford used Remington's epic canvas *Downing the Nigh Leader* as his inspiration for the great concluding chase scene. In this scene, there is a desperate dash for Lordsburg over the barren waste in the glaring sun with Apaches in hot pursuit. It didn't matter at all to John Ford that Monument Valley is in Utah and Lordsburg in southwestern New Mexico. The images carried the myth.

No other region or era in American history has so vividly captured the imagination of the public. In our mind's eye,

Discuss what Remington meant when he referred to "the men with the bark on."

151

In a morality play, the characters themselves personify moral qualities.

Discuss other "larger-than-life" characters in current films, TV, etc.

The historian, Frederick Jackson Turner, held that the frontier promoted fierce independence, individualism, greater democracy and like traits. Critics say that it actually promoted the very opposite, due to the need for collective security and safety in numbers.

Discuss the Indians' feelings about wealth. Contrast this with the attitudes and goals of those who came into the land of the Native Americans.

most of us can visualize the scenery of the Old West, the way people dressed in the days of the gunfighters and the drama of the cattle drives. We have a store of ready images for the invincible good guys and the detestable bad guys. Take a moment and reflect on any other thirty-year period in the history of the United States. Do you have visual memories of this period as vivid as those of the Old West?

The Western movie became a very *American* morality play. Most of us associate certain qualities with the West: fierce independence, rugged individuals going it alone, clear-cut issues of good and bad. These qualities are not necessarily true of that time in history. Still, we feel these things ought to be true. Most of us like this myth and have adopted the values that it represents. Thus the story we enjoy telling ourselves—the myth of the West—has actually become a part of the American experience.

The vast landscape, with its parade of larger-than-life characters and dramatic events, lingers in our collective memory like riders on the wind. And where is the real West? It is there just as Frederic Remington depicted it.

THE REAL WEST

The Plains Indians were rich, but not in the way the white man defined wealth. In fact, the idea of personal ownership of land or game was foreign to Native Americans and hard for them to understand. They were wealthy in the sense that they had everything they needed and wanted in great abundance. Such wealth seemed to them to be without limit. They were rich in freedom and obligated to no one.

They were also spiritually wealthy. Their sense of harmony with the earth provided a strong basis for their religion. To the Plains Indians the buffalo became a major part of their religious rituals and the ethical code of the tribe, which included tests of character for the young men.

Often, after a successful hunt, a buffalo robe, finely decorated and embroidered with quills, was taken to the top of a hill. There it was offered to the being the Sioux called *Wakan Tanka*, the Great Spirit. This ceremony was a thanksgiving to Wakan Tanka for the gift of the buffalo, who gave their lives so that their brothers, the Indians, could live.

The great herds also made the Plains Indians rich in a material sense. The buffalo provided the major source of

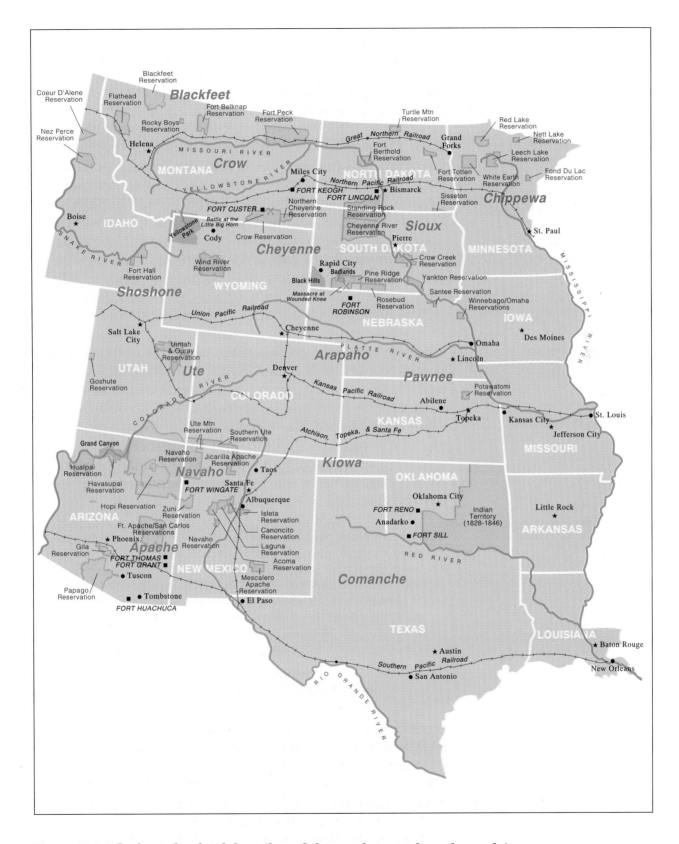

Figure 109. The homelands of the tribes of the northern and southern plains.

food—fresh meat directly after the hunt and pemmican and jerky—which saw them through the periods between hunts and the long winters. The thick, warm hides made fine beds and wonderful wraps in cold weather. They were often beautifully decorated for ceremonials, and some were used as barter to trade for other needs. The heaviest hides provided the warmest and lightest mobile home ever created, the plains **tipi** (tee-pee), or lodge. The Indians' outer clothing, from breechclouts, leggings, and sturdy moccasins to elegant dresses and shirts, came from female buffalo hides. The soft calf skins became fine underwear in the hands of a skilled artisan. Sinews and bones made thread, implements, and weapons. Horns and hooves were used in religious rituals. Even the plentiful dried buffalo chips provided reliable fuel.

The unsettled Plains were a true paradise for the Native Americans. Vast buffalo herds roamed from Saskatchewan in the north across the endless reach of the Plains to the Gulf of Mexico, as we can see from Figure 109. The buffalo were so well adapted to their environment that it would have taken a catastrophe of unimaginable proportions to destroy them. While they roamed, the Plains Indians enjoyed a way of life superior in freedom, comfort, and abundance to that of any similar group of people on earth. But the catastrophe came, and when it came, it was man-made. Santanta, Chief of the Kiowas, described it in this way:

> I love to roam over the prairies. There I feel free and happy, but when we settle down, we grow pale and die. . . . These soldiers cut down my timber; they kill my buffalo; and when I see that, my heart feels like bursting . . . has the white man become a child that he should so recklessly kill and not eat? When the red men slay game, they do so that they may live and not starve.

MONARCHS OF THE PLAINS

A buffalo, when it gets going, can sprint at thirty miles an hour. Many bulls weigh over two thousand pounds. The early Plains Indians, on foot, armed with just bow and arrow, must have been ingenious hunters. The illustration by George Catlin (Figure 110) gives you an idea of the clever methods that the early hunters used to approach the animals. When they managed to get close to the herd, there was no shortage of targets. Estimates of the numbers of buf-

Figure 110. Early Plains hunters used deceptions such as this to hunt, before the tribes tamed horses. George Catlin, *Buffalo Hunt Under White Wolfskins*. No date. Watercolor on paper. 8″ x 10″. From the artist's watercolor sketchbook. The Thomas Gilcrease Institute of American History and Art, Tulsa.

falo ranged from fifty million to over one hundred twenty-five million. Explorers spoke of a virtual carpet of buffalo as far as the eye could see (Figure 111) and, on the Great Plains in the nineteenth century, that was a very long way indeed. The artist William Jacob Hays described such a scene: ". . . as far as the eye can reach wild herds are discernable; and yet, farther behind these bluffs . . . the throng begins, covering sometimes the distance of an hundred miles . . . so vast is their number that travellers on the plains are sometimes a week passing through a herd"

Hunting tactics changed dramatically when the Plains Indians found and tamed wild horses. These animals were the descendants of horses first brought to America by the early Spanish explorers.

Figure 111. Hays's canvas offers some idea of the immense herds early travelers encountered. William Jacob Hays, *A Herd of Buffaloes on the Bed of the River Missouri*. c. 1860. Oil 36″ x 72″. Thomas Gilcrease Institute of American History and Art, Tulsa.

These Indian ponies, although they sometimes appeared small and scrawny, had great stamina and were well adapted to the hot, dry terrain. They gave the Indians a mobility they had never dreamed of and the ability to range far and wide in search and pursuit of the buffalo. The Plains Indians became superb horsemen, and on horseback they were the picture of ease and elegance. Remington's *Fantasy from the Pony War Dance* (Figure 112) gives us an idea of the admiration he had for the Plains warrior's horsemanship. With the horse, Indians could now send out an advance party to track the herds. This allowed the main hunting party to travel at an easier pace, saving their buffalo horses for the actual chase.

Individual hunters selected their own kills. This was not without danger. You can see the result of this sort of surprise in *The Buffalo Horse* (Figure 113).

THE END OF THE HUNT

A number of factors brought about the destruction of the buffalo, and with them, the Plains Indian way of life. In the

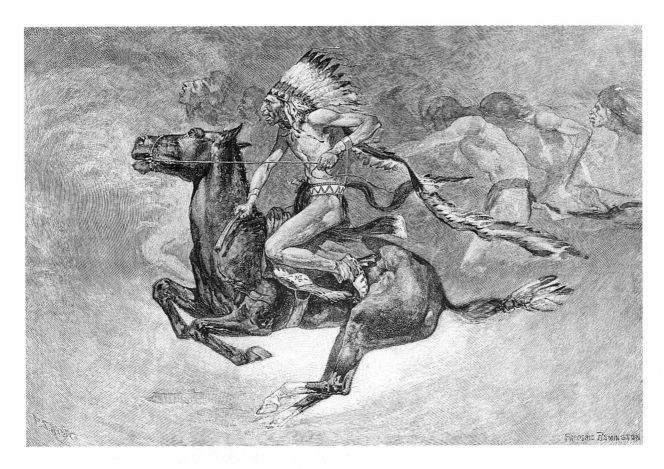

Figure 112. The artist admired the daring horsemanship of the Plains Indians.
Frederic Remington, *Fantasy from the Pony War Dance*, as printed in *Harper's Magazine*, December 1891. The Amon Carter Museum, Fort Worth.

last half of the nineteenth century, buffalo tongues became a delicacy, and buffalo robes were a popular item in the eastern United States. By the middle of the 1870s, it is estimated that there were more than twenty thousand buffalo hunters on the plains. The carcasses were skinned for the hides and left to rot in the sun.

The herds also disrupted the progress of the railroads. Some railroad lines paid hunters to clear the way. As work proceeded, shooting the beasts from a moving railroad car became a popular "sport." In the few cases that protective laws were passed, they proved to be impossible to enforce on the immense spaces of the plains. As the numbers of the great herds began to drop sharply, bones littered the vast prairie. Even these were eventually gathered and utilized by the fertilizer industry.

The invention of big, efficient buffalo guns greatly hastened the process, even beyond the expectations of the

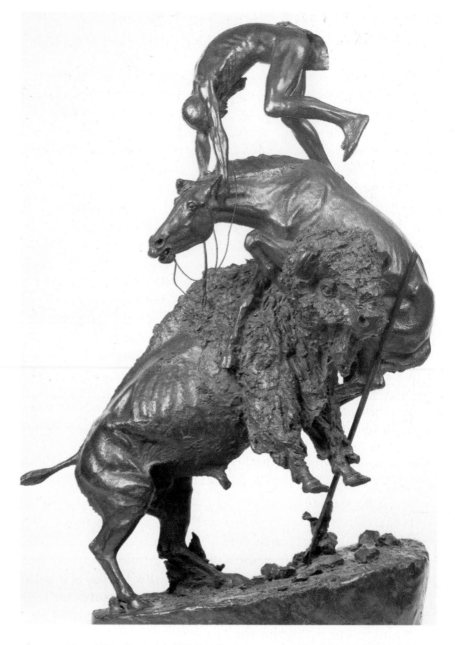

Figure 113. The dangers of the hunt. Frederic Remington, *The Buffalo Horse.* 1907. c. December 12, 1907; cast between 1907 and 1914. Bronze. Height 36″; base 21″ x 11″. Roman Bronze Works. Courtesy the Thomas Gilcrease Institute of American History and Art, Tulsa.

hunters. With these weapons, hundreds of the animals could be slain at a time. Hunters fired so frequently that they had to throw water on their guns to cool the metal. The plains of Texas were cleared first. Then the hunters moved up through Kansas to the northern plains. No one, red man or white man, could quite believe that the great

herds were truly gone. At the turn of the century, it was estimated that there were fewer than eleven hundred buffalo left in the United States.

As the buffalo were slaughtered, the Native Americans fought with great determination to preserve their way of life. However, their numbers and weapons were far fewer than the invader's. Ultimately, they fell to the forces of Manifest Destiny. The famous Indian victory at Little Big Horn in 1876, popularly known as Custer's Last Stand, was actually the last victory of any significance for the Indians. A few skirmishes followed. These ended abruptly and tragically at the terrible massacre at Wounded Knee in 1892. From that time onward, the Plains were lost to the Native Americans.

Proud warriors, once dressed in beautifully decorated buffalo robes, now wore cheap agency-issued clothing. The warm buffalo hide tipis were also gone, replaced by canvas tents which rotted quickly and left the occupants cold and wet. People who had proudly supported themselves subsisted on government-issued beef, often of the poorest quality. The fiercely independent Plains Indians became unwilling wards of the state. Confined to reservations, they fell prey to all the illnesses and vices brought by their conquerors to the Plains. The buffalo were gone.

Remington happened to be near Wounded Knee at the time of the massacre. Remington was thirty-one years old. The West he loved had changed so much; he returned only to do his color studies (Figure 114). His host on one such trip described him at work:

> After the scene was sketched, he would daub a lot of primary colors on the board and, taking a brush, he'd mix a shade he wanted. Then, taking up another brush, he'd dab spots of color all over the canvas. Throwing that brush to the ground, he would take another and start on another color, repeating the process of putting it on spots wherever the color hit his eye. Finally he would get so many daubs of paint on the canvas that it looked more like a sample of Joseph's coat of many colors than a picture. And then he would start mixing some dark paint for the shadows. Once he had his shadows in, the picture stood out, completed.

One of these trips took Remington to a ranch near Cody, Wyoming, not far from the basin of the Big Horn River. The Big Horn Mountains were in the background. This visit was in the terribly hot summer of 1908. On the last leg of his railroad trip, he wrote, ". . . ran right up the River Gap of

Indian "agencies" were set up on reservations. They handed out military surplus clothing, and some second-hand clothing and other supplies donated from states in the East.

Indicate this area on the map on page 153.

Figure 114. In later years, the artist went West only to make color studies. Frederic Remington, *Shoshone.* 1908. Oil on board, 12″ x 16″. The Buffalo Bill Historical Center, Cody Wyoming.

the Big Horns and I recognized it all the way having ridden over it years ago with Indians, Wolf Voice, Ramon and others, all dead now."

It is not hard to imagine Remington, who had become a huge man by then, mopping his brow in the stifling railroad coach, gazing out at the buffalo grass yellowed by the searing heat. His mind might have drifted back to that earlier trip as a younger, more robust man, on horseback with his friends of those days, "Wolf Voice, Ramon and others, all dead now." In his mind's eye perhaps a painting started to take shape—riders hurtling over the rim of a hill, disappearing in the dust into memory and myth.

THE WEST REMEMBERED

Remington painted *Buffalo Runners* in his new studio in Ridgefield, Connecticut. The figures are the product of his memory and imagination. The landscape and background are the result of his color studies made in the West. In this Impressionist style, the artist has left out many specific

Figure 115. Remington completed this painting in his New York studio using studies done in the West. Frederic Remington, *Ghost Riders.* c. 1909. Oil on board. 12" x 18". The Buffalo Bill Historical Center, Cody, Wyoming.

details. He focused on the grace and drama of the chase, the magnificent horses and riders, and on the enduring landscape. In the latter part of his career, Remington went to ". . . search for the beautiful," and something elusive, mysterious, and symbolic came into his work. The characters he had known were gone, but the landscape and the light prevailed.

In *The Buffalo Runners, Big Horn Basin* Remington brings up a happier time, possibly in the trading days of the 1850s or 1860s, before the white men arrived in large numbers, a time of relative peace on the Plains. The buffalo were still numerous. Hides could be traded for rifles and other interesting new things such as trade-cloth (for light clothing). During this time, the chiefs who fought at Little Big Horn in 1876 would have been young and vigorous, as those in the painting are. The riders in the painting would most likely be Sioux or Cheyenne. These two tribes are the ones most

161

often depicted in movie scenes of mounted warriors in their fabulous warbonnets and warpaint. As they rode in Remington's mind, any of the great chiefs would have appeared just as the leader of *Buffalo Runners* does—a free, proud master of his fate.

"I HAVE LANDED AMONG THE PAINTERS"

Remington's show in 1908 at Knoedler's Gallery in New York brought him much of the recognition he had desired. The *New York Times* carried a favorable review, and the *New York Globe* noted that, "Frederic Remington sounds a purely American note. His color is purer, more vibrant, more telling, and his figures are more in atmosphere" Remington said, "It was a triumph. I have landed among the painters, and well up, too." Reviews of his show in 1909 confirmed his position.

A great number of Remington's paintings in the 1908 and 1909 shows dealt with Indian subjects. In his early writings, it appears that Remington was ambivalent about the Indians. His job was to travel with the cavalry who were engaged in skirmishes with Indians, but he was fascinated by these people the calvary fought. In an article written in 1890, he suggested the formation of Indian cavalry units. This, he reasoned, would put the horsemanship and daring of the Indians to use, and help them to avoid the lack of purpose that was inherent in life on a reservation. Remington wrote two novels in his lifetime, *John Ermine of the Yellowstone* and *The Way of an Indian*. In each of these novels, he portrayed the conflict of the frontier from the Indian's viewpoint.

He believed that the relationship the Indian had with nature was an unfathomable mystery to the newcomers who were "taming the West." The difference in ways of thinking, to Remington, created a tragic cultural gap which could not be bridged. Ultimately, he felt, the tragedy would be the Indian's.

While he knew that the freedom the Plains Indians had enjoyed was over, he still was fascinated by a quality of mystery about them that he felt so strongly. No matter how much he studied them, he could not get to the bottom of it.

The problem must have truly absorbed him, for he painted them almost exclusively during the last years of his life.

Impressionism, with its softened lines and vibrating light, was an ideal approach to expressing the mystery. In Remington's portrayals of Native Americans there is no ambivalence. These men have a grace and dignity few artists' protrayals have equaled. Remington didn't see the Indians or paint them in the European image of the "Noble Savage." His Indian is of his own real and natural world. His bronze of *The Savage*, Figure 116, shows a fierce, uncompromising nobility, and not a little contempt. In contrast, his *Sioux Chief*, Figure 117, turns calmly to the viewer, his face reflecting the confidence of a man whose opinion of himself needs no outside reinforcement. We can see the same self-esteem in the features of the leader of the buffalo runners (Figure 118). This is not the staid, formal gaze pictured by so many artists preceding Remington. Remington's Indians are somewhat stronger medicine.

Next, look at the calm resolve of *The Outlier* in Figure 105. The horse, as in so many of Remington's paintings, looks right at us with a direct, almost questioning, gaze. On the rider's face is a look of calm, resigned acceptance, and we see the hint of vulnerability in the thin arms. This is one of the last of Remington's paintings. It expresses on canvas his own words: "My West has passed utterly out of existence so long ago as to make it merely a dream. It put on its hat, took up its blankets and marched off the board; the curtain came down, and a new act was in progress."

Frederic Remington died of appendicitis at the age of forty-eight on the day after Christmas, 1909. In a eulogy to his friend, Theodore Roosevelt said, "The soldier, the cowboy and rancher, the Indian, the horses and cattle will live in his pictures, I verily believe, for all time."

Shortly before his death, Remington had begun developing models for what would have been the most spectacular project of his career—a group of immense human figures to be placed near the mouth of New York harbor, each taller than the Statue of Liberty. The figures were to be American Indians.

When the frontier disappeared entirely, Remington could find little to care for outside of his work. In *The Buffalo Runners, Big Horn Basin*, the old days live again. The artist shows us what the Indians were to him—sun-washed, wind-tossed, unconquered. The herd is forever just over the

The term "Noble Savage" comes from the philosopher Jean-Jacques Rousseau although he never actually used it. His philosophy was that people are "naturally good" and only exhibit less desirable qualities when separated from "a natural life." Rousseau himself was a scoundrel. Voltaire said, "He (Rousseau) is the most unhappy of human beings because he is the most evil."

Figure 116. The simplicity, power and pride of this image made it one of Remington's most popular bronzes.
Frederic Remington, *The Savage*. 1908. c. December 14, 1908; cast c. 1914. Bronze. Height 10 3/4"; base 4 1/4" x 4 1/8". The Roman Bronze Works, cast no. 5. Courtesy Frederic Remington Art Museum, Ogdensburg, New York.

Figure 117. "...they never gave quarter and they never asked for it." This image is a part of a Remington tribute to the fighting Sioux. Frederic Remington, *A Sioux Chief*. 1901. Pencil and pastel on composition board. 31 7/8" x 22 7/8". Courtesy Sid Richardson Collection of Western Art, Fort Worth.

Figure 118. The artist again captures the resolve, pride and courage of the Plains warrior. Detail from *The Buffalo Runners, Big Horn Basin* (Figure 94).

next ridge. No white men, no talking wires, and no firewagons intrude. The vacant land beckons. We are drawn into Frederic Remington's West, a place beyond time, a place where we can still join the wild riders.

Ask if the students understand what "talking wires" and "firewagons" are.

Summary Questions

1. Explain Manifest Destiny.
2. How did Frederic Remington get his first job as an artist, and how did this job connect the artist with Manifest Destiny?
3. How did fast-shutter-speed photography change the way that artists depicted animal movements?

These questions may be used as a written assignment or a take-off point for class discussion.

Have the students use the four-step art criticism process with *The Buffalo Runners.*

4. Explain the term *foreshortening.* Point out other examples of foreshortening in this book.

5. How did the term *Impressionism* originate?

6. Define *Impressionism;* describe techniques Impressionists used.

7. How did Impressionist techniques alter the work of Frederic Remington?

8. How did the loss of the buffalo affect the Native Americans of the Plains?

9. Explain how the art of the Old West affected motion pictures and television.

UNIT

FORMS OF EXPRESSION

The Artist and The West

From the earliest days of exploration of the North American conti-nent, Europeans were fascinated with this "New World." Artists were commissioned to come to North America in the late sixteenth century to bring back visual descriptions of the life they found there. John White, whose watercolor painting Indians Fishing *is shown in Figure 119, arrived off the Carolina banks in 1585. He became the first artist to make drawings of the Native Americans, the ani-mals, and the plants of the region.*

As the Eastern Seaboard of the United States was settled and the doctrine of Manifest Destiny captured the imagination of the American public, a great demand arose for visual images of the vast territory to the west. Explorers and traders brought back fantastic descriptions. Often artists were hired to accompany expeditions to sketch and paint the landscape and the people who inhabited this unknown region. Some of the early artists were highly imaginative people who fed the public a bit more romance than they had actual-ly witnessed. The public devoured any information they could get hold of. Eventually, the major magazines ran stories and drawings of this strange new territory in every issue. Realistic images and those that conveyed a story were in great demand in the nineteenth century. Western art was a thriving institution.

Figure 119. One of the earliest depictions of life in North America. John White, *Indians Fishing.* 1585. Watercolor. Reproduced by courtesy of the Trustees of the British Museum.

DRAWING

See the schedule for this unit on page T-60 of this TAER.

The earliest explorers in North America thought they would find a route to China via the Northwest.

168

From the time of the early explorers in North America, there was a great curiosity in Europe about the American frontier. A seventeenth century French Canadian cartographer named Charles Bécard de Granville (duh grahn′-veel) left us a record of plant and animal life in the Ontario, Great Lakes, and upper New York State regions. De Granville was not an accomplished artist, but he certainly had a lively view of nature and a vivid imagination. He included many details in his pictures which seem to have escaped other artists of the time. His renditions of various plants and animals are quite fantastic.

Figure 120. This buffalo is a fine example of de Granville's vivid imagination.
Attributed to Charles Bécard de Granville. *Grand Boeuf du Nouveau d'Anemar En Amerique.* No date. Pen and ink.
14″ x 9 1/2″. Page from an album attributed to the artist. c. 1701. The Thomas Gilcrease Institute of American
History and Art, Tulsa.

As we can see in Figure 120, which is a picture of, presumably, a buffalo with cat whiskers and a smile, de Granville took some liberties with his subjects. This picture and many others he produced were widely distributed in Europe. Europeans, at this early stage of the New World's development, had a great curiosity about the types of animals found in America. The grasp of geography by the average person was not extensive. The notion that this region might be a part of the fabled "Indies" of the Far East had not completely disappeared. Many of de Granville's drawings gave useful details of the coats and colorings of various animals and birds found in North America. However, de Granville could not resist including a tiger, a sea horse, and a fantastic sea monster with a human head among the animals he found in North America.

169

Figure 121. Bingham was a master at drawing the male figure.
George Caleb Bingham (1811–1879), *Fiddler*. 1846. Brush and black ink and wash over pencil on rag paper. 10 1/8″ x 8 1/8″. Courtesy of the People of Missouri. Acquired through the generosity of the Louis D. Beaumont Foundation.

The artist's fantasies leave us wondering what the civilized Europeans who viewed this remarkable collection must have thought of this strange New World.

By the early 1800s, the Frontier had moved westward to the banks of the Missouri and Mississippi rivers.

George Caleb Bingham drew many scenes of life along the Missouri and Mississippi Rivers. Each figure was carefully drawn in pencil or ink. As we can see in his preliminary sketch of the fiddler (Figure 121) for his painting *The Jolly Flatboatmen* (Figure 138), Bingham was a master draftsman. Daily life, not harsh drama, was his territory. There is very

little along the Missouri or Mississippi Rivers that escaped his fine hand, sensitive observation, and fertile imagination.

Humor and Realism in Western Drawing

In addition to his mastery of the horse in motion, Frederic Remington was highly skilled in picturing many other animals. They are presented with warmth and humor in simple scenes of daily life.

The burro was the beast of burden in Mexico and the southwestern territory; it was the reliable carrier of every household need. Look at the patient resignation on the face of the burro in Figure 122. This laundryman's burro, with his load of melons, also carries a scrawny neighborhood cat who has hitched a ride. With just a few strokes of the pen, Remington shows us that this cat is alert, curious, and obviously enjoying the passing scene.

For religious and cultural reasons, the southwestern Apaches did not like to have their picture taken or their image reproduced in any way. This made sketching an

Figure 122. The artist departs from frontier action to capture a charming scene in the old Southwest. Frederic Remington, *Mexican Burros.* 1889. Pen and ink on artist's board. 12 1/2" x 15 3/4". Amon Carter Museum, Fort Worth.

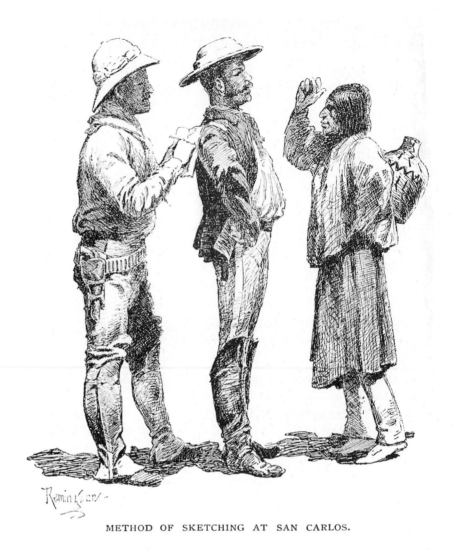

METHOD OF SKETCHING AT SAN CARLOS.

Figure 123. A frontier artist occasionally used unusual methods.
Frederic Remington, *Method of Sketching at San Carlos.* As printed in *Century Magazine,* July 1889. Amon Carter Museum, Fort Worth.

Apache a risky business. In *Method of Sketching at San Carlos* (Figure 123), Remington indicates the occasionally devious methods he tried in order to make sketches. His soldier comrade from the Tenth Cavalry regiment engages the Apache in conversation while Remington, resting his sketch pad on the soldier's back, works quickly.

We will see two paintings of the renowned Western artist Charles Marion Russell in the section on painting. His art often involves irony and great warmth. The drawings, illustrations, and letters of Russell best reveal his sense of humor.

Figure 124. Russell's studio as his mother may have imagined it. Charles M. Russell, *Contrast in Artist's Salons—My Studio as Mother Thought*. 1891. 7 1/2" x 8 1/2". Pen and ink wash on paper. Amon Carter Museum, Fort Worth

A young man from a well-to-do family in Missouri, Russell moved to Montana in 1880. His *Contrast in Artist's Salons—My Studio as Mother Thought* (Figure 124) is a drawing in which he depicts how his mother back in St. Louis must have imagined his studio: an elegant Victorian salon with then-fashionable Oriental touches. *Contrast in Artist's Salons—Charley Painting in His Cabin* (Figure 125) shows us the reality. The cowboy artist crouches on a box in a bare room, cowpunchers' equipment hangs on the wall, and an Indian friend watches the work in progress.

Egyptian and Turkish objects became fashionable in Paris, London, and New York in the late 1800s. They were called "orientalist."

173

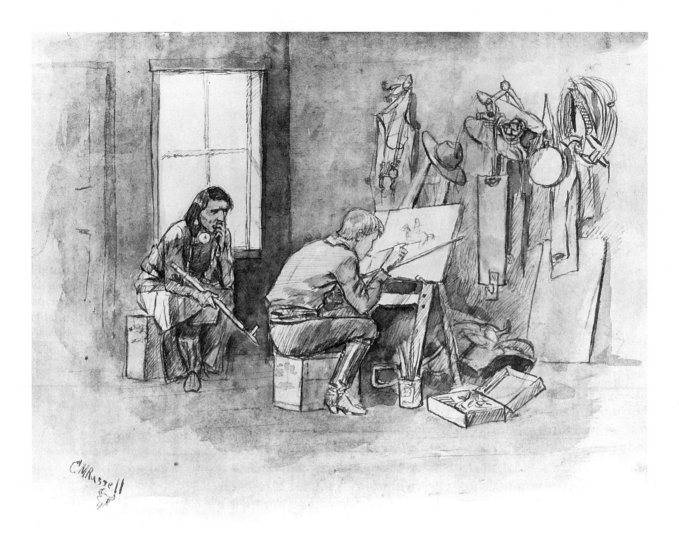

Figure 125. Russell's real studio. Charles M. Russell, *Contrast in Artist's Salons—Charley Painting in His Cabin*. 1891. Pen and ink wash on paper. 6 5/8" x 8 3/4". Amon Carter Museum, Fort Worth.

W. R. Leigh was a European-trained artist who first travelled west from his home in New York in 1906. He made this journey every year thereafter. His desire was to produce uniquely American art, and he believed the grandest scenes from nature made the greatest artworks. His fine oil paintings reflect his belief.

Leigh was also a superb draftsman who had the ability to capture the essence of an animal's characteristics with his pencil. The stoic, immovable buffalo (Figure 126) knew no fear of predators. In this drawing Leigh managed to convey both the immensity of the buffalo and its placid, detached manner. His studies of the grey wolf (Figure 127) indicate the great pains the artist took to render the true physical

Figure 126. Leigh's pencil captures the immensity and power of the monarch of the Plains. W.R. Leigh, *Untitled Study of a Buffalo.* Unsigned. No date. Pencil sketch on paper. 14″ x 20″. The Thomas Gilcrease Institute of American History and Art, Tulsa.

Figure 127. Leigh sketched small nature studies in the West and created larger, finished works in his New York studio. W.R. Leigh, *Untitled Study of a Grey Wolf.* Unsigned. No date. Pencil and ink sketches on paper. 14″ x 17″. The Thomas Gilcrease Institute of American History and Art, Tulsa.

THE FAR SIDE By GARY LARSON

"Say . . . Wait just a dang minute, here . . . We forgot the cattle!"

Figure 128. *The Far Side* **cartoon by Gary Larson is reprinted by permission of Chronicle Features, San Francisco, California.**

The great cattle trails were the Chisholm, the Goodnight-Loving, the Western and the Shawnee which were used in the 1850s through the 1870s. This ended in the 1880s when railroads came south and the open range was fenced.

characteristics of this valiant and wily predator. In the sketch of its face, a sense of the mystery of the grey wolf has also been captured.

And last, but by no means least, is Gary Larson, the contemporary humorist and cartoonist. In the cartoon (Figure 128) he neatly pokes fun at one of the cherished myths of the Old West, the great cattle drive. The whole purpose of these drives was to get the herd, in marketable condition, from the great plains of Texas up to the railheads where they could be sold and transported to the major city beef markets. The legends of the men who ran these drives have made them all appear as larger-than-life figures, and the purpose of the drive seems of secondary importance.

Larson is not a political cartoonist or a crusader. His cartoons are strictly for enjoyment, and he is very, very successful. This example may, at first glance, look rather easy to do. Look closer. First we appreciate the humor, then the success of achieving just the right expression on the faces of the men as well as the central character's horse. As we consider the drawing even more carefully, we appreciate the artist's use of the compositional principles of design.

DRAWING ACTIVITIES

1. The art of drawing is probably the basic skill an artist has. Although the artist may work in other media, he or she knows drawing is a prime medium for expressing ideas. Drawings can be done in a number of ways with a variety of tools. In this activity, and the next three, we will explore drawing media in such a way that you can compare and contrast the visual impact of each.

Drawing tools are relatively inexpensive and portable. The pencil, probably the most common drawing tool, is made from graphite of varying degrees of softness (2B–6B) or hardness (2H–9H). There are also drawing pencils made with charcoal that have different degrees of softness. You can draw on almost anything from napkins to fine Bristol board. The surface must accept the medium and hold it to the working surface.

Look through the book and find drawings by master artists. Compare and contrast the drawing techniques used by these artists. Try out some of the techniques on a scrap piece of paper; experiment with different tools. Discover the differences in the degree of light and dark values each tool can produce.

Do three or four quick sketches of a still life, concentrating on the composition and use of the visual elements of line, space, and texture. Select a sketch and render it, using only graphite pencils.

Provide time to look at and discuss a wide variety of drawings, past and contemporary. Note the similarities and differences in the drawings of different cultures.

Figure 129. Student art.

Do not use permanent markers made with an acetone base. These can be very dangerous to your health.

CAUTION

Review the use of color and principles of composition.

2. Let's continue the exploration of drawing tools by working with markers. Markers vary greatly, from permanent to washable, from felt-tipped to nylon-tipped, and their colors range widely. Markers are a great drawing tool because they provide an even, long-lasting flow of color. Depending on the tip, they can be used to cover large areas or to produce fine details. The marker line can be brushed with water to produce a wash.

See if you can find examples of different ways artists have used markers. Most examples will be fairly contemporary; markers have not existed for too many years. Try out the many ways a wide-tip marker can be turned and angled to produce lines of different qualities. Look at your sketches of the still life from Activity 1 or do sketches of a new still life. You may visually move objects within your drawing and add your own background design.

3. Over the years pen and ink has been a favorite tool among devotees of the art of drawing. From dipping quills to modern fountain pens holding an ample supply of ink, artists have experienced the excitement of this versatile medium.

Speed Ball B points have a fairly constant line and come in different widths. Chisel point pens such as C–4 can produce thick or thin lines, depending upon the way the point

Figure 130. Student art.

is held. Steel point and the delicate crow quill point provide a fine variable line or extremely fine line. Fountain pens with reservoirs have a variety of points, can be refilled easily, and are convenient to carry on field trips. There is another group of drawing tools that produces wonderful and unexpected lines. Bamboo pens cut to points can carry ink

Have the class collect as many pen and ink drawings as they can. Give the students extra credit for those they can find in magazines and newspapers. Allow time for the students, as a class, to examine all of the drawings.

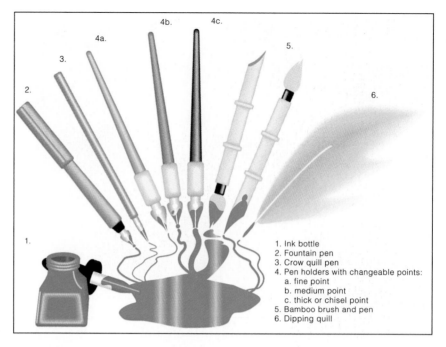

1. Ink bottle
2. Fountain pen
3. Crow quill pen
4. Pen holders with changeable points:
 a. fine point
 b. medium point
 c. thick or chisel point
5. Bamboo brush and pen
6. Dipping quill

Figure 131. Pens.

After the first drawing, stop and critique the class work and again look at artists' drawings, past and contemporary.

Review the completed drawings. Emphasize the inherent qualities of each medium and discuss the compositional qualities of selected works.

quite well, and all kinds of wires and sticks can be dipped at will to make delightful lines. Your teacher will tell you which pens to use in this activity.

Before you begin your still-life drawings, experiment to see just how each pen can distribute the ink on the paper. You have had enough experience in drawing still-life setups by now that you will not need to sketch first. Study the still life, thinking about its composition, and start your drawing. Draw the main features first, and then plan the textures you wish to use. Watch out for drips and smudges. Last, work over the whole drawing, adding details as needed.

4. The first three activities have given you a great deal of experience in using various drawing tools and drawing from a still life. Notice that the still-life setups have been changed. Select the one that is nearest to your work station or the one that interests you most. You can also *visually* take any part of one and place it into another. Artists often do this to improve their compositions or to increase interest in the piece.

To introduce another change in this activity, combine two or more drawing mediums in any way that will contribute to the work. Capitalize on the softness of graphite or charcoal, the brilliancy and flowing quality of markers, and the clarity of pen and ink.

Figure 132. Student art.

PAINTING

In the nineteenth century, there were no movies and no television. To understand the importance of visual art to the people of that time, we must realize that images of the

unknown parts of the continent on which they lived were produced by individual artists.

At the beginning of the nineteenth century, most Americans thought of the West either as a great desert or as a natural paradise teeming with wildlife and inhabited by exotic natives. Actually, regions which lay west of the Mississippi River contained scattered military outposts and were the domain of adventurous traders, trappers, and rough mountain men. For the average person, a journey to this largely unknown area would have been a hazardous undertaking.

Early depictions of Native Americans were done in artists' studios. Leaders of various tribes were periodically brought to the Capitol in Washington. This was done to impress Indian leaders with the enormous power and wealth of the United States. Quite often the leaders were, if not actual prisoners, under great stress during these "visits."

One of the most important portrait artists of the time was Charles Bird King (1785–1862), who had studied in England. King's work was often compared to that of the great French Romantic painters. The Superintendent of Indian Trade commissioned King to create a gallery of portraits of Indian visitors to Washington. This was intended to be a lasting record of a people considered at the time to be doomed by the march of progress. The fashionable style in European art was Romanticism. King's portraits, such as that of *Mak-hos-kah, Chief of the Gowyas (White Cloud)* in Figure 133, romanticized his subjects. *Hayne Hudjihini, Eagle of Delight* (Figure 134) with her European dress and jewelry (obviously loaned to her for this 1821 portrait by King) would not look out of place in a London or Paris salon flanked by the works of other European Romantic artists.

Painting Nature's Nobleman in His Eden

In Europe, many intellectuals in the last half of the eighteenth century thought of primitive people as being closest to God, since they were closest to nature. The idea of the "Noble Savage," living in harmony with the natural world, became a popular theme in European literature, philosophy, and art.

George Catlin (1796–1872) was an American artist greatly influenced by this theme. He envisioned the West as a garden spot, a boundless Eden where proud and noble people rode free in a happy, natural condition. In 1832

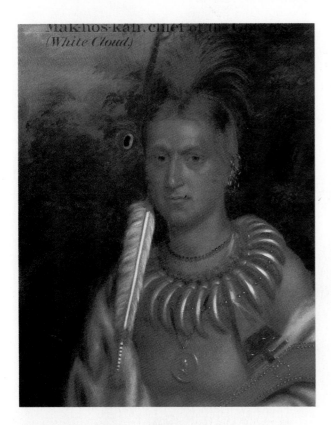

Figure 133. Charles Bird King's portraits of Native Americans were unusual in the early nineteenth century because they depicted the Indian as an individual with his own identity.
Charles Bird King, *Mak-hos-kah, Chief of the Gowyas (White Cloud)*. 1925. Oil on wood. 24" x 17". The Thomas Gilcrease Institute of American History and Art, Tulsa.

Figure 134. The artist's choice of clothing for the subject of this portrait is an ironic reflection of the government's belief that the Indian was doomed by the march of progress.
Charles Bird King, *Hayne Hudjihini, Eagle of Delight*. 1825. Oil on wood. 17" x 14". The Thomas Gilcrease Institute of American History and Art, Tulsa.

Catlin began a remarkable five-year journey through the West. During his travels he compiled a portfolio of works accurately depicting the landscape of various regions and the daily lives of the Native Americans who lived there. He kept carefully detailed notes. Later he published a portfolio of lithographs and an important book entitled *Letters and Notes on the Manners, Customs and Conditions of the North American Indians*. He created Catlin's Indian Gallery, a travelling exhibit which became a major attraction in America and Europe.

Catlin was a champion of the Native American and the way of life he saw along the upper reaches of the Missouri River. He knew this way of life was in grave danger as the idea of Manifest Destiny grew stronger and stronger in the mind of the American public. Because of this fear, Catlin was consumed with recording all that he saw. He wrote that

183

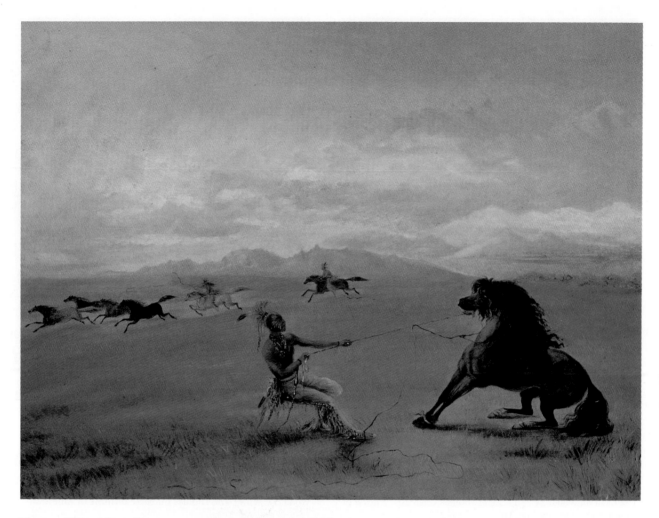

Figure 135. After they captured and trained wild horse various tribes were able to roam the Great Plains in pursuit of the buffalo. George Catlin, *Catching the Wild Horse.* Unsigned. No date. Oil on canvas. 12 1/4″ x 16 1/2″. The Thomas Gilcrease Institute of American History and Art, Tulsa.

Use classroom Reproduction #14.

the only way to salvage this culture would be to declare everything west of the Mississippi River a national park.

In such landscapes as *Catching the Wild Horse* (Figure 135), Catlin gave his audience a fresh view of the West he loved, and tried to dispel the notion that the interior of the continent was all a desert. He was trained to be a portrait painter. Each of the subjects is clearly an individual in two of his finest portraits, *Mint* (Figure 136) and *Buffalo Bull's Back Fat* (Figure 137). The first of these portraits is notable for its exquisite rendering of the details of dress and decoration, and the stunning presence of Mint herself. In the second, the uncompromising authority of the warrior chief of the Blackfeet is impressed upon the viewer. As a young man, Catlin had said that he wanted to be a history painter. In the end, he made history himself with his own extraordi-

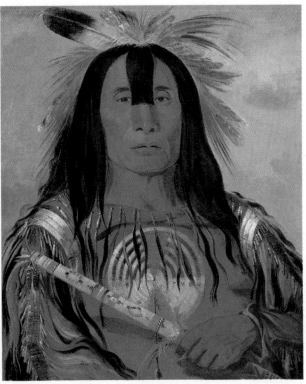

Figure 136. Catlin travelled two thousand miles up the Missouri River to paint the Mandan and other tribes. George Catlin, *Mint, a Pretty Girl*. 1832. Oil on canvas. 29″ x 24″. National Museum of American Art, Smithsonian Institution, Washington, D.C. Gift of Mrs. Joseph Harrison, Jr.

Figure 137. Catlin's outdoor studio became neutral ground for mortal enemies who waited in turn to have their likenesses rendered on canvas. George Catlin, *Buffalo Bull's Back Fat, Head Chief, Blood Tribe*. 1832. Oil on canvas. 29″ x 24″. National Museum of American Art, Smithsonian Institution, Washington, D.C. Gift of Mrs. Joseph Harrison, Jr.

nary record of his adventures. The historical annals of the United States are greatly enriched by George Catlin's records of Native Americans.

Painting Everyday Life on the Missouri

In 1832 George Catlin wrote,

> "The Missouri is, perhaps, different in appearance and character from all other rivers in the world; there is a terror in its manner which is sensibly felt the moment we enter its muddy waters from the Mississippi. From the mouth of the Yellowstone River . . . to its junction with the Mississippi, a distance of 2000 miles, the Missouri, with its boiling, turgid waters, sweeps off in one unceasing current; and in the whole distance there is scarcely an eddy or resting place "

George Caleb Bingham (1811–1879) was born in Virginia but settled in Missouri early in life. "Old Muddy," as the Missouri River was called, was the background of many

Trace the 2000 mile course of the Missouri River on a large map with the students.

185

river scenes he painted. Bingham depicts a veiled region of mystery of the remote upper reaches of the river.

The settlers along the lower part of the Missouri heard wild, amazing tales of adventure from the rivermen who braved the remote upper stretches. These rivermen knew that "Old Muddy" was unpredictable and capable of changing course with no notice after the heavy spring run-off. Submerged logs and fast-changing currents were a constant hazard. Flat-bottomed boats were an absolute necessity. These flatboats carried the cargo of the commercial adventurers. Bingham himself lived on the banks of the river in central Missouri. By the time he had painted *The Jolly Flatboatmen* (Figure 138) small but growing settlements dot-

Figure 138. Bingham built this composition carefully from numerous pencil and ink sketches. George Caleb Bingham, *The Jolly Flatboatmen.* 1846. Oil on canvas. 38 1/8" x 48 1/2". Private Collection on loan to the National Gallery of Art, Washington, D.C.

ted the lower reaches of the river. What tales the rivermen must have related to those early settlers!

Bingham was a **genre** painter; that is, he painted scenes from everyday life. He had taught himself to paint by studying the great masters of the Renaissance. His combination of subject matter and technique made his paintings unusual in his day. He painted *The Jolly Flatboatmen* in 1846, at the age of thirty-four.

Bingham had introduced a new element into American art. His subjects were not great figures from history or mythology. They were ordinary human beings at their daily work. By making the everyday working person appealing, even heroic, Bingham originated the tradition of American Realism in art.

In *The Jolly Flatboatmen* the struggle with the ominous river upstream is left far behind. The dancer snaps his fingers, the fiddler taps his foot, and the boy beats time on a metal pan. The onlookers are relaxed as the craft drifts downstream toward us. The composition is orderly, and the pyramidal shape imposes a sense of calm. (We have seen how Emanuel Leutze imposed a sense of calm on a desperate scene with a similar, stable geometric design.)

Notice that Bingham has picked up the pinks and blues of the men's clothes and echoes the tones in the distant mountains and sky. These repeated tones contribute to the happy, relaxed aura of the painting. The appeal of Bingham's dancing boatman is as fresh today as it was in the last century. This popular artwork is a lasting testament to America's vitality and energy.

Strange things can influence history. Manifest Destiny suffered a setback in the 1830s when the fashion in Europe in top hats changed from beaver to silk. You might ask how this change affected the trappers in the upper Missouri River.

Bingham's pastoral images depicted serene rural life. Monumental images such as those of Bierstadt and Moran were meant to overwhelm the viewer (and did).

Painting Paradise

Moving from Bingham's peaceful scene on the Missouri River to the West depicted by Albert Bierstadt (beer-stat') and Thomas Moran, we travel from the pastoral to the monumental. In the last half of the nineteenth century, Bierstadt (1830–1902) became the king of the romantic landscape. In contrast to Bingham's mysterious river, Bierstadt shows us a West of distant peaks, broad-shouldered mountains, and dramatic gorges which dwarf all human and animal life. Here we see a West in which scenes of tranquility contrast with terrifying turbulence. Dark masses in deep shadow are opposed by shafts of brilliant sunlight on peaceful meadows. In *The Rocky Mountains—*

Figure 139. Bierstadt's paintings were "blockbuster" attractions, and thousands came to view them. Albert Bierstadt, *The Rocky Mountains—Lander's Peak*, 1863. Oil on canvas. 73 1/2" x 120 3/4". The Metropolitan Museum of Art, Rogers Fund, 1907. Photographed by Geoffrey Clements.

Lander's Peak (Figure 139) Bierstadt exaggerates the vertical drama of the Wind River range to achieve monumental grandeur. Bierstadt painted the absolute "blockbusters" of his time. He was probably the most successful artist in captivating the American imagination with the Rocky Mountains.

Thomas Moran (1837–1926) was born in England but always wanted to paint American landscapes. In 1871 Moran, along with William Henry Jackson, was offered the opportunity to go West on the Hayden expedition. The expedition's purpose was to survey certain western territories. Moran was to paint and Jackson was to photograph vistas that had been only crudely sketched before. They had seen only pencil sketches of the great canyon the explorers called "The Yellowstone." When Moran arrived at Yellowstone, he was simply astounded. He said that the Grand Canyon of the Yellowstone was "beyond the reach of human art." Despite these words of hesitation, he painted it. You can see the result in Figure 140.

Some students may enjoy tracing the history of the national park system in the U.S.

Figure 140. Moran was transfixed when he first viewed the canyon's incredible array of colors. Thomas Moran, *The Grand Canyon of the Yellowstone*. 1872. Oil on canvas. 84″ x 144 1/2″. National Museum of American Art, Smithsonian Institution. Lent by the U.S. Department of the Interior, Office of the Secretary.

Moran's paintings of the region and Jackson's photographs did a great deal to pave the way for the creation of the national treasure that George Catlin dreamed of. The beauty and grandeur their art revealed helped convince a nation, and Yellowstone National Park, the cornerstone of the national park system, was created.

The Twilight of the Wild Riders

C. M. ("Charley") Russell (1864–1926) travelled west as a young man and stayed. He worked as a cowpuncher under the big skies of Montana, and, like Frederic Remington, watched with great regret as the Old West disappeared.

Cowtowns were often the scene of dramatic conflict. After a week of ranch chores, cowboys were ready to let off steam. This weekend rowdiness was offensive to the homesteaders who lived in these towns. Thus, the townspeople and the cowboys were often at odds, while the merchants,

189

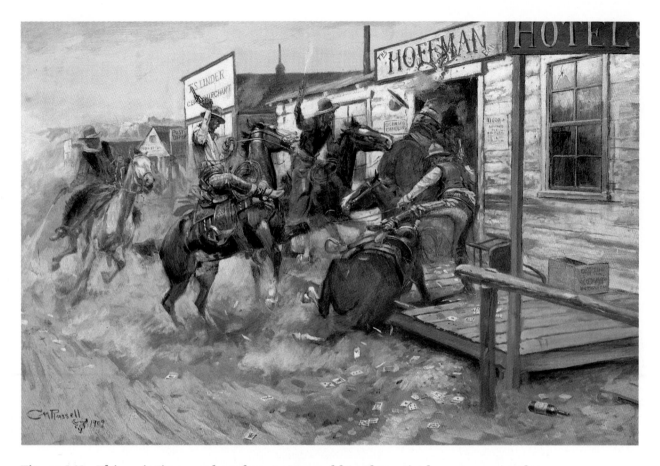

Figure 141. This painting was based on a story told to the artist by some wrangler companions about a night of wild revelry in a cowtown. Charles M. Russell, *In Without Knocking*. 1909. Oil on canvas. 20 1/8" x 29 7/8". Amon Carter Museum, Fort Worth

Time is a big factor as it is nearly sunset.

saloon keepers, and not infrequently, undertakers, prospered. In his 1909 painting *In Without Knocking* (Figure 141), Russell recalls his days on a cattle ranch back in the 1880s. The color, composition, and the action of this painting have been used and re-used in motion pictures.

Russell had a fine insight into human behavior and a warm sense of humor. His work is lifted out of the ordinary by simple but powerful statements which tell us of his sensitivity to the ironies of life. In 1915 he painted *Meat's Not Meat 'Til It's in the Pan* (Figure 142). He has caught the true mood of the moment. We feel the artist's empathy for the predicament of the man in the painting. He has pursued and shot a bighorn sheep, an animal noted for its ability to scale high peaks and steep cliffs. One wrong move and the bighorn will slip into oblivion, and might take the hunter and his horse with it. How will the hunter get it off the ledge? How does the artist tell us that the canyon is very,

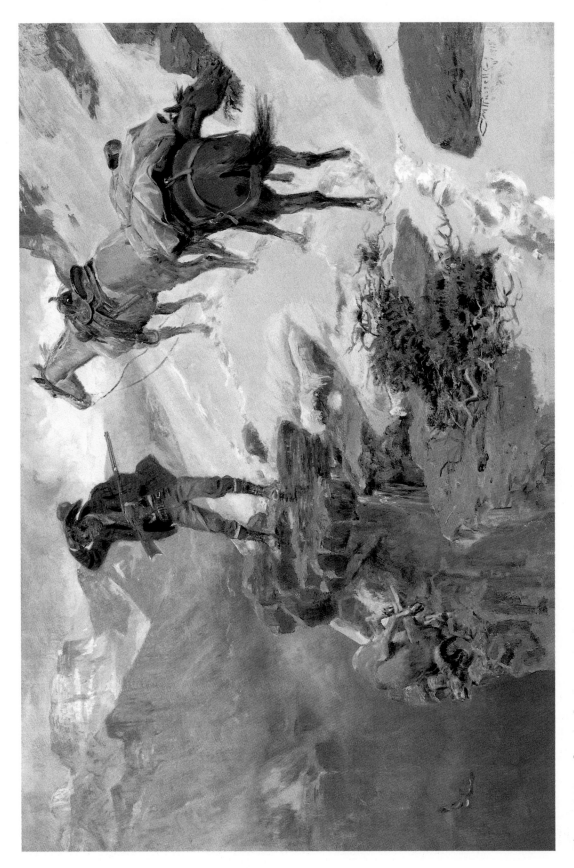

Figure 142. What is the irony in this painting? Charles M. Russell, *Meat's Not Meat 'Til It's in the Pan*. 1915. Oil on canvas. 24" x 36". The Thomas Gilcrease Institute of American History and Art, Tulsa.

What should have been the hardest part of the hunt turns out to be the easiest part. What should have been the easy part may turn into disaster. That is the irony here.

The Zuni are Pueblo Indians living in Western New Mexico. Their jewelry designs and art are widely admired.

Arroyos are creek beds which are dry most of the time, but can become turbulent torrents of water during thunderstorms.

Use Classroom Reproduction #15.

very deep? Does the hunter have much time to solve his problem? What is the irony of this scene?

A contemporary of Russell, Thomas Eakins (1844–1916) is considered by many to be the greatest painter America has produced. In 1887 Eakins had been dismissed as Director of the Pennsylvania Academy of Fine Arts. He went west that summer to find release from worries and to relax. Upon his return, he rode home from the Philadelphia train station fully outfitted in cowboy attire. A good friend, Frank Hamilton Cushing, was a naturalist who had lived with the Zuni (Zoo'-nee) Indians for five years. In order to paint Cushing's portrait the way he felt it should be done, Eakins converted his studio to make it closely resemble the interior of a Zuni home. In this portrait (Figure 143) Cushing is pondering Zuni fetishes that he is holding in his hand. A *fetish* is an object believed to have the power to protect its owner. Cushing's face reveals the sadness that comes from the knowledge that the old ways he observed are being wiped out. We can see that he feels the loss deeply.

The Far Side of the Rio Grande

Georgia O'Keeffe (1887–1986) spent a vacation at the thriving art colony of Taos (towse) in New Mexico during the summer of 1929. That holiday changed O'Keeffe's life. Although she lived in New York, she returned to New Mexico every summer thereafter. O'Keeffe was not drawn, however, by the art colony, but by the land. Hectic socializing and art talk, which was so much a part of the art colonies, was not to her liking. She began staying with friends at a place called the Ghost Ranch, which was on the western side of the Rio Grande. An old ranch near the remote settlement of Abiquiu (a'-bi-kew) seemed perfect for her home, so she bought it. For several years O'Keeffe spent the winter months in New York, but, following the death of her husband (the noted photographer Alfred Stieglitz), she moved permanently to Abiquiu.

Here she was surrounded by an almost unearthly landscape of hills striated with bands of red, pink, black, and white. Beyond her patio, rough arroyos (uh-roy'-yos) and rock formations stood silent in the clear light and the dark desert shadows under an intense blue sky.

Every day O'Keeffe walked this terrain. She explored it as if no one had ever seen it before. The paintings that resulted from her vision are modern, and different from

Figure 143. Eakins's perceptive portrait of his naturalist friend, Frank Cushing, shows how Cushing felt about the passing of the old ways of the Zuni of the Southwest. Thomas Eakins, *Frank Hamilton Cushing*. c. 1894. Oil on canvas. 90" x 60". Thomas Gilcrease Institute of American History and Art, Tulsa.

what had gone before. They defy labeling. *The Grey Hills* (Figure 144), painted in 1942, depicts the timeless quality she saw and felt in Abiquiu. The hills are wrinkled and folded, layered in startling color. They tell us not of history, but of pre-history. O'Keeffe painted the timeless, eternal ele-

Discuss Prehistory.

Figure 144. The West of Georgia O'Keeffe's imagination was unlike the West portrayed by earlier artists. Georgia O'Keeffe, *The Grey Hills.* 1942. Oil on canvas. 20" x 30". © 1990 Indianapolis Museum of Art. Gift of Mr. and Mrs. James W. Fesler.

ments which made her chosen homeland of the high desert so compelling to the viewer.

In New Mexico, she said, half a painter's work was already done. Perhaps so, but for her part, O'Keeffe contributed a unique way of seeing. She constantly searched for the marvelous which she tried to capture and make known to us. She once advised a friend to paint his world as though he was the first man to see it. This aspect may be the most astonishing quality of Georgia O'Keeffe's work. We feel that we have happened upon a brand new world.

Recent Developments

In 1962 the Institute of American Indian Art was founded in Santa Fe, New Mexico. Fritz Scholder, a former instructor at the Institute, and one of his pupils, T. C. Cannon, among others, have made an indelible impression on contemporary American art. Cannon died as a result of an automobile accident in 1978, but his *Collector #5,* which is also known as *Osage with van Gogh* (Figure 145), is widely recognized. It makes an important visual statement about the modern Native American condition. The Osage is beautifully dressed in largely traditional clothing and seated in a Victorian wicker

An excellent example for students to analyze critically.

194

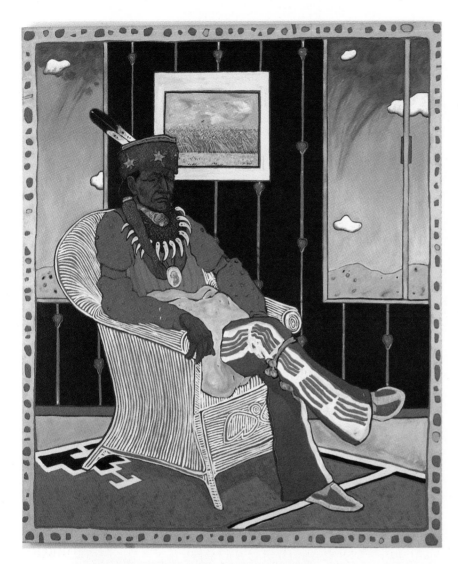

Figure 145. This beautifully dressed Osage sits between the symbols of two worlds: the Navaho rug on the floor and the van Gogh painting on the wall. T.C. Cannon, *Collector #5 (Osage with van Gogh)*. 1975. Oil and acrylic on canvas. 72″ x 60″. Courtesy of Mr. and Mrs. Richard Bloch, Santa Fe. Photo by Tony Vinella, Santa Fe.

chair. On the floor is a Navaho rug; on the wall, is van Gogh's *Wheatfield*. The man occupies the space between the symbols of the two cultures. It has become a cliché that the Native American is torn between two cultures. It is a fact that many Native Americans must straddle two worlds. At the same time, it is also a fact that a great many manage to do so very successfully—to live as modern citizens of the United States while cherishing their rich heritage.

Every summer, throughout the United States, many powwows are held. These gatherings combine ceremonial

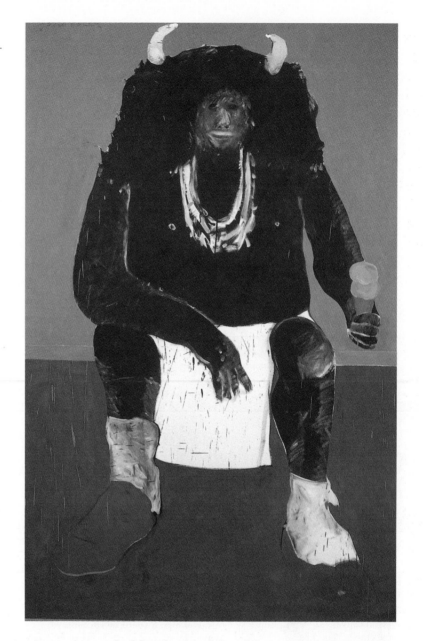

Figure 146. Scholder depicts his subjects in modern colors and paints with bold brushstrokes. Fritz Scholder, *Super Indian No. 2.* 1971. Oil on canvas. 90″ x 60″. Courtesy of Mr. and Mrs. Richard Bloch, Santa Fe, New Mexico.

The effect is powerful because the man wears ceremonial dress.

dances and other cultural events with rodeos and social tribal meetings. Powwows are also great tourist attractions. Some of the audience, caught up in the vitality and beauty of the action, forget that the modern Native American is not always comfortable being constantly perceived as a romantic figure. On the edge of the action the inevitable vendor stands, offering everything from spun candy and ice cream to peanuts and buffalo burgers. In his celebrated painting *Super Indian No. 2* (Figure 146), Fritz Scholder gives us a

Native American in traditional dress with a small pink ice cream cone in his fist. This is a direct reminder that the man we see is not a romantic myth, but a real person living and functioning in today's society.

Harry Fonseca has created a number of paintings with a coyote figure (or figures) as the center of interest. In Indian lore the coyote is often depicted as a smug, sophisticated, and devilish clown. This is, of course, almost the exact opposite of the image that Hollywood has created in the Roadrunner cartoons.

In *A Chorus Line*, Figure 147, we see a group of high-stepping coyotes dressed in swallow-tail coats performing before an audience on a stage lit by gaslight. The self-satisfied look on the faces of these coyotes shows us they know their act is well received, and they are enjoying themselves. We can join the audience and enjoy it too.

Figure 147. Harry Fonseca's sophisticated coyotes give us a show. Harry Fonseca, *A Chorus Line*. 1987. Mixed Media and Acrylic on canvas. 76″ x 96″. Courtesy of the artist and Elaine Horwitch Galleries, Tucson, Ariz.

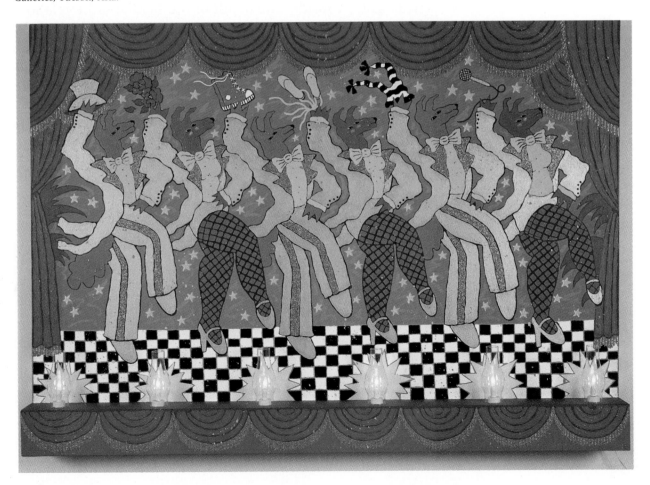

PAINTING ACTIVITY

Look at master works, past and present, and discuss how each artist placed the figures to achieve the best composition and the desired expressive quality.

In this activity you will paint a picture including several human figures. Painting the human figure may seem difficult, but if you treat it as just another group of shapes or forms, the task will be much less difficult. As you look at the model, think in terms of its different planes and forms and of how they are to be arranged. Look for the relationship of one shape to another. Pay special attention to how they fit together. Recall your earlier experiences in drawing activities.

First do a number of rapid sketches using thinned paint and a soft brush. Omit the details. This will give a more fluid feeling to the forms than a pencil sketch does. Place the first figure in the sketch so that it occupies a dominant space. Change the paint color to block in the second figure, then the third, and so on, until all figures are placed. In placing each figure, consider the depth of the field and the relationship of one figure to another. Let them overlap. Block in the background and any other forms in the same manner. You can separate them later as you paint each figure in detail. Let this dry before proceeding to add the details to each figure and the background.

Critique each step of the work as it progresses. Think about your use of the visual elements and compositional principles as you add details and define the overall composition.

SCULPTURE

Choosing the most appropriate medium for a subject is of real importance for an artist. We have seen that Remington and Russell chose to draw some pictures, paint others. Both of these men also worked in bronze sculpture. Consider the medium selected by the sculptors you will study in this section.

Drama in Bronze

Frederic Remington had a highly successful debut as a sculptor with his celebrated *Bronco Buster,* which we saw on

page 101. His first sculpture using the traditional technique called the lost wax process was *The Norther,* pictured in Figure 148.

The **lost wax process** of bronze casting was not a new idea in Remington's time; ancient Greeks had used this method. First, the artist makes a model in a heat-proof material. Wax is applied to this model (the core). The artist can then make slight alterations in the wax that covers the core. When the artist is satisfied that he or she is ready to have a casting made, the wax is very carefully surrounded by a heatproof mold of fine pipe clay. This pipe clay, when hardened, will reproduce every detail of the wax. Next, the entire sculpture is heated to melt the wax. The wax drains off through small drainpipes which have been inserted in inconspicuous places. The wax, and the wax alone, is thus "lost," leaving the space it occupied between the core and the mold of pipe clay. Molten bronze is then poured into the space left by the wax. The bronze picks up each detail from the pipe clay. The result is a hollow bronze sculpture with a surface exactly like the surface of the sculptured wax.

The technique of the lost wax process fascinated Remington, for it allowed him to make changes in each

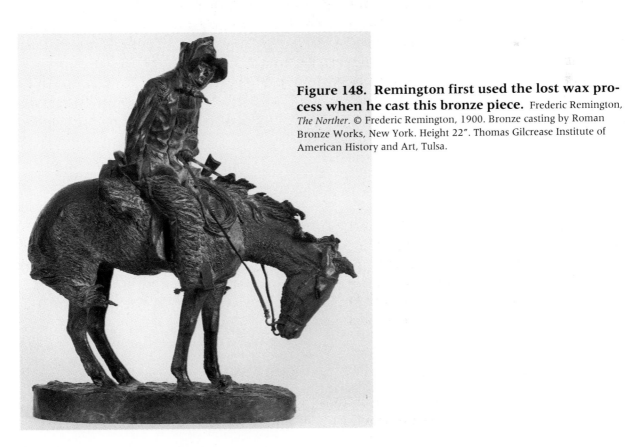

Figure 148. Remington first used the lost wax process when he cast this bronze piece. Frederic Remington, *The Norther.* © Frederic Remington, 1900. Bronze casting by Roman Bronze Works, New York. Height 22″. Thomas Gilcrease Institute of American History and Art, Tulsa.

casting. He could add molten wax with a brush and then build it up, or carve a bit away with a scalpel or other instrument. This enabled him to individualize each casting of a piece of sculpture. It also gave him the opportunity to keep experimenting with, and improving, each of his bronzes. He was able to alter the position of a limb or a tail or a detail of hair or dress.

The Norther is an amazing debut in lost wax casting. The horse's eyes are closed, its mane and tail blow forward in the icy wind. The rider has one hand down under his leg in an attempt to warm it. His hat brim is pulled down and his collar is pulled up against the onslaught of the fierce north wind. His rigid back and neck give us a sense of his discomfort. The bronze is so finely cast that the hairs under the horse's jaw appear frozen; we can almost feel the cold. In their shared adversity, the man and the horse have turned inward, facing away from the frigid north wind.

The basic form of *The Norther* is echoed in James Earl Fraser's familiar image of a defeated warrior, *The End of the Trail* (Figure 149), cast in 1918. Part of Fraser's childhood

Figure 149. As a child, Fraser witnessed the losses of Indian lands in the West, and many years later he created this eulogy in bronze.
James Earle Fraser, *The End of the Trail.* 1918. Bronze. Height 33 3/4″, Base 6 1/2″ x 20 3/4″. The Buffalo Bill Historical Center, Cody, Wyoming.

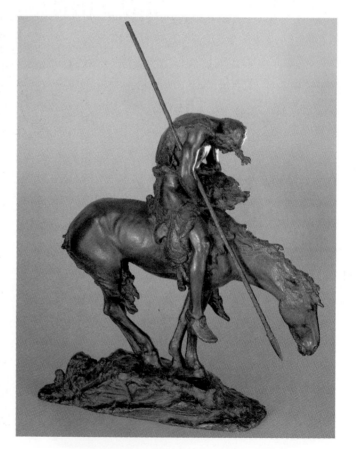

was spent in the Dakota Territory. He recalled that Indians often stopped by the family's ranch to camp and traded wild game with his father for chickens.

Then the soldiers began pushing the Indians onto reservations beyond the Missouri River. As a child, Fraser wondered about this continuous push westward. His father told him that if the government continued this policy, someday the Indians would be pushed into the Pacific Ocean. These memories led to his *End of the Trail,* which can be seen at the National Cowboy Hall of Fame and Western Heritage Center in Oklahoma City.

Solon Borglum's 1906 sculpture, *On the Border of the White Man's Land* (Figure 150), has a great emotional presence. The man and his horse are united in harmony with

Figure 150. Borglum, a Westerner who had trained in Paris, made his first studies for this compelling bronze at the Crow Creek Agency in South Dakota. Solon Hannibal Borglum (1868–1922), *On the Border of the White Man's Land.* 1906. Bronze statuette group. Height 19″. The Metropolitan Museum of Art, New York, Rogers Fund, 1907.

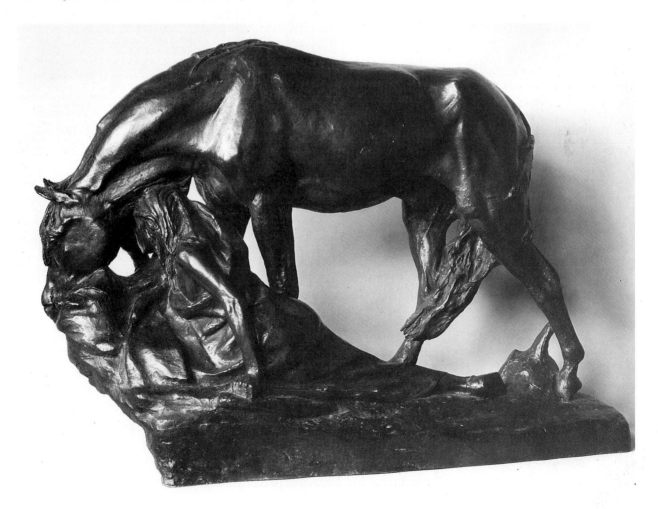

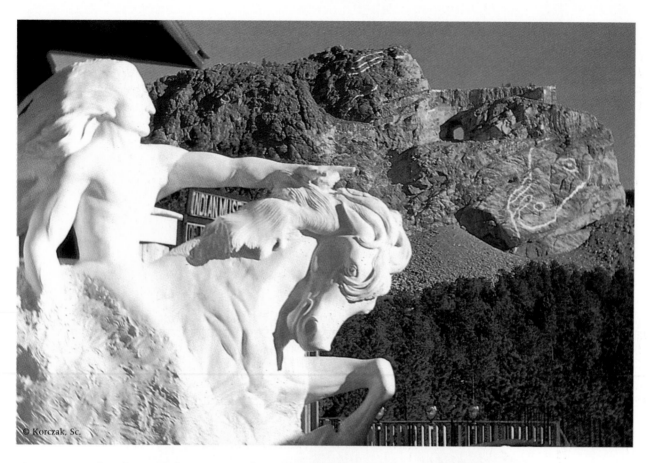

Figure 151. This figure is being carved on the mountain in the background. Korczak Ziolkowski, *Model, Crazy Horse Memorial,* The Black Hills, South Dakota. 1948–present. 1/34th scale. Photo by Robb DeWall, 1990.

the world they inhabit—a world which will be forever altered by the people they are quietly watching.

A Monumental Work in Progress

In 1948, Korczak Ziolkowski (1908–1982) began work in South Dakota on a monumental sculpture of the noted Sioux general, Crazy Horse. A model of the work is shown in Figure 151. It will be carved out of the mountain seen behind the model. When completed, it is to be immense: 563 feet high and 641 feet long. It is the largest sculptural undertaking ever known and, when complete, will be the focal point of a vast Indian educational and cultural center. Although Korczak died in 1982, the work on the mountain is being continued by the sculptor's wife and family, using detailed books of plans and measurements he and his wife prepared for that purpose. The great chief is to be seen for-

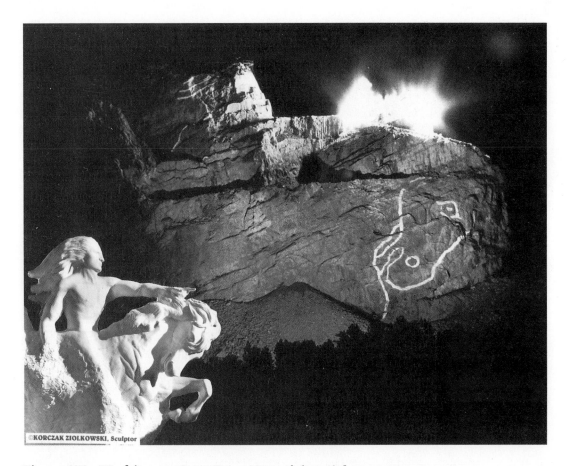

Figure 152. Working on *Crazy Horse Memorial* at night. Korczak Ziolkowski, *Model, Crazy Horse Memorial*, The Black Hills, South Dakota. 1948–present. 1/34th scale. Photo by Mark Wanek, 1990.

ever galloping through the Paha Sapa (pah'-hah sah'-pah), the sacred Black Hills of the Sioux.

The Crazy Horse monument is a work in progress as it has not yet been completed. Another kind of work in progress is one that uses the ever-changing elements of nature to make it complete. *The Lightning Field* (Figure 153) by Walter De Maria is a celebration of both the land and the sky. It stands in a flat land basin in west-central New Mexico, surrounded by distant mountains. Lightning is frequently generated in this area, and De Maria planned his sculpture to attract the lightning and celebrate its power and visual drama.

The sculpture is composed of 400 stainless steel poles, each 2 inches in diameter, standing at an average height of 20 feet, 7 1/2 inches. It is arranged so that all of the tops are level with one another. They are in a grid with 16 rows of 25 poles stretching east to west and 25 rows of 16 poles stretching north to south. The total east-west dimension of

Locate the Black Hills on the map on page 153 for the students.

203

Figure 153. The artist has said that no photograph or other recorded images can totally represent *The Lightning Field,* and that it must be experienced in person.
Walter De Maria (b. 1935), *The Lightning Field,* 1974–1977. Stainless steel poles. Average height of poles: 20′ 7 1/2″. Overall dimensions: 5,280 feet by 3,300 feet. Near Quemado, New Mexico. Collection of the DIA Art Foundation. Photograph by John Cliett. © 1980 DIA Art Foundation.

the sculpture is one mile, and the north-south dimension is approximately half a mile. The artist tells us: *"The Lightning Field* is a permanent work. The land is not a setting for the work, but a part of the work." De Maria would like visitors to *The Lightning Field* to contemplate the immense expanse of the setting. He tells us further:

> Because the sky-ground relationship is central to the work, viewing *The Lightning Field* from the air is of no value. Part of the essential content of the work is the ratio of people to a large amount of space. It is intended that the work be viewed alone, or in the company of a very small number of people, over at least a twenty-four hour period. The light is as important as the lightning.

So strongly does the artist feel that one must personally experience his work that he advises; "No photograph, group of photographs or other recorded images can completely represent *The Lightning Field.*"

It is not difficult to believe that nothing could replace the splendid display of electricity one perceives while standing alone in a landscape that suggests infinity. De Maria says that "isolation is the essence of land art."

Would you like to visit?

SCULPTURE ACTIVITIES

1. *Narrative art* is a general term for art that tells us a story. We have looked at some powerful examples of narrative art in painting and sculpture. In this section on sculpture, for example, think of the story that *The End of the Trail* and *On the Border of the White Man's Land* brings to your mind.

Select an event or a story that you believe could be depicted well in a piece of sculpture. This may be a historical event, a family or school event, a sports event, or a story you have read whose essence could be captured in a simple, three-dimensional piece of art. Limit yourself to no more than two characters to portray, and produce your narrative sculpture in clay.

2. The human figure has been the artist's main inspiration for sculpture. These figures have taken many forms, from the realistic to the abstract. Materials for sculpture have varied greatly, often depending on the local materials available to the artist.

Sculpt the human figure in a material available to you. One possibility is flexible bailing wire. Begin by doing a number of sketches of figures in action poses. As you draw, think of the pencil line as a continuous piece of flexible wire. Then translate your drawing into wire. Start with a loop for the head and continue down through the figure, bending and twisting the wire to develop a form in space. Emphasize the action of the figure. Notice in Figure 154

Figure 154. Wire sculpture, student art.

Review, if necessary, the proportions of the human body.

how forms are repeated to create a sense of graceful movement. After you are satisfied with the composition of the figure, attach it to a base cut in proportion to the overall size of the figure. Paint the wire one color, such as flat black.

ARCHITECTURE

The architecture of the West has a long history which can be directly traced to the ancient people known as the Anasazi.

Traditional Dwellings

You may want to point out the Four Corners area on a map.

The Anasazi (ah-nah-sah'zee), or "Ancient Ones," were a peaceful, corn-raising culture which flourished for over a thousand years in the Four Corners area of the United States. This area is the place where four states (Utah, New Mexico, Colorado and Arizona) meet. The Anasazi built the first pueblos and are generally believed to be the ancestors of the present pueblo-dwelling Indians.

Their earliest pueblos were pit houses covered with brush. Later they built above-ground homes made of native clay. Applied in layers, it hardened in the sun and produced sturdy walls. They laid large logs across the top of the walls and criss-crossed them with reeds, sticks, and brush. They had no heavy cutting tools, so they let the ends of the logs protrude through the edges of the walls. Rainwater was channeled out through little spouts in the side walls which extended out far enough to protect the vulnerable walls.

As the population grew, rooms were added. Pueblo "apartment houses" evolved into communities along the Rio Grande in New Mexico. In these multi-storied structures, each additional level was set back the depth of the unit beneath. In the early days of the multi-level pueblos, there was no ground-level entry. For defense reasons, only ladders provided access to the upper floors, and the first-storey rooms were entered from the top.

Pulling these ladders up is like locking doors today.

The Spanish settlers arrived in the late sixteenth century and brought their own building methods with them. However, they also adopted and adapted some of the Indian ways with architecture. The Spaniards mixed the native mud with straw and spread it in wooden forms to create adobe bricks made of earth and straw. They had learned this

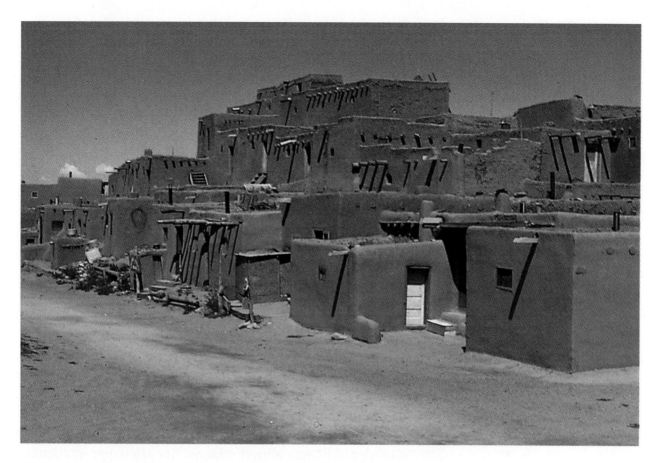

Figure 155. The pueblo stands at the foot of a beautiful mountain on lands considered sacred by the people who live there. *Taos Pueblo*, Taos, New Mexico. c. 1450–1500. The Granger Collection, New York.

technique from North Africans. They brought to the New World iron tools such as the ax and the adze, a tool used to shape wood. The big logs called *vigas* (vee'-gahs), which were used for the roof, could be made into square-edged shapes. The Spaniards quickly adopted the idea of the *enjaradora* (en-hah-rah-do'-rah) or woman plasterer. While the men of the Pueblo learned adobe brick-making and wood-working, the women's function was to coat the adobe brick walls with mud plaster. This process gives these structures their characteristic sculpted surface. The older pueblo-styled buildings, which were made of successive layers of mud gradually built up, have a more rounded and sculptural quality. The structures made of adobe brick covered with a layer of mud are more angular in appearance and are broadly described as "territorial" in style. The roofs of these buildings appear flat. They are, in fact, slightly tilted, having a somewhat higher elevation at the center. The walls extend a

Thus, everyone was put to work.

207

foot or so above roof level, forming a parapet. The drainage *canales* (cah-nah'-lays), literally "little canals," extend through this top portion of the wall.

As we noted, the very early dwellings had openings in the ceilings for entry, light, and ventilation. European style windows arrived with the Spaniards. Later influences added more and more architectural variations. Today there is a wide assortment of adobe structures throughout the Southwest, ranging from the traditional sculpted homes to highly abstract modern structures. Many are built of wood or steel frames and then covered with a modern type of plaster rather than traditional adobe.

The colors are the colors of the desert—terra-cottas and warm sand tones. What is more, their spiritual roots derive from the Pueblo people and their ancestors, the Anasazi, who created architectural poetry from native clay under the same desert sun.

The Circle Unbroken

The circle is a central symbol in Plains Indians' existence; it is important to their spiritual and intellectual life. The sacred medicine wheel represents the four cardinal directions. The hoop of life symbolizes the never-ending circle of life from birth, through maturity, to old age and death.

The circle is also often found in the material life and art of the Plains Indians. *Tipi* (tee-pee) is a Dakota word which means "a place for living." The base of the tipi is a circle. The women of the Plains tribes were the designers, builders, and owners of their tipis. Ingenious and resourceful, they created the ideal dwelling for their wandering way of life. They would erect and dismantle their tipis countless times during their lifetimes.

The tipi (or lodge) is snug in the winter and well-ventilated in hot weather. It is so stable and sturdy that it can withstand a gale-force wind, yet two women can erect one within an hour. The tipi was probably the world's most efficient mobile home.

The tipi's cover was made of dressed buffalo hides carefully stitched together with buffalo sinew in a fairly complicated pattern (see Figure 156). The cover was stretched over a strong tripod of poles. The tripod was tied together at the top prior to raising it. Then all but one of the remaining poles were leaned against the first three at proper

The differences in architecture of the Plains and the Pueblo Indians reflect their varying ways of life, but each is a very significant example of form following function.

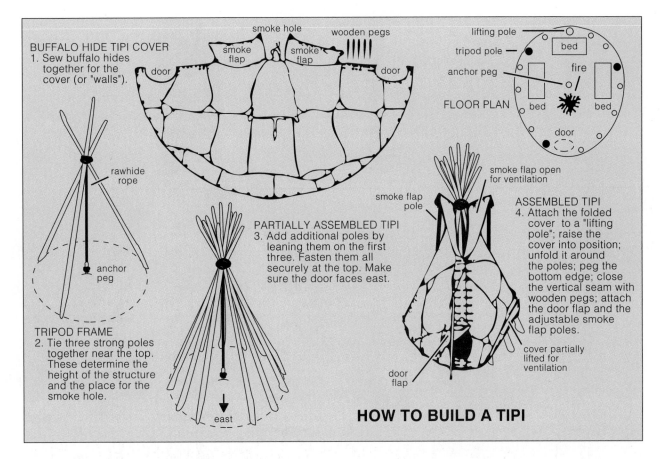

Figure 156. How to construct a tipi.

points, tied, and anchored to a single peg in the ground outside the tipi.

This framework appeared conical, but the tipi was not a true cone; it tilted slightly. This slight tilt allowed more headroom at the rear and better ventilation, with an off-center smoke hole. The tipi always faced east, where the day was born. (West was considered the direction of danger and death.)

The carefully folded cover was fastened to a lifting pole and raised into position over the framework. After that, it was a relatively easy matter to unfold the cover around the poles, peg the bottom edge, close the one vertical seam with wooden pegs, and attach the door flap. In hot weather, the bottom portion of the cover was raised for more ventilation. Two lighter poles were inserted in the pockets of the smoke flaps. By moving the poles, the flaps could be adjusted to allow for changes in wind direction. In the case of rain or snow, they could be completely closed.

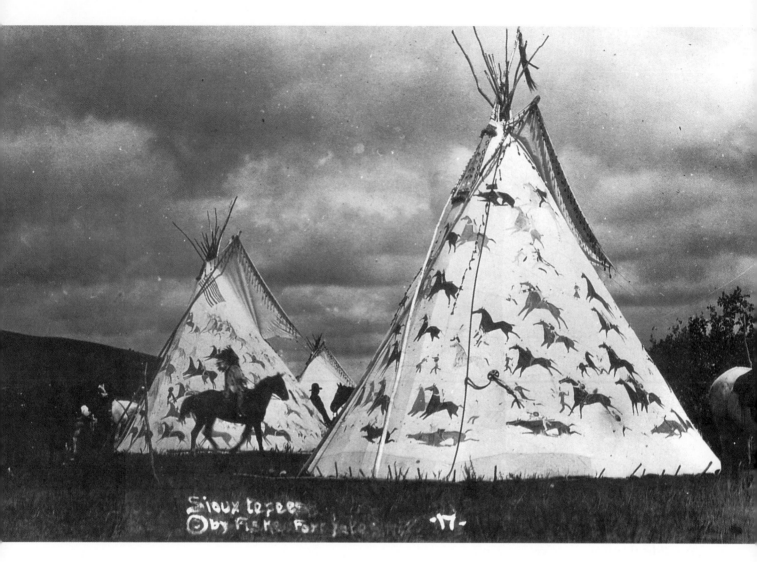

Figure 157. The decorations on this tipi demonstrate the design skills of the Plains artists. Historic tipi of Hunkpapa Dakota Chief Old Bull. c. 1900. Photo taken by Frank Fiske. National Anthropological Archives, Smithsonian Institution.

An average-sized tipi was fifteen to seventeen feet in diameter at the base. Some council lodges and medicine lodges were twenty-two or more feet in diameter and were extensively decorated (Figure 157). The interior lining of the tipi consisted of hide panels which covered the lower fourth of the poles and the perimeter of the floor. This effectively blocked cold drafts, and also deflected drafts upward, improving smoke ventilation. After a tipi lining was sewn, it was decorated by its owner with pictures of past tribal events or traditional geometric designs. Occasionally, tribal history or pictures of battles were painted on the exterior by the tribal historian.

Ancient Influences, Modern Design

The building plan that you see in Figure 158 is called *The Turtle*. Do you see why? *The Turtle* was designed principally by Dennis Sun Rhodes of the Arapaho tribe. The building is called the Native American Center for the Living Arts (NACLA). It houses an organization which works to preserve Native American arts and culture. The building is in Niagara Falls, New York.

What do you see when you look at this turtle? Not a sleepy or lazy creature, curled up in its shell and inactive. Rather you see a turtle that means business! Its head and feet are extended as though it were aggressively on the move. This building in the form of a turtle generates a sense of power.

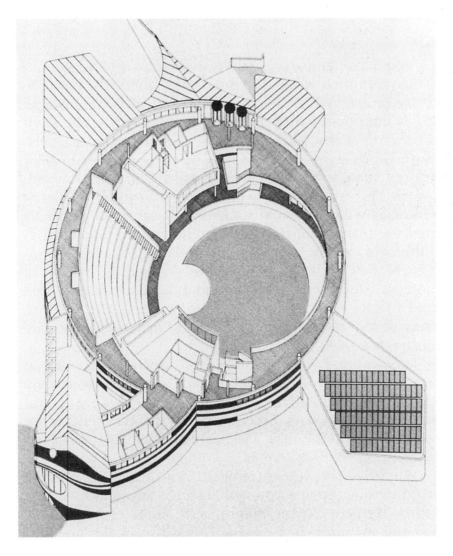

Figure 158. The design of this building recalls the central creation legend of the Iroquois people. Dennis Sun Rhodes, *The Turtle*, The Native American Center for the Living Arts, Niagara Falls, New York.

Ask students if they can think of any building in their community that is architecturally symbolic. Have them describe how.

Why is this building shaped like a turtle? What does it symbolize? According to a legend of the Iroquois people, Earth was created on the back of a giant turtle. The continent of North America is called "The Great Turtle Island." As a result of this legend, the symbol of the turtle appears in the history and art of many American cultures. It has been used to represent not only Earth, but also long life and great spiritual powers. Do you understand now why the NACLA building was designed as a turtle?

ARCHITECTURE ACTIVITIES

1. Many contemporary architects strive to achieve harmony between their works and the surroundings. They wish to create designs which seem to be a part of the landscape, rather than ones which appear to be imposed on the environment. Many ancient builders also achieved this. Aesthetic concerns may not have been uppermost in their conscious minds, but their structures were in harmony with nature. This is so largely because they had to use materials which were at hand, and sometimes because they actually used the features of the surrounding countryside, such as cliffsides, to create secure dwelling places. Excellent examples are the cliff dwellings of the Anasazi and the pueblos of those that followed them. The mounds, made of grass and mud by the early Plains people, and the beautiful tipis, made of slim poles covered with finely decorated hides, are further examples.

Look around your neighborhood, town, or city and at the countryside to observe the terrain features in your area. What color is the soil? What kinds of trees and other vegetation are there? Do you have a rocky environment? If so, what colors are the rocks? List as many natural features as you can.

When you feel you are familiar with the terrain, imagine the kind of house that you would create to complement the natural features of your environment. Think of shapes, colors, and materials to be used. Think also of the practical

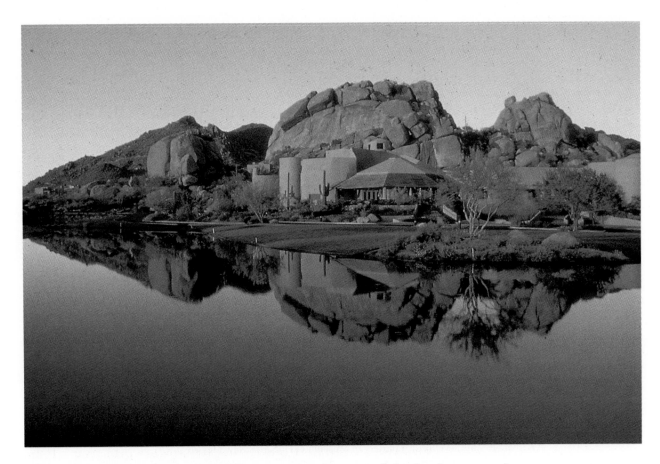

Figure 159. Many successful buildings seem to be part of the landscape, such as this one in Arizona. Courtesy, *The Boulders*, Carefree, Arizona.

things an architect must think of, such as climate and weather problems.

Put your thoughts down on a notepad. Add sketches. Remember to add annotations about the materials you could use and the architectural features of the building you are creating. Remember that people must live in comfort as well as beauty.

PHOTOGRAPHY

The Saint Francis of Assisi Church in Ranchos de Taos (rahn'-chose day-towse), New Mexico, is one of the most often photographed and painted buildings in the world. The thick adobe walls are replastered each year, by hand, by Native Americans.

Barbara P. Van Cleve photographed this church in color at night. The result is *Big Dipper over St. Francis of Assisi*

213

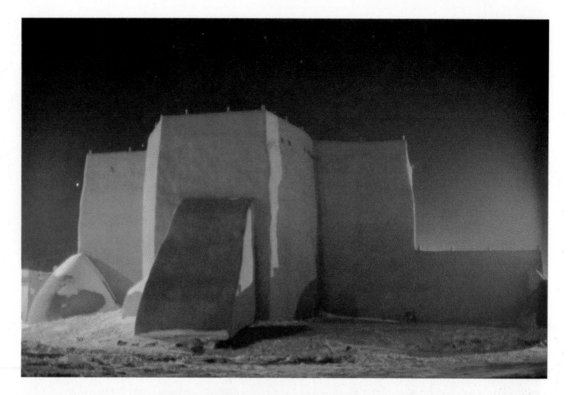

Figure 160. The artist says that the Big Dipper, full and waiting, added the ultimate touch of symbolism on this Christmas Eve. Barbara P. Van Cleve, *Big Dipper over St. Francis of Assisi Church at Ranchos de Taos, 1981.* Ektachrome print from Ektachrome transparency. 6 1/4″ x 9 1/2″. © Barbara P. Van Cleve, 1981. Courtesy of Museum of Fine Arts, New Mexico.

Church at Ranchos de Taos (Figure 160). She describes her experience when she made this photograph:

> I had gone up to Taos to watch the Christmas Eve ceremonies at Taos Pueblo and had planned to photograph the church at night. . . . I was looking for something unusual in color to happen—I hoped. I had not dared to hope that the stars would be recorded on film as stars and not "star tracks." One of my real pleasures in this image is that the viewer can clearly see the Big Dipper . . . suspended above and behind the church . . . and the Big Dipper adds the ultimate touch of symbolism: full and waiting on this Christmas Eve over one of the most beautiful churches in the Southwest. . . . I was privileged to see this and be able to make an image that would convey much of the real experience as well as the symbolic experience.

Sometimes while an artist is working, the unexpected occurs and produces exceptional results. At such times, the artist is the first to feel the joy of the occasion.

The ancient cliff houses in Canyon de Chelly (duh-shay') in northern Arizona, were discovered in 1849. Timothy H. O'Sullivan's photograph was taken from a niche fifty feet

Mention that the *photographer* has the opportunity to take immediate advantage of such serendipity.

214

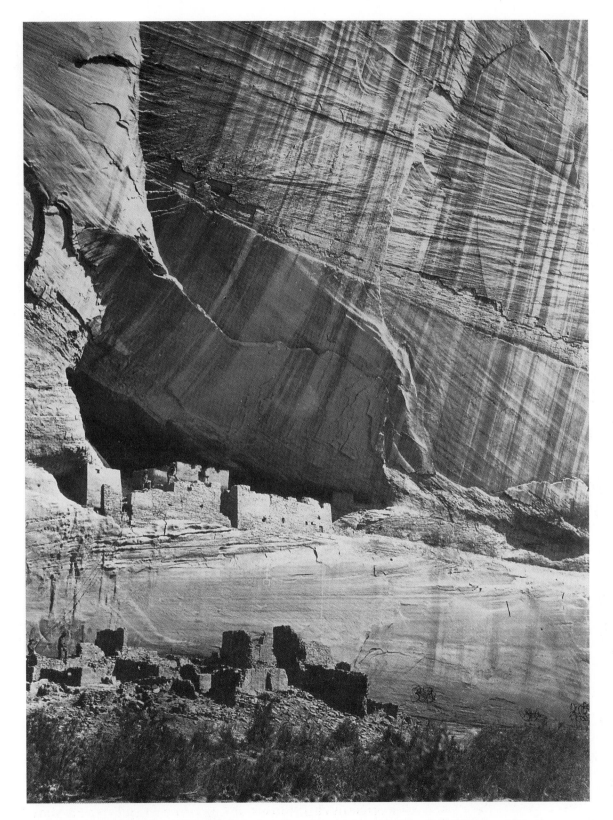

Figure 161. No one is certain precisely why the ancient Anasazi civilization disappeared. Timothy O'Sullivan, *Ancient Ruins in Canyon de Chelly*, New Mexico. 1873. The Denver Public Library, Western History Department.

Figure 162. Student art, time exposure.

The Anasazi climbed up and also down to reach their dwelling places. They carved niches in the sides of the cliffs for hand and foot holds. Each of them memorized the precise intricate pattern. If an intruder didn't know the pattern, he would be hopelessly stuck on the cliffside.

above the present canyon bed. O'Sullivan accompanied several expeditions in the West with his camera. He was known for his daring and innovative photography. For example, he photographed the first underground scenes of miners at work.

This photograph is a particularly interesting example of early techniques in photography. Many early photographers studied paintings in order to learn about compositional designs. An artist named Richard Kerns had painted the Anasazi home in Canyon de Chelly from this vantage point in 1849. O'Sullivan admired Kern's composition, and took his photograph from the same point.

Today the canyon is inhabited by Navahos who farm the land and grow fruit in this beautiful canyon, as the Anasazi ancestors did 1500 years before.

PHOTOGRAPHY ACTIVITIES

1. Many works of art and especially old photographs show the signs of age. In the case of paintings, the colors often darken, and cracks in the paint start to appear. Old photographs tend to take on a brownish tone. This is caused partly by age but also by the kinds of chemicals used in the paper and in the developing process. Many people greatly prize this effect of aging in photographs. Many movies have been made in "sepia tone," which gives this browning effect. If you like old things, you can have "instant old" photographs. The process to achieve this look can be done in the classroom under normal light. The silver is bleached out with one chemical and replaced with a toner (or second chemical).

Choose a photographic print that has good contrast and choose an appropriate subject. Sepia toning would probably not be appropriate for a picture of a Chicago skyscraper, for example. Good choices might be trees, landscapes, portraits (in old costumes), farm animals, or objects like rope, wagons, or old buildings. You will need a pair of rubber gloves. This process will be closely supervised by your teacher.

2. In this activity you will take time exposure photographs. Night exposures offer many possibilities for experimentation. You can photograph night scenes with many cameras, using a time exposure. Use a tripod or a table for support, as you will need long exposure times. Use the B (bulb) or T (time) shutter settings for exposures longer than those already measured on your shutter-speed dial. With these shutter settings, you can hold the shutter open for times ranging from a minute to half an hour. With the T setting you do not have to hold your finger on the shutter-release button for the exposure duration. For aperture-preferred automatic cameras, set the aperture on the smallest opening in a low light situation, and your camera will "choose" a slower or longer shutter speed to compensate.

Note that if your subject is moving, its image will be continuous and blurred against the stationary background. An illustration of this effect is shown in Figure 162. Such blurring often gives an interesting abstract effect. Experiment

Be very careful with the chemicals, and listen carefully to the teacher's instructions.

You may want to refer to a book of photographic techniques, such as *Special Problems* in the Time-Life series.

with various exposure times and fast film (high ISO number). Try more than twenty frames.

Good subjects for time exposure are fireworks displays, flashlights, moving automobile headlights, lightning, neon signs with movement in the neon, lighted fountains, candlelight, and moving human figures in spotlights.

CRAFTS

Craftworks are both beautiful and useful. We will look at several examples produced by ancient and modern people.

Navaho Weaving

The homeland of the Navaho is an immense reservation covering vast areas of northeastern Arizona, southern Utah, and northwestern New Mexico. It is an arid region with a harsh and dramatic beauty. Many Navahos earn a living raising sheep, and have become masters at carding, spinning, and dyeing wools. In the past, these wools were woven into colorful blankets. Traders who bartered with the Navaho saw the value of the blankets. They became more and more interested as the Navaho weavers began to produce rugs as well as blankets. Each type of rug had unique regional designs. Today the work of contemporary Navaho weavers is world famous. Regional styles such as Two Grey Hills, Ganado, and Burnt Water are magic names to collectors.

At the annual Indian Market in Santa Fe, New Mexico, two sisters, Barbara Teller Ornelas and Rose Ann Lee, received five awards in 1987. The Best in Show award went to their *Two Grey Hills Tapestry*, which we see in Figure 163. The sisters were only able to work on it part-time. This tapestry was on the loom for four years. The actual weaving took two and one-half years. Over the first part of the four-year period, six to eight months were spent preparing the wool from five sheep. The black wool was altered chemically with aniline dye. All of the other colors are the natural shades of the wool. They were cross-carded (two or more tones were blended together) to create the various grey and brown tones.

Carding is preparing the wool for weaving.

Ganado, Two Grey Hills, and Burnt Water refer to regions of the big Navaho reservation on which these designs are produced.

Figure 163. Except for the black areas, all the colors are created, not with dyes, but from the natural shades of the wool. Barbara Teller Ornelas and Rose Ann Lee, *Two Grey Hills Tapestry*. 60" x 104". Photo © by Jerry Jacka. Reproduced with permission from *Beyond Tradition: Contemporary Indian Art and Its Evolution.* © 1988 by Jerry and Lois Jacka. Northland Publishing, Flagstaff, Arizona. All rights reserved.

Another exceptional weaving is the rug with Burnt Water design we see in Figure 164 by Sadie Curtis and Alice Belone. Six Navaho weavers and dye artists from this region of the Navaho reservation dyed wool yarn in no less than twenty-five colors. These colors were created from a variety of vegetable dyes, which the dye artists made from natural plants, and from insects. They are blended with great subtlety to create this remarkable rug.

Pottery of the Southwest

In the Valley of the Mimbres. Can you guess when the bowl pictured in Figure 165 was designed? If you said that you thought it was a modern work, that is understandable. The design has a contemporary look. However, this bowl was made in a remote valley in southwestern New Mexico about nine hundred years ago. It was most likely made by a

Figure 164. The subtle blending of twenty–five colors created from natural vegetal dyes and from insects make this rug outstanding. Sadie Curtis and Alice Belone, *Burnt Water-Style Rug.* 9′ x 6′. Photo © Jerry Jacka. Reproduced with permission from *Beyond Tradition*: *Contemporary Indian Art and Its Evolution.* ©1988 by Jerry and Lois Jacka. Northland Publishing, Flagstaff, Arizona. All rights reserved.

woman artist who painted it using a brush made from the fibers of the yucca plant and a paint which consisted of an iron-bearing mineral base mixed with water.

The paint was very difficult to remove, so the artist needed a sure and steady hand. Her designs were carefully worked out in advance. She was one of the Mimbres (mim'-brays) people who occupied their valley from A.D.

On a map of New Mexico, locate the course of the Mimbres and the Gila rivers in the Southwest area of the state.

Figure 165. Look at the fine lines in this design and think of the Mimbres artist with a yucca brush and a mineral paint which was very hard to erase. *Mimbres Classic Black-on-White Bowl* with rabbit design. Swarts Ruin, Mimbres Valley, New Mexico. A.D. 1000–1150. The Peabody Museum of Archaeology and Ethnology, Harvard University. Photograph, Hillel Burger. © President and Fellows, Harvard College. All Rights Reserved.

100 to A.D. 1150. The style of this particular bowl is called Mimbres Style III, which places it in the height of the Mimbres Classic Period (A.D. 1000 to A.D. 1150). Pottery from this period features sophisticated geometric designs as well as designs that depict various animals and mythic forms. Many examples have survived intact because they were buried with the dead.

The Mimbres buried their dead underneath the floors of their homes. A beautiful bowl with a painted interior was inverted over the face of the departed person. It is as though the living wanted to provide their dead relatives with an eternal panorama, although no one knows exactly why they did this. Regardless of why they did it, we are fortunate to

The Mimbres people used a fine clay which is known as kaolin. Europeans tried for centuries to duplicate Chinese porcelain-making methods before finding kaolin in Europe.

have recovered these remarkable designs which disappeared so long ago and have not resurfaced in any other culture.

The careful symmetry of the designs creates the illusion of motion. The exterior of these Mimbres bowls is rough; the interior of each features a painting rather than simple decoration.

The bowl in this photograph is one of the finest examples of the expression of Mimbreños. It is not spectacular simply because it was made many centuries ago. It would be an exceptionally fine piece of work in any era in history. Other bowls present a parade of stylized turtles, lizards, sheep, fish, and a host of other fantasy figures. This cosmic carnival enchants the viewer; recovering these artworks is like finding notes sent to us across many centuries from a highly talented, remote, and largely unknown people.

A New Tradition from an Old Heritage. The rich heritage of southwestern Native American pottery has inspired fine earthenware in our own time. Native American potters Maria and Julian Martinez of the San Ildefonso (sahn eel'-day-fon-so) pueblo of New Mexico carefully studied remnants of traditional black pottery which was unearthed during archaeological digs near the pueblo. During the nineteenth century, the pottery of the San Ildefonso pueblo had been black-on-cream ware. Inspired by the designs and color of these ancient black bits of pottery the Martinezes decided to make a change. In 1918 they produced their first decorated black vessels.

The vessels were made by Maria and were decorated by Julian in polychrome designs. The highly burnished pots of Maria and Julian have an unusual silvery-black color. They are painted after they are polished so the painted area appears a dull black on a polished surface. The vase (Figure 166) is an example of the polished black-on-black pottery invented by Maria and Julian Martinez.

The demand for this pottery became so great that the Martinezes shared the secret of their process with the other San Ildefonso potters. The painting was done by men after the women had made the pots, just as Maria and Julian had done. This procedure represented a second departure; traditionally, the women had made the pots from start to finish. Maria inspired yet another change when she began signing her work. In time, potters of other pueblos followed her example, identifying their work and creating a significant market for individually signed Native American pottery.

Figure 166. This vase was first polished, and then painted, so that the painted areas are a dull black. Maria Martinez, *Long-Neck Pot.* 1961. Black on black, feather design. H: 11 3/4″, W: 7 7/8″. Clay. Courtesy the Wheelwright Museum of the American Indian. Photo: Hawthorne Studio, Santa Fe. No. 40/234.

CRAFT ACTIVITIES

1. The process for making a coil pot you have probably used before in elementary school. Think of the coils as ropes which you will use to make a container. In this activity you will use a template to help you shape a coil pot. A *template* is a pattern or mold used to guide the form of a piece being made. Where do you get one? You will make your own template.

After you have looked at a number of pictures of symmetrical containers, prepare at least half a dozen side-view sketches of containers you would like to make. Discuss all of your classmates' sketches; then make any adjustments that you wish to your own. Select one sketch for your pot. Take a piece of cardboard and draw half of the side view of your

Figure 167. Student art, coil pot.

Figure 168. Student art, slab pot.

Be careful in cutting.

CAUTION

chosen container design, in proportion to the actual size of the pot you wish to make. Your teacher will help you finish your template.

Decide on the size of the base and cut it from a slab of clay. Be sure to make it large enough so that you can get your hand inside to attach each coil. Place the template next to the base and attach the first coil so that it just barely touches the template. Attach each additional coil in the same manner, always using the template as a guide, until you have reached the top of the template. Move the template around to all sides of the container as you work. Make sure that the shape of the container follows the design. When you reach the top of the template, you should have an almost completely symmetrical container.

You may decide to keep the appearance of the coils, or you may wish to smooth the surface and add other surface decorations such as texture, applied shapes, or incised designs.

The availability of inexpensive images of the new land and people of the West influenced many people to migrate westward. We will look at three nineteenth century examples.

Dog Dancer!

"The dogs accompanied the rapid and violent beat of the drums, by the whistle of their war whistles, in short, monotonous notes, and then suddenly began to dance." So wrote Prince Maximilian (max-uh-mill'-yun), a Prussian aristocrat and naturalist who traveled the regions of the Upper Missouri shortly after the time of George Catlin, around 1840.

In Figure 169 we meet the warrior Pehriska-Ruhpa (per-is'-kuh ruh'-pah), a leader of the Hidatsa (he-dat'-suh) Dog Dance

The Mandan and Hidatsa Indians of the Upper Missouri had various military societies. Warriors celebrated victories with a ceremonial dance.

Figure 169. "The four principal dogs wore an immense cap hanging down upon the shoulders, composed of raven's or magpie's feathers...." (From Prince Maximilian's journal of March 7, 1834, describing the Mandan Dog Dance.) Karl Bodmer, *Pehriska-Ruhpa, Minitarri Warrior in Costume of Dog Dance.* c. 1840. Aquatint. 24 7/8" x 18 1/8". Courtesy Buffalo Bill Historical Center, Cody, Wyoming.

Society whom Maximilian observed. From the eye-witness reports, it appears that this man put on an unforgettable spectacle. Maximilian was fascinated by the costumes and the energy and gracefulness of the Dog Dancers. The aristocrat was also a stickler for detail. He had brought with him a young Swiss artist named Karl Bodmer, whose work impressed Maximilian. Bodmer's depiction of Pehriska-Ruhpa is generally regarded as the most striking portrait of an Indian ever done. The dancer and warrior posed for several days in full ceremonial dress. Regardless of the urging of Maximilian, Bodmer did not sacrifice aesthetics for accuracy. The aquatint of Pehriska-Ruhpa has both feeling and technical excellence. It makes us feel the movement of the dancer and the drama of his dance.

The Brief but Daring Saga of the Pony Express

The fabled transcontinental dash of the Pony Express is one of the most frequently told stories of the Old West. In reality its life was very short. The Pony Express began fast mail service in the spring of 1860, guaranteeing ten-day delivery of letters between St. Joseph, Missouri and Sacramento, California. Much of the territory covered was total wilderness. This advertising poster (Figure 170) gives us little idea of the often hair-raising events the carriers faced. The horse glides along in a leisurely "rocking horse" gallop. The rider seems to be a serene gentleman, who might have little more on his mind than enjoying the scenery.

In reality, the courier spent much of his time bent over his horse's mane, bathed in dust and sweat, the animal's hooves scarcely touching the ground. The recruiting advertisements offer a more candid perspective; "WANTED: Young, skinny, wiry fellows, not over eighteen. Must be expert riders willing to risk death daily. Orphans preferred. Wages $25.00 per week...."

This frenetic chapter in the legend of the West came to a close when the transcontinental telegraph wires met in September 1861. On October 26th, the Sacramento *Bee* bid a heartfelt good-bye: "Our little friend, the Pony, is to run no more. Farewell and forever, thou staunch . . . swift-footed messenger . . . Nothing that had blood and sinews was able to overcome your energy and ardor; but a senseless thing that eats not, sleeps not, tires not—a thing that cannot distinguish space—that knows not the difference between a rod of ground and the circumference of the globe itself, has encompassed, overthrown and routed you."

Figure 170. Do you think this poster offers an accurate idea of the Pony Express rider's life? Unknown artist, *Pony Express Poster*. n.d. Lithograph. 31 3/4" x 45". Part of original Buffalo Bill Museum Collection. Courtesy Buffalo Bill Historical Center, Cody, Wyoming.

But legends beget legends: One of the eighty young men selected to ride for the Pony Express was a fatherless fifteen year old named William Frederick Cody. He would become the author of his own myth and ride into the history of the West as Buffalo Bill.

Postcards of the West

Long before the era of mass communication, various means were found to drum up support for the idea of Manifest Destiny. For example, scenes which appeared on lithographs and postcards proved to be quite effective in spreading the word.

Fanny Palmer was an Englishwoman who settled in Brooklyn, New York, in the 1840s. She created the scene which we see in Figure 171 for the famous lithographers Currier and Ives in 1868. *Across the Continent: "Westward the*

Figure 171. This print foretold the arrival of the transcontinental railroad. Fanny F. Palmer, *Across the Continent: "Westward the Course of Empire Take Its Way."* 1868. Toned lithograph (hand colored). 22 3/4" x 31 5/8". Amon Carter Museum, Fort Worth.

Course of Empire Takes Its Way" is something of a fantasy. The artist composed it from stories she had heard of migrations that had taken place prior to the Civil War. It was soon used as a postcard. (Presumably, the entire title was not printed on the back of the card; little room would have been left for a message.)

The scene hints of boundless land, water, timber, and game. The settlement pictured is a beehive of happy activity. The train is headed down seemingly endless tracks west. Intrepid passengers populate the coaches. Overlooking the scene are two peaceful Indians who appear to be in imminent danger of suffocation from the smoke of the train's engine.

When this popular postcard first appeared on the market, there was no transcontinental railroad. In fact, those who had read railroad surveys had concluded that any route west to the Pacific would have to pass through coun-

try which would remain an inhospitable wasteland forever. Fanny Palmer's postcard may have been only an imaginative piece of propaganda at the time, but in the end, was she more right than wrong?

PRINTMAKING ACTIVITIES

1. Look at paintings or photographs of landscapes. Can you find in these pictures any shapes that repeat? Do any shapes overlap others? In this activity, you will make a collograph which repeats shapes found in rural or urban landscapes.

First use a dark magic marker to sketch a landscape on a piece of lightweight cardboard. Think of the shapes you see in the scene. Sketch only the big shapes in the scene, being careful to allow for overlapping. You will add details later. Cut out the cardboard shapes and glue them onto another sheet of cardboard. Next glue the details on. If, for example, you are using skyscraper shapes, add windows. Are they all the same size and shape? Are there any decorative elements around the windows? Adding texture and details like power lines, door knobs, light posts, bus stops, or different kinds of trees makes a collograph more interesting.

When you have finished the details, paint your plate with a coat of acrylic polymer, or whatever your teacher suggests. This seals the plate, making it easier to print.

To make prints of your plate, roll waterbase ink or thick paint onto the plate with a **brayer.** Medium pressure should be used to cover the plate with a thin, even coat of ink. Carefully lift the inked plate from the inking area, and place it face up on a clean sheet of paper. Then place another clean sheet of paper over the inked plate. The paper should be large enough to leave a margin of at least an inch on all sides. Quickly rub the covered plate with your fingertips or the heel of your hand. Peel off the paper. Your first print is finished. Hang it up to dry and repeat the printing process until you have five prints. These five prints are your edition.

Figure 172. Collograph, student art.

Check the safety of any paint the students use.

If this is the students' first experience with collographs, see page 284 in Book One for an introduction to the process.

Figure 173. Student art.

2. In this activity, you will make a linoleum block print. You must begin with a drawing the same size as the block you will be printing. A 6 by 6-inch drawing would be a good size. On manila paper with a marker, sketch an illustration of a dream or a nightmare. It could be one that you have had or have read about in literature. Pay particular attention to the repetition of line and shape. After you have finished several sketches, spread them out side by side. Which one makes the best use of line and shape? Are there any areas that need work? Remember, in a print, you must consider

Figure 174. Linoleum print, student art.

the areas you do not ink as carefully as those that you do. You will find that a simple, bold sketch is best for a linoleum block print.

When you are satisfied with your drawing, carefully transfer it with a sheet of carbon paper to a 6 by 6-inch linoleum block. With a magic marker or grease pencil, thicken and emphasize the drawn lines.

Before you begin cutting your block, practice cutting on a scrap of linoleum. You will need a bench hook, two blades, and a linoleum cutter handle. Hold the handle, with one of the blades screwed in it, in one hand. Place your other hand over the end of the handle to help push.

Place the linoleum scrap on the bench hook and cut away from you. For the best results, make cuts no more

At no time
should you put
your hand or
fingers in front
CAUTION
of the blade
as you cut.

Figure 175. Student art.

Figure 176. Student art.

than an inch in length. Shorter cuts are easier to control than long, deep ones.

After you are familiar with the feel of the cutter and the resistance from the linoleum, you are ready to begin cutting the actual block. Linoleum printmaking is a process in which you must cut away the areas you wish to remain white. Therefore, cut away all areas that do not have drawing. To put it in a slightly different manner, cut away the light areas and leave the black drawing. The more attention you give to cutting away small areas the better your print will be in the end. A linoleum cutter is difficult to handle, and more than once you may find that your hand slips and cuts something that you did not want to cut.

You will be ready to print when you have completely removed all nondrawn areas from your block. First, make registration marks so that your print will be in the center of your paper. To make registration marks, place a sheet of printing paper on the printing surface. With a crayon, carefully draw an outline of the page on the surface. Remove the paper, and place the linoleum block in the center of the square registration mark. Now draw a line around the block with a crayon.

For printing you will need an inking tray (plastic trays from grocery stores work well), a brayer, water-base ink, a

Figure 177. Student art.

Figure 178. Student art.

sponge, and printing paper measuring at least 10 by 10 inches.

Roll out some water-base ink on the inking tray with a brayer. Lightly roll the inked brayer over the block. Rather than putting a lot of ink on at once, quickly build up the ink with many thin coats. With a damp sponge, wipe away all the ink on the edges so that the borders of your print will be clean. Place a piece of paper over the block, making sure it lies within the registration lines you have drawn. Quickly rub the back of the paper with the bowl of a spoon or the tips of your fingers. Carefully peel the paper off the block. Put the first print in a safe place to dry while you re-ink the block and print again.

When the whole class has completed the printing project, display your prints and discuss what you think about the final outcome. You may be surprised that the finished print does not resemble the original drawing. It's not supposed to; it's different. Each method of getting ideas or images on paper is different from another. Each has its own qualities. Linoleum block printing at its best has the qualities of surprise and change.

UNIT

SPECIAL PROJECTS

The Artist and the West

ART HISTORY

1. It is hard for Americans of today to understand the importance of the first transcontinental railroad to the people of the United States in the middle of the nineteenth century. This great linkage of the East Coast to the West Coast would allow people and goods to move quickly within our continent's borders. It also connected Europe to Asia *through the United States.* When the golden spike was driven through the last rail at Promontory Point, Utah, in 1869 to complete the line, 8,000 miles of rough sailing "around the Horn" of South America when transporting goods and people from one coast to the other could be avoided.

Public interest in this project was so great that at times there were more reporters, photographers, artists, politicians, and well-wishers than workers on the work site. This group of witnesses left a remarkable record of a dramatic

Remind students that this was *before* the Panama Canal.

The wild drive to link the continent by rail created the Credit Mobilier Scandal. The students will (or are) encountering this in their American history classes.

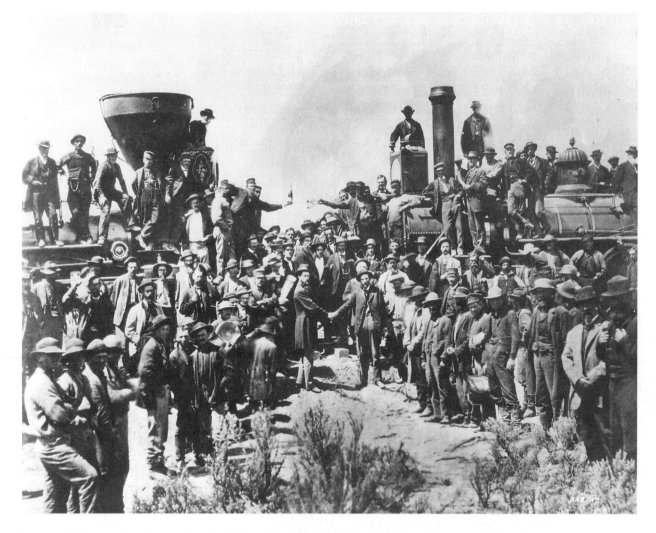

Figure 179. On May 10, 1869, the Union Pacific (1,038 miles) and the Central Pacific (742 miles) met at Promontory Point, Utah. The Union Pacific immediately began to advertise the new service which carried passengers "Through to San Francisco in less than Four days..." A.J. Russell. May 10, 1869. Photo courtesy the Library of Congress.

Manet's *The Fifer* is one of the most important of the Post-Impressionist paintings. It appears on page 239.

event in American history and produced some of the great images of the West. A. J. Russell's 1869 photograph (Figure 179) is one of these. The era is a rewarding one for research in art history and American history. Select titles from the bibliography and ask your social studies teachers for advice about your research.

2. You have seen the influence that the Impressionist painters had on other artists, including Frederic Remington. After only twelve years, the public's enthusiasm for Impressionism waned. Many of the Impressionists joined other new artists in "Post-Impressionism." Locate books or articles about the Impressionists and the Post-Impressionists.

Take notes on what you read and prepare a talk or research paper to present to your class.

It is interesting to see how tastes change. Today, major works by Impressionist and Post-Impressionist artists are bringing the highest prices in the art world. Another interesting sidelight is that Claude Monet, whose 1874 painting, *Impression: Sunrise,* was the first to be labeled "Impressionist," outlived them all, and continued making his Impressionist paintings until his death in 1926.

3. On June 25, 1876, George Armstrong Custer led 267 officers and soldiers of the Seventh U. S. Cavalry to their death. The battle site was a place the Indians called "The

Figure 180. Leonard Baskin's drawings of General Custer are among the most haunting portraits of this legendary figure. Leonard Baskin, *Drawing of General George A. Custer*. Courtesy of the National Park Service, Harper's Ferry Center, Harper's Ferry, West Virginia.

Comanche survived, but had multiple wounds. He was nursed back to health by the regimental blacksmith, a man named Gustave Korn. Comanche was, for many years, used in parades as the "riderless horse" to commemorate the dead. Korn was killed at Wounded Knee in 1890. Comanche, it is said, grieved to death. The Seventh Cavalry had him stuffed and placed under glass in the library of the University of Kansas. He was twenty-nine years old when he died.

A good encyclopedia will cover this subject, as will any good history of art text. Students' research should reflect an understanding of Manet's focus on the **surface** of the painting.

Valley of the Greasy Grass," the valley of the Little Big Horn River. There is no single military event in United States history that has generated as much controversy, mystery, conjecture, and art as has Custer's Last Stand. A recent count lists 115 significant paintings of this event. Custer has been portrayed in so many movies that no one has a comprehensive count, but among his portrayers are Robert Shaw, Leslie Nielsen, Errol Flynn, and Ronald Reagan.

Prepare a report on Custer's Last Stand. Research this event by examining the art it has generated and reading the recollections of the Native American warriors who participated in the battle. You may discover a footnote to the history of the battle: the only army survivor was Captain Keogh's horse, Comanche. If you come upon the ultimate fate of this horse, put it in your report.

APPRECIATION AND AESTHETIC GROWTH

1. Édouard Manet (man-ay') (1832–1883) was a painter whose work cannot be classified in any one style or period. Manet gave great encouragement to the Impressionists, and many of his paintings are, in fact, impressionist works. Manet's place in the history of art is unique. Your project will be to research why this is so, and seek to understand the unique qualities of his work.

When Manet painted *The Fifer* (Figure 181) in 1866, he had just returned from Spain where he had studied the works of the Spanish master Diego Velásquez. The influence of Velásquez, combined with the influence of Japanese block prints, is evident in this painting. Research and write a report on how these influences can be seen in *The Fifer,* and conclude your report on the reason Édouard Manet's work is important in the history of art. One source is the Art History section of this textbook. Your teacher will suggest other sources.

2. As he worked to master color, Frederic Remington kept a diary of "color notes." This not only helped him record the colors he saw, it also forced him to look more closely and to be more aware of color. In writing descriptions of the colors he saw, he forced himself to analyze precisely what he was seeing. He wanted to take fresh looks at colors as if he were seeing them for the first time—as a child perceives color. Can you remember how, as a child, colors seemed so vivid

Figure 181. How did the work of Diego Velásquez and Japanese block prints influence Manet? Édouard Manet, *The Fifer* (Le Fifre). 1866. Oil on canvas. 63" x 38 1/4". The Louvre, Paris. Cliché des Musées Nationaux, Paris.

to you? Did you try to decide which color was your favorite?

If you have not tried keeping color notes, do so for a week. Then hold a class discussion on the results. For example, discuss the effects you and other members of the class have noticed in your awareness of color.

3. The art of Native Americans is a national treasure. A study of it can be richly rewarding and can become a life-long source of surprise and delight. A way to begin is to consider the differences in the life-styles of the Plains Indians and the Pueblo Indians. This will help you to understand the great diversity in Native American art, and to make an initial generalization.

The Plains Indians roamed the northern and southern plains with the buffalo. The Pueblo people lived in one place and raised crops and livestock. These differences resulted in great differences in the art of the two groups. For this project the class should divide into two groups. Group One will research and report on the arts and crafts of the southwestern Pueblo people such as the Hopi and the Zuni. Be alert for information showing how settled life affected their choices of subject matter, media, and style of art. Then take examples from at least two of the pueblos and show the differences in images used and in execution.

Group Two will research and report on the art of the Plains Indians such as the Sioux, Kiowa, and Comanche. Information gathered should show how the much more mobile life-style of these people affected the forms of expression they selected.

Whether you are researching the Plains Indians or the Pueblo Indians, include the following subjects in your report:

- The objects that the various tribes created.
- The materials used.
- The sources from which the materials were obtained.

EPILOGUE TO PART II

From Impressionism to Modern Art

In this section we have seen the effect of the Impressionists on the work of Frederic Remington. Impressionism was valuable to him in his quest for mastery of color. Some of the departures the Impressionists made were the result of the scientific discoveries and technological advances of the last half of the nineteenth century. In the science of optics it was proven that images perceived by the human eye change with the intensity of light. In other words, the color of any

object is modified by the intensity of light in which we see the color. Additionally, the color of an object to our eyes is modified by the color of objects near it. We noted examples of this phenomenon in our study of color in the section on the visual elements of art. For example, do you recall that when we placed complementary colors next to each other, their intensity was heightened?

Impressionist painting also takes advantage of a natural phenomenon, that is the tendency of the human eye to fuse or blend colors seen from a distance. Up close, we see most Impressionist paintings as a conglomeration of short brush strokes of color. However, at a short distance from the work, we easily see the composition the artist wants us to see. Additionally, these side-by-side brush strokes of color "fuse" together in our eyes into a color which is a mixture of the colors applied next to each other on the support. This "fused" color is a more intense hue than one mixed on the palette and applied to the support. For example, short, choppy strokes of yellow placed next to blue strokes will appear, at a distance from the canvas, a more intense green than a green mixed on the palette.

Impressionists painted shadows in deep shades modified by the surrounding colors; they did not use black and grey for shadows.

Color was also used to define objects rather than line. The Impressionists saw that objects were not actually outlined in nature, so they eliminated these lines in their works.

Claude Monet (whose *Impression: Sunrise* was the first painting to be labeled "Impressionist") was intrigued by the changing effects of light. He would paint many canvases of the same subject at various times of day and in varying atmospheric conditions. By painting the same subject at regular intervals, Monet could explore the variety of effects of light on that same subject. We see two of his paintings of Waterloo Bridge in London as Figures 182 and 183. As this shows, Monet was not only interested in the effect of the sun at different times of day, he was also interested in the effect of fog on the light and thus on the bridge and its surroundings. He painted this bridge sixteen times.

Monet's method in studying the effects of light was to get three or more canvases set up and ready to paint a single subject. His own garden was a favorite subject for him. One of the canvases was used to capture the scene in early morning sunlight, another at midday, another in late evening light. He would begin early in the day with the

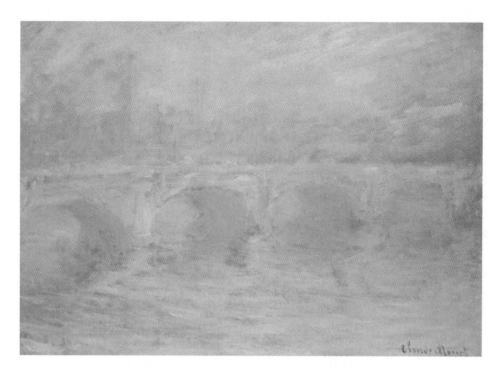

Figure 182. Monet was concerned with the effects of light. Claude Monet
(French, 1840–1925), *Waterloo Bridge, London, at Sunset.* 1904. Oil on canvas. 25 3/4" x 36 1/2".
National Gallery of Art, Washington, D.C. Collection of Mr. and Mrs. Paul Mellon.

Figure 183. The same scene at a different time in different weather.
Claude Monet, *Waterloo Bridge, Grey Day.* 1903. Canvas. 25 3/8" x 39 3/8". National Gallery of Art,
Washington, D.C. Chester Dale Collection.

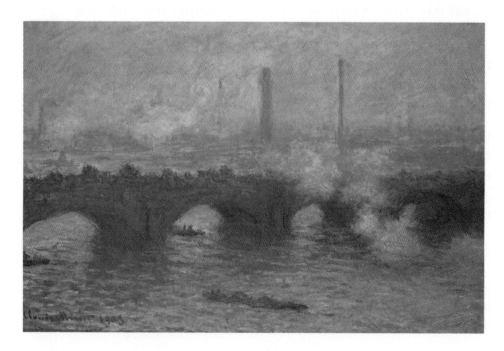

morning canvas. Then, when the sun shifted, he would move to the midday canvas. Finally, he would turn to the evening canvas.

The Impressionists were different from the classic representational painters in yet another way. In many Impressionist paintings, there is a feeling of spontaneity. Look at the two paintings in Figures 184 and 185. One is by Camille Pissarro (pee-sahr'-row), the other by Edgar Degas (day-gah'). The composition of each of these paintings is almost like a snapshot, as if whatever happened to appear on the scene at a particular moment was captured and put on canvas. The Impressionists had been greatly influenced by the camera. In these two paintings, figures and objects at the edge of the canvases are "cut off" as they often are in a snapshot. They don't *appear* to be posed as they would be in a more traditional painting.

Paul Cézanne (1839–1906) was a friend of Camille Pissarro. Both had been Impressionist painters during the

Winsor and Newton Co., in 1841, put oil paints in collapsible tubes, which was a boon to outdoor painting.

Use Classroom Reproduction #16.

Figure 184. Light itself became Pissarro's subject, the major element in his paintings. Camille Pissarro (French, b. West Indies, 1830–1903), *La Place du Théatre Français*. 1898. Oil on canvas. 28 1/2″ x 36 1/2″. The Los Angeles County Museum of Art. Mr. and Mrs. George Gard de Sylva Collection.

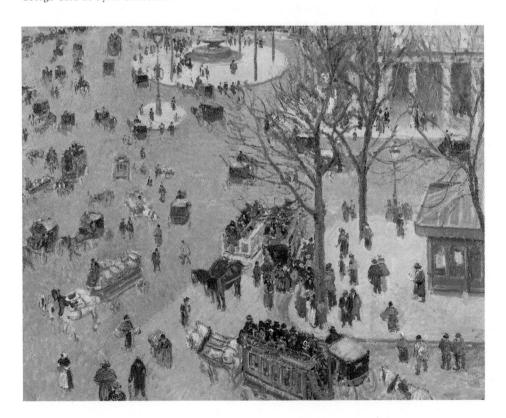

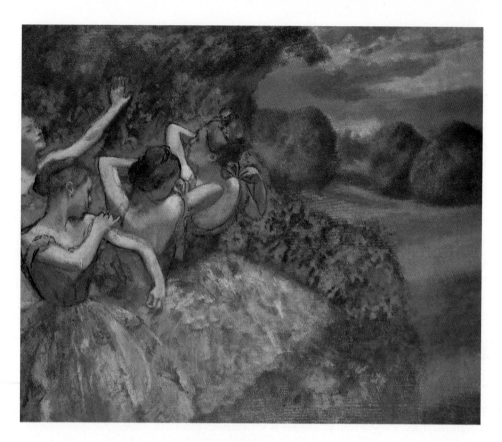

Figure 185. The work of Degas foretold new ways of placing figures in a scene and of arranging angles of vision which would become familiar years later in photography and motion pictures. Edgar Degas, *Four Dancers*. c. 1899. Oil on canvas. 59 1/2″ x 71″. National Gallery of Art, Washington, D.C. Chester Dale Collection.

In several books Cézanne is simply called a Post-Impressionist, or even the founder of Post-Impressionism. The authors feel that this is too restrictive.

1870s. Cézanne wanted to go farther in his work, and the public had begun to tire of Impressionist works in the 1880s. There was a general feeling at that time that Impressionism was reducing the viewer to the role of a mere passive observer of "superficial beauty." The last major exhibit of Impressionist works in the nineteenth century was held in 1886.

Cézanne felt the need for line and geometrical order as well as for light and beautiful effects. His need for order led him to combine the formal values of traditional painting with the beautiful effects of Impressionism. Rather than staying with short daubs and strokes of color, he used planes of color to define mass and volume. In order to get the strict compositional effects he wanted, he deliberately distorted his subject matter, but with a sharp clarity. Cézanne was so careful and painstaking with each of his

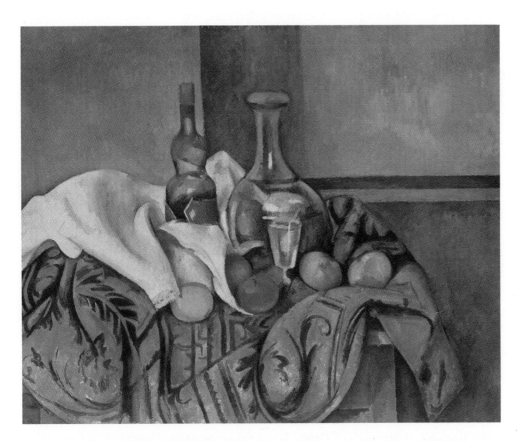

Figure 186. As bottles and fruit become cylinders and spheres, Cézanne presents us with an architecture of color. Paul Cézanne, *Still Life with Peppermint Bottle.* c. 1894. Oil on canvas. 26″ x 32 3/8″. National Gallery of Art, Washington, D.C. Chester Dale Collection.

paintings that we can see, if we study them closely, how his distortion achieves an almost perfect balance and unity. A landmark example is his *Still Life* (Figure 186). Take time to critically analyze this important painting.

Throughout his life Cézanne painted many canvases of the mountain near the village of Aix (akes) in France. We see two of his versions of the mountain here in Figures 187 and 188. In his later painting (Figure 188) notice that he has used color in clearly defined planes and eliminated all unnecessary detail.

Three hallmarks of Cézanne's work are deliberate distortion to achieve balance and unity, the use of planes of color, and the elimination of detail he considered unnecessary. As we shall see in the next section, these characteristics of Cézanne's work formed the bridge between Impressionism and modern art.

Lead the students through the process of critical analysis. Discuss balance and unity and Cézanne's achievement in this respect. They must think of the painting without the distortions as well as with them. It is more important for them to *understand* the distortions and their contribution to a unified painting than to determine personal preferences.

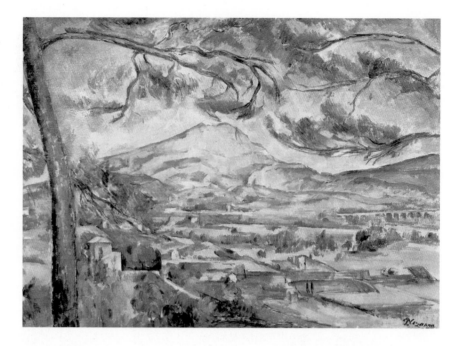

Figure 187. This painting of the mountain is a series of lines and clearly defined planes of color. Paul Cézanne, *La Montagne Sainte-Victoire*. c. 1886–1888. Approx. 26″ x 35 1/2″. Courtauld Institute Galleries, London. Courtauld Collection.

Figure 188. Another view of the mountain painted fifteen years later. Paul Cézanne, *Mont Sainte-Victoire*. 1902–1904. Oil on canvas. 27 1/2″ x 35 1/4″. The Philadelphia Museum of Art. George W. Elkins Collection.

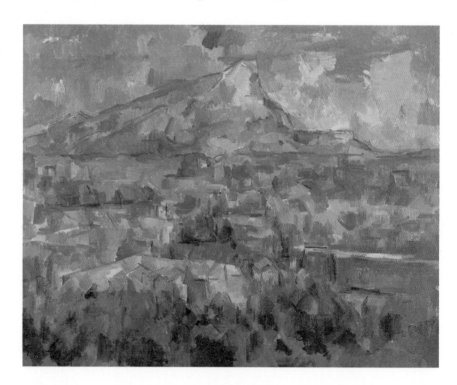

PART

III

THE ARTIST IN
THE INDUSTRIAL
WORLD

UNIT

LET'S GET LOST IN A PAINTING

The Bridge

by Joseph Stella

From time immemorial, bridges have excited, mystified, and even terrified the human imagination. In many ancient myths, when a bridge was built, the river gods required a human sacrifice. In overcoming a natural water barrier, man had dared to change the landscape and defy the laws of nature. For such feats the river gods demanded their price.

Before New York City's Brooklyn Bridge was completed in 1883, it had already become a modern myth. During its construction, John Roebling, the designer and chief engineer, died in a freak accident on a pier. His son, Washington Roebling, continued his work and completed the bridge. During the construction the younger Roebling, too, had a mishap, which left him paralyzed.

1. See the schedule for this unit on page T-61 of this TAER.
2. TRB: Review the suggestions for "The Open-Ended Encounter" on page T-57.
3. Use Classroom Reproduction #4.

The Brooklyn Bridge took fourteen years to build. During that time the newspapers were filled with reports of scandal, corruption, and the deaths of workers. The idea of such a huge undertaking staggered the imagination. The Brooklyn Bridge would be larger than the Egyptian pyramids and the biggest structure ever built in America. Little was known of the genius and vision of John Roebling, or the dedication of his son Washington. Still, the public imagination had been stirred. Who was this lunatic Roebling, sitting paralyzed at his desk, field glasses in hand, directing the work below?

The Brooklyn Bridge was officially opened in 1883. Chester A. Arthur, President of the United States, led the first walk across. To the many speakers at the opening dedication, the Brooklyn Bridge was a look into the future—a victory for American science and technology. For the first time, steel had replaced iron. The use of cables had changed

Figure 189. Notice how the bridge and the Statue of Liberty dominated the New York City skyline in 1885. Currier & Ives, *The Great East River Suspension Bridge.* c. 1885. Lithograph. Courtesy of the New York Historical Society, New York.

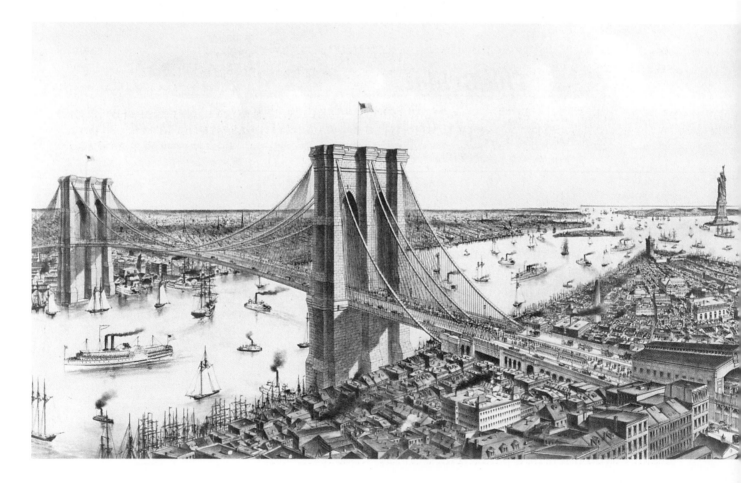

forever the method of building suspension bridges. And wonder of wonders, light was coming from Thomas Edison's marvelous new invention, the electric lamp!

Besides benefiting business and commerce, the Brooklyn Bridge was a "people's bridge." The main riverspan of 1,600 feet over New York Harbor had two levels. Roadways on the lower level were for trains, wagons, and horse-drawn carriages. Above the roadways was one of John Roebling's ingenious ideas—a promenade for walkers.

The public celebrated the opening in grand style, with parties, dancing, and fireworks throughout the night. On Memorial Day 1883, a week after the opening, another incident added to the myth of the Brooklyn Bridge. As thousands strolled along the promenade, a voice cried out: "The bridge is falling!" Panic followed. In the rush to escape, twelve people were trampled to death. At the dawn of a new age, the river gods had claimed more victims.

When the bridge opened, it joined two separate cities: New York and Brooklyn. Fifteen years later, Brooklyn became a borough of New York, adding approximately one million people to the city. New York City is now composed of five boroughs: Manhattan, Brooklyn, Queens, the Bronx, and Staten Island. The map shown in Figure 190 shows all five boroughs and the location of the Brooklyn Bridge.

Ask students which famous bridges they know of and how they came to hear about them.

If possible, show some photographs of the Brooklyn Bridge during its construction.

Figure 190. Map shows the location of the Brooklyn Bridge between Manhattan and Brooklyn.

A BRIDGE FROM PAST TO FUTURE

Much has happened to New York City in the last hundred years, and the Brooklyn Bridge has had an important role in the change. John Roebling's prophecy of "millions of people crossing the bridge" has been fulfilled. On the lower level automobiles and trucks have replaced horse-drawn vehicles, but on the promenade pedestrians still enjoy the breathtaking "path to the stars." For over a hundred years this awesome miracle of technology has cast a spell on the human imagination. It has been painted, drawn, and photographed more than any other bridge in the world. Poets compose poems about it. Authors write about it. Playwrights write plays that take place in its shadows. In movies spies whisper and lovers stroll on it. Travelers and tourists from all parts of the world come to see it. It is as much a part of the natural landscape as Niagara Falls or the Grand Canyon. In a sense it is more. Designed by the German-born John Roebling and built by the sweat of immigrant workers, it faces the Statue of Liberty. The Brooklyn Bridge has become a universal symbol of America's experience, achievement, and dreams.

To the artist Joseph Stella, the Brooklyn Bridge was a national shrine and a personal obsession. Obsessions are thoughts which will not leave the mind. Stella's obsession with the bridge—its history and design—led him to live near it, walk on it often, make countless sketches and six large paintings of it. His 1922 painting (his second painting of the bridge) is a landmark work in the history of modern art in America. Before looking at Stella's bridge, go back to the map of New York and the photographs of the bridge. Locate Manhattan, Brooklyn, and the bridge. Then go to the painting pictured in Figure 191. Do you recognize it as the Brooklyn Bridge? How? Try to determine where you are standing on Stella's bridge.

At first glance, the pointed arches suggest a doorway instead of a bridge. If it is a bridge, where is the part that goes over the river, and what are those long white strips hanging down? The pointed arches are the doorways of the bridge. You walk through them when you enter or leave it.

Explain that the Brooklyn Bridge is a monument to the American people as well as to the country itself.

Point out that Stella was still fascinated by the bridge, despite the fact that it was already forty years old.

Figure 191. Joseph Stella, *The Bridge.* The fifth panel of *Voice of the City of New York Interpreted.* 1920–1922. Oil and tempera on canvas. 88 1/2" x 54". Collection of the Newark Museum. Purchase 1937, Felix Fald Bequest Fund. Photograph © The Newark Museum. ➤

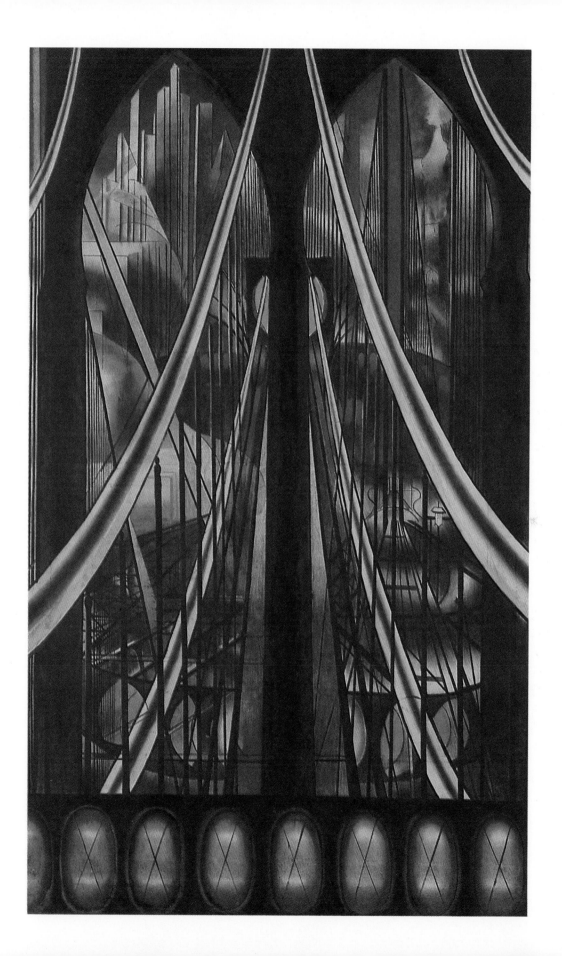

Stella chose to paint the arches and the tower. He included the four main cables (the long white strips) and the city beyond. But where is the riverspan—the part that goes across the river? It is there, but can you find it?

A POINT OF VIEW

That's right—you are standing on it, suspended over the river. This is the artist's point of view—the place from which Stella looks at the bridge. The artist and the viewer are in the middle of the bridge looking at the tower. From this position, the eye level is halfway up the tower. Figure 192 shows the eye-level line of the painting.

Stella plays tricks with the eye-level line in order to present the bridge his way. The arches soar 105 feet above the walkway. We would have to be about 55 feet tall to see from the eye level in the painting. If he had made the view 5 or 6 feet high, the eye level would be approximately that of the small figure in the drawing. We would not see very much,

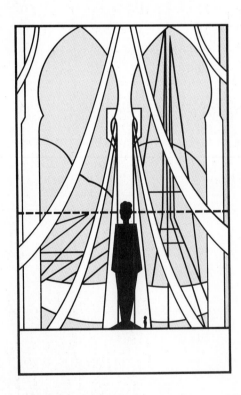

Figure 192. The eye-level line is an imaginary line showing where the eye spans when looking straight ahead. The line moves higher and lower as the eye moves higher and lower.

and the height of the towers would overpower us. Standing on the promenade, we would also not see what is underneath. So Stella gave the viewer X-ray eyes, showing the roadway with cars and flashing headlights under the walkway. The understructure of the bridge consists of I-beams and arches of steel braces and supports. All are part of Stella's story, so he placed them in the very center of the painting.

To Stella the bridge was two different worlds. At night he often walked alone on the promenade. He heard the wind hum through the cables and the sound of the traffic below. He saw moving headlights flashing through the structure and plankings. The quiet space and distant stars seen from the promenade were far different from the view on the lower level. That was a ferocious, frantic world of rushing traffic and the deafening whine of tires on steel gratings. The noise filled the air around the bridge like a dense cloud. What the eye did not see, the ear could hear from that position on the promenade. He painted that noise with color and line. The red, blues, and greens in the corner angles and gridwork below the eye level, in the lower half of the painting, describe the hubbub of the lower roadway. Across the bottom, a row of oval lights suggests the tunnels and subways below the bridge under the East River.

By looking at the photograph (Figure 197), can you tell on which end of the bridge you are standing? At which tower you are looking? There are two clues. The first is the skyscrapers beyond the tower. Those tall buildings can only be the Manhattan skyline. The second clue is the small square shape midway up the central column in the painting. The detail shows the tower on the Manhattan side. (Figure 193).

Explain that Stella was not painting what he saw, but what he felt about the city. Though there are elements from reality in both the bridge and the view of Manhattan, the painting is an abstract version of both subjects.

Figure 193. Detail from *The Bridge* (Figure 191) shows the square shape on the central column.

The arches in front are in the Brooklyn Tower. Stella painted the bridge from the Brooklyn side with Manhattan in the background. His Manhattan is not the real city; none of the buildings is recognizable. It is a fantasy city. The buildings are not steel, stone, nor glass. Their thin lines with flickering shadows pass over their pale walls above dark blue and gray clouds of smoke and fog. Stella's buildings float in air and do not rest firmly on the bedrock of Manhattan.

AN UNMISTAKABLE LANDMARK

Let's go back to 1922, the year of Stella's painting. He called his work simply *The Bridge*. Most people, even if they were not familiar with New York, immediately recognized *The Bridge* as the Brooklyn Bridge. Why?

The answer is the boardwalk and the arches of the towers. The Brooklyn Bridge is the only bridge in the world with a promenade deck where people can walk and sit on benches, and with Gothic arches in each tower. These arches are high and narrow, with a point at the top of the curve. They are called "Gothic" after a style of architecture used in great stone cathedrals built hundreds of years ago in Europe. The Gothic style revolutionized architecture by creating soaring height and an appearance of lightness. In the 1840s Gothic architecture became popular in America. This style was a fitting choice for the bridge with which Roebling was to revolutionize American engineering. Since the Gothic style gives the feeling of height, it suited Roebling's purpose for "his cathedral to the stars." That Roebling was aware of the importance of his monument can be seen from his different drawings for the towers (Figures 194, 195 and 196). He first designed Egyptian-style towers, then round Roman arches, which he finally changed to Gothic arches.

By 1922, most of the world was familiar with these arches. The title, *The Bridge,* could only have meant the Brooklyn Bridge. People knew it even if they did not understand the painting.

They might have understood a photograph more easily. In a photograph, at least everything is where one expects to see it. The photograph taken by Richard Benson to illustrate Hart Crane's famous poem, "The Bridge" (1930), is a good

Roebling borrowed designs from Gothic churches. Ask what this implies about what he thought of the bridge.

Figure 194. Egyptian arch.

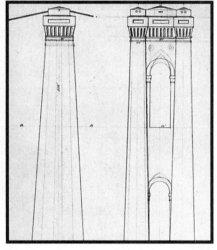

Figure 195. Roman arch.

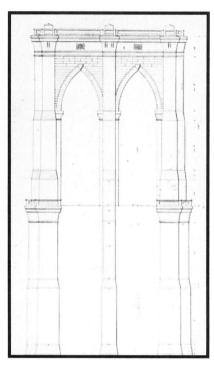

Figure 196. Gothic arch.

example (Figure 197). Crane had seen Stella's painting, and the photograph suggests that the photographer might also have seen it. The photograph is a more accurate picture than Stella's painting. But Stella was saying something about the bridge that a photograph can't say.

Both pictures show the arches, but the photograph also shows the whole tower and the sky and buildings on both sides of it. Both pictures show the steel ropes. In the photograph the steel ropes are like a spider's web or a net, because the shot includes the diagonal ropes. The painting shows only the vertical steel ropes (not the diagonal ropes), and it also includes the four long white cable casings. The four main cables are too high above the camera's eye level to be captured in the photograph. The photograph shows the cables lying over the roadway on each side of the board-walk, but it cannot show us the roadway underneath.

Stella could select the parts of the bridge he wanted in his painting, and leave out the parts he did not want. Benson could select which view he wanted, how close to get to the towers, how far to the left or the right on the board-

257

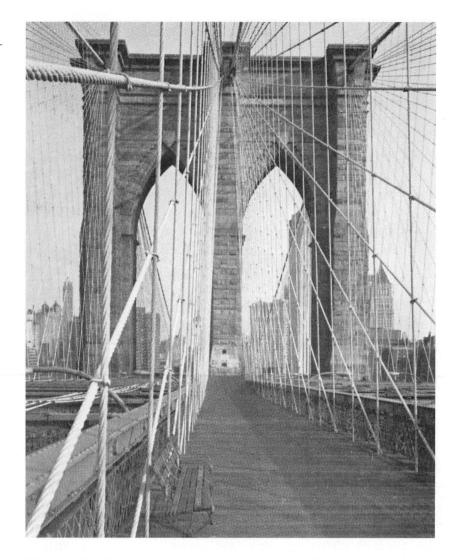

Figure 197. This 1930 photograph was taken from the promenade level. Richard Benson, photograph of the Brooklyn Bridge. 1930. The Limited Editions Club.

Emphasize the liberties Stella took in his depiction of the bridge. Explain that taking such liberties is an important trait of the modern artist.

walk, and the direction in which to point the lens. He could control the light, the shutter speed, and the focus. But he could not change the shadows; he could only wait for the sun to do that. His camera eye level was only three or four feet from the boardwalk.

Figure 198 shows where Benson stood to shoot his photograph. Notice how far away he is from the tower and how long the camera eye level is. Compare it with the drawing on page 254 of the eye level in the painting.

In the drawing of Benson's photograph the dotted line around the arches is the portion of the bridge which Stella uses in his painting. Notice how few of the buildings are visible inside the arches of the photograph. Benson's photo-

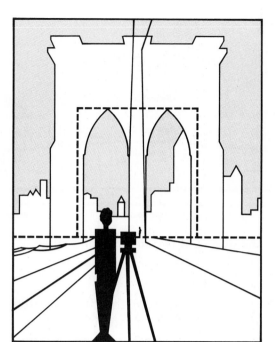

**Figure 198. Benson took
his photograph at eye level,
a distance from the tower.**

graph shows the Manhattan skyline of 1930. Stella's paint-
ing of 1922 shows buildings that had not yet been built. His
skyline is more like that of today than of 1922. The camera
can capture only what is there and what the photographer
chooses to focus on. Stella painted what the camera cannot
see. That is one difference between a photograph and a
painting. Each requires a well-trained eye and a special kind
of imagination. The artist and the photographer must be
able to visualize what the finished picture will be. Each
looked for the truth of the bridge as he imagined it, but
which one shows the true bridge?

There is no one answer. The bridge has as many truths as
there are creative artists. To the writer Henry James the
bridge was a "mechanical spider" working on the sky. The
line in Hart Crane's poem, "unspeakable thou Bridge to
thee, O love," tells of a poet's freedom when he walked the
bridge to escape the city. What was Roebling's truth? What
was Stella's truth? The answer to the first question sheds
light on the second.

The emphasis on what lies
beyond realistic depiction is
another trait of modern art.

ROEBLING'S DESIGN

For years the citizens of Manhattan and Brooklyn had
wanted and needed a bridge. In winter when the water
froze, travel and commerce were almost impossible. In addi-

Ask students whether they
prefer Benson's vision or
Stella's. Discuss the advan-
tages and demands of both
mediums.

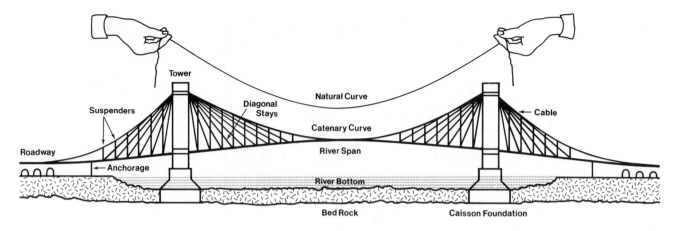

Figure 199. The drawing shows the design of the suspension bridge.

tion it was felt that the bridge could reduce major problems of crime and overcrowding. Bridge engineers had submitted many plans, but the engineering problems posed by the river remained unsolved. The East River's currents were difficult and tricky. The river had some of the busiest ship traffic in the world, and federal law required that a bridge not interfere with navigation. A bridge would have to be built high above the water and ground level of both cities. The task seemed impossible.

Roebling's solution was a suspension bridge with two stone towers (the Manhattan Tower on one side and the Brooklyn Tower on the other) resting on the solid bedrock of the river bottom. Figure 199 shows the two stone towers and the principle of a suspension bridge.

Roebling's design was a symbol of perfect balance when natural forces are at rest. The "natural forces" were the weight of the towers (the force of gravity) against the natural curve of the cables. Four main cables suspended between the towers supported the riverspan from vertical steel ropes called suspenders. These cables formed a natural curve in the same way the rope curves between the two hands in the diagram.

At such a height a powerful wind could raise and twist the long riverspan. So Roebling designed a series of radiating steel ropes called stays that cross and are clamped to each of the suspenders. Together the stays and tower (or suspenders) and riverspan form right triangles.

The relaxed natural curve of the cables and the strength of the right triangles represented natural forces at rest. The recognition of the geometrical forces in nature was a mathe-

matical principle discovered by the ancient Greek philosopher Pythagoras. Roebling used this principle for his bridge.

STELLA'S DESIGN

In the Benson photograph you immediately recognize the bridge. Not so in Stella's painting. Part of the reason why Stella's bridge is difficult to identify is because it is an "abstract" work. The word *abstract* has challenged artists and critics, and to this day it has mystified the public. It has several different meanings. For our purposes, **abstract** literally means "to take out from." In abstract art the artists takes something out from the natural or "real" appearance of objects. In order to understand abstract art, we must look at it with different eyes and a new attitude. We must experience it—perhaps even participate in it—before we recognize it. Instead of giving us a "realistic" picture, Stella invites us to feel the height and symmetry of his bridge.

An abstract artist can claim that his or her concept is actually *more* realistic than the mere *optical* realism of, for example, a photograph, or a realistic rendering.

GRAND SWEEP AND SYMMETRY

At the very first glance, we can feel the sweep and symmetry of Stella's "abstraction." The strong vertical lines of the arches create a sense of height and upward motion. Locate the promenade. Although horizontal, it has the appearance of being vertical. Stella's promenade feels the way people first described it as—a "passageway to the stars."

How did Stella create his illusion of height? Go back to the painting again. Determine how the positions of the towers, cables, and vertical lines create height and balance.

The size is the first clue. *The Bridge* is a vertical painting; that is, it is taller than it is wide. The three dominant vertical lines of the towers meet and push the eye upward to the pointed Gothic archways. Stella continues the vertical idea in the placement of the cables. In their grand sweep, the three sets of cables look like steps pushing the eye ever upward (Figure 200).

All this upward motion would make no visual sense if Stella did not balance the design and bring the eye to rest. Look at the arrangement in the diagram. The two Gothic arches have the shapes of bloated triangles. The three sets of

Ask students why the public is mystified by abstract art. Students might offer that abstract art does not present things as they appear, and that many people find this disconcerting.

Have students diagram the vertical lines. Point out that the feeling viewers get is closely related to what they are seeing.

Figure 200. The diagram shows the vertical sweep of Stella's design for *The Bridge* (Figure 191).

262

cables meet to form triangles which create stability and symmetry. **Symmetry** means that both sides are equally balanced. The constant repetition of the triangles is called triangulation. Roebling had constructed his bridge around the principle of the right angle of triangles. Stella planned his

Figure 201. Stella's use of the isosceles triangle in his painting echoes Roebling's design for the bridge.

painting around the isosceles triangle, a triangle that has two equal sides. (Figure 201 shows both types.) In this way he celebrated the triangulation of Roebling's design without copying it.

Stella's bridge is balanced and at rest. The triangles give the upward vertical movement a solid base. The bridge is symmetrical, but is the painting? Go one step beyond the bridge. Look through the archways. Decide if the painting is symmetrical.

The idea of balance is a traditional one in art. Point out that Stella combines the radically new with the traditional.

Distance and Depth

At first glance the painting seems symmetrical, but that is an illusion. The major structures—the sets of cables and the archways—create a symmetrical design. Inside the arches different things are happening. Through the left arch are the tall buildings of Manhattan; through the right are the heavy structure of the bridge and the lower roadway. The archways create a double image, as if one is a mirror of the other. Notice how Stella repeated the vertical buildings of the left archway in the vertical idea of the bridge in the right one. It is a visual trick. What is happening inside each archway is totally different. There are not one, but at least three separate stories: the drama and symmetry of the bridge, the distant buildings of the left portal, and the roadway underneath through the right.

In the archways, Stella created distance and depth. He shows distance by overlapping one object on another or by placing objects higher and smaller on the canvas. In the left archway the Manhattan skyline is the most distant part of the painting. Stella placed the buildings higher and smaller, overlapping other buildings and cloud shapes. The buildings are the most distant part of the painting.

Figure 202. The diagram shows how Stella used lines to create depth in his painting.

You might want to combine this discussion with a brief review of the principles of perspective.

An artist can also show depth by lines that converge to a point. Before going to the diagram (Figure 202), can you locate the deepest part of the painting (depth) in the right archway?

Follow the lines of the roadway to the very end. The imaginary point where they meet takes you into the deepest part of Stella's space. The converging lines of the roadway create what is called in art the illusion of depth. You are

standing on his bridge looking at the distant buildings. At the same time you are still inside the artist's space—feeling the life of a roadway you cannot actually see, even though you know it is there.

At this point you are now lost in the artist's painting. If he has succeeded, you are everywhere at once—you feel the sensations of the vertical motion of the city, the frenzy of traffic on the road below—all framed by the heavy weight of the abstract symmetrical structure. Does it make any difference that Stella's painting is not a realistic representation of a bridge? Probably not. Abstract art makes demands on the viewer. If you are willing to stay with the artist, the word *abstract* is no longer a threat.

In 1922 Stella's *Bridge* won immediate praise. In time it was recognized as a landmark painting. It helped introduce abstract art in America. For Joseph Stella, as well as the general public, *The Bridge* was a leap into the twentieth century. Until this work, Stella had been known mostly for his portraits of immigrants in New York City and his haunting drawings of life around the Pittsburgh steel mills. These he painted in a traditional style. In *The Bridge* he used a technique called Cubism to create the depth in the roadway. For Stella, an untrained artist, mastery of Cubism was a major achievement. An Italian immigrant, Stella accomplished still more by creating a universal symbol of American life.

It took Stella twenty years from the first time he saw the bridge to paint it. During that time, he completed two educations: one as an artist, the other as an immigrant in New York City. From one he learned how to paint. From the other he learned what to see in the land of opportunity. He needed both educations to paint his bridge.

STELLA AND THE ART WORLD

Joseph Stella was born in 1879 in Muro Lucano, a small Italian village near Mount Vesuvius, and received his education in nearby Naples. At the age of nineteen he joined his brother in New York City's Lower East Side—a neighborhood then inhabited mostly by immigrants. Although he had shown much artistic talent as a youngster, his father, a poor village lawyer, wanted Joseph to become a doctor. After one year of medical studies, the budding artist quit and in 1897 enrolled in the Art Students League of New

How might Stella's interest in immigrants and workers have affected his attitude toward the Brooklyn Bridge?

York. Later he studied at the New York School of Art, where he came under the influence of an important American artist and a leader of the Ash Can School, Robert Henri.

The Ash Can Artists

At the beginning of the twentieth century, revolutions were taking place against traditional ideas of art and beauty. One of these revolutions was the Ash Can School, so called because its members painted everyday activities in the city streets. Such paintings shocked a public used to the romantic work of the nineteenth century. People wanted their art to be pretty and expected to see happy portraits, still lifes, and peaceful landscapes. Times had changed—the Ash Can artists wanted to paint the world as they saw it. They saw an industrial world of factories and factory workers, a world of people on the streets, on rooftops, in restaurants, and in the theater. They painted the poor and the immigrants in an urban world created by big business and industry. The Ash Can School showed a new idea of beauty that was really a new concept of truth.

The artist Childe Hassam painted the Brooklyn Bridge through the eyes of the Ash Can painters, although he was not considered one of them. His painting, *Brooklyn Bridge in Winter,* (Figure 203), has certain features of the Ash Can style. It shows us a city of bleak buildings, and rooftops heavy with dirty snow on a dismal day in 1904. Hassam painted it from a high point, probably from a window above the other buildings. It is a long-distance view that includes both towers. The nearer tower is vague in the mist and smoke, but the distant tower is still more vague, almost lost. Hassam's painting also shows tenements crowded together in the part of the city where Stella lived (the Lower East Side).

Joseph Stella was not one of the Ash Can painters, but he was a part of the Ash Can world. He came to America expecting to find New York City full of opportunity and the dreams of his favorite poet, Walt Whitman. Instead he found a city of dirty, crowded streets, walled in by tall buildings. He found himself imprisoned between dark tenements, under spider webs of clothes lines with laundry blocking out the sun. He walked about day and night with his pencil, charcoal, and sketch pads, drawing his Italian immigrant neighbors. For a change of environment, he walked about

Ask: What method of giving the illusion of depth does Hassam use here that Stella does *not* use in *The Bridge?* Point out the faint detail in the distance in Hassam's painting.

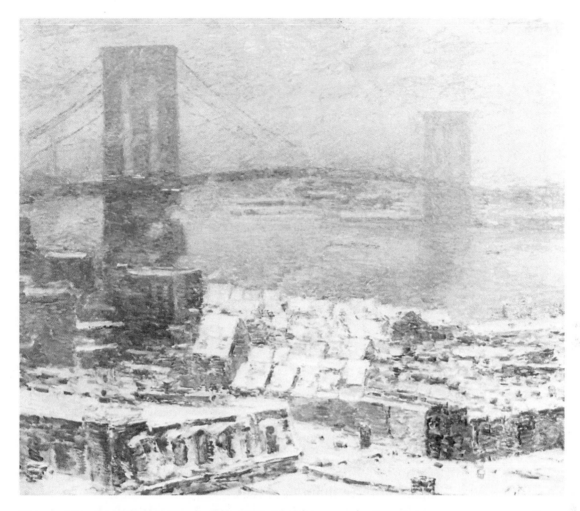

Figure 203. *Brooklyn Bridge in Winter* **by Childe Hassam, has features common to the Ash Can School.** Childe Hassam, *Brooklyn Bridge in Winter.* 1904. Oil on canvas. 30″ x 34 1/16″. Museum Purchase, 1907. In the Collection of the Telfair Academy of Arts and Sciences, Inc., Savannah, Georgia.

Manhattan in the theater district and out on the Brooklyn Bridge to smell the clear air and feel open space around him.

The Ash Can painters made pictures of factories and immigrants popular in some magazines. As a result of this interest, Stella was hired between 1905 and 1907 to illustrate books about working people and about immigrants arriving at Ellis Island. Two assignments for *Survey* magazine affected him for the rest of his life.

He went with a journalist to report on a mine disaster in Monogah, West Virginia. Almost the entire male working population was buried alive when the mines caved in. He sketched the grief and despair of the women, and the tragic, weary faces of the men who survived, only to become the gravediggers of the town. They dug out the bodies of their

267

Figure 204. *The Croation* **is an early sketch by Joseph Stella.** Joseph Stella, *The Croation.* 1908. The Hirshhorn Museum and Sculpture Gardens, Smithsonian Institution.

fathers, brothers, sons, and friends and then had to dig again to bury them in graves.

Stella's other assignment was in Pittsburgh. He drew the steelworkers in factories, the miners, and families in the dark, dank shacks they called home. He wrote later that he tried to show "the spasm and pathos of those workers condemned to a very strenuous life, exposed to the constant MENACE OF DEATH." Many drawings were of the huge monsters, the machines themselves. He had discovered the dark nightmare within the American dream. Out of all that power, force, and energy; coal and steel; smoke and noise came giant buildings and bridges, but also poverty, disaster, and death.

A Journey and a Discovery

In 1909 Stella returned to the warmth of his native Italy. There he visited the great museums and studied the glazing techniques of the Renaissance masters. But fifteenth- and sixteenth-century techniques were too slow and time-consuming for the emotions Stella wanted to express. One day

when trying to paint a mountain outside Muro Lucano, he threw down his brushes. He had finished imitating the past. In 1911 Stella went to Paris to discover the art of his own time.

The Break with Realism. The Ash Can revolution in America was only a small part of a bigger revolution in the art world. Paris was the center of that revolution. It was here in the early part of the twentieth century that modern art had its beginnings. Artists from all over the world came to Paris to look at the way Henri Matisse used colors and Pablo Picasso placed an object in space. These geniuses and their fellow artists were creating new ways of making paintings, new ways of seeing life.

Modern art was not one, but several, revolutions going on at the same time. The word *modern,* in this context, is difficult because it does not refer to time, such as the present. Modern art is a term that refers to the way artists were breaking away from painting traditions established by a thousand years of Western art. In the early 1900s artists began looking at the world with different eyes. Many of them were no longer interested in reproducing the natural appearance of life or things, what are called "realistic pictures."

They were interested in going beyond a realistic image to express something they saw in its color, shape, or line, something a camera could not do. The motto for the modern artist came from Matisse when he said: "One must not imitate what one wants to create."

That statement meant different things to different artists. For Matisse the colors of a table could have their own personality. Matisse could paint a table with such power that the viewer might or might not recognize it until he or she felt the values and emotions of Matisse's color. Another modern artist might paint only the structure of the table by abstracting its lines, shapes, or geometrical pattern. A viewer might recognize it—but again might not, because the artist was making new demands. A third artist might ask the viewer to look at all sides of the table at the same time from different angles. A fourth and fifth artist might use combinations of these styles.

In a sense this is not all new; artists for thousands of years have "abstracted" by putting their feelings into the shapes of objects. The twentieth-century, "modern" artist goes beyond the traditions of the past by making the viewer think and see in a different way. In order to recognize the

Stella's need and willingness to be different is characteristic of modern artists.

Have available examples of paintings by Matisse and Picasso from the period.

subject, the viewer must first experience something about it through the mind and emotions of the artist.

The subject of modern art is complicated—critics and historians do not agree on many things about it, how it started or what it means. The types of "modern" artists are so varied and their techniques so different, that whatever is said describes some but not all. At the turn of the century, artists were no longer content to copy. They looked for a new visual language in order to express the feelings of a new age—an age of science, technology, machines, and structures like the Brooklyn Bridge.

Cubism and Futurism. Paris was the center of these art revolutions, and it was here that Stella found himself in 1911. He met Matisse and Picasso and became involved in two new art movements. How strange! He had gone back to Europe to study the art of the past, but instead he confronted the future.

The styles which especially appealed to him were Cubism and Futurism. When Stella first met the Cubists, he said he was so upset he could not paint for six months. What was Picasso doing? His paintings looked so mechanical, with sharp angles and gray and brown colors. Everything looked like broken or exploding cubes. The style was called **Cubism,** and the painters Cubists. The Cubists set the course of Western art in a new direction.

What did the Cubists see? They saw geometrical structures and patterns in all objects. Trees, mountains, furniture, were seen as combinations of geometrical shapes, such as cones, spheres, and cubes. The Cubists also saw things in three dimensions and experimented with new ways of showing three-dimensional objects on a two-dimensional surface. In traditional paintings, the artists had shown objects from one viewpoint only. The Cubists sometimes included four or six sides: right and left, top and bottom, front and back. They painted objects such as chairs, tables, fruit in bowls, people, buildings, and musical instruments, depicting all sides, even the insides, at the same time. This was called the *principle of simultaneity.* We can't see all sides of an object at once, but the Cubists depicted all sides as visible simultaneously—that is, at the same time.

Albert Gleizes, one of the original Cubists, visited the United States and painted two Cubist pictures of the Brooklyn Bridge. One of these is shown in Figure 205.

Have available for students some examples of the Cubist paintings of Picasso and Braque.

This is a partial definition of Cubism.

Emphasize the great variety that characterizes modern art.

Figure 205. *On Brooklyn Bridge* **by Albert Gleizes is a Cubist interpretation of the bridge.** Albert Gleizes, *On Brooklyn Bridge.* 1917. Oil on canvas. 63 3/4" x 50 7/8". Solomon R. Guggenheim Museum, New York. Photograph by Robert E. Mates.

Have students identify elements that both Gleizes and Stella used in their paintings, such as the cables, towers, and buildings in the background.

Mention that, in Western traditions, artists had been trained (as your students have been trained) to paint what they *see*, rather than what they *know* about an object. The Cubists paint what they know as well as what they can see. Thus Cubists can claim their works are actually *more* real than optical realism.

Point out that the curved tower interrupts the sweeping upward movement. Stella chose not to interrupt this movement.

This is not a realistic representation. Gleizes chose the most recognizable parts–the network of cables, stays, and suspenders; the arches; the buildings; and the headlights of cars at night. Then he rearranged them to dramatize the dynamic forces. With the curved lines of the cables sweeping upward, and the lines of the stays pointing downward, he created two strong opposing movements. The overlapping angles and shapes cause the eye to move quickly from place to place. Across the middle, a row of circles inside other circles is like the glow of headlights at night driving straight at us. Above the noisy angles and shapes, the arch rises majestic and strong. The buildings at the bottom of the painting represent Brooklyn and those at the top, Manhattan. Gleizes has given us an interpretation of the bridge in the Cubist style instead of a representation. He rearranged the parts to emphasize the bridge's most dramatic and dynamic features. Joseph Stella used Cubist techniques with more restraint. Compare his painting (Figure 191) with that of Gleizes.

In the lower half of Stella's bridge, the artist applied the principle of simultaneity by showing us the understructure of the bridge at the same time that he shows us the front of the arches. On the left, he shows us the inner structure of the bridge. On the right, he shows us a long view of the roadway as it tapers to a point. Now, look at the full painting again. Notice how two sets of suspenders rise to the top of the arch. There Stella shows us a view of the bridge as it might look from a distance, without the towers. If we were standing in front of the arches, such views would be impossible. However, a painter can create such views using the principle of simultaneity.

In the beginning of the book we noted that one difference between a photograph and a painting is that the painters are free to add what they want. This does not mean that the artist is free from the elements and principles of design. Both Gleizes and Stella made changes in the bridge to suit their designs. In the Gleizes work, notice how he curved the center of the tower instead of giving it the Gothic point. His curved arch repeats the curve of the circles and gives a visual harmony to the design by turning the eye downward instead of directing it up and off the canvas.

Look again at the photograph of the bridge (page 258) and locate the stays. Stella omitted them because this is a tall, thin painting. The diagonal stays would have broken the vertical motion of the angles and cubes. Each painter

used Cubism in his own way. Each was free to break down different views of the bridge, but had to fit the pieces together again and lock them into a design that makes visual sense.

While in Italy, Stella had become acquainted with another group of modern artists; in Paris he embraced their work. These were the Italian Futurists. The **Futurists** glorified the noise and speed of the new century. They painted the total city environment, including the sights, sounds, smells, speed, and mechanization of modern civilization. Since sounds and smells are invisible, the Futurists invented *lines of force* that curve, twist, dash, or cut across their paintings to show dynamic energy and great force of movement.

Both the Cubists and the Futurists were responding to the Machine Age. They were interpreting the energy of the twentieth century in their art. In 1911 Stella returned to the United States and experimented with Futurism. His bridge, painted in 1918, shows the Futurist technique (Figure 206).

Ask students how an artist might depict a loud noise or a fast-moving car.

SIX BRIDGES

Stella chose to paint the first of his six bridges "in the mysterious depth of night." Many nights he stood alone in the middle of the bridge, feeling lost in the surrounding darkness. Memories of cold winter nights in Brooklyn depressed him. The mountainous skyscrapers of Manhattan seemed to crush him. The roar of the trains beneath him and the shrill voice of the trolley wires shook him. He heard the "strange moanings of appeal from the tugboats . . . through the infernal recesses below." He felt, he said, "deeply moved, as if on the threshold of a new religion." For twenty years he had been obsessed by the bridge.

Finally Stella felt he had the technique and skills to say what he wanted to say about the bridge. Paris had given him the start. He needed to find a way to express in paint the sounds of traffic and subways and the movement of lights. He had to learn to change a tower into a shrine or a cathedral and to show the electric force and energy of the bridge. He learned how through Futurism. To express his vision, Stella needed a canvas larger than himself. It was seven feet high and six feet four inches wide. In 1918, the very size of the canvas was unusual.

Ask students why artists might spend so much time looking at a subject they want to paint.

Figure 206. Stella's *Brooklyn Bridge*, the first of his paintings of the bridge, uses Futurist techniques. Joseph Stella, *Brooklyn Bridge*. 1917–1918. Oil on canvas. 84″ x 76″. Yale University Art Gallery, New Haven, Connecticut. Gift of Société Anonyme.

This is a mysterious bridge. It is not a solid stone and steel cabled bridge. It is an illusion built of shrieking sounds and moving lights. It is a structure created by lines of force. Can you find them? They cut across the face of the bridge like searchlights, creating angles and triangles. They criss-cross the upper sections like telegraph wires. They converge at points in the tunnels of the lower section. The colors flash over them like the lights of moving cars.

The Brooklyn Bridge has two towers, the Manhattan Tower and the Brooklyn Tower, but Stella painted three, one above the other. In this way, he glorified the towers and the Gothic arch. The two bottom towers are in the shadows. The top rises above the rest of the bridge, almost as high as the skyscrapers behind it. He re-created the bridge, as he said, "as the shrine containing all the efforts of the new civilization of America." In this painting he created more than just a shrine. It was a whole cathedral. The top part of the painting creates a feeling of walking on Roebling's bridge. People passed through the high, narrow Gothic arches rising heavenward. They looked up at the network of cables, stays, and suspenders. It was as if they were in a cathedral open to the sky and stars—a cathedral built to glorify stone, steel, and industry. While painting it, Stella said he had in mind the verses of Walt Whitman: "I hear America singing; I hear America bringing builders—here is not really a nation, but a teeming nation among nations." Such verses found their symbol in the arches of the bridge.

If the top of the painting is religious, the lower part is the darker side of America. What was this dark side of America that Stella struggled with so much, and where is it in the painting? Look again at Figure 206. Notice the red glow in the diamond shape. You will also find a red glow in his other paintings of the bridge, often in the tunnels.

What is the red glow? Is it just a light? The critic Irma Jaffe found similar red glows in the smokestacks of Stella's factory drawings. She suggests the red glow comes from his memory of Mount Vesuvius, the volcano near his home in Italy. It is the lava boiling. It is also the red molten steel in the vats of steel mills, the red fires powering engines. Perhaps Stella was showing us his memory of the tragic deaths in the Monogah mine disasters, where an entire village of mine workers was buried alive.

Hidden in the depths of the bridge is something Stella might not have known he was painting. Perhaps it was another way his mind found to express his feeling about the

Explain that abstract art sometimes reminds us of other things. Thinking of these other things while looking at a painting can help the viewer understand it.

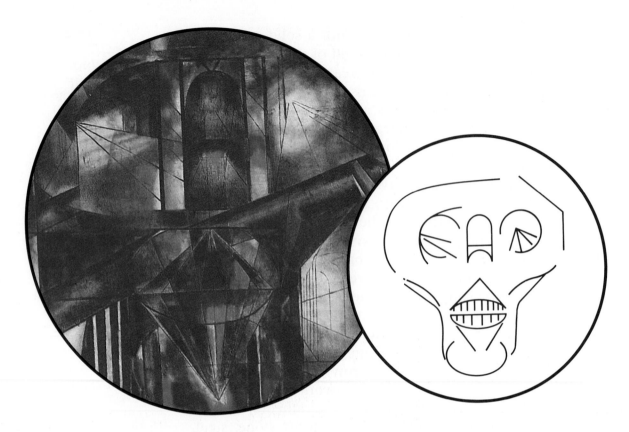

Figure 207. The drawing on the right shows the skull shape contained in the detail of *Brooklyn Bridge* on the left. Detail, *Brooklyn Bridge* (Figure 206).

two sides of the American dream: death and destruction within progress and industrial growth. Look carefully at the round Roman arch, the tunnels on each side of it, and the diamond shape below it. The arch is like the hollow nose of a skull, the tunnels its eye sockets, and the diamond shape its teeth. Figure 207 will help you see the shape.

The head of death hidden in the painting is a reminder of the deaths of immigrants in mine disasters, factories, and the building of the bridge. In this first of the bridge paintings, Stella described the glory of America's engineering and industry. At the same time, he painted the tragedy he found in the cost of human lives to achieve such progress.

STELLA'S CITY

Soon after he completed this painting, Stella began his major work, *Voice of the City of New York Interpreted*. This is a series of five paintings arranged geographically around

 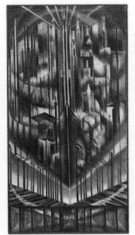 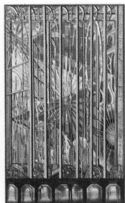 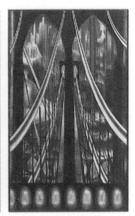

Manhattan: (1) *The Port;* (2) *White Way I;* (3) *The Skyscrapers;* (4) *White Way II;* and (5) *The Bridge* (Figure 208). The five paintings together give powerful impressions of the speed, sound, and constant motion of city life. Stella intended *New York Interpreted* as his major work and added drama by writing flowery descriptions of each panel. As you look at the panels, do Stella's words add to the meaning?

> ***The Port*** "You have reached the harbor; you are standing where all the arteries of the great giant meet; and a quiet sea and sky overwhelm you; you have left the noise and glare of Broadway; all the hardness and brilliancy fade away in the stillness of the night."

The Port (New York Harbor) has more open space than the other four panels. There is a spiritual feeling in the blue-greens of the dark sky and sea. In the upper left, Stella painted a row of smokestacks to "rise like a triumphant song of a new religion"—the religion of industry. Below them, among telegraph poles and storage tanks, the factories are hidden in darkness. The port by night is quiet, dark, mysterious. Only a few distant ships move across the silent water.

> ***White Way I*** "Here are some sensations produced by the confusion of light and sound as one emerges from subterranean passages to the street above."
> ***White Way II*** "Another interpretation of the sensations produced by the confusion in the streets."

The Great White Way was a popular name for the theater district off Broadway in Times Square. The brilliant

Figure 208. These five paintings are, from left to right, *The Port, White Way I, The Skyscrapers, White Way II,* and *The Bridge.*
Joseph Stella, *Voice of the City of New York Interpreted.* 1922. Five panels, left to right, *The Port, White Way I, The Skyscrapers, White Way II, The Bridge.* Oil and tempera on canvas. Collection of the Newark Museum. Purchase 1937, Felix Fald Bequest Fund.

Have students study the five paintings and describe the environment of the city depicted in the group.

277

white lights on marquees and billboards seem to form a bright and glittering road leading to the stars and, for some, to stardom. In contrast to *The Port*, these panels are ablaze with brilliant light. They sparkle with the laughter and jewels of the theater district, with the neon nightlife of Manhattan. *White Way I* clamors with sounds and lights.

> **The Skyscrapers** "An interpretation of the city's colossal skyscrapers blended together in a symphony of lights in the shape of a high vessel's prow."

All the panels are the same height except *The Skyscrapers*. By making it the tallest and the central panel, Stella intended it to dominate the other panels, just as the skyscrapers dominate the city. They make everything seem small, even the Brooklyn Bridge. *The Skyscrapers* is symmetrical, with the buildings coming together in the center to form the prow of a ship. The shape of the buildings suggests the Flatiron Building, a narrow triangular structure that was one of the tallest in New York City when Stella made this painting. The real buildings were constructed of stone and steel. They are not Stella's thin, light, airy skyscrapers. What have we then? Stella, in his fantasy city, had a prophetic vision. He created buildings anticipating those of today. Stella's are the glass-mirrored steel walls of today's buildings. His is a vision of a city to come, in which the buildings float, row upon row.

> **The Bridge** "An abstract representation of that engineering epic in steel. A sinewed span of human energy."

This is Stella's bridge of 1922 that we looked at earlier. Although part of *New York Interpreted,* it is a complete painting by itself. From its position on the extreme right, it towers over the city. It is there, a haven from the hectic motion of life in the other panels. In its solid symmetry you feel the calm of Stella's night. Of all the panels, *The Bridge* is the most popular.

At the bottom of the five panels is a border, called a *predella*. Notice how it extends across each panel, with a similar design—a row of ovals, circles, and arches. They represent the subways and tunnels which crisscross under New York City and the rivers on each side of Manhattan. The spoked wheel and hubcap shapes represent the thousands of trains, trucks, and automobiles that drive through these tunnels day and night. The predella helps tie all five panels together into a single design.

Ask students why Stella chose to represent the traffic and tunnels with this symbol. They should realize that representing the hundreds of cars and trucks would have been impossible.

The choice of using multiple panels tells something about Stella's intentions for his work. Five panels make a polyptych. A polyptych was a small altar-piece used in Italian churches during the Middle Ages. At the bottom of the polyptych was the predella. Although his city resembles a ship, it has the feel of a gigantic cathedral. Inside this cathedral is a ferment of commotion. This is not traditional religion, nor is it traditional art. It is religion of the twentieth century—the age of the machine, science, and technology, in which millions of people are thrown together in cramped space. We see no people in Stella's city, but it is full of human emotions. We see life whirling around at indescribable speeds with ferocious energy. The effect is what Stella wanted—it is dizzying. His vertical city pushes ever upward to unlimited heights and goals. Yet once we are inside it, the constant repetition of vertical lines feels more like the bars of a prison. Is *New York Interpreted* a cathedral, a prison, or both? Look again and decide.

There are enough modern styles to fill volumes. *New York Interpreted* is considered America's most important Futurist work. In it Stella used lines of force to unify the five panels into one large painting, and to show energy, light, and movement inside each separate panel. Go to the painting and find lines of force. Then go to the drawing (Figure 209), which shows some of these lines of force. The major diagonal and curved lines move your eye past the verticals to the other panels. Look at the pictures below and find some lines of force not in the drawings. Notice, also, the

Figure 209. These drawings show the abstract design of Stella's *Voice of the City of New York Interpreted* **(Figure 208).**

vertical curves in *The Bridge,* on the far right. They stop your eye and hold it inside the panel. When the viewer looks at the panels from left to right, the last panel is a giant exclamation point at the end of a sentence!

The Bridge of an Outsider

Stella went on to do four more paintings of the bridge. He returned again to Italy and France, where he lived from 1929 to 1934. In Paris an important exhibit was being planned. Stella wanted one of his paintings of the bridge in the show, but there was not enough time to have it shipped to him. So he painted another bridge in 1929.

Stella called it *American Landscape* (Figure 210). What kind of landscape is it? Where are the trees? The hills? It is a vertical landscape of buildings, factories, warehouses, and bridges. Compare this painting with the first two. Compare the buildings. How are they different? These buildings are solid. They do not float on clouds. They are more like a wall. The buildings are gray and black with shafts of blue, red, and green. The suspenders of the bridge are wider, more like the iron bars of a closed gate. Again, below the bridge are the fiery red arches. Where are we as we look at this bridge? What is our point of view? We are not on the bridge, but off to one side. The bridge is left of center. The sweeping curve of cables crosses over our vision to block our view. We are kept outside.

Stella painted this bridge from memory on the other side of the Atlantic Ocean. It is no longer an open door; it is a closed gate. Although Stella glorified New York City in his painting, he was not at home there. As an immigrant, he felt he was an outsider. This bridge is a barrier to the city. He is outside looking in. Yet, when he was inside, the walls of the city seemed like a prison. He never really felt at home in Europe or America.

The style of this third bridge came from still another art movement in the United States. American artists were responding to the machine and industrialization. Instead of painting the effect of industry on people's lives, they glorified the machine itself. These artists were called **Precisionists** because they painted geometrically precise pictures of smooth-surfaced machinery, buildings, bridges, and interiors. They simplified objects by cleaning them of all textures and details. The machinery was painted as if brand new with no rust, grime, or sooty surfaces. They painted

Ask students why Stella titled the work *American Landscape.* Help students see that the bridge had become a symbol of American life to Stella.

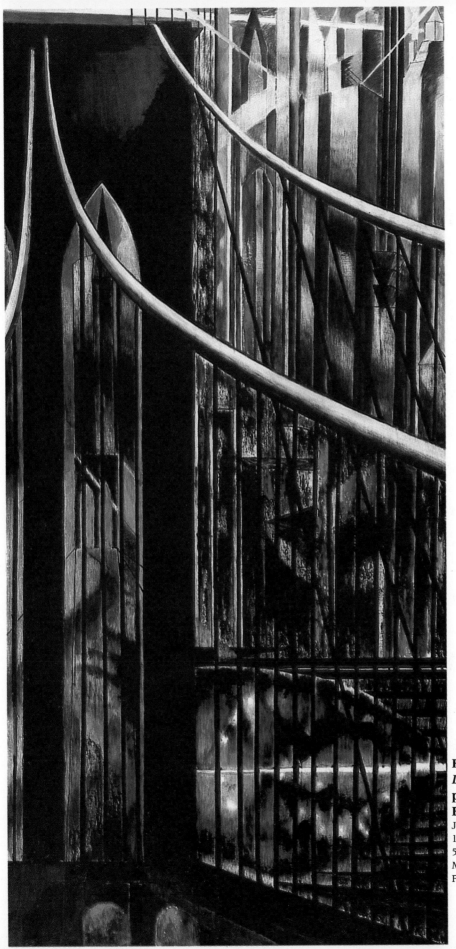

Figure 210. *American Landscape* **was Stella's third painting of Brooklyn Bridge.**
Joseph Stella, *American Landscape*. 1929. Oil on canvas. 79 1/8" x 39 5/16". The Walker Art Center, Minneapolis. Gift of T.B. Walker Foundation, 1957.

new machines for a new century, a new age. The Precisionists usually did not include people or nature in their paintings. Industry was making the United States a world power. It was this the Precisionists celebrated. This was the new industrial landscape that Stella celebrated in his *American Landscape.*

Variations of the Bridge

Stella's fourth painting of the bridge, in 1936, was a simplified version of his second (Figure 211). In this work the lower structure is gone and there is no second bridge in the right arch. The buildings are straighter and plainer. Something else has happened. The mysterious, threatening darkness of the earlier bridges has been replaced by a mist.

Three years later, in 1939, Stella returned to the color and drama of the *New York Interpreted* bridge. He called it *Brooklyn Bridge: Variations on an Old Theme* (Figure 212), because he repeated certain symbols and designs from the *New York Interpreted* panels. These skyscrapers are more solid than his earlier ones. By 1939 the buildings in New York City were taller and more like Stella's prophetic vision. Here Stella's buildings stand on a row of arches instead of floating on the clouds of smoke and mist of the earlier painting. On a platform in the upper left section, the frame of a single flat for a stage set stands alone. It is the theater district with the light of *White Way I.* This tower has space and stars around it. Rays of light project from the skyscrapers to the stars. Strips of bright yellow border the sides of the tower. The roadway is open. Blues and yellows replace the dark mystery of the subways and tunnels.

Stella painted his last bridge in 1941 when he was sixty-three. He called it *Old Brooklyn Bridge* (Figure 213). It is almost exactly like the first one he painted twenty-three years earlier. Compare both versions. *Old Brooklyn Bridge* has the same basic design, but Stella simplified it. Notice how he removed some of the lines cutting across the surface of the painting—especially in the upper and lower right corners. There are fewer tiny shapes in the tunnels and lower half. The buildings and bridge structures are more solid.

Explain that a stage "flat" is a piece of theatrical scenery.

BRIDGE OF MANY MEANINGS

Stella died in 1946. He has a permanent place in the history of American art as our leading Futurist. He had no stu-

Figure 211. *Bridge*, **was the fourth version he did of the Brooklyn Bridge.** Joseph Stella, *Bridge*. 1936. Oil on canvas. 50 1/8" x 30 1/8". San Francisco Museum of Modern Art. WPA Federal Arts Project allocation to San Francisco Museum of Art.

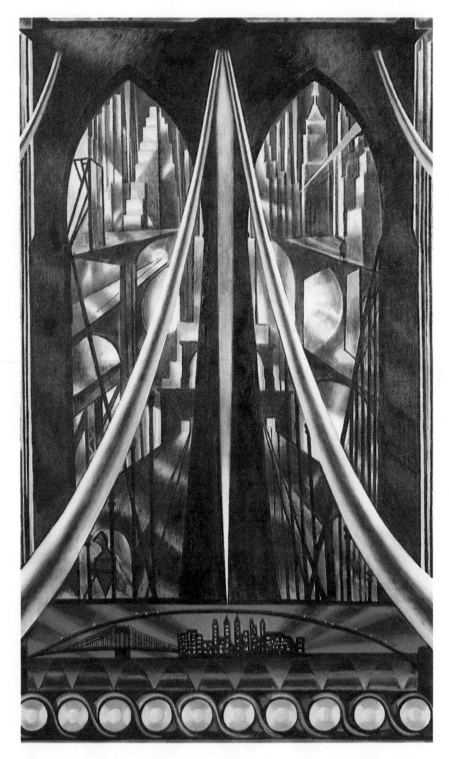

Figure 212. *Brooklyn Bridge: Variations on an Old Theme* **was Stella's fifth interpretation.** Joseph Stella, *Brooklyn Bridge: Variations on an Old Theme*. 1939. Oil on canvas. 70" x 42". Collection, The Whitney Museum of American Art.

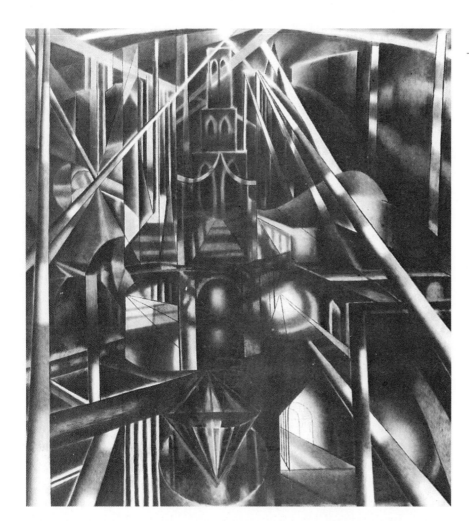

Figure 213. *Old Brooklyn Bridge,* **completed in 1941, was the last version Stella did of the Brooklyn Bridge.** Joseph Stella, *Old Brooklyn Bridge.* 1941. Oil on canvas. 76″ x 68″. Museum of Fine Arts, Boston.

dents to carry on his ideas. However, his paintings of the Brooklyn Bridge inspired other artists and writers to see it as a symbol of the American dream, a cathedral, a collection of force and energy, and a gateway to a new world.

There are now countless paintings of the Brooklyn Bridge. Roebling gave us a gift—a bridge of many meanings. It was itself a work of art. For Roebling it represented the perfect balance of natural forces at rest, a perfect merger of architecture in the stone towers and engineering in the steel ropes, cables, and riverspan. Each artist finds his or her own meanings and turns them into art.

Joseph Stella showed us a bridge of ever-changing meaning. Under the spell of the bridge, Stella painted it as three different symbols. Each one represented a part of him-

Discuss how Stella's immigrant background and experiences in life led him to choose the bridge as the subject for so many paintings.

self. Each reveals another part of his obsession. The first symbol was a cathedral, expressing his spiritual search and exaltation. The second was an open gateway to the city, welcoming him as an outsider, the eternal immigrant. The third was the closed door locking him out. The next two paintings repeated the gateway bridge, and the last painting, *Old Brooklyn Bridge,* was almost a copy of his first bridge—the cathedral, the shrine to the "Civilization of America."

Compelled by his obsession with the Brooklyn Bridge, Stella opened our eyes to the possibilities as well as to the satisfactions of modern art. But what does it mean when an artist says he has "an obsession with a bridge"? Obsessions, like passions, have no logic or reasonable explanations.

The paintings of the bridge shed some light on this mysterious obsession and offer a clue to the relationship between the artist and his work. Go back again and look at his six different paintings of the bridge. Even as they are different, how are they the same?

His first bridge is considered "Futurist" in feeling, but it really is not a Futurist painting. Futurist paintings glorified speed and consisted of restless motion. Stella's first bridge has motion, but it also has stability. The second bridge has even more. In this second one, his most famous, the structure's heavy weight frames the activity. In all six paintings, even though the bridge soars, it is as solid as steel and stone.

Although Stella finally rejected the Futurists, there is reason to understand his fascination with them. Futurists glorified the speed and motion of modern life. Stella's own life was filled with restless motion. He had come to the United States as a young man, when the bridge was only fourteen years old. With his own eyes he witnessed the explosion of New York into what he called the "imperial city" of the twentieth century. Stella loved his city, but he never really felt at home there, or anywhere else for that matter. He was an immigrant in New York, and a wanderer in life. Several times he went from New York to Europe and back again. Throughout his life, this restless man wandered between countries, just as he wandered between different styles of art. In his later years he mastered modern art, yet he continued to make lovely portraits in the style of the old masters.

For his big paintings of the bridge, Stella chose abstract art. Perhaps only in this style could he describe and make visual sense out of the towering city and the restless rush of modern urban life. But in making "visual sense" out of it all, he gave the bridges the stability and calm he never had in

his own life. The bridges, closed or open, exits or entrances, reveal much about this man on the move, this twentieth-century nomad, this unhappy bird of flight in search of his cage. In his paintings of New York and its Brooklyn Bridge, we see his personal turmoil in the chaos of modern life. But we also feel how Stella imposed order on all this chaos. If we experience the bridge through the mind of this modern artist, we can feel his emotions and peer into his heart. Is this just a wild idea? For who really knows the reasons for obsessions, or why the artist paints? But the evidence is there: a restless life at peace under the solid frame of the bridge.

His different paintings of the bridge opened up new ways of seeing the triumph and the tragedy of the American landscape. All the artists who give us their different views of the bridge open up new ways of seeing the world as well as ourselves. We look at these bridges, not knowing if they are entrances or exits. The very act of entering a new place means leaving an old one. This bridge, and all bridges, are paths that rise above barriers in our way.

We all build our own bridges, but along the way the river gods demand sacrifice. When a human being makes sacrifices, it is called growing up. When a river is sacrificed to a bridge, it is called progress. Roebling sacrificed his life to a gateway to the future, and to a bridge between the nineteenth and twentieth centuries. Joseph Stella's sacrifice was a life marked by his uneasy obsession with a bridge. But this obsession was only part of a bigger obsession—the obsession to paint it. In his art he changed the nation's view of the landscape. As in the ancient myths, he made his sacrifice and paid his price. But this wanderer's achievement stands as solid as the bridge.

Summary Questions

1. Why was the Brooklyn Bridge such an important symbol to Joseph Stella?
2. Name three ways in which Stella's 1922 painting of the bridge differs from Richard Benson's photograph of it.
3. What did artists of the Ash Can School paint?
4. Why did artists like Stella go to Paris?
5. What is Cubism?

You may use these questions either as a written assignment or as a take-off point for class discussion. Answers will vary, but students should be able to substantiate their responses from information in the text.

6. What is Futurism?
7. What did the Precisionists celebrate in their work?
8. How did Stella use the principle of simultaneity in his 1922 painting of the Brooklyn Bridge?

REVIEW, THE VISUAL ELEMENTS OF ART AND COMPOSITIONAL PRINCIPLES OF DESIGN

This is a brief review. You may want to refer again to pages 42–60 in Part One.

In Unit 1 you learned about the visual elements of art: color, shape, form, line, space, and texture. You read also about the principles of design: balance, emphasis, movement, variety, proportion, and unity. Stella's painting of *The Bridge* gives us another good opportunity to analyze the artist's use of these elements and principles.

The Bridge is a painting that is mostly lines, shapes, colors, forms, and textures. Stella used abstract lines and shapes instead of exactly reproducing the bricks, cables, walkways, and benches. This allowed him to paint what he felt and thought about the bridge.

To give the effect of a soaring structure rising to the sky, Stella created a symmetrically balanced design (both sides are equal) with an upward movement. Six cables sweep upward, carrying your eye with them with such force they go off the top of the canvas. Three cables come in from each side. Can you find them in the diagram shown in Figure 214?

The symmetrical balance is repeated in the two Gothic arches cut through the black silhouette of the tower wall. To keep the painting from being too repetitious and balanced, Stella made the design inside the two arches asymmetrical. Thus, both sides are balanced but not exactly equal.

This is a blue, black, and gray painting, with dark brooding tones and flashes of light for relief and value contrast. Small warm glows of a reddish brown provide a color contrast with the colder blue-grays and blacks.

The two rows of oval shapes in dark strips at the base support the entire structure. They are similar in shape but

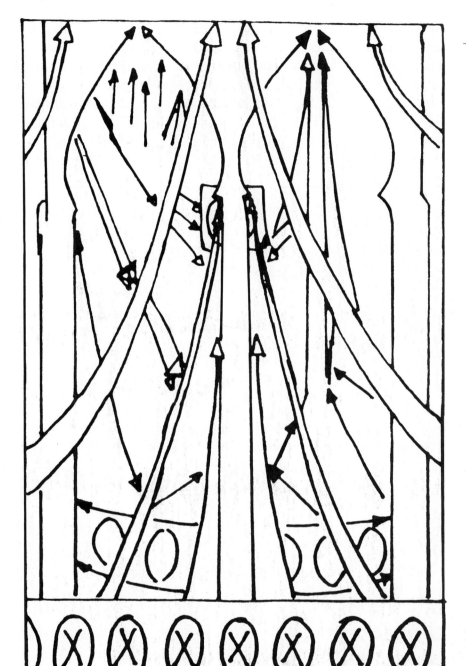

**Figure 214. This diagram of
The Bridge shows the sweep
of lines that gives the work
symmetrical balance.**

different in meaning. The ovals in the lower row are like
tunnels under a river. Their edges are soft; they glow with
an inner light of blue and red. They have X's marked across
them. In the upper row the ovals are cut into the side of a
metal beam with sharp edges. We look through them, not
into them.

Students should now be prepared to critically analyze *The Bridge.*

There is not a rich variety of textures in the painting. It has a smooth surface, and most of the features are smooth. The brushstrokes give an illusion of mystery and mood, rather than the textures of solid stone, wood, and steel.

Stella succeeded in what he set out to do, and brought to the painting everything he knew about designing and painting. *The Bridge* is a spiritual symbol of the Industrial Age.

UNIT

FORMS OF EXPRESSION

The Artist in the Industrial World

The twentieth century has been one marked by new discoveries, new technologies, new ways of thinking, living, and learning. Artists, responding to an ongoing mood of change, experimentation, and newness, have created unique means of expression to document their vision.

The twentieth century has been a time of trains, cars, planes, and rockets and is distinguished by crowded cities, engine noises, honking horns, and screaming whistles. It has been, among many things, a time of noise and speed. How have these effects been translated into art?

Recall with the students some of the many inventions and changes that have occurred during the twentieth century.

This unit is an in-depth introduction to modern art. Students should be encouraged to work in as many media as possible. Review the activities for the visual elements and the principles of design.

DRAWING

On the following pages is a selection of drawings done between 1900 and the present. They have been made with a variety of materials, for example, pen and ink, pencil, and charcoal. The drawings represent many different "schools" of expression. The artist in the twentieth century has attempted to describe forms in new ways. Such efforts have led to many strange and sometimes difficult-to-understand drawings.

The following drawings are all abstract or semi-abstract. Look carefully at them. What kinds of lines do you see and what are the lines doing or expressing? What kinds of shapes and forms do you see and what do they appear to mean? Do you sense energy in a drawing? Is it quiet and calm or noisy and turbulent? Which drawings do you like the best and why?

Eduardo Paolozzi was born in 1924. His *Drawing for a Saint Sebastian* (Figure 215) was made in preparation for a welded sculpture. The drawing shows the viewer a modern mechanized human being. The character is filled with springs and wires and even what appear to be electrical circuits. Does it appear to you that you might be able to plug this man into a socket? What is Paolozzi telling us?

The heavy lines of Henri Matisse's *Dahlias and Pomegranates* (Figure 216) do more than enclose space to make a shape; they become shapes themselves, and even give the appearance of form. All of the works of Matisse have a look of simplicity that can be deceptive. He spent the last years of his life arranging paper cut-outs in designs. Matisse felt strongly that art should be fun and relaxing. He loved art and loved to make art. His works are always interesting to analyze, and this is no exception. Look for the unity of his composition in *Dahlias and Pomegranates*.

David Smith (1906–1965) was best known as a sculptor. His work is abstract, and often it is as flat as a two-dimensional representation. The drawing *Untitled II* strongly suggests his sculptural pieces. What title would you give to this drawing? You may feel perfectly justified in saying that Smith's title is best.

The army doctor of Albert Gleizes (1881–1953) can be a disturbing image. Can you see the doctor? Is he facing you? Would you guess that this person is a doctor if you did not know the title of the work? What other things has Gleizes included in this drawing?

As students examine the drawings on the following pages, have them discuss and characterize the lines they see in each and the artists' manner of achieving them.

292

Figure 215. What is Paolozzi telling us?
Eduardo Paolozzi, *Drawing for a Saint Sebastian*. 1957.
Ink and gouache with collage. 13 1/2″ x 9 7/8″.
Solomon R. Guggenheim Museum, New York. Photo,
Robert E. Mates.

Gleizes was a noted writer on art as well as an artist. He wrote on Cubism, and was one of the artists represented at the famous Armory Show of 1913 in New York. We will look more closely at Cubist artists and Cubism in the next section.

Mark Tobey (1890–1976) was an American artist who travelled extensively in the Far East and was greatly influenced by oriental art and, most especially, calligraphy. His style, which he called "White Writing," became closely identified with him, and was very popular. The drawing we see in Figure 219, *Remote Field*, is an example of this technique. What do you see in Tobey's remote field?

Look again at these drawings and observe the many ways in which an artist can use lines. It is now time for you to practice your drawing skills.

PART THREE:
THE ARTIST IN THE
INDUSTRIAL WORLD

Figure 216. Matisse makes heavy lines become shapes. Henri Matisse, *Dahlias and Pomegranates*. 1947. Brush and ink. 30 1/8" x 22 1/4". Collection, The Museum of Modern Art, New York. Abby Aldrich Rockefeller Fund.

Figure 217. What title would you give to this work? David Smith, *Untitled II*. 1961. India ink, egg yolk, and watercolor. 25 1/2" x 39 3/4". Collection of the Whitney Museum of American Art. Gift of Candida Smith

Figure 218. Can you point out lines and shapes that indicate the figure is a doctor? Albert Gleizes, *Study No. 6 for Portrait of an Army Doctor.* 1915. Ink on paper. 8 3/8" x 7 1/8". Solomon R. Guggenheim Museum, New York. Photo, Robert E. Mates.

Figure 219. The artist was greatly influenced by oriental calligraphy. Mark Tobey, *Remote Field.* 1944. Tempera, pencil, and crayon on cardboard. 28 1/8" x 30 1/8". Collection, The Mueseum of Modern Art, New York. Gift of Mr. and Mrs. Jan de Graaf.

DRAWING ACTIVITIES

If students have difficulty in thinking up ideas, small group discussions will help. Mention that they might begin by looking at the various survival methods used on spacecraft. All ideas should be considered and developed or revised until they are usable.

1. Artists have refined sensibilities and are able to imagine and visualize images that they may not be able to describe except in their art. The personal touch is added by artists even when they are making very realistic images.

Your next assignment can be based on reality or on your own imagination. Whichever you choose, some research will be needed. Your task is to produce a drawing of some aspect of life under the surface of the earth or under water. Suppose for the time being that our atmosphere were to become so polluted that we all had to adapt to living underground or under the water. Your composition must, therefore, include both people and animals. You will need to research fish and water plants, the habitats of animals that burrow underground, and, perhaps, proposals for underground or underwater habitats for humans. Remember to include some creature comforts for the people and the animals.

2. Imagine that you are looking out of one particular window at your home. From memory, draw a picture of what you see from that window. The scene may include people and animals that are frequently seen from that window.

Have the students describe any effects this activity had on the way they look at the world around them. Did you find any commonalities in the types of changes they made after they adjusted their pictures? What types of things did they forget to include? If there are such commonalities, discuss them with the students.

Take the drawing home and compare it with the real view that you see as you look out of the window you selected. Make changes and corrections that are necessary and bring the drawing back to class with you the next day.

Discuss your drawing with the class. Comment on the scene that you have produced. Note the differences between your memory drawing and the final product after you had made the changes based on the actual view from that window. When you adjusted your picture, were you influenced by the compositional principles of design to make some changes?

If you are using Book One of this series, Classroom Reproduction #5 (*Backyards, Greenwich Village*) may be useful here.

3. Up to this point, all of your drawing activities have been of things, people, or places. You have dealt with the shapes and forms of specific images as you placed them within a composition. In this activity you will look at and draw the *spaces* between shapes and forms. We call these, as you may recall, the *negative spaces*.

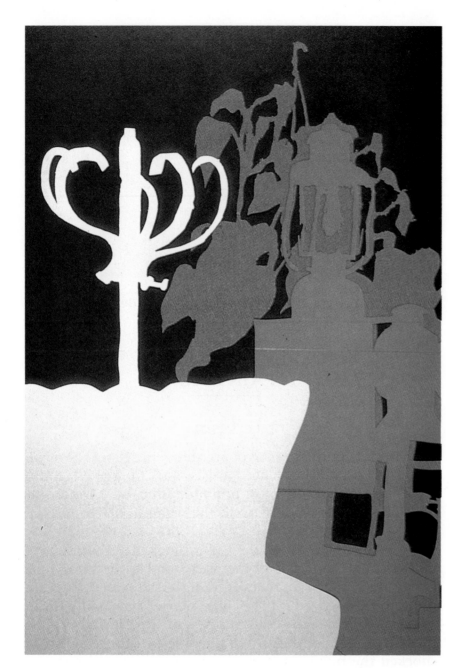

Figure 220. Student art.

Study the arrangement on the modeling stand. Look at the spaces between the objects, around the objects, and outside of the arrangement.

Take a pencil, or other drawing tool that your teacher suggests, and draw the *spaces* only. Try hard to concentrate only on the negative areas. You may find that a composing frame will help you define the outer limits of your composition.

You may want to use this same activity as the first Painting Activity for this section. If you do, have the students paint negative spaces directly without drawing them first.

Figure 221. A trace of Cubism is shown in this detail from Stella's *The Bridge* (Figure 191).

PAINTING

Cubism

Remind the students that Cubists broke Western traditions by painting what they knew about the subject rather than just what they saw. Non-Western traditions contribute to this as many were not tied to Western concepts of realism and linear perspective.

Throughout the history of art, different schools or movements in art have influenced artists. In the twentieth century *Cubism* has had the most profound influence. We can see a bit of the Cubist influence in the detail from *The Brooklyn Bridge* above.

As we learned earlier, the Cubists looked at their subjects from all angles and put all the planes and angles on the picture surface. Viewers saw everything at the same time. Later the Cubists discovered the geometrical designs and patterns of African masks and sculptures, and they included these ideas in their paintings. At first many Cubist paintings shocked the public, who, for over six hundred years, had learned to look at objects from a single point of view. The many facets of a Cubist work confused people.

Use Classroom Reproduction #17. You may also want to use the Cézanne, #16.

Look at *Fruit Dish* (Figure 222) by Pablo Picasso. This is one of the less complex Cubist paintings, but it shows the surfaces quite well. Compare what you see with what you know. The table is horizontal—at least it should be—and the bowl is vertical. But is it? The table is flat against the wall. The shadows at the base of the bowl are tilted upward. The viewer is slightly above the table. What kinds of fruits are shown? Picasso does not really want you to know. He wants

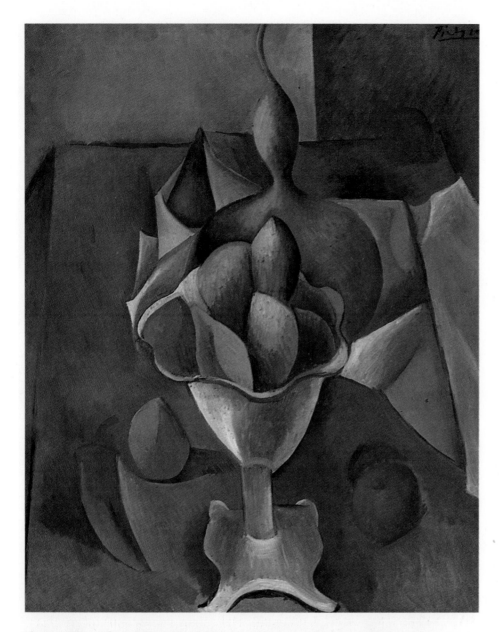

Figure 222. The objects in this early Picasso painting, *Fruit Dish* (1908–1909), are slightly abstracted. Pablo Picasso, *Fruit Dish*. 1908–1909. Oil on canvas. 29 1/4″ x 24″. Collection, The Museum of Modern Art, New York. Acquired through the Lillie P. Bliss Bequest.

you to see the fruit shapes. Picasso forces you to see these familiar objects as shapes and forms in themselves.

Picasso painted *Fruit Dish* between 1908–1909 in the early days of Cubism. At that stage, the Cubists were looking at and analyzing their subject matter and painting it all.

About 1912 some Cubists began including real wallpaper instead of the painted shapes of wallpaper, real sheets of

299

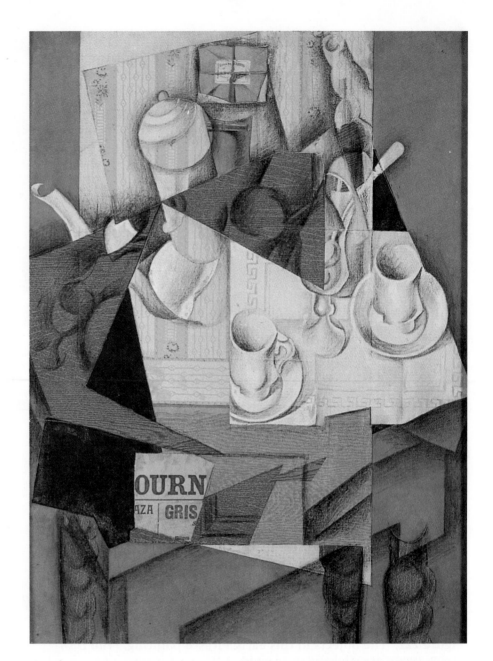

Figure 223. What materials did Juan Gris use in this collage called
Breakfast? Juan Gris, *Breakfast*. 1914. Cut-and-pasted paper, crayon, and oil on canvas. 31 7/8″ x 23 1/2″. Collection, The Museum of Modern Art, New York. Acquired through the Lillie P. Bliss Bequest

music or newspapers, real rope and pieces of wood rather than painted representations. *Breakfast* (Figure 223) by the Spanish artist Juan Gris (gree) is an example of this type of Cubism.

Gris made this painting of pasted paper, crayon, and oil paints on canvas. He put in some real things and painted or

drew others. Can you tell which is real and which is not? The cups and saucers are drawn in crayon over pieces of cut and pasted paper. The wood shapes, newspaper, and cloth are cut out, affixed to the support, and painted to look real. The one piece of real material that has the most continuous pattern under the drawing is the wallpaper. By cutting out shapes, or using real pieces of wood, cloth, and wallpaper, the artist is saying, "Common objects may be used to form an aesthetically pleasing composition."

One does not need to know very much about Cubism or Futurism to enjoy Joseph Stella's *Battle of Lights, Coney Island* (Figure 224).

Students might compare the techniques of the Futurists to depict sounds with Morris Graves's *Bird Singing in the Moonlight*, Figure 72, page 98.

Figure 224. Stella captures the bizarre excitement of an evening at the amusement park. Joseph Stella, *Battle of Lights*: *Coney Island*. 1913. Yale University Art Gallery, New Haven, Connecticut. Gift of Société Anonyme.

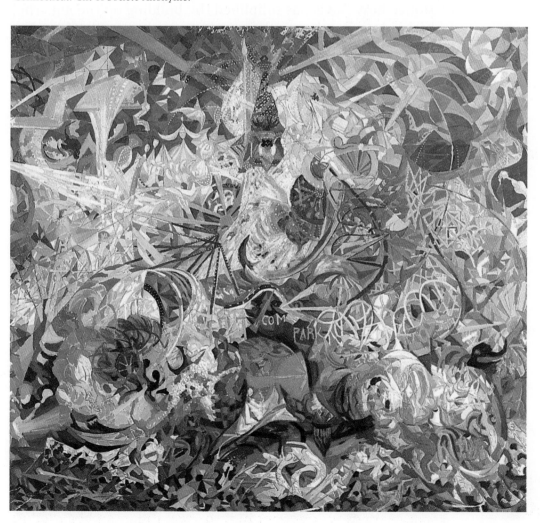

Ask the students if they understand why Stella called this painting an *arabesque.* There are three meanings of "arabesque": an intricate pattern of Arabian design, a ballet position, and an elaborate melodic passage in music. Perhaps Stella had all of these in mind? What other words could be used to describe this work? Students may make a list on the blackboard.

Stella has caught the vitality of the park with the expression of flashing, dynamic movements and an orgy of light and sound. The Futurist lines of force radiate in all directions from the head of the turbaned potentate.

In describing this painting Stella said, "I built the most intense, dynamic arabesque that I could imagine in order to convey a hectic mood, the surging crowd and the revolving machines generating . . . violent, dangerous pleasures."

Adaptations of Cubism Stuart Davis spent many years searching for his own individual style. Finally, after studying in Paris and returning to the United States, Davis found his own approach to Cubism. Davis drew everything in line first, and once he felt it complete as a line drawing, he painted in the shapes. Later he used cut paper.

In *House and Street* (Figure 225), Davis divided his work in half and framed it almost as two frames of a movie film. Notice how Davis has simplified the building on the left. The basic ideas are there—the windows, a short wall of bricks,

Figure 225. Notice how Stuart Davis simplified familiar objects and signs in *House and Street.* Stuart Davis, *House and Street.* 1931. Oil on canvas. 26" x 42 1/4". Collection of the Whitney Museum of American Art. Purchase.

two fire escape ladders, a railing, and either a wall ventilator screen or a window with Venetian blinds closed down. There is no texture or pattern on the left and no feeling of depth. Compare this frame to the one on the right. What similarities and differences can you find?

Charles Demuth was another American artist who looked for a way to combine his own sense of realism with Cubism. In his painting *My Egypt* (Figure 226) Demuth began with the silos. He drew them carefully, and then abstracted them by drawing lines across them, from the

Figure 226. How does Charles Demuth use line in his work, *My Egypt*? Charles Demuth, *My Egypt*. 1927. Oil on composition board. 35 3/4" x 30". Collection of Whitney Museum of American Art. Purchase with funds from Gertrude Vanderbilt Whitney.

Compare Bearden's painting
of the Queen of Sheba with
other famous paintings of roy-
alty.

Use Classroom
Reproduction #19.

upper left and right sides of the painting. Look carefully. The lines are not part of the structure of the silos, nor of the nature of the subject matter. The change of color tones within the shapes gives an illusion of stained glass windows. The overall effect is striking and clean.

Why do you suppose Demuth titled his painting *My Egypt?* When you think of Egypt, pyramids come to mind. Perhaps Demuth is saying, these silos are our pyramids, our monuments.

Another American who made his own adaptations of Cubism is Romare Bearden. Bearden uses techniques for collage that have become entirely his. Along with fabrics, papers, and painting, he uses photocopied images and photography. *She-Ba* (Figure 227), painted in 1970, is one of Bearden's more colorful works.

You know that a collage is made of various materials, such as scraps of cloth, papers, and pictures, with various textures. Can you figure out what materials Bearden used to make *She-Ba?* In the museum where *She-Ba* hangs, the card beside it reads: "Paper, cloth, synthetic polymer paint on composition board."

Bearden treated some of the paper and cloth to give his own effects and textures. Note the striped trim at the bottom of the maidservant's skirt and the dotted scarf around She-Ba's neck. Bearden also used photographs and newspaper. The umbrella looks as if it were cut from an enlargement of a newspaper photograph and the maidservant's skirt was cut from a photograph of sprayed graffiti on a plaster wall. The throne She-Ba is seated on is from a magazine advertisement for wood paneling. The large green and blue squares for the background and for She-Ba's dress are shapes of paper painted blue and green. A filigree of cut glossy paper was used for the crown, arms, faces and hands. Gold paper dangles trim her scarf.

This picture is Bearden's tribute to the Queen of Sheba. It is a cut-and-paste tribute, in the materials of today, to a great heritage.

The Cubist movement was brief, but Cubism has dominated the art of the twentieth century. Cubism forced people to open their eyes to the world and space around them. It changed the way people thought about art. Each new group of artists has changed it to suit their purposes. What will happen to Cubism in the future? Only the twenty-first century will know.

**Figure 227. Compare the figure *She-Ba* by Romare Bearden to
figures of ancient Egypt.** Romare Bearden, *She-Ba*. 1970. Collage of paper, cloth,
synthetic polymer paint on composition board. 48" x 35 7/8". Wadsworth Atheneum,
Hartford. The Ella Gallup Sumner and Mary Catlin Sumner Collection.

The Artist and the City

Like Joseph Stella, many modern artists have given their
vision of life in the city. How, for example, would you com-
pare the bridge of the painter, Ellsworth Kelly (Figure 228)
and the photographer, Edward Steichen (Figure 229)? In
both cases, you are more aware of soaring and dynamic
lines expressing streamlined movement than of a bridge. Do

Have students compare the
photographs of bridges in
Figures 197 and 229. Where
were the cameras placed in
each photograph?

**Figure 228. Strong curved
lines convey the dynamism
of the modern city.**
Ellsworth Kelly, *Brooklyn Bridge VII*.
1962. Oil on canvas. 7' 8 1/2" x 37'
5/8". Collection, The Museum of
Modern Art, New York. Gift of
Solomon Byron Smith.

**Figure 229. Where did Edward Steichen stand when he pho-
tographed** *The George Washington Bridge*? Edward Steichen, *The George
Washington Bridge*. Reprinted with the permission of Mrs. Joanna T. Steichen.

they remind you of Stella's work? How do they compare
with Benson's photograph (Figure 197)?

Now look at some of the most famous visions of the city
in painting.

Edward Hopper's (1882–1967) painting *Early Sunday
Morning* (1930) is a vision of what is to come. This is the city
in the morning, and the long shadows cast by the hydrant
and the barber pole play against the dark red buildings.
There is total silence. *Early Sunday Morning* is typical of

Figure 230. Do you find this painting soothing, or strangely unsettling? Edward
Hopper, *Early Sunday Morning*. 1930. Oil. 35″ x 60″. Whitney Museum of American Art, New York.

Hopper's work. At first glance the viewer might feel that everyone is sleeping peacefully and will awake to a pleasant, leisurely Sunday. Upon reflection the viewer may sense isolation and unease. Is there really anyone behind those curtains?

The Subway (1938) by George Tooker (b. 1920) gives the viewer an immediate sense of loneliness and bewilderment in the big city. The vertical lines seem to make the subway station a prison. No way out is depicted. The people are different, yet much the same. They either cannot, or are afraid to, connect with one another. They seem frightened, alone, anonymous.

Look at *Broadway Boogie-Woogie* (Figure 232) by Piet Mondrian (1872-1944). Mondrian's city is a grid exploding in lines of color. The squares resemble musical eighth notes of the "boogie-woogie" beat, a jazz form popular in the 1940s with eight beats to the musical bar. The primary colors make these lines seem to shout with the commotion and vitality of the busy city.

The Hopper and Tooker works are good examples for students to use for art criticism.

This is Classroom Reproduction #7.

This is Classroom Reproduction #8.

307

Figure 231. The people seem to feel the heavy weight of the outside world above them. George Tooker, *The Subway*. 1950. Egg tempera on composition board. 18 1/8" x 36 1/8". Collection of the Whitney Museum of American Art, New York. Purchase, with funds from the Juliana Force Purchase Award.

Figure 232. Mondrian's abstract view of the city was the last painting he completed. Piet Mondrian, *Broadway Boogie-Woogie*. 1942–43. Oil on canvas. 50" x 50". Collection, The Museum of Modern Art, New York. Given anonymously.

In actuality, Broadway is the one major avenue in Manhattan that cuts diagonally through the borough.

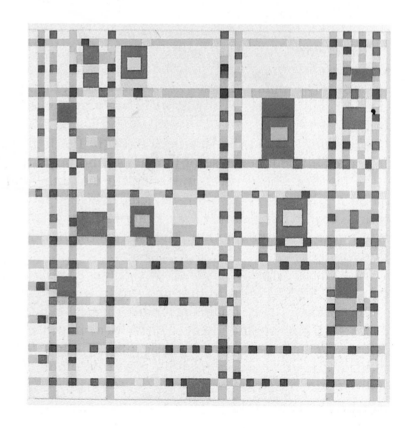

The accompanying photograph (Figure 233) is of office buildings at dusk. What similarities can you find between the photograph and *Broadway Boogie-Woogie*?

Op Art

Many painters of the twentieth century have experimented with abstractions of form, movement, and time.

Look at what artists Julian Stanczak and Hannes Beckmann did by moving patterns of vertical stripes about

Figure 233. Compare this photograph of the city at dusk with *Broadway Boogie-Woogie*? Photograph from the private collection of Mr. Robert L. Fisher, Jr., Birmingham, Alabama (Anderson).

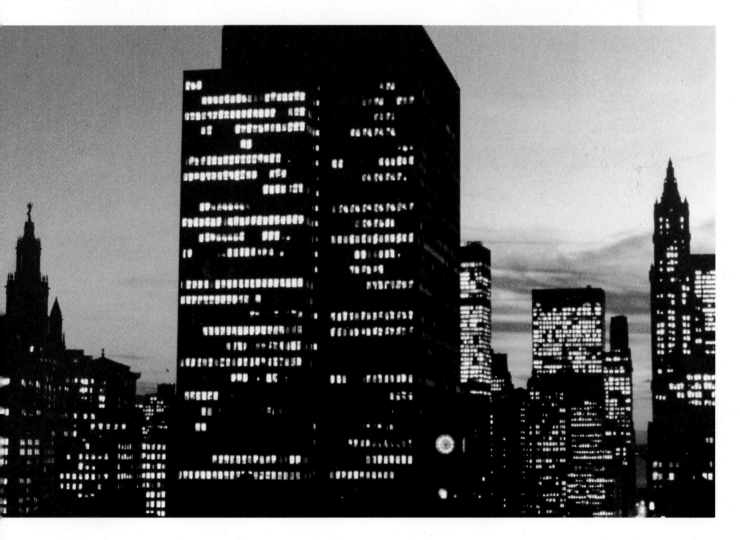

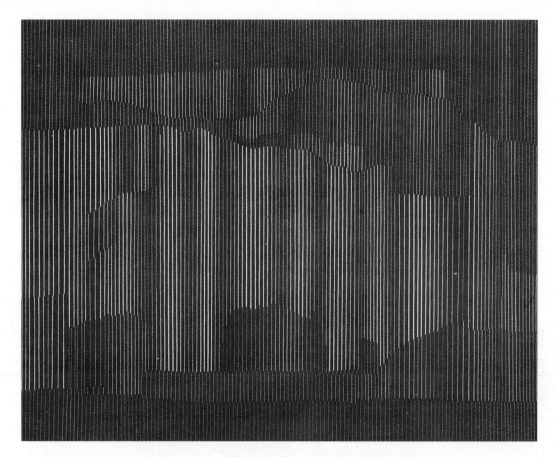

Figure 234. Notice how your eye travels when you look at Julian Stanczak's *Nocturnal Interlude.* Julian Stanczak, *Nocturnal Interlude.* 1960. Courtesy American Republic Insurance Company, Des Moines

in *Nocturnal Interlude* (Figure 234) and *Neither/Nor* (Figure 235). Such art is called Op Art because of its purely optical emphasis. These works are totally abstract. In some paintings the interaction of colors creates optical vibrations. The repetition of lines and patterns causes a sense of movement. Sometimes artists have used mathematical models or systems to help them achieve a certain optical effect.

Look closely at Bridget Riley's painting *Current* (Figure 236). Compare it to Margaret Bourke-White's photograph *Contour Plowing* (page 332). What are some differences between the two? Riley has taken her painting, of synthetic polymer paint on composition board, a step further as an abstraction than has Bourke-White. In *Contour Plowing*, you are looking at the undulating lines of plowed fields. In *Current* you are only looking at a series of waving vertical lines. At first, *Current* appeals to the viewer's curiosity.

310

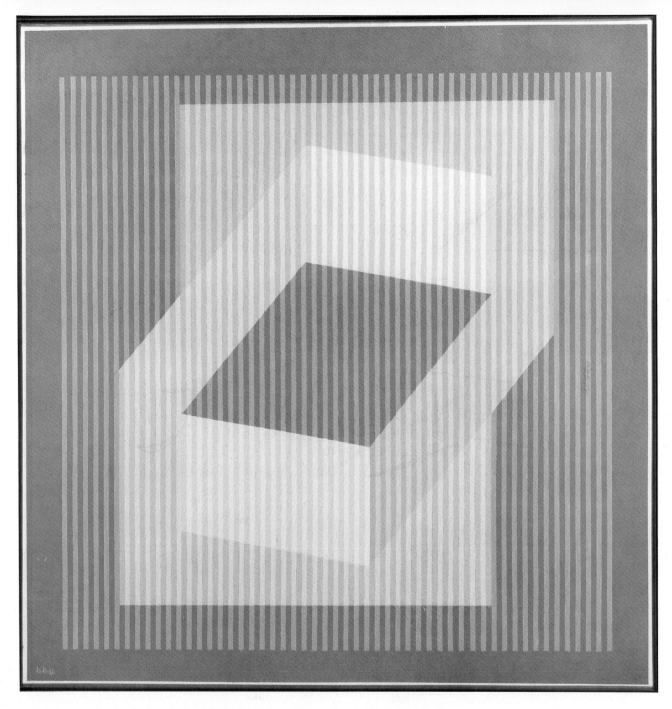

Figure 235. Why do you think Hannes Beckmann called this painting *Neither/Nor*?

Hannes Beckmann, *Neither/Nor*. 1909. The Museum of Fine Arts, Boston.

However, beware! As you look at it, *Current* almost locks your eyes into its pattern. If you look at it long enough, you might even get a bit dizzy, so effective and powerful are its image and impact.

Figure 236. Compare the movement in Bridget Riley's *Current* to that in *Nocturnal Interlude*. Bridget Riley, *Current*. 1964. Synthetic polymer paint on composition board. 58 3/8″ x 58 7/8″. Collection, The Museum of Modern Art, New York. Philip Johnson Fund.

PAINTING ACTIVITIES

312

1. Discuss with your classmates some positive aspects of the Industrial Age that might be glorified in the manner of

Figure 237. Student art.

Joseph Stella's bridge. One of the group should act as the recorder and list these items on the blackboard.

Next, make a list of some of the aspects of the age which represent its dark, materialistic side. List these on the blackboard beside the list of the positive aspects. Choose a subject or two from the list to be the basis for an original painting about the industrial age. Use whatever type of paint seems most appropriate for your subject. As you progress, think of a title for your work that best conveys your meaning.

2. Look again at Mondrian's *Broadway Boogie-Woogie* on page 308. This is the last painting that he completed. Mondrian died in 1944.

Follow any single line with your eye. You will see that the little squares of color catch the movement of the city like flashing lights on a busy thoroughfare. The overall effect is somewhat like looking at moving traffic from a helicopter.

Mondrian arrived at his proportions and relationships by "feel" rather than by exact measurement. His sense of asymmetrical balance was so specific that critics well-acquainted with his work have no difficulty telling fakes from original Mondrians.

In this activity you will create your own purely abstract work based on Mondrian's work. Select a workable size of white paper for a ground support. Measure and cut strips for lines and shapes (rectangles) in the primary colors. Lay out various arrangements on the white paper and make adjust-

Some of the things the students will probably identify that might be glorified are automobiles, skyscrapers, bullet trains, computers, robotics, subways, and monorails. If they overlook such life-saving advances as X-ray equipment, respirators, and iron lungs, you may want to suggest these. Some dark-side aspects usually identified are overcrowding in cities; acid rain; smoke, smog, and other air pollutants; disposal of industrial waste; and nonbiodegradable materials.

It will be helpful to have several examples of Mondrian's later works (1920–1944) for student study as they undertake this assignment.

Figure 238. Student art.

As a follow-up, present a col-
lection of Cubist and semi-
abstract art, all of which should
be unfamiliar to the students.
Ask them to analyze the items.
How do they relate to new,
strange works of art as a result
of this project?

As an extra project, a student
might research and report on
the two phases of Cubism,
Analytic (1908–1912) and
Synthetic (1913–1914).

ments in size and position as you deem necessary. When you are satisfied with the result, paste the lines and shapes down on the ground support.

3. In this activity you will create a painting in the Cubist style. Review the principle of simultaneity (pages 270-272). Look again at Picasso's *Fruit Dish* on page 299, and other examples of Cubist still lifes that you find in the library. Set up a still life in the classroom. Analyze the still-life model from several points of view and sketch it from two or more positions, including at least one side view and top view. Combine the two or more points of view in a single drawing on a third sheet of paper. Finally, paint the still life in a monochromatic or a neutral color in poster tempera.

4. Study the Cubist collage by Juan Gris (page 300). Using the Cubist still life that you have just created, transform it into a color collage, using assorted paper materials. You may want to draw more objects and shapes on the background.

SCULPTURE

In the twentieth century, artists have responded to change in many ways. They have created all sorts of new expressions and used new materials to catch the spirit of the

times. They have produced works of art that represent or reflect ideas rather than realistic statements.

Abstract art influenced sculpture as profoundly as it influenced painting.

Ideas Expressed in Steel and Bronze

The sculptor Giacomo Balla (bah'-lah) created the aluminum and steel relief *Plastic Construction of Noise and Speed* (Figure 239). Do you "see" noise and speed when you look at this sculptured relief? How fast do you think it is going? What type of noise is it making? Why do you think so?

Figure 239. Balla has used dynamic lines to create turbulent motion. Giacomo Balla, *Plastic Construction of Noise and Speed*. 1914-1951. Reconstructed 1968. Construction of aluminum and steel on painted wood mount. 40 1/8" x 46 1/2" x 7 7/8". The Hirshhorn Museum and Sculpture Garden, Smithsonian Institution. Gift of Joseph H. Hirshhorn, 1972.

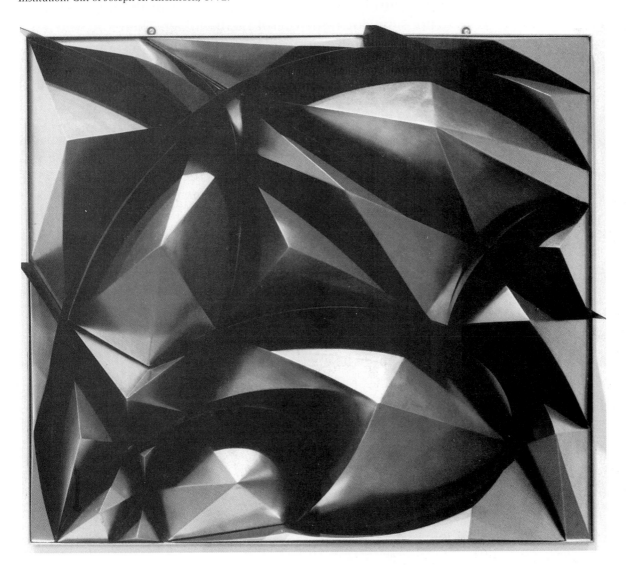

Plastic Construction of Noise and Speed does not show some-one running fast or a train whizzing by, nor does it show people making noise or factory horns blasting. Therefore, it is not a realistic work of art. Still, as you have already seen, the work does re-create a look and sense of both speed and noise. It is an abstraction of actual speed and noise; it portrays the *idea* of speed and noise. Rather than show one example of something making noise or traveling at great speed, it suggests the idea of *all* speed and noise.

Plastic Construction of Noise and Speed is not static. That is, it does not appear to be quietly standing still. Rather, it has the appearance of turbulent motion. Its lines of force are going in all directions, giving the viewer a sense of being caught in the midst of high-speed traffic. The materials are aluminum and steel; their smooth, shining reflective surface adds to the look of high speed. The slick texture of the materials does not slow down the eye of the beholder. Therefore, the mind follows the eye and slides about in all directions following the dynamic lines of the overall composition. The artist has made use of modern materials to help put across his idea of noise and speed.

New materials have suggested new concepts to artists in the twentieth century, as has the exploration of space. People have been to the moon. If there were birds and animals on the moon, what might they look like? Joan Miró (mih-roh') suggests a form for one in his bronze sculpture *Lunar Bird* (Figure 240). This bird is seven and a half feet tall, no taller than an ostrich. But what a strange creature this is! Do you find *Lunar Bird* frightening or funny—or both? Its wings seem to be flapping, but do you think it can fly? Its legs are almost elephant-like. Why do you imagine a bird on the moon needs legs like that? It also has antennae on its head, protruding eyes, and a pointed tongue. *Lunar Bird* seems to be lifting its wings and head as its tongue sticks out of its open mouth and it cries out.

As a cock crows to greet a new dawn, Miró's bird is rearing up, crowing to greet a new age—the space age. How does Joan Miró's *Lunar Bird* compare to Arnaldo Pomodoro's *Hommage to a Cosmonaut* (Figure 241)? *Hommage to a Cosmonaut* was made of bronze in 1962. It is just over five feet high and wide. What do you see when you look at it? Perhaps this sculpture, too, symbolizes a welcome to the space age. The "picture" however is not entirely clear. What adds mystery to the composition? What might it signify?

Have students design a memorial to the first United States astronauts to travel in space.

Figure 240. Can you imagine this bizarre creature bounding over the lunar landscape? Joan Miró, *Lunar Bird*. 1945. Enlarged 1966, cast 1967. Bronze. 90 1/8″ x 81 1/4″ x 59 1/8″. Hirshhorn Museum and Sculpture Garden, Smithsonian Institution, Washington, D.C. Gift of Joseph H. Hirshhorn, 1972.

Enormous changes have taken place throughout the twentieth century. People are not shocked by new developments in the form of new ideas, new jobs, new gadgets. Change is seen as good. People want to own or know about the latest things. Do you think that is good or bad or both? Why?

Figure 241. This work conveys new and strange worlds not yet fully known. Arnaldo Pomodoro, *Hommage to a Cosmonaut*. 1962. Bronze. 62 1/2" x 62 1/2" x 18". Hirshhorn Museum and Sculpture Garden, Smithsonian Institution, Washington D.C. Gift of Joseph H. Hirshhorn, 1966.

Horses and Riders

Do you recall the statues of men on horseback by the sculptors Andrea Del Verrocchio (page 100) and Frederic Remington (page 101)? Both of these statues were done in a realistic manner. They had many details to help you understand the sculpture. Look now at two statues of riders on horseback that have fewer details and are more abstract. *The General* (Figure 242) is a bronze statue by Hugo Robus done in 1922. *Little Horse and Rider* (Figure 243) is a polychromed bronze sculpture by Marino Marini (mah-ree'-nee). Both are more simplified in form than *Equestrian Monument to Bartolommeo Colleoni* or *Bronco Buster*. In all four sculptures the rider and horse appear as one figure, but the artists have chosen very different ways to show this. In the statue called

Students may wish to sculpt their own versions of a horse in motion.

**Figure 242. In *The General* by Hugo Robus, the horse and rider
are united through the similarity of their forms.** Hugo Robus, *The
General*. 1922. Bronze. 18 7/8″ x 20″ x 8 3/4″. Hirshhorn Museum and Sculpture Garden,
Smithsonian Institution, Washington D.C. Gift of Joseph H. Hirshhorn, 1966.

The General, both the horse and the rider lean forward
together from the neck and head. The forms in both of their
bodies are similar. What other relationships between the
rider and the horse can you find? Robus is more interested in
portraying the idea or sense of a rider and horse united, per-
haps for combat, than in all the trappings and details. By
concentrating on repetitions of forms and rhythms, the artist
shows a strong relationship between this rider and the horse.

What do you see in *Little Horse and Rider*? How is it differ-
ent from *Bronco Buster* (page 101)? What might it represent?
What idea can you find in it? How are the forms, lines, and
movement of the rider and horse similar? How is this sculp-
ture different from *The General?* How is it similar? Which do
you prefer? Why?

There are, of course, no abso-
lutely correct or incorrect
answers to these questions.
The important thing is the visu-
al evidence the students use
to support their answers.

Looking at Common Things in New Ways

Look next at *Guitar* (Figure 244), a sculpture made of
sheet metal and wire, by the Spanish artist Pablo Picasso.
Picasso constructed this piece in 1911 or 1912. Up until
then, most sculpture had been modeled or carved. Picasso,

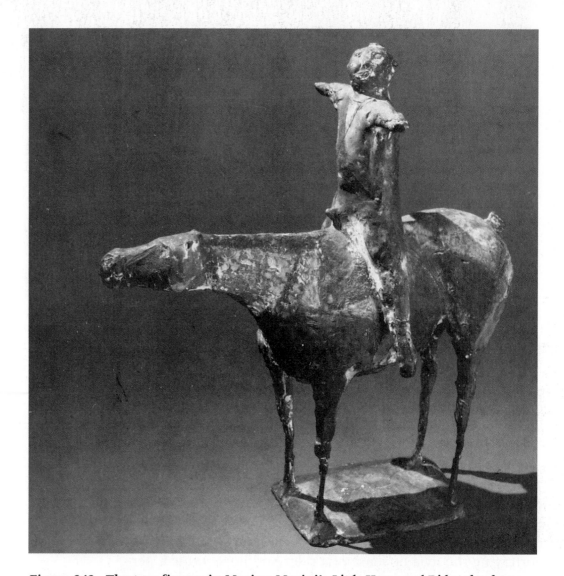

Figure 243. The two figures in Marino Marini's *Little Horse and Rider* also have similar lines. Marino Marini, *Little Horse and Rider*. 1949. Polychromed bronze. Edition of 12. 17 3/8" x 17" x 8 3/4". Hirshhorn Museum and Sculpture Garden, Smithsonian Institution, Washington D.C. Gift of Joseph H. Hirshhorn, 1966.

Discuss the importance of Picasso's innovation: assemblage. Review the fact that common objects, even junk, can be transformed into aesthetically pleasing works by the imaginative use of the compositional principles.

in *Guitar,* assembled pieces rather than carving a form out of one piece of material.

In *Guitar* the basic shapes which make up a guitar have been isolated and rearranged to make an interesting new form. By abstracting and rearranging the various shapes that make up the form of a guitar, the artist makes the viewer join him in looking at it in a new way.

Compare *Guitar* to *Black Widow* (Figure 245), a sculpture by the American artist Alexander Calder, and *Dormeyer Mixer* (Figure 246) by Claes Oldenburg. What do the three sculptures have in common? For one thing, they direct you to

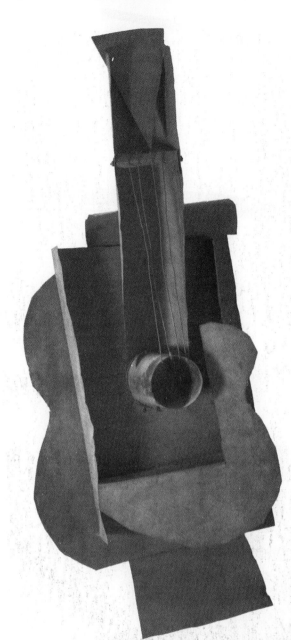

Figure 244. *Guitar* **by Pablo Picasso is assembled rather than carved.** Pablo Picasso, *Guitar*. Sheet metal and wire. 39 1/2" x 13 1/8" x 7 5/8". Collection, the Museum of Modern Art, New York. Gift of the artist.

look at common, everyday objects in new ways—almost as if you had never really seen them before. Picasso rearranged basic shapes in *Guitar.* Calder dramatized the commonly known form of a spider in *Black Widow.* Oldenburg greatly enlarged the scale and size of a household appliance in *Dormeyer Mixer.* These artists compel attention to things by shocking, amusing, or confusing the viewer.

Calder's sculpture *Black Widow* represents one of his **stabile** or earthbound sculptures. A **stabile** is an abstract sculpture made to appear like a mobile, although it is actually stationary. It is constructed of sheet metal and painted

Discuss the terms *mobile* and *stabile.*

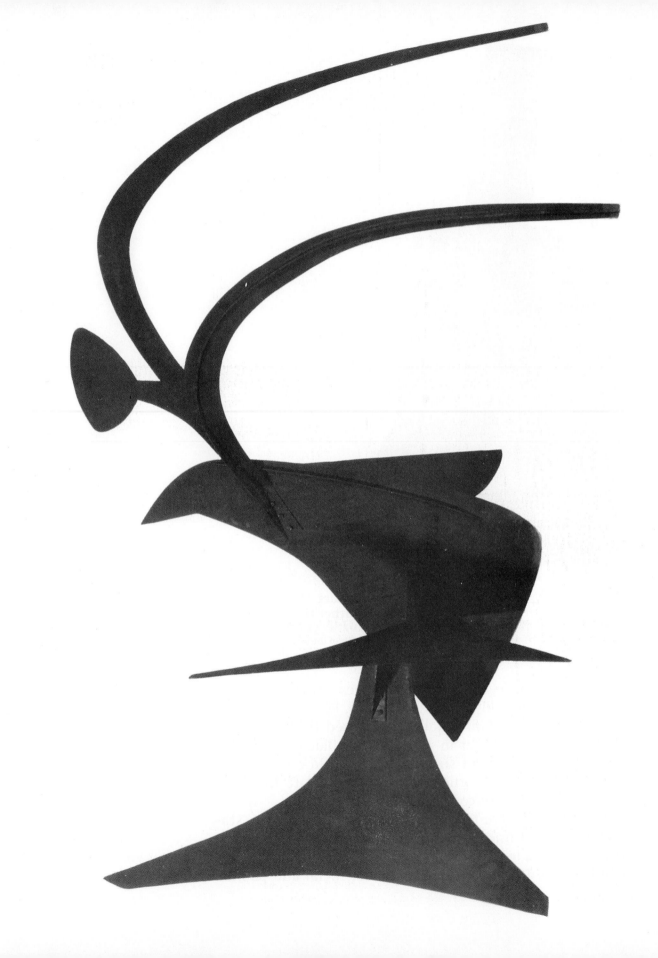

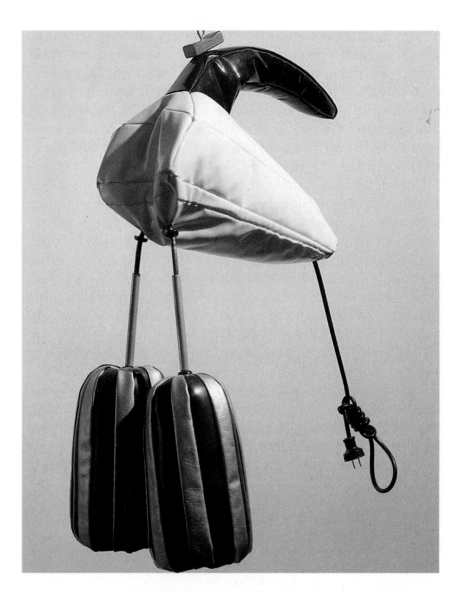

Figure 246. *The Dormeyer Mixer* **by Claes Oldenburg transforms
the size and material of an everyday object.** Claes Oldenburg, *The
Dormeyer Mixer*. 1965. Vinyl, wood, and kapok. 32″ x 20″ x 12 1/2″. Collection of the
Whitney Museum of American Art. Purchase, with funds from the Howard and Jean
Lipman Foundation, Inc.

black. Sometimes Calder painted his stabiles in white or
bright primary colors. In his stabiles Calder combined influ-
ences of Cubist abstraction (seeking basic forms and shapes
of an object and reconstructing it with some alterations)
with a wonderful sense of playfulness.

What do you see when you look at *Black Widow*? Is it
scary or funny? Or is it both? Why?

◄ **Figure 245.** *Black Widow* **by Alexander Calder is a stabile.** Alexander
Calder, *Black Widow*. 1959. Standing stabile: painted sheet steel. 7′ 8″ x 14′ 3″ x 7′ 5″.
Collection, the Museum of Modern Art, New York. Mrs. Simon Guggenheim Fund.

This is also Classroom
Reproduction #5.

You may wish to use the
Special Project which begins
on page 369.

Oldenburg calls attention to ordinary objects by removing them from their normal context, changing their scale, and sometimes changing them from hard to soft. A mixer, a simple kitchen tool, is transformed by the artist into a monument simply by greatly enlarging it in scale. Perhaps Oldenburg wants you to stop and see the form of a mixer in a way you never have before. Why would he want you to look at a mixer in a new way? What do you see?

Since Picasso constructed his Cubist *Guitar* in 1912, methods of assembling have become popular in sculpture. Sometimes an artist assembles **found objects**. These are bits and pieces of junk, such as pipes, cans, broken furniture, wheels, or just about anything that intrigues the artist. Such sculpture is called **assemblage.** The artist brings these objects together in a way that makes their original identity apparent. At the same time, the objects take on a new context and new identity in their reassembled form.

Sculptures assembled from found objects need not be made of many objects. Two or three objects put together in a unique way can have a surprising effect. Look at *Bull's Head* (Figure 247), made by Pablo Picasso in 1943. What is *Bull's Head* assembled from? Simply a bicycle seat and handle bars. Who would have thought of such a combination!

Picasso reported his inspiration for this assemblage in this way:

> One day in a rubbish heap, I found an old bicycle seat beside a rusted handle bar, and my mind instantly linked them together. If my bull's head were thrown in a junk pile, perhaps some boy would say, 'Here is something that would make a good handlebar for my bicycle.'

Let's look at a few other sculptures that use found objects in imaginative ways.

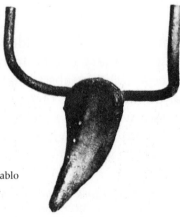

Figure 247. *Bull's Head* by Pablo Picasso is an ingenious assemblage. Pablo Picasso, *Bull's Head*. 1943. Handlebars and seat of bicycle. Height 16 1/8".© 1990 ARS/SPADEM, New York.

She-Goat (Figure 248) is by Pablo Picasso, and *Bird* (Figure 249) is by José De Creeft. Perhaps in other centuries such sculptures would have been considered ridiculous and meaningless. In the twentieth century such sculptures have a special meaning, aside from the people or things they represent immediately. Picasso said this about his sculpture,

The goat's body is a wicker basket; her udders are two flower pots. Metal pieces brace her legs and shoulder. Around these Picasso applied plaster, then cast them in bronze.

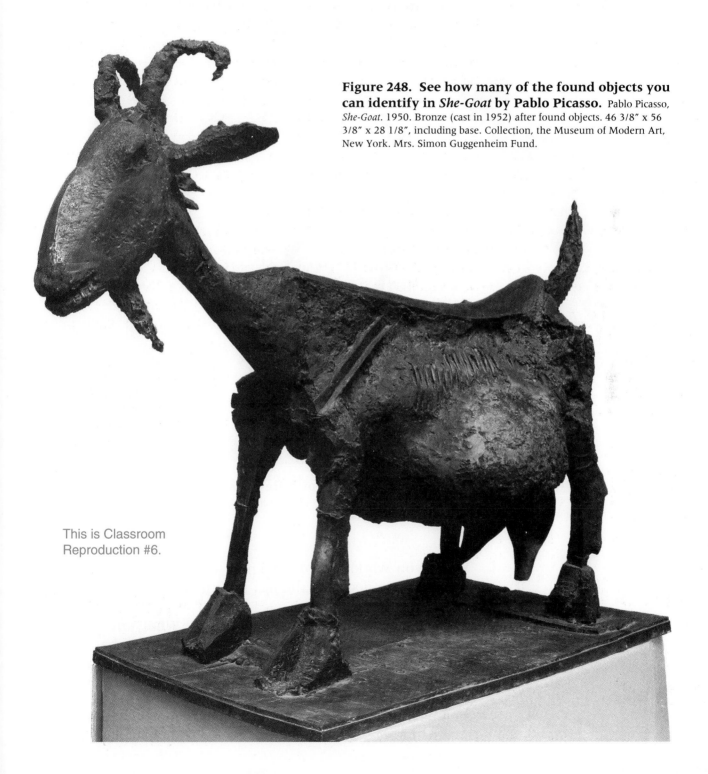

Figure 248. See how many of the found objects you can identify in *She-Goat* by Pablo Picasso. Pablo Picasso, *She-Goat*. 1950. Bronze (cast in 1952) after found objects. 46 3/8" x 56 3/8" x 28 1/8", including base. Collection, the Museum of Modern Art, New York. Mrs. Simon Guggenheim Fund.

This is Classroom Reproduction #6.

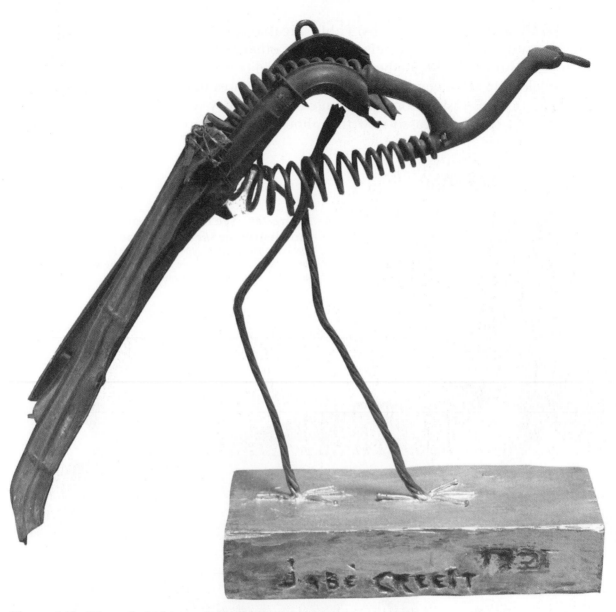

Figure 249. Discarded objects from the industrial world are transformed by the artist. José De Creeft, *Bird.* 1927. Found objects. 11 3/4" x 13 3/8" x 3 1/2". Hirshhorn Museum and Sculpture Garden, Smithsonian Institution. Gift of Joseph H. Hirshhorn, 1966.

"When you work, you don't know what is going to come out. It is not a decision; the fact is it changes while you are at work."

What might the special meaning be? What interesting idea might the artist be expressing about these changing times? Perhaps, the artist is saying that because everything keeps changing, the use of objects changes as well. What was useful for one reason yesterday is useful for a new reason today. Identify at least one found object in each of these three sculptures. Compare the original purpose of the object

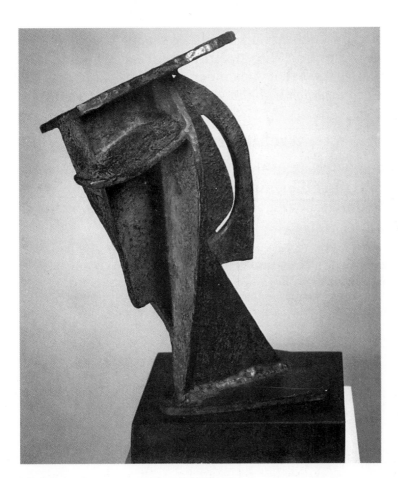

Figure 250. *Head: Construction with Crossing Planes* **by Alexander Archipenko uses both solid and hollow materials.** Alexander Archipenko, *Head: Construction with Crossing Planes.* 1913; reconstructed c. 1950. Cast in 1957. Bronze. 17" x 10" x 12 5/8". Hirshhorn Museum and Sculpture Garden, Smithsonian Institution. Gift of Joseph H. Hirshhorn, 1966.

with the way it is used in the sculpture. For example, in *Bird*, a spring has become the body of a bird. The artist might be saying through this that everything is always changing in the twentieth century. On another level, the artist may simply be having fun with materials—exercising his own imagination.

You have looked at some examples of sculpture that are slight abstractions. *Head: Construction with Crossing Planes* (Figure 250) is a bronze sculpture made by the Russian-born American artist, Alexander Archipenko. Archipenko, who moved to the United States in 1923, was one of the first sculptors to use both solids and hollows in his forms. As a result, his sculptures are both convex (curving outward) and concave (curving inward). Archipenko's work influenced many modern sculptors. *Head* is more abstract than the sculptures you have already seen. Its form has been reduced to a few shapes and lines. You have already learned how the

Students might experiment in working with solids and hollows in a clay or soft stone sculpture.

Cubists broke things up into basic shapes—geometric figures, planes, and lines—to portray the basic structure of those things. That is what Alexander Archipenko attempts to do in *Head: Construction with Crossing Planes*. Is he successful?

Architectural Sculpture

Many artists of the twentieth century have worked in architectural dimensions. Look at the sculpture *Green Fall* by Sylvia Stone (Figure 251). It consists of geometric shapes

Figure 251. Sylvia Stone used geometric shapes and reflective surfaces to create the illusion of architecture in *Green Fall*. Sylvia Stone, *Green Fall*. 1969–70. Wood, stainless steel, Plexiglas. 67 1/2″ x 20 1/2″ x 62″. Collection of Whitney Museum of American Art. Purchase, with funds from the Howard and Jean Lipman Foundation, Inc.

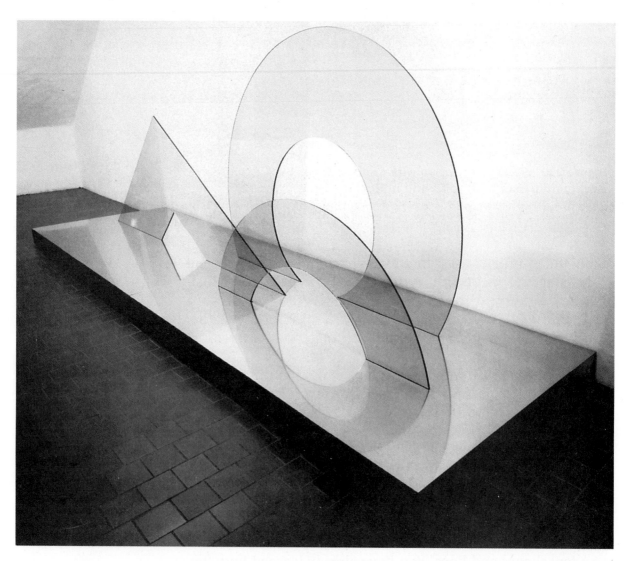

cut from Plexiglas and mounted on steel. The steel functions as a base, but by reflecting the Plexiglas forms attached to it, denies being a base at the same time. This optical illusion creates a sense of movement. If you were to walk around the sculpture, you would see that the reflections constantly change, producing an effect of moving lights and surfaces. *Green Fall* is just over five and a half feet in height and over sixteen feet in length. The viewer responds to the work in part because of its size. Such a large "environmental" sculpture is meant to provide the illusion of a fantastic piece of architecture. The viewer is invited to imagine what it would be like to enter and move about this structure of changing lights, reflections, and forms. *Green Fall* means to involve the viewer in a strong visual experience.

What does the word *amphisculpture* (am'-fi-sculp-ture) mean to you? Take a look at Figure 252, *Amphisculpture*, which was designed by the artist Beverly Pepper. In this case, it is an artwork that is both an amphitheater and an outdoor piece of sculpture set in grass. The site is the AT&T Long Line headquarters in Bedminster, New Jersey. *Amphisculpture* is a form of **environmental art** that is

Figure 252. Why is *Amphisculpture* a good title for this work by Beverly Pepper?
Beverly Pepper, *Amphisculpture*. 1974–77. Poured concrete and ground covering. 8' high x 14' wide x 270' diameter. Collection American Telephone and Telegraph Headquarters, Bedminster, New Jersey. Photograph, Gianfranco Gorgoni.

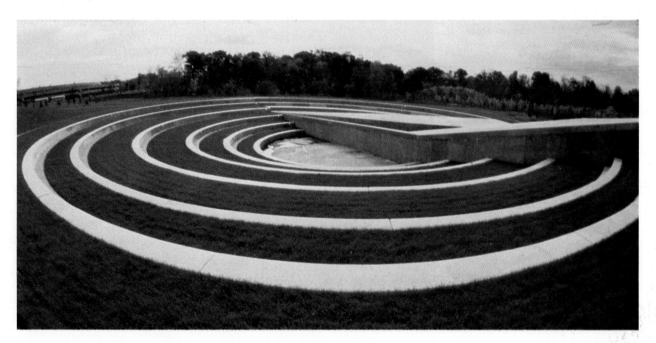

meant to provoke a degree of participation or involvement by the viewer.

The purpose of *Amphisculpture* is to give employees a pleasant retreat outside of the headquarters in which to sit or stroll. It is a work they can get involved with and enjoy. *Green Fall* invited the viewer to get involved by walking around the sculpture. *Amphisculpture* goes even further. The artist has invited you, the viewer, to actually enter the work and become a part of it.

SCULPTURE ACTIVITIES

Before the students begin, you may want to review the compositional principles of design with them, especially movement, repetition, and balance.

Encourage the students to work in pairs, as it often takes two people to string a mobile.

Suggest that the students begin by joining their arrangement from the bottom up, rather than from the top down.

 If you use a super glue, discuss use with your teacher.

CAUTION

Demonstrate the use of, and remind the students to be very careful with, glues and sewing.

1. Not all sculptural forms sit on solid bases. Some are suspended from the ceiling and move through space. These are called **mobiles.** One of the most famous sculptors working in the mobile form was Alexander Calder. His work can be found in many large public buildings throughout the world.

Look through available resources to view his works. Make sketches of some of the most interesting pieces. Study how Calder joined the pieces of his mobile.

Proceed by making a mobile for home or school. Begin by looking for a location where a mobile could be hung easily and viewed clearly. Next, plan your mobile, keeping in mind that you will be repeating forms which will move. Once your plan is ready, make the mobile. What materials will you use? You might consider wire for supports, mat board for the shapes, and glue and sewing thread to attach shapes to the support system. As you work, experiment with different ways to achieve balance. Add color or texture. Then hang the finished mobile and view your work.

2. Work with other members of your class to produce a large found-object sculpture. Go on a "junk hunt." Collect both unique and common objects, for example, one shoe, a broken car seat, old bed springs, a wooden crate, ice tray dividers, old clothes, and whatever else intrigues you. Look for the unusual. This may take several days or weeks to complete. Be prepared to store all the "treasures" until the day for building the sculpture.

When you have a sizeable collection, discuss ideas for assembling them into one large piece with the whole class. Make a few sketches. Plan ways to attach the parts to the whole. Concentrate on the kind of balance your sculpture will have.

3. Imagine an environmental work such as *Amphisculpture* on your schoolgrounds. Where could it be located? How would students use it? Walk around the school grounds. Might an environmental piece of sculpture work into the plan of the schoolgrounds? Plan such a work. Try to create an environment that the viewer will be encouraged to enter. First sketch it out in its relationship to the school building. Next make a heavy paper model of it. One model from the class might be presented to the principal to be considered as a possible piece of sculpture for the schoolground.

PHOTOGRAPHY

Many of the advances in photography have been made in the twentieth century. As a result, photographers have been able to use the camera to create unique works on film.

Do you recall the photograph *Mahatma Gandhi, Spinning* by Margaret Bourke-White that was discussed on page 114? *Contour Plowing* (Figure 253) is a more abstract work by the same photographer. If you did not know the title of this photograph, what would you think you were looking at? Why?

Photographers, like other artists, have responded to the spirit of experimentation during the twentieth century. Margaret Bourke-White photographed a plowed field from an angle that removes it from its usual context. This unusual view directs your attention to the beautiful rippling pattern created by the farmer's contour plowing. As a result, you see a plowed field in a new way. The aerial perspective shows a field, not as furrows of earth prepared for growing crops, but as a design you might otherwise have missed. Bourke-White shows you that your point-of-view, the position from which you look at something, can greatly alter not only what you see but also the meaning it appears to have.

The photographer Edward Weston suggests that you look at a common vegetable, the onion, in a new way in his photograph *Onion Halved* (Figure 254). By cutting an onion in half and taking a close-up of one half, Weston directs your vision to an image you probably were not aware of before.

Display the sketches and discuss the designs and the likelihood of each one's success as a balanced piece. Allow students an opportunity to revise their sketches if they want to. Help the students in choosing assemblage pieces from the class collection. Help students experiment to achieve balance.

Ask the students to look in the *Readers' Guide to Periodical Literature* at the library to find information on environmental art. What do artists such as Robert Smithson, Sylvia Stone, and Christo say about their work? Why do they do it? What do they say is its meaning? Tell the students to bring in actual quotes by these artists. Discuss and dissect their words. This can help students delve further into the meanings and messages of art.

Plan an exhibit of photographs collected by students from their own work, or from magazines that illustrate abstract forms in nature.

Students might draw or paint examples of interior space, such as the inside of an orange, apple, or onion.

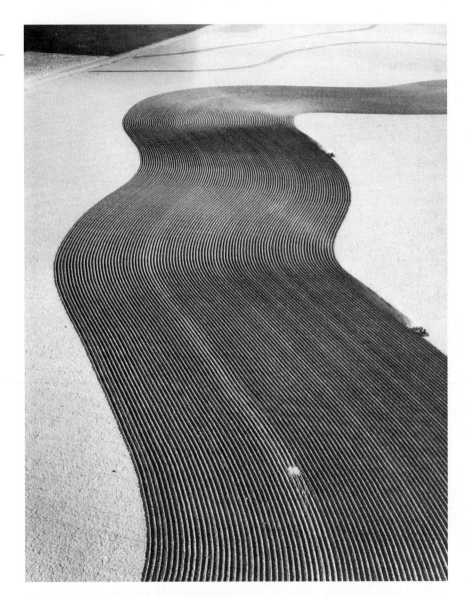

Figure 253. Compare the design effect of *Contour Plowing,* **by Margaret Bourke-White, with that of Bridget Riley's** *Current* **in Figure 236.** Margaret Bourke-White, *Contour Plowing.* 1954. Margaret Bourke-White, *Life Magazine,* © 1954. Time, Inc.

During the twentieth century people have explored not only outer space but also inner space. In his microscopic exploration, Weston asks you to move closer to the object you are looking at—to forget what it is normally called and see it as something else. As you move closer to the onion, it begins to look less like an onion half. If you get very close, you see not the rings of the onion, but individual shapes and forms. The onion is not just a vegetable but a structure, a form built up of concentric circles. You enjoy it as an abstraction.

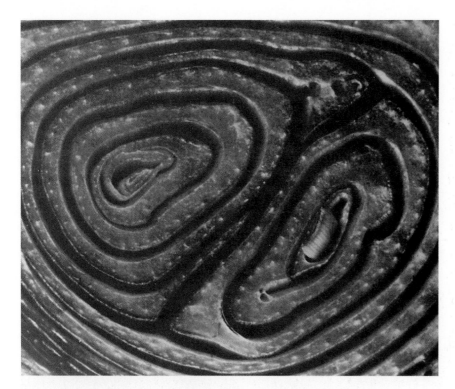

Figure 254. *Onion Halved* **by Edward Weston asks you to see a familiar object in a new way.** Edward Weston, *Onion Halved.* 1930. 7 7/16" x 9 5/16". Photograph courtesy The Art Institute of Chicago. Gift of Max McGraw, 1959.

Another photograph by Edward Weston is *Two Shells* (Figure 255), taken in 1927. In what ways are *Two Shells* and *Onion Halved* different? For one, in *Shells*, you see the whole object. However, it is presented in such a way that you see it as a form more than as shells. What does the form of the shell, photographed close up and dramatically lighted, suggest to you? One of the things that makes this form so interesting is that it looks somewhat like a living thing that is beckoning you toward it. Or perhaps the photographer Weston, like the sculptor Archipenko, means for you to see and appreciate the beautiful swelling curves and hollows that make up the form.

Paul Strand, in his photograph, *Garden Iris, Georgetown Island, Maine* (Figure 256), closes in on a clump of iris leaves. They appear not as leaves of the iris plant, but as bending, curling ribbons of light and dark forms with interacting textured planes and diagonal lines. What relationship do you find between *Garden Iris, Georgetown Island, Maine* and *Contour Plowing?* Do you see how the photographers have focused on the lines and forms in nature rather than on the scene or object they delineate?

Figures 255 and 256 may remind students of Precisionist paintings. If they are interested, have them also research some of O'Keeffe's paintings in which she isolates natural objects in much the same way as these photographs have done.

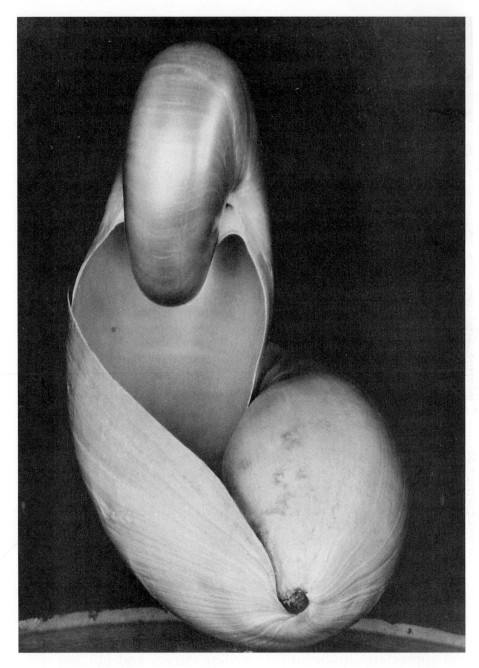

Figure 255. *Two Shells* **by Edward Weston makes the nonliving look alive.** Edward Weston, *Two Shells*. 1927. Gelatin silver print. 9 9/16" x 7". San Francisco Museum of Modern Art. Albert M. Bender Collection. Bequest of Albert M. Bender. Photograph by Edward Weston. © 1981 Arizona Board of Regents, Center for Creative Photography.

Take a walk in the neighborhood and find examples of repetition of lines, such as those in Adam's fence. If possible photograph the objects and display them.

Look next at the photograph *The White Church, Hornitos, California* (Figure 257) by Ansel Adams. How is it similar to both *Iris* and *Contour Plowing?* In what ways is it different? For one thing, it is not completely abstract, but rather has suggested abstractions in it. Where are these suggested elements of abstraction? Look at the fence and the shadows on the fence on the hill to the left of the fence.

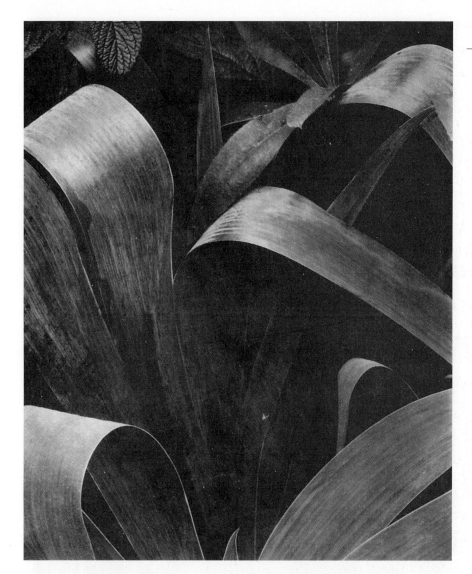

Figure 256. *Garden Iris* **by Paul Strand makes the iris leaves appear to be abstract lines, shapes, and forms.** Paul Strand, *Garden Iris, Georgetown Island, Maine.* 1928. 9 9/16″ x 7 7/8″. The Metropolitan Museum of Art, Alfred Stieglitz Collection, 1955.

In John Albok's *Central Park* (Figure 258), the city's buildings and their reflections are quiet reminders of the time of day. The only movements are ripples in the water made by the peaceful ducks. This photograph is a statement of the need for more parks in the city.

The vision of New York City that you see in Figure 259 comes from the 1927 futuristic film entitled *Metropolis* which was directed by the Austrian-born Fritz Lang. Lang was inspired by his first trip to New York City. In the center of this vertical city rises an enormous building with spikes, an awesome sight. What can this mean? See the film.

Lang's *Metropolis* (1927) spawned many imitations, including the significant Frankenstein films of the 1930s.

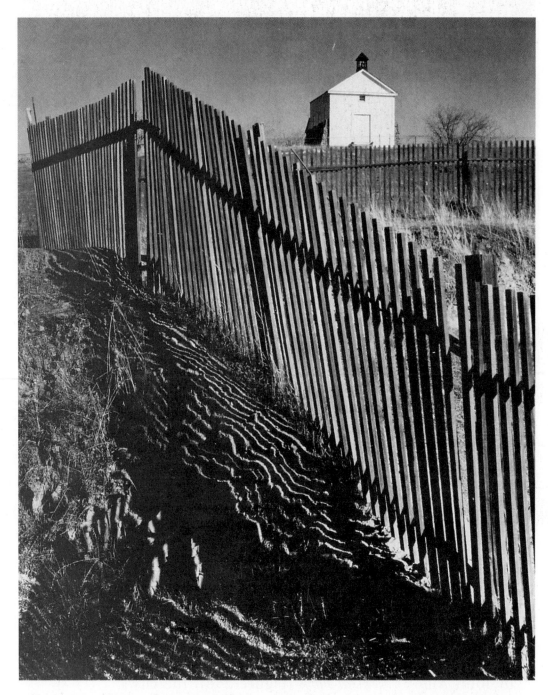

Figure 257. Discuss the suggested elements of abstraction in *The White Church, Hornitos, California*. Ansel Adams, *The White Church, Hornitos, California*. 1946-48. Bromochloride print. 9 3/8″ x 7 3/8″. San Francisco Museum of Modern Art. Gift of Mrs. Walter A. Haas. Photograph by Ansel Adams. Courtesy the Ansel Adams Publishing Rights Trust. All rights reserved.

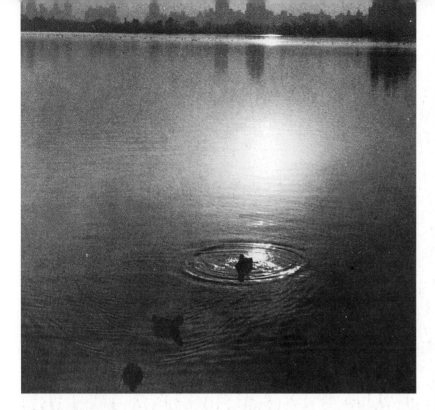

Figure 258. Compare John Albok's visual statement about New York City in his photograph *Central Park*, with that of Piet Mondrian in *Broadway Boogie-Woogie* (Figure 232). John Albok, *Central Park*. Photograph. The Metropolitan Museum of Art, New York. Gift of John Albok, 1959.

Figure 259. Fritz Lang's futuristic view of the city. Fritz Lang, still from the film, *Metropolis*. 1927. Courtesy Museum of Modern Art/Film Stills Archive.

PHOTOGRAPHY ACTIVITIES

1. Many photographers are daring experimenters. Some have created abstract images by distorting an object. For example, you might take a photograph of a familiar object from an unusual camera angle which will show the subject in a new way.

Choose a subject that you are interested in capturing on film. View it from above. Compose the picture from a ladder, stairs, or a balcony. As an alternative, you may want to view the subject from below, from the ground or floor. You might want to photograph something from under a glass tabletop, or suspend the object and position yourself beneath it. Many ordinary objects, when viewed from unusual angles, can be transformed with surprising results.

2. Look at some professional photography books in the library, paying particular attention to photographs of sculpture and architecture. Look for abstraction, distortion, and the relationships of the photographs to the horizontal and vertical axes of the sculpture or architecture. If the camera is not parallel to the horizontal and vertical axes of the subject, distortion will occur in the photograph. If it is possible to do so in your community, select two or three sculptures or buildings and photograph them from unusual viewpoints. Shoot at least twenty frames.

CAUTION

Use extreme care. Remember that the thing of first importance is to pay attention to your own safety, not the camera angle.

ARCHITECTURE

Like other art forms, architecture has evolved in many new and experimental ways during the twentieth century. You have already looked at several examples of unique buildings in other units. The two buildings discussed here derive their shapes from abstract forms.

Abstract Forms in Building

The Trans World Airlines (TWA) Terminal (Figure 260) was designed by the Finnish-born architect Eero Saarinen

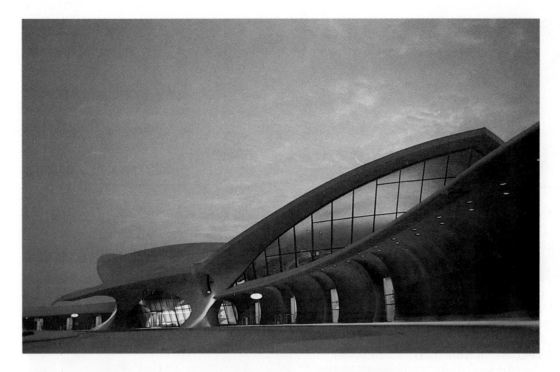

Figure 260. How does Saarinen's _TWA Terminal_ suggest flight? Eero Saarinen. _TWA Terminal_, Kennedy International Airport, New York. 1962. Photo Researchers, Inc. (Page).

(sahr'-ih-nin) and is part of the John F. Kennedy International Airport in New York City.

Do you remember how Giacomo Balla, in his sculpture, _Plastic Construction of Noise and Speed,_ attempted to portray an image of noise and speed? In a similar way, the design of the TWA Terminal conveys the idea of aerodynamics through the lightness and rounded edges of its forms. The broadly sweeping lines of the terminal seem to portray the sense of flowing air currents. It is remarkable that an effect of such lightness is conveyed through the use of a material like concrete.

The shape of the TWA Terminal is pleasantly exciting and inviting. It suggests a horizon in motion, the spirit of adventure. What else do you see in the forms of the TWA Terminal?

The American Pavilion (Biosphere) was designed by the American architect R. Buckminster Fuller and built for EXPO 67 in Montreal, Canada, in 1967. Two views of it are shown in Figures 261A and 261B. Fuller's contribution to architecture was in the technology of structure. One of his most successful structural inventions was the geodesic

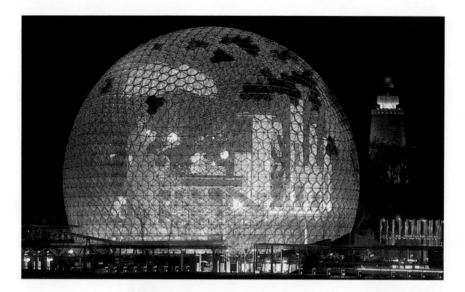

Figure 261A. Have you ever been to a large fair or exposition? Were there buildings like R. Buckminster Fuller's *The United States Pavilion (Biosphere)* for EXPO '67, in Montreal? R. Buckminster Fuller. *United States Pavilion (Biosphere)* for Expo '67, Montréal. Geodesic dome constructed of steel pipes and transparent acrylic. 250' in diameter. Photo Researchers, Inc. (Kinne).

Figure 261B. Another view of the *Biosphere* (Figure 261A).

Have students find examples of the use of Fuller's dome for a variety of purposes, such as playground climbing equipment, private homes, office buildings, and factories, and stadiums.

dome, which you see in the United States Pavilion. A geodesic dome is made of standardized parts and can cover a very large area. Geodesic domes are meant to be an efficient means of providing the maximum amount of interior space.

Geodesic domes are either spherical, as in the American Pavilion, or polyhedric (many-sided). Steel ribs form the skeleton or frame. The ribs are covered by four- or eight-sided forms. These covering forms can be transparent or opaque. They have been made of such materials as plastic, metal, and even cardboard. Imagine a geodesic dome covered with transparent forms of glass or plastic of many different colors!

R. Buckminster Fuller believed that entire cities could be covered by such structures, which would allow the interior climate to be completely controlled. Fuller was a man who tested his dreams—a truly original inventor.

I. M. Pei and His Computer Images

Since the time of the Renaissance architects have faced the great problem of trying to portray a building to their clients before it is built. Many people have difficulty imagining a three-dimensional building from a two-dimensional image. Scale models are one solution. They may help, but they are limited in size. They cannot convey the feeling of being *inside* the finished building. The architect has been trained to see this way. The lay person has not.

I. M. Pei created some of the most innovative buildings of the twentieth century. However in the middle 1980s, Pei himself was having trouble with a new project. This project was to build a new symphony hall for the city of Dallas, Texas (Figure 262). The clients wanted the building to face the new Dallas arts district, as it was a major addition to that district. They also wanted it to be oriented at an angle to take advantage of a spectacular view of the downtown skyline which was unique to the site.

Figure 262. View from the southwest of the Morton L. Myerson Symphony Center in Dallas, designed by I.M. Pei. Courtesy of Pei Cobb Freed & Partners. Photograph reproduced with the permission of Richard Payne, A.I.A.

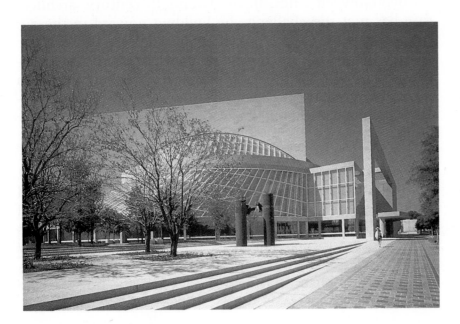

Pei's approach to his work was to begin with a complete visualization of the new project in his mind. From this visualization, he drew sketches for his staff. He then directed the production of the detailed plans for the project. In this case, the changing geometries of the angles and curves required to meet the client's expectations were terribly complex. The building needed to face west, and it also needed to face southwest. Pei said, "I can conceive it in my mind, but I can't begin to draw it. This is a time when the computer became a very useful tool to me. I asked our computer specialist to generate a series of computer drawings showing the perspectives walking along a line."

Figure 263A, B, and C are three "stills" from the sketches generated by the computer. As Pei worked with them, the entire sequence of these sketches grew into something very much like an animated film. This allowed Pei to "take a walk" through his lobby, stroll up the grand staircase, and view the mezzanine. He was able then to "see" what he had and consider the effect of possible alternatives and alterations. He could get the feeling of the place, the feeling of what it was like to be *inside* of his un-built building. The computer images had become a visible representation of the architect's mind. This solved Pei's problem. What he had conceived could now be drawn. Pei concluded, "It's probably the first time it's been done so extensively, but it's not the last time."

As the population of the world continually increases, architects face the challenge of providing livable conditions for overcrowded cities. In the twentieth century, architecture has met the challenge by building upward in the air; the result is the familiar skyscraper. A skyscraper can rise only so far to still function safely and effectively. As architects reach the practical limits of upward building, they turn their attention to other new frontiers: the oceans, underground habitats, and outer space.

Marine Cities

In such cities as ancient Amsterdam, Bangkok, and Venice, canals took the place of streets, and water provided the avenues of travel and communication. Today, architects are exploring the possibility of creating environments for large populations in the oceans. They must solve problems of new materials and a new ecology if they are to create these floating cities.

Figures 263A,B,C. Via computer drawings, the architect was able to take a visual tour of his structure before it was built. Courtesy of Pei Cobb Freed and Partners. Photograph reproduced with the permission of Richard Payne, A.I.A.

Figure 263A. Computer sketch for Symphony Hall lobby.

Figure 263B. Computer sketch for Symphony Hall grand staircase.

Figure 263C. Computer sketch for Symphony Hall mezzanine.

343

Figure 264. The terraced inner walls of *Sea City* is planned to have 16 storeys of housing for 21,000 people. Photograph of the scale model courtesy of Pilkington Plc., U.K.

Sea City (Figure 264) was designed by a team of Great Britain's leading architects and engineers for the Pilkington Glass Age Development Committee of 1971. The project, as designed, would be built on concrete stilts in a shoal area fifteen miles off the east coast of England. The water in the area proposed is less than thirty feet deep. The project would support over 20,000 inhabitants. It would be protected by a floating breakwater, and a 180-foot-high city wall. The top sections of this city wall are to contain apartments connected by sidewalks and escalators with shops, restaurants, and other conveniences. Public buildings, schools, offices, and hospitals are to be built on islands of floating pontoons held in position by anchor chains. Power installations would be fueled by undersea natural gas. Sea-fish farming is to help produce food.

A number of architects have proposed plans for similar marine cities. They are land-anchored, but ocean-oriented. Architect Paul Maymont's Bay City proposal would extend the city of Tokyo out into Tokyo Bay, accommodating 10 million more inhabitants.

Underground Cities

In Japan, precedents have already been established for extensive underground buildings. The world's longest underwater passage, the Seikan (say-kan) Tunnel, is $33\frac{1}{2}$ miles long and connects Japan's islands of Honshu (hahn-shoo) and Hokkaido (hoh-kye'-doh). The Asahi (ah-sah-hee) Television Studio is built 66 feet below ground. Many feared that employees of the studio would experience claustrophobia in this environment. Chief Engineer Shiji Takahashi (tahk-ah-hah'-shee) tells us how this problem was overcome: "Creating an illusion is not so difficult as one might think. When it's raining up there, we use a special shower to create a rainy night in the underground studio too."

Some planners believe a good compromise would be to build offices and shops underground and free the land for housing. People would become vertical commuters, going down to work and shop, and up to their homes and recreational facilities.

The possibility of huge underground cities is also being explored in Japan. Tetsuya Hanamura (hahn-ah-moo'-rah), the chief of a proposed development, believes: "An underground city is no longer a dream. We expect it to actually materialize in the early part of the next century."

Hanamura's project is named Alice City (Figure 265) after Lewis Carroll's heroine Alice, who went underground chasing the White Rabbit down a rabbit hole. Alice City would surprise Carroll's Alice, for it would be about 500 feet below the surface and support 100,000 people.

Can you think of other problems posed by underground cities? (Possible cave-ins, fire and smoke, or ventilation problems, earthquakes.)

Cities in Outer Space

Science fiction is filled with descriptions of cities in outer space. Although we currently lack the technology to make these cities, we do have some idea of what they will be like.

The cost of hauling construction material from Earth would be prohibitive, but there is a logical alternative. Using the Earth's moon for mining in low gravity and then trans-

Figure 265. A view of a domed underground "skyscraper," from plans for the proposed twenty-first century *Alice City*. Courtesy Taisei Corporation, Tokyo.

porting the material mined in zero gravity to the construction site seems a good solution.

There are many challenges. How will scientists create artificial gravity so that settlers can lead a relatively normal life? Probably by making the space city rotate to create centrifugal force to approximate the pull of gravity. How would architects and designers make this space seem like a home?

They might import the features of earth landscapes, such as hills and rivers. Mirrors would direct sunlight into the windows. Special blinds—perhaps mechanical, perhaps chemical—would block the sunlight each day to create an artificial night. The center of the city would not rotate. This is where ships would dock from the voyages back and forth to Earth.

Architecture of the twentieth century began with the early days of the skyscraper. It has developed so rapidly we now have plans for inhabiting outer space. We can only dream of the possibilities that will materialize in the next century.

ARCHITECTURE ACTIVITIES

1. If you are particularly interested and challenged by the problems that architects face and would consider facing them yourself, you should read further on the subjects of marine cities, underground cities, and space platforms and stations. Pick one of these topics for a report to the class. Research your topic in the library. Illustrate your report with sketches and diagrams of possible solutions to practical problems in architecture.

2. Your town or city or community is a standing historical record in architecture. Compile a history of the architecture of your community. Use photographs and sketches that you gather and make; use the public library and local records, historical plaques, and so on. Early views of streets and buildings are particularly helpful. Part of your report should be based on the impact that changing means of transportation have had on the community.

3. As an alternative to Activity 2, you may want to make a photographic record of local buildings that have been designated as historical landmarks, or of local monuments to various heroic figures and causes. An exhibition of this type is always welcome in a community, and well attended.

4. Select one type of architecture, such as houses, churches, office buildings, schools, or shops. Sketch or photograph the different architectural styles that have appeared in your

You may want to suggest interested students include the visions of such writers as H. G. Wells and Jules Verne with Activity 1.

Activities 2, 3, and 4 are provided as alternatives, depending upon your community's size, access to records, etc.

Point out, if necessary, that people were much more stationary in the early part of the century, and the great movie houses were designed to "transport" the patrons both by the entertainment and by the exotic atmosphere of the surroundings. In the latter part of the previous century, magazines, prints, postcards, and gallery shows of paintings served this purpose, as we saw in "The Artist and the West."

Discuss the difference between looking at something and watching something. Watching implies change and movement in the watched object. Looking implies stillness. Which activity is the more active? With students, look through this book and find five examples of art to look at and five to watch. Have the class discuss reasons for their choices.

community as it grew. Add the dates to each sketch or photograph and add notes as appropriate.

5. In the 1920s fabulous movie theaters were built. Today many of the greatest of these "screen palaces" have fallen to the wrecker's ball. Movie houses of today are merely functional echoes of the palaces of the past. If you are fortunate enough to have one of the remaining great movie theaters in your community, take a tour through it and study it closely. Think of the effect it must have had on the patrons of the old silent movies of the 1920s and the role it performed as a cool place and an escape from the problems of the Great Depression of the 1930s. How and why have our movie-going habits changed? How does this relate to the architecture of our theaters? How is this related to the changes in the way we live today?

CRAFTS

You may recall that craftspersons produce works that are both beautiful and useful. We will look at some twentieth century craftspersons who have moved toward abstraction and have utilized new technologies and materials.

New Directions in Ceramics

During the 1950s and 1960s the movement toward abstract art strongly affected many ceramists working in America. By the 1960s many ceramists were working toward changing form and surface in clayware. Among these artists was Toshiko Takaesu (tock-uh-ay'-zoo), the creator of *Painted Bowl* (Figure 266), made about 1962.

Takaesu forged new directions in the design, finish, and form of clayware. She opened up a new range of expression for the form of the vessel by negating its function; in other words, the object no longer served its traditional purpose. For example, a bowl did not have to hold fruit or flowers to satisfy Takaesu. She might place something inside as a reminder that the bowl was once meant to hold things, paying tribute to the spirit of the bowl, and then close up the top, creating a closed form.

In *Painted Bowl*, the bands of glazes are allowed to flow into one another, which creates soft edges and some accidental effects of color and shape. The design of *Painted Bowl*

Figure 266. Takaesu's vessels do not serve the traditional functions of receptacles.
Toshiko Takaesu, *Painted Bowl*. c. 1962. Stoneware. 1 7/8" x 13 1/2". Everson Museum of Art, Syracuse, New York. Photograph by Courtney Frisse, Salt City Imageworks.

suggests a variety of images as the bowl is rotated. As it is positioned in the illustration, it appears as a sort of landscape in which one hazy form bleeds into another. Can you find shapes that might be sky and clouds? Mountains? Hills? Flatland, or, perhaps, a river?

The clay form *Ceremonial Cup #4* (Figure 267) by Richard Hirsch takes us even further into new dimensions of an old form. Hirsch uses an ancient Japanese firing technique called *raku* (ra-koo') for the effects he wants for his futuristic work. In the Raku method, the pot is taken from the

349

Figure 267. Hirsch uses the ancient Japanese firing technique called *raku*. Richard Hirsch, *Ceremonial Cup #4*. Ceramic. Height 15 3/4″. Courtesy, Museum of Fine Arts, Boston. Gift of Norman and Mary Louise Meyer.

kiln (the heat-proof furnace for firing ceramics) while red hot, and put immediately into a combustible material, such as straw, shredded paper, sawdust, or leaves. The red-hot pot sets these combustible materials on fire, which creates black smoke and blackens the pot. The quick cooling that follows causes the pot to crackle, or develop fine hairline cracks that absorb the black smoke.

Hirsch has a large collection of traditional Japanese iron teapots and Chinese bronzes. He began to add legs, similar to those in the pieces of his collection, to his rounded ves-

sels. Gradually his vessels became smaller in relation to the legs of his works. His works, which he calls "space vessels" or "ceremonial cups," combine the ancient with the futuristic.

As you look at *Ceremonial Cup #4*, what do you think Hirsch meant it to be? Whatever you decide, it is an intriguing form, rooted in the past, reaching for the future.

Artistry In Glass

James Carpenter is an artist in glass. He uses glass for the sculptural effects light can give in a building. A beautiful example is the Christian Theological Seminary Chapel in Indianapolis, Indiana.

This building is a stunning joint effort of Carpenter and the architect, Edward Larrabee Barnes. The spiritually moving effect is achieved by the light which comes into the chapel through a large chancel window (Figure 268) and

Some possible answers to the last question may be: a spaceship, a launching tower, a meteor, a three-tailed comet, an altar, an elephant, a tooth.

Figure 268. Carpenter derives sculptural effects by using light. James Carpenter, artist; Edward Larrabee Barnes, architect. *Interior View of Chancel Window, Christian Theological Seminary Chapel,* Indianapolis, 1987. Clear and dichroic glass. Photographed by Balthazar Korab.

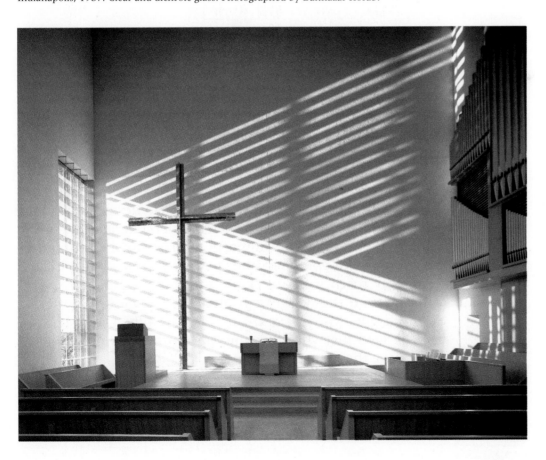

upper skylight. Clear and dichroic glass are used. *Dichroic* (die-crow'-ick) literally means "having two color varieties." Dichroic glass is coated with microthin layers of rare metallic oxides. It reflects and transmits specific wavelengths within the spectrum of light. The molecular structure of the coating acts like tiny prisms.

The chancel window measures $29^1/_2$ by $8^1/_2$ feet. Great visual strength and majesty come from the nontraditional stained-glass design by James Carpenter. These windows have horizontal planes set between structural glass fins which form two-foot-square grids. The dichroic glass designed by Carpenter reflects pink-yellow light upwards and transmits blue-green light downward. These light rays scatter different colored lines around the otherwise white interior. Carpenter tells us: "I consider myself a sculptor working with light."

CRAFT ACTIVITY

1. In this activity you will create a slab container with a top. It will be made of flat pieces of clay joined together. While it may, in some ways, seem easier than the last container you made, you will have to be even more careful in measuring, cutting, and handling the clay.

Day One: Select a square or rectangular design, one that has right angles for corners. Sketch several designs and give special attention to the proportions. For this first attempt, limit the size of your container to one in which your fingers can easily reach from the bottom to the top. When you are satisfied with the design, cut pieces of tagboard as patterns for each side. Measure and cut very carefully. Later on, you will be glad that you took the time to make a precise pattern. Save the pattern.

You will be cutting out *seven* pieces of clay for your container. Why the seventh piece? You will eventually shape it and attach it to the *underside* of your top piece. Its purpose will be to prevent the top from sliding off the container.

Figure 269A. Student art.

Figure 269B. Student art.

What this means now is that you will need *three* pieces the size of the bottom and top instead of just *two*.

After you are sure that all of your tagboard pieces fit together perfectly, roll the slab of clay out until it is one-fourth of an inch thick. Again, measure this as carefully as you can. Cut out each piece, using your patterns. Use a downward thrust with the knife rather than a dragging cut. This will help keep the pieces "squared up" at the corners. Check to make sure that each corner is as near to a right angle as possible. Check the pieces against the tagboard pat-

 Use extreme caution as you handle the knife.

353

terns again for size. This is enough for today. Store the clay pieces on a heavy flat surface, and cover them with another light, but sturdy, flat surface. Wrap this carefully for overnight storage. Don't add much moisture to the clay; you want the pieces to become slightly harder before you begin work in the next period.

Day Two: Take a small piece of soft clay, and add water until you have a mixture that is about the consistency of mayonnaise or sour cream. This mixture, called *slip,* will be the glue you will use to bind the joints together. Use a small tool to carefully scratch the surfaces of the joints so that they will provide a rough surface for the slip to cling to.

Be sure each joint is well covered with slip, then join the pieces together. Try not to let slip ooze out at the edges. Use your finger to smooth out any excess on the inside or the outside.

Next, measure the thickness of all of the walls of your container. The thickness should be the same on all sides. Get the piece of tagboard that you used as the pattern for the top and bottom. Draw these thickness measurements on this piece of tagboard. Carefully cut the tagboard to reduce it by the thickness measurements you have just made. You now have a pattern that is slightly smaller than the size of the top and bottom pieces, and which should fit snugly just inside the top of the container. Next, use this pattern and cut the seventh piece of the clay down to this size. After you have cut this piece, check to see that it does, in fact, fit snugly inside the top of the container. Now, glue this new piece to the underside of the top with slip. Use enough slip to be sure that the two pieces stick together at all points. If you leave any air pockets, the top will crack when it is fired. An alternate method is to cut out the middle of your seventh piece, and attach only a quarter-of-an-inch rim or lip to the underside of your top. Whichever method you choose, be sure that the piece attached fits snugly and easily inside the top part of the container. You can use this same method (and you needn't be as precise) to add a base to the bottom. That's enough for today. Store your project on a flat base board, and let the joints dry overnight.

Day Three: It is now time to decorate your container. At this stage, the clay should be what is called leather-hard. You might carve designs in the sides and top. You may want to add texture. Every little bump or rough spot will appear

Again, use caution with the knife.

CAUTION

Have the students place their mark on the bottom and on the underside of their tops. Check for dryness, and fire the containers. After firing, place the tops on the shelf, top side down. This will sometimes prevent warping.

much larger after the piece is fired. If you want bumps or rough spots, fine. If not, you can use steel wool or sandpaper now, before the piece is fired. Let it thoroughly dry once more, and see if more refinement is needed. Remember that there comes a time in any project when the artist must say, "That's it. I'm through."

PRINTS AND POSTERS

Many artists have been printmakers since the Renaissance. We will take a look at some excellent modern examples, and begin with one that may surprise you.

Abstract Prints

The images and methods of expression that characterize the twentieth century are also found in the prints of the period. To begin with, however, look at the etching called *The Drawbridge* (Figure 270) by the Italian artist Giambattista Piranesi (pih-ruh-nee'-zee). This etching was made, not during the twentieth, but during the eighteenth century. It shows you that artists had begun to express themselves through abstract imagery long before the twentieth century. What abstract forms and lines can you see in *The Drawbridge*?

Although Piranesi spent most of his life recording the architectural ruins of ancient Rome, *The Drawbridge* is part of a series he did based entirely on his imagination. The series, called *Carceri* (car-sehr'-ree), consists of sixteen etchings showing the interiors of a prison. How do Piranesi's abstractions of form, line, and space add to the nightmarish feeling of imprisonment? Look carefully. Do the various parts of the drawbridge go anywhere? Do they really connect with one another? Or is this etching, perhaps, just a maze to entrap you?

In *Three Spheres* you see how the artist can "play" with basic shapes. *Three Spheres* (Figure 271) is a lithograph made by M. C. Escher in 1953. Escher has taken a basic form, the sphere, and played with it by stacking one sphere on top of another. By his use of shadow and converging lines, he has suggested that the spheres are soft and collapse like balls of sponge under weight.

Students might compare the bridges of Piranesi with those of Stella.

Figure 270. *The Drawbridge* **by Giambattista Piranesi is one of the earliest works (eighteenth century) using abstraction.** Giambattista Piranesi, *"An Immense Interior with Numerous Wooden Galleries and a Drawbridge in the Centre."* c. 1750. Etching. 21 5/8" x 16 1/8". Print Collection, Miriam and Ira D. Wallach Division of Prints and Photographs, The New York Public Library, Astor, Lenox, and Tilden Foundations.

Figure 271. Note the precision with which Escher executed *Three Spheres.* M.C. Escher, *Three Spheres.* 1953. Lithograph. © 1990 M.C. Escher Heirs/Cordon Art, Baarn, Holland.

The American artist Lyonel Feininger, (1871–1956) in his lithograph *Manhattan Skyscrapers* (Figure 272), uses only a few lines and a bit of shading to suggest a city of towering buildings. In your mind's eye, can you fill in the forms that Feininger has suggested?

Ask students to consider how Escher achieved the three-dimensional feeling in this lithograph.

Posters as an Art Form

While public announcements and signboards go far back into history, the *poster* is an art form actually based upon the invention of lithography in 1798. At first, lithography was primarily used to reproduce other art, as we have seen in previous sections of this book. In the nineteenth century, artists began to design directly onto the lithographic stone, and lithography became a direct creative medium. Some of the world's leading artists made posters in addition to their creations in other art forms.

Such announcements are found in the ruins of Pompeii.

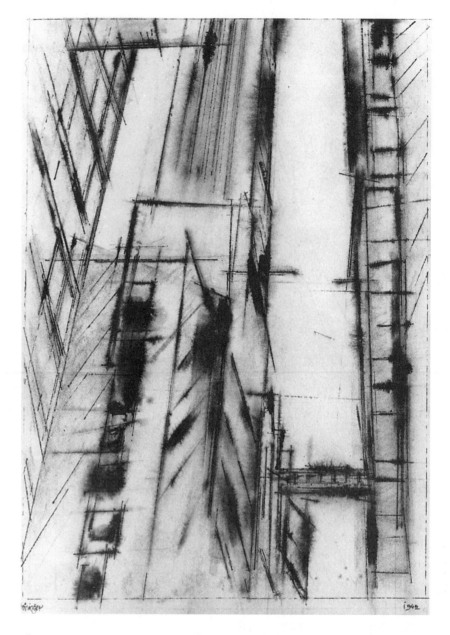

Figure 272. Compare Lyonel Feininger's *Manhattan Skyscrapers* to a photograph of an urban skyline. Lyonel Feininger, *Manhattan Skyscrapers*. 1942. Ink on paper. 21 3/8″ x 15 1/4″. Collection of the Whitney Museum of American Art.

Use Classroom Reproduction #20.

In 1927 the French artist called Cassandre (kah-sahn'-druh) created a poster that to this day is considered a masterpiece of this art form (Figure 273). Study Cassandre's *Étoile du Nord* and try to determine its message from the visual impact.

The French words *Étoile du Nord* mean "the North Star" in English. This poster announced the introduction of pullman

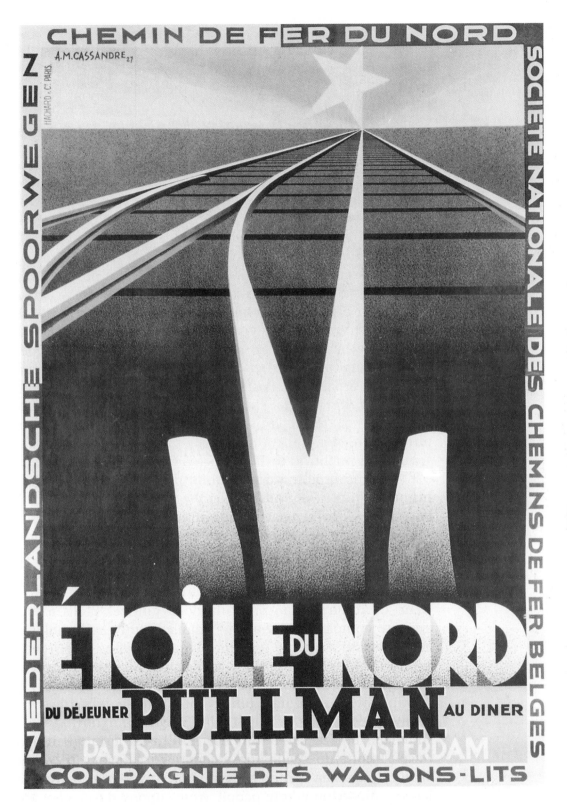

Figure 273. This poster makes the viewer feel the power and speed of the new train. Cassandre, *Étoile du Nord*, 1927. Poster. Courtesy La Bibliothèque Nationale, Paris.

car service from Paris, France, to Brussels, Belgium, and Amsterdam, Holland. Although there is no train in the poster, there is a powerful message in the clean lines of the track and the implied efficiency of the technology. We sense the reliability of the railway system and comprehend the vast spaces it efficiently covers. The prospective passenger is enticed to board the new train and feel secure in its great strength and haunting beauty. The artist completed the visual message with the enormous star representing the northern destinations of the lucky passengers. Critics consider this poster to be the very essence of poster art. Its impact is immediate, and it is intended to entice the viewer to a specific action—to buy a ticket on this train.

In this section of the book you will make a poster. Keep in mind that there is an essential difference between a poster and a painting. While both are art forms, and both are based firmly on the visual elements and compositional principles, their *intents* are quite different. The viewer goes to a museum on his or her own time to look at, think about, and enjoy a painting. Posters demand immediate attention. If they get this, they are successful. If not, they fail, regardless of other artistic considerations. Posters have but one purpose: to persuade the viewer to do something. That something might be to buy a product, to go to a movie or the theater, to make a donation, or perhaps to join an organization. Instead of waiting for the public to come to it, a poster goes directly out on the street to grab attention. Its message must be grasped at a glance, as most of us don't have, or will not take, the time to study a poster carefully.

A good example of the difference between posters and paintings can be found in the works of the French master Henri de Toulouse-Lautrec (tuh-loose'-loh-trek'). His paintings are complex and warrant detailed study and analysis. His posters, though, are simple and direct. Although Toulouse-Lautrec's technique is always recognizable (caricature; simple, flat shapes; and decorative, distinct lines), his posters differ greatly from his paintings. Look closely at his painting entitled *At The Moulin Rouge* (moo-la' roozh), shown in Figure 274. Compare it with his poster entitled *Divan Japonais* (dee-von' zshap'-oh-neh), Figure 275. *At the Moulin Rouge* is a complex work. The Moulin Rouge was a famous nightclub where people were supposed to be having a good time. However, Toulouse-Lautrec shows us joyless figures with stony, mask-like faces. The effect is rather nightmarish. His poster *Divan Japonais* was an advertisement

In actuality, Lautrec had difficulty depicting anyone having a good time, no matter how well-dressed or handsome or beautiful.

Figure 274. The artist portrays some truths about the nightlife he observed. Henri de Toulouse-Lautrec, *At the Moulin Rouge*. 1892. Oil on canvas. 123.0 cm. x 141.0 cm. The Art Institute of Chicago, Helen Birch Bartlett Collection, 1928. Photograph, © 1990, The Art Institute of Chicago.

Figure 275. This poster is an advertisement for an evening out at a club called "Divan Japonais." How does the message differ from that in the painting? Henri de Toulouse-Lautrec. *Divan Japonais*. 1893. Poster. 26" x 18". Scala/Art Resource, New York.

If Fukuda's imaginative approach inspires some students to try a similar one, encourage their efforts.

Figure 276. The artist presents the viewer with an ingenious use of line and of positive/negative space.
Shigeo Fukuda, Poster for *Art Gallery Tokyo*. May 23–May 25, 1975. Silkscreen on paper. 40 7/8" x 28 3/4". Collection of Walker Art Center, Minneapolis, Art Center Acquisition Fund, 1982.

for a supper club in Paris. The technique is the same, but the effect is simple and direct. This is an ad for an enjoyable evening mingling with sophisticated, well-dressed people.

Poster art is now considered an international art form. Professional and commercial artists use advances in technology and reproduction processes to create visual messages for advertising and communication. Before you make your poster, look at two more poster masterpieces. One is for a Japanese department store (Figure 276) and the other (Figure 277) announces a sweet corn festival.

Shigeo Fukuda (foo-koo'-duh) made an ingenious poster for the Keio store which can be enjoyed as art, but it has a

SHIGEO FUKUDA : May 23 to 28. 1975 ☒ KEIO DEPARTMENT STORE·5F ART GALLERY.TOKYO

direct and simple message. With just a few unforgettable lines in black and white we get the message—women's and men's clothes and shoes are at Keio's.

What would you expect to do at a sweet corn festival? Stephen Frykholm (frick-holm) thought about that, and decided that the best thing to do with sweet corn is to eat it. He entices us by an image of an open mouth with deep red lips and strong white teeth engaged in eating a huge mouthful of perfect corn kernels in Figure 277. The idea is to get the viewer's interest focused on corn *right now*. Perhaps then he or she will say "Hey, I'd like some corn. Why don't we go to that festival?

POSTER ACTIVITY

1. You have just looked at some of the most extraordinary posters ever produced. The activity that follows is designed to give you the widest possible latitude in designing your poster. First there are some things that you should consider.

Discuss the common characteristics of these four examples of poster art. Also discuss the differences among the four. Did the style that each artist used seem appropriate to the subject? Why is that?

Next, recall some poster you have seen that made an impression on you. If none comes to mind, perhaps those recalled by others in the class will jog your memory. In your class discussion, try to reach some conclusion, or conclusions, about why some posters seen were memorable and some not. Did any of those seen spur you to act as the poster suggested?

The poster artist has much to consider. Here are some of the important considerations:

■ This may be my only chance at this particular audience. My poster may be plastered all over the country, but I can't expect any person to look more than once. I hope to get that one chance with the majority of those who pass by.

■ What is my message? I must make a firm decision before I start. Cassandre's message was "Take the train to the North."

Figure 277. The artist persuades the viewer to take action with a simple, unmistakable image of pleasure.
Steve Frykholm, *Sweet Corn Festival*. 1970. Silkscreen with lacquer finish. 39 1/4" x 25". Collection, The Museum of Modern Art, New York. Gift of Ivan Chermayeff.

Time spent on discussing the variety of the four artists' styles will be rewarded in the creative work that follows.

Use Classroom Reproduction #20

363

Features vs. Benefits is a subject stressed in almost all marketing courses. You may have a lively discussion on the difference of a "Feature" and a "Benefit" by thinking of a variety of products and services.

If that "message" caught the viewer, then he or she might look further and see that there would be an enjoyable breakfast and dinner available on the luxurious pullman cars. But if the viewer didn't catch the "Take the train to the North," the rest of the message would be lost.

■ At what audience am I aiming? Children? Teens? Mothers? Ultra-sophisticates? Retirement age people? I must attract my targeted audience at the expense of all others, if necessary.

■ My statement in this poster must clearly illustrate the *benefit(s)* to the viewer, rather than a feature of what I am pushing. Remember that mouth of Frykholm's enjoying that corn. The *corn* is a feature, the *enjoyment* pictured is a benefit.

■ Is part of my message a definite date? Is that vital to my message?

After class discussion, either you will choose your subject or one will be assigned to you by your teacher. If your topic is assigned, don't be discouraged at all. Each of the four artists of the posters that you have just studied was glad to get assignments, and happy to analyze carefully the best way to handle them.

The list below contains a variety of topics for your consideration and discussion. If the class uses these for discussion, consider the five points above for each topic.

a. A major golf (tennis, basketball, or other sport) tournament coming to your area on a forthcoming weekend.

b. A recruiting poster for the "Save the Anteater" society.

c. The opening of air service from your nearest major airport to a smaller city.

d. Mother Hubbard's Dog Bones—an old favorite product.

e. The forthcoming opening of the State Fair.

f. A lecture at a local auditorium by The Invisible Man.

g. A rummage sale by parents and teachers to benefit . . . (something needed at your school).

h. Jack's Famous Bean Seeds—a brand new product no one has heard of.

i. The "Old West" retirement home and spa at Gunsight, Arizona.

Use the visual elements and compositional principles carefully as you draw your poster; letter it, and paint it with tempera. Make it one of your goals to enjoy this project. One of the most enjoyable aspects will be sharing those posters the class has made.

UNIT

SPECIAL PROJECTS

The Artist and The Industrial World

ART HISTORY

1. African tribal art has had a profound effect upon modern art. A major exhibit, which toured the United States in 1985, powerfully displayed this by putting comparative examples of the two art forms side by side. The works of Picasso, Gris, Brancusi, and other modern masters of Cubism were displayed next to examples of sophisticated tribal works. The relationships were remarkably clear, and the public had the chance to see how the modern artists had drawn on this part of African heritage. This quote is from the catalogue which accompanied the exhibit:

"The word 'primitive' may still have negative associations for some readers, but when Picasso declared that 'primitive sculpture has never been surpassed,' he used the word ('primitive') in another, wholly positive sense. His judgment reflects the revolutionary new outlook of these

Figure 278. Modern artists were greatly influenced by the tribal art of Africa. Congo, *Mask, Kwele Initiation Society*. Giraudon/Art Resource, New York.

pioneer artists who, at the beginning of this century, opened Western eyes to the beauty, power, and subtlety of tribal arts. . . ."

This exhibit has long since been dismantled, but you can make your own analysis of the tribal art of Africa and the sculpture and painting of modern Cubist artists. You can find many good art books in the library with beautiful examples of African tribal art. There will probably be just as many reference books and magazine articles on Cubist art. You will find the matching process fascinating, and you will have little trouble seeing the influences of the tribal art on

Figure 279. The artist is moving away from traditional linear perspective and chiaroscuro to angularity and sudden changes of plane. Pablo Picasso, *Buste de Femme ou de Marin.* 1907. Oil on board. 53.5 cm. x 36.2 cm. © SPADEM 1983. SPADEM/Art Resource, New York.

such artists as Matisse, Picasso, Alberto Giacometti, André Derain, Maurice Vlaminck, and many others. You may make some quite original discoveries that previous scholars have missed. If you work alone on this project, share your findings with your class.

2. George Tooker's *The Subway* (page 308) is painted in egg tempera. Working with this medium is a very slow, exacting process which restricts an artist's output to only two or three works a year.

Research the methods of making egg tempera. Include in your research good examples from the Renaissance and from modern masters who continue to use this technique. Satisfy yourself that you understand the steps involved in this technique, and the purposes for which it is still used. Can you explain why Tooker felt it so important to use egg tempera in *The Subway*? Do you think that he was correct, and that the impact of his work would have been diminished if it had been rendered in oils? Make an oral or written report as your teacher directs.

3. Piet Mondrian's works are widely reproduced. His *Broadway Boogie-Woogie* appears on page 308. Find other examples of Mondrian's work in art books, magazines, or prints. Are you surprised by what you find? Arrange the examples along a timeline which illustrates the stages of his changes in style, from the representational to the very limits of abstract art. *Broadway Boogie-Woogie* (1944) was his last completed painting. Do you see any shift at all in this painting from others of his later works? Photocopy a few key paintings; show them to the class in chronological sequence, and lead a discussion of Mondrian's progress.

4. Picasso said that "The work one does is another way of keeping a diary." Picasso's "diary" is one of the most remarkable and varied in art history. His work parallels the history of art during his lifetime. As in studying the works of Mondrian, you are apt to find several surprises as you study Picasso's lifetime works. His work is so complex and varied that it is not as easy to see a direct line of progression as it is in studying Mondrian's work. As you look at the varied art of this prolific artist, keep this quote from him in your mind: "In our mutilated epoch, nothing is more important than enthusiasm."

Photocopy a few key works, show them to the class in chronological sequence, and lead a discussion on Picasso's art.

5. Robert Henri lived from 1865 to 1929. If you were to do a serious study of Edward Hopper, Stuart Davis, John Sloan, Frederic Remington, Yasuo Kuniyoshi, Rockwell Kent, and many other well-known and revered artists of this era, Robert Henri's name will occur in the study of each of them. Why? Why was he so good at what he did? Make an oral report to the class.

1. Figure 230, Edward Hopper's *Early Sunday Morning,* and Figure 231, George Tooker's *The Subway* are reproduced on pages 307 and 308 in the text. At first glance, these two paintings would seem to have little in common other than an urban setting. What other thing, or things, could be said about their kinship? Study the paintings; then write an essay comparing the similarities.

2. Look again at Tooker's *The Subway.* Who are these people, wrapped in their shroud-like coats, afraid to look at each other? The men have the same face, older or younger. One man descends to the level below. One man stands and waits. The central figure, a woman, approaches us while anxiously looking to her right. Another woman enters the barred gates. It all resembles a prison; they enter, but no one leaves. Three men stand half-hidden in wall niches (or telephone booths with no phones). No one communicates. Tooker said, "I was thinking of a large modern city as a kind of limbo. The subway seemed a good place . . . being underground with great weight overhead seemed important."

Tooker's use of perspective in this painting is interesting. Can you explain how he uses linear perspective to express the isolation of the people? Describe the devices Tooker uses to direct the viewer's attention throughout the picture.

How do these people affect you? Express your answer by staging a short production with an improvised set of a subway station. Each student actor should select a person in the painting and develop a monologue for that character. (Remember, there are no "star parts" in the world that Tooker has shown us here.) As the scene begins, each person should be in her or his place, just as in the painting, static or "frozen." One by one, each character will deliver his or her monologue. While talking, that character may move about the stage, but by the end of each monologue, the character is back in the original position.

3. Claes Oldenberg's *The Dormeyer Mixer* (page 323) has dimensions of 32 by 20 by $12\frac{1}{2}$ inches. This is a shockingly large mixer. Oldenberg has changed the metal and plastic parts of an actual mixer into soft shapes of vinyl stuffed with kapok. Why did this man make a soft sculpture of an ordinary kitchen appliance which actually is hard metal and plastic? And why did he make it so large? Is it really so important in our lives? Is this art? Oldenberg said about his work, "If I

Horizontal lines, such as those in the Hopper, are generally considered to be restful. Many will feel that in this case, they are something else. In fact, they evoke a feeling of unease, an impending doom. Is anyone alive in there? One critic said "There is an invading army, just off-stage, waiting to come in and take over."

Hopper affects many viewers in strange ways. The feeling of loneliness can be at least as unsettling in this painting as in Tooker's.

Discuss "limbo" with the students in the context Tooker meant. In addition to being the place for souls barred from heaven (though they are blameless), it is also a place of restraint or confinement, a place of neglect or oblivion, and an intermediate or transitional place.

Use Classroom Reproduction #5.

Use Classroom Reproduction #17.

Ask students to see how Picasso achieved the illusion of depth. Note the overlapping and the one dark fruit in the upper right-hand corner.

didn't think that what I was doing had something to do with enlarging the boundaries of art, I wouldn't go on doing it."

The pull of gravity is as important to Oldenberg's soft sculpture as the ability to resist gravity is in traditional sculpture. Oldenberg's sculpture contradicts our relationship to the environment. His irony lies in making things that are inherently *hard,* such as Dormeyer mixers, bath tubs, and light switches, out of *soft* materials such as canvas, vinyl, and kapok. He also makes soft objects such as hamburgers and baked potatoes *rigid* in hard plastered forms. Small objects such as electric wall plugs are made huge so that we consider their sculptural qualities. Oldenberg is not just glorifying these things; he makes them monumental, so they no longer remain what they were in our minds. The giant clothespin becomes an architectural structure. The enormous lipstick which he installed on the campus at Harvard University becomes a rocket ship at lift-off. He has memorialized an ice-cream bar in Times Square in New York. By doing this, Oldenberg makes his own commentary about the materialism of the Industrial Age and the values of consumerism.

Look at examples of large sculptural pieces near commercial or public buildings. These examples may be in your community, or found in magazines or books. Select a public spot in your community which would be appropriate for an Oldenberg-type piece of sculpture. Make a large sketch of this site. Decide upon the object which would be most appropriate for the site you have selected. Draw this object; then enlarge it as Oldenberg does. Cut it out, and place it within your large sketch of the site.

Are you happy with the result? If this were actually erected on this site, what would the public reaction be?

4. Look again at *Fruit Dish* on page 299. Picasso's style here is not the fractured, fragmented forms that are found in his later Cubist works. In this painting, Picasso has limited his palette to greens, yellow-ochres, cerulean blue, cool browns, black, and white. The objects retain a semblance of their original forms. The base of the bowl is viewed from an angle of approximately 45 degrees, while the profile of the bowl is seen from the side, and the inside is seen from above. The fruits in the bowl are side by side and above each other, rather than deeply filling the bowl.

Eric Satie (sah-tee') was a French composer and a friend of Picasso's. Together they worked on the musical score and

stage sets for two ballets. At times Satie would play the piano as Picasso painted or sculpted.

Arrange a still life with fruit, or, if possible, get a pear and slice it in three pieces to use as your model. Play a recording of Satie's *Three Pieces in the Form of a Pear*. Sketch and then paint the arrangement in the mood of the music and in the Cubist style.

Listen to another composition by Satie entitled *Gymnopedie* (zhim-know'-pay-dee) *Numbers 1, 2, and 3*. You will probably find the three pieces strange and quite soothing. At first, you may have difficulty distinguishing differences among the three sections numbered 1, 2, and 3, but there *are* subtle differences. Listening to the three has been likened to viewing a piece of sculpture from three angles. Do you see why? You may want to paint another arrangement while listening to this unusual piece of music.

5. Joseph Stella caught the amusement park in all of its vitality—the flashing dynamic movements, the orgy of light and sound in *Battle of Lights, Coney Island*. The painting penetrates with the Futurist's lines of force. They radiate out in all directions from the head of the turbaned potentate, which was, you recall, a landmark at the Coney Island amusement park.

In describing this painting, Stella said, "I built the most intense dynamic arabesque that I could imagine in order to convey a hectic mood, the surging crowd and the revolving machines generating . . . violent, dangerous pleasures."

Choose a particular public event or choose a place which has a natural vitality surrounding it. Interpret this place or event in a Cubist or Futurist-style drawing or painting.

6. Select a building, monument, or any other structure in your community that you can photograph from several different angles (without endangering yourself). If you completed Activity 2 in the last photography section, you may want to use some of those images in this activity. Make drawings from the photographs of each angle of the structure, and arrange them in a Cubist-style picture. Then cut, trim, and paste the photographs in a Cubist-style montage.

Ask the music teacher for advice and help if possible.

Again, use caution with the knife.

CAUTION

PART

IV

ART
APPLICATIONS

UNIT

GRAPHIC DESIGN AND ADVERTISING ART

GRAPHIC DESIGN

Less than forty years ago, fewer than twenty per cent of Americans worked in information-related jobs. Today, the majority of Americans spend their working hours creating, processing, or distributing information.

Most of us are now in the business of communicating with one another.

Communication is the process by which understanding is reached through the use of symbols. The symbols can be words or graphics or a combination of both. The word *understanding* is key to the definition of communication. Effective communication is of great importance in this electronic age.

For many years schools trained a graphic artist to be an important member of a team. The graphic artist worked with the art director, the journalist (or author, or copywriter), and other team members to present information in an

Figure 280. A graphic journalist prepares a graphic layout which combines the effective use of words and the visual elements and compositional principles.
Photo courtesy of David Hanover.

Relate the decrease in *types* of jobs, such as those of paste-up artists to the overall increase in jobs due to the information explosion of the past few years.

effective manner. Other traditional team members included typographers, paste-up artists, air-brush artists, layout artists, letterers, and calligraphers. Today, with the computer's help, the graphic artist has taken on many functions of these other team members.

Another important development is the overlapping of the functions of the writer and the graphic artist. Many experts see a future in which communication will be the province of a new breed called **graphic journalists.** The graphic journalist combines the effective use of words and the knowledge of how to present them with stunning graphics. People with this combination of skills are already working in many newsrooms and editorial offices. A person considering entering the field of graphic design should consider this trend and try to prepare himself or herself for the role of the graphic journalist. This means that he or she must understand graphics and typography as well as the process of communication. This process includes:

■ The *reason* for the message. Is it to give information? Is it to sell something? Is it to try to persuade people to adopt a cause?
■ The *message* itself. Is it clearly stated and attractively presented?
■ The *media* selection. Should it be TV? Radio? Magazines? Newspapers? A combination of some or all of these? If magazines, then which ones, and why?

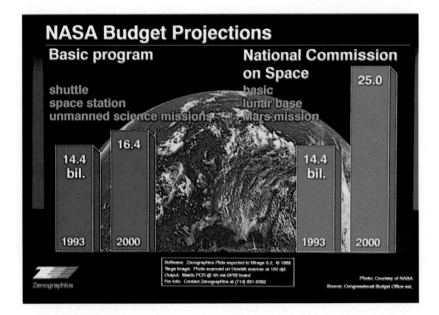

Figure 281. An example of a bar chart generated by a graphic journalist.
Courtesy of NASA.

■ The *audience* for this message, and its characteristics. What is the targeted age group? Which media do the group trust? What are the common interests, leisure activities, and other characteristics of the targeted audience?

■ *Feedback.* How can you obtain information that will show you the effectiveness of your communication? Should you use surveys? Should you make studies of buying patterns?

The graphic designers of the future will also need to know type styles, printing processes, the state-of-the-art graphic capabilities of the computer, color, design principles, paper characteristics, and camera and video capabilities. If you have a strong sense of good design and the desire to study hard and work hard, there will be a future for you in the challenging world of graphic communications.

Activity 1—Graphic Design In this activity you will work with a classmate to create a logo and letterhead for a business venture you have chosen. You may select one of the following businesses, or another approved by your teacher:

Garden shop and nursery	Brake repair shop
Art supply store	Hardware store
Book store	TV or radio station
Flower shop	Rent-a-car corporation
Frozen food specialty shop	Gourmet food store

Figure 282. Examples of business logos.

The first thing to consider for your new business is its name. It might be a simple combination of your two names, a name that clearly tells what the business is, such as "Safety Rent-a-Car," or some combination of both.

When you have decided on a name, consider a logo for your business. Begin by studying well-known logos, such as network and local television logos, corporate logos, and logos of successful local businesses. What characteristics do the logos have in common? Here are some important characteristics for you to consider as you design your business logo:

1. Is it appropriate for the business?
2. Is it easy to identify?
3. Could it stand alone and identify your business?
4. Is it simple enough to reproduce well on stationery and envelopes, advertising pieces, sides of delivery vans, mailing labels, printed forms, presentation folders, and work clothes?
5. Will it enlarge, or reduce, and still reproduce well?
6. Does it contain elements that may become outdated?

Taking these questions into consideration, design your logo.

The next step is to design your stationery. The letterhead you design will often be the first contact you have with

your prospective customers. It must make a good impression, yet not overwhelm your printed message. It should include your logo.

There are two basic methods of designing a letterhead:

1. The *traditional* method has a centered logo with the company name below it. It is symmetrical. The company's address, phone number, and fax number should be included. These can be centered at the bottom if you feel it improves your design.

2. The *modern* method is asymmetrical. The company's name and logo may appear on the left, but are counterbalanced by a two- or three-line address on the right.

ADVERTISING ART

Advertising communication is persuasive communication. Its purpose is to convince people to do something or accept something.

Whether discussing a major advertising campaign, a small advertisement, a brochure, or a one-page announcement, there are two key things to consider: creativity and strategy. Creativity simply means using new and unique ways to present graphics and words. Strategy is the approach to the problem of how to convince your audience to do what you want them to do.

The first step in strategy planning is to develop a *strategy platform*. This is based on research about the company producing the product, the product itself, the media to be used, and the targeted audience. The strategy platform is a joint effort of the graphics designer and the person who will supply the words (the copywriter). In advertising the strategy has five steps and is often referred to by the first initials of each step, AIDCA.

The first A stands for *Attention*. If an ad fails to get attention, all is lost. The attention grabber may be effective words printed in the correct type style or spoken on the radio or television screen, or it may be an effective piece of art, or a combination of these elements.

The I stands for *Interest*. Something in the working of the the *copy* and the *layout*, or something spoken, must stimulate the interest of the reader, listener, or viewer, and do so quickly.

The D stands for *Desire*. The target audience must want
to buy the product or respond to the appeal. At the very
least, this stage of the strategy must make the audience
want to know more about it.

The C is for *Conviction*. This is the step in which the
advertising team makes the audience ready to spend money
for this product or respond favorably to the appeal. The
audience must, by this point, clearly understand the advan-
tages of whatever is being promoted, and its importance to
the audience.

The last A is for *Action*. The communicator must provide
the audience with a definite, easy-to-follow plan of action.
The audience must know exactly where to get the product,
the time limit on any special price or offer, how to use a
coupon they may have received, how and where to sign up
for volunteer service, and so forth. If the audience is unsure
of what action is required, the communicator can be sure
that the entire message will be forgotten.

An advertising agency may have many different employ-
ees with many different responsibilities, or it may be a one-
person enterprise. Skill in the principles of design is one
vital prerequisite. If you have a strong background in art
and also enjoy expressing yourself in words, a career in
advertising should certainly be one to consider.

Activity 2—Advertising Start to look at magazine and
newspaper advertisements and listen and watch radio and
television commercials to see if you can identify the ele-
ments of AIDCA. You can judge them by their effectiveness
in using this formula. Make notes on the television ads. You
may notice that one common mistake is to stress the last A
to the point that you have forgotten the message entirely.
Clip some print advertisements you consider worthy of class
discussion, bring them to class, and compare your reactions
to those of your classmates.

UNIT

FASHION, INTERIOR, AND LANDSCAPE DESIGN

FASHION DESIGN

Each time you make a clothing decision, such as what to buy or what to wear, you are making a fashion design decision. You are using many of the same design principles that an artist uses in creating a work of art. Just as the elements and principles of design affect other visual media, so too do they affect fashion design.

■ **Lines** Look at a shirt with stripes. This is a classic example of the use of line in design. As you probably know, vertical lines on a shirt may make you look taller and thinner, because they lead the eye up and down. This makes the distance from side to side seem less significant.

■ **Form** The garments you wear create a form. For instance, a blazer with large shoulder pads will create a much broader, boxier form than would a fitted top or sweater.

Figure 283. How do the visual elements of art influence your choice of what clothes to buy?
Photo courtesy of David Hanover.

- **Shape** Shapes are created in garments by the lines of the fabric, seams, pockets, lapels, and other features. Look at a favorite shirt or top. How many shapes do you see?
- **Texture** Texture may be used to provide variety, emphasis, and balance in fashion design. The smooth surface of leather is a popular texture, as is the thicker, coarser texture of wool fabrics.
- **Color** What is your favorite color? Is this the same color you feel you look best in? What colors look good together? These are all issues in fashion design.

As you can see, we use the visual elements and compositional principles when we choose what clothes to buy and wear. Fashion designers also use them when designing new fashion styles—new forms, new colors, new textures, new uses of shape and line. You probably haven't thought of your clothes as "wearable art", but that's just how fashion designers think of their creations.

Fashion designers come from a variety of backgrounds, but most have studied art seriously. Formal training is given at recognized schools of design. Here the students are introduced to the technical aspects of fashion design (such as the construction of patterns) and also to the key elements of art and the principles of successful fashion design: the manipulation of line, texture, and color. Graduates of these schools

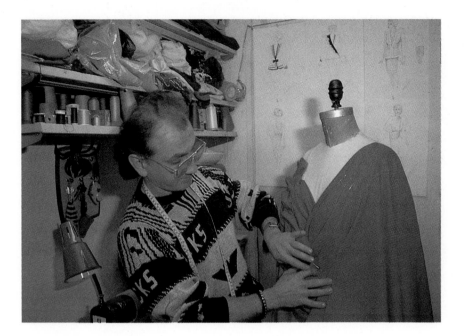

Figure 284. A fashion designer at work.
Photo courtesy of David Hanover.

might find employment in various sectors of the garment industry while learning their trade. Eventually some may become "apprenticed" to a designer. A very talented and fortunate person might find work in the shop of one of the top American, Italian, French, or Japanese designers. However, the producers of mass-produced, ready-to-wear clothing need continual injections of bold, new ideas in design. Both the designer shops and the ready-to-wear shops also need another ingredient—marketing.

Fashion marketing is the presentation, promotion, and advertising of specific collections targeted for carefully identified segments of the buying public. Fashion marketing is a unique field which requires training in the visual arts.

The stylist is an important person in fashion marketing. Stylists have different talents and specialties, but each must be expert in several areas. The stylists who create fashion shows need a wide knowledge of periods of art history, because they are required to re-create the visual "feeling" of various periods for a designer's collection. For example, a designer may have a collection that was inspired or influenced by the style of the 1930s in the United States and Europe. The stylist must re-create the visual atmosphere of that era, including the architectural style, interior design, landscape design, and automobile design. These elements are used to support the creations of the fashion designer.

Discuss the variety of images used in marketing fashion from the sophisticated images of high fashion to the flyers from discount stores. Discuss the purpose of each type.

Figure 285. Good fashion photographers must be able to grasp the spirit of the clothes the designer has created.
Photo courtesy of David Hanover.

Another kind of stylist directs the work of **fashion photographers** and **illustrators.** Have you noticed the elaborate advertisements in magazines for clothes by various designers? Have you also noticed that the "props" in these ads—the furnishings, rugs, pictures, curtains—all complement the garments perfectly? This stylist does much the same work as the fashion show stylist, but in this case, the product consists of visual images on the printed page. Color, line, and texture are essential to the creation of these ads. The stylist sets the tone. The good fashion photographer must be able to grasp the spirit of the clothes the designer has created and then, by lighting, camera work, the creative input of the stylist, and his or her own imagination, successfully translate this spirit into images for the viewer. So many images compete for the viewer's attention that stylists, photographers, and illustrators who can create memorable images are in great demand.

The demand for catalogue shopping has created many other photographic jobs in fashion. Still photography for just one of the many catalogues most households receive each week may involve two hundred images.

There is also the stylist who works for companies who make fabric. A fabric stylist must be able to foresee trends which will influence designers. He or she needs to have the vision to know when trends will reverse or change significantly. While the public may currently favor strong, bold colors, the fabric stylist, through research and knowledge of past

trends, may be convinced that there will soon be a shift to soft, earthy tones. Geometric patterns that are popular in one year may be replaced by florals in another. Strong textures may give way to smooth fabrics, or they may be replaced by "graphics" such as plaids. Will checks be in or out? Will prints be big and brassy, or small and refined? The importance of the fabric stylist's judgment cannot be overemphasized, since factories weave according to his or her instructions. It is a high pressure job (as are most jobs in the fashion industry), and the fabric stylist must establish a track record of being right.

Now we come to the person who pulls together the designer's creations, the work of the stylists, the photographers, and the illustrators. This person is known as the art director. An art director may be an employee of a fashion house, may work independently or for an advertising agency, a sales promotion group, or a chain of department stores. It is the art director's job to see that the designer's collection is shown to the public with consistency and maximum impact. Many of us can identify the work of several big-name designers from its "look." It is the behind-the-scenes thinking and hard work of the art directors and the stylists that have created this identity.

Fashion display is also an essential part of the marketing "mix." The window of the department store (and the windows of the electronic department store, the catalogue) offer a variety of opportunities for professionals to exercise artistic judgment. Even the finest of designs needs the enhancement of proper display, and this skill can lead to a rewarding career. Especially prized is the display artist, working for a department store or chain, who can be highly creative within a specified budget.

We have briefly mentioned the fashion illustrator in presenting a designer's work to the public. Other fashion illustrators make distinctive illustrations for major fashion stores and specialty shops. These stores want to create an image of themselves in the mind of the consumer. Some illustrators are employees of a chain or a store. Others are what is termed "free-lance," which means they are independent agents who take on specific projects for an agreed fee. In addition to developing a unique style, fashion illustrators must have the ability to get along with a wide variety of people and the ability to work under the pressure of strict deadlines.

Beyond the creation of the style of the garments, many other design areas overlap the world of fashion. Clothes

Can the students recall any especially interesting window displays they have seen? What made these memorable? Relate this discussion to the visual elements and compositional principles.

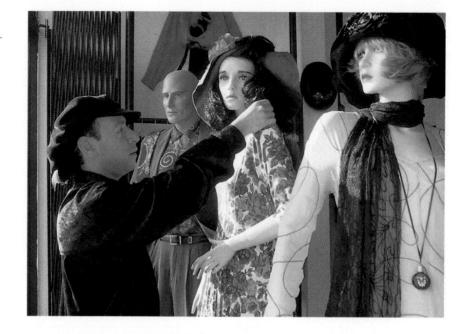

Figure 286. A fashion display artist at work.
Photo courtesy of David Hanover.

need accessories. Some design houses create their own. Others employ people to seek out the appropriate items, such as handbags, shoes, stockings, eyeglasses or sunglasses, hats, and even buttons. Jewelry design is a closely related field. Whether the jewelry is made from precious stones or "found" objects, it can be a fascinating fashion design area, which many consider an art form.

A person entering the field of fashion need not have great talent in studio art. Designers have skill in sketching and drafting, but their refined judgment is of equal importance. Many successful people in fashion design have prepared themselves by attending a design school which offers training in the aesthetics of color, style, line, and texture, and in the history of the fashion and decorative arts. A few schools offer training in the business aspects of fashion by teaching fashion marketing (sales promotion, advertising, distribution, and finance). So even if you do not possess strong studio skills, entry into this world may be open to you. You *do* need to have a very good "eye" for line, color, form, and texture. You should study art history and enjoy it. If the practical applications of aesthetics to everyday life appeal to you, and if you are willing to work very hard, then you should continue art courses in high school, and research further training beyond high school.

There are several fine schools of design in the United States which offer a broad array of courses for developing

the skills needed for a career in fashion design. You will need to plan well ahead. These schools are very much in demand. It takes solid preparation and planning to find an opening.

Activity 1—Fashion Illustrator Fashion illustrations are a unique art form. The art form has its own rules. The single purpose is to make the garment pictured seem desirable. You may have noticed that fashion illustrations seem somehow different, but have you considered in what way they differ from other illustrations?

As you will recall, the Greek ideal for the proportions of the human body was that the head should be portrayed one eighth the size of the body. We now consider the ratio to be approximately one to seven and one-half.

Use a ruler to help you in your research. You will also need several copies of fashion magazines, such as *Vogue* or *Glamour,* and several copies of the local newspaper.

Measure the heads and the bodies in several examples of fashion illustration. Calculate the ratio of the head to the entire body in each. Record your findings. What ratio is used? Why do you think this is done in fashion illustration?

Select a garment from your examples of fashion illustrations that is particularly appealing to you. Sketch that garment on a figure that has a head to body ratio of approximately one to seven and a half. Next, try some body-elongation sketches with the same garment. Compare the results. What conclusion can you draw from this?

If you have examples of good fashion illustrations from the past, they will be of great help with this activity.

INTERIOR AND LANDSCAPE DESIGN

As you have learned, fashion designers apply the elements and principles of design to produce wearable art. Interior and landscape designers also use the elements and principles. In interior design, space is the area with which the designer must work. Floor space can be filled with furnishings, left empty to create an open atmosphere, or divided by furnishings. As in clothing design, lines are used to lead the eyes. Should the drapes have stripes? The carpet? Texture may be used to create variety, emphasis, and unity. What materials should be used for upholstery? What about

Figure 287. Two interior designers discuss the use of color in a proposed design.
Photo courtesy of David Hanover.

the walls and the ceilings? What type of textures should these have? The characteristics of the room, and its uses, are considered in order to select and create an effective color scheme. The result should evoke a feeling of unity.

Interior designers create the setting and atmosphere in which people live and work. A well-designed work environment leads to higher worker productivity for two reasons. First, people and objects are grouped in an efficient manner. Second, the workspace is attractive and enjoyable. Efficient and pleasant working conditions almost always lead to increased productivity.

In the home, the interior designer must consider the unique characteristics and requirements of a family, as well as those of each family member, to create the most attractive and functional use of interior space.

An interior designer works with a number of clients. Some designers specialize in commercial, or office, design; some, in home design. In either case, clients are presented with options based upon the designer's research of their individual requirements. When a decision is made, the designer arranges for the purchase of furnishings, cabinets, lighting fixtures, fabrics, carpeting or other floor treatments, and accessories. Additionally, he or she supervises the work of those who install, or build, these things. An interior designer's work is just as important in restorations and renovations as it is in new homes or offices.

What attributes should an interior designer have? First, and probably of greatest importance, he or she must have a strong "feel" for the compositional principles. Without this, the designer will not be a success, regardless of other positive qualities. Assuming that the person has this "feel," he or she must constantly study the range of options to offer clients. The good designer is always just ahead of the market in knowing when and where new and improved products can be obtained. A solid background in, and appreciation of, historical periods in art is essential. Many designers concentrate on certain periods of design, learn all they can about these selected periods—wall coverings, fabrics, patterns, lighting fixtures, floor coverings, and colors that were used—and come to feel a great affinity for these eras. Interior designers must also truly enjoy working with people and supervising many different kinds of workers. Last, but by no means least, is the attribute of being a decision maker. With the enormous number of options available in fabrics, floor coverings, and other components the designer must consider, efficient decision making is vital.

Activity 2—Interior Design In this activity you will choose a period from the history of interior decoration and decorate a room in this style.

Begin by looking for the article on interior decoration in a good encyclopedia. There will be photographs in this section illustrating styles of the major periods of interior decoration. Select a period that is of particular interest to you. If possible, expand your research by a visit to the public library. Look for books with many illustrations of the period you have selected. Select interior features of a room (or a composite of several rooms) that appeal to you, such as tall windows, elaborate fireplaces, or ceiling moldings. Also select furnishings and accessories, such as chairs, sofas, tables, and lamps. Sketch these structural features and objects. Design a room appropriate for the period you have chosen. Don't forget natural and artificial lighting. When you have completed your sketches, make a drawing of your decorated room.

Landscape Design

Much of what has just been said about the attributes of a successful interior designer applies to the **landscape**

designer. In many cases the two work together to provide the client with a coordinated indoor-outdoor environment.

In landscape design, the compositional principles are as important as they are in interior design. In addition, a landscape designer must possess an almost encyclopedic knowledge of all types of plants and trees in the area and the growing characteristics of each. The landscape designer is much more than just an advisor on shrubs; he or she is an architect of outdoor space. This space must complement the structures built on it and provide restful, relaxing areas for office workers, as well as for residents and homeowners.

If an actual site that could contain a park is currently available in your community, you may want the students to consider its use rather than the one described in this activity.

Activity 3—Landscape Design In this activity, you will design a "vest pocket park." Many such parks are created in large cities using very small spaces. Some fill the space left when a building is torn down, and some fill natural spaces between, in front of, or behind buildings.

Imagine that you are a landscape designer and have been given a piece of land measuring 60 by 200 feet in which to create a restful environment for nearby office workers. At night, the areas will be deserted, so you will have to plan for fencing and gates for protection. The area is completely surrounded by skyscrapers which touch the park property line on three sides. There is the constant hum of the big city during all working hours in this location. Plan a haven for the prospective users of this small area. Assume it faces south. You will need seating, trees, perhaps sound-deadening or sound-suppressing devices, such as a waterfall or special panels.

If you enjoy planning such a project, you may want to consider this field when you select courses in high school and college.

U N I T

12

INDUSTRIAL AND TRANSPORTATION DESIGN

INDUSTRIAL DESIGN

Every manufactured item that you own, or come into contact with each day, is a product of industrial design. The ballpoint pen you write with was designed by an industrial designer. The automobiles you ride in and the jet aircraft you fly in are also the products of industrial design.

The industrial designer's job is to design products that will successfully compete with those of his company's adversaries—the competition.

There are two basic considerations for the industrial designer of any consumer product: *appearance design* and *functional design*. The two are inseparably linked. Appearance design is often of more importance to the consumer than functional design. This fact may seem irrational, but it is of tremendous importance to industrial designers, who must carefully balance appearance and functional design.

Figure 288. A motorcycle designed with CAD.
Courtesy of American Small Business Computers.

Some students will exhibit a good working knowledge of automobile design, and should be encouraged to contribute other examples of influential automobile design.

The history of automobile design provides fascinating examples of the necessity for this balance. One classic example in automobile history is the introduction of the Chrysler *Airflow* in the early 1930s. Automobiles began as mere carriages with an engine added, and they were still very "boxy" in appearance in the 1920s and early 1930s. The Airflow was a radical departure. The public immediately rejected the Airflow and continued to buy the more boxy shapes of the competitors. Yet, by the end of the decade, most automobile designs closely resembled the streamlined look of the Airflow.

Today, major industries, such as automobile and aircraft, use computer-aided design (CAD). This allows many designers to enter data and images which describe a new product. The computer becomes an electronic drafting tool. Computer controls allow the designer to rotate an image in any direction and display cross sections of any internal portion.

An automobile or aircraft can also be tested by the computer for performance characteristics, such as wind resistance, stress, vibration, and noise. This means a new model can be modified continually before tooling and production begins. In the case of a new model of automobile, remember that the computer is also taking into consideration the input of the marketing department based on consumer preferences in styling. No matter how sophisticated the process, appearance design is always part of the equation.

Activity 1—Industrial Design You have ready-made laboratories all around you for testing the importance of appearance design and functional design. These laboratories are your local department stores, hardware stores, drugstores, and supermarkets. A way to start your study is to pick some common manufactured items, such as telephones, radios, stereos, television sets, typewriters, or another product which interests you. Go to a store that carries several competing brands of the product you have selected. Consider the appearance of each of the competing products. Think of where you would put the product, other objects in the room that it should complement, the style of the product, and your own taste.

Next, consider the functional advantages and disadvantages of each competing product. Does one seem obviously superior? Does its functional superiority make it appear less attractive than its competitors?

Choose the product you consider the best. Analyze your choice. How much were you influenced by the product's attractiveness? How much by its apparent functional superiority? In this exercise, you have considered the problem that industrial designers face every day—how to get the utmost value in function combined with the most appealing product design.

APPENDIX

Note to Teachers: The art history timelines which appear in this appendix have been reproduced in transparency master format for your convenience. You might wish to use these to make your own overhead projector transparencies or student handouts to accompany class discussion of art history.

A BRIEF HISTORY OF ART

ANCIENT ART

The history of art begins approximately 30,000 years ago, during a period called the **Paleolithic** (pay-lee-oh-lith'-ic) Age. *Paleo* comes from a Greek word which means "ancient," and *lithic* means "stone" in the Greek language. In this age, human beings made pictures deep in caves, and many of these pictures survived (Figure A-1). Thus part of that ancient world was captured for posterity.

Cave paintings were not discovered until late in the nineteenth century. There was much speculation about what they were, who painted them, and when they were painted. In these paintings, animals were rendered in great detail, while people were represented as stick figures, such as a preschool child might draw. Powerfully rendered animals dominated the pictures, and many believe that the pictures were part of the ritual of the hunt for the nomadic people of the Paleolithic Age.

The **Mesolithic** (meh-zoh-lith'-ic) Age (8000 B.C. to 3000 B.C. followed the Paleolithic. *Meso* means "middle" or "between" in Greek. During this period, people began congregating in areas where food gathering was possible. This simplified their lives, and led to the first efforts to raise crops.

The **Neolithic** (nee-oh-lith'-ic) Age (3000 B.C. to 1500 B.C.) followed the Mesolithic. As you might guess, *neo* means "new'. In this age, there was steady progress in many cultural areas. The Stone Age ends in this period, as the people in four fertile river basins of the ancient world began what is now termed a "civilization". We will look at the culture of these four river civilizations, and then look at the beginnings of art in Africa and the Western Hemisphere.

Mesopotamia—The Tigris and Euphrates River Civilizations

The Greek word for "between rivers" is *Mesopotamia* (mess-uh-poh-tay'me-uh). The settlement of the land between the river valleys of the Tigris and Euphrates Rivers consisted of many villages. As the people learned to control the flooding in the area, their way of life was greatly improved. The small villages prospered and grew. The people were thankful for their prosperity and believed they were blessed by gods who made their crops grow. They worshipped the sun god, the water god, the earth god, the moon god, and others.

Figure A-1. Cave painting.
Group of Stags. Caves at Lascaux. c.
15,000-13,000 B.C. Dordogne, France.
Art Resource, N.Y.

Their art reflected these religious beliefs. The Mesopotamians built enormous temples called **ziggurats** (zig'-uh-rats) (Figure A-2). Dedicated to a god, these mud brick temples could be seen for many miles over the flat plains between the two rivers. Inside, these structures were lavishly decorated with fresco paintings and sculptures.

The history of this civilization was a bloody one. It was in constant danger of being overrun by invaders who lived under harsh conditions in the surrounding desert. Many remaining Mesopotamian relief carvings depict battle scenes.

The Nile River Civilization

The vast desert which surrounded the Nile provided a fair measure of protection from invasion for the area and for the Nile's life-giving water. So, along this long valley of the Nile, many quite similar settlements began. The entire Nile valley gradually became one large community. The need for dams and levees for flood control led to the rise of powerful leaders who could organize such large projects. This unification occurred around 3000 B.C. High priests of the Nile dictated the religious art of the region. Later, the art also became political, much of it dedicated to celebrating the achievements of the great monarchs. Most of the art was created for the tombs of these

monarchs. We have seen examples of Egyptian tomb painting and relief sculpture in Book One on pages 61, 63, and 241. An enormous amount of labor was required to construct these tombs, which we know as the Pyramids of Egypt.

The Indus Valley Civilization

The Indus Valley civilization began around 3000 B.C. and flourished in Southwest Asia for many hundreds of years. About 1800 B.C. it was overrun by invaders from nomadic tribes. During the time of this civilization there were truly great civic accomplishments, such as wide thoroughfares, piped fresh water, elaborately decorated public pools, and drains for waste removal and flood control. Brick homes were common, and these were built with fired brick rather than the sun-dried bricks used in Mesopotamia.

The scale of the art was smaller and of a more personal nature than that of the other river civilizations. Gold, silver, and semiprecious stones were commonly used. Two distinct types of sculpture are evident. One was formal and rather stiff in design and execution. It is generally believed that the subjects depicted in this style were the holy men of the Indus civilization. In total contrast, the other style was quite informal, with natural, lifelike poses. The informal style was an important

Figure A-2.
A Mesopotamian Ziggurat.
View from the southeast of the partially restored Third Sumerian Dynasty Ziggurat at Ur. c. 2100 B.C. The Granger Collection, New York.

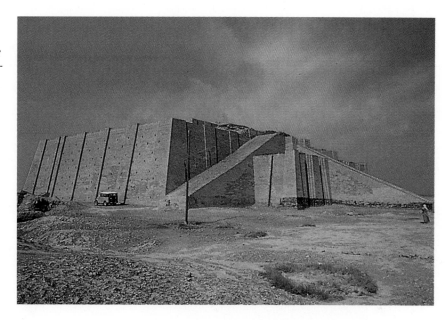

influence on the sculpture of India for many centuries to follow.

The Yellow River Civilization

The development of the Yellow River basin cultures was somewhat different. Neolithic artisans had made fine pottery and carved jade since approximately 4000 B.C. The Bronze Age began in China around 2200 B.C.

Dynastic rule began on the Yellow River. A **dynasty** is a succession of rulers of the same line of descent. Chinese art is classified by the dynasty in which it was produced. The oldest surviving artifacts in bronze come from the Shang Dynasty. This is the first dynasty about which a great deal is known. It began around 1700 B.C. The bronze casting of the Shang Dynasty is unsurpassed (Figure A-3). Shang artists also worked in jade and marble. There are some excellent examples in Book One on pages 114 through 116.

Chinese civilization is unique in that a clear path can be traced almost as far back as the earliest use of bronze in China (2200 B.C.) to the present. For nearly 4,000 years, Chinese art has survived and kept many of the virtues which we see in the Shang Dynasty. It has survived because of its ability to absorb the new while honoring the traditions of the past. It has a unique flexibility. Consider, for

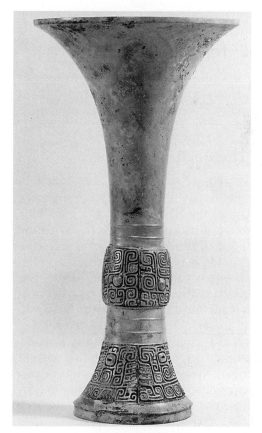

Figure A-3. Bronze vase from the Shang Dynasty. *Ku: Wine Beaker*, late Shang period, China. 13th - 12th century B.C. Bronze. Height 10 9/16". The Cleveland Museum of Art. John L. Severance Fund.

Understanding and Creating Art—Timeline 1

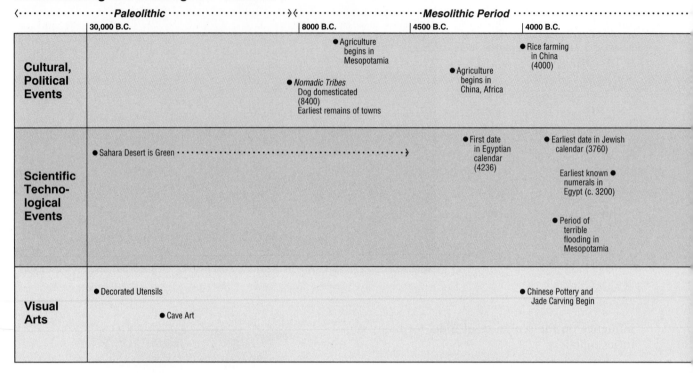

⟨·····················*Paleolithic*·····················⟩⟨·····················*Mesolithic Period*·····················

	30,000 B.C.	8000 B.C.	4500 B.C.	4000 B.C.
Cultural, Political Events		● Agriculture begins in Mesopotamia ● *Nomadic Tribes* Dog domesticated (8400) Earliest remains of towns	● Agriculture begins in China, Africa	● Rice farming in China (4000)
Scientific Technological Events	● Sahara Desert is Green ·····················⟩		● First date in Egyptian calendar (4236)	● Earliest date in Jewish calendar (3760) Earliest known ● numerals in Egypt (c. 3200) ● Period of terrible flooding in Mesopotamia
Visual Arts	● Decorated Utensils ● Cave Art			● Chinese Pottery and Jade Carving Begin

example, the Chinese sages who simultaneously admire the bamboo for its ability to bend without breaking, and jade for breaking without bending.

The Beginnings of Art in Africa

The first art in Africa was that of cave dwellers. Thousands of years later, the great Nok culture developed in Northern Nigeria. With the Nok culture began the long tradition of sculpture in Africa. The Nok culture is unusual in that it bypassed the Bronze Age entirely. Iron smelting had developed fully in the Nok culture by 1000 B.C. Nok artists made terra cotta figures of monkeys, snakes, and many other animals of the region. These figures are generally found with iron-working equipment. The Nok created human images that are particularly significant for their individuality. The personality of each subject is communicated powerfully. The quality of the work of the Nok artists indicates that there must have been a long tradition of sculpture. In the third century B.C., the Nok culture vanished, leaving few traces. However, the style and individuality of Nok art influ-

Figure A-4. This is a fragment; only the nose and mouth remain. Fragment of the face of a tubular head. Tonga Nok. c. 500 - 400 B.C. Terracota. Height 6 1/4". Jos Museum, Nigeria. Courtesy Nat'l. Comm., of Museums and Monuments, Lagos.

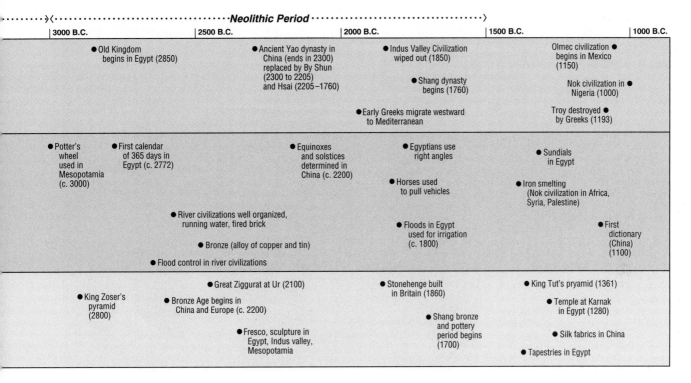

	Neolithic Period			
3000 B.C.	2500 B.C.	2000 B.C.	1500 B.C.	1000 B.C.

● Old Kingdom begins in Egypt (2850)

● Ancient Yao dynasty in China (ends in 2300) replaced by By Shun (2300 to 2205) and Hsai (2205–1760)

● Indus Valley Civilization wiped out (1850)

Olmec civilization ● begins in Mexico (1150)

● Shang dynasty begins (1760)

Nok civilization in ● Nigeria (1000)

● Early Greeks migrate westward to Mediterranean

Troy destroyed ● by Greeks (1193)

● Potter's wheel used in Mesopotamia (c. 3000)

● First calendar of 365 days in Egypt (c. 2772)

● Equinoxes and solstices determined in China (c. 2200)

● Egyptians use right angles

● Sundials in Egypt

● Horses used to pull vehicles

● Iron smelting (Nok civilization in Africa, Syria, Palestine)

● River civilizations well organized, running water, fired brick

● Floods in Egypt used for irrigation (c. 1800)

● First dictionary (China) (1100)

● Bronze (alloy of copper and tin)

● Flood control in river civilizations

● King Zoser's pyramid (2800)

● Great Ziggurat at Ur (2100)

● Stonehenge built in Britain (1860)

● King Tut's pyramid (1361)

● Bronze Age begins in China and Europe (c. 2200)

● Temple at Karnak in Egypt (1280)

● Shang bronze and pottery period begins (1700)

● Fresco, sculpture in Egypt, Indus valley, Mesopotamia

● Silk fabrics in China

● Tapestries in Egypt

enced all African art to come (Figure A-4) and, as we will see, had an important role to play in twentieth century art.

The Beginnings of Art in the Western Hemisphere

In what is now Central America, a culture based on hunting and foraging was slowly replaced by a culture based on the raising of a form of corn called maize. This process began around 7000 B.C. By 1500 B.C. there were settled agricultural villages in the region known today as Mexico.

The Olmec civilization evolved in southwestern Mexico. It is considered the "mother culture" of the pre-Columbian world. (The term *pre-Columbian* refers to the New World before the coming of the Europeans.) During the six hundred year period from 1150 to 500 B.C. the Olmec culture thrived. Its influence was felt throughout the large area now known as Mexico.

Olmec images that survive today are almost all of human beings, and most particularly of the human head. The astonishing size of these pieces,

and the extreme hardness of the stone used to create them, make the Olmec artists seem almost superhuman. We can only speculate about the purpose of these enormous carved heads which the Olmec people somehow transported sixty miles from their quarries.

Heads, such as the one you see in Figure A-5, are the best known Olmec works, but there are many fine smaller pieces of Olmec art in museums around the world. If you can remember what this head looks like, you will probably be able to recognize Olmec pieces wherever you encounter them.

INTERLUDE

Histories of the visual arts have traditionally concentrated on European (or what is often called Western) art, tracing its traditions from ancient Egypt to Greece, then Rome, the Middle Ages, the Renaissance, and on to the latter part of the nineteenth century. By that time, outside influences on Western art become too important to ignore, but before the late 1800s non-Western art is often

Figure A-5. A giant Olmec head.
Colossal *Olmec Head* c. 800-600 B.C. Mexico. Basalt. Height approximately 6 feet. San Juan, Teotihaucan. Museo Jalapa. Foto Films/Art Resource, N.Y.

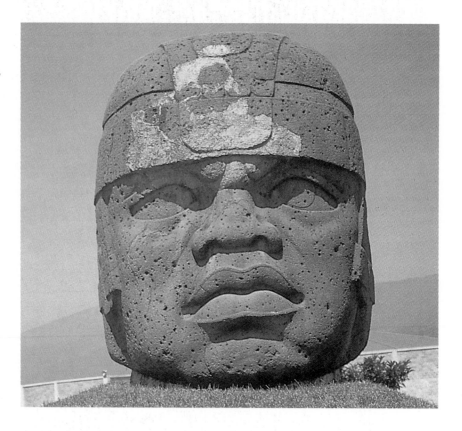

ignored. There are two problems with taking such an approach to the history of art. The first is that without some appreciation of non-Western traditions in art it is hard to understand why they had such an impact on Western art. Second, this approach assumes that the traditions of non-Western art are of less importance than Western traditions, that they are too hard to understand or are, in some way, inferior. As you will discover, this is not so.

We will now look briefly at Western art traditions from the time of the ancient Egyptians to the last part of the nineteenth century. Then we will study the art traditions of non-Western civilizations for the same period. During this long period, there was contact among the many great world civilizations. However, the results of the contact were much more important in the fields of commerce than in art. The artistic traditions of European, African, Asian, and Native American art were the result of the genius of the people in these various cultures. The traditions were developed within the separate cultures without highly significant outside influences. Important exceptions will be noted.

In the final section, we will weave all of the threads together, and explore the impact of these diverse traditions on one another in the age of world-wide communication.

WESTERN ART

The Egyptians

Around 2800 B.C., the period known as the Old Kingdom of the Nile was maturing. The royal architect, Imhotep, created a monumental funeral district for a King named Zoser. Among the palaces, temples, and other assorted structures built for Zoser's resting place was the first pyramid, a monument designed to last forever.

Forever was an important concept for the ancient Egyptians. They believed that, when a person died, the spirit left the body temporarily but would return. Upon returning, it would need a body to return to. Then the body, and its returned spirit, would need his or her personal belongings.

The average person had very few personal possessions, but for royalty the number of possessions posed quite a problem. Kings' tombs had to be carefully planned to hold royal treasures for the king's use and enjoyment through eternity. A problem remained, however. No matter how huge the burial chambers and storage rooms, they could not hold all that the monarch had accumulated. To compensate for this the kings hired artists to make pictures of their palaces, land, livestock, pets, and other personal possessions. Such things were depicted on the walls of their pyramids along with scenes of their triumphs in life. The ornate coffin of an Egyptian king appears on page 198 of Book One.

Egyptian art became highly stylized over thousands of years. There are several examples in Book One on pages 61–65. The sameness of Egyptian life and art over a period of 4,000 years is quite remarkable. There were successful invasions from time to time; there were benevolent rulers and terrible despots; but the average person continued to till the fields and was occasionally obliged to help in an enormous community effort or building project. We have learned a great deal about the Egyptians, their traditions, and their culture. They invented a system of picture writing called hieroglyphics (high´-er-o-glif´-icks), and they invented ink. Many of the pyramids and temples have been looted through the centuries; but many remain, and the wealth of art that they hold tells us much about the people of ancient Egypt.

The Glory of Greece

In a period of approximately three hundred years, the remarkable people of Greece provided the foundation of Western art, politics, science, and philosophy. The Greeks acknowledged that their civilization was a continuation of the Mesopotamian and Egyptian civilizations that came before them. The difference is in the way the Greeks developed their traditions.

Development is a good word to remember when you think of the Greeks. They boldly experimented and quickly adopted and adapted new ideas. For example, the oldest surviving Greek statues are carved from marble (Figure A-6). We know that these statues were an adaptation of still older wooden statues which have not survived the ages.

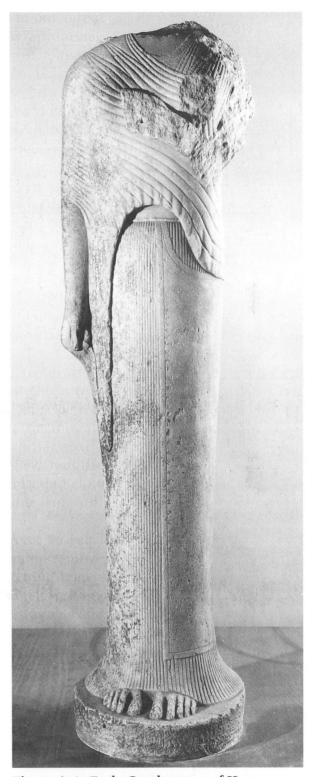

Figure A-6. Early Greek statue of Hera.
Hera from Samos. c. 560 B.C. Marble. Height approx. 6′4″.
Louvre, Paris. Courtesy Cliché des Musées Nationaux, France.

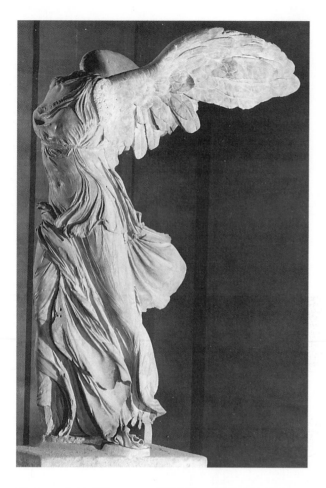

Figure A-7. The graceful Nike of Samothrace.
Nike of Samothrace. Greece. c. 190 B.C. Marble. Height approx. 8'.
Louvre, Paris. Courtesy of Cliché des Musées Nationaux, France.

How do we know this? The earliest marble statues are straight and tall and the poses are wooden. They look as though they were carved from the trunk of a tree. Typically, the Greek artists developed their sculpture from early woodenness into graceful, natural poses. The Greek sculptors took advantage of the different sizes of the blocks of marble. We can see this development by looking at figures A-6 and A-7.

The Greeks strove constantly for perfection in all of the arts. The proportions of their architecture have been copied throughout the centuries. Greek sculpture of the human body achieved almost perfect proportions, and these idealized figures were used by athletes as models for the development of a more perfect body. From rather crude beginnings, all of the fine arts were transformed in the short

history of these remarkable people to examples which are the foundation of Western civilization.

In 404 B.C., after a war that lasted for a generation, the great, enlightened city-state of Athens was defeated by the uninspired Spartan city-state. The glorious days of Greece were ended. Alexander the Great conquered the known world, and Greece fell in 323 B.C. A group of great Mediterranean sailors called Etruscans spread the art of Greece throughout the area and to the Roman Empire. Rome was to "liberate" Greece in 146 B.C., and Rome was to conquer the world.

The Grandeur of Rome

Roman art was so heavily influenced by the art of Greece that scholars have only recently given the Roman artists the credit due to them for their originality. Greek statues had been carted off to Rome and copies had been made from molds. While there is no doubt that Grecian art was the strongest influence on Roman art, the Romans developed a more natural style than that of the Greeks. A tradition in Roman households was to keep death masks of their ancestors, which were, of course, very realistic. This tradition led to more realistic portrayals in art, as opposed to the highly idealistic ones in Grecian art. An example of this realistic style is Figure A-8.

The Romans were among the great builders of history. Many of the bridges, roads, buildings, and aqueducts of the Roman Empire still exist. They may be found throughout Europe. The Roman invention of concrete made much of their construction possible. Shortly after the time of the birth of Christ, the Colosseum was completed. This immense structure held 87,000 spectators. Roman architects had perfected the arch and the barrel vault. They then combined multiple arches and intersected them around an axis which resulted in a dome. In homage to Roman gods, the great domed Pantheon was completed in A.D. 125. To enter the interior of the Pantheon is an unforgettable experience. The huge circular floor is topped by a sphere. The diameter of the interior and the height of the dome are the same, 144 feet. Try to envision this. It is almost one half the length of a football field. The weight of the dome is supported not only by the thick walls, but also by arches hidden in the walls by the architects.

The well-chronicled fall of the Roman Empire was more of a gradual erosion than a sudden fall. The Empire had become so widespread that governing it and protecting its borders became too big a burden for a city-state form of government. The city of Rome itself fell to barbarians called West Goths (also called Visigoths) in A.D. 410.

The Middle Ages

After the fall of the Roman Empire, a period of migration began. People wandered, searching for a place with some stability. There was precious little security for those who inhabited the former provinces of the Roman Empire. It was a world in ruins. The once great highways were decaying; the old order lay in chaos. What remained of classical Greek and Roman manuscripts gathered dust in abbeys and monasteries. These were the "Dark Ages," and they lasted for almost four centuries.

There were only a few lights in this darkness, but they were important lights. St. Benedict began building monasteries. His "Foot Soldiers of Christ" brought a measure of protection to the countryside. Those who had talent and ambition entered the Church. The Benedictines took in the needy, cared for the sick, and grew crops. Their followers grew in numbers, and new churches were needed. Naturally, the builders made use of a style that they knew. Many featured the Roman arch, and some were domed in the style of the Pantheon. However, new churches became increasingly larger.

During the eighth century the system of *feudalism* began. In this system the peasants (called *serfs*) worked the land for their lords, and the lords provided vital protection. Eventually, feudalism produced a calmer environment in Europe, in which towns were created and grew. The larger communities had tradespeople, and trade among communities became common. This rustic trading economy evolved into a money-based economy. Craftspersons became numerous and highly specialized; they formed guilds, which established professional standards for membership. The small, Romanesque churches began to be replaced by cathedrals (See Figures A-9 and A-10).

In 1144, the Abbot of St. Denis, a monastery near Paris, played an important part in architectural history. The abbot, named Suger, decided to enlarge his monastery in a very unusual way. The

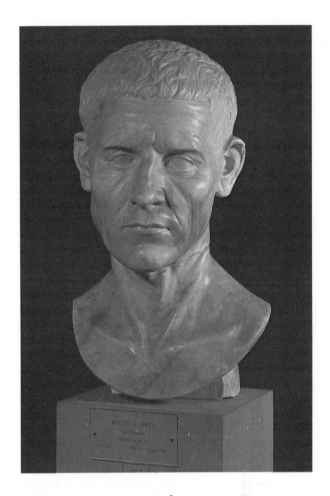

Figure A-8. Roman sculpture was very realistic. Bust, presumably of the Roman general Sulla. (c. 138-78 B.C.) Marble. Lifesize. Venice, Museo Archeologica. Scala/Art Resource N.Y.

builders Suger selected introduced a new skeletal type of construction—ribbed vaults. This construction method included the creation of windows. Suger believed the divine radiance of heaven poured in with the light these windows admitted.

A new style of architecture spread, as civic pride resulted in funds to construct similar cathedrals in many parts of Europe. This meant work for architects and stone masons. The high spires of the cathedrals were raised to the glory of God. Ironically, their architectural style was named *Gothic* as a scornful criticism. The Italian critic Vasari thought it wrong to deviate from established Romanesque building traditions. He gave the style the name of

Understanding and Creating Art—Timeline 2

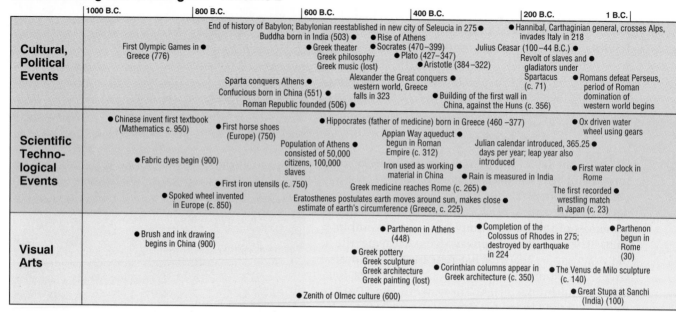

	1000 B.C.	800 B.C.	600 B.C.	400 B.C.	200 B.C.	1 B.C.
Cultural, Political Events	First Olympic Games in Greece (776)	End of history of Babylon; Babylonian reestablished in new city of Seleucia in 275 ● Buddha born in India (503) ● Sparta conquers Athens ● Confucious born in China (551) ● Roman Republic founded (506) ●	● Rise of Athens ● Greek theater ● Socrates (470–399) Greek philosophy ● Plato (427–347) Greek music (lost) ● Aristotle (384–322) Alexander the Great conquers ● western world, Greece falls in 323 ● Building of the first wall in	China, against the Huns (c. 356)	● Hannibal, Carthaginian general, crosses Alps, invades Italy in 218 Julius Ceasar (100–44 B.C.) Revolt of slaves and ● gladiators under Spartacus (c. 71) ● Romans defeat Perseus, period of Roman domination of western world begins	
Scientific Techno- logical Events	● Chinese invent first textbook (Mathematics c. 950) ● First horse shoes (Europe) (750) ● Fabric dyes begin (900) ● First iron utensils (c. 750) ● Spoked wheel invented in Europe (c. 850)	● Hippocrates (father of medicine) born in Greece (460 –377) Population of Athens ● consisted of 50,000 citizens, 100,000 slaves Greek medicine reaches Rome (c. 265) ● Eratosthenes postulates earth moves around sun, makes close ● estimate of earth's circumference (Greece, c. 225)	Appian Way aqueduct ● begun in Roman Empire (c. 312) Iron used as working ● material in China ● Rain is measured in India	Julian calendar introduced, 365.25 ● days per year; leap year also introduced	● Ox driven water wheel using gears ● First water clock in Rome The first recorded ● wrestling match in Japan (c. 23)	
Visual Arts	● Brush and ink drawing begins in China (900)	● Zenith of Olmec culture (600)	● Parthenon in Athens (448) ● Greek pottery Greek sculpture Greek architecture Greek painting (lost)	● Completion of the Colossus of Rhodes in 275; destroyed by earthquake in 224 ● Corinthian columns appear in Greek architecture (c. 350)	● Parthenon begun in Rome (30) ● The Venus de Milo sculpture (c. 140) ● Great Stupa at Sanchi (India) (100)	

the barbaric Goths who sacked Rome. The name survived, but the scorn was forgotten, and the Gothic style prevailed.

Stained glass bathed the interiors of Gothic cathedrals with a jeweled radiance. These glowing colors influenced artists producing illuminated manuscripts in monasteries. The windows took up much of the interior space formerly devoted to fresco painting and tapestries. Because they no longer had the great wall expanses of the Romanesque churches, painters were forced to seek other surfaces, such as wood and canvas, on which to paint.

Romanesque art had, for centuries, depicted the insignificance of the human being, in contrast with the concept of an all–powerful God. People of the time saw life as a preparation for the hereafter. The citizens of a Gothic city, while still glorifying God, were able to look around and enjoy some aspects of the world in which they lived. The groundwork was being laid for the great flowering of the human spirit we call the Renaissance (ren'-uh-sahns).

The Renaissance

Renaissance is a French word meaning "rebirth." The humanism of St. Francis, one of the most

Figure A-9. A Romanesque church. Main facade and entry, *Notre Dame la Grande*. 12th century A.D. Poitiers, France. Giraudon/Art Resource, N.Y.

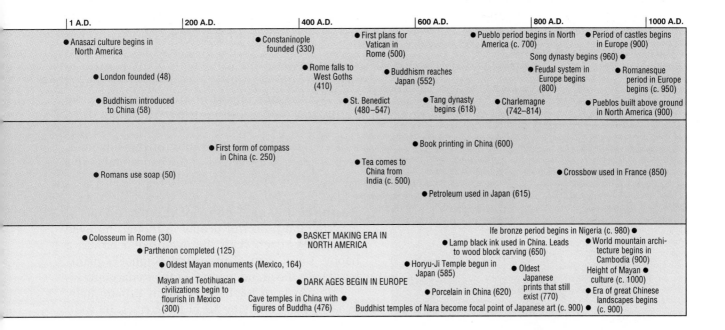

1 A.D.	200 A.D.	400 A.D.	600 A.D.	800 A.D.	1000 A.D.
● Anasazi culture begins in North America	● Constaninople founded (330)	● First plans for Vatican in Rome (500)	● Pueblo period begins in North America (c. 700)	Song dynasty begins (960) ●	● Period of castles begins in Europe (900)
● London founded (48)	● Rome falls to West Goths (410)	● Buddhism reaches Japan (552)		● Feudal system in Europe begins (800)	● Romanesque period in Europe begins (c. 950)
● Buddhism introduced to China (58)		● St. Benedict (480–547)	● Tang dynasty begins (618)	● Charlemagne (742–814)	● Pueblos built above ground in North America (900)

● First form of compass in China (c. 250)

● Book printing in China (600)

● Romans use soap (50)

● Tea comes to China from India (c. 500)

● Crossbow used in France (850)

● Petroleum used in Japan (615)

			Ife bronze period begins in Nigeria (c. 980) ●	
● Colosseum in Rome (30)	● BASKET MAKING ERA IN NORTH AMERICA	● Lamp black ink used in China. Leads to wood block carving (650)	● World mountain architecture begins in Cambodia (900)	
● Parthenon completed (125)		● Horyu-Ji Temple begun in Japan (585)	Height of Mayan ● culture (c. 1000)	
● Oldest Mayan monuments (Mexico, 164)		● Oldest Japanese prints that still exist (770)		
Mayan and Teotihuacan ● civilizations begin to flourish in Mexico (300)	● DARK AGES BEGIN IN EUROPE	● Porcelain in China (620)	● Era of great Chinese landscapes begins (c. 900)	
	Cave temples in China with ● figures of Buddha (476)	Buddhist temples of Nara become focal point of Japanese art (c. 900) ●		

Figure A-10. A Gothic cathedral. West facade of *Salisbury Cathedral*. Begun c. 1220 A.D. Granger Collection, New York.

beloved of medieval saints, was combined with a renewed interest in the Greco-Roman spirit, which emphasized the importance of this world. The individual regained importance in everyday thought, life, and art. A family named Medici became very wealthy and powerful in Florence, Italy. The Medici, the rulers of the city, supported art and scholarship as patrons with a generosity that had not been seen before. (Nor has it been seen since.)

Around 1440 Cosimo de Medici built the first public library since ancient times. Cosimo's grandson, Lorenzo the Magnificent, presided over the "Golden Age" of Florence, and made it a city of unsurpassed beauty and splendor. After Lorenzo died in 1492, Florence, successfully invaded by France and Spain, fell. The Medici were expelled and the Renaissance moved from Florence to Rome. But the influence of the Medici did not end. Lorenzo's son became Pope Leo X, and Leo X was the patron of Raphael and Michelangelo.

Titans of the Renaissance

Leonardo Today we occasionally speak of a person who has a variety of interests and talents as a "Renaissance man." No one in history embodies

Figure A-11. The legendary *La Giaconda* (*Mona Lisa*). Leonardo da Vinci. *Mona Lisa.* About 1503-05. Oil on panel. 30 1/4" x 21". The Louvre, Paris. Courtesy Cliché des Musées Nationaux, Paris, France. © Photo R.M.N.

We have seen his great painting of *The Last Supper* in Book One (page 101). This painting is the standard by which any other painting on this subject must be judged. In spite of the deteriorating condition of the painting, it is still possible to marvel at the magnificent drawing of each head and the dramatic impact of the scene. Locate the vanishing point, and consider the logic of it. Leonardo's *La Giaconda* (*Mona Lisa*) is also legendary. The obvious relaxation of the subject as well as the expressiveness of the hands makes this a landmark in portraiture. See Figure A-11.

Raphael Raphael enjoyed the patronage of wealthy and powerful people. Although he lived only thirty-seven years, he lived like a prince, a happy, social man-of-the-world. Raphael's paintings typify the grand manner of the Renaissance.

He was born Raphael Sanzio in Urbino, Italy, in 1483. After studying art in three cities, he went to Florence, where he met the great architect Bramante. Bramante was so impressed by the artistic abilities of the young man that he took him to Rome to work for Pope Julius II. Julius died soon after and was succeeded by Leo X, a Medici, as you recall. Leo, who immediately recognized the talent of Raphael, was a good man for Raphael to find favor with. As a Medici, Leo was not against spending some money.

Raphael was influenced by Leonardo and Michelangelo. His madonnas have been acclaimed for their dignity, grace, and sweetness. The soft modeling of his madonnas reflects Leonardo's *Mona Lisa*. Raphael was known as "Il Divino Pittore"—the divine painter. When Bramante died, Raphael was named architect-in-chief of St. Peter's Cathedral, but he did not live to execute his ideas.

Raphael was greatly loved. When the "prince of painters" died, all Rome wept at his funeral.

Michelangelo If Raphael loved society, Michelangelo was his opposite. Raphael said that Michelangelo was "as lonely as a hangman." The words often used to describe Michelangelo are *intractable, irascible, tormented, impatient*—impatient with himself as well as others. He was totally devoted to his art, and completely confident in his work. He was a painter, poet, architect, and engineer, but considered himself a sculptor. He believed sculpture to be a superior calling, for a sculptor could, he

this ideal better than Leonardo da Vinci. Scholars have said that his genius was so colossal that it defies understanding. Leonardo believed that it was possible for art to provide a source for scientific understanding. Because artists are the best observers, Leonardo said they were the best equipped to investigate the natural world. His work shed light on an astounding number of disciplines, including botany, zoology, anatomy, light theory, mechanics, and weaponry. He drew designs for an enormous range of proposed inventions, such as underwater diving bells, aircraft, various weapons (including a stink bomb), and chariots. All of his scientific investigations, he said, were aimed at making him a better painter.

said, somehow share in the divine power to "make men."

Unlike Leonardo, Michelangelo did not trust mathematical method. To achieve proportion he felt that one must "keep one's compass in one's eyes and not the hand, for the hand executes, but the eye judges." His art departs from the strict form of the Renaissance, but then Michelangelo's art departs from all other art. It has great expressive strength and a sense of tragic grandeur. *Terribilita* is the word for this in Italian—the sublime combined with the fearful and awesome.

Michelangelo created works that defy the greatest writers' description. A detail of his Sistine Chapel ceiling painting appears on page 230 of Book One. The moment pictured, when the spark of life jolts into Adam from the hand of God, can only be appreciated; it cannot be described or duplicated. Michelangelo's *The Last Judgment*, another immense work (48 by 44 feet), is probably the most famous painting in Rome.

Michelangelo's seventeen-foot-tall statue of *David*, completed in 1504, was a direct link back to the Greek artists, with their sense of balance, proportion, and the beauty of the human form. It established Michelangelo as the most famous artist in Italy. He stands as a lonely colossus in art, striding across the centuries, the supreme genius whose work lives forever.

This was the Renaissance.

Figure A-12. Bronzino's cool, refined *Portrait of a Young Man*. Bronzino, *Portrait of a Young Man.* c. 1550. Oil on wood panel. Approx. 37 5/8" x 29 1/2". Metropolitan Museum of Art, New York. (H.O. Havermeyer Collection, bequest of Mrs. H.O. Havermeyer, 1929.)

Mannerism

Critic Giorgio Vasari, who coined the name Gothic, also originated the term *La Maniera (The Manner)* for describing the works done according to the high classical standards of the Renaissance. This term assumed a different meaning between 1520 and 1600. Painters who were known as **Mannerists** believed in a strong personal interpretation of compositional rules in painting. (Figure A-12). Works began to appear with the human figure idealized or somewhat abstracted. This led to distorted and elongated figures and unreal effects, which often appeared supernatural. For example, see El Greco's *View of Toledo* on page 93 of Book One. Mannerists used new color combinations which were a great departure from the rich hues of the grand masters of the Renaissance. Unusual combinations of violet, sea-green, light blue, rose, and lemon-yellow seem to shimmer in the works of the Mannerists. By the late sixteenth century, Mannerism had trouble developing further in color variations and in distortion. It was succeeded by a wondrous period in art, the Baroque.

Baroque

Baroque (buh-roke') was a term scholars used to describe any tedious piece of reasoning in the Middle Ages. Today, we recognize the vitality and greatness of the age of the Baroque. The period of the Baroque lasted from approximately 1600 to the early 1700s. During this period, the technical skills of artists were pushed to their limits; many feel that nothing has surpassed the art of the Baroque. It expresses the profound hopes and fears of its time, as well as the extremes of human emotion.

Figure A-13. Bernini's *David*. Gianlorenzo Bernini, *David*. 1623. Marble. Life-size. Galleria Borghese, Rome. SCALA/Art Resource, N.Y.

Everything about the Baroque seemed to be on a grand scale. A good place to begin is the architecture. King Louis XIV of France came to the throne at the age of five in 1643 and ruled for seventy-seven years. He built a great palace at what had previously been the royal hunting lodge at Versailles (vur-sigh'). This palace was a symbol of absolute power.

Baroque buildings were a combination of Greco-Roman style and Baroque enthusiasm. In architecture everything was sacrificed to dramatic effect, including convenience. For example, the kitchen at Blenheim Palace in Oxfordshire, England, lay 400 yards from the dining room.

There are many great artists of the Baroque period. In painting, their styles varied considerably, but a common characteristic was the use of light and darkness for effect. Look at the classroom reproductions of Velásquez´ *Maids of Honor* and Rembrandt's *Self Portrait.* Sculptors used space in a way that it had not been used before. Here we will

consider two particularly interesting Baroque artists who seem to capture the very essence of the period: Bernini and Rubens.

Gianlorenzo Bernini (bur-nee'-nee) was a technical virtuoso. He captured strong emotion in his work. As he prepared to carve his *David* (Figure A-13), Bernini spent days in front of his mirror looking at his own face again and again, trying to get the exact expression he wanted to put on David's face. Look at David. Do you think Bernini achieved the expression he wanted?

Let's consider why this work is so typically Baroque. First it is heroic. It demands its own space, and it also demands the space around it. Bernini selected the most dramatic instant in the story and gave us the one pose in a sequence that can be followed in our mind's eye. It demands the space for David to complete the action of hurling that stone at Goliath. Can you imagine this piece in a small niche in a corner? Energy bursts from David and flows toward his adversary. We can catch the entire story at first glance and then take the time to marvel at the artist's virtuosity.

Peter Paul Rubens was ideally suited for the bold age in which he lived. Rubens grew rich from his art but never lost his disciplined, amiable nature. He loved life, his fine home, his family, and his work. He was assisted by several apprentices in his studio who often finished details in his paintings. Rubens's output was enormous. He painted with spirit—big canvases for the big Baroque palaces. Like Raphael, Rubens was a successful and happy artist and man-of-the-world. His painting, *The Lion Hunt* (Figure A-14), is an example of the extravagant activity of the Baroque, which broke away from the tensions of the Mannerists.

Rococo

The word **rococo** (ruh-koh'-koh) is derived from the French word **rocaille** which means "little pebbles" or "shells." It is an appropriate name for this period of art, whose intricate designs remind us of the intricacies of a shell.

Louis XIV died in 1715 after seventy-seven years of rule in France. After his death, the court at Versailles was almost abandoned as people left this shrine to the emperor to build town houses in the city. Paris was the social capital of Europe in the eighteenth century. There has never been

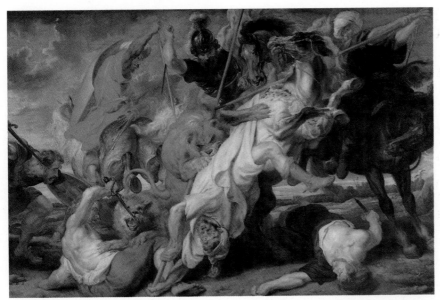

Figure A-14. Ruben's extravagant painting, *The Lion Hunt*. Peter Paul Rubens, *The Lion Hunt.* 1617-18. Approx. 8' 2" x 12' 5". Alte Pinakothek, Munich.

another period with such a focus on interior decoration. Famous, and not-so-famous, painters decorated the walls and ceilings of these homes. There were delicately carved portals, huge crystal chandeliers, and many elaborate mirrors. The paintings of the best known artists of the day were full of gaiety and color, showing laughing people enjoying themselves.

Louis XV replaced Louis XIV and reigned in France until 1774. The young king who then assumed the throne, Louis XVI, was uninterested in his official responsibilities. Meanwhile, the peasants and the citizens of Paris had become increasingly bitter about their poor living conditions and what they considered the excesses of the aristocracy. The Rococo period ended abruptly with the French Revolution of 1789. It had been in some ways the most trivial period in European history, and in some ways the most civilized.

We should not leave the Rococo period without noting the music of this time, which was far from trivial. The foundation for all modern music had been laid by the great Baroque master Johann Sebastian Bach (bahk). The composers of the Rococo period built their miraculous creations on Bach's foundation. Joseph Haydn was the father of the modern orchestra. Christoph Willibald Gluck revolutionized opera by creating strong plots and characters and simplifying the music. The immortal Wolfgang Amadeus Mozart (mote-sart) also composed during this period. Perhaps you can take

Figure A-15. The Rococo style is evident in this interior view of the Hôtel de Soubise in Paris. Boffrand Gabriel-Germain (18th Century), Salon della Principessa, Hôtel de Soubise, Paris. Photo courtesy SCALA/Art Resource, New York.

the time to listen to two compositions that will tell you more about the differences in Baroque and Rococo than words ever could. If you can, compare the thunder of Bach's *Toccata and Fugue in D Minor* to the exquisite strains of Mozart's *Concerto in E Flat Minor*.

Understanding and Creating Art—TImeline 3

	1,000 A.D.	1100 A.D.	1200 A.D.	1300 A.D.	1400 A.D.
Cultural, Political Events	● Macbeth defeated at Dunsinane, Scotland (1054)	● Chinese invent playing cards (1120) ● Oxford University founded (1167) ● Start of First Crusade (1096)	● King Richard the Lionhearted returns from Crusades (1194) ● Magna Carta (1215)	● Marco Polo returns to Italy from Far East (1295) ● Geoffrey Chaucer born in Britain (1340)	Portugese traders reach ● Benin, West Africa (1472) Ballet begins at Italian ● courts (1490) Gutenberg ● Bible (1455) ● Florence under Medici rule (1450–1492)
Scientific Techno-logical Events	● Water-driven mechanical clock in China (1090) ● Chinese use explosives (1151) ● Leif Ericson is supposed to have arrived in Nova Scotia in North America (1000)		● Glass windows in English houses (1180) ● Tiled roofs in London (1212)	● Steel crossbow used in battle (1370)	Leonardo ● invents the parachute (1480) Christopher Columbus ● discovers New World The symbols ● + and – used (1498)
Visual Arts	● Oldest existing example of Yamato style painting in Japan (1068) ● Mesa Verde pueblo in Colorado (1073) ● Tower of London (1078)	● Angkor Vat in Cambodia (1150) ● Gothic cathedral at St. Denis (1144) ● Mumbres pottery, New Mexico (1150) ● Gothic period begins in Europe Notre Dame Cathedral in Paris (1167)	● Toledo cathedral begun in Spain (1227) ● Goose quill used in writing (1250)	● Ming dynasty begins in China (1366) ● Aztec and Inca civilizations thrive (1300) Jan van Eyck perfects ● oil painting (1430s) Michelangelo born (1475–1564) ● ● Jan van Eyck, Dutch painter, born (1383–1441) RENAISSANCE PERIOD IN EUROPE ●	● Hans Memling (Dutch) ● Leonardo born (1430–1495) completes ● Leornardo da Vinci *The Last* born (1452–1519) *Supper* (1498) Raphael born ● (1483–1520) Michelangelo's *Pieta* at St.Peter's in Rome (1498)

Neo-Classicism

The period that followed the French Revolution brought a return to the styles of the Greco-Roman era which is called **Neo-Classicism.** It was a reaction against all that the Rococo period stood for. It quite successfully revived classical architecture. This influence was felt throughout the Western world and was particularly important to Thomas Jefferson in the United States. Jefferson developed his own architectural style based on Roman origins; a fine example is his Virginia home, *Monticello* (see Figure A-16). In France, the period was dominated by artist Jacques-Louis David (dah-veed´). David's severe, somber paintings had contributed to the revolutionary unrest in France. His theme was self-sacrifice, and he greatly revered ancient Rome. The revolutionary leader Robespierre was an associate of David. After the revolution, David was elected to the National Convention, where he voted to behead Louis XVI. He became the director of artistic affairs. In this role he tried to impose his own severe tastes in art on all of his countrymen. He proposed a law to destroy the works of certain painters, and another that would forbid all art except that of patriotic subjects. (This had been tried before and has been tried since. It never works.)

Figure A-16. Jefferson designed Monticello for his home. Thomas Jefferson, *Monticello*. Designed 1770. © Unifoto, Washington, D.C. © Philip Stewart.

The political life of France was volatile in those days. When Robespierre was deposed and executed in 1794, David fell from favor. However, he made a startling comeback with the rise of Napoleon in 1799. As "First Painter" to the Emperor, David recorded Napoleon's public life. One of his many paintings of the emperor is that of Napoleon leading his men across the alps (see page 27 of Book Two). However, Napoleon, after creating an

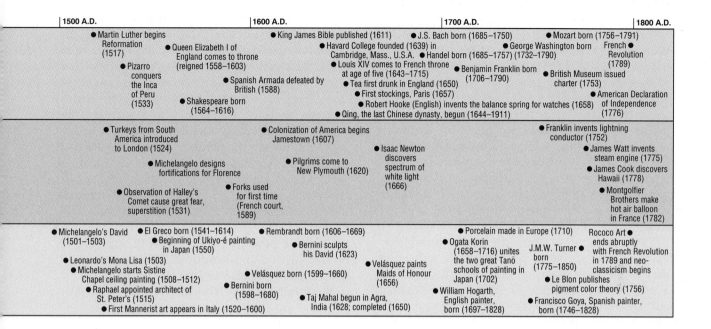

1500 A.D.	1600 A.D.	1700 A.D.	1800 A.D.

• Martin Luther begins Reformation (1517)
• Queen Elizabeth I of England comes to throne (reigned 1558–1603)
• Pizarro conquers the Inca of Peru (1533)
• Spanish Armada defeated by British (1588)
• Shakespeare born (1564–1616)
• King James Bible published (1611)
• Havard College founded (1639) in Cambridge, Mass., U.S.A.
• Louis XIV comes to French throne at age of five (1643–1715)
• Tea first drunk in England (1650)
• First stockings, Paris (1657)
• Robert Hooke (English) invents the balance spring for watches (1658)
• Qing, the last Chinese dynasty, begun (1644–1911)
• J.S. Bach born (1685–1750)
• Handel born (1685–1757)
• Benjamin Franklin born (1706–1790)
• Mozart born (1756–1791)
• George Washington born (1732–1790)
• French Revolution (1789)
• British Museum issued charter (1753)
• American Declaration of Independence (1776)

• Turkeys from South America introduced to London (1524)
• Michelangelo designs fortifications for Florence
• Observation of Halley's Comet cause great fear, superstition (1531)
• Colonization of America begins Jamestown (1607)
• Pilgrims come to New Plymouth (1620)
• Forks used for first time (French court, 1589)
• Isaac Newton discovers spectrum of white light (1666)
• Franklin invents lightning conductor (1752)
• James Watt invents steam engine (1775)
• James Cook discovers Hawaii (1778)
• Montgolfier Brothers make hot air balloon in France (1782)

• Michelangelo's David (1501–1503)
• Leonardo's Mona Lisa (1503)
• Michelangelo starts Sistine Chapel ceiling painting (1508–1512)
• Raphael appointed architect of St. Peter's (1515)
• First Mannerist art appears in Italy (1520–1600)
• El Greco born (1541–1614)
• Beginning of Ukiyo-é painting in Japan (1550)
• Bernini born (1598–1680)
• Rembrandt born (1606–1669)
• Bernini sculpts his David (1623)
• Velásquez born (1599–1660)
• Velásquez paints Maids of Honour (1656)
• Taj Mahal begun in Agra, India (1628; completed (1650)
• Porcelain made in Europe (1710)
• Ogata Korin (1658–1716) unites the two great Tanō schools of painting in Japan (1702)
• William Hogarth, English painter, born (1697–1828)
• J.M.W. Turner born (1775–1850)
• Le Blon publishes pigment color theory (1756)
• Francisco Goya, Spanish painter, born (1746–1828)
• Rococo Art ends abruptly with French Revolution in 1789 and neo-classicism begins

Empire, fell at Waterloo, and David was exiled to Brussels, Belgium, in 1816.

Romanticism

Romanticism was a strong reaction to Rococo and also to Neo-Classicism. It swept through Europe in the first half of the nineteenth century. Romantic artists painted highly emotional scenes using brilliant colors. Some bad art was produced as well as some very great art. The name most often associated with Romanticism is that of Eugéne Delacroix (del-ah-krwa´), although he should be remembered for being more than a Romanticist. Delacroix's bold use of color emphasized the drama of the scenes he painted and influenced almost all artists who followed him. In his portraits, Delacroix seemed to capture the romantic spirit of those he chose to paint. Delacroix's portrait of Frédéric Chopin, one of the great Romantic composers, captures the composer's spirit as well as his likeness (Figure A-17).

Realism

Realism dominated the art of the second half of the nineteenth century. The Realists rebelled against both the excesses of Romanticism and the

Figure A-17. Delacroix's *Portrait of Frédéric Chopin.* Eugéne Delacroix, *Frédéric Chopin.* 1838. Oil on canvas. 18″ x 15″. The Louvre, Paris. Courtesy Cliché des Musées Nationaux, Paris, France. © Photo R.M.N.

reverence for classic themes of the Neo-Classicists. The attitude of the Realists is expressed by their leader Gustave Courbet (coor-bay´) (1819–1877). When asked to add some angels to one of his paintings (a common practice at the time), Courbet said, "I have never seen angels. Show me some angels, and I will paint one."

Realism was an international movement. Its artists were concerned with depicting ordinary people doing ordinary things. If a subject had dirty feet, the dirt was included in the picture. Thomas Eakins, an American Realist, painted the operating amphitheater at the Gross Clinic in Philadelphia with the patient on the operating table, and Dr. Gross' scalpel and hands covered with blood.

The camera was coming into popular use. Paintings and sculpture were about as realistic as they could get. It looked as though art had reached a dead end. In what new direction could it possibly go? Answers came, and they came from unexpected sources.

INTERLUDE NUMBER TWO

In the first section of this history we traced the development of art in various parts of the world from prehistoric times to the end of the time period known as B.C. Our second section was devoted to the history of Western art, from its beginnings to the end of the nineteenth century. The section that follows is devoted to non-Western art traditions, from their beginnings through the latter 1800s. In the final section we will discuss art from the late 1800s to the present time, a period in which improvements in world-wide communication brought all the cultures of the world face to face.

NON-WESTERN ART

African Art

You will recall that in the first section we studied the art of the Nok civilization in Northern Nigeria. Art historians know that the Nok terra cotta figures were the result of a long tradition because of the refinement of the style and the sophistication of

the workmanship. The source of that tradition, however, is unknown; very little remains today of works produced before the Nok period. With the disappearance of the Nok culture around the third century B.C., another long period elapsed with few remaining traces. We know from scattered remains that a more naturalistic style, based upon the highly stylized, exaggerated art of the Noks, was developing. This style is best defined in the art of the Ife (e´-fay), a culture which emerged some 1300 years after the Nok culture ceased to exist. The city of Ife is located about 150 miles south of the site of the Nok civilization. Despite the long time period between the two cultures, there is no doubt of the Nok influence on Ife art.

The Ife perfected the "lost wax" method of bronze casting and produced lifelike castings of their kings. The palace in the city of Ife is still the spiritual home of the Yoruba (yoh-roo´-buh) people, who are the most prolific artists of Africa. Ife art of the period that began around A.D. 1000, combines post-Nok naturalism with the exaggeration of the Noks. Nok and Ife sculptors are unique in African art, for both sculpted the human figure to life-size scale. In Ife art of A.D. 1000 to 1200, we see the beginnings of modern African sculpture. (Figure A-18).

During the latter part of the twelfth century, an Ife master in bronze was a guest in the mighty city of Benin (buh-nin´) on the western coast of Africa. The artisans of Benin learned the art of bronze casting from this master. In 1472 Portuguese traders came to Benin. By that time the city was quite prosperous and had skilled artisans in many fields.

The Portuguese sailors described the city in detail. The king greeted them from an enormous palace. He sat upon an ivory throne under a canopy of Indian silk. The palace had beautiful courtyards, each with its own sentries. The walls surrounding the buildings in Benin were so highly polished they appeared to be marble. Many houses had intricately carved bronze birds perched on their walls and rooftops.

Africa had many other important kingdoms. The Ashanti (uh-shon´-tee) Kingdom is especially noted for its woven pieces. Ashantis reserved one special fabric for their ruler's use. This fabric, called Kente cloth, was woven from threads of pure gold and silk. It was perhaps the most luxuri-

ous cloth ever produced. An important ritual piece was a stool carved from a solid block of wood completely covered in hammered gold. This became the symbol of the Ashanti Kingdom.

African society has a long tradition of the dance. There are fine pieces of sculpture which express the vitality of the dance. In many cases masks were part of the rituals. These masks were later to have a significant influence on Western art. Masks often portrayed the profession of those who wore them. For example, one might portray a judge, another a policeman or a soldier. Many others represent animals.

In the section that follows we will discuss the effect of masks and other African art on the art of the twentieth century. African sculpture is a complicated, but most interesting, area of study. Examples range from very realistic to highly abstract. We rarely see examples of painted African sculpture in museum collections, yet most *are* painted. The mood or expression may also be deceiving. Expressions of terror or anger may only be meant to be amusing. Today, many Western traditions have been adopted or adapted by African artists. Others continue the art of their own proud traditions.

Art of the Far East

There are several influences common to the art of the Far East, and yet each of the cultures—Chinese, Japanese, Indian, Cambodian, Thai, Vietnamese—has its own character and traditions. A lifetime study of the art of the Far East could only begin to give you an appreciation of its diversity and richness. We will look at some of the highlights of this amazing body of artistic expression.

India You may recall the development of the Indus Valley civilization and its abrupt ending by invasion around 1800 B.C. From that time, all traces of art in that part of the world were lost for a thousand-year period. Few pieces remain from this long period, but we will see the influences of these invaders much later in the art of India.

The birth of Buddha in 563 B.C. is one of the significant events in world history, as well as in the history of Eastern art. Buddha was born a prince, and in his lifetime was a teacher of ethics. His teachings are the basis of one of the world's great religions. The Emperor Asoka (322–185 B.C.)

Figure A-18. An Ife king. Ife king figure, Yoruba. 10th - 12th centuries A.D. Bronze. 18 1/2″ tall. Ife Museum, Nigeria. Courtesy the National Commission of Museums and Monuments.

was converted to Buddhism, and his conversion led to a rebirth of art. Great columns were erected to commemorate the life of Buddha. Monuments to Buddha, called stupas (stoo´-puhs) followed, such as the one known as the Great Stupa at Sanchi. Until the second century A.D., images of Buddha were considered irreverent. This belief changed dramatically, and the image of Buddha became one of the most important expressions of art in history. Buddhism spread throughout Southeast Asia, and influenced the art of many cultures.

Figure A-19. The pagoda is the architectural symbol of China.
Pagoda of Six Harmonies. A.D. 1153. Sung Dynasty. Hongchow, China. The Granger Collection, New York.

The other great influence on the art of India was that of the Hindu religion, with its supreme deities Siva and Vishnu. The roots of this influence go back to the invaders of the Indus Valley civilization many centuries before. Hindu temples were designed to be the residence of a god rather than to be houses of worship.

The gracefulness of the sculptured figures of the Hindu deities and their thousands of attendants is the very essence of Southeast Asian sculpture. These figures echo the Indus Valley civilization's realistic style in sculpture. They also echo the religious tradition of those who invaded and conquered the Indus Valley back in 1800 B.C.

The Hindu and Buddhist religions struggled for supremacy in Southeast Asia. One result is a series of the most elaborate architectural wonders of the ages—the great stupas of Buddhism and the Hindu temples dedicated to Siva and Vishnu.

China The great dynasty of Shang ended in 1027 B.C. It was overthrown by the Zhou (sometimes spelled Chou; pronounced joh), a dynasty that endured until 227 B.C. Shang traditions in bronze continued and, in the later Zhou era, jade carving reached a peak of perfection. The philosopher Confucius (kun-few'-shuss) lived from 551–479 B.C. Confucius was born at a time of great turmoil in the Zhou dynasty, and during his lifetime he constantly sought social reforms. His philosophy, which emphasized the need for social justice endured through the many cen-

turies of Chinese dynastic rule and was the dominant force in Chinese culture until the founding of the Chinese Republic in A.D. 1913. During the 2,000 years of Confucian dominance, important traditions in Chinese art were established. Apprentices spent years copying established masters and then produced their own images of the natural beauty of China. In Chinese art, human beings are treated as another part of nature. They are no more or less important than the trees, mountains, waterfalls, and rivers. (This characteristic is further discussed in Book One, pages 87 to 89.)

The influence of Buddhist art in China is most noticeable in the pagodas (puh-go'-duhs), which are the architectural symbol of China (Figure A-19). Pagodas are the Chinese adaptations of the massive Buddhist stupas of India.

Many dynasties have followed the Zhou. Some dynasties lasted for centuries; some were comparatively short. Several are known for particular excellence in one or more forms of expression. If you are planning to visit a museum that has a collection of Chinese art, it will be of help to spend time studying the specialties of some important dynasties before your visit.

One very important dynasty was the Tang (A.D. 618–907). Tang art has been described as the "international style," as the Tang empire extended from the Caspian Sea on the west to the Pacific Ocean on the east. It included Manchuria, Korea, and Vietnam.

Figure A-20. The "Cradle of Japanese Art."
Kondo (Golden Hall) Horyu-ji, Asuka period, 7th century A.D. Nara, Japan, Courtesy Shashinka Photo Library, New York.

We hope you can take the time to enjoy examples of painting and ceramic art of the Song (sometimes spelled Sung) and the Ming dynasties. You may find it to be, as many others have, the most satisfying art of all.

Japan The geography of the Japanese islands played an important role in the development of Japanese art. First, the separation of Japan from the Mainland delayed many of the cultural revolutions that had swept India and China. By the time these revolutions reached Japan, the art forms had reached maturity. Second, the Japanese islands are formed of volcanic rock. This rock is very dense and difficult to carve or to use in architecture. Wood became the basic building material, while bronze, clay, and lacquer (which comes from tree sap) were used in three-dimensional art.

In A.D. 552 a Korean ruler sent a bronze figure of Buddha to the Emperor of Japan. (Remember that this was 1,000 years after Buddha's time.) From this modest, late beginning, a great wave of Buddhist art swept Japan. Buddhist temples were erected and Buddhist sculpture dominated the relatively brief period of A.D. 552 to 645. These years were known as the Asoka (uh-soke´-uh) Period, named for the Japanese capital at that time. Although brief, this period was very important in the history of Japanese art. The temple of Horyu-ji (hor´-you-gee) at Nara (Figure A-20) was built around A.D. 610. It is called the "Cradle of Japanese

Art." Through the years much of the original wooden temple has been replaced or restored, but some original parts survive today. These surviving parts are the oldest existing wooden buildings in the world.

Many other influences were to come to Japan from the mainland through the years. In the middle of the ninth century, trade with China ceased as a result of bad relations between the two countries. Japan became somewhat isolated. From that time, Japanese art developed its own traditions, occasionally borrowing from the cultures of its trading partners.

As you study Japanese painting and prints, you will see references such as "Yamato-e" or "Ukiyo-e." The *e* means "pictures of." *Yamato-e* means "pictures of Yamato," the area around Kyoto and Nara. *Ukiyo-e* means "pictures of the passing world." Hokusai's famous series of prints, the *Thirty-Six Views of Mount Fuji* (1824) is an important example of Ukiyo-e. You may recall one of these prints (on page 00 of Book One) that influenced Winslow Homer and many other Western artists.

Yamato-e art was highly decorative. Through the centuries Japanese art has acquired a delicacy and simplicity that mask the discipline that is required to accomplish such beautiful work.

Southeast Asian Countries The art of Cambodia, Thailand, and Java began on similar paths.

Understanding and Creating Art—Timeline 4

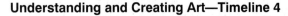

	1800 A.D.	1810 A.D.	1820 A.D.	1830 A.D.	1840 A.D.
Cultural, Political Events	● U.S. Capital moved to Washington D.C. from Philadelphia (1800) ● Louisana Purchase by U.S.A. from France (1803) ● U.S.-Britain War of 1812 (1812–1815)	● Napoleon defeated at Waterloo (1815)	● Monroe Doctrine, U.S.A. (1820) ● Missouri Compromise (1821)	Sitting Bull born ● (1834–1890) ● Nicholas I becomes Czar of Russia (1825) ● French Foreign Legion founded to serve in French colonies in Africa (1831)	● Texas wins Independence from Mexico (1836) ● Queen Victoria of England reigns (1837–1901) ● First American University degrees granted to women (1840) ● Charles Dickens publishes *Oliver Twist* and *Nicholas Nickleby* (1838)
Scientific Technological Events	● Eli Whitney makes muskets with interchangeable parts (1800) ● Robert Fulton produces first submarine, "Nautilus" (1801)	● George Stephenson builds first practical steam locomotive (1814) ● U.S.S. Fulton, first steam warship, launched (1815) ● Boston installs gas streetlights (1822)	● Waterproof fabric invented by Charles Macintosh (1823)	● First railroad line (France 1832) ● Patent for reaping machine issued to Cyrus Hall McCormick (1834) ● Samuel B. Morse's telegraph (1837) ● Horse drawn trolleys in New York City (1832)	● Kirkpatrick Macmillan builds first bicycle (1839) ● Thomas Edison born (1847–1931) ● Alexander Graham Bell born (1847–1922)
Visual Arts		● David exiled from France (1816) ● Courbet born (1819–1877) ● European Art: Romantism (c. 1820–1850) ● Prado Museum founded in Madrid, Spain (1818)	● Discovery of the Venus de Milo (1820)	● Manet born (1832–1883) ● Homer born (1836–1910) ● Cézanne born (1839–1906) ● Monet born (1840–1926)	● Photography begins (1838) ● Cassatt born (1845–1926) ● Levtze paints *Washington Crossing the Delaware* (1849)

However, its development was quite different in each.

Sea trading with India brought about a dramatic surge of art in Cambodia and Thailand at the start of the fourth century A.D. Both Hindu and Buddhist influences entered Cambodian art at that time.

A most unusual concept of architecture and sculpture began in Cambodia around A.D. 900. This is the concept of the "world mountain." The first example was the incorporation of a real mountain into the architectural design of a shrine. From this beginning, enormous complexes of highly decorated stone evolved. The temple to the Hindu god Vishnu at Angkor Vat is one such complex (see page 263, Book one). Another is the Bayon at Angkor Thom (Figure A-21).

The artists of Thailand concentrated on bronze and developed unique images of Buddha which were much different from other Buddhist art. The images have much simplicity and linear detail, such as double outlines around the features of the faces.

The immense stupa of Borobudur (boh-roh-bu-dur´), created in the eighth century A.D., is the most important monument in Javanese art. This enormous structure has over ten miles of relief

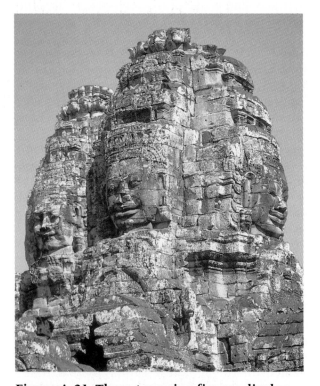

Figure A-21 These towering figures display the well-known Cambodian smile. Detail of the Bayon. Angkor Thom, Cambodia. Late 12th - early 13th century A.D. Art Resource, New York. INVC/Giraudon/Art Resource, N.Y.

| 1850 A.D. | 1860 A.D. | 1870 A.D. | 1880 A.D. | 1890 A.D. | 1900 A.D. |

● American Civil War (1860–1865)
● Louisa May Alcott publishes *Little Women* (1868)
● U.S. installs first public telephone (1877)
● Massacre at Wounded Knee (1892)
● Population statistics, (1851) (in millions): China 430 Germany 34, France 33, Great Britain 21, U.S. 23
● President Lincoln assassinated (1865)
● Mark Twain publishes *The Adventures of Tom Sawyer* (1875)
● President Garfield assassinated (1881)
● Sir Arthur Conan Doyle publishes first Sherlock Holmes story (1887)
● Charles Blondin (French) crosses Niagara Falls on tightrope (1864)
● Jules Verne publishes *Around The World in 80 Days* (1872)
● Spanish-American War (1898)
● Lewis Carroll writes *Through The Looking Glass* (1871)
● Franklin Delano Roosevelt born (1882–1945)

● Crystal Palace built in London (1851)
● Pasteur develops process of pasteurization (1864)
● Bell invents telephone (1876)
● Movie camera invented (1891)
● Suez Canal constructed (1859–1869)
● Law of heredity outlined by Gregor Mendel (1865)
● Edison and J.W. Swan produce first electric lights (1880)
● Edison invents phonograph (1877)
● Rabies vaccine developed by Pasteur (1885)
● Henry Ford builds his first car (1893)
● Alfred Nobel invents dynamite (1866)
● Gatling gun, 10-barrel rapid fire gun, invented by R.J. Gatling (1862)
● London installs electric streetlights (1878)
● First electric elevator (1889)

● van Gogh born (1853–1840)
● Whistler paints *The Artist's Mother* (1872)
● Last Impressionist exhibit in century (1886)
● Remington born (1861–1909)
● Henri Toulouse-Lautrec born (1864–1901)
● Joseph Stella born (1877–1946)
● George Seurat born (1859–1891)
European art: Realism, Impressionism
● Edward Muybridge publishes photo of horse in motion (1882)
● Grant Wood born (1892–1942)
● Louis Sullivan, American architect born (1856–1924)
● Frank Lloyd Wright born (1869–1959)
● Rivera born (1886–1957)
● Henri Matisse born (1869–1954)
● Picasso born (1881–1973)
● O'Keeffe born (1887–1986)

carving. It reveals the dominance of Buddhist influence in Java at that time, despite the country's Hindu beginnings. In later Hindu temple carvings we can see the beginning of caricature that is so evident in the Javanese shadow puppets (as we have seen in Book One, page 274).

The kingdom of Champa (chom´ pah), a neighbor and great rival of Cambodia, existed from the third century A.D. until 1471. Champa is today known as Vietnam. Champan sculpture is distinct from Cambodian. Both often depict the Hindu god Siva, but the Champan heads are carved in a much coarser style and the bodies give the impression of more physical strength than do those of Cambodia. Dragons and other mythical beasts are depicted in later Champan art, along with much elaborate and intricate detail.

The Art of the Western Hemisphere (Before European Exploration)

Maya and Teotihuaca Two Central American cultures were established in the third and fourth

centuries A.D. They were the Mayan (my´-uhn) and the Teotihuacan (tay-oh-tee-whah´-kun).

The Mayan civilization was located on the Yucatan Peninsula of what is now Mexico, and extended into Honduras and Guatamala. The Maya produced huge ritualistic temples to their gods of the harvest. The relief sculpture of these temples, with its ornate style, is considered among the finest ever produced.

Carving on Mayan temples is on the outer walls, for their rituals were performed in the open air, where the gods could witness them. And what rituals! Among them was a game in which a ball was batted overhead, representing the sun. There was a strong incentive to win this game. The leader of the losing team was sacrificed to the sun god.

The Maya were particularly interested in time and its measurement. Their accomplishments in mathematics and the measurement of time are stunning. They easily predicted solar eclipses, and measured the orbit and revolution of the planet Venus with an error rate of only one day in 6,000 years.

The Teotihuacan civilization began about the same time as the Mayan. The word *teotihuacan* means "where one becomes a god" and refers to the city of that name, which was located just north

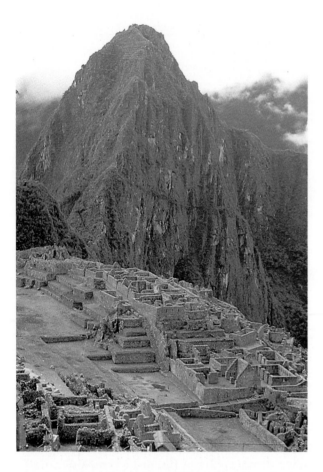

Figure A-22. The ruins of the Inca city of Machu Picchu. The ruins of the 15th century Inca city, Machu Picchu, Peru. The Granger Collection, New York.

and expanded, quickly building an empire. At the height of the Aztec power, their language spread throughout Mexico, and it is still widely spoken.

Aztec art can be puzzling. To understand it requires some knowledge of the Aztec religious rituals. The Aztecs believed that the sun god was locked in a never-ending battle with darkness. Each evening the sun god died; each morning the revived sun god drove the darkness away. This nightly revival of the sun god required blood—human blood—and the Aztecs practiced human sacrifice to nourish the sun god. The great stone temples and the elaborate costumes of the Aztecs were part of this ritual, as were the larger-than-lifesize stone carvings of their gods. These sculpted pieces were adorned with such things as skulls and representations of human hearts. In A.D. 1520 the Spanish conqueror Hernando Cortes, aided by many people under Aztec domination, overthrew the Aztecs.

Inca The Inca people were contemporaries of the Aztecs but lived 2000 miles to the south. The time span of these cultures is similar, for both were toppled by Spanish conquest. Francisco Pizarro ended Inca rule in 1533.

The native ground of the Inca was what is now known as Peru. However, at one time, the Inca civilization included most of the northern part of South America and had made inroads to the south. Inca temples were made of dry masonry, which means they did not use mortar. In this process the stonecutting has to be very precise. The famous ruins of the Inca city of Machu Picchu (Figure A-22) lie on a small plateau high in the Peruvian Andes. It is one of the most beautiful sites in South America.

Probably the most astonishing accomplishment of the Inca was their system of roads and bridges. The "Royal Road of the Mountains" was thirty feet wide and 3,750 miles long. The conquering Spaniards were awestruck. Using this road network, the Inca had a system for delivering messages similar to the old "Pony Express" in the western United States. The Inca, however, used human runners instead of horseback riders.

of present-day Mexico City. A very large city for its time, its population was approximately 100,000. The Teotihuacans constructed the largest pyramid in Mexico, which was dedicated to their sun god. It is approximately 700 feet wide at the base and 200 feet tall, and was part of a broad avenue of elaborately carved temples.

Aztecs—The People of the Sun In the fourteenth century the Aztec culture developed on the present-day site of Mexico City. The predecessors of the Aztecs in this region were known as the Toltecs. The Toltec empire had crumbled for many of the same reasons the Roman Empire collapsed. The Aztec people took advantage of the situation

Many artistic achievements of the Native Americans of North America are discussed in *Understanding and Creating Art*. These achievements range

from the ingenious architectural innovations of the Anasazi (the "ancient ones") two thousand years ago to twentieth century masters of traditional Native American forms of expression, as well as oil painting, lithography, bronze casting, and other forms associated with European traditions. Here we will look at the art of one group of Native Americans which developed independently of the others—the Eskimo.

In the past few decades, Eskimo art has been "discovered" and is quite fashionable. It appears in many museum collections and private collections. The Eskimo people have taken the utmost advantage of the raw materials available to them to make their art. These natural materials are whalebone, walrus ivory, stone, driftwood, and skins. The art is generally geometric in design and is often abstract and sophisticated. The subjects of Eskimo art are usually the animals on which the Eskimos are so dependent.

Eskimo architecture takes advantage of available materials, such as driftwood in Greenland, or stone and wood in other parts of the far north. In Labrador many Eskimos live in igloos in the wintertime. These structures are much more interesting than they appear at first glance. For example, blocks of clear fresh-water ice are cut at the beginning of winter to use as skylights. The igloo is an ingenious creation providing comfortable shelter in very harsh conditions.

Figure A-23. Manet's *The Fifer* draws the viewer's eye to the painting's surface. Édouard Manet, *The Fifer*. 1866 Oil on canvas. 63" x 38 1/4". The Louvre, Paris. Courtesy Cliché des Musées Nationaux, Paris, France. © Photo R.M.N.

BEYOND REALISM

New Directions for Western Art in Europe

When we left Western art late in the nineteenth century, the dominant force was Realism. However, you may recall that Realism seemed to have nowhere to go. The camera freed many artists from producing illustrative material. ("Freed" is the word often used, but "put out of work" was often the case.) The French poet and critic, Theophile Gautier (go-tyay´) said, "It is well known that something must be done in art, but what?"

The last great realist of this age was Édouard Manet (mah-nay´) (1832–1883). Manet's art was

to provide the beginning of an answer to Gautier's question.

Japanese block prints had become very popular in the 1860s. *The Great Wave off Kanagawa* by Hokusai is an excellent example. Manet closely studied the work of such Japanese artists as Hokusai and began to simplify his work and experiment with color.

He painted *The Fifer* (Figure A-23) in 1866, shortly after returning from Spain, where he had

spent a month studying the works of Velásquez. *The Fifer* is a very important painting because in it we can see how Manet broke with traditions that had dominated Western art since the Renaissance. In the Renaissance tradition painters used modeling (color and shading) to give the illusion of form and depth. This realistic method gives the viewer the sense of looking through the surface, as though through a window, to the subject of the painting. In this tradition, the purpose was the successful imitation of nature.

Let us now look again at *The Great Wave off Kanagawa.* Unlike the work of the realists, its colors are flat and lack gradation. They stand right next to each other. Now look again at *The Fifer*. Manet uses flat patches of paint with no modeling. The eye of the viewer is attracted to the painting's *surface*. The patches of color and the brushstrokes make the surface as important as the subject of the painting. This is no mere representation of the subject. The painting itself is the reality for the artist, and Manet has called our attention to *his* reality—the canvas. This break with the traditions of the Renaissance influenced all art that followed in the Western world. Manet pointed the way to nonrepresentational art.

The Impressionists drew inspiration from Manet. (If you have not studied the introduction to Impressionism in Book Two this would be a good time to do so.) They also admired Japanese prints and were very interested in the fleeting impressions that were obtained by camera "snapshots." By taking the intensity of light and atmospheric conditions into consideration, they gave their version of what the real world was like. Their efforts led art away from the purely representational and toward the dominant style of the twentieth century, which can be described as antirealistic.

Paul Cézanne (say-zahn´) thought that Impressionism, while beautiful, lacked a feeling of permanency. (Cézanne is also discussed in Book Two.) He wanted to make paintings that he felt were more solid, with what he considered lasting value. He sought more structure than he saw in Impressionist works. The Impressionists assumed that all the eye sees is color. Cézanne reasoned that, if the Impressionists were correct, it must follow that color would fulfill all of the structural functions of perspective, light, and shadow in painting. Color, and color alone, must be used to give depth and form to painted objects. He began experimenting with color to test these ideas for himself.

After many experiments, Cézanne concluded that color alone was not enough, and that line was also necessary. He needed line for organization. His works have a sense of order and serene harmony and are often described as containing "planes of color." Look at the two paintings of La Montagne Sainte-Victoire in Book Two. Can you see these "planes of color?" As the earlier and later paintings of the mountain reveal, Cézanne continually simplified, leaving out all unnecessary detail.

Probably no artist has ever been more concerned with the compositional principles of design than Cézanne. He would work on a painting for years, attempting to assemble natural objects into a perfection of design. The Cézanne still life (your classroom reproduction #16) took years to complete and was finished in 1890. Distortions were carefully made to create as perfect a design as possible. The arrangement of this still life produces order and clarity, and yet we see the distortion. Cézanne believed that art was not only the result of a reaction of the eye, but also of an action of the mind. After him, painting would not be the same.

During this time, there was great progress in architecture. Joseph Paxton's giant Crystal Palace Exposition Building in London (1851) was an architectural milestone, and not simply because it was constructed of iron and glass. Of equal importance was the fact that the entire structure was built in only six months. Many similar buildings followed. One unforeseen problem was the vulnerability of such structures to fire. After several had burned, architects devised a way to cover the iron framework with various forms of masonry which wouldn't burn.

Elisha Cook Otis invented the safety elevator, and the first electric safety elevator was installed in New York City in 1889. Steel began to replace iron in construction, and the combination of the steel framework and the elevator led to the modern skyscraper.

The first of the new architects to demonstrate that "form follows function" was Louis Sullivan. In many of Sullivan's buildings we can imagine the steel superstructure by looking at the building from the outside. Sullivan did *not* say that "beauty follows function," but many great architects

believe that it does. Others of the twentieth century feel differently, and we have many styles of skyscraper architecture now.

Some skyscrapers are popularly described as "post-modern." What this apparent contradiction in terms means is that an architect may adopt or incorporate some aspects of previous architectural styles or make embellishments of his or her own. The steel structure of these buildings is so strong that the outside and interior walls can actually be constructed from the top down. Try to imagine how this concept would strike a builder of a Romanesque church in the Middle Ages, whose thick walls had to support the roof.

THE TWENTIETH CENTURY

The pattern of deviation from Realism had begun. We have seen it start with Manet, continue with the Impressionists, and develop further by the careful, deliberate distortions of Cézanne. When you look at the art of the twentieth century, you may ask, "What is all this? I can see what Cézanne was doing, and I can see why he did it. But this stuff! How can one begin to understand it or enjoy it, and is it really worth trying to do so?"

There is no question that it takes a great deal of effort to understand modern art. In this section we give you the background to understand *why* Modern Art is as it is, and a small introduction to *what* it is. The Book Two introduction to Cubism and Futurism should also help you. However, you will have to make the effort to become deeply involved. No one can do this for you.

Let's begin by trying to understand the *why* of modern art. In the late 1800s many artists felt that realism could go no farther. This was also a time of unprecedented growth in technology. Countries were no longer isolated from one another. Traditions in the visual arts from many world cultures were being explored by Western artists for the first time. As we have seen, many of these art traditions were *not* representational. Western artists were not just attracted, many were overwhelmed, by the sophistication of the works which had evolved from different cultures. For example, in 1905 the French artist Maurice Vlaminck (vlah-mank´) showed an African mask to his friend, the painter André Derain (duh-rain´). Vlaminck

records that Derain was "speechless and stunned." That incident profoundly affected Derain's work. We can see the effects of non-Western art on many other artists in Part III of Book Two. The influence of non-Western art traditions on Western artists is one thing to remember and look for in modern art. Gautier had said, "Something had to be done in art, but what?" This part provides some examples of what artists thought could be done.

A second important *why* also relates to advancing technology, but in quite a different way. Technological and scientific advances have changed the way we view ourselves and the world around us. New theories in physics tell us there are no absolutes in space or time. Motion is relative to other objects (or systems of objects) which are also in motion. We are told the universe is expanding at an ever-increasing rate. Space and time are related. Time is really just another dimension—the fourth dimension. Faced with these theories, artists began to ask, "What is real in such a world, and how can I possibly capture it?"

The response of many artists was to decide that it was up to them to interpret what was real. For centuries artists had tried to portray the third dimension, depth, on a two-dimensional surface. Now artists were faced with a fourth dimension. Then why, many asked, should I try to give the illusion of only three dimensions on a canvas? Why not use the fourth dimension, time, to look at the subject of a painting from several different viewpoints?

The twentieth century brought terrible wars and bloody revolutions. Such destructive events made existence itself seem meaningless, and life a joke to many artists. As a result, artists experimented boldly. Many abandoned the idea of representing what they could see. Instead they tried to rebuild reality from their own personal experience.

As you have seen in your textbooks, not everyone in the twentieth century art world felt this way. Many artists, such as Andrew Wyeth, made their own versions of realistic art. Others, such as Georgia O'Keeffe, developed their own styles and are not easily classifiable. However, several general trends are indicated. They should be considered.

Modern art has a rather bewildering array of "isms". We will discuss several of the movements

Understanding and Creating Art—Timeline 5

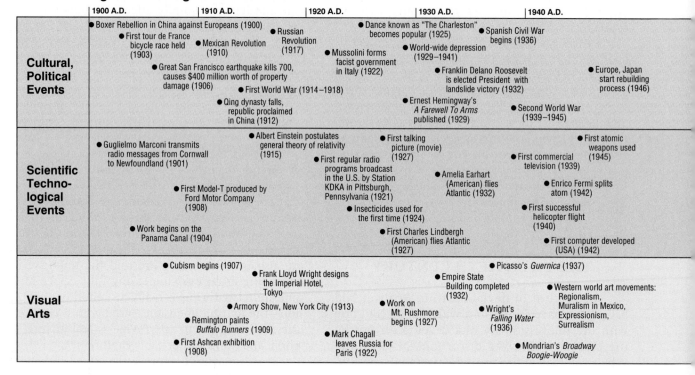

	1900 A.D.	1910 A.D.	1920 A.D.	1930 A.D.	1940 A.D.
Cultural, Political Events	● Boxer Rebellion in China against Europeans (1900) ● First tour de France bicycle race held (1903) ● Mexican Revolution (1910) ● Great San Francisco earthquake kills 700, causes $400 million worth of property damage (1906) ● First World War (1914–1918) ● Qing dynasty falls, republic proclaimed in China (1912)	● Russian Revolution (1917) ● Mussolini forms facist government in Italy (1922)	● Dance known as "The Charleston" becomes popular (1925) ● World-wide depression (1929–1941) ● Franklin Delano Roosevelt is elected President with landslide victory (1932) ● Ernest Hemingway's *A Farewell To Arms* published (1929)	● Spanish Civil War begins (1936) ● Second World War (1939–1945)	● Europe, Japan start rebuilding process (1946)
Scientific Technological Events	● Guglielmo Marconi transmits radio messages from Cornwall to Newfoundland (1901) ● First Model-T produced by Ford Motor Company (1908) ● Work begins on the Panama Canal (1904)	● Albert Einstein postulates general theory of relativity (1915) ● First regular radio programs broadcast in the U.S. by Station KDKA in Pittsburgh, Pennsylvania (1921) ● Insecticides used for the first time (1924) ● First Charles Lindbergh (American) flies Atlantic (1927)	● First talking picture (movie) (1927) ● Amelia Earhart (American) flies Atlantic (1932)	● First commercial television (1939) ● Enrico Fermi splits atom (1942) ● First successful helicopter flight (1940)	● First atomic weapons used (1945) ● First computer developed (USA) (1942)
Visual Arts	● Cubism begins (1907) ● Frank Lloyd Wright designs the Imperial Hotel, Tokyo ● Armory Show, New York City (1913) ● Remington paints *Buffalo Runners* (1909) ● First Ashcan exhibition (1908)	● Work on Mt. Rushmore begins (1927) ● Mark Chagall leaves Russia for Paris (1922)	● Empire State Building completed (1932) ● Picasso's *Guernica* (1937) ● Wright's *Falling Water* (1936) ● Mondrian's *Broadway Boogie-Woogie*	● Western world art movements: Regionalism, Muralism in Mexico, Expressionism, Surrealism	

in modern art in this section. It may be helpful for you to think of modern art as having two major divisions. You may think of artists as being either *Expressionist* or *Abstractionist*. Works that are dominated by emotion may be thought of as **Expressionist.** Works in which formal, logical analyses seem dominant may be considered **Abstractionist.**

Expressionism comes from within. Artists use distortion and alteration to display the intensity of their feelings about their subjects, and reveal new worlds to us. Vincent van Gogh was a forerunner of Expressionism. A post-World War Two extension of Expressionism is called **abstract expressionism.** In this style, the artist is freed entirely from nature as well as from all traditional standards. The name is, as you can see, a combination of the two large divisions of modern art. It is generally associated more with Expressionism, as it is more akin to the emotional in art than the cool, unemotional approach of Abstractionism.

Abstractionist art does not come from within, but from without. The abstract artist selects, ana-

lyzes, and simplifies the subject. Much of Cubism, which is discussed in Book Two, can be classified as semi-abstract. This means that, if we look hard, we can identify most of the objects in a Cubist work.

There are many diverse movements in twentieth century art. The introduction to Cubism and Futurism in Part III of Book Two discusses two of them. We will now look at some of the other movements in twentieth century art.

Henri Matisse was a member of the group named the Fauves, which means "Wild Beasts" in French. **Fauvist** paintings were highly expressionistic with truly wild uses of intense color. For an example, see Matisse's painting of his wife, known as *The Green Stripe*, in Book Two.

Precisionists painted goemetrically precise pictures of smooth-surfaced objects, generally machines, buildings, bridges, or interiors of buildings. Joseph Stella's *American Landscape* in Book Two is a good example.

Dada is a movement that began as a protest against war in 1916. The term *dada* was reputedly

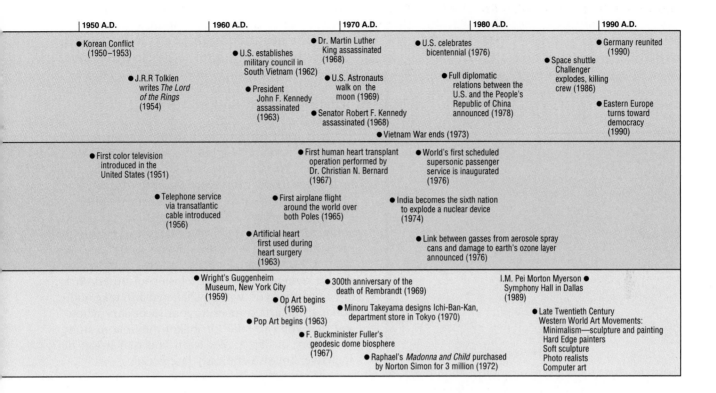

selected at random from a French dictionary. The dadist movement rejected all accepted conventions; it is aptly described as being anti-everything, including Dada. Its creations, as you can imagine, ranged from the fantastic to the absurd. Marcel Dechamp's photograph of the Mona Lisa with a moustache is an example of Dadist art.

Surrealism succeeded Dada, and was greatly influenced by the work of psychiatrists in the analysis of dreams. The Surrealist artists pictured the curious emotional quality of dreams, often with illogical collections of objects in dream-like landscapes. Surrealism was very popular in the period between the two world wars (1918–1939). As an art form, it was somewhat limited by the fact that artists were painting very personal feelings from dreams which may mean little to mass audiences.

The Swiss-German artist Paul Klee (clay´) had a simple, easily recognizable style of fantasy that had universal appeal. Look at his watercolor *Twittering Machine* (Figure A-24). What do you think is going on here? What purpose could possibly be served by turning that crank? Assuming this machine works when the crank is turned, could the twitters it produces be an adequate substitute for the twittering of real birds? What is Klee telling us about our industrialized world?

Op art artists produce physically unstable images which cause the illusion of movement in the viewer's eye. Op art was first introduced in the 1940s. Bridget Riley's *Current* in Book Two is an excellent example.

Claes Oldenberg's *The Dormeyer Mixer* (see your classroom reproduction) is a soft sculpture, and an excellent example of **Pop art**. The Pop art movement, which began in the 1950s, forces us to take a close look at familiar, everyday objects and think of their qualities as a part of, or an entire composition.

There are many other movements in modern art. Pop artists began to use multiple camera images to produce works depicting motion picture stars, such as Marilyn Monroe. This evolved into a form known as **Photo-Realism** in the 1970s. Photo-realistic works are made by projecting a photographic image onto a canvas and then painting over it. This movement has also expanded into

Figure A-24. What is Klee telling us here?
Paul Klee, *Twittering Machine*. 1927. Pen on oil transfer drawing on paper, mounted on cardboard, 25 1/4 x 19 inches. Collection, The Museum of Modern Art, New York. Purchase.

sculpture, with the purpose of always making the pieces as realistic as the object itself.

Where does this leave us as the twenty-first century begins? It is hard to predict new directions, but we are surrounded by a rich variety of styles with echoes from the past as well as glimmerings of the future.

This brief introduction to the history of the visual arts is simplified, but the authors have taken pains not to over-simplify. The examples and artists discussed here were carefully selected to illuminate a particular era or an artistic tradition of a part of the world. As much as possible, the works and artists chosen were *not* covered extensively in the other parts of your texts. None should be considered the "favorites" of the authors, or those you should remember to the exclusion of others. It is our hope that you will be challenged to take additional visual arts courses in your secondary school, and that you can take (or make) the time to study art history in depth. We warn you that it can be addictive, but also endlessly fascinating.

A P P E N D I X

CAREERS IN ART

INTRODUCTION

In this course you have studied art, and you have created art. Along the way, you have seen how artists in many fields earn a living.

There are comparatively few of us with the talent, determination, and patience to produce museum quality works of art. If you are one of the few, no more need be said to you about careers in art. Nothing will keep you from your destiny.

The skills you are learning are basic for an exciting career in one of many interesting fields. This appendix is designed as a reference which may be of help to you in planning secondary school courses and, perhaps, post-secondary school work. Your art teacher, your guidance counselor, and your school and community librarians can all help you locate more detailed information about specific art-related careers. We have grouped the career opportunities by category, ranging from careers in business and industry to careers in the preservation of history and education.

There is no such thing as a complete list of the opportunities for careers in the field of art. In the coming years the need for graphic communicators and similar careers will expand at an ever-increasing rate. You may well work in a medium that has not yet been imagined. The most important thing to remember is that art will always be based on the visual elements and compositional principles.

Graphic Design

Graphic designers are employed in many businesses. Among these are advertising agencies, newspapers, magazine publishers, book publishing houses, television studios, and art departments of retail stores

Note to Teachers: As a part of your class discussion of careers in art, you might want to invite your school guidance counselor to speak to your class. He or she should discuss where and how your students can get the additional education and training required to pursue the careers outlined in this appendix.

Figure B-1. A graphic illustrator prepares art for a publication.
* Photo by David Hanover.

and manufacturing companies. **Graphic designers** present information in a visually attractive and interesting manner.

The graphic designer must have a good command of the visual elements of art and the compositional principles of design. He or she also must understand the basics of graphic design, typography, and printing. The ability to write well will become of increasing importance for the very best jobs in an organization. Persons who have both graphic and journalistic skills are called **graphic journalists.**

Graphic journalists fill important roles in newsrooms and editorial offices in both print and electronic media. We will discuss the role of the graphic journalist further in the section on publishing and journalism.

Advertising Art

Graphics contribute to the fundamental purpose of advertising—persuasion.

A large advertising agency has several positions that demand skill in art. Some artists work in print media, some in electronic media. The graphic artist works closely with the copywriter to produce print ads. Photographers and illustrators produce the images used in print ads. The graphic designer arranges the images to express the message.

Creating television commercials requires the talents of many people. The job functions are the same as those necessary for producing a motion picture, and all workers must be skilled artists. These workers are the director, art director, animators, cinematographers, costume designers, prop managers, set designers, make-up artists, and other specialists, depending on the specific needs of various commercials.

If you are particularly interested in advertising, continue to take art courses in high school as well as courses in communications.

Fashion Design

There are many specialized positions in fashion design. They require highly skilled persons with a thorough background in art. They also require people who can work under pressure.

Whether working for a high fashion designer or a mass producer of ready-to-wear clothing, the fashion designer presents seasonal collections to the public each year. Each collection should be innovative, fresh, and identifiable as a product of the particular design house. Color, line, and texture are the basics in fashion design.

Employment positions in fashion design include fashion photographers, fashion illustrators (a very specialized career field), graphic designers, fabric specialists, fashion show specialists, display artists, set designers, and the clothing designers themselves. Many fashion houses produce their own accessories such as jewelry, eyeglasses, and perfume. Each of these requires packaging and promotion and, consequently, designers.

The Entertainment Industry

The need for persons with artistic talent in the entertainment industry provides many opportunities for artists of widely varying talents. These talents are as diverse as the various branches of the industry—motion pictures, theater, television, radio, opera, and ballet. There are specialized positions such as set designers, make-up artists, prop artists (who build, acquire, and manage the props used by the performers), animators, costume designers, cinematographers, color specialists, lighting specialists, special effects personnel, and the art director as well as the director herself or himself.

The entertainment industry also needs graphic designers, photographers, and illustrators for displays, brochures, advertising, programs, performance schedules, and billboards.

In this field talented people can advance quickly. On the other hand, they must start at entry-level positions to learn the specialties of the field they have chosen.

Publishing and Journalism

Design is of critical importance to the success of a book publishing house. Book designers plan and execute the layout of the books. Many designers are specialists in one or two fields of book design. For example, some work on elementary and high school textbooks, others specialize in college level texts, others in books on highly technical subjects such as medicine, and others in books of fiction and nonfiction. The book designer works under the supervision of the art director. Most publishing houses use a system that requires approval of every stage of book design, so the designer works closely with the authors, editors, and marketing personnel. The designer selects the type and type size, acquires or makes illustrations and photographs, selects colors for the design, designs the cover and makes or acquires art for the cover, and gives the book an overall feeling of unity.

Consider the design of this textbook. It is a book about the visual arts, so it should be attractive and showcase much great art. It also must

Figure B-2. A magazine designer.
Courtesy of Robert Holgren.

be useful and logically put together. For example, if the text on a page is about a Renaissance artist, the images on that page should feature work by that artist or of that period.

Magazine designers must completely understand their target audience. The graphic style of a high fashion magazine, such as *Vogue* or *Glamour,* would not be appropriate for a magazine on hunting and fishing, such as *Field and Stream,* or a newsmagazine, such as *Newsweek* or *Time.* A well designed magazine will have a feeling of unity throughout. Look at several different types of magazines in the library. Do you see a coordinated design throughout, or does a particular magazine appear to be a series of unrelated articles with no unity of design? Does the design seem appropriate for the target audience?

The use of computers has revolutionized graphic design in publishing. Using the computer the graphic designer can make changes in layouts quickly. This allows the designer to try many options that would formerly have taken hours. The result is greater freedom of expression.

Computer graphics have made the modern newspaper editor a graphic journalist. Reporters compose their stories on computers. Stories from the wire services, such as the Associated Press and Reuters, are electronically transferred to the computers of the news department. Wire service photographs are also sent by satellite and stored for review on the computer by the graphic journalist.

The graphic journalist can call up all of this information on the computer screen. The reporters' stories can quickly be edited and reorganized if necessary, by sending the appropriate instructions to the computer. The graphic journalist switches to the page mock-up program. A grid appears on the screen. Then he or she uses the grid to lay out the page, mixing photos, illustrations, and copy. The graphic journalist types out headlines and chooses the type style and type size for each story. At the press of a button, the laser printer furnishes a printed copy of the final page before the newspaper goes to press.

Figure B-3. An industrial design team.
Courtesy of International Business Corporation.

Illustrators, photographers, cartoonists, political cartoonists and, of course, art critics are among the other important positions in publishing.

Industrial Design

Industrial designers design everything from toothpaste dispensers to supersonic aircraft and nuclear submarines. Those that design products for the consumer market must consider appearance as well as function. Successful consumer products combine these two qualities.

Complex products, such as automobiles, are designed by teams of industrial designers, each expert in a particular field. Teams must strive to fit the safety, comfort, and appearance features of the interior into the streamlined aerodynamics of the exterior. The engine and other components under the hood must fit within the space that is under the hood. In practice, all of these considerations lead to design compromises. Computer aided design (CAD) has been of tremendous help to automobile designers in making such compromises.

If you have the opportunity to do so, look carefully at an automobile produced in the 1930s or 1940s and compare it with a new model. Start by looking under the hood of the old car. It wasn't much of a design problem to get the engine in there was it? With the limited number of gauges, the design of the dashboard was almost entirely a problem of appearance rather than functional considerations. Bench seating was standard, and was more a concern of the upholsterer than the designer. Now look at the new car. As you look under the hood, notice how the components fit tightly into the available space. The instrument panels for the driver are much more complex and are designed so that everything is within easy reach for safety. New safety features, such as air bags, must be fitted where other components were placed previously. Comfortable seating with several (or a large number of) options is available.

Successful industrial designers completely understand the characteristics of the materials with which they work. The great industrial designers have such mastery of the compositional principles that their designs successfully blend form and function.

Interior Design

The interior designer plans the interiors of buildings and homes and supervises the completion of these plans.

The first trait that an interior designer must possess is an extraordinary sense of the visual elements and compositional principles. He or she must also have the ability to present ideas clearly to clients. This presentation often includes detailed drawings, sample swatches, paint samples, and other items.

Successful interior designers build a network of sources for fabrics, wall coverings, lighting fixtures, floor coverings, kitchen and bathroom equipment, and art. They also build a network of contacts with skilled and reliable craftspersons. The interior designer must have the ability to supervise those craftspersons who carry out the plans, and to do this within a prescribed budget.

An interior designer may increase efficiency in a business by the arrangement of work space, the placement of desks, machines, and aisles, and the type and location of lighting. By making the workplace a more pleasant and comfortable place, the interior designer may also improve efficiency.

Museums

Mention the word *museum,* and the first image that comes to mind is most likely an art museum. In thinking about career choices, remember that there are many other kinds of museums, and each type employs working artists or provides opportunities for free-lance artists. Other types of museums include museums of science and natural history, aquariums, medicine, technology, aircraft, and railroad. These museums need photographers, technical illustrators, designers of exhibitions, display artists, and graphic artists for catalogs and promotions.

The art museum employs many people with a variety of artistic abilities. The curator of the art museum is an art scholar. The curator is in charge of acquiring pieces for the museum's collection as well as properly displaying them. The collection should be planned and arranged to give the viewers maximum educational as well as aesthetic value. The curator has a staff of exhibition designers and display artists to help with this function.

Many museums have education departments with a staff of specialists who prepare educational publications and programs in electronic media using the museum's collection. The staff also trains volunteer museum lecturers. These volunteers are called docents.

Several of the larger museums employ artists and craftspersons to design reproductions of works in the collection. These reproductions are sold at the museum and through catalog sales. The catalogs themselves are created by museum staff artists.

Another important position is that of the conservator. Conservators see that the collection is properly maintained and restore objects that

have been damaged or that need cleaning after the accumulation of centuries of soot.

Art Education

The qualifications for a career in art education include a minimum of a four-year college degree. The art teacher has an extensive knowledge of the major forms of expression, as well as knowledge of teaching procedures and of child growth and development.

A person who is considering art education as a career should truly enjoy developing the talent and challenging the abilities of others. He or she also must be willing to spend time developing an extensive knowledge of art history and aesthetics.

While preparing to teach in the public or private schools, most education majors must decide whether they want to specialize in elementary or secondary education in order to take the appropriate courses in college. Those who plan to teach at the college level will earn graduate degrees in their specialties.

Museum science courses may be taken by those who wish to specialize in museum education. Specialized courses are also available for those who wish to enter art therapy. Art therapists work with persons who are physically or emotionally handicapped, as well as with the blind and deaf. Art therapists use art as a means of opening communication.

GLOSSARY

A

Abstract art A twentieth century style of art in which ideas and subject matter are treated geometrically, or distorted to communicate meaning which is not a part of the subject matter itself. Abstract art stresses the visual elements and compositional principles more than the subject.

Abstract Expressionism A movement that began in New York City in 1946. The style is a revolt against all traditional styles and emphasizes spontaneous expression. It was termed *action painting* in 1953 by the critic Harold Rosenberg.

Acrylic paint Pigments mixed with an acrylic binder.

Aerial perspective A method of depicting depth on a flat surface by making distant objects smaller, placing them higher on the picture plane, and painting them in cooler colors, and in lower contrast and detail than closer objects. See also *Perspective*, compare *Continuous perspective* and *Linear perspective*.

Aerodynamics A branch of physics that treats the effects of the laws of motion of air and other gases on bodies in motion.

Aesthetic judgment The process of describing, analyzing, interpreting, and evaluating a work of art.

Aesthetics The study of the visual, literal, and expressive qualities of a work of art and the viewer's response to it. Also the branch of philosophy which is concerned with the qualities of art that create aesthetic responses and with the unique nature of art.

Air brush An atomizer which applies a fine spray of paint using compressed air. The tool allows smooth gradations of tone.

Alla prima A painting technique in which all color is laid on the support surface in one application, with little or no preliminary drawing or underpainting.

Allegorical figures Symbolic figures whose actions express generalizations or truths about human conduct or experience.

Amphistructure A structure that is part amphitheater and part sculpture.

Amphitheater An oval or circular building consisting of an arena surrounded by rising tiers of seats. The structure was invented by the Romans for tournaments and displays. The Colosseum in Rome is a good example.

Analogous colors Colors containing a common hue which are found next to each other on the color wheel, for example, blue and blue-violet.

Anasazi (ah-nah-sah'-zee) Navaho for *"the ancient ones,"* the ancestors of modern pueblo dwellers. The Anasazi culture arose in approximately A.D. 50.

Animation The process by which a sequence of images is projected rapidly, one after the other, creat-

ing the illusion of movement. Examples are film and television cartoons.

Apex The uppermost point.

Appliqué (ap-lih-kay') The technique of attaching shapes to a background by sewing or gluing.

Aqueduct A masonry channel used to convey water; invented and widely used by the ancient Romans.

Arch A curved structure spanning an open space.

Architecture The art of designing and constructing buildings, bridges, and so on.

Armory Show The first large exhibition of modern art held in America. It was held in New York City in 1913 and had a wide influence on the American art that followed it.

Art Creative work which results in objects and images often revealing beauty and insight. In the visual arts, these creations are intended to communicate meaning through symbols and images. In music, meaning is conveyed by sound; in literature, by words; and in ballet, by body movement.

Art criticism In the visual arts, the skill of understanding and making personal judgments on works of art.

Artisan A person expert in a skilled trade; a craftsperson.

Artist A person skilled in one of the fine arts, especially painting, drawing, sculpture, and so on.

Art nouveau (art noo'-voh) The "new art" of the 1890s, characterized by sinuous lines and highly foliated decoration.

Arts and crafts movement The revival of interest in hand-made crafts in late nineteenth-century England. The movement grew into an alliance of art and industry headed by William Morris. An abundance of hand-woven textiles, finely designed furniture, pottery, books, household utensils and wallpapers resulted.

Ash Can School An early twentieth-century group of artists who depicted scenes from everyday life in the city. The group, originally known as "The Eight," banded together in 1907, held their first exhibition in 1908, and helped organize the Armory Show of 1913.

Assemblage (uh-sem'-blidge) A three-dimensional work of art which is an extension of *collage*. It is also a building technique using a number of objects.

Asymmetrical balance Also called *informal balance*. In a two- or three-dimensional work it is the illusion of visual equality of sides of a design without the use of identical portions.

B

Background The part of the picture plane that appears to be farthest from the viewer.

Balance The compositional principle of design in which all of the elements appear to have equilibrium. There are three types of balance: formal or symmetrical, informal or asymmetrical, and radial.

Baroque (buh-roke') A style of art and architecture which originated in Italy at the end of the sixteenth century and lasted until the middle of the eighteenth century. The art of the Baroque has extraordinary energy, expresses strong emotion, and is characterized by strong contrast of light and dark.

Barrel vault A stone or brick roof in the shape of half a cylinder. It often covers rectangular space and is known as a *tunnel vault*.

Baseline The line (usually at the bottom of a drawing or painting) which represents the ground or floor, especially in artwork of young children.

Bas-relief (bah'-ree-leef) Also known as *low relief.* Architectural sculptured decoration with parts carved so as to project slightly from a surface (less than one half of the depth of the sculpted object). There is no undercutting of the object at all. Compare *High relief.*

Binder A medium mixed with pigment to make paint, dye, or crayon. It is also referred to as the *vehicle.*

Block A piece of wood or linoleum which is first engraved, then inked and pressed on a ground support to create a print.

Brayer A roller with a handle used to apply ink to a surface (such as a block).

Brushstroke The observable stroke by the artist's brush on a ground support.

Brushwork The character with which paint is applied to the ground support. The brushwork of each great painter is unique, and it can be admired independently of the subject of a painting.

Buddhism A religion of central and eastern Asia growing from the teachings of the Gautama Buddha (563–480 B.C.) Buddhist art was highly influential in all of central and eastern Asia.

Buttress A support projecting from the face of a wall which resists outward thrust. In Gothic architecture the *flying buttress* is an arch, projecting over the side aisle of a cathedral, which helps direct the outward thrust downward. The effect is the illusion of a floating, unsupported roof.

C

Calligraphy An Oriental method of elaborate brushstroke handwriting. Also any artfully produced, beautiful handwriting.

Canvas A closely woven cloth surface prepared for an oil painting. Also sometimes used to refer to the painting itself.

Caricature An exaggerated image often ludicrous, and often used in editorial cartooning. The practice of caricature goes back to ancient Rome.

Cartography Mapmaking.

Cartoon 1. A full-sized drawing made in preparation for a large painting, tapestry, or stained glass window. 2. A modern satirical drawing such as a political cartoon. 3. A panel strip or comic strip, humorous or serious. 4. An animated cartoon.

Carving The shaping of stone, wood, marble, or any block of material by the process of reduction, or taking away.

Casting The shaping of metal, usually bronze (an alloy of copper and tin) by the use of a mold.

Center of interest The area of an artwork that first attracts a viewer's eye.

Ceramics The art of pottery making. Pottery is shaped and then fired in a kiln or oven, which strengthens it.

Chiaroscuro (kyar-uh-skyoo'-roh) Italian for "clear and dark." The method developed during the Renaissance of arranging light and dark areas of a painting.

China Popular name for porcelain ware and statuary. It was so named because the Chinese first mastered the art of making fine porcelain. It took many centuries for Europeans to master the process. During those centuries the porcelain pieces became known as "China."

Clay Earthy material that is plastic when moist and stiffens as it dries.

Coil A long, snakelike roll of clay used in making pottery.

Collage The technique of building a low relief or two-dimensional picture by applying materials such as cloth or paper or cardboard to a ground support. It may be done in conjunction with a painting, or the whole work may consist of these applications. Also the work created by such techniques.

Collograph A form of relief printing in which prints are made by applying materials to blocks, inking the raised portions, and pressing the block to a surface. Also, the print resulting from this process.

Color A visual element of art with the properties of hue, value, and intensity. The eye perceives color through the reflection of light from the color to the eye.

Color scheme A scheme for organizing the colors of the palette selected for an artwork.

Color spectrum The array of colors visible to the human eye, produced by passing white light through a prism. The colors of this spectrum always follow the same sequence (red, orange, yellow, green, blue, and violet). The rainbow produces the same colors as white light when it passes through raindrops.

Color wheel A convenient display of the color spectrum bent into a circle. It is useful in organizing color schemes.

Communication The process by which understanding is reached through the use of symbols.

Compass A steel instrument used for drawing arcs and circles.

Complementary colors Two colors which are directly opposite one another on the color wheel. They are the colors which are least like one another, and which become dull when mixed. Placing them side by side intensifies each by creating the strongest possible contrast.

Composition The arrangement of the visual elements in an artwork; often used to refer to a work of art itself.

Compositional principles of design Rules by which artists organize the visual elements of art. They include repetition, variety (or contrast), emphasis, movement and rhythm, proportion, balance, and unity.

Computer art A broad term which may include computer graphics but usually applies only to artwork created on the computer, of a representational, abstract, or expressive nature.

Computer graphics Refers to the business diagrams, charts, graphs and page layouts created by graphic artists. It also includes the images, designs, plans and diagrams produced on a computer by designers, engineers, architects, and craftspersons, intended to be developed into other works of art such as buildings, cars, sculpture, etc.

Computer-generated imagery Refers to visual images, symbols, and designs generated by the computer, as graphics or works of art.

Conceptual art A drawing made from the imagination or memory in which the artist renders what is known about a thing, rather than what can be seen by looking at the subject.

Conservator The employee of a museum who sees that all pieces of art are properly cared for and restores, or arranges restoration of, those pieces needing special care.

Continuous perspective A technique of depicting objects on a two-dimensional surface which does not take into account the effect of optical recession. There is no vanishing point. The opposite of linear perspective.

Contour The boundary which delineates a form and distinguishes one form from another in a picture.

Contour drawing A method in which artists keep their eyes continuously on the subject while concentrating on reproducing the lines of the subject.

Contrast The compositional principle of design in which the artist chooses a variety of colors, textures, and patterns to add interest to a work.

Cool colors Those colors of the spectrum that suggest coolness such as blue, green, and violet. Cool colors seem to recede when used with warm colors. Compare *Warm colors.*

Craft guilds These guilds emerged in the late Middle Ages so that masters could set strict standards for their crafts and an apprentice system could be established. The apprentices studied and practiced the craft before becoming members of the guild.

Crafts The many forms of art that are useful as well as beautiful. Examples are quilting, ceramics, jewelry making, and weaving.

Crayons Sticks of pigment and wax which are used to make art.

Credit line A standard method of identifying a work of art reproduced in, for example, a book. It usually includes the name of the artist, the title of the work, the date the work was finished, the medium, size (height × width × depth), the source (museum, collection, or gallery), location of the source (city), donors of the work and date donated (if applicable).

Crosshatching A method of shading which gives the illusion of depth on a two-dimensional surface by the use of crossed sets of drawn or etched parallel lines.

Cubism An art movement in which subject matter is separated into geometric shapes or abstract designs, and which combines several different views of the subject. The first Cubist exhibition was in 1907.

Culture A particular stage of advancement of a civilization and the characteristics of that stage, such as its art and the skills, ideas, customs, and behavior of its people.

Curator One who selects the objects for a museum and maintains its collection.

Cursor The small arrow, cross (+ sign), or blinking light which indicates the position on the monitor screen where input will begin.

D

Dada French for hobbyhorse. A movement in art which originated at the beginning of the First World War and whose experimental art reacted against that war. The intent of the Dadaists was to go against all established conventions in art.

Dark Ages A period following the fall of the Roman Empire (from the fifth to the ninth century) which was characterized by migration of peoples, much political upheaval, and great social insecurity. Poverty and ignorance were widespread, and culture declined.

Design The plan for the arrangement of the visual elements in a work of art.

Design proportion The relationship of visual elements arranged to elicit response to the visual, literal, and expressive qualities of the artwork.

Dimension A measurement in one direction. In representational art, the three dimensions are height, width, and depth. Time is considered the fourth dimension, and many abstract artists have attempted to represent this fourth dimension visually.

Disk A flat, magnetized, circular storage device upon which computer programs, texts, and data are saved. See also *Flexi disk, Floppy disk,* and *Hard disk.*

Disk drive The device in which you place a disk; it reads the disk and sends its data, commands, and programs to the computer.

Distortion The twisting of a normal or original shape for dramatic effect.

Dome A combination of multiple arches or vaults around an axis which forms a hemispheric (half of a sphere) roof. Some domes are not true domes, since they may be, for example, octagonal.

Dominant element The visual element that is noticed first in a work of art, such as, perhaps, color in an Impressionist painting, or line in op art. Compare *Subordinate elements.*

Dye Pigment, or pigments in liquid, which may be soluble or insoluble. Dyes are used to give new color to material.

E

–e A suffix in the Japanese language which means "pictures of." Examples are Yamato-e (pictures of the

region around Kyoto and Nara) and Ukiyo-e (pictures of the passing world).

Easel A tripod or stand on which the artist places the canvas or surface for a painting or drawing, or on which a work of art is displayed for viewing. In computer art, the easel is the working area on the monitor screen. It includes the window box, menu bar, color and pattern palettes, and the tool box.

Elements of art See *Visual elements of art.*

Embroidery Decorative stitching on fabric; also a piece with such work.

Emotionalism A means of making judgments about works of art on the basis of their emotional appeal to a viewer. Emotionalism may be only part of an aesthetic judgment. Compare *Imitationalism* and *Formalism.*

Emotive proportion The relationship of objects or figures in an artwork that conveys the artist's emotion about the subject. The arrangement, and relative importance of objects or figures, may not be absolutely realistic.

Emphasis A compositional principle of design in which the artist emphasizes one part of a work by the use of color, size or shape or a combination of these. Emphasis defines the *center of interest* and generally gives the work its meaning.

Engraving The process of cutting a design into a metal printing plate. Also, the artwork which results when the ink is applied to the plate and pressed to a surface. In the United States paper money is made by this process.

Environmental art A form of art which provokes participation or involvement by the viewer.

Equestrian statue A sculpture of a figure on horseback.

Etching A process in which a design is cut into a plate by repeated baths of acid; also, the resulting print. Compare *Engraving.*

Expressionism A twentieth–century aesthetic movement which rejected the representation of natural subjects. Expressionists believe that art should communicate the artist's emotions rather than a realistic image, and they use distortion as an important means of emphasis.

Eye level The horizontal line or line level with the eye in linear perspective.

F

Fabric Material produced by weaving, felting, or knitting. Examples are cloth, felt, and lace.

Façade 1. The front, or visible part of a building. Also, and less commonly, the visible front of anything. 2. A false front designed to give a favorable impression or to trick the eye.

Fauves (fove) French for "wild beasts." Artists so named because of their radical use of intense, pure color for emotional and decorative effect. The Fauvists' movement was the first important aesthetic movement of the twentieth century.

Fiber A long, continuous, fine piece of something, usually woven or spun into thread.

Figure In art, generally, the human form. Also, the area enclosed by planes or surfaces, as in a *solid figure.*

Fine arts The arts that are purely expressive rather than functional.

Fire The application of heat for the purpose of hardening pottery.

Flexi disk A plastic-encased, 3.5-inch disk for recording and saving data on computer which is inserted and removed from the slot in the disk drive.

Floppy disk A paper or plastic-encased, 5.25-inch disk for recording and saving computer programs and data.

Flying buttress See *Buttress.*

Folk art Decorative objects made by persons without formal art training. It is generally unsophisticated but not necessarily unskilled.

Font All the letters, and numbers of one size and type style. On a computer, the typeface which is selected; it names or identifies the style and size of the letters, numbers, and other symbols for data, commands, and text.

Foreground The area of the picture plane that appears closest to the viewer.

Foreshortening The effect of the application of the principles of perspective by the artist in depicting a figure or object. The result is lifelike, and appears to have depth. To achieve this effect, artists are trained to render exactly what they see, rather than what they know about the subject.

Form The three-dimensional visual element of art. Sculpture, for example, is three-dimensional with height, width, and depth. Artists use a variety of methods to give the illusion of form on a two-dimensional surface.

Formal balance A means of creating the feeling of visual equality on both sides of an artwork, achieved by the use of identical or very similar elements on each side of the composition. Also called symmetrical balance. Compare *Asymmetrical balance* and *Radial balance.*

Formalism A method of evaluating an artwork by critically judging the relationship of the visual elements of art to each other, and the artist's use of the visual elements. Compare *Imitatationalism* and *Emotionalism.*

Found objects Natural or manufactured objects chosen by an artist to create all or part of a collage or assemblage.

Free-form forms Irregularly shaped forms, as opposed to geometric forms. See also *Free-form shapes.*

Free-form shapes Irregular, often natural appearing shapes as opposed to those which are geometric. See also *Free-form forms.*

Fresco Italian for "fresh." A method in which pure powdered pigments are mixed in water and applied to a wet, freshly laid plaster ground support. The colors fix as the surface dries, and the painting becomes a part of the plaster wall itself.

Futurism A movement begun by Italian artists in 1909. These painters attempted to represent machines or other objects and figures in motion, as well as sounds and smells. Futurists used what they called lines of force that curve, twist, dash, and cut across their paintings to show dynamic energy.

G

Gable The outside (usually triangular) section of a building's wall which extends upward from the eaves to the top ridge.

Gallery A place for exhibiting art. Also a commercial enterprise exhibiting and selling art.

Generate To produce programmed images and data on a computer screen.

Genre (zhon'-ruh) art Artworks that depict scenes from daily life.

Geodesic dome A prefabricated hemispherical dome made of light, strong, polygon shaped bars and covered with a thin but strong material; the invention of American engineer R. Buckminster Fuller.

Geometric forms Regularly shaped forms which can be precisely measured by mathematical formulas, as opposed to free-form forms. See also *Geometric shapes.*

Geometric shapes Shapes which can be precisely measured by mathematical formulas.

Gesture drawing A line drawing of a human figure which captures the movement and feel of the subject.

Glaze In ceramics, a thin, glossy coating fired into the piece. In painting, a transparent layer of paint which, when applied over another layer, modifies and reflects the light passing through.

Gothic A style of architecture and painting developed in Europe in the late Middle Ages. Gothic paintings are severe, formal portraits; Gothic architecture is characterized by slender vertical piers counterbalanced by pointed arches, vaulting, and flying buttresses.

Goths Barbarians who overran the Roman Empire and sacked Rome in A.D. 410.

Gouache (goo-ahsh') A method of painting using opaque watercolors. Also, a picture painted by this method. The opaqueness comes from using glue as the binder and adding a bit of white.

Gradation A technique highly developed by Renaissance painters in which one color is blended skillfully and almost imperceptibly into another in a painting, creating realistic, lifelike effects.

Graphic arts The visual arts applied to a flat surface, such as drawing, painting, lithography, engraving, etching; also, the techniques and crafts associated with each of these arts.

Graphic journalist A journalist who combines his or her writing skills with graphic design knowledge to produce informative graphics and/or publications.

Grid The pattern that results from intersecting vertical and horizontal lines on a surface.

Ground See *Ground support.*

Ground support The surface on which a drawing or painting is executed.

Guild See *Craft guilds.*

H

Handy A small clay shape that is smooth and pleasing to the touch.

Hard disk A 3.5-inch storage device of several million bytes (megabytes), in a non-removable case, for recording and storing large quantities of programs and data.

Hardware The basic equipment of the computer: monitor, disk drive, printer, hard disks, keyboard, and other peripherals such as joy stick, mouse, koala pad, or light pen.

Harmony In art, the combining of the visual elements of art in such a way that the similarities bind the picture into a pleasing composition.

Hatching A method of shading through the use of parallel lines. See also *Crosshatching.*

Hessian A German soldier paid to fight for the British during the American Revolution.

Highlight The small, brightest (usually white) area of a painting or drawing which depicts the strongest reflection of light in the work. Compare *Shadow.*

High relief Sculptural decoration to architecture, in which the parts of the sculpture are part of the architectural element, but project outward more than one half of their depth. Compare *Bas-relief.*

Horizon The line or point at which the earth and sky appear to meet.

Horizontal lines Lines that are parallel to the horizon or baseline.

Hue One of the three properties of color. It is the name given to a color whose unique properties give it a definite place in the color spectrum. See also *Value* and *Intensity.*

I

Icons Symbolic images which represent saints, religious persons, or other symbolic meanings. In computer art, icons are the simple pictures which represent tools, lines and shapes in the computer tool box.

Imitationalism A method of evaluating a work of art by judging the degree to which the image represents the actual subject. Compare *Formalism* and *Emotionalism.*

Impression The imprint made by the pressure of a block or printing press on a ground surface. Also the name of a single copy made by this process.

Impressionism A style of painting which originated in France in the last half of the nineteenth century. It is characterized by bold brushstrokes of pure color laid next to each other to represent the effects of light on the subject.

Industrial Revolution The technological changes which led to economic and cultural change when the majority of workers became industrial workers, following the development of large-scale factory production in the last half of the eighteenth century.

Informal balance See *Asymmetrical balance.*

Input The data, commands, or programs which are entered into the computer for processing, display, and retrieval.

Intensity The brightness or dullness of color. Full intensity colors appear on the outer rim of the color wheel and are dulled when mixed with their complementary (or opposite) color, as shown in the interior sections of the color wheel. One of three properties of color. See also *Hue* and *Value.*

Intermediate color A color made by mixing a primary color with its adjacent secondary color. Blue-green is an example. Also known as *tertiary colors.*

Interpretation An explanation of the meaning of an artwork, based upon the viewer's observation and analysis.

J

Jade A gemstone, usually green, used in jewelry and carving, which can take a high polish.

-ji (gee) Japanese suffix meaning "temple." It follows the name of the temple, as in Horyu-ji.

Joy stick A small device with a movable upright stick (like a gear shift), used to move the cursor around the computer screen, (left and right, up and down, or in circles), to enter commands or objects, and to make selections on the computer screen.

Judgment The viewer's evaluation of an artwork, based on observation, analysis, and interpretation.

K

Kaolin A white, high-firing, non-plastic clay found in scattered deposits in Europe, North America, England, and Asia, used in making china and porcelain.

Keyboard An input device, consisting of several rows of keys with alphabetical letters, numbers, command keys (escape, return, etc.), and function symbols, used for entering data and commands on the computer.

Kiln A heated enclosure, such as an oven or furnace, used to harden clay.

Koala pad An input device with a magnetized pad that responds to pressures; it transmits images drawn on its surface by a special stylus to the computer screen.

L

Landscape A drawing, painting, or print depicting a natural scene.

Lapis lazuli (lap'-is laz'-yoo-lee) A semiprecious stone, usually rounded and of a bluish-violet color.

Light pen A pen-shaped input device sensitized to activate images or enter data when applied to the surface of the computer screen or to a magnetized pad or tablet.

Line The visual element of art that is a continuous mark made on a ground support and has one dimension—length.

Linear perspective A technique for giving the illusion of depth on a two-dimensional surface by the use of one or more vanishing points from an eye-level line. In *one point linear perspective* all lines recede and meet at a single point, forming guidelines to determine the relative size of objects on the picture plane. See also *Perspective.* Compare *Continuous perspective* and *Aerial perspective.*

Lines of force See *Futurism.*

Lintel A horizontal crosspiece over a window, door, or other opening which spans the opening and carries the weight of the load above it.

Lithography The process of making printed images from a stone or plate on which a drawing or design has been made.

Loom A frame for weaving.

Lost wax process A method used in bronze casting which enables the artist to make changes in each casting by altering wax applied to a mold.

Low relief See *Bas-relief.*

M

Manifest Destiny A statement or policy prominent in the 1800s which supported the expansion of the United States to the limits considered "natural" or "inevitable."

Mannerism A style of European art which emerged in the last half of the sixteenth century. Mannerism broke away from the Renaissance traditions with a more expressive view of the landscape and the human figure. The pictures tended to be emotional with distorted shapes and bright, garish colors.

Mass drawing A process in which the artist concentrates on the weight, balance, and movement of the subject. It is usually accomplished by using the side of a drawing tool, which is approximately one-half to three-fourths of an inch wide.

Mat To frame a picture with a border heavier than the ground support. Mats are often cardboard.

Matte (mat) surface A dull, lusterless surface, such as paper. Compare *Shiny surface.*

Matte paintings Background paintings used in motion pictures to depict unusual and fantastic scenes.

Medieval Of or pertaining to the Middle Ages.

Medium The material used by an artist to create a work of art. A painter's medium is paints; a sculptor's, metal, wood, or marble, etc.

Menu A list of choices or options shown on the computer screen.

Menu bar The horizontal or vertical strip of titles or icons on the computer screen that lists the menu options.

Mesolithic Age Greek for "middle stone age." The period from 8000 B.C. to approximately 3000 B.C.

Mexican muralists The early twentieth-century Mexican artists who sympathized with the revolution in Mexico and who advocated mural painting as "people's art," since all could see the murals if they were painted on public buildings and walls. Prominent Mexican muralists were David Alfaro Siqueiros, Diego Rivera, and José Clemente Orozco.

Middle Ages A period of European history of approximately one thousand years following the fall of the Roman Empire and preceding the Renaissance.

Mimbres Spanish for "willows." Members of an ancient farming group of Native Americans in southwestern New Mexico. Their beautiful painted pottery is highly prized today and, though it was made around 1,000 years ago, looks as modern as anything produced since that time.

Mobile A piece of sculpture made of balanced suspended shapes which move freely with air currents.

Monitor The screen upon which computer entries and images are displayed and modified.

Monochrome Greek for "one color." A work completed with a color scheme using only one hue and all of its values.

Montage A composite picture made by combining two or more separate pictures.

Monumental art Art of a very large size, usually dedicated to the memory of some noted person. Examples are the Pyramids, the Sphinx, and the sculpture at Mount Rushmore.

Mosaic (moh-zay'-ik) A surface decoration made by inlaying pieces of colored stones or tile to form a pattern or picture. Also, the finished product.

Motif (moh-teef') A recurrent design element that sets the theme for a work of art.

Mouse A small input device on a wheel-ball which enters data into a computer and guides a pointer (arrow) around the screen to locate text; which inserts, moves, or modifies text, graphics, and data; or which gives instructions to the computer.

Movement A compositional principle of design in which the artist controls the movement of the viewer's eye within the work. This is *visual movement* as opposed to *actual movement* of a work (see *Mobile*).

Mural A painting, usually large, on a wall or ceiling.

Muralismo The tradition of people's art, exemplified by the murals of the Mexican Muralists of the twentieth century. See *Mexican muralists.*

N

Narrative painting A painting from which the viewer can get a story.

Negative print In photography, an image produced by reversing a positive print.

Negative space The empty space surrounding shapes and forms in an artwork. Negative space can

be above, under, beside, and, in the case of sculpture and architecture, within the work. Negative space is said to define its opposite, positive space. Compare *Positive space*.

Neolithic Age Greek for "new stone age." It is a period from approximately 3000 B.C. to 1500 B.C.

Neutral colors Black, white, and gray.

O

Off-the-loom A weaving process by which linear materials (weft through warp) are woven without using a loom.

Oil paint Pigments mixed with oil. Oil painting has been dominant in easel painting since the sixteenth century.

Opaque Not transparent, not allowing light to pass through.

Op art A shortening of *optical art*. A form of abstract art characterized by patterns which create an optical disturbance or illusion in the viewer's eye.

Operator See *User*.

Output Data or information resulting from computer processing and available to the user as a monitor display, a printout (called hard copy), or a file stored on disk.

Overlapping A method of showing depth in a painting, drawing, or sculptural relief. One object extends over another, covering part of the other, thus giving the appearance of greater closeness to the viewer.

P

Pagoda The Chinese version of the Buddhist stupa. The pagoda has become the architectural symbol of China. See *Stupa*.

Paint Pigment mixed with a binder.

Painterly Characterized by highly competent brushwork, it employs the techniques of chiaroscuro and gradation. The word originated to describe the style of the painters of the Renaissance.

Paleolithic Age Greek for "old stone age." In art, the ancient period from approximately 30,000 B.C. to 8,000 B.C., notable for cave paintings in various parts of the world.

Palette A tray used for mixing colors. Also the colors selected by an artist for a painting. On a computer program, the horizontal or vertical bar of colors, values, and patterns from which you select what you want to fill shapes, forms and spaces with.

Papier mâché (pay'-pur muh-shay') French for "mashed paper." A mixture made of newspaper and paste applied to a wire structure to create an assemblage.

Parallel lines Two lines that extend in the same direction, always equidistant, never meeting.

Pastels Sticks of pure powdered pigments mixed with resin or gum. In working with pastels an artist can see the exact effect of the colors immediately as there is no drying process which could effect a change.

Paste-up A model for a printed page as designed by a "paste-up artist." Most media now prepare paste-ups on computers rather than on paper or cardboard.

Perspective The technique of giving the appearance of three-dimensional space on a two-dimensional surface through the use of converging lines, overlapping, color (cool colors recede, etc.), detail, and variations in object size, and by the placement of objects on the picture plane. See also *Linear perspective*, *Continuous perspective*, and *Aerial perspective*.

Photogram A shadowlike image that is made by placing objects between a light source and light-sensitive paper.

Photography The art or technique of producing images on a sensitized film through the chemical reaction to light.

Photomontage A composite photograph made by combining two or more photographs.

Picture plane The surface of a painting or drawing.

Pigment A coloring substance which may be finely ground and mixed with a binder to make paint or dye, with resin or gum to form pastel sticks, or with wax to form crayons.

Pixel Short for *picture element*; the smallest single unit, or point of light, displayed on the computer screen.

Point of view The angle from which the artist sees the subject of his or her composition. Occasionally, also the angle from which the viewer sees the work.

Polyptych (pahl'-ip-tik) A picture or relief carving, usually an altarpiece, which is made up of four or more panels.

Pop art An artistic style which started in the United States in the 1960s, drawing its subject matter and techniques from the "popular" culture, such as advertising, product design, comic strips, television, and moving picture images.

Portfolio In computer art, the portfolio is the disk which contains examples of art work, images, notes and sketches. It is also a folder to hold examples of art work, notes, and printouts from the computer.

Portrait A work of art depicting a person, frequently only the head, or head and upper torso.

Positive space Shapes or forms in both two- and three-dimensional art. The spaces surrounding, between, and within the positive spaces are called *negative space*.

Post-Impressionism A painting style of the late 1800s that followed Impressionism and rebelled against it by emphasizing structure and the artist's subjective viewpoint. Post-Impressionists believed that Impressionism, while beautiful, lacked permanency. Leading Post-Impressionists were Paul Gauguin, Georges Seurat, Vincent van Gogh, and Paul Cézanne. See also *Impressionism*.

Pottery The shaping of clay into earthenware, stoneware, or porcelain.

Powwow A conference of Native Americans.

Precisionists Artists who painted geometrically precise pictures of machinery, buildings, bridges, and interiors to show the effects of industry. Their work, created in the 1920s and 1930s, is characterized by areas of flat color and precise contours.

Predella An Italian word naming the small strip of paintings which form the lower edge of a large altarpiece. It usually contains narrative scenes from the lives of saints.

Primary colors Red, blue, and yellow.

Principles of design See *Compositional principles of design*.

Printer Any device that prints text and graphics on paper from a computer.

Printing plate The prepared surface used to produce images in the printing process.

Printmaking The process of making an image which can be repeatedly reproduced by stamping, pressing, or by squeezing paint through a stenciled shape.

Prism A piece of glass of a triangular, wedge shape which can be used to separate white light into its spectrum of colors.

Profile The side view of the face of a figure, or a drawing of such a view.

Programming The process of writing a set of directions that control the operations of a computer.

Proportion The compositional principle of design that is concerned with the correct relationship of the various parts of the design, such as the parts of the human figure.

Pyramids Huge, elaborate burial monuments of the ancient Egyptian rulers. Pyramidal structures are found in other civilizations, most notably in Mexico.

Pueblo A communal dwelling place of the tribes of Pueblo Indians, constructed of adobe, in the southwestern United States.

Puppetry The creation and manipulation of nonliving objects which give the illusion of life in order to entertain an audience.

Q

Quilt A bedcover consisting of two layers of cloth filled with cotton, wool, or down, and held together by stitched designs. One side is generally decorated by diverse pieces of cloth sewn in a design, or by elaborate patterns of stitchery, or a combination of both.

R

Radial balance A form of balance in drawing and painting in which the most important object or figure is placed in the center and the other parts of the composition radiate around this central figure or object. Compare *Asymmetrical balance* and *Formal balance*.

Realism A European art movement of the nineteenth century which was a reaction against the idealism of the Romantic Movement. Realists painted street scenes, often depicting dirty, unpleasant figures. Gustave Courbet organized the first Realist exhibit in 1855.

Real texture Texture that one can actually feel, as opposed to *visual texture*, which is a creation of the artist.

Recede To move back or to appear to do so. Cool colors can be described as receding when placed with warm colors.

Refraction In art, the breaking up of a light ray (such as white sunlight) by causing the ray to pass through a medium (such as a glass prism). This process produces a spectrum of the colors of the ray.

Relativity A theory postulated by Albert Einstein in 1916 which related mass, motion, and energy. Its impact on the sciences and on many abstract artists was enormous.

Relief A work of sculpture in which the forms project out from the surface or are sunk into the surface. See also *High relief* and *Bas-relief*.

Renaissance (ren-uh-sahns') French for "rebirth." The Renaissance was the intellectual rebirth of Europe which began in Italy in the fourteenth century.

Repetition The compositional principle of design in which one visual element or object is repeated.

Reportage drawing Drawing from memory.

Representational art Renderings in which the natural world is depicted accurately. Compare *Abstract art*.

Representational proportion The relationship of objects, which appears to be optically correct in a composition, created through their arrangement by size and relative distances.

Reproduction A copy of a piece of art.

Restricted palette The selection of a limited range of hues for a color scheme.

Rhythm The compositional principle of design in which the artist repeats the same visual element or objects to create the illusion of movement and hold and direct the viewer's attention.

Ribbed vaults Structural supports used to distribute the downward thrust of a roof evenly and to allow the use of lighter material for the roof. See *Vault*.

Rococo (ruh-koh′koh) A very elaborate artistic style which began in France immediately following the Baroque period in the eighteenth century and spread throughout Europe. Rococo artworks are characterized by great charm, subtlety, and delicate colors and designs; rococo music is characterized by elegance and formality.

Romanesque (roh-mahn-esk′) A style of architecture and sculpture prominent in Europe during the mid-to-late Middle Ages, rooted in the Roman Empire styles. Cathedrals had Roman arches, and many had domes. They required thick windowless walls to support the heavy roofs. The interior walls were painted, filled with mosaics, sculpted, and hung with tapestries.

Romanticism A European style of art prominent during the early nineteenth century, characterized by brilliant colors, exotic settings, and a great deal of drama and action.

S

Samurai A warrior class which existed in Japan in the sixteenth century and served feudal lords.

Sculpture Three-dimensional artworks created by carving, modelling, assembling, or casting.

Seascape A painting or drawing of the sea, or one in which the sea is the dominant component.

Secondary colors Colors made from equal mixtures of the primary colors: green (blue + yellow), orange, (red + yellow), and violet, (blue + red).

Sepia (see′pee-uh) A reddish-brown pigment prepared from the ink of scuttlefishes, such as the octopus.

Shade A hue, made darker in value by the addition of black or a darker hue. Compare *Tint*.

Shading Darkening parts of a picture by hatching, or the use of dark hues to create the illusion of a three-dimensional form. Also the gradation of one tint or shade into another. See *Hatching* and *Crosshatching*.

Shadow The area of a painting or drawing containing the reflection of the least amount of light, used to help create the illusion of form. Compare *Highlights*.

Shang Dynasty (1700–1027 B.C.) The first of the great dynasties in China. The bronzework of the Shang Dynasty is still unsurpassed.

Shape The visual element of art that has two dimensions: height and width. A shape is formed when a line crosses itself, creating an enclosed space. See also *Geometric shapes* and *Free-form shapes*.

Shiny surface A surface that reflects light. Compare *Matte surface*.

Silhouette (sill-oo-wet′) The outline drawing of a shape or form filled in with black or a uniform color.

Silkscreen A screen made of fine silk which is stretched on a frame and treated in such a way that it becomes a stencil. The image is made by squeezing paint through the untreated areas.

Sketch To quickly draw a preliminary study of a scene or figure. Also, the drawing itself.

Slip A mixture of clay and water used to fasten two pieces of clay together (for example a handle to a cup) or to coat a piece before firing, for special effects.

Soft sculpture A piece of sculpture made of soft materials (for example, a fabric cover stuffed with kapok).

Software A program or programs used to direct the computer to execute a specific task.

Solvent A substance, usually a liquid, that is capable of dissolving another substance or substances. Great care should be taken when using a solvent.

Song (or Sung) Dynasty (A.D. 960–1279) A period of unequaled accomplishment in painting and ceramics in China.

Space The visual element of art that is the void, or area surrounding and within shapes and forms. Shapes and forms are defined by space. See also *Positive space* and *Negative space*.

Special effects In motion pictures, images or sound content added through the process of film editing or other work that takes place after the filming has been completed.

Spectrum See *Color spectrum*.

Stabile An abstract sculpture similar in many ways to a mobile, but made to be stationary.

Stained glass Glass colored by the addition of pigments, then cut and arranged in a design. Stained glass was important for its decorative effect in Gothic cathedrals.

Stencil In the silk-screen process of printing, the surface through which ink is pressed and on which an image is formed.

Still life A picture of an arrangement of inanimate objects. Also, these objects, when used as a subject for a picture.

Stippling The technique of applying small dots of color with the tip of the brush in painting, or small dots of black or gray in drawing.

Stitchery The process of ornamenting a fabric by passing a threaded needle through the fabric. Also, the item made or decorated in this way.

Stone Age The period of history in which human beings used instruments, weapons, and utensils made of stone.

Stop-action photography The use of fast shutter speeds to achieve a photograph of a figure or object in motion.

Story boards A series of drawings that displays the outline of a story, for example, for television advertisements, animated cartoons, and motion pictures.

Stupa (stoo'-puh) A monument to Buddha. Stupas originated in India but are found throughout eastern Asia.

Subject That which an artwork represents. In a portrait, it is a person; in a landscape, the actual scene; in abstract art, it may only exist in the artist's mind.

Subordinate elements The elements of an artwork that are less noticeable than the dominant element.

Subtractive method The sculptural process of taking material away from a solid block.

Sunk relief A method of carving in which the design is entirely sunk beneath the surface of the block. See also *Relief, Bas-relief, High relief.*

Support surface See *Ground support.*

Surrealism A style of art developed shortly after the First World War which depicted the working of the subconscious and unconscious mind—the mind's fantasies and dreams.

Symbol Greek for "token" or "sign." In art, a visual image that represents something else.

Symmetrical balance See *Formal balance.*

Symmetry The balance of relationships among the visual elements and compositional principles. See *Asymmetrical balance, Symmetrical balance, Radial balance.*

T

Tang Dynasty A Chinese dynasty ruling from A.D. 618—907, famous for its art and literature. Tang art was designated the international style as the empire extended from the Caspian Sea on the west to the Pacific Ocean on the east.

Tapestry A woven, embroidered, or painted ornamental fabric used as a wall hanging.

Technique A means of expressing oneself visually through working with materials.

Tempera A paint in which pigments are mixed with egg white or other opaque liquids.

Template (or *templet*) A guide or pattern for the formation of a shape, such as a square or triangle.

Terra cotta A durable clay that is usually reddish brown in color after being kiln-burnt. Terra cotta is usually unglazed.

Tertiary color See *Intermediate color.*

Texture The visual element of art that employs the sense of touch; the feel of an artwork's surface. Texture may be natural, and actually have the feel that it appears to have, or visual, and only give the appearance of that texture. See also *Visual texture.*

Three-dimensional Having height, width, and depth, as in a sculpture. Compare *Two-dimensional.*

Thrust The stress that tends to push an architectural member of a structure outward.

Time exposure Exposure of film for a relatively long time. Also, the photograph that results from this process.

Tint A lighter value of a hue, created by the addition of white. Compare *Shade.*

Tipi A conical-shaped dwelling of the North American Plains Indians usually made of animal skins held up by an understructure of slim poles.

Tools Implements used to apply paint to a support surface, such as brushes, palette knives, sticks, or fingers.

Transparent The property of a material that allows light to pass through it so that objects beyond can be seen. Compare *Opaque.*

Two-dimensional Having height and width but not depth, as in a painting, print, or photograph. Compare *Three-dimensional.*

U

Unity The compositional principle of design in which all of the visual elements come together both as subject matter and as a design to create a feeling of wholeness and completeness.

User The person who is using the computer or giving the commands to the computer.

V

Value The degree of lightness or darkness of a hue, dependent upon the amount of light a surface reflects. One of the three properties of color. See also *Tint*, *Shade*, *Intensity*, and *Hue*.

Vanishing point The point at which receding parallel lines appear to converge on the horizon.

Variety The compositional principle of design through which different colors, shapes, forms, lines, patterns, textures, and sizes are used to add visual interest to an art work.

Vault An arched structure, such as a roof or ceiling.

Vehicle See *Binder*.

Visual arts The arts that are created to be seen.

Visual elements of art The elements artists use to create works of art: color, line, shape, form, space, and texture.

Visual movement See *Movement*.

Visual texture The illusion of texture created by the artist on a flat surface. See also *Texture*. Compare *Real texture*.

Volume The space within a form, such as an architectural form.

W

Warm colors Those colors of the spectrum that suggest warmness, including red, yellow, and orange. Warm colors seem to advance when used with cool colors. Compare *Cool colors*.

Warp The lengthwise threads in weaving.

Watercolor Transparent pigments mixed with water which are used as paint. Also painting made with such paints.

Weaving Forming a cloth by interlacing strands of material such as yarn.

Weft The horizontal threads in weaving.

Window The open working area displayed on the computer screen in which the imagery, data, and text appear when generating graphic images, charts, graphs, textual information, or when entering commands. The window is a temporary work area.

Woodcut An engraved block of wood. Also the print made by applying ink to this block and pressing it upon a surface.

World Mountain Massive architecture and sculpture created from a Cambodian concept around A.D. 900. An important example is the temple at Angkor Vat.

Y

Yarn A continuous strand of spun fibers used in making cloth, knitting, or weaving.

Z

Zhou (or Chou, Dynasty) (zhoe). A Chinese dynasty which lasted from 1027 to 227 B.C. During this period jade carving reached a peak and the philosopher Confucius (551–479 B.C) lived.

Ziggurats (zig'-uh-rats) Giant stepped temples of mud bricks constructed by ancient Mesopotamians. The interiors were decorated with fresco and sculpture.

INDEX

ACKNOWLEDGMENTS

Student Art

1. From the teaching files of the Palm Beach County, Florida, Schools:

Figure 57	*Figure 62B*	*Figure 173*
Figure 58	*Figure 167*	*Figure 175*
Figure 61	*Figure 168*	*Figure 176*

2. From the teaching files of the Duval County, Florida, Schools:

Figure 177
Figure 269B

3. From the teaching files of the authors:

Figure 59	*Figure 92*	*Figure 154*	*Figure 178*
Figure 60	*Figure 129*	*Figure 162*	*Figure 220*
Figure 71	*Figure 130*	*Figure 172*	*Figure 269A*
Figure 91	*Figure 132*	*Figure 174*	

TEACHER'S NOTES AND COMMENTS

TEACHER'S NOTES AND COMMENTS

TEACHER'S NOTES AND COMMENTS

TEACHER'S NOTES AND COMMENTS

Teacher's Annotated Edition and Resource Book

For

UNDERSTANDING AND CREATING ART

Book Two

Second Edition

CONTENTS

P A R T

THE ARTIST AND
HEROES AND HEROINES

Unit One
Washington Crossing the Delaware

T E A C H I N G :
Washington Crossing the Delaware

Pre-teaching Preparation
1. Read the text, pages 3 to 41.
2. Read *The Open-Ended Encounter*, pages T-57 to T-58 in this TAER.

Materials Needed
1. A student textbook for each student.
2. Classroom Reproduction 1.

Objectives
1. The students will understand a history painting as a historical document as well as a personal statement of the artist.
2. The students will use critical thinking skills as they study the work.
3. The students will understand the use of a dominant geometric shape for compositional purposes.
4. The students will be introduced to historical

influences in art from the time of the battle of Trenton to the time Leutze painted *Washington Crossing The Delaware* (1849).
5. The students will prepare intuitively for the formal study of the visual elements of art and the compositional principles of design which follows immediately.

Time Span
1. Two to five sessions, depending upon the length of your course. (See Scheduling Your Course, pages T-59 to T-61 of this TAER)

Method
The method described in *The Open-Ended Encounter* (pp T-57 to T-58) is highly recommended. However, the text is arranged in sections which may be assigned for reading and later discussed in class, by

using the questions and suggestions listed below and the teacher annotations on the student pages. These questions, successfully used by many teachers, focus on form and key points. You will undoubtedly develop other key questions as you teach this section.

Specific Procedures

1. Place Classroom Reproduction 1, *Washington Crossing The Delaware*, where all students can see it. (The students will also refer to the various illustrations in their textbooks during discussions.)

- Before the students read or discuss any part of the text material, have them look closely at the reproduction (or the reproductions in their texts). This particular painting, with its unusual history, provides a unique teaching opportunity. The students have probably seen this work before, and may have already formed opinions about it. Its importance as a teaching tool is in the students' abilities to look at the painting as an aesthetic experience. By the end of this encounter they should be aware of their changed perceptions of the work.
- You can begin the encounter by asking some simple questions about what they see. For example:
- Whom do you recognize?
- Is that the same face as the one on the dollar bill?
- Who are the people in the boat?
- What are they doing?
- Why are they crossing?
- What time of day is it?
- Why do you think it is sunrise rather than sunset?
- How would you characterize the look on Washington's face?
- Have the students find the size of the painting. (It is on the credit line on page 3). Discuss the immense size. Pace it off in the classroom (20 feet in length) and note that the height is almost three-quarters as high as its length. This is truly a monumental painting.
- The students are now ready to read the first pages of the text aloud. These pages focus on the reasons for the crossing and the state of the American Revolution at the time of the Battle of Trenton.

2. These questions and observations may be used with the section entitled *Commanding Composition*:

- Pages 6 to 16 deal with the painting as a composition. The students are asked to see how the artist used triangles and circles to create motion and stability in the composition. After the students have located the major triangles, have them go through the entire composition to locate as many triangles as possible. While much has been written about whether Washington should, or should not, be standing in a rocking boat, the aesthetic analysis gives several reasons why the artist depicted him standing. You can challenge the students by asking why they think Washington is standing and use the text for analysis and discussion

- Have the students look at diagrams 4 and 5 which show the complexities of the ice floes. As the students analyze these diagrams, ask if they see a facial configuration. Look back at the ice floes in the reproduction of the painting with the reproduction, or book, turned sideways. This leads to an interesting speculation: Was the artist offsetting the serene Washington with the grotesque death mask in the water just below him?

3. *Many Painters, Many Pictures Section:*

- This section focuses on the importance of the Battle of Trenton in American history. The students will look at other artists' versions of the crossing. After looking at the other versions, ask the students why they think Leutze's version has remained so popular. You may add that, in the opinion of many critics, the others are better paintings. Ask if they agree with the statement that "only in Leutze's painting do we get the drama and courage of Washington."

4. *Historical Portrait Section:*

- Discuss the importance of art as a historical document. Remind the students that there were no cameras to record Washington's crossing.
- Ask the students to look carefully at the other men in the boat. Discuss Prince Whipple, an important and tragically neglected figure in American history.

5. *Theatrical Effect Section:*

- The comparison with David's painting of *Napoleon Crossing the Alps* illustrates the theatrical effect in both works.
- Notice how both artists' use of the compositional principles focuses the viewer's eye directly on the calm visages of the heroes.
- Review the importance of the triangle in both compositions.

6. *Portraits of Washington Section:*

- Ask the students which image of Washington they would have chosen if they were Leutze?

- Why do they think Leutze chose the Houdon bust?
- Stress the amount of pre-painting research Leutze did to validate his painting.

7. *What the Artist Had in Mind Section:*

- Recall the date when Leutze completed this work. Remind the students of the failed revolution in Germany, and the theme of "crossing a river."
- Refer back to the immense size of this painting and discuss just what a monument is. What other monuments have the students seen or are familiar with? They will see several others in the forthcoming pages.

8. *A Symbol of Courage and Liberty Section:*

- These last pages can be read aloud.

- Ask the students what they see in the painting that they hadn't seen before.
- Have they changed their feelings about this painting as a result of their study?

9. *Evaluations:*

- The summary questions may be used as a written exercise, or as a basis for class discussion.

10. *Extensions:*

- If your classes are also taking American history, this would be a good time to discuss possible joint projects with the history teacher, as there is a close correlation to the American history course in many sections of this text.

TEACHING:
The Visual Elements of Art and the Compositional Principles of Design

Pre-teaching Preparation

1. Read the text material, pages 42 to 60.
2. Assess the students' knowledge of the elements and principles. If they have used *Understanding and Creating Art, Book One* in a previous course, this section can serve as an excellent review. If not, you may wish to consider using the test questions from the Unit test package that pertain to the elements and principles as a pre-test to determine the amount of time to spend on this section.

Materials

1. Classroom Reproduction 1.
2. A student text for each student.

Objectives

1. The students will be able to identify and will understand the visual elements of art.
2. The students will be able to identify and will understand the compositional principles of design.
3. The students will understand that artists use the visual elements of art to create artworks. The structural principles for using the visual elements are the compositional principles of design.

Time Span

This section is, of course, of vital importance to all that follows. Time allotment depends entirely on the previous experience of the class. If this is a review, two periods should be ample; if entirely new to the class, five periods or until you are satisfied they are ready to proceed.

Method

The text and its illustrations, with *Washington Crossing the Delaware* as the basis for class discussion of the elements and principles, will be used.

Specific Procedures

Introduction

Make sure the students understand clearly the difference between a visual element and a compositional principle. This distinction will eliminate confusion and help them to sort the elements and principles correctly as they study them, as well as throughout this course. Discuss the first three introductory paragraphs to fix this concept in their minds.

TEACHING:
The Visual Elements of Art and the Compositional Principles of Design

1. Color

- It is important for the students to review Newton's spectrum here, even if they have studied it before. We can see color only if there is light by which it may be distinguished. We will be referring to this again when Impressionism is formally introduced. Explain that the pigment color theory is the practical process in which paints are mixed to produce the colors the artist sees as he or she paints. The result, however, can appear very different in different degrees of light intensity, as we know from our everyday experiences with dawn and dusk.

Properties of Color
Upon completion of this section, the students should:
- Understand and be able to give exact definitions of hue, value, intensity, tints and shades.
- Understand how to make a tint and a shade.
- Be able to point to full-intensity hues on the color wheel.
- Understand how intensity of a hue may be changed.
- Understand how artists use intensity as one way to simulate depth in a painting.

The Color Wheel
- Take the text step-by-step starting with the primary colors through the end of the section on color.

 Whether this is a review or an introduction, be sure the students have each step of the text firmly established in their minds before proceeding to the next step.
- In discussing warm and cool colors, ask the students to tell you where a line should be drawn to separate the "warm" colors from the "cool" colors. (Between yellow and yellow-green extending through the separation of red-violet and violet.)

2. Line

- The key point is that lines are *one-dimensional*. Discuss Leutze's use of line in *Washington Crossing the Delaware* as outlined in the text. Do the students understand the concept of an *implied* line? Can they find other examples in the text? (If they have problems, suggest the cover painting.)

3. Shape and Form

- Discuss *shape*. The key point is that shapes are *two-dimensional*. Make sure the students understand when a line becomes a shape. They should be able to demonstrate how to measure the two dimensions of a shape.
- Refer to the credit line under any drawing or painting in this textbook. Show students that both dimensions of the work are given and that it is standard practice to list height first.
- Discuss other ways to make shapes, such as using the side of the chalk to make a square, or rectangle, or using a four-inch paint brush to make a shape.
- Discuss *form*. The key point is that *actual* forms are *three-dimensional*. Discuss the text section on the difference between actual forms and the illusion of form on a two dimensional surface.
- Discuss the illustration (figure 44). If this is the class's first introduction to shape and form, have the students practice shading and highlighting to give several shapes (including free form shape) the illusion of form. The purpose of this exercise is for you to see that they understand the concept, not to judge drawing skill.
- Look at any credit line in the textbook accompanying an illustration of sculpture. Show that the third dimension (depth) is listed last, after height and length.

4. Space

- The students should be able to define positive and negative space.
- Discuss architecture as an example of positive space to create useful negative space. Also consider furniture, cooking utensils.

5. Texture

- The key point is to distinguish between real (or natural) textures and visual texture. We can *feel* real textures, but visual textures are an illusion we see but can't feel.
- *Washington Crossing the Delaware* is an excellent

place to look for visual texture. The students may make a list of the many different visual textures they find in this painting.

THE COMPOSITIONAL PRINCIPLES OF DESIGN

1. Introduction

- Review the concept of the compositional principles. Relate them in the visual arts to structural principles in other fine arts.
- Discuss the fact that the compositional principles were used by artists for many centuries before they were established formally during the Renaissance. You may want to extend this to say that we may use the principles as references to understand and enjoy art from all world cultures. However, in studying the art of other cultures, we may need to know much about their traditions to fully appreciate master works. In China, paintings are judged by the character and quality of the brush stroke rather than by the compositional principles.

2. Repetition

- Have the students point out the repetitions cited in the text on the classroom reproduction of *Washington Crossing the Delaware*. Ask them to look for other repetitions in the painting, not mentioned in their textbooks. (For example, the boats in the background.)
- Use a few other classroom reproductions (or other sources of your choosing) for class practice in seeing and understanding repetition.
- Point out that too much repetition may become monotonous. It may make fine wallpaper, but not necessarily art. You may want to call the students' attention to figure 236 on page 312 (Bridget Riley's *Current*) and ask, "What keeps the repetition from becoming boring and monotonous?"

3. Variety (or contrast)

- Discuss the examples cited in the text using *Washington Crossing the Delaware*.
- Have the students point out examples of the effective use of contrast in a few of your classroom reproductions (or other works of your choice).

4. Emphasis

- Discuss *center of interest*. Use the text and discuss emphasis in *Washington Crossing the Delaware*.
- Use other classroom reproductions and other images in the text (or examples of your choice). Discuss the methods artists use to create emphasis.

5. Movement and rhythm

- Using the text as a guide, discuss movement and counter-movement in *Washington Crossing the Delaware*. The students should be able to demonstrate how Leutze keeps the eye in the painting.
- Have the students point out rhythmic patterns in this painting. You may find it helpful to have the students use tracing paper, or clear plastic, with grease pencils to draw the most prominent lines of the work. After they have done this, have them point out repetition, movement and rhythm by using the lines they have drawn. Save the students' work to use in discussing balance.

6. Proportion

- Discuss the text material using classroom reproduction number 1. This is an excellent painting to use as an example in discussing the three types of proportion. The section on painting that follows (page 84) has other fine examples. The students should be able to point out examples of representation of emotive and design proportions.
- Point out that proportion is one of the compositional principles that is often exaggerated by artists for effect. They often (as we will see) stretch the compositional principles to their limits for interesting and beautiful results. Each viewer must decide individually if these efforts are successful.

7. Balance

- Discuss the three types of balance with the students. Have them look at the line drawings they made while discussing movement and rhythm. What do these lines show them about balance in *Washington Crossing the Delaware*?
- Have them look for, and identify, the three types of balance in other images in the text, the classroom reproductions, and images you introduce. Some interesting examples to discuss in this part of the text are:

The Fall of Icarus (Brueghel) page 69.
The Preacher (White) page 72.
The Cradle (Biggers) page 75.
Washington at Princeton (Sanford) page 85.
St. George and the Dragon (Raphael) page 89.
Benjamin Franklin Drawing Electricity from the Sky (West) page 90.
Joan of Arc (Bastien-Le Page) page 91.
Esther and Ahasuerus (Gentileschi) page 93.

If this is the students' first encounter with balance, you may want them to do the following activity:
• Select a geometric shape.
• Cut the shape selected in six different sizes from a sheet of colored paper.
• Place the shapes, evenly divided in number, on each half of a sheet of white paper.
• Look to see if one side looks heavier than the other.
• Try moving the shapes so that one side has more shapes but the sides seem to balance.
• Take a small piece and, with a crayon, change its color to a bright contrasting color.

• Start again. What difference does the brightly colored piece make in the number of pieces needed to achieve balance?
• When you have an arrangement you are happy with that demonstrates balance (symmetrical, asymmetrical, or radial), paste all the pieces down.
• Discuss the students' works with the class.

8. Unity

• Ask why the authors chose to put *unity* as the last of the compositional principles to be discussed.
• Have the students discuss the text section on unity in relation to *Washington Crossing the Delaware*. Using the questions in the first paragraph, ask if the students consider the painting unified? The students should support these statements by examples of the artist's use of the elements and principles.
• Have the students make the comparison suggested in the last paragraph. Their statements must be supported by specific examples.

TEACHING:
The Illusion of Space in Art

Pre-teaching Preparation
1. Read the text, pages 60 to 70.
2. Have the students bring in old magazines for practice in diagramming.

Materials
1. A student textbook for each student.
2. Pictures from magazines for practice diagramming of vanishing points (optional).

Objectives
1. The students will understand linear perspective.
2. The students will understand aerial perspective.
3. The students will be able to demonstrate linear perspective by showing how lines converge to a vanishing point.
4. The students will understand that there are other conventions, such as continuous perspective, used in other cultures.

Time Span
One to two periods, depending on the previous experience of the class with linear perspective.

Specific Procedures
1. Have the students look at the set of photographs (figure 46 A to E) which show linear perspective.
2. Discuss the text material. Add that we are so accustomed to perspective in real life, we rarely think of it as a phenomenon. In the photographs, we see that the wall, for example, appears to get gradually shorter the farther it is from our point of view. We know that it is not really shorter. In representational art, however, we must record what we see, not what we know about the subject. This is why this section is important.
3. Renaissance artists had very strict rules and mathematical formulas for calculating perspective. Today most artists rely on their own visual perception,

though there are some recent ones (such as Thomas Eakins) who establish their own metric rules.

4. Using the diagrams (figures 48 and 50) as guides, have the students demonstrate linear perspective (one or more vanishing points) by drawing directly on magazine illustrations (using a ruler).

5. Discuss point of view and the importance of *not* changing one's point of view once it is established.

6. Note that objects at the same distance from the artist's point of view are in correct proportion to one another (such as the pedestrian and the receding automobile in figure 46A). However, they both dwarf the approaching car (in the distance) from the point of view depicted here. If the pedestrian took an immediate 90° turn to his left to cross the street, he would appear to be the same height all the way across the picture plane, while the automobile would get smaller and smaller, as it recedes toward the vanishing point.

7. Some human beings have much more difficulty than others with linear perspective. If some class members are experiencing difficulty (as you can see from their experiences in paragraph four above), consider giving those students the following activity, which can be done by a group at the chalkboard, or individually on drawing paper:

• Either review the illustrations in this section of the textbook, or provide other images of streets or railroad tracks lined with telephone poles or trees, showing various vanishing points.

• Write words on the chalkboard that describe this phenomenon: horizon, vanishing point, extension lines, parallel lines, shading, nearest object.

• Have the students draw a long, straight railroad lined with telephone poles in such a way that it appears to go off into the distance, They should start with the horizon. Then they will pick a *vanishing* point. Next they will add the closest object (the nearest railroad tie) and add the extension lines (the track from that tie to the vanishing point.) This is followed by adding the other ties, making those that seem to recede into the distance smaller, closer together, and higher on the picture plane. Then add the nearest telephone pole and draw extension lines from the top and bottom of the pole to the vanishing point. Next draw all succeeding poles parallel to the first pole, and within the extension lines which get smaller, closer together and higher on the picture plane.

The students should then shade the side of the telephone poles (closest one first) not facing the light source (arbitrarily chosen from either left or right of the picture). This shows *shallow* space. The following illustration shows the sequence for this exercise.

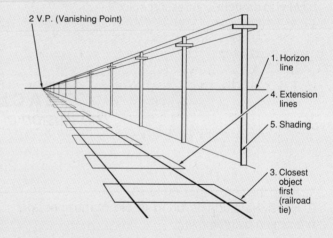

2 V.P. (Vanishing Point)

1. Horizon line
4. Extension lines
5. Shading
3. Closest object first (railroad tie)

TEACHING:
Art Criticism

A four-step process of art criticism was introduced early in U*nderstanding and Creating Art, Book One* and practiced throughout that course.

If your class has not had previous experience practicing art criticism, there is an introduction to art criticism included in your set of black-line masters, carefully outlining the steps of 1) description, 2) analysis, 3) interpretation, and 4) judgment. The work used for this introduction is *Washington Crossing the Delaware*.

The process continues to be practiced throughout this volume and each student should profit from having his or her own personal copy for review, and for the future.

Unit Two
Forms of Expression

TEACHING:
Forms of Expression

Each form of creative expression (drawing, painting, sculpture, etc.) has carefully sequenced creative activities. In each form of expression, the activities are preceded by a variety of provocative examples in that form. These opening discussion sections may be used in a number of ways, and their use may well depend upon the length of the course, the time allotted per class period, and the individual plans of each teacher. One or more examples may be used prior to each studio activity or all may be discussed prior to using the studio activities. A wide variety of examples has been chosen in each form of expression from the art of many historical periods, as well as from many worldwide cultures. Many teachers have developed their own excellent examples in the various forms of expression, as models to share with the students. The authors submit these examples as useful additions to those that have proven effective for you.

The heart of the art program is, of course, the students' creative expression. In these texts an outline of each activity is included in the student text, and each activity has a complete lesson plan in the Teacher's Resource section of the TAER. Annotations on the student pages direct the teacher to the lesson plans. The activities in the student text are worded to give the teacher wide latitude. The lesson plans are very specific, and each contains objectives, materials needed, specific step-by-step strategies, and methods of evaluation.

LESSON PLANS:
Drawing Activities

Activity 1. Reportage

Focus:
- Observation and memory of detail.

Objectives:
- *Understanding* Objective:
 — The student will understand the importance of close observation in drawing.
 —*Creative* Objectives:
 — The student will produce drawings from memory that show at least 50% of the details of the pocket item used.
 — (Optional) The student will produce recognizable drawings of places (school, streets, cafeteria) familiar to all students.

Materials:
- Drawing tools: pencil, conté, charcoal or markers
- Drawing paper at least 12 by 18 inches

Time Span:
- Need not take a complete period, but suggest that reportage drawing be repeated several times a month, perhaps by those students who have finished other work early.

Strategies:
- This opening activity is a review of work in Book One. Reportage drawing should be practiced as often as possible.

- Have the students perform the activity exactly as outlined in the student text. Discuss the results with the class.
- Optional extension:
 — Make a list of places around the school familiar to all the students (cafeteria, gym, front, side or back entrances to school, etc.)
 — Have each student select one location and draw it from memory.
 — Have the students do an actual sketch of the location chosen and compare the results with the memory drawing.
 — Critique the results with the class.

Evaluation:

- Evaluate the pocket item on the details remembered. Does the student need more practice?
- Compare the memory sketch of a location with the later sketch from observation.
 — How accurate was the memory sketch?

Activity 2. Full-Figure Contour Drawing

Focus:

- Keen observation of the figure as a whole.
- Expressive quality in drawing.

Objectives:

- *Understanding* Objective:
 — The student will understand contour drawing techniques.
- *Creative* Objective:
 — The student will produce several full-figure contour drawings of a posed model.

Materials:

- Drawing tools, pencils, charcoal, conté, markers
- White drawing paper 12-by-18-inches or larger and newsprint for sketching

Time Span:

- One period (two if the class has no previous experience in contour drawing.)

Strategies:

- Review contour drawing techniques with the class. Discuss techniques:
 — Contour lines are non-existent in nature.
 — Contour lines show edges, limit shapes, define relief and separate objects in a drawing.
 — Contour lines may be drawn slowly, with emphasis on detail, or rapidly to emphasize emotion.
 — Contour lines may be continuous, or there can be new beginnings as necessary.
 — The lines should be the result of following what the eye experiences as it moves around the edges (contours) of the figure or object.
 — Some distortion is healthy as it shows the results of experimentation and discovery.
 — Contour drawing should eliminate what the artist knows about the subject and record what the artist sees.
 — The students should draw with the whole hand keeping the wrist rather stiff.
 — They should avoid shading or penciling-in shadows.
 — Start by selecting a point somewhere on the outer edge of the figure to begin. Imagine you are actually touching this spot. Use your eyes as an extension of the sense of touch.
 — When the edge of the figure changes direction, or when you can no longer see the progression of its edge, you should stop and lift the drawing tool. A line may originate from an edge but does not always remain on the edge.
 — You then look for, and follow, the contour at the point which departs from the edge.
- Pose a draped model.
- The students should sketch standing up. They are free to move about the room. If space is limited for movement, several models may be used.
- The students will prepare several quick sketches of the posed model to get the feeling of the attitude/positioning of the model.
- The students will each produce two or three full-figure contour drawings from their sketches.
- Each student will select one for exhibiting.

Evaluation:

Critique the results with the whole class.

- Describe how individual students achieved movement and how this contributed to the expressive quality of the drawing.
- Assess the line quality of each student.
- Assess the use of the compositional principles in the total drawing.

Activity 3. Student Portraits

Focus:

- Capturing a person's "inner light."

Objectives:

- *Understanding* Objective:
 — The student will understand how an artist works to capture the character of the subject from his/her appearance and what the artist knows about the subject.

- *Creative* Objectives:
 — Portrait skills: proportion and likeness.
 — Media skills: drawing skill with various tools.
 — Research skills.

Materials:
- Drawing tools: pencils, charcoal, conté, colored chalk
- 12-by-18-inch heavy drawing paper

Time Span:
- One period research, writing and preparation.
- Two periods for drawing (one for each partner) and critique.

Strategies:
- Briefly review the proportions of the human figure.
- A quick recap:
 — The figure length is about seven and a half heads.
 — The shoulders are about twice the width of the head.
 — The length of the arms, excluding the hand, is approximately the length of the trunk.
 — Legs are tapered.
- Review the proportions of the human head:
 — The eyes are located approximately one-half the distance from the chin to the top of the head.
 — Ears generally extend from the eyes downward to the level of the tip of the nose.
 — The mouth is not wider than the eye span.
 — In profile, the head is more like the shape of a square.
 — In full face, the head is more like an oval.
- Students will work in pairs on this activity. One will assume the role of the artist, the other the historical subject to be drawn. Then they will reverse roles.
- Each student should choose an identity of a character from his/her favorite time in history. Each will write a short personal profile. The profile will contain fictional information about the character, his/her life, deeds, beliefs, family, ideals, home.

 For example: My name is René Bonnard. I am the son of a French nobleman. I heard about the fight for freedom and independence and decided that I must join General Washington's forces to help. I believe that a person's freedom is everything and a cherished right worth fighting for.

 When I came to this country I purchased a small farm where I raised crops and fine horses. I am considered a good horseman and an expert swordsman....
- For the actual setting, the student assuming the

role of the sitter may wish to dress in character, and bring in appropriate props for his/her character.
- During the sitting, the personal profile should be shared between artist and subject through conversation, much as Gilbert Stuart did in order to learn about his clients.
- After the completion of the work the students will change places, assume the opposite roles, and complete the other portrait.
- Have a class critique when all portraits are finished and displayed. Ask:
 — What do the portraits tell us about the subjects?
 — Does the portrait suggest a truthful or real-life likeness of the subject?
 — Did the artist render the work to please the subject or the artist?
 — What was the image of the subject the artist was trying to create? Was he/she successful?
- When their questions have been answered, the students should share their personal profiles and discuss the success of the artists in capturing the "inner light" of the subjects.

Evaluation:
- In addition to the questions in the critique, consider the composition itself in relation to the elements and principles.

Variations:
This activity is placed early in the text, in the drawing section, to give the students an experience from which the teacher can evaluate the stages of skill development of each class member.

You may prefer to use this activity as a painting activity or to have the student artists use clay to model a bust.

Activity 4. Different Light Conditions

Focus:
- Changes in shape and form due to the light source.

Objectives:
- *Understanding* Objective:
 — The student will recognize, and be able to point out, changes in shape and form caused by changed light sources.
- *Creative* Objective:
 — The student will produce three drawings of the same object under three different lighting conditions.

Materials:
- A strong spotlight that can be moved about the room

- Drawing tools: pencils, charcoal, conté, markers.
- Drawing paper 12 by 18 inches

Time Span:

- Two periods (one and one-half for drawing; one-half for critique).

Strategies:

- Discuss master drawings that show a strong light source such as *The Preacher* by Charles White (page 72) and *Gross Clinic* (page 73) by Thomas Eakins.
- Place a white object on the modeling stand. Move the spotlight two separate times and discuss how the object is changed as the spotlight is moved.
- Select and set up a fairly simple still life (consider a piece of sculpture) and situate the spotlight for the first rendering.
- Allow sufficient time for completing the first drawing. Write#1 on the back and indicate the direction of the light source for each student's work.
- Move the spotlight two more times; repeat the process each time.
- When all three drawings are completed, have students discuss how their drawings changed.

Evaluation:

- Analyze and compare how the students showed the change of light source.
- Compare how the changing light source changed the composition.
- Did the student faithfully record what he/she saw, rather than what he/she knew about the subject?

Activity 5. Drawing Two Figures with Strong Light Source.

Focus:

- Effect of light on a composition.
- Drawing from unusual viewpoints.

Objectives:

- *Understanding* Objectives:
 — The student will practice selecting an interesting point of view for a good composition.
 — The student will understand how to render strong contrast in light and dark.
- *Creative* Objectives:
 — The student will produce sketches of two figures.
 — The student will render a drawing of two figures.

Materials:

- Spotlight to provide strong light source
- Drawing tools: charcoal, graphite, conté, crayon
- Newsprint for sketching

- White drawing paper for final (18 by 24-inches)
- Polaroid camera, film

Time Span:

- Three periods.

Strategies:

- Discuss rendering the human figure and how to select a good point of view.
- Pose two figures in a relaxed, comfortable position.
- Provide a strong light source (spotlight).
- Take a polaroid snapshot of the two figures to assist in re-posing the models for continued work.
- Allow time for the students to select positions that give each a clear view and the probability of an interesting composition. Discuss this with the students as they make their selections.
- Have the students begin their sketches.
- Critique the students' work on an individual basis as it progresses.
- After the first two periods of this activity, the students should be ready to select the sketch that provides them with the most interesting composition. Discuss this individually with each student.
- Have the students complete their final drawing on white drawing paper.

Evaluation:

- Evaluate on the compositional principles.
- Assess the varying degrees of light and dark achieved.
- Does the point of view chosen add interest to the composition?
- How is the student progressing with figure proportions?
- Examine the relationship of the figures, considering the point of view.

Activity 6. Skill Development (head, hands, feet).

Focus:

- Developing skills in drawing.

Objectives:

- *Understanding* Objective:
 — The student will observe and analyze how to draw heads, hands and feet.
- *Creative* Objective:
 — The student will demonstrate progress in drawing skill.

Materials:

- Newsprint
- Drawing pencil, knead erasers

Time Span:
• Two periods, with follow-up throughout the course.

Strategies:
• Make this lesson important and interesting to the students. Be enthusiastic, and encourage all efforts and indications of progress.
• Show students master examples. White's *The Preacher* (page 72) is an excellent place to start. For an exceptional example of the expressive use of heads, hands, and feet, have them turn to Gentileschi's *Esther Before Ahasuerus* on page 93. Next, look at the calm hand of the surgeon versus the agonizing hand of the woman in Eakins's *Gross Clinic* page 73. Show other examples of your own choosing.
• The use of a one-inch grid may make the beginning stages easier.
• Have the students follow the text suggestions as they practice. Save and date the first attempt, and the last three of each student's drawings.

Evaluation:
• Look for the development of skills. The important thing is to work enthusiastically with the students as they practice and progress.
• Is the student progressing?

Activity 7. Mood and Character, Using Head, Hands and Feet

Focus:
• Expressing character.

Objectives:
• *Understanding* Objectives:
 — The student will develop observation skills.
 — The student will carefully consider the expressive qualities of head, hands and feet.
• *Creative* Objective:
 — The student will use his/her skills to add feeling and interest to a full-figure drawing.

Materials:
• Drawing tools
• Drawing paper (18-by-24-inch.)
• Newsprint for sketching

Time Span:
• Two periods (split).

Strategies:
• Discuss the project with the class during the previous session on head, hands and feet. They are to closely observe the characteristics of classmates and choose one as a subject.

• The students will closely observe their subject for a few days, noticing characteristic gestures, habits, how the person sits, stands, etc. They should notice if the person is usually smiling, and how he or she looks when thinking. Remind them not to ignore the legs and feet. When the subject is sitting, are the feet crossed? Wound around the chair leg?
• The students will make preliminary sketches (unobserved) and render their finals in the classroom.
• Exhibit the result and critique with the class.

Evaluation:
• Does the drawing successfully use the head, hands, and feet to show mood and character of the subject?
• Does the drawing capture the characteristics of the subject? Did the class recognize the subject?
• Is the student progressing in the skill of drawing head, hands and feet?
• Is the drawing a successful composition? Is the figure placed appropriately on the picture plane?

Activity 8. Futuristic Heroes and Heroines

Focus:
• Imagination and inventiveness.
• Drawing skills and use of media.
• Use of visual elements and compositional principles.

Objectives:
• *Understanding* Objective:
 — The student will think creatively about this project and describe the visual appearance of a future hero or heroine.
• *Creative* Objectives:
 — The student will visually represent his/her imaginative idea.
 — The student will produce a drawing which shows competency in the use of the compositional principles.

Materials:
• Newsprint for sketching
• Drawing paper (12-by-18-inch or 18-by-24-inch) for final work
• A wide assortment of drawing tools and supplies (Students will choose their own tools in this activity.)

Time Span:
• One period for discussion and preliminary sketching.
• One period for final production.

Strategies:
• Have the students read the general instructions for their project in the textbook. Spend enough

time on the class discussion so that every student has some point of departure:

— Discuss various heroes and heroines of the past. Have a student recorder make a list (from class discussion) on the chalkboard. Discuss what kind of people they were; what were their contributions (medical, military, artistic, peace, civil rights)?

— Discuss futuristic writings and movies. What kind of heroes and heroines are depicted in the future?

• Review figure proportions if you feel it necessary.
• Students will imagine their own futuristic heroes and/or heroines and begin preliminary sketches.
• As students are deciding on the final sketch, discuss how they will use the compositional principles. Remember they may use *color* if they wish.
• Encourage the use of great detail in the final work.
• The students will produce their finals on drawing paper.

Evaluation:
• Evaluate each student's final work on:
— Inventiveness.
— Drawing skills.
— Unity of composition.

Activity 9. Calligraphy

Focus:
• Design qualities.
• Expressiveness and inventiveness.

Objectives:
• *Understanding* Objectives:
— The student will understand the connection between visual symbols and verbal symbols.
— Look at printed words and numbers from the point of view of visual imagery.
— Apply the use of the visual elements and compositional principles in the analysis of calligraphic works.

• *Creative* Objective:
— The student will create a series of plates using calligraphic symbols.

Materials:
• Drawing paper (white or black)
• Drawing and painting tools: pencils, markers, graphite, rapidograph, bamboo, chalk, conté, pen and ink, oil pastels and brushes (the paint should be thinned to a flowing consistency)
• Clean-up supplies

Time Span:
• One period to review past and contemporary calligraphic works.
• Two to four periods for experimentation and productions.

Strategies:
• Discuss early (prior to the printing press) handwritten manuscripts.
• Show the class commercial examples from newspapers and magazines or other sources you may have.
• Provide a range of tools from which the students may choose.
• Allow time for them to practice forming letters. Remind them the core of calligraphy is the spontaneity of the line.
• Have the students experiment with the "feeling" of the moving tool without a pre-determined direction.
• Have them give spontaneous reactions to spoken words such as: exploding, jazz, waltz, loud cry, bubbling brook, firing of a rocket. (Use ink and brush.)
• Examine the resulting images to see if there is a relationship between the word and the image.
• Next have them try to achieve a correlation between the lines they draw and a word—make the word look like the action.
• They are now to change to a large-size chisel point pen and have the students hold the pen at a 45 degree angle. Keep the pen at 45 degrees, the stroke at 45 degrees and the form of the line (the letter) at 45 degrees. This is a disciplined skill that beginners should not avoid.
• Next try a few sheets of random lines repeated over and over.
• Have the students:
— Make an overall pattern, using the wide pen point, by taking one word (perhaps the student's name or initials) and repeating it in the same letter style varying the pressure and ink flow. Some letters may overlap.
— Have the students evaluate this as a composition using the instructions in their texts.

Extension:
• Have the students:
— Prepare a plate with an alphabet and numbers using the wide-point pen and a round-hand style.
— Use one letter or number and see how many variations they can make with the wide-point pen.

— Write their names, a poem, song verse, quotation, recipe, etc.

• Depending on the time available, proceed with developing skills in the chancery cursive and manuscript alphabets. When students can control the basic alphabet they can spend more time on inventiveness and expressive quality.

Evaluation:

• Critique students' calligraphic plates on:
— Competency and skill in the use of the tools.

— The fluid quality of the line.
— The use of repetition and emphasis in the designs.
— Uniqueness and expressive qualities.

Students who are fascinated with calligraphy should be encouraged to practice at every opportunity. Try to provide many such opportunities during the year when they finish early, or are working on a class project that calls for limited input during a class period.

LESSON PLANS:
Painting Activities

Activity 1. Portraits of Washington

Focus:

• Portrait skills: proportion and likeness

Objectives:

• *Understanding* Objective:
— The student will understand that a portrait is the artist's interpretation of the subject.

• *Creative* Objective:
— The student will give his/her individual interpretation of George Washington.

Materials:

• 12-by-18-inch white paper
• Glue
• Sheets of tissue paper in assorted colors
• Drawing pencils
• Colored pencils
• Markers
• Brushes
• Containers for glue and water mixture

Time Span:

• Two to three periods.

Strategies:

• Have the students turn to page 34, figure 29 (The Athenaeum portrait of Washington).

• Review the information about this portrait and how Stuart seemed to capture the "inner light."

• On 12-by-18-inch paper, have the students make a general-outline sketch of Washington's face, using the Athenaeum portrait as a guide. The lines should be fairly dark. The students are *not* to add shading, just the outline at this stage.

• Remind students that many artists painted Washington and that many, in fact, have copied this portrait (including Emanuel Leutze). The students are not to copy the portrait but to give their personal interpretation of Washington, using color to strengthen their own perceptions of Washington's heroic qualities. They may consider the face, his clothes, the background. Tell them to use their imaginations for their personal interpretations.

• Have the students apply color by using small shapes of colored tissue paper cut to fit the contours of Washington's face. A solution of glue and water should be brushed over the tissue paper shapes to secure them to the paper. The colors selected will vary as they should represent the students' conceptions of Washington's heroic characteristics.

• After the glue has dried, the drawing will be visible underneath. Using markers or colored pencils the students may redraw the visible lines and add shading and contour lines, working with the portrait until the desired results are achieved.

• You may prefer to have this activity be accomplished in tempera.

• Critique the results with the class.
— What might have been Stuart's reasons for choosing the colors he used in his portrait of Washington?
— What were the reasons the students chose the colors they did? Do the colors chosen heighten aspects of Washington's character?
— How would a portrait in black and white capture these same characteristics? Could it?

Evaluation:
- *Imaginative* use of color: can the student explain his/her color selection and placement?
- *Proportion and likeness:* is the student making progress in figure and facial proportions?
- Is the student's work carefully crafted?
- *Overall design:* Is the portrait placed properly on the surface? Is this a unified design?

Activity 2. Discussion Activity: Categories of Figurative Works of Art

- The students, working independently, find works of art in the textbook (and from other sources you may wish to provide) that are examples of figures in action, repose, genre art, mythological and allegorical art.
- The students will discuss the examples found. Each student should understand the various categories. Here are some examples the students may select from this textbook:
 1. Action:
 Buffalo Runners, Big Horn Basin pages 134 to 135
 Downing the Nigh Leader page 150
 End of War, Starting Home page 86
 2. Repose:
 Super Indian #2 page 196
 On the Border of White Man's Land page 201
 Mahatma Gandhi page 114
 3. Genre:
 The Jolly Flatboatmen page 186
 Early Sunday Morning page 307
 At the Moulin Rouge page 361
 4. Mythological and allegorical:
 Benjamin Franklin Drawing Electricity from the Sky page 90
 Joan of Arc page 91
 St. George and the Dragon pages 88 to 89

Time Span:
- Two periods

Activity 3. Historical Event

Focus:
- Critical thinking.
- Successful use of the visual elements and compositional principles.

Objectives:
- *Understanding* Objectives:
 - The student will research and report on the subject of his/her painting.
 - The student will understand how and why artists choose subjects for historical painting.
- *Creative* Objectives:
 - The student will document the event that he/she paints.
 - The student will create a painting of the event based on the documentation.

Materials:
- Tempera/acrylic/watercolor
- History and/or social studies books for reference
- 12-by-18-inch paper (or mural paper)
- Brushes
- Clean-up supplies

Time Span:
- Six periods: two for research and sketching, three for painting, one for critique.

Strategies:
- Divide the class into groups of four or five students.
- This activity may be assigned as an individual painting by each class member, or assigned as a mural for each of the small groups.
- Guide each group to select a painting of a historical event. If the class is taking American history, you may want to confine the events to American history.
- Provide history/social studies reference materials for the students to research the painting, as well as the event upon which it is based. (Don't overlook state historical events.)
- Have students keep a diary of their findings. The following questions will help direct their research:
 - Why did the artist select the particular event as subject matter for the painting?
 - What was the social climate at that particular time in history?
 - Who played major and minor roles in the event?
 - Were they a major or minor influence in the conclusion of the historical event?
 - Are there conflicting accounts of what actually happened?
 - Were there sacrifices by the people involved in the event? Did this event change the course of history? How?
- The students should document dates, quotes, opinions in their diaries.
- When the documentation has been completed, the students will paint their version of the event. If you prefer to have the groups do a mural, help them plan what will be shown, how the objects will be arranged compositionally, and who will paint each section of the mural.

• When the paintings are completed, hold a class critique. Each small group should make a short report on their historic event and display their paintings or mural.

Evaluation:

• Evaluate the paintings or mural on the successful use of the elements and principles.

• Evaluate the works on the imaginative ways the students presented the historic information. How does it differ from the example the group started from? Does the work show the fruits of the research?

• Consider the contributions individuals made to the group research and the development of the students' critical thinking skills.

Extension:

Students may want to discuss their paintings or mural in a joint session with the history teacher concerning the information their works conveyed about the historic event depicted.

Activity 4. Painting Sounds

Focus:

• The imagery of sounds.

• The interpretive use of color.

• The expressive qualities of a painting.

Objectives:

• *Understanding* Objective:

— The student will be able to discuss the expressive qualities of works of art.

• *Creative* Objective:

— The student will interpret specific sounds and translate them into images.

Materials:

• Newsprint for sketches

• Drawing paper and/or watercolor paper

• Drawing tools—pencils, graphite, oil pastels, tempera or watercolor (your choice, or let the students choose)

Time Span:

• Approximately four periods. The size of the works will affect the time allotment.

Strategies:

• Discuss Graves's *Bird Singing in the Moonlight* and you may also want to refer forward to Klee's *Twittering Machine* in the history appendix, page A-30. Discuss the strong expressive quality of each work and how the artists achieved the feeling or mood of the work. Use other examples you may have or prefer.

• Individually, or in a group, have the students tape natural sounds found around the school, the outside of the school, or at home.

• Listen to the tapes in class, first for the quality of the sounds, then to identify the sounds.

• Have the students draw a number of quick sketches to the sounds using colored chalk.

• Each student will choose one sound to interpret through visual symbols and paint, considering the tone, volume, rhythms or timbre of the sound.

• When each is completed let the classmates try to identify the sounds painted.

• Discuss the use of the visual elements and compositional principles in each work and the methods students used to achieve the expressive quality desired.

Evaluation:

Base the evaluation on the interpretation of the sound.

• Can the student identify objects, happenings and/or environments from sounds?

• Do the color and composition project an emotional quality?

• Does the use of the elements and principles present a unified work?

• Does the work exhibit satisfactory technical skills?

TEACHING:
Sculpture Activities

Activity 1. New Clay Sculptural Form

Focus:

• Imaginative qualities using clay.

Objectives:

• *Understanding* Objective:

— The student will research and plan (through sketching) a new clay sculpture form.

- *Creative* Objective:
 — The student will modify geometric forms to produce a new and unusual form.

Materials:
- Newsprint and drawing tools for sketching
- Firing clay, clay tools, canvas to cover working surface, plastic bags to store work in progress.
- Clean-up supplies

Time Span:
- One period for discussion, planning, sketching.
- Three periods for working with forms.

Strategies:
- Discuss futuristic methods of transportation, housing, industrial and personal adornment products. (You may want to read pages 342-347 in the last part on planned environments of the future on earth and in outer space.)
- Discuss UFO sightings etc. as suggested in the annotation.
- Have the students sketch ideas after reading the text information. Display and discuss these sketches. The sketches should indicate that students are to work with small geometric forms, pyramids, cones, cubes and spheres.
- Select a basic size that is relatively small—about two inches. Experience has shown that if the size is left unchecked, the forms can become monstrous.
- Groups may be formed as the students work if some are working on a similar theme (living on the moon, farming the sea, 25th century jewelry, etc.).
- As students work and compare ideas, allow some modification of their original sketches.
- Clay can be burnished to a very smooth surface or carved at the leather-hard stage.
- Backgrounds can be painted for displaying the clay products.

Evaluation:
- Base the evaluation on inventive and imaginative qualities and technical skill.
- Assess the work on the success, or lack of success, in utilizing and modifying the basic geometric forms.

Activity 2. Balance in Sculpture

Focus:
- Balance in sculpture.

Objectives:
- *Understanding* Objectives:
 — The student will understand, by experience, the problems of achieving balance in sculpture.

— The student will assess the suitability of a material for a designed sculpture.
- *Creative* Objectives:
 — The student will create a work in which a working knowledge of balance is revealed.
 — The student will exhibit skill in the manipulation of three-dimensional materials.

Materials:
- Thin strips of wood or bamboo (perhaps an old match stick blind)
- Pieces of scrap mapboard; cutting tools, utility knives, scissors, mat knife
- Glue, thread, tape, staplers, straight pins, hot glue gun
- Newsprint for sketching
- Boxes large enough to hold work in progress
- Blocks of wood for making bases for the finished pieces, if needed

Time Span:
- Four periods: one for discussion and sketching, two to three for studio time.

Strategies:
- Look at and discuss balance in sculpture from works in this book and others you may wish to show. Include representational and abstract works. Discuss the evidence of symmetrical and asymmetrical balance.
- Students should try several sketches of their ideas for each kind of balance.
- Demonstrate the use of all cutting tools available and caution the students about careless use. Follow up as they work.
- Each student will produce two small sculptures, one showing symmetrical balance, the other asymmetrical balance.
- Critique work in progress.

Evaluation:
Evaluate the work on:
- The degree of evidence of symmetrical or asymmetrical balance.
- Whether the balance changes as the work is seen from all directions.

LESSON PLANS:
Architecture Activities

Activity 1. Environmental Planning

Focus:
- The first activity is an observation, recording and understanding activity designed to:
 — develop critical thinking skills.
 — introduce the second activity.

Objectives:
- The students will consider:
 — Environments created by human beings as subjects for conservation efforts, as well as natural environments.
 — The importance of good design and planning for long term durability, convenience, public pride and low maintenance.
- The student will make sketches of three locations and alter these sketches to depict how these locations looked when they were first completed. Some locations may have aged well, some not so well. The student should be able to analyze the reasons for this.

Time Span:
- Two periods.

Activity 2. City Planning

Focus:
- Planning an urban environment.

Objectives:
- *Understanding* Objective:
 — The student will experience planning a practical, attractive urban environment.
- *Creative* Objective:
 — The student will render a drawing of his or her plan.

Materials:
- Newsprint for sketching
- Pencils, straight edges, compasses

Time Span:
- Two periods.

Strategies:
- Discuss the previous activity in class. What variety of urban settings did the students select for that project? Shopping centers? Parks? Buildings?

- Have one student act as recorder at the chalkboard. Ask the students to name positive and negative aspects that they noticed about the places they researched in the previous activity. For example, positive aspects for a city park might be heavy use, general cleanliness considering use, convenient placement of facilities such as water fountains, restrooms, trash containers, variety of recreational opportunities for all ages, etc. Negative aspects might be sparse use, trash, poor shade, trampled grass, inconvenient facilities, etc.
- After a few minutes for making this list, discuss possible methods a city planner might use to improve the environment of these locations. Have the students make notes. They must consider the entire area surrounding the locations for clues to help them make improvements. For example, are trampled paths in a park the result of people taking short cuts through the park to get from busy spot A on one side to busy spot B on the other? Are people using lobbies of buildings for the same purpose? Is there trash because of few trash baskets? Should underground walkways or skyways be considered between buildings? Moving sidewalks? Covered walkways in shopping centers? Should playground equipment be relocated in a park? From their notes and sketches have the students draw a plan which would improve one of the locations they have selected. They should be fully prepared to discuss why each change was made.

Evaluation:
- Did the student contribute to the class discussion? Was his/her reasoning sound?
- Were the proposed changes the student drew imaginative? Are there other simpler ways to solve the problems?
- Did the student make many, some, or few changes?
- Evaluate each student's interest in the project. Some will probably be very interested, and they should be encouraged to practice this activity on their own and to be sure to do all architectural activities in this course.

<div style="border:1px solid">

LESSON PLANS:
Photography Activities

</div>

Activity 1. Telling a Story

Focus:
- Communicating through photography.
- Using the elements and principles in photography.

Objectives:
- *Understanding* Objectives:
 — The student will be able to identify how photographic images tell a "story."
 — The student will understand how the use of the elements and principles contributes to the expressive quality of photographs.
- *Creative* Objectives:
 — The student will collect photographs from newspapers and magazines that "tell a story."
 — The student will classify the images collected by the expressive quality in each photograph.
 — The student will take a series of at least ten photographs that will have photojournalistic qualities.

Materials:
- Camera, black and white film, print paper
- Darkroom equipment and supplies (or processing)

Time Span:
- One period for looking at and discussing examples students found and brought to class, and deciding on their courses of action and story line.
- Optional: one period for a professional photojournalist to visit class.
- Darkroom time (depends on facility).
- One period to discuss and critique results of student photography in class.

Strategies:
- Ask students to bring several photographs from old magazines or newspapers that, in their opinion, tell a story.
- Discuss the examples in the text, those in your own collection, and the examples the students bring.
- Call attention to how the visual elements and compositional principles contributed to the expressive quality. Diagramming some of the pictures may assist in the assignment.
- If a professional photojournalist can visit the class, plan some of the questions the class would like to discuss with him or her during the period before he/she arrives.
- Discuss events in the school for the past week that the students think would provide a story line for photographs. Students will outline other stories they have individually selected.
- Students should take (and process if possible) at least ten photographs. After a preliminary review, have them select (with your help) two or three to be enlarged.
- Mount and display the selections for class discussion.
- Critique with entire class. Emphasize the success each had in telling the story, and the compositional arrangement of each.

Evaluation:
- First evaluate the identification and use of the visual elements and compositional principles:
 — Is there clear evidence of the compositional arrangement in the photograph?
 — Does the photography communicate an expressive quality? If so, what quality, and how was it achieved?
- Next evaluate the success or lack of success in telling a story:
 — Is the story told simply and clearly?
 — Do you need additional information (print) to get the point of the story line?
 — Would the student modify the photograph and, if so, how?

Activity 2. Montage

Focus:
- Repetition to create rhythm and movement.
- The relationship among shapes, dark and light, and textures.
- The compatibility of two photographs to produce a visually exciting image.

Objectives:
- *Understanding* Objectives:
 — The student will recognize and discuss the similarities and differences in the arrangement of the visual elements in two or more photographs.

— The student will be equipped to defend the compatibility of two images he/she selects for the montage.
- *Creative* Objective:
 — The student will select two images to produce a thematic montage.

Materials:
- A large assortment of black-and-white photographs
- Scissors, metal-edge rulers, mat cutters
- Adhesives, mat board, envelope for holding work in progress

Time Span:
- One period for looking at and discussing montages.
- One period for selecting two photographs and cutting them up.
- One period for putting them together.

Strategies:
- Collect samples of montages (ahead of time) for class discussion.
- Discuss the theme with some good examples; compare their visual impact and the overall compatibility of the examples.
- Have the students select two photographs each.
- Plan the spacing of the separations to include desirable visual clues from both images.
- Caution them on the cutting process for safety.
- They should take great care to see that all cuts are straight and parallel and to keep each side in sequence by lightly numbering the back of each piece as it is cut.
- Equal care must be exercised in attaching the split photographs to the backing.

Evaluation:
- Unification of image into one theme:
 — Did both images have the same theme?
 — Did the combination strengthen the theme? Lessen it?
 — Is *each* photograph enhanced by the combination?
- Effective use of elements and principles:
 — Does the montage have a balance of dark and light areas?
 — Is the textural pattern of each piece (strip) enhanced by the arrangement?

Activity 3. Hand Coloring

Focus:
- Placement of color for interest, emphasis.

Objectives:
- *Understanding* Objectives:
 — The student will identify photographs suitable for hand coloring.
 — The student will assess the area for coloring based on the compositional principles.
- *Creative* Objectives:
 — The student will take a series of photographs that will display the visual qualities suitable for hand coloring.
 — The student will employ hand-coloring techniques on the photographs he/she selects.

Materials:
- A series of black-and-white photographs
- Oil or water-based colors, colored pencils, food coloring, photo-flo, bleach, acrylic, Edwal toners, Marshall's oil and retouch colors, Berg colors
- Palette for blending color
- Brushes, cotton swabs, soft cloth
- Envelopes (approximately 9-by-12-inch) for storing work in progress
- Clean-up supplies

Time Span:
- One period to discuss examples of hand coloring.
- One period to experiment with color-application techniques.
- One period to apply color to photographs.
 (The schedule assumes students will be assigned the task of taking the photographs outside of class time.)

Strategies:
- Examine hand-colored photographs discussing the placement of the color. Start with the student art accompanying this activity.
- Stress the importance of the elements and principles in this process. The artist can get truly unique results with the process by clever use of the principles.
- Have the students diagram the light and dark areas of the photographs. This may assist them in identifying the best places to plan color to enhance the composition.
- Allow students to experiment with application techniques.
- Students will then select and hand color at least three photographs.
- Critique the results with the class, emphasizing the compositional principles.
- Mat and label at least one from each student for exhibition.

Evaluation:
- Evaluate the finished product on:
 — The appropriateness of the photographs chosen.
 — The arrangement of light and dark.
- The contribution the color makes to the composition.
- The sensitivity to the intensity of the color applied.
- How the color adds (or subtracts) from the expressive quality of the photographs.

Resources:
(For complete credit line information, see Bibliography)
 — *Creative Darkroom Techniques,* Kodak, p. 131.
 — *Photo Year*, 1973, Time-Life Series, pp. 126-133, 161.
 — *Art of Photography*, Time-Life Series, p. 155.

Unit Three
Special Projects

<div style="border:1px solid">

TEACHING:
Special Projects

</div>

A *Special Projects* section concludes each major part of Book One and Book Two. The special projects are divided into two categories:

- Art History
- Appreciation and Aesthetic Growth

The projects may be as simple as having students make comparisons of significant works of art, or as complex as a formal critical analysis of a work. Some may be used as class projects, some may be selectively assigned to groups of students with common interests, and some may be assigned to individuals with very specific interests and special abilities. Many of the activities involve the relationship of the visual arts to other areas of fine arts, as well as to other areas of the curriculum and to the students' daily lives.

The projects are written to leave the teacher wide latitude in use. You may decide that some should be used for research and subsequent class discussion, some for written reports and some for creative expression activities, or a mixture of these, depending upon the varying capabilities of your students.

Each project does have a common characteristic. Each is designed to challenge the critical thinking abilities of the students.

You may wish to use these projects to take advantage of student interest in a particular subject throughout the course.

PART

THE ARTIST AND THE WEST

Unit Four
The Buffalo Runners, Big Horn Basin

TEACHING:
The Buffalo Runners, Big Horn Basin

Pre-teaching Preparation
1. Read the text, pages 131 to 165.
2. Read *THE OPEN-ENDED ENCOUNTER*, pages T-57 to T-58.

Materials Needed
1. A student text for each student.
2. The classroom reproduction of *The Buffalo Runners, Big Horn Basin*.
3. The classroom reproduction of *A Dash for the Timber*.

Objectives
1. The students will be introduced to the development of American art in the period 1850-1910.
2. The students will understand the impact of the camera on the painting of animals in motion.
3. The students will study and understand Impressionism.

4. The students will use critical thinking skills.
5. The students will practice the four-step process of making critical judgments in art.
6. The students will study and understand the influences of historical events on art, as well as the influence of art on history.
7. The students will see the development of an artist's skills through his/her perseverance and hard work.

Time Span
1. Two to five days, depending on the length of your course.

Method
1. The method described in *The Open-Ended Encounter* (page T-57) is highly recommended. However, the text is arranged so that reading may be assigned and then discussed by the use of the questions listed below and the teacher annotations on

the student pages. The questions focus on some of the key points. You will undoubtedly develop your own questions and techniques as you teach this section.

Specific Procedures

Place the large classroom reproductions of *Buffalo Runners* and *A Dash for the Timber* in a prominent spot so that all may see them. (The students will also be using the text illustrations from time to time.)

1. Before the students read any of the text:

• Ask them to look closely at *The Buffalo Runners*. Name and discuss the figures, the objects they carry, the clothing of the riders, the colors, the background hills, the sky, and any other things the students introduce into the discussion.

• Ask the students if they can identify the leader of this group. Why do they think this man is the leader? What qualities do they see in this face? Is he a good rider? How can they tell?

• The painting is called *The Buffalo Runners*. Where are the buffalo?

• What time of day is it? How can one tell? (Look at the shadows—midday.)

• What time of year is it? (Probably early autumn due to the color of the grass and the clothes of the riders.)

• Ask the students to look very closely at the reproduction of this painting in their book and then look again at the classroom reproduction. What differences can they see from close observation (in their hands) and those of the painting several feet from them? (The brushstrokes and the color laid next to each other seem to blend when viewed from some distance.)

2. These discussion topics and questions are for the discussion of the camera's effect on animal painting:

• Have the students look at Muybridge's photograph and Meissonier's running horse. Also refer the students to page 85 (*Washington at Princeton*) and the two versions of *St. George and the Dragon* (pages 88 to 89). Can they understand the depth of Meissonier's chagrin? Have they seen "rocking horse" style horses depicted before? Tell them to watch for them; they will see them from time to time and they will know something about when they were rendered.

• Direct their attention now to *A Dash for the Timber*. Ask them to point out the effect of Muybridge's photos on Remington. Note the date of this painting (1889).

3. We now begin the comparisons between the two works. Direct the class's attention to the classroom reproductions as much as possible. The text illustrations of the details will be helpful also.

• Begin by asking the students to point out *overall* differences. Here are some possible answers:

 a. Actual conflict is shown in *A Dash*.

 b. *A Dash* has much more detail; it seems more realistic.

 c. The colors in *A Dash* seem cooler.

 d. Brushstrokes are much more obvious in *The Buffalo Runners*.

 e. The colors are not blended in *The Buffalo Runners* as they are in *A Dash*.

• Carefully consider any other points of comparison the students bring up. Discuss each of the points of comparison by looking at the illustrations and the text of the next few pages.

4. Impressionism section:

This is the introduction of Impressionism to the students. Discuss the Monet on page 146 along with the text description. Ask the students to show the effect Impressionist techniques had on Remington's *The Buffalo Runners* and also on *The Luckless Hunter* (page 148).

 At this point, you may, depending on your schedule, want to pursue the beginnings of non-representational art in the nineteenth century with the class. If so, consider using the text sections beginning on page 240 and also consider using part of the art history section beginning on page A-25.

5. The section of the text entitled *CAPTURING THE FOREVER* introduces the myth of the West, how this influenced Remington and other artists, and how their works contributed to the myth.

6. The next three short sections (*THE REAL WEST*, *MONARCHS OF THE PLAINS*, and *THE END OF THE HUNT*) may be used as reading assignments since they tell a fascinating story that should be understood in order to understand Remington's art, as well as that of many other artists students will study later in this part of the text. Here are some useful follow-up questions:

• Why are the Plains Indians described as being "rich?" What did they have that made them rich? (Freedom, abundance of food, clothing, shelter. They were rich spiritually.)

• Where were the Plains Indians located in the United

States? (Review the map on page 153, and also use a large wall map, if available.)

- Ask students to describe the importance of the introduction of the horse to the Indians.
- Ask students to explain the significance of the buffalo to the plains tribes.

7. The last sections deal with Remington's development as a painter and sculptor during the last years of his short life. They also deal with the loss of his beloved West to the forces of Manifest Destiny, and his artistic reaction to that loss.

- Ask why students believe Remington painted mostly retrospective scenes in the last years of his life.
- Ask students if they think the use of Impressionism was a good choice for Remington for his retrospective paintings. Why?
- Have the students look at the two heads on pages 163–164. Ask which they prefer, and why? The discussion should bring out the fact that both of these works illustrate the inherent pride of the subjects. If the students are particularly interested

in the sculpture of Remington, you may want to continue this theme by using the material about the "lost wax" method of casting which centers around the casting of Remington's *The Norther*. This material begins on page 199. Another early Remington bronze, *The Bronco Buster*, is in the section on Heroes and Heroines, page 101.

8. *The Buffalo Runners* is an interesting painting to use for critical analysis. During the course of this unit the students have performed the first step (description), the second (analysis), and much of the third (interpretation). They are now ready to make their own interpretation of this painting, and their own critical judgment. This is an excellent opportunity to review the three types of judgments: imitational, formal, and emotional. The students will enjoy making a judgment, but they should be prepared to discuss specific reasons for their judgments.

Evaluation

1. The summary questions may be used as a written exercise, or as a basis for class discussion.

Unit Five
Forms of Expression

TEACHING:
Forms of Expression

Each form of creative expression (drawing, painting, sculpture, etc.) has carefully sequenced creative activities. In each form of expression, the activities are preceded by a variety of provocative examples in that form. These opening discussion sections may be used in a number of ways, and their use may well depend upon the length of the course, the time allotted per class period, and the individual plans of each teacher. One or more examples may be used prior to each studio activity or all may be discussed prior to using the studio activities. A wide variety of examples has been chosen in each form of expression from the art of many historical periods, as well as from many worldwide cultures. Many teachers have developed their own excellent examples in the

various forms of expression, as models to share with the students. The authors submit these examples as useful additions to those that have proven effective for you.

The heart of the art program is, of course, the students' creative expression. In these texts an outline of each activity is included in the student text, and each activity has a complete lesson plan in the Teacher's Resource section of the TAER. Annotations on the student pages direct the teacher to the lesson plans. The activities in the student text are worded to give the teacher wide latitude. The lesson plans are very specific, and each contains objectives, materials needed, specific step-by-step strategies, and methods of evaluation.

LESSON PLANS:
Drawing Activities

Activity 1. Still-life Drawing (Pencil)

Focus:
- The surface quality and character of pencil drawing.
- The use of the visual elements and compositional principles.

Objectives:
- *Understanding* Objective:
 — The student will examine and discuss qualities of pencil drawings.
- *Creative* Objective:
 — The student will create a pencil drawing of the still life in the style of your choice (realistic, abstract, contour, etc.).

Materials:
- Drawing pencils of at least three different degrees of softness/hardness
- Newsprint for planning, white drawing for final
- Erasers and fine sand paper (for sharpening pencils)

Time Span:
- Two periods.

Strategies:
- Look at and discuss drawing by master artists, past and contemporary. Begin with the Bingham sketch for *The Jolly Flatboatmen in Port*, page 170, and W. R. Leigh's studies of the buffalo and wolf, page 175.
- Set up one or more still-life arrangements in the classroom. Various light sources can add interest.
- Have the students experiment with the varying degrees of value that can be achieved with the pencil.
- The students will do three or four preliminary sketches. Emphasize the overall composition. Select one for final rendering.
- Next have them block in the basic composition, paying special attention to light and dark areas.
- They will then work over the whole drawing plan from the lightest areas to the darkest.
- Help the students critique several times during the development, making adjustments and adding details last.
- Display all work and conduct a class critique.
- Each student should keep his/her final drawing for later use and comparison.

Evaluation:
- Discuss the total class production based on identifying the varying drawing techniques, the quality of the line, the distribution of light and dark, and the use of compositional principles.

Activity 2. Still-life Drawing (Markers)

Focus:
- The surface qualities of work done with markers.
- Line quality using markers.

Objectives:
- *Understanding* Objective:
 — The student will analyze the difference between the surface qualities of a drawing done with markers and one done in another medium.
- *Creative* Objective:
 — The student will generate a still-life drawing using the unique qualities of markers (in one dark color).

Materials:
- Water-based markers with a variety of tips (Each student is to use one color only.)
- Pencil for sketching for each student
- Soft bristle brush and water for each student
- Newsprint and 12-by-18-inch drawing paper
- Use the same still-life set up as in previous activity

Time Span:
- Two periods.

Strategies:
- Discuss the visual qualities of markers on paper. Markers provide an excellent medium for compositions using shallow space.
- Have the students try to achieve:
 — solid flat areas
 — a directional pattern within solid areas
 — bold line statements
 — variations in width of lines
 — variations in intensity of lines
 — a soft gradation with a wash.
- The students may use one of their previous sketches, if you are using the same still-life setup, or prepare a few sketches of a new setup.
- The students will select one sketch each for their finals based on their most successful compositions.

- They will then complete their drawings.

Evaluation:

- Assess the achievement of line quality in the variations listed above.
- Critique the overall composition on the visual elements and compositional principles.

Extension:

- The students may draw on dampened paper so that lines will bleed and run. After drying their drawings, they can add details over the first application.

Activity 3. Still-life Drawing (Pen and Ink)

Focus:

- Variety and sensuous quality of line.
- Use of the visual elements and compositional principles.

Objectives:

- *Understanding* Objective:
 — The student will recognize and understand the similarities and differences in pen and ink drawings and other drawing media.
- *Creative* Objective:
 — The student will execute a still-life drawing using pen and ink without preliminary sketches.

Materials:

- White drawing paper 12-by-18-inches
- Pen staffs with an assortment of points (Speed Ball B points, steel points, crow quill pens, and an assortment of bamboo pens)
- The students, at your direction, may provide other found tools appropriate for drawing.
- India ink in individual bottles (Cardboard stabilizing bases can be made for ink bottles.)

Time Span:

- One period for discussion and experimentation with line.
- Two periods for completing still-life drawing.

Strategies:

- Discuss pen and ink drawing. Start with Remington's cat and burro, page 171.
- A practice and experimentation time should be provided in the first session. Have the students practice with various pen points making line, texture, geometric shapes, giving them shading to show form. They should practice showing movement, variety, balance, by varying points and strokes.
- Students may be tired of the same still-life arrangement, so it may be rearranged.
- Caution students about using permanent ink and the accidents that can happen.

- Do not allow students to move about the room after beginning their drawing.
- Critique the work in progress encouraging concentration on line quality and composition.

Evaluation:

- Display all student work. Have each student write a paragraph (short critique) of the total class work. Next have them write another paragraph about three examples which they believe show inventive composition and consistent quality of line. They must tell why the three were chosen and how the effects were achieved.
- Have individual students discuss how they could change either the techniques used or the composition for their next pen and ink drawing.

Activity 4. Drawing—Mixed Media

Focus:

- Drawing skill and composition.
- Mixing of different drawing media.

Objectives:

- *Understanding* Objectives:
 — The student will be able to discuss various drawing media used by master artists.
 — The student will be able to discuss how different artists achieve line quality in various drawing media.
- *Creative* Objective:
 — The student will produce a drawing in which two or more drawing media are used.

Materials:

- Pencils of a variety of softness/hardness
- Charcoal
- Markers (black and of various colors)
- Ink and assorted pen points
- Drawing paper 12-by-18-inches

Time Span:

- Two periods.

Strategies:

- Re-examine drawings in the textbook and others shown in the previous drawing activities. Discuss the visual qualities and how they were achieved with various drawing tools.
- Make new still-life arrangements. This could be an assignment for selected students or part of extra credit. Encourage students to bring contributions to school for a "still-life bank." Add a piece of patterned fabric to each still life if not included.
- Have the students select their drawing tools and begin work.

- Provide on-going critique of individual work as it progresses.

Evaluation:
- With the class, critique the results on:
 — control of the various media used
 — variety of line
 — quality of line
 — composition.
- Have each student review all of his/her own still-life drawings using the same criteria. Diagramming some of the compositions may help students in evaluating their use of the compositional principles.

LESSON PLANS:
Painting Activity

Activity 1. Painting Figurative Groups

Focus:
- The relationship of one figure to another.
- The placement of figures in a group.

Objectives:
- *Understanding* Objectives:
 — The student will understand and be able to discuss cultural and historical influences on master works in painting.
 — The student will expand his/her knowledge of how artists use the elements and principles in painting groups of figures.
- *Creative* Objectives:
 — The student will complete three compositions (or your option) containing at least three figures.
 — The student will use the same figures in each composition, but in different relationships to one another.

Materials:
- Newsprint for sketches
- Watercolor and tools for initial sketching
- Assorted collection of brushes to suit the painting medium selected
- Watercolor and acrylic paint
- Appropriate supports for the media selected
- Clean-up supplies

Time Span:
- One period for looking at and discussing figurative works of art.
- Two periods to sketch and transfer selected images to supports.
- Four to six periods for painting, depending on overall size of work that you select.

Strategies:
- Look at paintings throughout the text, past and contemporary examples, having three or more figures. Add examples you wish to show the class.

Discuss the historical and cultural influences that may have affected the works.
- Discuss how the figures relate to one another, and how the artist used the figures in the composition.
- Discuss how figures might be used in the students' work to communicate a theme such as a festival, cooperation among the figures, danger, etc.
- Have the students sketch one posed model with thinned watercolor to get the feeling of the model and reinforce their skills with watercolor.
- Add a second model and repeat the process; then a third and again repeat the process. Students are sketching these models to help in the development of the figures he/she will place in their paintings.
- Each student will choose a theme and fit the figures into the composition. Remind them to pay attention to balance and movement within the picture frame.
- Each student will prepare three (or the number you choose) final sketches and transfer each to a support.
- After selecting the medium for their finals, the students will proceed to block in figures and color.
- Critique student work as it progresses.

Evaluation:
Base the evaluation of each student's work on the composition, variety and movement of figures, the communication of the selected theme, and the technical skill displayed.
- Do the figures seem to know and/or be aware of the others within the composition?
- Does the arrangement of the figures add to a well-balanced composition?
- Does the work communicate the selected theme? Does the sequence show a progression? Does the change make a difference in the theme?
- Evaluate the progression of the student's skill and craftsmanship.

LESSON PLANS:
Sculpture Activities

Activity 1. Narrative Sculpture in Clay

Focus:
- Conveying a story in sculpture.

Objectives:
- *Understanding* Objective:
 — The student will review the concept of narrative art and appreciate outstanding examples.
- *Creative* Objective:
 — The student will create a narrative sculpture.

Materials:
- Newsprint and drawing tools for sketching
- Firing clay, clay tools, canvas to cover working surface, plastic bags to store work in progress
- Clean-up supplies

Time Span:
- One period for discussion, planning, sketching.
- Two to three periods for completion and critique.

Strategies:
- Discuss narrative sculpture. Use the examples in the text, as well as others you may wish to introduce. There may be examples in local parks you shouldn't overlook. Be sure the students understand the story that, for example, Borglum was telling in *On the Border of the White Man's Land*, page 201. You might include Bernini's *David* (in the history appendix) on page A-14. Note how we have an implied antagonist (Goliath). We can almost *feel* his presence. Ask why this is so.
- Have the students choose a topic, plan the composition and do their sketching. Remind them that they will be working in three dimensions and indicate the compositional problems.
- The students will begin their clay work.
- Critique the work in progress.
- Fire the individual pieces or have the students burnish them at the leather-hard stage, if appropriate.

Evaluation:
Base the evaluation upon:
- Inventive and imaginative qualities in telling the story.
- Technical skill displayed.
- The success of the piece as a composition. Is the student progressing? Is there one obvious "better" view of the piece, or has the student been successful in making a successful composition from several viewpoints?

Activity 2.
Wire Sculpture—Figure in Action

Focus:
- Attitude and energy expressed in wire sculpture.

Objectives:
- *Understanding* Objective:
 — The student will understand how to express action and movement in sculpture.
- *Creative* Objective:
 — The student will create a sculpture of a human figure in action.

Materials:
- Flexible bailing wire
- Pliers (cutting, needle nose, regular)
- Tacks and hammers
- Wood for base
- Thread and glue for joining wire
- Nails and glue for base
- Flat black paint
- Sketching materials, newsprint
- Sculp-metal liquid
- Papier mâché materials and/or muslin dipped in plaster
- Pieces of sheet metal (flexible copper or aluminum)

Time Span:
- Two to three periods.

Strategies:
- Discuss the strategies outlined in the student text. Optional: Discuss adding solid materials to the surface of the wire.
- Pose a model in several action positions, approximately five minutes a position.
- Have the students sketch the model. Remind them that they are to think of the pencil line as a continuous piece of flexible wire. They should make a minimum of four sketches.
- Pass out the wire (cut in approximately 25-inch-long pieces) and other materials.
- Make sure the students are arranged so they are not crowded.

- Discuss safety procedures with the class.
- Review procedure for joining wires together (thread with touch of glue).
- Establish a work place for painting, adding papier mâché, sheet metal, etc.
- Critique work in progress.
- Have the students add other material to the wire surface if you have decided on the option or....
- Have them mount their piece to the base and paint it.

Evaluation:
The evaluation should be in parts, based upon the previous experiences of the students in wire sculpture.

If the students completed the wire sculpture activities in *Understanding and Creating Art, Book One*, or have had previous experience in wire sculpture, you should expect a well-crafted, expressive piece.
- Did the student carefully consider how his or her piece would look from several viewpoints?
- To what extent does the figure express action and movement?
- Do the materials added to the wire contribute to the composition? Are they appropriate? Appropriately placed? Would the piece be better without them?
- How does the craftsmanship of each student's work compare with that of others?

LESSON PLANS:
Architecture Activities

Activity 1. Architectural Harmony with the Environment

Focus:
- Creative planning in architecture.

Objectives:
- *Understanding* Objectives:
 — The student will understand the relationship of the environment and architecture.
 — The student will consider the effect of the environment on architectural design.
- *Creative* Objectives:
 — The student will study the environment in his/her locale, take notes and make sketches to help him/her design a house in harmony with the environment.
 — The student will make a preliminary design for a house and decide upon materials to use, and architectural features which complement the environment.

Materials:
- Pencil, notepad
- Newsprint for sketching
- Drawing paper, 12x18 inches, tools of students' choice

Time Span:
- One half period for introduction.
- One period after studying, note taking and sketching an assignment.

Strategies:
- Discuss the information in the text with the students.
- Have the students research the local environment as an assignment. They should come to class with notes prepared on the climate, natural terrain features, trees and other vegetation, soil types, and sketches of these features.
- In class have the students prepare a drawing of a house that would be appropriate for the local environment. The house should be placed in a background that is typical of the region.

Evaluation:
- Evaluate this project on the imagination shown in the house design and the quality of the research on the local environment.
- Evaluate the drawing on the compositional principles.

Activity 2. Architectural Shapes
Focus:
- The use of architectural shapes in design.

Objectives:
- *Understanding* Objective:
 — The student will understand how artists use shapes (such as architectural shapes) as a design in an art work.
- *Creative* Objective:
 — The student will produce a painting using juxtaposed and overlapping architectural shapes.

Materials:
- Drawing paper
- Sketching tools
- Scissors, ruler
- Glue
- Support for painting
- Tempera or medium of choice for painting

Time Span:
- Two periods.

Strategies:
- Discuss the text material on the activity with the students. They are to vary the size from small to medium and large as they sketch. As they are to cut these shapes out, they need only sketch the outline shape of each building.
- When their sketches are complete they will cut out the shapes and arrange them into a composition.
- If they pierce or cut holes in the various buildings, suggest that the hollow spaces should be considered carefully in conjunction with the shape of the building, as well as how they fit in the entire composition.
- When the composition is to the students' satisfaction, they will glue it to drawing paper.
- The students will then use rulers to lay out the composition on the ground support and paint the final composition in a medium of your choice.

Evaluation:
Consider:
- The imaginative use of shape.
- The use of color.
- The overall composition. What added to the quality of the design? What subtracted from the quality?

Extension:
The design activity can be accomplished using arrangements from nature, house plants, flowers and vegetables or people.

LESSON PLANS:
Photography Activities

Activity 1. Sepia Toning

Focus:
- The chemical aging process of photographs.
- The expressive quality of the subject matter.

Objectives:
- *Understanding* Objectives:
 - The student will understand the aging process of photographs.
 - The student will analyze and validate the authenticity of photographs based on visual clues.
 - The student will recognize contemporary images appropriate for sepia toning.
- *Creative* Objectives:
 - The student will select a photograph, from those available, that has the desired qualities for sepia toning.
 - The student will treat the print in the process of sepia toning.

Materials:
- An assortment of photographs
- A pair of rubber gloves for each student participating
- Photo lab tongs for each chemical tray (no aluminum)
- Chemicals:
 - Bleach
 - Sepia Toner
- Running water for washing prints
- Racks or a clothes line and spring pins for drying

Time Span:
- One period for research, discussion and procedures.
- One to two periods for toning process.
- One period for critique and matting for exhibition.

Strategies:
- READ AND REVIEW PROCEDURES BEFORE STARTING THIS ACTIVITY. Here are two good resources:
 - *The Essential Darkroom Book*, by Tom Gilland, Mark Scanlon, American Photo Book Publishing, New York, 1981.
 - *Creative Darkroom Techniques*, Eastman Kodak Co., 1973.
 See pages 104–121.
- Look at and discuss examples of toned works in publications.
- Discuss contemporary images that would warrant toning. Have the students make selections. Improperly processed prints will result in developer

or fixer stains when toned.
- Always work in a well-ventilated area.
- Discuss safety procedures with the students.
- Follow the procedure listed in the books suggested above.
- Wash and dry the prints.
- Make selections and mat for exhibition.

Evaluation:
- Consider the appropriateness of the photos selected:
 — Is the image timeless; without modern objects?
 — Is the density of the dark areas high in relation to the bright or light areas?
 — Are there stains from the original processing?
- Consider the success or lack of success of the toning.

Activity 2. Time Exposure

Focus:
- Camera techniques for time exposure.
- Inventive approach to night photography.

Objectives:
- *Understanding* Objectives:
 — The student will understand the techniques used in published photographs.
 — The student will discuss the composition of time-exposure images.
- *Creative* Objectives:
 — The student will apply techniques used in night photography.
 — The student will translate available night light into shutter settings.

Materials:
- Camera with adjustable shutter speeds and T (time) or B (bulb) setting.
- Tripod
- Flash light
- Tri-X film

- Darkroom and equipment/supplies for developing film
- Mat board, glue/tape

Time Span:
- One period for discussion of published works, discussion of camera setting and tripod use, discussion of possible locations for night photography.
- Two or more periods for developing and then discussion of the time exposure shots.

Strategies:
- Discuss examples of time exposures.
- If possible, invite a local camera store representative to show and discuss various types of tripods and adjustable cameras.
- Discuss the use of the tripod and allow time for practice in setting up.
- Suggest that students spend time observing night lights that may make good time-exposure images.
- A night meeting of the class at a chosen spot may be helpful.
- Stress the need to keep accurate records of all settings.
- Develop the film and critique the results with the class.
- A follow-up assignment may be needed.

Evaluation:
- Quality of the photograph:
 — Are the light images clear and sharp (was the camera properly focused)?
 — Are the dark areas defined well?
 — If the subject was moving, does the blurred image contribute to the composition?
 — Does the student's ledger on camera settings indicate that he/she approached the assignment in an orderly manner?
 — Does the image communicate an expressive quality?

LESSON PLANS:
Craft Activity

Activity 1. Coil Pot

Focus:
- Construction techniques and skill development.
- Designing a symmetrical container.

- Using a template.

Objectives:
- *Understanding* Objective:
 — The student will understand the techniques of making a coil pot.

- *Creative* Objective:
 —The student will design and construct a symmetrical container using the coil method.

Materials:
- Moist firing clay
- Cardboard for templates
- Varnish or polymer medium and utility brushes
- Heavy cardboard or masonite board for working surfaces
- Utility knives or paring knives
- Rags and plastic to cover (and store) work in progress
- Slip or small cans of water and brushes
- Shells, feathers, rope, sticks, etc., for possible decorative use.
- Clean-up supplies

Time Span:
- Two periods for viewing examples, selecting desired designs, making templates.
- Three to five periods for completion of coil pot.
- One to two periods for completion of surface decoration (before and after firing).

Strategies:
- Display several examples of coil-constructed containers if you have them; use photographs and slides if you don't.
- Discuss the proportions (width to height) and changes in vertical profiles (where the pot curves or changes direction).
- Discuss the relationship of the size of the base to the size of the top.
- These discussions might include quick exercises in diagramming balance and movement.
- If you have visual examples of coil pots with surface decorations of various objects such as shells, rope, sticks, etc., discuss the successful (or not so successful) use of these decorative additions.
- Caution the students on the use of knives for cutting.
- Have the students prepare a series of sketches of their proposed containers. Critique the class output and make changes or adjustments based on the critique.
- The students will enlarge their sketches to the desired size and make templates and their bases.
- The students will prepare the clay.
- The students will then proceed with coil making and attach coils to their bases as stated in the textbook.
- When the student has reached the top of the template and has a symmetrical container, he/she should complete the pre-firing surface decoration.
- After firing, the students will consider the addition of other decorative materials.

Evaluation:
The evaluation should be based on:
- The student's skill in construction technique:
 —Was the student able to control the moisture in the clay?
 —Was the clay wedged satisfactorily?
 —Are the coils a consistent diameter?
 —Were the coils attached securely and evenly?
- The design of the student's container; the translation of the design to the template.
- Did the design show effective use of the compositional principles? Balance? Proportion? Unity? Is the design appropriate for the technique in using a template?
- To what degree does the surface decoration fit the design of the container? Does it add or subtract from the visual quality of the container?
- If materials were added are they inventively and uniquely attached?

LESSON PLANS:
Printmaking Activities

Activity 1. Relief Collograph

Focus:
- Repetition of shapes in a relief collograph.

Objectives:
- *Understanding* Objectives:
 —The student will understand (review) the printing process.
 —The student will understand how to get desired effects in the collograph printing process.
- *Creative* Objective:
 —The student will make a series of prints of landscapes, cityscapes, or objects of his/her choice that show repetition.

Materials:
- Corrugated cardboard

- Drawing tools—dark markers
- Cutting tools—mat knives and sharp scissors
- Polymer medium or water-based varnish to seal the painting plates
- Water-based ink or liquid acrylic paints, inking tray, brayers
- Envelopes for holding the student's cut shapes before final gluing
- Clothes line and spring-type clothes pins for drying

Time Span:
- Two periods for design and making plates.
- Two to three periods for printing and critique.

Strategies:
- Spend time looking at photographs of landscapes and cityscapes for repetitive patterns. Many examples can be found in magazines and trade journals.
- If the students have not had previous experience with the relief printing process, discuss the procedures with them.
- Each student will sketch his/her composition following the text instructions.
- Caution the students about the use of knives.
- When the students have completed their printing plates, cover the entire surface with polymer medium or a coat of acrylic varnish.
- Set up enough printing stations to allow one-half of the class to print at one time (if possible in your space).
- The students will now work as partners. While one partner prints, the other helps by handling the clean paper and hanging the individual prints to dry. They then reverse roles.
- Critique the result with the entire class.

Evaluation:
- How successful is the design? Did the student select a model that would display the repetition of shapes?
- How successful was the printing process? Is it done neatly? Is the ink applied smoothly?
- Is there a good balance between positive and negative spaces?
- Did the student show imagination in the details such as trees, light posts, door knobs, etc.?
- Did the student use the entire surface? Do any shapes bleed off the print plate?

Note About Ink: There are two kinds of printer's ink, water-based and oil-based. "Water-based" inks can be thinned and cleaned up using water. All other inks, using some kind of solvent such as acetate, mineral spirits or turpentine, are considered "oil-

based". These chemical solvents are toxic and are generally not acceptable for classroom use.

Check with your purchasing agent and your administration, for the legal regulations regarding the use of toxic materials in a school.

Activity 2. Linoleum Prints: Dreams

Focus:
- Successful completion of linoleum block prints.
- The qualities and differences in different printing methods.

Objectives:
- *Understanding* Objectives:
 - The student will understand the process of making block prints.
 - The student will appreciate the various methods of printmaking and consider the advantages of each.
- *Creative* Objective:
 - The student will make prints from a linoleum block which demonstrate a good grasp of the compositional principles.

Materials:
- Manila paper
- Six-by-six-inch linoleum blocks (or similar)
- Scraps of linoleum for practice
- Linoleum cutters, blades
- Bench hook for each student (need both left and right-handed stops)
- Printing paper at least ten by ten inches
- Pencils, erasers, crayons, markers
- Inking trays (plastic grocery trays work well)
- Brayers
- Water-based ink
- Sponge

Time Span:
- Two periods for planning, sketching, transferring to the linoleum block.
- Two to three periods for cutting block, printing.
- One period for critique of work, discussion of various printing processes.

Strategies:
- Discuss the process with the class. Go over the instructions in the text and emphasize safety precautions.
- Be sure you have enough bench hooks so that each student will have one to use. Make both left and right-handed stops. This is a major safety factor.

- Have the students proceed in the sequence of the text instructions. Provide ongoing help and critique, especially as students practice cutting scraps of linoleum. At this stage they must understand that they are cutting away the areas they wish to remain white (or the color of the paper they will print on).
- When the actual printing process begins, partners may work together, as they did in the previous activity.
- When the prints are dry, display for critique.
- Critique the results with the class. What are the reasons for successful prints, and less successful ones? Stress the importance of understanding what went wrong, as well as what went well, for future print making, using any of the printing processes.

Evaluation:
- Evaluate the craftsmanship of the student. Did he/she pay close attention to cutting away the smaller areas?

- Evaluate the print as a composition.
- Evaluate how well the student used the inherent qualities of this printing process.

Extension:
- If time permits, a second exposure to this activity can be rewarding in observing students' improvements. An interesting variation is to reverse the process. Use the students' original drawings, and have them cut away the dark areas that they have drawn, rather than use the white areas of their drawings. This is an excellent time to reinforce the concept of positive and negative space.
- Have the students select different colored sheets for printing. The color selected should enhance the theme of their prints.

Unit Six
Special Projects

TEACHING:
Special Projects

A *Special Projects* section concludes each major part of Book One and Book Two. The special projects are divided into two categories:

- Art History
- Appreciation and Aesthetic Growth

The projects may be as simple as having students make comparisons of significant works of art, or as complex as a formal critical analysis of a work. Some may be used as class projects, some may be selectively assigned to groups of students with common interests, and some may be assigned to individuals with very specific interests and special abilities. Many of the activities involve the relationship of the visual arts to other areas of fine arts, as well as to other areas of the curriculum and to the students' daily lives.

The projects are written to leave the teacher wide latitude in use. You may decide that some should be used for research and subsequent class discussion, some for written reports, and some for creative expression activities, or a mixture of these, depending upon the varying capabilities of your students.

Each project does have a common characteristic. Each is designed to challenge the critical thinking abilities of the students.

You may wish to use these projects to take advantage of student interest in a particular subject throughout the course.

PART

THE ARTIST IN THE INDUSTRIAL WORLD

Unit Seven
The Bridge

TEACHING:
The Bridge

Pre-teaching Preparation
1. Read the text, pages 249 to 287.
2. Review *The Open-Ended Encounter*, pages T-57 to T-58.

Materials Needed
1. A student textbook for each student.
2. Classroom Reproduction 4.

Objectives
1. The students will be formally introduced to abstract art.
2. The students will use critical thinking skills.
3. The students will practice the steps of the critical judgment process.
4. The students will be familiar with, and understand, the major art movements of the early years of the twentieth century.

Time Span
1. Two to five sessions, depending upon the length of your course.
(See *Planning and Scheduling Your Course*, pages T-59 to T-61.)

Method
The method described in *The Open-Ended Encounter* is recommended. However, the text of *The Bridge* is arranged in sections under various headings, which may be assigned for reading and discussed later in the classroom, using the annotations in the text and the suggestions listed below in the *Specific Procedures* section, as well as those you desire.

Specific Procedures
Place the classroom reproduction of *The Bridge* in a spot where each student can see it. Have the students also use the pictures in the text as various sections are discussed.

1. Before reading or discussing the text pages themselves:

- Ask the students what, specifically, they *see*. What do they think the various objects are in this painting?
- Ask about the *arches*. What is the shape? What do we call this shape?
- What do they see as they look through the arches?
- What could those oval shapes at the bottom represent?
- What is the mood of this painting?

2. Concentrate on the first four pages of the text.

- Briefly discuss the location of the bridge. Be sure, by questioning them, that the students clearly understand where it is located in the United States, as well as where it is located in New York City.
- What was the dream of the Roeblings? Discuss its importance in terms of economics and communication.
- Discuss Stella's obsession with this bridge. Be sure students understand what an obsession is. Remind them to keep the idea of obsession in mind as they continue to study this painting.
- The text asks, "Where is the riverspan—that part that goes across the river?" Ask them to point that out, if they can. If they have trouble with this, tell them to look at the Currier and Ives lithograph (two pages before). Does that image help to determine the point of view in the painting?

3. These questions may be used with the next six pages headed *POINT OF VIEW*:

- Where is the photographer's eye-level line in figure 197?
- How does this compare with the point of view that Stella chose?
- What are the differences between a photograph and a painting? Benson's photograph is invaluable as a help in looking at Stella's painting, as well as a record of the bridge at the time. Stella's artistic vision gave him a way to express his obsession and his feelings about the bridge, a feeling we can share.

4. These questions may be used with the next six pages under the headings *ROEBLING'S DESIGN*, and *STELLA'S DESIGN*:

- Ask the students to define *abstraction* as it is used here to describe Stella's work.
- What did Stella "abstract" in this painting?

- How did Stella create the illusion of height?
- How did Stella create the illusion of depth? If students are having trouble with this, point out the converging lines, overlapping, smallness of objects in the distance and placement on the picture plane. Take the time to be sure the students thoroughly grasp each of these techniques in this painting.

5. These questions and suggestions may be used with the text section *STELLA AND THE ART WORLD*:

- Read, or have the students read about, Stella's early experiences in America.
- Ask the students to tell you what an "Ash Can School" painter painted, and why this group was called the "Ash Can School."
- Ask what Matisse meant when he said, "One must not imitate what one wants to create." If the students have just studied the work of Cézanne, this might be a good time to refer back to the way Cézanne handled his compositions.
- What did the Cubists see?
- What is the *principle of simultaneity*? Use the Stella and Gleizes examples for the discussion. You may want to show the examples by Picasso and Gris on pages 299 and 300. Discuss the vital importance of the compositional principles in abstract art.
- How did Futurist artists show us things, such as sounds and smells and speed, which we cannot actually see in real life?

6. These questions and discussion suggestions relate to the pages under the heading *SIX BRIDGES*:

- Ask the students if they think the painting is more successful, or less successful, when it is seen as a part of the series entitled *NEW YORK INTER-PRETED*. Discuss the entire five panels as one composition. Does the composition have balance? Unity?
- Recall that, as Stella grew older, the city grew upward, and began to look much as it did as he depicted it in 1922. *The Bridge* was a visionary work, and it is interesting to compare it with his later paintings of the bridge.
- Discuss the *Precisionists*. What did the Precisionists celebrate?

7. The last few pages of the book, under the heading *A BRIDGE OF MANY MEANINGS*, is a good section to read aloud with the students. Redefine the key terms and ideas such as the artist's obsession with the bridge, the importance of the bridge in commerce, the turmoil of the city, and abstract art.

8. As a final exercise, you may want the students to analyze this work formally, and make an aesthetic personal judgment. Remind the students that what they have been doing is part of this process. They have observed very closely, so they can *describe* what they see, they have *analyzed* the painting in relation to the compositional principles of design, and they have come a long way in the *interpretative* process. They now should describe what Stella was saying in producing this work, and what it means to them—their personal interpretation. A review of the elements and principles, using the painting as the example, immediately follows. You may want to use it as part of this exercise.

Have the students changed their minds about this painting during the course of this study? If so, why? Do they understand how the process helps them make a better judgment?

Evaluation:

Use the Summary Questions as a written exercise, or discuss them in class.

TEACHING:
Reviewing the Visual Elements of Art and the Compositional Principles of Design

Procedures

This short section is provided for a review of the elements and principles and to discuss the importance of the elements and principles in abstract art and, most specifically, in an analysis of *The Bridge*.

If you used the final exercise on the previous page, this discussion should be helpful in the second step of the process.

Unit Eight
Forms of Expression

TEACHING:
Forms of Expression

Each form of creative expression (drawing, painting, sculpture, etc.) has carefully sequenced creative activities. In each form of expression, the activities are preceded by a variety of provocative examples in that form. These opening discussion sections may be used in a number of ways, and their use may well depend upon the length of the course, the time allotted per class period, and the individual plans of each teacher. One or more examples may be used prior to each studio activity or all may be discussed prior to using the studio activities. A wide variety of examples has been chosen in each form of expression from the art of many historical periods, as well as from many worldwide cultures. Many teachers have developed their own excellent examples in the various forms of expression, as models to share with the students. The authors submit these examples as useful additions to those that have proven effective for you.

The heart of the art program is, of course, the students' creative expression. In these texts an outline of each activity is included in the student text,

and each activity has a complete lesson plan in the Teacher's Resource section of the TAER. Annotations on the student pages direct the teacher to the lesson plans. The activities in the student text are worded to give the teacher wide latitude. The lesson plans are very specific, and each contains objectives, materials needed, specific step-by-step strategies, and methods of evaluation.

LESSON PLANS:
Drawing Activities

Activity 1. Undersea or Underground Life

Focus:
- Imagination and inventiveness.
- Drawing skill development.
- Use of visual elements and compositional principles.

Objectives:
- *Understanding* Objective:
 — The student will research the environment selected and contribute imaginative ideas to the discussion.
- *Creative* Objective:
 — The student will visually represent ideas for an undersea or underground environment with people and animals.

Materials:
- Newsprint for sketching
- Drawing paper for final work
- A variety of drawing tools

Time Span:
- One period for presenting the concept and looking at images.
- One period for discussion of the research and sketching.
- Two periods of working time on the drawings and critique.

Resources:
- Architecture section of this part of text, beginning on page 392.
- Slides, magazine pictures, documentary movies of insects, undersea life, image of animals and insects which live underground or in caves or mine shafts, volcanoes, etc.
- Jacques Cousteau slides, documentaries.
- Excerpts from *Through The Looking Glass*, *Twenty Thousand Leagues Under the Sea*, *Journey to the Center of the Earth*.

Strategies:
- Look at, and discuss, imaginative works and images of this theme with the class.
- You may wish to assign research prior to the next class session. Students may use the resources cited above, or find others in the library.
- Students discuss their research, make small sketches of individual forms of life, and perhaps change the images to meet the requirements of the new undersea or underground environment. For example, they might put gills on people or animals, clothing suitable for a "coral reef" party or "under volcano" barbecue, or design a transportation system for either environment, etc.
- Remind the students to carefully consider the compositional principles as they plan and work.

Evaluation:
- Inventiveness of the idea.
- Drawing skills.
- Unity of the composition.

Extension:
- Have the students do a split composition—the top part of the environment prior to the disaster, the lower part after life has adjusted to the disaster.
- Include outer space as a possibility for life after the disaster.

Activity 2. Drawing from Memory

Focus:
- Memory drawing, correcting from reality.

Objectives:
- *Understanding* Objective:
 — The student will test his/her memory by rendering a drawing of a familiar scene without the advantage of looking at it.
- *Creative* Objective:
 — The student will create a final composition based on memory *and* the corrections necessary to make the drawing accurate and a unified composition.

Materials:
- Drawing paper
- Drawing tools

Time Span:
- Two periods.

Strategies:
- Because the activity is clearly stated in the text, you may want to surprise the class by asking them to draw some other familiar scene from memory, such as another view at home or in, or around, the school.
- If the location you select is at home, follow the instructions in the text and discuss the adjusted drawings with the class the next day. Pay particular attention to adjustments made to improve the drawing as a composition.
- Discuss the fact that, as artists, students are constantly developing a heightened awareness of their visual surroundings. Exercises such as this should be practiced as much as possible.

Evaluation:
- Evaluate on the basis of the use of the compositional principles.
- Consider the interest the student displayed in making his or her drawing accurate, as well as a good composition.

Activity 3. Negative Space

Focus:
- Negative space defines shapes and forms.

Objectives:
- *Understanding* Objective:
 — The student will review the concept of negative space and how it defines shape and form.
- *Creative* Objective:
 — The student will render a drawing, concentrating on the negative spaces only.

Materials:
- Drawing tools
- Drawing paper

Time Span:
- One to two periods.

Strategies:
- Review the concept of space with the students. Recall that we started with discussing how space defines shape and form, as in a doughnut or Swiss cheese. You may want to go back to the figure-ground drawing of the faces/vase on page 54. Review positive and negative space in architecture. In the case of architecture, would students say the positive space defines the negative space?
- Discuss some paintings and drawings in the text that clearly show positive and negative space, and others that have very little negative space.
- Set up a still life on the modeling stand. The objects used should have well-defined positive and negative spaces, such as part of a tea service, with a variety of negative spaces around, between and within the objects selected.
- Have the students concentrate on and lightly draw the negative spaces. When they have finished their drawing, have them fill the negative spaces with hatching, or by coloring them with crayon. They are to leave the positive spaces empty, and put in no details at all.
- Discuss the results with the students. What problems did they have that they may not have anticipated? What shapes have they created?

Evaluation:
- Do the students have the concept of positive and negative space fixed in their minds?
- How did the student handle overlapping of positive shapes from his/her point of view in the drawing? Were the students able to concentrate on and capture the negative space?

LESSON PLANS:
Painting Activities

Activity 1. Industrial Age

Focus:
- Imaginative composition.

Objectives:
- *Understanding* Objectives:
 — The student will consider the positive and negative aspects of industrial growth.

— The student will choose a theme and decide upon the most appropriate medium to present his/her interpretation.

- *Creative* Objective:
 — The student will render a painting, interpreting his/her version of an aspect of the industrial age in the medium and style of his/her choice.

Materials:
- Appropriate ground supports
- Painting supplies—student's choice

Time Span:
- Two sessions for discussion, choosing a theme, planning, sketching.
- Three to four sessions for work.

Strategies:
- Encourage the students to consider a variety of styles and select the style most appropriate for the subject matter each of them chooses.
- Follow the sequence in the text. Note the annotations, particularly if the students get bogged down in negative aspects.
- Discuss how the artists in the text depict modern life in the industrial age; note the variety of the expression—Stella, Tooker, Mondrian, Hopper.
- The students will select their themes, choose appropriate media and complete their works. Each must bear an appropriate title.

Evaluation:
- The use of the elements and principles.
- Appropriateness of the work to the theme chosen.
- Originality.
- Imaginative quality of expression.
- Skill development in the medium chosen.

Activity 2. Abstract Painting

Focus:
- Student creates a purely abstract work.

Objectives:
- *Understanding* Objectives:
 — The student will critically analyze Mondrian's work, *Broadway Boogie-Woogie.*
 — The student will understand how Mondrian interpreted his theme in this painting.
- *Creative* Objective:
 — The student will create a purely abstract design based on Mondrian's work.

Materials:
- Classroom Reproduction 8
- White drawing paper (12 x 18 inches or similar size)
- Scissors for each student

- Colored sheets in the primary colors and black

Time Span:
- Two to three periods.

Strategies:
- This exercise in design may be expanded to a major unit on Mondrian if you wish to include the special project section on Mondrian that appears on page 368. If you include that special project, it will be most helpful to have many examples of Mondrian's earlier (pre-1920) works, as well as his pure abstract works.
- Discuss Mondrian and his change from representational art to the purely abstract. *Broadway Boogie-Woogie* is quite complex compared to most of Mondrian's other purely abstract works. Point out that he uses all three primary colors in this work and no black.
- If at all possible, play some recording of 1940s boogie-woogie piano and point out the eight beats to the bar of the left hand. Perhaps the music teacher can help with this. When he died, Mondrian was working on his unfinished *Victory Boogie-Woogie.*
- Discuss this design project with the students. Remind them again that their "Mondrian" need not be as complex as *Broadway Boogie-Woogie* (but can be). Experimentation will be the most interesting part of the activity and students must always keep the compositional principles in mind. This is a particularly good time for a review of asymmetrical balance. Look at the various ways Mondrian achieves balance in his works.

Evaluation:
- Base the evaluation on the effective use of the elements and principles. The students should be able to make a unified composition.

Activity 3 and 4. Cubist Still Life

Focus:
- Principle of simultaneity.

Objectives:
- *Understanding* Objective:
 — The student will understand the principle of simultaneity and the cubist movement.
- *Creative* Objective:
 — The student will create a painting using the principle of simultaneity as a cubist artist.

Materials:
- Poster tempera (or your choice)
- Sketching tools

- Newsprint
- 12x18-inch paper or appropriate ground support of your choice
- Paper materials for collage

Time Span:
- Three to four class periods.

Strategies:
- Before embarking on this activity, consider activity number four directly below it. If you decide to use number four, this activity should be completed in a monochromatic scheme. If you decide to eliminate activity number four, you may want to expand the color palette for this activity.
- The principle of simultaneity and cubism should be reviewed. This is introduced, on page 270, in the section on *The Bridge*. It is further discussed in the history appendix, in the section headed *The TWENTIETH CENTURY*, which begins on page A-27. This is an excellent time to use this (or review it).
- Set up the still life (or supervise the setting up).
- Have the students analyze the still life from several points of view, and sketch from two or more positions.
- The students will finish sketching, combine their various sketches into a single drawing, transfer to the final and paint.
- Follow the directions of activity four if you are having the students complete the collage.
- Critique finished work with the class.

Evaluation:
- Does the student understand the principle of simultaneity? Does he/she have a working knowledge of the history of modern art from the representational to the abstract? Does he/she understand why the cubists use simultaneous representation?
- Does the student's painting demonstrate an understanding of cubism?
- Did the student choose interesting points of view for his/her composition? How do the points of view work together?
- Evaluate the work as a unified composition.

LESSON PLANS:
Sculpture Activities

Activity 1. Mobiles

Focus:
- The compositional principles of movement, balance and repetition.

Objectives:
- *Understanding* Objectives:
 — The student will recognize how artists use the visual elements and compositional principles in mobiles.
 — Interpret the expressive qualities in mobiles produced by master artists.
- *Creative* Objective:
 — The student will:
 a. Produce a mobile.
 b. Translate an expressive quality into the mobile produced.
 c. Diagram the movements of a mobile.

Materials:
- Newsprint for sketching
- Stiff or rigid wire (coat hangers), thin strips of lightweight wood (from a matchstick or slat blind), scrap mat board, string or monofilament line
- Scissors, utility knives, wire cutters, small drill or hole-punch, pliers, glue

Time Span:
- One period for looking at mobiles and planning.
- Four to six periods for construction to allow both partners to complete their mobiles.

Strategies:
- View as many examples of mobiles as possible.
- Have the students observe the movement, and diagram the movement, of a mobile. Tell them to try to imagine ribbons attached to each arm and the resulting pattern the ribbon makes. They can also diagram the negative spaces between the arms of the mobile as it moves. They should carefully consider the colors used, and the color relationships, as the mobile moves.
- Each student should sketch his or her first idea, keeping the balance in mind.
- Each might consider a theme for his/her mobile such as spring, dawn, midnight, fire, etc. It is not mandatory to have a theme, but fun to try.

- Caution the students on using knives, drills.
- The students will work in pairs, as it is helpful to have an extra pair of hands to help with tying and balancing.
- Plan for locations to hang the work in progress and the finished works.
- Provide large envelopes to hold shape and parts prior to, and during, construction.

Evaluation:
- The quality of movement and balance.
- The visual impact of the total space.
- Craftsmanship.

Activity 2. Found Objects

Focus:
- Aesthetic visual qualities.
- A well-balanced and unified sculpture.

Objectives:
- *Understanding* Objectives:
 — The student will recognize the visual elements and compositional principles when looking at past and present examples of sculpture.
 — The student will be able to explain symmetrical and asymmetrical balance as he/she looks at a sculpture.
- *Creative* Objective:
 — The students will, together, produce a sculpture to which all contribute some parts.
 Note: This activity can be a fine learning experience and fun for the class, but the size and extent must be carefully monitored. The "junk" collection can get out of hand and storage can become a problem. You may prefer to have the students make individual works.

Materials:
- Junk collected
- Materials for connecting pieces

Resources:
- *Sculpture From Junk*, by Henry Rasmussen and Art Grant, Reinhold, 1967.
- *Sculpture From Found Objects*, by Herbert Reed and Bert Towne, Davis, 1974.

Time Span:
- Four periods.

Strategies:
- Students should review pages 321 to 326 in the text and look at other examples you may have of sculpture assembled from found objects.
- Have the students diagram the artists' use of the elements and principles.
- Before sending students out to collect junk, hold a discussion period to assess possible available items. Be very precise about the amount and size of what may be included. When the text says "old bed springs" it doesn't mean an entire set, for example. Consider items such as those used by Picasso, Stankiewicz, and De Creeft (see pages 321 -326.)
- Assuming that the sculpture(s) will be made, decide whether each student will produce an individual piece or whether this will be a group effort.
- For a group effort, the selection of a location for the finished piece will determine the extent of the junk collection.
- For individual pieces, the extent of storage space will determine the size and extent of the collection.
- When there are enough materials to begin, have students sketch ideas for the composition.
- Plan carefully with the students the best ways of joining parts to the whole.
- Consider the maintenance and safety hazard of the sculpture. Caution the students on possible safety considerations.
- It may be impossible for all students to work on one piece of sculpture, so plan for alternative activities to be done concurrently. This is an excellent time to practice drawing skills. Keep a visual record (drawings) of each piece of junk collected. Later these might be put together to form a diary of the work in progress.
- Plan a formal unveiling of the sculpture, with printed invitations, programs, speakers, press coverage and refreshments.

Evaluation:
- Have each student write a critique of the sculpture, discussing the use of the visual elements and compositional principles.
- Ask students why they chose the particular piece of junk to be placed at a selected spot within the whole. What does it contribute to the whole?

Activity 3. Environmental Art

Focus:
- Designing environmental sculpture.

Objectives:
- *Understanding* Objective:
 — The student will understand the possibilities of creating a pleasant environment for human use.

- *Creative* Objective:
 —The student will build a model of such an environment.

Materials:
- Newsprint, sketching tools
- Cardboard, heavy paper, glue, staplers, string, tape to secure parts of the model

Time Span:
- One period for reviewing, planning.
- Three periods for completing models.

Strategies:
- Discuss Beverly Pepper's *Amphisculpture* (page 329). Environmental sculpture encourages people to use it, and to enjoy it.
- Discuss a place on your school grounds where such an environmental sculpture might be located.

If necessary, walk around and discuss possible sites. Remind the students that the size does not have to be nearly as large as that created by Pepper. The most important thing is to make it so that it invites use.

Evaluation:
- You may want to structure this activity as a contest in which each student submits a model. If so, a panel of judges (such as other teachers) could judge and critique the models. Part of their critique should be focused on whether the model encourages the viewer to enter. Another part should be the appropriateness of the model to the setting. The model selected as best could then be presented to the principal for consideration.

LESSON PLANS:
Architectural Activities

Activity 1. Written Report—
Architecture of the Twenty-First Century

- The activity is suggested for those students who have a particular interest in architecture and who may be considering a career in architecture or related fields. The sources in the bibliography should be supplemented by asking the librarian for up-to-the-minute sources on this subject.

Activities 2, 3, 4, and 5.
History of Architecture in Your Community

Note: These activities are alternatives which depend upon the size, facilities, and historical background of your community. Students may also choose one approach of the four, or some possible combinations.

Focus:
- Architectural history.

Objectives:
- *Understanding* Objectives:
 —Students will understand the architectural history of the community.
 —Students will have a better insight into the development of the community in which they live.

- *Creative* Objectives:
 —Students will create reports accompanied by sketches and/or photographs and/or historical documents and images that will give a history of the architecture in the community.
 —(Optional) Upon completion of the above objective, the students will hold an exhibition of their findings for parents and/or interested members of the community.

Materials:
- Cameras, newsprint, drawing paper, film as needed

Time Span:
- One period for discussion planning.
- This can be an on-going project over a period of several weeks. Periodic deadlines for progress reports in class should be scheduled.

Strategies:
- Discuss the scope of these projects with the students. Consider technological changes that have influenced not only the architecture but the growth of your community.
 For example, consider:
 —Steel framework and the safety elevator made modern skyscrapers possible.
 —Transportation improvements (horse-drawn trolleys, electric trolleys, buses, automobiles, subways, etc.) made expansion to suburbs

possible.

— The effects of new methods of heating and cooling on the architectural design of houses, buildings. (Consider the decline of front porches, ceiling height, etc.)

• Have students select one of the projects (or a combination, if you prefer) and begin work. You may want to bring in appropriate experts to discuss historical topics with the students and answer their questions. Your personal call, or visit, to the appropriate public library and other significant sites may be helpful in enlisting community cooperation for this project.

• When the students have collected the information, hold a class discussion. Several students may want to share and combine their findings and prepare a public exhibition with invitations, publicity, visits by dignitaries, and refreshments. An alternative may be to put the students' work on exhibition at the public library, or some other appropriate community institution.

Evaluation:

• Base the evaluation on the quality of the research and what each student contributed to the architectural history.

LESSON PLANS:
Photography Activities

Activity 1. Unusual Angles and Effects

Focus:

• Imaginative use of camera angles to photograph common objects.

Objectives:

• *Understanding* Objective:
 — The student will learn how ordinary objects can produce interesting results by the imaginative use of the camera.
• *Creative* Objective:
 — The student will produce imaginative images of common objects.

Materials:

• Camera, film, dark room with developing and enlarging equipment and supplies
• Mat board, glue

Time Span:

• One period for looking at examples, discussing and planning.
• Processing and enlarging time, depending on your facilities and number of students.
• One period for critique.

Strategies:

• Discuss the examples in this section of the text. If possible, use further examples from the resources listed below.
• Emphasize the importance of the artist's imagination in producing these images. If the artist can look at objects in a new way then he or she has solved half

the problem. Consider what Weston did with the two shells; what Strand did with the iris; how Bourke-White viewed the plowed land.

• Discuss possibilities in the school, home, in the classroom.
• Each student should decide on his/her subject, make several images to bring in for processing and discussion.
• Discuss results, use evaluation points (listed below) for class critique.

Resources:

• *Time-Life Series*:
 The Camera, pages 224–227.
 The Print, pages 127–129, 177.
 Light and Film, pages 128, 211.
 Special Problems, page 71.

Evaluation:

Base the evaluation on:

• Imaginative imagery of common objects, familiar scenes.
• Attention to the compositional principles by the photographer.
• The control of light and dark.
• The clarity of the image.

Activity 2. Distortion

Focus:

• Creating distorted images.

Objectives:
- *Understanding* Objectives:
 - The student will understand how to achieve distortion in photographs.
 - The student will understand the purposes for which artists use distortion in photography.
 - The student will be able to point out how a specific image was distorted by the camera.
- *Creative* Objective:
 - The student will photograph objects to produce distorted images.

Materials:
- Camera, black and white film, dark room with developing and enlarging equipment and supplies
- Mat board, glue

Time Span:
- One period for discussion, planning.
- Processing and enlarging time, depending on your facilities and number of students.
- One period for critique.

Strategies:
- Discuss the previous activity and the differences between abstraction and distortion. Have the students look at the photographs in the text in which Weston and Bourke-White have given us

abstractions by the use of unusual points of view. Perhaps some of the photographs taken by the students in the previous activity distorted the subject. If so, point out the distortion.

The resources listed below will be most helpful in the discussion.

- The students should choose their subjects carefully and shoot at least twenty frames.
- After processing, critique the images with the class.

Resources:
- Time-Life Series:
 The Camera, pages 426, 224–27, 126.
 The Print, pages 127, 129, 177.
 Light and Film, pages 34, 128, 147, 211.
 Special Problems, page 71.

Evaluation:
- Did the student achieve distortion in some of his/her shots?
- Does the student understand the difference between abstraction and distortion in photography?
- Consider the compositional principles of the photograph. Does the distortion make a unified composition?

LESSON PLANS:
Craft Activity

Activity 1. Slab Container with Top

Focus:
- Construction techniques and control of the medium.
- Design appropriate to the medium.

Objectives:
- *Understanding* Objectives:
 - The student will be able to discuss the merits of individual slab-constructed pieces.
 - The student will understand how to design a container and construct his/her design by the slab method.
- *Creative* Objectives:
 - The student will translate the design into a well proportioned container.
 - The student will exhibit technical skill and craftsmanship.

Materials:
- Firing clay
- Wedging board
- Heavy cardboard or masonite boards (approximately 12-by-18-inches)
- Wire clay cutters, clay knives, small right-angle squares
- Canvas, plastic bags and wrap for storing work in progress
- Rolling pins, or sections of two-inch pipe
- Brushes and small cans for water or prepared slip
- At least six pairs of runners or sticks $1/4$ to $1/2$ inch thick and about 15 to 18 inches long.
- Sponges, rags, newspaper for cleaning

Time Span:
- One period for considering examples and discussing the attributes of containers.

- One period (optional) for making textured tiles.
- One period for making pattern pieces.
- One period to roll the slabs and cut the pieces.
- Two to three periods for construction.
- One period for critique.

Strategies:
- Discuss examples of ceramic containers. Emphasize the design of the containers you show them in relation to the function of each.
- Discuss joining techniques that have been used.
- The students will draw sketches of containers they may wish to make. Critique these sketches with the class and discuss construction techniques that are described in the textbook.
- The student will select his/her sketch.
- Follow the detailed instructions in the text.
- Make patterns.
- Demonstrate the application of various kinds of texture and have the students experiment in making textures.

Note: If the students have not experienced making textured tiles (as in *Understanding and Creating Art, Book One*) or need a refresher, you may consider having the class produce a series of textured tiles at this time before proceeding.

- Demonstrate how to roll clay between two sticks or runners.
- Be sure the students have enough plastic wrap or bags to hold work in progress. Provide paper towels or rags for wrapping.
- Begin the working process by having the students make their patterns.
- Caution the students to be careful in all cutting operations.
- Two students can collaborate on rolling the clay slab and cut both of their container parts from one slab.
- Demonstrate joining techniques using the scratch-water technique and slip technique. Stress limiting the addition of excess moisture.
- Have the students pay close attention to the instruction in the texts and critique their progress as they work.
- When they have joined the pieces and made the top, have them decorate when the clay is leather-hard.
- Dry and fire the work.

Evaluation:
The evaluation should be based on:
- The design for the container and its form and function.
- Does the shape and size fit the use for which it was planned?
- Does the work display the student's sensitivity to the natural properties of clay?
- Does the design fit the medium, or does it appear that the container should have been made of plastic, wood or metal?
- Consider the skill with which the clay was handled:
 — Are the slabs of a consistent thickness?
 — Are the sides stable, not warped?
 — Are the joined edges smooth and tight?
 — Is there a sag, or does the piece show strength in the upward movement?
- Consider the visual elements and compositional principles:
 — Is the container well-balanced?
 — Does it have a feeling of unity?
 — Does the texture seem appropriate to the size and shape, as opposed to seeming to be layered on top of the surface?

LESSON PLANS:
Poster Activity

Activity 1. Posters

Focus:
- Purposes of posters.
- Quality of the design.

Objectives:
- *Understanding* Objectives:
 — The student will be able to clearly communicate the purpose of his/her poster.
 — The student will identify the target population.
 — The student will understand the history and the development of posters.
- *Creative* Objectives:
 — The student will synthesize the visual elements to the most basic level.

— The student will lay out the design of the poster to achieve the purposes of the poster.
— The student will produce a poster to achieve visual recognition and communicate with the target audience.
— The student will incorporate the visual elements and compositional principles to produce a unified statement.

Materials:
• Drawing tools: markers, pencils, color sticks, pen/ink
• Painting tools, poster tempera
• Clean-up supplies

Time Span:
• One period for looking at and discussing posters.
• One period for selecting subject, sketching.
• Two periods for production.
• One period for critique.

Strategies:
• Discuss the examples in the text and others you wish to use.
• Have the students choose a subject (with your approval), or assign a subject to the students.
• Emphasize the importance of the elements and principles in posters.
• Provide on-going critique as the students work.

Evaluation:
• A poster is more than words and images designed to attract attention. The evaluation should be based on the degree of success achieved in communicating with the viewer. The poster must impart a concept clearly with the fewest words possible. It should utilize the visual elements and compositional principles in such a way that it departs from the viewer's normal everyday visual experiences. In a sense the poster must shout to the viewer "Look at me! I have an important message for you!"
— Can the concept or message be read from across the street or at the end of the hall?
— Does the poster have an immediate emotional impact on the viewer?
— Would the poster cause the viewer to take some kind of action as a result of seeing the poster?
— Is the poster well-designed using the visual elements and compositional principles to produce a work of art as well as deliver the message?

Extension:
• There are, of course, posters accompanying school functions, parent organization functions etc. The text section and the activity above are recommended as an introduction to fix the poster's history and purposes firmly in the student's mind before embarking on other school projects which may need posters.

Unit Nine
Special Projects

TEACHING:
Special Projects

A Special Projects section concludes each major part of Book One and Book Two. The special projects are divided into two categories:
• Art History
• Appreciation and Aesthetic Growth

 The projects may be as simple as having students make comparisons of significant works of art, or as complex as a formal critical analysis of a work. Some may be used as class projects, some may be selectively assigned to groups of students with common interests, and some may be assigned to individuals with very specific interests and special abilities. Many of the activities involve the relationship of the visual arts to other areas of fine arts, as well as to other areas of the curriculum and to the students' daily lives.

PART IV

ART APPLICATIONS

The *Art Applications* section that follows contains topics that may be used at your discretion to capitalize on the special interests students may develop during the course in various career opportunities in art.

The topics have associated activities designed to help the students understand the field and to understand the problems and opportunities faced by practitioners in various career paths.

Appendix II is a brief survey of careers in art and closely related fields in which competency in the visual elements and compositional principles is a prerequisite.

Unit Ten
Graphic Design and Advertising Art

```
T E A C H I N G :
Graphic Design
```

Procedures

1. Have the students read the text section (pages 375 and 377).
2. Discussion suggestions:
- Effective communication.
 "*Avian vertebrates of homogeneous plumage* *congregate gregariously*" is an example of ineffective communication. Discuss the importance of effective communication in this era of information overkill.
- Next discuss just what effective communication actually is. If the class has done the poster activity which begins on page 363, you may want to refer to

it. Discuss the five-part process outlined for effective communication listed in the text.
- Summarize by discussing how a person interested in a career in graphic communications should prepare himself/herself.

Activity 1. Graphic Design

Focus:
- Practical introduction to graphic design.

Objectives:
- *Understanding* Objective:
 — The student will understand the importance of *well-designed* graphic symbols in business.
- *Creative* Objective:
 — The student will design a business logo and use it in designing a letterhead.

Materials:
- Newsprint, tools for sketching
- Drawing paper, pen and ink, ruler, compass

Time Span:
- One period for discussion and planning.
- One period for creating logo and letterhead.

Strategies:
- Discuss familiar corporate logos, such as those of television networks, telephone companies, makers of breakfast cereals, soft drinks, etc. What are some of the characteristics of these logos? How do they match the list of important characteristics in the text?
- Divide the students into pairs. Have them consider the problem presented in this activity and choose an appropriate business for their logo.
- Using the text suggestions, the students will create a company logo and, using the logo, produce a well-designed company letterhead.

Evaluation:
- Review the list of important characteristics of a logo in the text. How does the students' logo stand up to these prerequisites?
- Was the logo successfully transferred to the letterhead?
- Considering the logo the students created, is the design of the letterhead appropriate?

TEACHING:
Advertising Art

Procedures:
1. Discuss persuasive communication. Be sure the students understand that, in addition to effectively communicating, advertising's purpose is to persuade people to take some specific action.
2. Discuss the five steps of the strategy platform. Tell the class that they will use these five steps in the activity.

Activity 1. Advertising

Focus:
- Analysis of the effectiveness of advertising.

Objectives:
- The student will analyze the effectiveness based upon specific criteria.

Materials:
- Advertising examples the students select and bring to class.

Time Span:
- One period for discussion of the strategy platform.
- One period for analysis of advertising.

Strategies:
- Have the students bring an example of advertisements in newspapers and magazines. Have them make notes on radio and television commercials or tape them and bring some to class (if they and/or you have the equipment).
- Discuss the positive and negative effects of the examples brought to class. Analyze these examples by using the AIDCA process.

Evaluation:
- Base the evaluation on the critical thinking skills of the individual student. Was the student able to see how various advertisements strive for attention, try to create interest and desire, achieve conviction and promote action?
- Did the student react favorably to good graphic design in advertisements?

Unit Eleven
Fashion, Interior and Landscape Design

TEACHING:
Fashion Design

Procedures

1. Use the text information as a basis for discussion of the varied positions in the fashion industry, and the variety of background and training required to be successful in each. You may want to use several illustrations from fashion magazines and newspapers as examples. Stress how much creative effort has been expended in bringing these images to the public—the designer and various stylists involved in creating the garment, the marketing effort, the illustrator or photographer, etc.

Activity 1. Fashion Illustrator

Focus:
• The individuality of the fashion illustrator.

Objectives:
• *Understanding* Objective:
— The student will recognize how fashion illustrations distort proportion to make a garment appear more desirable and glamorous.
• *Creative* Objective:
— The student will experiment with fashion illustrating.

Materials:
• Fashion magazines, high-fashion newspaper ads

• Newsprint, sketching tools
• Ruler

Time Span:
• One period for discussion and sketching.
• One period for critique.

Strategies:
• Furnish copies of fashion magazines and newspaper advertisements of high-fashion garments such as long dresses, coats, raincoats drawn by fashion illustrators.
• The students need not make the measurements individually, but all must see the body to head ratios, which will be approximately 10:1.
• Have the students perform the sketches as suggested in the text.
• Discuss the results with the students.

Evaluation:
• Does the student understand what the fashion illustrator is striving for?
• Does the student understand the marketing process in the fashion industry?
• Do the student's sketches present the garment selected to advantage? Is there too much detail? Not enough detail?

TEACHING:
Interior Design

Procedures:

1. Use the text material as a reading assignment and then as a basis for discussion.
2. Have a student go to the chalkboard as a recorder. List the attributes of a successful interior designer.

Before they begin, remind the class that first and foremost is the ability to use the visual elements and compositional principles successfully. No amount of study or expertise in the various periods, knowledge of materials, new options, etc. can overcome basic

weaknesses in the elements and principles. Discuss why this is so.

3. In the list of attributes the students prepare be sure they include the ability to listen carefully to the client's needs and individual differences; the ability to supervise others; and the ability to make decisions.

Activity 1. Interior Design

Focus:
• Decorating a room.

Objectives:
• *Understanding* Objectives:
— The student will study various periods of interior decoration and select a period of his/her choice.
— The student will study the period of choice in depth.
• *Creative* Objective:
— The student will plan and execute a design for a room decorated in the style of his/her choosing.

Materials:
• Sketching tools, newsprint
• Graph paper, rulers, compasses
• Drawing paper 12x18 inches, drawing tools, crayons, markers

Time Span:
• One period for discussing the project.
• One period for research and sketching.
• One period for rendering final and critique.

Strategies:
• Discuss the project and the steps outlined below.
• Have the students consult a major encyclopedia (or other resources you may have) to study various periods of interior design.
• The students will each select a particular period for their use.
• Have the students research their periods independently. This may entail a visit to the public library or they can use any book or magazine you may have, or is in the school library. The students should make sketches of good examples from the periods selected. They should make notes on the size of furniture, architectural details, fabrics, accessories, typical lighting of the period, etc.
• In preparing their sketches, they may find graph paper helpful and rulers, compasses.
• The students will complete their final renderings of their period rooms in color.
• Critique in class and discuss the periods selected.

Evaluation:
• Base the evaluation on:
— Quality of the student's research.
— Drawing skills.
— Imaginative use of the various components.
— Use of the visual elements and compositional principles in the interior design.

TEACHING:
Landscape Design

Procedures

1. Discuss good landscape design, especially some good examples in your community. If the class has completed the architectural activities in this book, they should recall several examples of both good and poor landscape design they have previously analyzed. Recall the activities on city planning (page 111) and architectural harmony with the environment (page 212). Emphasize that the landscape design must complement the structures built upon the land, and that, in good landscape design, sometimes less is best, depending upon the natural terrain in your area.

Activity 1. Design a "Vest Pocket Park"

Focus:
• Total outdoor design.

Objectives:
• *Understanding* Objective:
— The student will consider creating a workable outdoor environment in a specified location.
• *Creative* Objective:
— The student will render a plan for a workable outdoor environment of a specified size and site.

Materials:
- Sketching tools, newsprint
- Drawing tools, graph paper, ruler, compass
- Drawing paper 12 x18 inches

Time Span:
- One period for discussion, planning and sketching.
- Two periods for rendering final drawing.

Strategies:
- Discuss the project. Be very specific about the area to be used. The one described in the text may be used, or a site in your community. If the latter is used, try to arrange for a visit to the site. Note the direction the park will face; consider the movement of the sun in various seasons. Discuss the availability of shade, seating, noise suppression—all of the things that would make the park attractive to those who would use it.
- Have the students complete the project.

Evaluation:
Base the evaluation on:
- Imaginative use of the space.
- Imaginative use of the various components of landscape design (consider the natural terrain of your community).
- Practicality of the finished park. Did the student consider the need for protection of the premises at night? Did the student allow for both sunny and shady areas? Is seating available in both? In the various seasons?
- Drawing skills.

Unit Twelve
Industrial and Transportation Design

> # TEACHING:
> ## *Industrial Design*

Procedures

1. Discuss the great diversity of industrial design. Discuss items in the school and the home that are the product of industrial design.

2. Discuss functional design and appearance design. First, be sure the students clearly understand the difference. Ask them for examples of purely functional design (such things as the instruments in the flight control panel of the airplane, versus the commercial airplane itself, which is a combination of function and appearance design). Discuss the Stealth Fighter, a result of functional design.

3. Automobile design will be of interest to many students. A special project you could suggest is to do a history of design of one or more of the large American auto makers using library resources and/or writing to the public relations department of the auto maker of the specific marque. In such a project the juxtaposition of appearance and functional design should be explored.

Activity 1. Research Industrial Design

- The activity is a good one to develop students' critical thinking skills. The product of the activity may be a written report, sketches, photographs or a combination of the above. Remind the students that in many home consumer goods, styling may be of greater importance to the consumer than function.

Appendix A *Art History*

Art history is emphasized throughout the course and is an important part of the body of the text. In addition, the first appendix is a brief history of art. It is to be used at the teacher's discretion, and provides a useful chronological aid for both teacher and student. The section is brief, but it is not oversimplified. A strong feature is the stress placed upon the art of world cultures. The important information given on non-western art and artists continues the pattern established in the textbook itself.

As far as possible, the works and artists selected are not those covered extensively in the main body of the text. The selections were made to illuminate a particular era or the artistic tradition of a specific part of the world. The accompanying timelines are provided for quick reference by teacher and student. The timelines coordinate events of world history, world culture, and advances in technology with important milestones in the visual arts.

Appendix B *Careers in Art*

This survey of careers in visual arts gives the students practical information about opportunities in various fields for those who possess art skills and training. The students are introduced to the challenges and problems faced by practitioners in many fields.

Both appendices are designed to be used whenever the teacher finds the interest of the student to be high in a particular area of history or whenever a student wants to know more about a possible career path. While the references in the text suggest immediate uses for the appendices, the authors hope that teachers will have further occasions to employ this material.

THE OPEN-ENDED ENCOUNTER

Art teachers often discuss reproductions of great works of art with their students to develop appreciation of style, technique, genre, etc. Many good teachers find that these discussions provide a natural opportunity to develop their students' critical thinking skills. Perhaps art teachers have a better opportunity in this respect than is available to their colleagues in other areas of the curriculum.

The authors of the *Understanding and Creating Art* program like to think of these opportunities as friendly encounters with art works. The opportunity to develop students' critical thinking skills is one of the most important aspects of the *Understanding and Creating Art* program. A development of analytical skills will be of inestimable value to the students in all areas of the curriculum. For the teacher this development can be one of the most rewarding and enjoyable aspects of teaching art. It is also a key reason why art should be considered the fourth "R" in the curriculum of every school system.

Friendly encounters are not difficult for teachers to prepare. There are two basic requirements for the teacher:

1. **Know the work of art to be discussed.** Feel comfortable about leading the discussion on the particular work selected.
2. **Listen to the responses of the students.** Use these responses to guide the discussion along the path planned by the teacher.

In the open-ended encounter, the teacher invites the students into the painting by asking friendly questions about the work. The response of the students leads to successive questions which require the students to look at the work more and more closely. Here are a few simple suggestions about questioning:

1. Planning: The authors have no "canned" set of questions for any work of art; nor do they suggest this approach. As all works of art are different, questions concerning various works will differ. The key to the questioning technique is the development of an overall strategy beforehand to keep the discussion going in the direction the teacher desires. The teacher does this, as the discussion progresses, by subtle replies to student responses. Make an overall plan for a friendly encounter.

2. Techniques: Remember throughout the discussion that there is a difference between a response and an answer. Answers have a right or wrong implication; responses do not. Friendly questions are open-ended and invite several responses.

As an example of this, consider a possible opening discussion of Homer's *The Gulf Stream*. The teacher may begin by asking about color, as color is so important in Homer's work. The first question might be "What colors do you see?". The question can have several responses. The responses will be "red, green, blue, gray, blue-green, white, brown, etc." The teacher might then reply, "Yes, reds, blues, all of those, and green. . . what kinds of green do you see?" Following this, the teacher might say "Let's look at the reds . . . what is that red stuff there in the water?" If one response is "Blood!" (as it probably will be), the teacher might say, "But what happens to blood in water? Does it float or dissolve? Do we need to ask the science teacher?"

After determining that the red stuff is seaweed, the teacher might ask, "What seems to have stirred it up?" This would lead to the group determining the direction of the water spout, the condition of the boat as a result of the storm, and speculation about the brave sailor in the boat. All of this flows smoothly and inevitably and is most enjoyable for everyone.

Some questions may appear to have only one answer, yet often involve more answers on closer analysis. In The Gulf Stream, such questions as "What color is the boat?" and "Which way is the waterspout moving?" are not nearly as simple as they may seem. Each requires a good deal of looking

T-57

and analysis. The textbooks and the lesson plans can be of great help to you with this.

Another category of questions is those which appear to be open-ended, yet have only one correct answer. These are ambiguous questions because the answer is not self-evident. For instance, with *American Gothic*, the question "Are these two people husband and wife?" appears to be a matter of interpretation. An answer of "yes" may be countered with "Why do you think so?" or an answer of "No", by "Why do you think not?" Each new question should encourage the students to think through their responses and to look at the painting for further clues.

The technique becomes easier and easier the more the method is employed, and the results are enormously rewarding. When the students realize what is expected of them, they are enthusiastic and confident in looking at, thinking about, and talking about art.

PLANNING AND SCHEDULING YOUR COURSE

Understanding and Creating Art, Book Two is designed for the widest range of student abilities and interests. It provides the teacher with high quality material which will accommodate students who have had a rich background of art instruction, as well as those who have had very little, if any, formal art instruction.

This means the text is comprehensive. More material is provided than could be covered in a full year course meeting five times per week. The careful *sequencing* of the material allows the teacher to match the abilities of the students to the appropriate places in the sequence of skills.

For Example:
- The visual elements of art and the compositional principles of design are presented in detail at the beginning of the text. Readiness for teaching the elements and principles is established in the opening unit, which is a detailed study of the painting *Washington Crossing the Delaware* by Emanuel Leutze. There is no assumption of previous knowledge, or experience, of using the elements and principles at the beginning of this text. If the students have had *Understanding and Creating Art, Book One* the previous year, this section can be used for re-teaching or a review rather than an introduction. The time allotted on the chart that follows would be significantly reduced.
- In the forms of expression section, some early activities may be eliminated or used for review.
- On the other end of the scale are the many unusual activities and experiences that will challenge the abilities and critical thinking skills of your most exceptional students, and those who come to this course with a solid background of previous art instruction. Some of the activities in the *Special Projects* section may be expanded into major projects.
- Another scheduling consideration to weigh as you outline your course is the equipment available for art instruction in your classroom and in your school. If, for example, darkroom facilities are not available, the time allocated in the lesson plans for darkroom time will not be used.

The detailed lesson plans for each studio activity contain a suggested time allotment to complete that activity. These suggestions are based on the average time other teachers have used. You may want to take longer on many and reduce the number you select. The sample schedule that follows is presented as a guideline for a full year, five-day-a-week course to be adjusted to your own goals and facilities.

If your course is a semester course (or less), the time allotments could be cut for many sections of the text. The authors suggest looking carefully at the *Scope and Sequence Chart* and the *Scope and Sequence Chart for Creative Expression* (these begin on page xii), along with the sample schedule which follows. Choose appropriate entry points in the sequence and select those experiences and activities which appear most appropriate for your students.

Of most importance is the ease of using the *Understanding and Creating Art* program. Let the sequence work for you; share and enjoy a variety of rich experiences with your students.

SAMPLE SCHEDULE

One Year Course
Five Days Per Week

Section of Text	Number of Sessions	
Part One: The Artist and Heroes and Heroines		
Washington Crossing the Delaware	3	
The Visual Elements and Compositional Principles	3	
The Illusion of Space	1	
Art Criticism	1	
Drawing and Drawing Activities	19	
Painting and Painting Activities	14	
Sculpture and Sculpture Activities	8	
Architecture and Architecture Activities	3	
Photography and Photography Activities	9	
Special Projects	2	Subtotal 63
Part Two: The Artist and The West		
The Buffalo Runners, Big Horn Basin	3	
Drawing and Drawing Activities	9	
Painting and Painting Activities	8	
Sculpture and Sculpture Activities	5	
Architecture and Architecture Activities	3	
Photography and Photography Activities	5	
Crafts and Craft Activities	6	
Printmaking and Printmaking Activities	9	
Special Projects	2	Subtotal 113

Section of Text	Number of Sessions	
Part Three: The Artist in the Industrial World		
The Bridge	3	
Review Elements and Principles	1	
Drawing and Drawing Activities	7	
Painting and Painting Activities	12	
Sculpture and Sculpture Activities	12	
Photography and Photography Activities	6	
Architecture and Architecture Activities	2	
Crafts and Crafts Activities	8	
Printmaking and Printmaking Activities	5	
Special Projects	2	Subtotal 171
Part Four: Art Applications		
Graphic Design	2	
Advertising Art	2	
Fashion Design	2	
Interior Design	3	
Landscape Design	2	
Industrial Design	2	
Book Two: Total Sessions	184	

MATERIALS

1. Paper

An inexpensive item that needs special care in storing and dispensing so that edges do not become tattered and torn. Most paper is packaged in 50 to 100 sheet packages or 500 sheets (reams) in sizes of 24" x 36", 18" x 24", and 12" x 18".

- **Newsprint paper** is excellent for most graphic art work. It is also very good for drawing and painting.
- **Manila paper** may be used for many art projects, especially for drawing and painting because of its slightly rough texture.
- **White drawing paper** may be used for special drawing and painting experiences.
- **Watercolor paper** may also be used for drawing in ink, size 16" x 22".
- **Construction paper** needs special care in storing in order to protect colors. Store it away from light to avoid fading. The assorted color packages have a greater selection of colors. Use for paper sculpture and construction; also use for chalk, ink, and other media.

Save usable scraps in open boxes to use for collages, cut and paste designs, etc.

- **Poster paper** is another lightweight, colored paper, desirable for cut and paste designs, collages, background displays, and other graphics work.
- **Tag board** is heavy enough for cutting shapes for rubbings. It is desirable for construction and sculpture because of its hard surface and durability; a good mounting paper for art reproductions.
- **Chipboard** is a very heavy cardboard-type paper, 30" x 40", that may be used as background for collage and other construction. May also be used for matting artwork for display.
- **Railroad board** is a 6-ply paper in size 22" x 28", colored on both sides in black, blue, buff, green, red, or white for displays, constructions, and mounting artwork. It can also be used for mats.
- **Matboard** is a 14-ply, 28" x 44", display and matting board; colored on one side in cream and white; ordered by the single sheet.

- **Mural paper** is a wrapping type of paper which comes in many different colors. Rolls may be obtained 36 or 48 inches wide and as large as 72 inches. The very large sizes make an excellent backdrop for photographing student art.
- **Stencil paper** for graphics comes in size 12" x 18"; 12 sheets to a package.
- **Tissue paper**, a colored tissue for collage, constructions, and tissue paper overlay. The colors in some brands bleed more than others when paper is wet.
- **Rice paper** is a lightweight, textured paper, which may be purchased for very special rubbings and prints.

2. Paint

- **Acrylic** paint is a quick-drying permanent medium which can be purchased in tubes or jars. School-grade acrylics are usually sold in large containers for classroom use. Acrylics are also an excellent medium for printmaking activities.
- **Liquid tempera** is available in gallon and quart jars, ounce jars, and pints.
- **Polymer** (Chromacryl, Derivan, etc.) paint is brilliant, smooth, creamy, and thick. It intermixes well; does not lose chromatic intensity when drying and never hardens in containers. Polymer has the consistency of an oil-base paint, but is softer to handle. It can be diluted to achieve watercolor effects and can be used with a soft brayer as a printing ink.
- **Powdered tempera** is packaged in one-pound containers. It may be made liquid with water to be used for painting. The addition of liquid starch gives it more body. It is best not to mix large quantities with water because the mixture sours after a few weeks. It may also be used without mixing with water.
- **Watercolors** are available in boxes, 8 to 16 colors and tubes in a variety of colors. Thinly diluted watercolor washes may be used for crayon resist activities.

3. Drawing Media

- **Crayons** (wax) unwrapped, 16 colors to a box are most useful.
- **Color Sticks** (erasable plastic) are available in an assortment of colors.
- **Chalk** may be ordered in assorted colors in boxes of 12 or 144 sticks of 12 colors. If colors are kept separate, it is easier to make a choice of colors.
- **Charcoal** is available in sticks of 24 to a box or compressed sticks of 12 to a box.
- **Drawing ink**—Black ink comes in quart or 3/4 ounce to 10-ounce sizes.
- **Drawing pencils** may be ordered with thick black lead.
- **Markers** have a color range in the hundreds. Use waterbase, not acetone base in the classroom.

4. Graphic Materials

- **Printing ink** is available in water base and oil base. It comes in tubes and jars (or cans) in many colors.
- **Colored chalk** and unwrapped crayons may be ordered for rubbings.
- **Tempera paint**, thinly diluted, or transparent watercolor washes, may be used with clay crayons for crayon resists.
- **Oil-base clay**, fresh blocks or soiled clay may be saved for printing.
- **Linoleum** mounted or unmounted may be obtained in large sheets and smaller pre-cut sizes. Unmounted linoleum is recommended.
- **Wood blocks** for printing, as well as cardboard and corrugated board, may be supplied from scrap material sources. The finer the grain and the softer the wood, the better for cutting.
- **Paraffin**, bees wax, and batik dyes on cotton or silk fabric may be used for batiks.

5. Adhesives

- **White paste** for pasting paper is available in gallon and quart jars. It is more convenient to use if placed in smaller, wide mouth plastic covered jars.
- **White glue** (vinyl) may be ordered in 4-ounce squeeze bottles. This glue holds heavy materials. It may also be diluted for tissue paper overlay, collage and for surfacing other mediums. White glue may be purchased in large bottles and later distributed in smaller squeeze bottles.
- **Wheat paste** is available in 2-pound packages. It is chiefly used for papier-mâché. It should be stored in a dry place that is free from insects. It is wise to mix only the amount to be used in one day, because the mixture sours if left standing.

6. Ceramic Materials

- **Firing clay** in red or white may be ordered in 50-pound cartons. It should be stored in airtight containers to retain its moisture. If it partially hardens, punch holes in the clay and soak in water, then rewedge. If it becomes totally dry, pound to powder and remoisten with water.
- **Grog** may be added to give texture for easier handling. It comes in 1-pound packages.
- **Glazes, majolica, mat, engobes**, and other types add an additional interest to ceramics, and have a special function of sealing the pores of pottery. Casein products may be used to seal and provide a finish to clay products.
- **Kiln wash**, a white powder mixed with water, is applied to the shelves and bottom of the kiln to prevent dripping glazes from sticking.

7. Some Other Construction Materials

- **Oil-base clay** or modeling clay is usually gray-green or terra-cotta in color: available in 1 pound or 5 pound packages. It is firm, but softens through use and warmth. It can be re-used and makes a good practice clay and may be used as forms for papier mâché masks.
- **Self-hardening clay** is a non-firing clay, available in various units. It may be moist in cartons, or dry in bags in which water is added. Once dry it can be painted and decorated with poster tempera and shellac.
- **Plaster of Paris** and similar materials are used alone or mixed with other materials, such as insulating granules. It is important to have large, covered, moisture-proof containers for storage before ordering these materials.
- **Ceramic tile** may be secured as scrap tile or may be purchased.
- **Plywood** may be secured from vendors or as scraps.
- **Wire** in various weights for many kinds of constructions and sculpture is usually obtained from vendors or scrap sources (telephone cable wire is a usable material).

8. Weaving and Stitchery Material

- **Round reed**, sizes 1 and 2 may be used in constructions such as mobiles for weaving, as well as other uses.
- **Raffia** may be ordered in 1-pound hanks.
- **Needles** with eyes large enough to handle yarn and thread.
- **Cotton yarn or rug yarn** for weaving and stitchery may be purchased from vendors or scrap material sources.
- **Burlap** and other fabric may also be obtained from vendors or from scrap material sources.
- **Odds and Ends**, such a buttons, beads, and discarded costume jewelry may easily be obtained from scrap material sources.

9. Cleaning Materials

- **Paper towels** are useful in many ways:
 — for controlling paint.
 — for cleaning and drying equipment and materials.
 — for controlling printing ink in the use of brayers.
 — for unusual textural surface for painting, graphics, etc.
- **Liquid soap** kept in labeled detergent or bleach bottles may be used for cleaning and washing art equipment, as well as for mixing with water and powdered tempera for scratch board, crayon etching, and silkscreening.
- **Scrubbing powder** should be on hand for cleaning sinks, pails, and other art materials from hands.
- **Hand soap**, especially one with an abrasive, removes paint and other art materials from hands.
- **Sponges and rags** from outside vendors and scrap material sources must be available in plentiful supply for various types of artwork and cleaning purposes.
- **Newspapers**, because of their absorbent quality, should be saved for use in covering work areas, etc. Have a definite storage place where they can be neatly stacked.

Characteristics and Qualities of Drawing and Painting Materials

Compressed charcoal comes in stick form or in block form. It is easy to show a full range of values with compressed charcoal. Drawing can be done with both the broadside and edge of charcoal to produce mass and line. Water or turpentine will dissolve charcoal if a wash effect is desired.

Conté crayon can produce both line and tone. It comes in stick or pencil form. It is made from a clay base with compressed pigments. Water or turpentine will dissolve conté crayon if a wash effect is desired.

Pencil or graphite sticks come in a variety of hardnesses from 9H (the hardest) to 7B (the softest).

Felt-tip marker can be purchased with either felt or nylon tips. They are available with waterproof or water-soluble ink. Tones can be created with the water-soluble type dipped in water.

China marker has a grease base and is easily smudged. If flows smoothly and can produce a high contrast in value drawing.

Polymer has adhesive qualities, will adhere to almost any surface and is impervious to temperature, moisture, sunlight, and other changes in the environment. It is non-toxic and will wash out of clothing, floors, desks, and brushes long after drying.

Crayon comes in stick form and requires no fixatives. Colors are available in a wide range of values. Both the sides and edges can be used in producing mass or line drawings.

Oil Pastel (i.e., cray paz) is oil based and comes in a wide range of color. The various colors can be blended, mixed, and used as solid color. The stick form can be used on both the sides and edges to create mass and/or line drawings.

Suggestions on the Selection and Care of Art Equipment and Materials

Equipment

1. **Paper Cutters** should be used properly:
 - to assure safety
 - to judge the right amount of paper to be cut at one time to get a clean cut and not abuse the cutter.
 - to set the guide to measure and cut in a straight line

2. **Mural paper** dispenser with cutting blade is essential for measuring and cutting large rolls of paper with care and to avoid waste.

3. **Ceramic Kiln**
 - Keep a partition around the kiln. Be sure to comply with local and state regulations.
 - Follow instruction guide for proper use of the kiln.
 - Add an extra shelf in the bottom which can be removed for cleaning.
 - Wash the kiln bottom, tops of shelves, and inside cover door before using, also wash the shelves between each firing if there is any spillage of glaze.
 - Arrange for each class to see the kiln if the students are engaged in a ceramic activity.

4. **Plastic garbage containers** are invaluable for the storing of clay, plaster, and other bulk materials that deteriorate from moisture and air. Galvanized containers may be used also, but are much heavier.

5. **Water containers** (plastic or metal), pails with handles, are needed to provide water for painting, ceramics, papier mâché, etc. Gallon and 1/2 gallon plastic bleach bottles are needed for water in all painting areas. Use these containers for distributing wheat paste also.

6. **Plastic dish pans** are useful for mixing wheat paste, washing brayers, and general clean up.

7. **Drawing boards** are invaluable for painting, drawing, graphics, etc., and should be used in the classroom or outdoors. Regulation boards of wood may be purchased; however, pressed fiber board is lighter in weight and less expensive. Masonite (a harder material) can be used with clothespins or metal clamps to secure the paper. A cart for storing and transporting boards makes them more accessible.

8. **Scissors**
 - Care for them properly to get the best use from them. Scissors for left-handed students should be available.
 - Discard bent or badly rusted scissors.
 - Store in containers that make "counting" easy, such as wood blocks with drilled holes, small cardboard boxes with punched holes, or small cans to hold enough scissors for each work group.
 - Before storing the scissors, remove rust spots with steel wool; place in tightly covered container after wrapping in a soft, oiled cloth.

9. **Knives** for cutting linoleum, wood stencil paper, mats, etc. should be ordered. Utility knives with extra blades stored in the handle are good for cutting mats. Special mat cutters are also available. Paper punches serve many purposes in the art department.

10. **Brushes**
 - Keep brushes, handles down, in a jar or can when not in use. Container should be tall enough to hold brushes upright and allow the bristles to stand above the rim of the jar. The same method may be used for brushes as suggested for scissors, with holes in cardboard boxes or wood blocks.
 - Proper cleaning and shaping of brushes after use is very important. Wash and rinse in cold, clean water, shape to point or wedge (according to type of brush) with fingers before placing in container.
 - Water paint brushes should never be used for lacquer, shellac, or any type of oil paint. Use special brushes for such work. Household or inexpensive 2", 3", and 4" brushes are handy for many purposes.

11. **Trays** of the type used in school cafeterias are useful for holding paint jars for a group of six or eight students. These trays are also excellent for using printer's ink and brayers for graphics.

12. **Paint jars** with plastic covers may be purchased. These are useful for holding a variety of colors. The plastic covers do not rust and can be easily removed if the jars and covers are kept clean and lubricated. Baby food jars with aluminum covers may be used for paint sets.

13. **Plastic egg trays** are favored by some art teachers because they are light and easier to transport. Enough for the classroom may be stacked in layers with cardboard between without removing the paint.

14. **Paint dispensers** for filling egg trays and small paint jars may be made from quart bleach bottles. This squeeze-type bottle may be made by punching a hole in the cap with an ice pick. Keep a nail in the hole so that paint does not become too dry.

15. **Brayers** for roller painting and printing are almost essential for each student. The brayers should be carefully washed with a stiff brush or sponge and spread on a newspaper to dry before storing.

16. **Ceramic Equipment**

 A few items are desirable in addition to fingers:
 - 5-gallon crocks with wood lids for storage
 - a wire for cutting clay
 - a wedging board
 - rolling pins or 1 1/2" dowels to roll out slabs of clay
 - small water containers to moisten clay
 - an assortment of gadgets to use for texture
 - sponges, steel wool, or sand paper for finishing
 - kiln shelves, shelf-supports, and stilts.

17. **Pen Staffs**, wood or plastic holders for lettering or drawing pen points.

18. **Penpoints** of a great variety should be available.

19. **Needles** for stitchery and weaving should be purchased. Needles with large eyes for threading raffia and yarn are handy.

20. **Sponges**—natural sponges used for painting and cleaning are better than polyfoam type.

21. **Other equipment** obtained for special art experiences might include:
 - hot plate for melting crayons for encaustics and wax for batik design
 - popcorn poppers (electric) are convenient for melting wax for batiks.
 - work bench, equipped with vise and carpenter's tools, is desirable for various types of craft work.

- wire cutters, pliers, screw drivers, and other simple tools should be considered basic because they are needed for most kinds of sculpture and constructions. Special boards should be designed to hang each tool in its proper place.
- looms of simple types and wood forms for stitchery are worthwhile additions to art rooms.
- forms of heavy cardboard, squeegee, and organdy for silk screens.
- pressing iron and board are useful in crayon on textiles, batiks, and for general use.
- a hand brush, straw broom, and small mop are convenient for emergency clean-up.

22. **Display Equipment and Materials:**
 - Pins.
 - Staplers, staples and staple remover are desirable for constructing displays.
 - Thumb tacks should be used only temporarily for display. Keep in a larger box or bowl for use with paint or drawing boards.
 - Masking tape, transparent tape, and dispensers. Masking tape can be satisfactorily rolled to adhere to light and medium weight, two-dimensional artwork in display areas.

KEYS TO TESTS

The objective tests which follow are submitted for use as your requirements dictate. They are not considered by the authors to substitute for the evaluation sections of the lesson plans, which are a basic part of the program.

The tests are, however, quite useful in measuring how well a student scores based on the information presented in the text. Thus, these tests are criterion referenced.

Results should provide you with specific areas in which a student, or several students, may need help.

The questions cover all areas of the text, and you may wish to provide additional questions, depending upon your own requirements, emphasis, and time constraints.

Correct answers are marked on the pages that follow. The test package is provided gratis in black-line master form by the publisher to teachers using the textbooks.

PART ONE

Unit One:
Washington Crossing the Delaware

Completion: Write the word, or words, that complete the sentences in the blanks at the left of the sentence.

Trenton 1. *Washington Crossing the Delaware* depicts the early morning of the battle of _____.

Emanuel Leutze 2..The painter of this historic work is named _____ _____.

Prince Whipple 3. The black man at Washington's right also appears in the painting of the crossing by Thomas Sully. His name was _____ _____.

triangular 4. Leutze achieved a feeling of stability by the repetition of several _____ shapes in this painting.

1776 5. This historic scene took place the day after Christmas, _____.

Pennsylvania New Jersey 6. The crossing of the Delaware River was made from the state of _____ to the state of _____.

Houdon 7. Leutze chose for his model of Washington, a mask by the French sculptor _____.

Napoleon Bonaparte 8. Washington's position in this painting recalls the position of _____ _____ in Jacques-Louis David's 1804 painting.

faces 9. The large ice floes nearest the viewer appear to be in the shape of human _____.

middle 10. Leutze painted the position of the boat to be near the _____ of the river.

True - False: Mark a **T** if the statement is true, or an **F** if the statement is false, in the blanks at the left of the statement.

F 1. Emanuel Leutze lived his entire lifetime in America.

F 2. The first thing most viewers notice about *Washington Crossing the Delaware* is the dangerous position of the boat.

T 3. George Washington's commanding presence gives the work stability.

F 4. The morale of Washington's men in the boat was high as they had enjoyed a string of several victories.

T 5. Leutze painted Washington Crossing the Delaware in his studio in Dusseldorf, Germany.

T 6. The boat is headed east into the first light of dawn.

F 7. After the Revolutionary War, there were few portraits made of Washington.

F 8. Gilbert Stuart was satisfied with each of his portraits of George Washington.

T 9. There was great turmoil in Europe at the time when Leutze painted *Washington Crossing the Delaware*.

F 10. Leutze managed to pack much detail into the relatively small painting.

The Visual Elements of Art and The Compositional Principles of Design

Completion: Write the word, or words, that complete the sentences in the blanks at the left of the sentence.

line

shape

form

color

texture

space

1. The visual elements of art are:

refraction

2. The process of bending and separating white light into its spectrum is called _____.

black

white

3. J. C. LeBlon, in his book, *Pigment Color Theory*, demonstrated that, in mixing colors, ____ is the sum of mixing all colors together, and _____ is the absence of all color.

opposite

4. Complementary colors are directly _____ each other on the color wheel.

intensity

5. _____ refers to the strength and purity of a hue.

green

orange

violet

6. The secondary colors are _____, _____, and _____.

implied

7. We can see the lines made by the rifles stacked in the boat in *Washington Crossing the Delaware*. We sense other lines such as that coming from Washington's intense stare. This type of line is called an ____ line.

length

8. Lines are one dimensional and the measurement is called _____.

guide

9. There are two ways to draw and paint lines. One is free hand; the other is by using a ____.

height

width

depth

10. The three dimensions of a sculpture are always listed in this order: ____, ____, and ____.

negative

11. The space around, within, and between forms or shapes is called _____ space.

Texture

12. _____ is the visual element that conveys the sense of touch.

Renaissance

13. The compositional principles of design were formally established during the _____.

repetition

14. Using the same visual element or object more than once in a composition is using the compositional principle of ____.

variety

15. Each of the soldiers in *Washington Crossing the Delaware* is wearing a different type of hat and coat. This is an example of the compositional principle of _____.

center

interest

16. The area of an artwork which is emphasized is called the _____ of _____.

rhythm

17. The ice in the background is laid out in long wave-like patterns. This is an example of the compositional principle of _____.

design

emotive

representational

18. The three types of proportion are: _____, _____, and _____.

symmetrical

radial

asymmetrical

19. The three types of balance are ____, ____, and ____.

unity

20. When the elements and principles work well together in an art work, the work is said to have the compositional principle of _____.

The Illusion of Space in Art

Multiple choice: Put a circle around the letter of the correct answer or answers.

1. A *vanishing point* is:
 a. a point just over the horizon.
 * b a point where receding parallel lines seem to meet on the horizon.
 c. a point that was on the horizon but has been obscured.
 d. proof that parallel lines never actually meet.
 e. the moment the magician waves his wand at the elephant.

2. To render a composition in linear perspective, it is important to:
 a. constantly change your point of view.
 b. frequently move your head for better angles.
 * c keep the same point of view.
 d. eliminate all unnecessary detail.
 e. draw parallel lines as guides.

3. Which of the following statements is *not* true in linear perspective?
 a. The eye-level line and the horizon line are the same.
 b. Objects nearer the artist are larger and have sharper color contrast and detail.
 c. There may be more than one vanishing point in a picture.
 * d Objects farther from the artist will appear larger than those nearer the artist.
 e. Objects nearer the artist block out objects farther away.

4. Which of the following statements best describe *continuous* perspective?
 * a. Lines stay parallel and do not get closer together as they recede. There is no vanishing point.
 b. Lines get closer together as they recede. However, there is no vanishing point.
 c. Clouds float over the entire scene.
 d. Continuous perspective ignores the concept of space and distance.
 e. There is always one point of view in continuous perspective.

5. Which of the following statements is *not* true of aerial perspective?
 a. Aerial perspective maintains a fixed point of view.
 b. Objects nearer the viewer are larger.
 c. Objects nearer the viewer show sharp contrast in color and detail.
 d. Objects farther from the viewer have less color contrast and detail.
 * e Objects farther from the viewer are in warm colors with vivid contrast and detail.

Units Two and Three

Forms of Expression and Special Projects

Multiple Choice: Put a circle around the letter of the correct answer or answers.

1. *The Preacher*, by Charles White, gives us a dramatic example of the illusion of depth by:
 a. overlapping.
 b. the fact that objects higher on the picture plane are farther away.
 c. the fact that objects farther away have less definition.
 * d. foreshortening.
 e. continuity.

2. Reportage drawing is:
 * a. drawing from memory.
 b. reporting exactly what the artist sees on the spot.
 c. quick sketching of outlines of objects.
 d. art that depicts current events.
 e. sketches of movements and gestures.

3. In drawing the human hand, the artist should:
 a. remember exactly what a hand looks like; ignore what he or she sees.
 b. draw from photographs of hands taken from various angles.
 * c. draw exactly what the artist sees, not what the artist knows about the hand.
 d. try to eliminate the hands from his/her drawing if at all possible.
 e. minimize the importance of hands as examples of expressive qualities.

4. Which of the following statements does *not* apply to J. M. W. Turner's *The Fighting Téméraire*?:
 a. The Téméraire symbolizes the end of the era of great sailing ships.
 b. The tug symbolizes the future of steam powered ships.
 c. The setting sun symbolizes the end of an era.
 * d. The warm colors of the sunset give a warm happy glow to the proceedings.
 e. The Téméraire, being behind the tug, has less detail, which makes her appear almost ghostlike in the sunset.

5. An equestrian statue features:
 a. figures of equal height.
 * b. a figure or figures on horseback
 c. heroes or heroines in battle.
 d. figures from the equestrian age.
 e. important animals in history, such as the buffalo.

6. An assemblage in art is:
 a. a group of statues on public view.
 * b. a three-dimensional work of art consisting of pieces put together.
 c. a gathering of artists.
 d. a series of equestrian statues in one location.
 e. a work carved from a block of stone.

7. Louis I. Kahn was:
 a. the leader of a Mongol tribe.
 b. a model for small religious images.
 * c. an influential American architect of the twentieth century.
 d. the architect who designed the John F. Kennedy memorial in Dallas, Texas.
 e. the architect of the pleasure dome in Xanadu.

8. Dorothea Lange photographed heroes and heroines:
 a. in the Pacific theater of combat in World War II.
 b. of the American frontier.
 * c. among the farmers and factory workers of America.
 d. during the Civil War battles in Virginia.
 e. of the motion picture industry.
9. The Washington Monument:
 a. includes a statue of Washington driving a chariot wearing a toga.
 b. was completed in less than one year.
 * c. is a 555 foot obelisk.
 d. has thirty-six marble columns.
 e. consists of two u-shapes forming an enclosure.
10. Giotto (1266?–1337):
 a. was a master of Renaissance architecture.
 b. built the Pantheon.
 * c. broke from the traditions of the Middle Ages by developing a more realistic style.
 d. taught Michelangelo and Raphael.
 e. gave us the rules that define the use of the visual elements and compositional principles.

True-False: Mark a **T** if the statement is true, or an **F** if the statement is false, in the blanks at the left of the statement.

 F 1. Thomas Eakins portrayed Dr. Gross as a hero in the field of astronomy.

 F 2. Cave paintings were painted near the entrance of caves so that many people could have access to them.

 F 3. Calligraphy was a method of sending messages by wire invented by Samuel F. B. Morse.

 T 4. Illuminated manuscripts were produced by scribes in the Middle Ages using calligraphy.

 F 5. Artists often paint horses white to show the fear the horses have of battle.

 F 6. Bastien-LePage painted Joan of Arc, in full armor, leading the French to victory at the City of Orléans.

 F 7. The Jefferson Memorial is at Mount Rushmore, South Dakota.

 T 8. William Edmondson worked primarily in limestone.

 T 9. Mahatma Gandhi, photographed by a spinning wheel by Margaret Bourke-White, was a leader in India who advocated peaceful change.

 T 10. The picture of a woolly rhinoceros on a cave wall in France proved to be more lifelike than the reconstruction made by scientists from bones.

PART TWO

Unit Four:
The Buffalo Runners, Big Horn Basin

Completion: Write the word, or words, that complete the sentences in the blanks at the left of the sentence.

Manifest Destiny 1. The idea that America should spread west to its natural continental boundary on the Pacific is known as _____ _____.

sculptor painter 2. Frederic Remington was widely admired in art for his work as both a _____ and a _____.

(Eadweard) Muybridge 3. The photographs by _____ in the 1880s forever changed the way artists depicted the horse galloping.

restricted 4. Between 1889 and 1909, Remington used a more _____ palette, which means he used fewer colors than in his earlier works.

(Claude) Monet 5. The term *Impressionist* came about in 1874 when a critic applied it to an oil sketch by _____.

light 6. Impressionists explored the effects of _____ on form.

buffalo 7. The Plains Indians' way of life was closely tied to the great herds of _____.

horses 8. Hunting tactics changed greatly when the Plains Indians tamed wild _____.

Wounded Knee 9. The massacre at _____ _____ in 1892 marked the end of the Plains Indians' way of life.

soft 10. As Remington became more of an impressionist, the outlines of his subjects were more _____.

True-False: Mark a **T** if the statement is true, or an **F** if the statement is false, in the blanks at the left of the statement.

 T 1. *The Buffalo Runners, Big Horn Basin* hangs in the Sid Richardson Collection in Fort Worth, Texas.

F 2. The lead rider in *The Buffalo Runners* is Chief Crazy Horse.

F 3. Remington spent many years in formal art training.

T 4. Remington was devoted to his work, and worked very hard for many years to improve.

F 5. Eadweard Muybridge proved in his photographs that the previous images painted of horses galloping were perfectly accurate.

F 6. After painting *A Dash for the Timber* in 1889, Remington was, at last, fully satisfied with his artistic skills.

T 7. Remington was influenced by the Impressionists.

T 8. Impressionist painters use bold brush strokes of pure color plus white, placed side by side to represent the effect of light on objects.

F 9. The viewer must get close to the painting to see what an impressionist painter wants the viewer to see.

T 10. Frederic Remington's works had an important impact on western movies.

Units Five and Six: Form of Expression and Special Projects

Matching: Match the artist in the left-hand column with the statement in the right-hand column which best describes the artist's work. Write the letter of the correct answer in the space provided.

n 1. Claude Monet

a 2. Charles Marion Russell

b 3. Charles Bird King

e 4. Albert Bierstadt

g 5. Fritz Scholder

j 6. Anasazi

m 7. Édouard Manet

i 8. Walter De Maria

c 9. George Catlin

k 10. Mimbres

o 11. Paul Cézanne

l 12. Karl Bodmer

h 13. Korczak Ziolkowski

f 14. Georgia O'Keeffe

d 15. George Caleb Bingham

a. His painting, *In Without Knocking*, recalls his days as a cowboy in the 1880s.

b. Painted Indian visitors to Washington D.C. in a romantic style early in the 19th century.

c. In the 1830s, he spent five years accurately depicting the western landscape and Native Americans.

d. Painted everyday life on the Missouri River, and originated the tradition of American Realism.

e. His "blockbuster" paintings of the Rocky Mountains captured the public's imagination.

f. Advised a friend to paint his world as though he were the first man to see it.

g. His *Super Indian No. 5* depicts the Native American living and functioning in today's society.

h. Began the largest project in sculpture ever undertaken—The Crazy Horse Monument.

i. His The *Lightning Field* is a celebration of land and sky.

j. The "Ancient Ones" who built the first pueblos.

k. Their sophisticated designs in pottery were made 1,000 years ago.

l. Accompanied Prince Maximilian of Prussia to the upper Missouri in 1840, and made some of the most striking portraits of Native Americans ever rendered.

m. His *The Fifer* shows the influence of Velásquez and that of Japanese print makers.

n. His oil sketch, *Impression, Sunrise* was the first work to be labelled "Impressionist."

o. His work forms a bridge between Impressionism and Modern Art.

Multiple Choice: Put a circle around the letter of the correct answer or answers:

1. Restricted palette means:

* a. The artist confines his/her color selection to comparatively few harmonious choices.

 b. The artist has purchased a palette that is too small to hold many colors.

 c. The artist will not try exotic foods.

 d. The artist paints miniature landscapes and still lifes.

 e. The artist paints infrequently.

2. Indicate the statements which are appropriate for Charles Marion Russell?

 a. He found the West to be exactly as his mother imagined.

* b. As a young man he worked as a cowpuncher in Montana.

* c. His work often tells us of his sensitivity to the ironies of life.

* d. He watched the old West disappear with a great deal of regret.

e. He depicted cowboys as well-mannered gentlemen, often misunderstood by towns-persons.

3. Thomas Moran's paintings of the West, and particularly those of The Yellowstone, helped form:

* a. Yellowstone National Park.

b. A friendship with Claude Monet.

c. Themes for Mimbres pottery.

d. The Lewis and Clark Expedition.

e. The urbanization of the Yellowstone River.

4. Georgia O'Keeffe:

* a. Explored the terrain around her adopted home in Abiquiu, New Mexico, as if no one had ever seen it before.

b. Lived her entire life in New Mexico.

* c. Constantly searched for the marvelous and tried to capture it.

d. Was married to Eadweard Muybridge.

e. Enjoyed having visitors and large parties.

5. The lost wax process is:

a. A method of extracting pure pigment from wax crayons.

b. A method of locating candles in the dark.

* c. A method of bronze casting which allows the artist to make changes in each casting.

d. The method of carving models in wax prior to the final carving in stone.

e. A method of super-heating wax until it vaporizes.

6. The Four Corners area is:

* a. Where the states of Utah, New Mexico, Colorado, and Arizona meet.

b. A busy intersection in Atlanta, Georgia.

c. Grid lock in Fargo, North Dakota.

* d. Where the Anasazi flourished for over a thousand years.

e. A method of constructing prefabricated buildings.

7. Sepia tone is:

a. A process for reproducing natural color in cinematography similar to technicolor.

b. The color of koalin clay.

* c. A brownish tone in old photographs.

d. The result of adding white to violet.

e. The color of water dripping in caves.

8. Good subjects for time exposure in photography would include:

a. a gravestone

* b. a fireworks display

* c. moving automobile headlights

d. a still life

* e. lightning

9. A nocturnal painting is:

a. a painting of people asleep.

b. a painting of a dream.

* c. a painting which shows the effects of moonlight and starlight.

d. the artist's impression of a piece of music.

e. a painting the artist painted only during the night.

10. Paul Cézanne:

a. was the first cubist painter.

b. was a leader of the Fauves.

* c. used color to clearly define planes.

* d. eliminated all unnecessary detail.

* e. deliberately distorted his works to achieve balance and unity.

True-False: Mark a **T** if the statement is true, or an **F** if the statement is false, in the blanks at the left of the statement.

F 1. George Caleb Bingham painted blockbuster scenes of the Rocky Mountains.

F 2. George Catlin painted Native Americans in European style clothes.

T 3. T. C. Cannon's *Osage with van Gogh* makes a strong statement about the modern Native American condition.

F 4. Harry Fonseca paints his coyote character as a shy, retiring creature.

F 5. Frederic Remington invented the lost wax process of bronze casting.

F 6. Today, all adobe structures resemble those of the Anasazi.

T 7. The circle is a central symbol in Plains Indian existence.

T 8. Many early photographers studied paintings in order to help them with their compositional designs.

F 9. The Stealth Fighter would be a wise choice for the sepia tone process today.

F 10. Currier and Ives were two famous Pony Express riders.

PART THREE

Unit Seven: *The Bridge*

Completion: Write the word, or words, that complete the sentences in the blanks at the left of the sentence.

Manhattan	1. In 1883, the Brooklyn bridge connected the cities of Brooklyn and New York. Today the bridge connects the borough of Brooklyn with the borough of _____ in New York City.
gothic	2. The Brooklyn Bridge has two _____ arches.
suspension	3. The Brooklyn Bridge is a _____ bridge with two stone towers balanced against the natural curve of cables.
abstract	4. In contrast with the realistic image we see in Benson's photograph, Stella's view of the bridge is an _____ work of art.
ash can	5. The ___ ___ artists show us a city of bleak buildings and poor people on the streets in an urban world.
mine disaster	6. Stella was greatly affected by a tragic ____ _____ in Pennsylvania when he worked as an illustrator for a magazine.
Paris	7. In 1911 Stella went to _____, which was the center of the Modern Art movement of the time.
simultaneity	8. The cubists often painted objects and figures showing several sides of their subjects at once. This is called the principle of _____.
futurists	9. The _____ glorified the noise and speed of the twentieth century and invented lines of *force* to show dynamic energy and great force of movement.
five	10. *The Bridge* is actually one of a series of _____ paintings by Stella entitled *Voice of the City of New York Interpreted.*

True-False: Mark a **T** if the statement is true, or an **F** if the statement is false, in the blanks at the left of the statement.

F 1. John and Washington Roebling escorted President Arthur on the first walk across the Brooklyn Bridge at the official opening.

T 2. There are two levels of the Brooklyn Bridge.

F 3. Stella's point of view was on the promenade walk of the Brooklyn Bridge.

F 4. In Stella's painting, the viewer is facing Brooklyn.

T 5. Roebling's design balanced the weight of the towers against the natural curve of the cables.

T 6. At first glance *The Bridge* seems perfectly symmetrical, but, on closer inspection, we see asymmetrical balance within the arches.

F 7. Stella began painting the Brooklyn Bridge the first day he saw it.

F 8. Stella returned to his native Italy in 1909 to study the Renaissance masters and found this style suitable for his life's work.

T 9. The Cubists saw geometrical structures and patterns in all objects.

T 10. Stella used the principle of simultaneity in *The Bridge* by showing us the understructure as well as the arches and the roadway.

Multiple Choice: Put a circle around the letter of the correct answer or answers:

1. Precisionists:
 a. painted the dark, gloomy side of urban existence in scenes of everyday life.
 b. painted covers for railroad timetables.
 c. used the principle of simultaneity to show several views of the subjects of their paintings.
 * d. painted precise pictures of smooth-surfaced machinery, buildings, bridges and interiors.
 e. invented lines of force that curve, twist, dash, or cut across their paintings to show dynamic energy.

2. Stella saw *The Bridge* as:
 * a. a cathedral.
 b. a threat to the ferry-boat.
 c. a potential traffic bottleneck.
 * d. a welcome to him, the eternal immigrant.
 e. a place for playwrights, spies, and tourists.

3. Stella's *The Bridge* is:
 a. a realistic rendering of the bricks, cables, walkways, and benches.
 * b. mostly lines, shapes, colors, forms and textures.
 * c. a blue, black, and gray painting with flashes of contrasting colors.
 d. a painting with a rich variety of textures.
 * e. a symbol of the Industrial Age.
4. The following statement(s) correctly refer to the balance in *The Bridge*.
 * a. Stella created a symmetrically balanced design with an upward movement using the two gothic towers and the three cables on each side.
 b. The painting is an excellent example of radial balance.
 * c. The design *within* the two arches is asymmetrical.
 d. The painting would be symmetrically balanced except for the rows of oval shapes at the base.
 e. The use of contrasting colors keeps the painting from being balanced.
5. Select the statement that best describes the texture of Stella's *The Bridge*:
 a. The artist uses bold brush strokes which call the viewer's attention to the surface of the painting.
 b. The artist depicts a rich variety of textures in the painting.
 c. The careful brushwork gives a smooth texture to the surface, but the viewer feels he or she can almost feel the texture of each stone in the tower and the twisted steel of the cables.
 d. The artist made the visual textures in one of the gothic arches much more noticeable than in the other.
 * e. The painting has a smooth surface, and most of the features are smooth.

Units Eight and Nine: Forms of Expression and Special Projects

Completion: Write the word, or words, that complete the sentences in the blanks at the left of the sentence.

point
of
view
1. At first, many cubist paintings shocked the public who had, for over six hundred years, been trained to look at objects from a of single _____ __ _____.

forms
shapes
2. Picasso forces the viewer to see familiar objects as _____ and _____.

collage
3. A _____ is made of various materials such as scraps of cloth, papers and pictures with various textures.

Op
4. Stanczak's *Nocturnal Interlude* and Beckmann's *Neither/Nor* are examples of ____ art.

(Piet)
Mondrian
5. *Broadway Boogie-Woogie* is an example of the purely abstract work of the Dutch painter _____ in the last twenty-five years of his life.

stabile
6. A ____ is an abstract sculpture made to appear like a mobile, although it is actually stationary.

found
objects
7. Pieces of junk, such as pipes, cans, broken furniture and wheels, used in sculpture are called _____ _____.

assemblage
8. When an artist brings such objects together to form a new identity, the sculpture is called an _____.

bicycle seat
handlebars
9. Picasso's *Bull's Head* is made from a _____ _____, and _____.

environmental
10. Beverly Pepper's *Amphisculpture* is a form of _____ art as the artist invites the viewer to enter the work and become a part of it.

geodesic
dome
11. R. Buckminster Fuller is an American architect famous for a contribution to the technology of structure, the _____ _____.

Alice
12. A huge underground city being designed in Japan is to be named after Lewis Carroll's heroine named _____, who chased a white rabbit down a rabbit hole.

Raku
13. Richard Hirsch's *Ceremonial Cup #4* was made using the ancient Japanese firing method called ____, which shows fine hairline cracks that absorb black smoke produced during the process.

dichroic
14. James Carpenter used ____ glass in the Christian Theological Seminary Chapel in Indianapolis, Indiana, which allowed him to reflect pink-yellow light upward and blue-green light downward.

Matching: Match the artist in the left-hand column with the statement which best describes the artist and/or his/her work in the right-hand column. Write the letter of the correct answer in the space provided.

f 1. Henri Matisse

k 2. Pablo Picasso

i 3. Romare Beardon

n 4. Edward Hopper

a 5. Piet Mondrian

j 6. Bridget Riley

c 7. Alexander Calder

d 8. Claes Oldenburg

l 9. Sylvia Stone

g 10. Margaret Bourke-White

h 11. Henri de Toulouse-Lautrec

m 12. Robert Henri

o 13. Beverly Pepper

e 14. Cassandre

b 15. I. M. Pei

a. A Dutch artist whose work became increasingly abstract in his lifetime. He painted *Broadway Boogie-Woogie*.

b. An innovative architect who used computer drawings to help him "see" an interior prior to its construction.

c. Noted for his mobiles and stabiles.

d. A sculptor who often uses soft materials to depict hard objects and vice-versa.

e. A French artist whose poster *Étoile du Nord* is considered a masterpiece.

f. Gave modern art its motto: "One must not imitate what one wants to create."

g. Experimented with the camera with such images as *Contour Plowing* after eleven years as a photojournalist for *Life* magazine.

h. This French artist's technique is always recognizable; his paintings and posters are equally well-known.

i. Developed his own unique cubist style in collage as we see in his 1970 *She-ba*.

j. A leading Op artist; her work locks the eye into her patterns.

k. Among his many artistic accomplishments, his 1911 sculpture *Guitar* led the way to assemblage.

l. Her architectural sculpture *Green Fall* produces an effect of moving lights and surfaces.

m. This great art teacher also was a leader of the Ash Can school.

n. His paintings, such as *Early Sunday Morning*, often evoke a mood of loneliness.

o. Her environmental works invite the viewer to enter them and participate in the experience.

Multiple Choice: Put a circle around the letter of the correct answer or answers:

1. The Brooklyn Bridge was unique among bridges in 1883 because:

* a. it was constructed of steel rather than iron.

 b. of its monorail.

 c. it did not cross a river.

* d. it contained a promenade level for people to walk on.

 e. it contained a level for fishing.

2. Stella's eye-level line in *The Bridge* is:

 a. on top of the gothic towers.

* b. approximately half way up the towers.

 c. on the promenade level.

 d. under the bridge.

 e. North of the Manhattan towers.

3. The Futurists:

 a. painted scenes of space flight.

* b. glorified the noise and speed of the new century.

 c. painted young children.

 d. were political cartoonists.

* e. invented lines of force.

4. Charles Demuth's *My Egypt* combines Realism and Cubism. The silos in this work:

 a. are reproductions of silos found in ancient Egypt.

 b. perhaps represent the city of Cairo.

* c. perhaps represent our present day version of pyramids.

* d. are realistically rendered, but abstracted by the lines drawn across them.

 e. are rendered in the Impressionist style.

5. Mark the following sentence(s) which describe(s) the fundamental difference between a poster and a painting.

 a. The fundamental purpose of a poster is to be enjoyed and appreciated at the viewer's leisure.

 b. Poster artists are not capable of rendering fine art such as an oil painting.

* c. Posters must catch the attention of the viewer to persuade him or her to do something.

 d. Successful posters do not necessarily use the compositional principles of design.

 e. Posters give complete details about their subjects.

PART FOUR

Unit Ten: Graphic Design and Advertising Art

Completion: Write the word, or words, that complete the sentences in the blanks at the left of the sentence.

communica-
tion

1. Graphic _____ is the process in which understanding is reached through the use of symbols.

graphic
journalist

2. The _____ _____ is a person who combines the effective use of words with the knowledge of how to present them with stunning graphics.

feedback

3. Information gathered, which shows you the effectiveness of your communication, is called _____.

persuasive

4. Advertising communication is _____ communication.

strategy

5. In advertising, _____ is the approach to the problem of convincing your audience to do what you want them to do.

Attention
Interest
Desire
Conviction
Action

6 - 10.
Strategy has five steps and often is referred to by the first initials of each step, AIDCA. These letters stand for:

Unit Eleven: Fashion, Interior and Landscape Design

Fashion Design

True-False: Mark a **T** if the statement is true, or an **F** if the statement is false, in the blanks at the left of the statement.

T 1. Most fashion designers have studied art seriously.

T 2. Marketing is a key ingredient in both designer and ready-to-wear shops.

F 3. Fashion marketing requires no training in the visual arts.

T 4. A stylist who creates fashion shows re-creates the visual atmosphere of an era that has inspired a designer's collection.

T 5. The increase in catalog shopping has created many jobs in fashion photography.

F 6. A fabric stylist's job is a low pressure position, as she or he can always change decisions at the last minute.

F 7. Display artists working for a department store or chain have the luxury of an unlimited budget.

T 8. A person entering the field of fashion design should have a good eye for line, color, form, and texture.

F 9. Fine design schools in the United States are now begging for applicants.

F 10. Fashion illustration sticks closely to the head-to-body ratio of one to seven and one half.

Interior and Landscape Design

Multiple Choice: Put a circle around the letter of the correct answer or answers:

1. An interior designer:
 a. is a well-trained member of a nation's intelligence network.
 * b. creates the setting and atmosphere in which people live and work.
 c. is the person in the architectural firm who plans room sizes.
 d. works on his/her own, has little contact with others.
 e. shows clients how to sacrifice beauty for efficiency.

2. The interior designer must consider:
 a. the unique characteristics and requirements of a family.
 b. a combination of attractiveness and the functional use of interior space.
 c. cost.
 d. arranging work schedules and supervision of those who carry out the designer's plans.
 * e. all of the above.

3. The attributes of a successful interior designer must include:
 a. a background in house painting and wallpaper hanging.
 * b. the ability to get along with a variety of clients.
 * c. a strong "feel" for the compositional principles of design.
 * d. a solid background in and the appreciation of historic periods in art.
 * e. the ability to make decisions.

4. The landscape designer:
 a. always works independently so that clients won't confuse landscape design with interior design.
 b. reminds clients to put plants inside when it freezes; waters and feeds plants.
 c. arranges for mowing, trimming, and raking of leaves, of his or her clients' grounds.
* d. often works with the interior designer and architect to provide the client with a total indoor-outdoor environment.
* e. is the architect of outdoor space.

5. The landscape designer provides:
* a. restful relaxing outdoor spaces for office workers.
* b. expert knowledge of the growing characteristics of each of the shrubs, grasses and trees in the area.
 c. landscape paintings.
 d. barns, sheds, birdhouses, bathhouses and other outbuildings which require construction skills.
 e. Christmas trees.

Unit Twelve:
Industrial and Transportation Design

Industrial Design

Multiple Choice: Put a circle around the letter of the correct answer or answers:

1. For any consumer product, the industrial designer must consider two basic things:
 a. comfort and ease-of-use.
 b. durability and ease-of-repair.
* c. appearance design and functional design.
 d. landscape design and interior design.
 e. proportion and balance.

2. Computer aided design (CAD) allows industrial designers to:
 a. work a four day week.
 b. play computer games with other industrial designers.
 c. ignore the marketing department and concentrate on functional design.
* d. modify new models continually before tooling and production begins.
* e. rotate images in any direction and display cross sections of any internal portion.

3. Some examples of industrial design are:
 a. a microwave oven
 b. a ball point pen
 c. the Nautilus submarine
 d. a waterproof watch
* e. all of the above

4. The following items all come from industrial designers. Of them, which would you believe depends the most on *appearance* design for acceptance?:
 a. A chef's set of kitchen knives.
 b. A professional driver's racing car.
 c. A microwave oven.
* d. A new model passenger car.
 e. A lap-top computer.

BIOGRAPHIES OF ARTISTS

Magdalena Abakanowicz (b. 1930) A Polish sculptor, born in Falenty, Poland, who is considered one of the foremost artists working in fiber in the world today. Her innovative Abakans of the 1960s initiated a new approach to the use of fiber. She insisted on its use as a material of serious artistic expression with no utilitarian application. Her work helped transform our perceptions of woven objects from craft to fine art.

Ansel Adams (1902–1984) America's most famous landscape photographer. His 1944 photograph, *Moonrise, Hernandez, New Mexico* is considered by many to be one of the most important photographs ever made. His images are mainly of the American West, mountains and unpeopled landscapes of the national parks in California, Wyoming, and New Mexico.

Vosdanig Adoian (called Arshile Gorky) (1904–1948) An American painter, born in Turkish Armenia, who played an important role in the birth of the New York School of Abstract Expressionism. In his mature work, his point of departure was always the observation of nature, followed by a process of abstraction and dislocation that led him to the creation of a subjective and symbolical world.

Alexander Archipenko (1887–1964) A Russian-American sculptor trained in Kiev and Paris, who became a citizen of the United States in 1928 and taught at the new Bauhaus in Chicago; later he opened his own sculpture school in New York in 1939. He broke the figure into masses of geometrical forms, such as cones, and sometimes colored the material or merged the figure with a painted background, thus creating sculpture paintings.

Frederick S. Wright, "Retrospective for Archipenko," *Art in American,* v, lv, May 1967.

Jean Arp (1887–1966) A poet, painter, and primarily a sculptor who studied in Paris in 1098 and became friends with Max Jacob, Picasso, Modigliani, and Robert Delaunay. In Switzerland, at the outbreak of World War I with other refugee artists, he founded the Dada movement. This was an antirational and anti-aesthetic movement. He produced collages, word reliefs, and sculptures which were primitive, but yet had universal meaning.

Herbert Read, *The World of Jean Arp,* New York, 1968.

Henry Bacon (1839–1912) An American painter and illustrator, born at Haverhill, Maryland. He served as field artist for *Leslie's Weekly* during the Civil War. Later he studied art in Europe and settled in Paris. He is noted for his watercolors of Normandy and Egypt.

Giacomo Balla (1871–1958) An Italian painter who was Futurism's astonishing advocate. He painted first in an academic style. Later he studied light and color and became a futurist. He tried to isolate motion on the canvas in experiments as early as 1914–16, although his work was not recognized for its avant-garde power until mid-century.

Jules Bastien-LePage (1848–84) A French painter remembered for his peasant genre scenes, such as *The Hayfield* (Luxembourg Museum, Paris). Although his technique was influenced by Impressionism, much of his work was in the tradition of Courbet and Millet.

Gustave Baumann (1881–1971) A printmaker and painter, born in Germany. He settled in Santa Fe, New Mexico in 1918 where he experimented in a wide variety of media, including woodblock prints, and carved marionettes with which he and his wife toured the state acting out Hispanic and Indian folk stories.

Herbert Bayer A painter and graphic artist born in 1900 in Austria, who studied under Kandinsky and became a teacher of layout and typography. In 1929, in Paris, he produced surrealist photo-montages which relate formally to Miró. In 1938, he moved to New York and worked in advertising and design for John Wanamaker's and J. Walter Thompson.

Alexander Durmer, *The Way Beyond "Art"—The Work of Herbert Bayer,* New York, 1947.

William Baziotes (1912–1963) A contemporary American painter of bold amoebic-form abstractions, which sometimes have symbolic meaning. Born in Pittsburgh, Baziotes taught and painted under the W.P.A. (1938–1941). He continued the surrealism that affected most New York painters in the 1940s.

Romare Bearden Born in 1914 in North Carolina. Bearden studied premedicine in college but was introduced to

George Grosz at the Art Students League, where he studied the draftsmanship of Hogarth and Ingres. During the Great Depression he was allied with other black artists and writers. He always believed that people were his only subjects. His collage-style images of the black urban experience caused an uproar, but he was successful in magazine commissions and obtained a Guggenheim fellowship in 1970.

Romare Bearden, *The Painter's Mind,* 1965.

George Bellows (1882–1925) Bellows was born in Ohio, spent most of his short life in New York and drew his subject matter from the city, especially the athletic club near his home that staged prize fights. After 1916 he worked on lithographs with expressive dramatic line.

Charles H. Morgan, *George Bellows, Painter of America,* New York, 1965.

Thomas Hart Benton (1889–1975) An American artist born in Neosho, Missouri to a politically prominent family. His father was a member of Congress, and young Benton first saw formal art in Washington, D.C. After World War I Benton traveled throughout the United States sketching. His subjects, especially the rural people, stimulated much of his artistic production. During the 1930s he became famous for his semi-historical murals depicting mid-western "regionalist" subjects and popular native imagery.

Albert Bierstadt (1830–1902) A German-born American landscape painter. He came to the United States as a child and grew up in New Bedford, Massachusetts. He returned to Europe in 1853 to study at the Düsseldorf Academy and later in Rome. In 1857 he returned to America and settled in New York in 1861. Inspired by the scale and grandeur of the West, he created vast and stirring landscape paintings.

George Caleb Bingham (1811–1879) An American painter of the backwoods, frontier life on the Missouri River, and steamboats. He attended the Pennsylvania Academy of Fine Arts and later was Professor of Art at the University of Missouri.

William Blake (1757–1827) An English poet, painter, and engraver. Blake began his training as a draftsman at the age of ten and by fifteen was an apprenticed engineer. His "Songs of Innocence" and "Songs of Experience" were the first collections of his poems printed and illustrated in color by a method devised by him. His art is noted for its symbolism, visionary quality, and uncompromising use of line.

Karl Bodmer (1809–1893) A painter of American Indians, born in Riesbach, Switzerland. He came to the United States as the documentary artist of an expedition organized by Maximilian, Prince of Wied. Many of his richly colored watercolors of the Indians of the Great Plains were later engraved as aquatints and published in a book by Maximilian.

Richard Parks Bonington (1801–1828) An English landscape painter who went to France and trained there as a boy. He was a friend of Delacroix, as well as a pupil of Grosz. He exhibited while quite young (at the age of 21), went to Italy at the age of 25, and died when he was 27. Although he was influenced by the sumptuous richness of the Venetians, he imitated their skill with more restraint.

Lee Bontecou Born in Rhode Island in 1931, she grew up in New York. She received a Fulbright scholarship to study in Rome 1957–58. Her early works were of fanciful animal forms built on metal armatures. By chance she put canvas and metal together and used them as her materials. A commission for a wall relief at Lincoln Center in New York in 1964 brought her increased fame.

Eleanor Munro, Originals: *American Women Artists,* New York, 1979.

Gutzon Borglum (1871–1941) An American sculptor who is famous for his gigantic Mount Rushmore National Monument in South Dakota. His many other works include the Twelve Stone Apostles on New York City's Cathedral of Saint John the Divine, and the six-ton marble head of President Abraham Lincoln (1908) in the United States Capitol rotunda.

Solon Hannibal Borglum (1868–1922) An American sculptor, born in Utah and reared in Nebraska, where he worked as a cowboy. The American West is an important part of his work, and he is known for his bronze sculptures of cowboys, Indians, and horses. Naturalism was the basis of his style. His heroism in World War I won him the Croix de Guerre.

Constantin Brancusi (1876–1957) A French sculptor born in Romania, Brancusi studied in Bucharest and then in Paris, including a brief study of sculpture with Rodin. He traveled widely and associated with Cocteau, Satie, Tzara, and Kokoschka. His revolutionary contribution was to follow, in sculpture, Cézanne's dictum that nature is based on the cube and the cone. The purity of his life influenced many others.

Georges Braque (1881–1963) A French painter born in Argenteuil. He was a color experimenter, at times limiting his palette to umbers, black and yellow. He painted simple objects, producing works of subtle harmonies and finely balanced compositions. He is credited, together with Picasso, with the development of Cubism.

Brassai (Gyula Halasz) (1899–1984) A Hungarian artist who studied painting in Budapest and Berlin and moved to Paris in 1923. His photos of Paris nightlife were published in 1933. He was known for his sharp angles and lighting that illuminated the seamier side of street life and the Paris underworld.

John Szarkowski, Looking at Photographs, Museum of Modern Art, 1973.

Pieter Brueghel, the Elder. (c. 1525–69) A Flemish painter who journeyed to Italy in 1552. He was touched by the social calamities of his century, the "century of beggars." His commissioned work on man's relation to nature was calm and large in scale. Late in life he became increasingly bitter about the blindness and cruelty of humanity.

Fritz Grossman, *The Paintings of Brueghel*, 1966.

Alexander Calder (1898–1976) An American sculptor born in Philadelphia, he trained first as an engineer, then attended evening drawing classes in New York. In travels to and from Paris he met Arp, Mondrian, and Leger, and became influenced by a number of the current vogues. He turned at first to static construction and then, in 1932, made his first mobile, a form of sculptural expression which allows the component parts to move. He also produced stabiles.

Mary Cassatt (1845–1927) An American painter, Cassatt traveled to France and Italy, met Edgar Degas, who suggested she exhibit in the Impressionist shows, which she did. She was strongly influenced by Japanese models. Her most common themes were mother and child, done with simplicity and freshness.

George Catlin (1796–1872) An American painter born at Wilkes-Barre, Pennsylvania who has left an invaluable record of the Native Americans as they appeared in the early frontier days. He began as a portrait painter but elected to record the Indian people. He traveled West, as a painter and explorer, and produced paintings depicting forty-five tribes in a meticulously realistic yet romanticized style. Many of these paintings are housed today in the Smithsonian Institution's United States National Museum.

Paul Cézanne (1839–1906) A French painter born in Aix-en-Provence. When refused admission to the École des Beaux-Arts in Paris, he studied the paintings in the Louvre. He overcame many of the sterile rulings of the academies and fathered his own unique manner of painting. He is considered by many to be the founder of modern painting.

Marc Chagall (1887–1985) A Russian painter born in Vitebsk. Having failed the entrance exam to St. Petersburg School of Arts and Crafts, he went to Paris to live and paint. His work is filled with strange and poetic images reaching back into the Russia he knew as a child. Considered a Modernist, he often painted floating figures and bright primary colors that created a dreamlike atmosphere.

Michel Eugene Chevreul (1786–1889) A French chemist whose writings on optics and the composition of light influenced the painters Seurat, Homer, and many others.

Christo Born in 1935 in Bulgaria, he studied at the Fine Arts Academy in Sofia and then in Vienna. He exhibited a wrapped Roman wall in 1974, and his running fence in Sonoma and Marin counties in California was built in 1976. A later work, finished in 1980, surrounded the islands in greater Miami Bay with polypropylene cloth. He is the author of twelve books and monographs on his projects.

John Singleton Copley (1738–1815) An American painter and engraver who established himself in Boston by developing a portrait style suited to the tastes of his New England patrons. His work impressed Sir Joshua Reynolds, and Benjamin West in London. West advised Copley to come to Europe, which he did in 1775. As a result of his travels and studies abroad, his style changed, and he proceeded to create modern history paintings.

José de Creeft Born in 1884 in Guadalajara, Mexico. An American sculptor, who at twelve worked as an apprentice in a bronze factory. He studied in Paris at the Académie Julien. In 1911 he worked in a stonecutter's workshop and learned carving. His work tends toward the monumental, with great interest in textures. Polished and rough surfaces are frequently juxtaposed so that smooth forms seem to emerge from a rough background.

Imogen Cunningham (1883–1976) Imogen Cunningham was one of the earliest and most important portrait photographers in the United States. Encouraged by her father to pursue her talent, she was a noted photographer when few American women considered it a possible profession. Her portraits stressed a commitment to the human quality of her subjects, rather than to the heroic. Her last work, *After Ninety*, was started when she was over ninety years of age.

John Stuart Curry (1897–1946) An American painter and muralist, born in Dunavant, Kansas. His popular scenes of Midwestern farm life (*Baptism in Kansas*, 1928; *Hogs Killing a Rattlesnake*, 1930) established him as the leading figure among the American regionalist painters. From 1936 until his death, he was Professor of Art at the University of Wisconsin.

Jacques-Louis David (1748–1825) A French artist born in Paris, he studied with Boucher. He traveled to Rome, where he developed his ascetic, classical style. Back in France he became involved in politics and ended up in prison after the fall of Robespierre. His paintings were a pictorial rejection of the splendor, riches, and escapist art of the last days before the Revolution.

Stuart Davis (1894–1964) An American artist, Davis was born in Pennsylvania, attended Robert Henri's art classes in New York and took inspiration there from dance halls and saloons. He set up common objects in his studio—an eggbeater, an electric fan, a rubber glove—and concentrated

on painting geometrical exercises. In Paris, he abstracted city scenes and transferred this style on his return to the United States in order to portray the color, composition, and movement of uniquely American life.

Walter De Maria (b. 1935) A leading figure among Minimalist and land artists. He pushed the Minimal notion to its limits, using chance as a means of depersonalizing and objectifying the creation of a work of art.

Charles Demuth (1883–1935) An American painter born in Pennsylvania and influenced by an early trip to Paris where he studied the Fauves and Cézanne. He became friendly with Stieglitz and Duchamp. His flower studies are important as watercolors—his preferred medium. Modern landscapes in oils, portraying his home in Lancaster County, are similar in prismatic effect to those of Sheeler and Feininger.

Arthur Dove (1880–1946) Dove was an illustrator at *Scribner's* magazine after college, despite his father's objections. He studied in France, but back in the United States his landscapes became abstracted and precisely controlled, according to color and proportion of objects. His life was beset by financial worries, and his late work became even more somber.

Frederick S. Wight, *Arthur G. Dove,* Berkeley and Los Angeles, 1958.

Duccio (c.1255–1318) A great Siennese master who prepared the change from Byzantine to Gothic by his use of multiple picture planes, brightened color and less stylized drapery. He successfully ran a large workshop, thus it is hard to attribute work definitely to him.

Albrecht Dürer (1471–1528) Dürer was the son of a German goldsmith and a precocious student of painting in his teens. He traveled to Italy and interpreted Italian Renaissance work in his northern Germanic way. He made a triumphal trip through the Low Countries. His great master paintings of religious subjects and his fine draftsmanship and printmaking make him stand out as one of the great artists of the Renaissance.

Erwin Panofsky, *The Life and Art of Albrecht Dürer,* London and Princeton, 1955.

Thomas Eakins (1844–1916) An American artist, born in Pennsylvania, who attended drawing classes at the Pennsylvania Academy of Fine Arts. He made anatomical drawings while at the Medical College. He also made fine figurative studies of athletes and was an expert at portraying the introspective moods of his subjects in portraits.

Harold E. Edgerton (b. 1903) An American photographer who taught at the Massachusetts Institute of Technology and in 1938 invented the gas-filled tube that is used in the electronic flash. Through his photographs, taken by "strobe light," Edgerton has produced staccato images of the flow of motion and the trajectory of an object moving at a rate approaching the speed of light.

William Edmondson (c.1883–1951) An American sculptor who lived and worked in Nashville, Tennessee. The son of slaves, he began carving in limestone in his fifties, after working for many years in repair shops. He primarily carved tombstones and sold them for $2.00 each. After twelve of his sculptures were exhibited at the Museum of Modern Art in New York in 1937, he doubled his prices to $4.00—if his clients could afford it. His subjects included birdbaths, biblical figures, prizefights, crucifixions and birds.

Maurits Cornelis Escher (1898–1972) A Dutch graphic artist born at Leeuwarden. His early work consisted of landscapes and townscapes in Italy. He later constructed over-all periodic patterns with repeating symmetrical configurations of animals, birds, and fish. His late work took on a surrealist tone of visual unreality. Mathematical concepts played a key role in many of these late prints.

Lyonel Feininger (1871–1956) A New York painter who studied in Hamburg and Berlin. He specialized in cityscapes where the Manhattan atmosphere was created by elongated shapes of buildings and structures.

John Ford (1894–1973) An American film director who started directing Westerns in 1917 and made many films. His preferred form was the Western, although he achieved fame for films of social or religious content as well. In his Westerns, his viewpoint is conservative and nostalgic.

Robert Frank Born in 1924 in Zurich, Switzerland, Frank was a Swiss-American photographer and filmmaker who came to New York, first to be a fashion photographer, and then a freelance photographer of American rebels and outcasts of society.

The Americans, Photographs by Robert Frank, Aperture/Museum of Modern Art, 1968.

Antonio Frasconi Frasconi was a graphic artist born in 1919 in Montevideo, Uruguay, who came to the United States in 1946 and studied under Yasuo Kuniyoshi. In 1960 he received the Grand Prix of the Venice International Film Festival for *The Neighboring Shore.* His work is represented in many of the leading collections of graphic art.

James Earle Fraser (1876–1953) A prolific creator of large-scale public monuments throughout the United States, as well as a designer of many medals and medallions, including the Navy Cross. In 1911 he designed the buffalo nickel.

Daniel Chester French (1850–1931) An American sculptor, born in Exeter, New Hampshire, whose work, mainly in bronze or marble, includes numerous portrait busts and statues of prominent Americans. His most famous work is the seated marble figure of Abraham Lincoln inside the Lincoln Memorial in Washington, D.C., completed in 1922.

Caspar David Friedrich (1774–1840) A romantic German landscape painter particularly noteworthy for his lovely renderings of the woods. He was greatly skilled in the expression of effects of light and seasons in nature. The majority of his works are in Dresden, Germany, where he lived most of his life.

Richard Buckminster Fuller Born in 1895, an American inventor, designer, and philosopher whose first invention, the Dymaxion House of 1927, was readily movable and hung from a central core, greatly reducing its use of material, weight, and cost. His geodesic domes are considered one of the most significant structural innovations of the twentieth century.

Harch, Alden, *Buckminster Fuller*, (1974)

Thomas Gainsborough (1729–1788) An English painter of portraits in landscapes according to the style of his teacher, Hayman, in London. He copied popular Dutch landscapes for his London dealers and was influenced by Ruisdael and Hobbema. He was one of the original members of the Royal Academy and unofficial portraitist of royalty.

Antoni Gaudi (1852–1926) A Spanish architect, considered a major figure in the architectural interpretation of Art Nouveau. His architecture appears to be sculpture. He allows his fantasy free play. It is often marked by highly plastic, curvilinear movement and flamboyant overstatement.

Artemisia Gentileschi (1597–1651) The daughter of an Italian painter, she studied the work of Caravaggio, settled with her father in Florence and painted emotionally-charged subject matter, such as Judith and Holofernes. She studied the night images of painters shown at the Capodimonte Museum in Naples, where she won fame after travels to London.

"Artemisia Gentileschi," *The Art Bulletin,* vi, June 1968.

Alberto Giacometti (1901–1966) Son of a Swiss painter, he enrolled in the School of Arts and Crafts in Geneva and then spent a year in Italy. After studying the Italian masters, he settled in Paris and began to create elementary simplified figures with elongated torsos and, often, large feet that seemed to ground them to earth. He was obsessed with solitude and also with the relation of humans in groups. His paintings and drawings were rendered in many quick lines.

"Alberto Giacometti," Museum of Modern Art catalogue, New York, 1965.

Vincent van Gogh (1853–1890) A Dutch painter who was raised in a family of clergy and worked as a salesman in his uncle's art gallery in the Hague. He studied theology but enrolled in the École des Beaux Arts in Paris. In 1887 he made friends with the Impressionists. His brother Theo always encouraged him. He moved to Arles in 1888 and painted with bright colors, but he experienced a series of mental crises and, at the age of 37, took his life.

The Complete Letters of Van Gogh, London, 1958.

Sidney Goodman Born in 1936 in Philadelphia, he studied painting at the Philadelphia College of Art and has exhibited in numerous group and one-man shows of contemporary figures and realism. His drawings have been shown at the Whitney Museum (1979–81) and at the Philadelphia Museum (1979). He has taught at Philadelphia College of Art, Tyler School, and the Pennsylvania Academy of Fine Arts since 1978.

Francisco Goya (1746–1828) A Spanish painter, born in rural Spain, who later traveled to Madrid. At first he was influenced by rococo artists like Tiepolo. During the 1780s he became revolutionary and yet managed to remain popular as a royal portraitist. His portraits were searching examinations of character. When Napoleon invaded Spain Goya produced emotionally intense paintings of the citizens' martyrdom. He turned increasingly inward and painted visions and nightmares.

Morris Graves Born in 1910 in Oregon, he was a self-taught artist who settled in Seattle in 1920. He worked as an easel painter for the Federal Arts project in 1936–37 and became a close friend to John Cage and to Mark Tobey. He traveled widely in Japan, Africa, and Europe. His portrayal of nature, of small birds and flowers and fish, done with subtlety to suggest the power of myth, was the subject of a major traveling exhibit organized by the Phillips Collection in Washington, D.C.

Ray Kass, *Morris Graves: Vision of the Inner Eye,* New York, 1983.

El Greco *(Doménikos Theotokopoulos)* (1541–1614) A Greek who painted in the Spanish manner. He went to Italy from Crete at the age of 19. He studied under Titian. He then traveled to Madrid to obtain two commissions for panels of a cathedral and a church. His early style recalled his Byzantine influence and study of Italian mannerists. He is well known for elongated figures and strong light contrasts.

Horatio Greenough (1805–1852) An American sculptor, born in Maine, he was one of a first generation of American neoclassical sculptors who studied in Italy, starting in 1924. He produced many marble portrait busts, a few reliefs, large public commissions, and the design for the Bunker Hill monument in Boston.

Juan Gris (1887–1927) A Spanish artist who attended art school in Madrid but moved to Paris when he was 19, because he was attracted to the work of Picasso and other compatriots there. The new artists showed simple cubist form, rejecting chiaroscuro and regular perspective.

James Thrall Soby, "Juan Gris," Museum of Modern Art catalogue, New York, 1958

Philip Guston (1913–1980) An American painter who was born in Montreal, Canada. He began as a figurative painter but eliminated representative references from his work in the late 1940s. His version of Abstract Expressionism, often termed Abstract Impressionism, fluctuated between a sensuous, lyrical, and subtly tinted manner and a more sober, discordant, less elegant style.

Marsden Hartley (1877–1943) An American painter, born in Maine, who first showed his work at Stieglitz's 291 Gallery–his so-called black landscapes. The Expressionists influenced his bold color and outline. In his dramatic landscapes of Maine and New Mexico, nature is seen as a symbol of moody power.

Robert Henri (1865–1929) An American painter notable less for his own art than for his spirit as a teacher and crusader against academic conservatism. He favored a new democratic humanism in both art and life. His teaching inspired independence and aesthetic progress, opening new areas of life as subjects for art.

Barbara Hepworth (1903–1975) A British sculptor born in Yorkshire, England. After carving simplified sculpture in marble and stone (around 1933) she turned toward abstraction. She worked with geometric forms, heightening spatial effects by incorporating strings and color.

Barbara Hepworth: *Drawings from a Sculptor's Landscape,* 1967.

David Hockney Born in 1937 in Yorkshire, England, Hockney attended London Royal College of Art and gained fame upon winning first prize there. He is known for draftsmanship and for recent experiments with fragmented pictures and photo collages. He has also done theater and opera sets, lithographs, and always returns to his figure studies, which he believes to be the most important exercises.

Hokusai (1760–1849) A Japanese artist born in the artisan class of Japan, who left home in his early teens to become an engraver. At age 26, he started illustrating his own texts and became one of the most important Japanese artists. At age 70 he produced *Thirty-six Views of Mt. Fuji,* and illustrated some 160 publications. He died at age 90. He was an artist of the people and depicted their restless energy in visions of a changing world.

Hans Holbein, the Younger (1497–1543) A German artist, born in Germany, who studied in his father's art studio but later left for Basel, Switzerland, and worked for a publisher. He produced realistic portraits and illustrated the Lutheran Bible in an era of religious and agrarian uprisings at the time of the Reformation. Journeys to London won him court appointments to paint well-to-do merchants and even King Henry VIII himself.

Winslow Homer (1836–1910) An American painter, born in Boston, who began his career as an illustrator. After a period painting scenes of the Civil War in watercolor and oil, he settled on the Maine Coast and painted fishing boats and the sea.

Edward Hopper (1881–1967) An American artist, born in New York, he was a student of Robert Henri in New York. The lonely mood of the city was one of his themes; often the geometry of buildings is revealed by an eerie light, such as in Nighthawks, (1941–42). His interest in landscape relates him closely to nineteenth-century American landscape painters.

Lloyd Goodrich, *Edward Hopper,* New York, 1976.

Jean-Antoine Houdon (1741–1828) A French sculptor. His extensive work includes the statue of George Washington in Richmond, Virginia.

Jean-A. Ingres (1780–1867) A French-born artist who studied with David in Paris, where he won the Prix de Rome in 1801. He settled in Italy, and, although he sent portraits back to Paris, he was forced to make a living selling pencil drawings. A commission for Montaban Cathedral established his success. His classicism stood in opposition to the romanticism being developed by Delacroix.

Philip Cortelyou Johnson An American architect, born in 1906 in Cleveland, Ohio, he was an ardent propagandist and theorist of modern architecture. In 1932, he wrote a book in collaboration with Henry-Russell Hitchcock, *The International Style.* Its title became the standard designation for the architectural revolution which followed World War I.

Joshua Johnston (1796–1824) An American artist, born in Baltimore, Maryland and considered to be the first professional African-American painter in the United States. His early paintings of Baltimore's prosperous merchant families conform to an 8th century English ideal in which softly painted, doll-like figures are shown against a dark background.

Louis Isadore Kahn (1901–1974) An American architect, born in Saare, Estonia, whose work reflects his taste for clean lines and classical order. His mature work provided a new image of modern architecture, linked both to the industrial age and to the splendors of the past. In 1955 he was appointed Professor of Architecture at the University of Pennsylvania, and his influence began to grow. His later projects brought Kahn the reputation of being "a classic of the avant-garde."

Gertrude Käsebier (1852–1934) An American artist who was from a pioneer family that traveled to Colorado in a covered wagon. On a trip to France, she discovered photography, which immediately engaged all her time. Back in New York in 1897, she opened a studio and revolutionized portraiture by placing a subject in everyday settings with

natural light. She was a member of the Photo-Secession. Her major series was on motherhood, but she also portrayed the Indians of the Plains.

Rockwell Kent (1882–1971) An American painter, born in New York, who first studied architecture at Columbia and then studied painting with Robert Henry. He loved nature and the effects of light and shadow playing over large planes. He was a wanderer who lived in Maine, Newfoundland, and Alaska. Accounts of his work are published in his text, *Of Men and Mountains,* 1959.

Rockwell Kent, *This Is My Own,* New York, 1940.

Charles Bird King (1875–1862) An American portrait and still-life painter, born in Newport, Rhode Island. He settled in Washington, D.C. where he was often called upon to paint visiting Indians. These paintings constitute a notable part of his work and are today considered important documentary material.

Franz Kline (1910–1962) An American painter born in Pennsylvania. After studying in Boston and London, he settled in New York and painted in a conventional manner, while earning his living by selling comic drawings and by decorating bars. In the late 1940s his own style emerged, using bold slashing lines in which black was the only color. Late in the 1950s he returned to some color, but the role of the black gesture on white canvas remained supreme.

Katherine Kuh, *The Artists' Voice,* New York, 1962.

Kaethe Kollwitz (1867–1945) A German artist who developed a sympathy for the downtrodden of her day. Her series, *The Weavers,* dealt with the conflicts of industrializing an agrarian economy. The sixteenth-century peasants' revolt inspired a series of prints. Her lithographs and woodcuts expressed political themes; she is equally well known for her studies of motherhood and the survival of spirit in adversity.

Hans Kollwitz, ed., *Diaries and Letters of Kaethe Kollwitz,* Chicago, 1955.

Ogata Korin Born in 1661 in Kyoto, Japan, he was a follower of Sotatsu. Korin was well known in Europe through numerous copies of his work. His famous screen of irises and those of wild, stylized waves are decorative, and have a style of their own. He is also noted for painting refined lacquer boxes.

Korin, *Library of Japanese Art,* 1960.

Liu Shou Kuan (Yuan dynasty) An artist who served under Kublai Khan, he is noted for his bamboo paintings and his essay on that art. He advised that the artist should first have a complete mental image, then begin work rapidly and "pursue the vision as the hawk strikes down for the hare."

Yasuo Kuniyoshi (1893–1953) A Japanese painter who studied at the Art Students League in New York with Kenneth Hayes Miller. His first paintings combined landscapes, children, and flowers in a dreamlike composition. The pictures of desolation during World War II gave way to gayer scenes of carnivals, such as *The Juggler,* which hangs at the Whitney museum.

Lloyd Goodrich, **Yasuo Kuniyoshi**, New York, 1948.

Adélaide Labille-Guiard (1749–1803) A French painter who worked in both pastel and oil. She was primarily a portraitist, although she produced historical paintings later in her life. In 1783 she was admitted to the prestigious Académie Royale. An exceptional teacher, she campaigned to make the Académie Royale accessible to other women.

John La Farge (1835–1910) An American painter who originally studied in Europe and later in America with William Morris Hunt. He painted romantic scenes of the mysterious and the frightening. He worked in murals and painted glass, becoming one of the most prominent decorators of churches in the United States. He traveled through the South Seas and Japan and published several books on his travels and art.

René Lalique (1860–1945) Lalique, a Frenchman, was the most successful glassmaker of the twentieth century. Throughout the 1920s and 1930s his work was hailed as representing the most sophisticated qualities of French decorative art. His glass includes bowls and bases, scent bottles, car emblems, clocks, jewelry, sculptural and architectural decoration of every kind.

Fritz Lang (1890–1976) An Austrian film director. The idea of destiny was a theme which recurred throughout his films. His silent films featured towering architectural sets and the expressionist style of acting. His later sound films combined social purpose and insight with expressionist elements.

Dorothea Lange (1895–1965) An American photographer, born in New Jersey, who studied with Clarence White and opened a portrait studio in San Francisco in 1919. During the Great Depression of the 1930s, she joined the Farm Security Administration and used her camera to show the plight of displaced families. During World War II she portrayed the Japanese-Americans who were forced to relocate. She produced sensitive essays for *Life* magazine on Mormon villages, the Irish countrywoman, and the public defender.

Paul Taylor and Dorothea Lange, *An American Exodus; A Record of Human Erosion,* New York, 1939.

Fernand Léger (1881–1955) A French-born artist who began his career as an architectural draftsman, and became friendly with Rousseau. He was attracted to theories of Cubism. During his experiences in World War I, he was

exposed to the world of technology. He began to paint mechanical objects as abstractions. He collaborated with Le Corbusier on murals and produced mosaics and ceramics; late in life he painted rural landscapes, with a fascination for objects and tools as symbols for man-made objects.

Werner Haftmann, *Painting in the Twentieth Century,* New York, 1966.

Leonardo da Vinci (1452–1519) An Italian painter, born in the small village of Vinci, who studied in the studio of Verocchio and assisted in his paintings. He received important commissions, such as *Adoration of the Magi.* In Milan, he worked on architectural projects and became famous at the courts of Mantua and Florence. He gave new life to portraits and landscapes. Leonardo's spirit of inventiveness and his wide-ranging skills and interests, epitomize the essence of the Renaissance.

Kenneth Clark, *Leonardo da Vinci,* Cambridge, Massachusetts and London, 1958.

Emmanual Gottlieb Leutze (1816–1868) An historical and portrait painter, born in Gmünd (Württemburg) but reared in Philadelphia, Pennsylvania. He returned to Europe to study art and lived in Düsseldorf for almost twenty years before returning to the United States in 1859.

Judith Leyster (1609–1660) Dutch-born Judith Leyster and her husband were Haarlem painters, students of Frans Hals. She painted groups of people drinking and laughing. The closeness of her style to Hals is illustrated by the fact that her *Lute Playing Fool* in the Rijks museum was long attributed to Hals.

Roy Lichtenstein (1923–1989) An American painter who took everyday objects as a basis for paintings, such as giant blow-ups of parts of comic strips, or huge reproductions of hamburgers. He was a member of the Pop Art Movement.

Harvey Littleton An American glassblower and teacher, born in 1922 in Corning, New York and responsible for the upsurge of interest in experimental glassblowing. He is a master technician, notable for freedom, gracefulness and purity of his work.

John Marin (1870–1953) An American painter, born in New Jersey, who planned to be an architect but was drawn to painting at the Pennsylvania Academy and the Art Students League in New York. He lived in Europe (1905–11) and later exhibited in Stieglitz's 291 Gallery in New York. The Venice Biennale honored him with a retrospective in 1950. He never followed a school, but painted his canvases and watercolors with expressive freedom, and unusual vigor of composition and line.

Marino Marini (1901–1980) An Italian artist who studied in Florence, where he admired early Roman and Etruscan bronzes. As a sculptor he developed his own unique modern line. His famous subjects, such as horse and rider, evolved over the years as portrayals of his understanding of the inner life. He gained fame in Rome and Milan as a teacher and sculptor of a number of portrait busts of the famous.

Maria Montoya Martinez (1880s–1980) and **Julian Martinez** (1879–1943) Maria, a Tewa Indian of the San Ildefonso Pueblo and her husband, Julian, created black-on-black pottery beginning in 1918, after a decade of experimentation. Maria made the pots by the ancient method of hand coiling clay; Julian decorated them. They worked in the new burnished blackware, rather than the traditional polychrome pottery of San Ildefonso. Julian excelled in painting geometrically stylized forms.

Henri Matisse (1869–1954) A Frenchman who studied law and then began painting. In 1899, he was influenced by Cézanne, then showed at the Salon d' Automne in Paris with his friends and became leader of a group called the Fauves (wild beasts). He settled in Nice and lived a long productive life in which he painted pictures that explored the relation between two and three dimensions; made paper cutouts; designed for the ballet; and drew line portraits.

A. H. Barr, Matisse: *His Art and Public,* New York, 1951.

Hans Memling (1430–1494) A painter born at Seligenstadt in Germany, who settled in Bruges, Belgium, where he was comfortably successful. His manner of painting is northern, cool, and unemotional, in contrast to the influence that was beginning to flow from Italy.

Michelangelo Buonarroti (1475–1564) A sculptor and painter born in Castel Caprese, near Florence, Italy. His fresco painting on the ceiling of the Sistine Chapel, completed when he was 37 years old, is considered to be one of the greatest achievements of all time in the arts. He himself felt that his greatest talent was in sculpture.

Gjon Mili (1904–1984) Mili came to the United States from Albania in 1923 and became a photographer for *Life* magazine. He is noted for photographing the famous in searching photo essays. Among his subjects are Picasso, Pablo Casals in exile, and an aged Sean O'Casey in his last interview. He often created multiple images, overlapped to suggest dramatic action.

Jean-Francois Millet (1814–1875) A French artist of the Barbizon School who first earned a living painting mythological and genre scenes, but retreated to the countryside of Barbizon and made that his sole subject matter. His figures of farm workers in the seemingly endless landscape attain grandeur in their honesty. Millet's work became popular only after he died, and his friend Corot had to arrange for an annuity for his widow.

Robert Mills (1781–1855) An American architect, born in Charleston, South Carolina, who became one of the most original interpreters of the Green Revival style. Mills was

especially interested in problems of sound construction. He is perhaps best known as the designer of the two major American monuments to George Washington.

Joan Miró (1893–1982) A Spanish Surrealist painter who lived in the United States and exhibited in the first Surrealist exhibition. His work, although seeming abstract, was symbolic. For him, painting was never form only for form's sake. He was alternately romantic, humorous, and mystical.

Piet Mondrian (1872–1944) A Dutch artist with a strict Calvinist father who wanted his son to be a teacher; Mondrian refused, and instead enrolled in art school. His landscapes were influenced first by Cubists. Later he abstracted colors to the primaries, plus black and white, and lines to the horizontal and verticals. He influenced a generation of young abstractionists such as Léger. He is important in the twentieth century because his progression to abstraction was methodical and experimental and yet well developed at every stage.

Michel Seuphor, *Piet Mondrian: Life and Work,* 1956.

Claude Oscar Monet (1840–1926) His painting, *Impression–Sunrise* helped create the name of the school of art known as "Impressionism." His work represented the highest ideals of Impressionism. He painted a series of poplars, haystacks, and cathedrals under various conditions and different times of day. Most famous of all are the *Water Lilies* (dating from the 1890s to 1923).

Henry Moore (1898–1986) An English sculptor born in Yorkshire, England, Moore was the son of a miner. He studied at Leeds, and became an art instructor at the Royal Academy. He gave up teaching in 1939 to live in the countryside outside London. His sculpture showed influences of Egyptian art, African masks, and pre-Columbian Mexican sculpture. He made massive reclining human figures for outdoor public places.

Herbert Read, *Henry Moore, a Study of His Life and Work,* New York, 1966.

Thomas Moran (1837–1926) An English-born American landscapist, etcher, lithographer, and engraver. His painting and landscapes of the American west are marked by their color and grandeur and include powerful vistas of the Grand Canyon, Yosemite Valley and Colorado.

William Morris (1834–1896) An English designer, poet, and critic, influenced by his love for the craftsmanship of the Middle Ages. He published a magazine, and later apprenticed to an architect, but became a craftsman and designer of furnishings. He founded his own company and produced wallpapers and chintzes. A social philosopher as well, he had a romantic faith in the idea of manual labor as therapy.

Asa Briggs, *William Morris: Selected Writings and Designs,* New York, 1964.

Wright Morris Born in 1910 in Nebraska. Morris has been a novelist and journalist, and a poet who was published photography books detailing the American experience of farming and settling the plains. He has received Guggenheim and Rockefeller grants, and has taught writing at San Francisco State College.

Wright Morris, *In God's Country and His People,* New York, 1968.

Sheng Mou A master Chinese painter who lived during the first half of the fourteenth century. He painted landscapes, figures, flowers, and birds.

Eadweard Muybridge (1830–1904) An eccentric and brilliant British pioneer in photography. Born in England, Muybridge emigrated to the United States in the early 1850s. He was responsible for the studies of horses in motion, proving that at full gallop the horse had all four feet off the ground.

Louise Nevelson (1900–1988) An American painter and sculptor born in Kiev, Russia, whose sculptured walls became internationally famous. These are wall-like reliefs made up of many boxes and compartments into which abstract shapes are assembled with commonplace objects and found objects. These constructions were painted black or white or gold. Nevelson is considered a leader in both assemblage and environmental sculpture.

Georgia O'Keeffe (1887–1986) An American painter born in Sun Prairie, Wisconsin. Her favorite themes were mountains, bones, flowers, and renditions of the architecture of cities. She lived in New Mexico for many years and was greatly influenced by its landscape and light. She married the photographer and collector, Alfred Stieglitz, who gave her great encouragement.

Timothy H. O'Sullivan (1840–1882) An American photographer who studied with Matthew Brady. He worked under Alexander Gardener photographing the American Civil War. He later documented exploratory and survey expeditions into the western United States. He made the earliest underground mine photographs using magnesium flash.

Claes Thure Oldenburg (1929–) An American sculptor and environmentalist born in Stockholm, Sweden. His oversized, stitched-together pieces, in such soft materials as vinyl or canvas, stuffed with kapok, are important sculptural innovations.

José Clemente Orozco (1883–1949) A Mexican painter who trained first as an architect. He painted large murals in fresco, depicting monumental figures in strong colors.

Albert Paley is Reference Artist in Residence at the School for American Craftsman at Rochester Institute of Technology, Rochester, New York.

Giovanni Paolo Pannini (1692–1765) An Italian artist of topographical and architectural views—both real and imaginary. His views often showed movements in imaginary landscapes.

Eduardo Paolozzi A Scottish sculptor, born in 1924 in Edinburgh, who attended the Slade School and later worked in Paris. He is concerned with materials being used to build unique images, often as a result of the conglomeration of the things that he uses.

Victor Pasmore Born in England in 1908, Pasmore, in the late 1930s, was painting interiors and landscapes in the style of Whistler. After 1950 he became an abstract constructionist, making objects of colored wood and Perspex. He has been an influential teacher of abstract principles of design in England.

Sir Joseph Paxton (1803–65) An English architect and designer whose Crystal Palace (1851) was a magnificent example of the prefabrication principle by which erection, construction and drainage are all integrated into one system. His handling of iron and glass in this vast building made it a precursor of the modern movement in architecture.

Charles Willson Peale (1741–1827) Peale was born in Maryland and lived in Pennsylvania. He was the founder and most famous member of an artistic family which included seventeen children. He was a watchmaker, saddler, and student of portrait painting under Benjamin West in London. After the Revolutionary War, he established a museum in Independence Hall, which included scientific curiosities and his portraits of famous men.

Ieoh Ming Pei (1917–1990) An American architect and teacher born in Canton, China. His work reflects skillfully controlled complexes of high-rise blocks and open plazas. He stressed flexibility yet established a strong formal order through his strict axial arrangements.

Beverly Pepper Born in New York in 1924, she studied in New York and Paris, first painting, and then sculpture, at the Atelier Fernand Léger. She has also been an advertising art director. Her large public outdoor sculptures have been installed at banks, universities, government, and commercial buildings. She is most famous for large geometrical site works.

Edward F. Fry, "Beverly Pepper Sculpture, 1971–75," San Francisco Museum catalogue, 1975.

Pablo Picasso (1881–1973) A Spaniard, born in France and the son of an art teacher, he studied painting in Barcelona. In 1900 he journeyed to Paris, which had become the art center for modernism. He produced Cubist paintings and evolved his famous rose and blue styles. Always a leading innovator of his artistic set, he, along with Braque, developed the art of collage. During the Spanish Civil War he painted his most famous work, *Guernica,* in which, perhaps for the first time, Cubism was used for social commentary. His later life was spent in producing prints and drawings, and in elaborating on favorite mythical themes.

Robert Rosenblum, *Cubism and 20th Century Art,* 1966.

Horace Pippin (1888–1946) An American artist who, as a child, made pictures of his family circle. He fought in World War I, was wounded, and resumed his art work when he returned. He studied at the Barnes Foundation outside Philadelphia. His paintings of antislavery activist John Brown are atypically political. Pippin was self taught; his technique reflects the naive art of the Pennsylvania Dutch area in which he lived, as well as the traditions of the African-American experience.

Giovanni Battiste Piranesi (1720–1778) An Italian artist, born in Venice, who was a pupil of Valeriani. He became an architect and engraver and left a great number of plates of Roman antiquities, prisons, ruins, and architectural features. These were handled in a distinctive manner, with dramatic use of light and shade.

Camille Pissarro (1830–1903) A French painter, born at Saint-Thomas in the West Indies, he went to France in 1855 and painted in the Impressionist manner, achieving a glowing sense of reality and atmosphere. A prodigious worker, he produced a great number of pictures, using oils, gouache, pastel, drawings in pencil, pen and ink, etching, and lithography.

Arnaldo Pomodoro Born in Italy in 1926, he studied sculpture, architecture, and theater. In 1964 he won a prize for Italian sculpture. He has produced works mostly in bronze, or combinations of different materials, in which he investigates organic and technological structures.

Raphael Sanzio (1483–1520) An Italian painter who, at a young age, created mythological and religious drawings while studying with Perugino. The Pope hired him in 1508 to decorate the papal apartments, called stanze, in the Vatican, which led to portrait commissions and altarpieces. He died at 37, at the height of his productivity, and was one of the greatest masters of the high Renaissance.

Luciano Berti, *Raphael,* New York, 1961.

Odilon Redon (1840–1969) A french painter and lithographer, who found inspiration in his dreams and the various media which expressed them: charcoal, etching, pastel, and lithography. Redon's genius lay in his skillful draftsmanship and the pictorial sense with which he interpreted his visions.

Rembrandt van Rijn (1606–1665) A Dutch artist who is considered to be one of the greatest masters of European art. His paintings, drawings, and etchings have been collected since the seventeenth century. His personal troubles and great works (*The Night Watch*—1642; and the self-portraits) helped create the myth of his unpopularity and isolation from Dutch society. The myth however, was not true. He continued to receive commissions until his death.

Frederic Remington (1861–1909)An American artist who attended Yale but went West in 1880. The West became his subject matter. He began by selling illustrations to *Harper's Weekly*. In 1887 he also began to exhibit at the National Academy of Design. His western sculpture, begun in 1895, met with immediate success. His illustrations in popular magazines brought demand for his canvases, in which he caught the movement and romance of the vanished frontier.

Harold McCracken, *The Frederic Remington Book,* New York, 1966.
Peter Hassrick, *Frederic Remington,* New York, 1973.

Hyacinthe Rigaud (1659–1743) A French artist who won the Prix de Rome in 1682. He was official court painter for Louis XIV and XV and painted the pomp of the Sun King. In his nonofficial portraits he followed the style of Rembrandt. He painted an average of 35 portraits a year for 62 years.

Bridget Riley Born in London in 1931, she studied at the Royal College of Art and taught art in various English colleges. She won the Grand Prix at the Venice Biennale of 1968. Along with Vasarély, her name became synonymous with Op Art in the 1960s.

"Bridget Riley," article in *Art in America,* April 1975.

Diego Rivera (1886–1957) Mexico's most famous painter, who developed his own style in elongated figures within dramatic murals. He studied the popular idioms of Cubism in Madrid and Paris, but, back home in Mexico he worked out his own style. His murals were done in Mexico City, Cuernavaca, Chapingo,and in San Francisco, and Detroit in the United States. In New York at Rockefeller Center he was assisted by Ben Shahn.

Diego Rivera, *My Art, My Life,* 1960.

Hugo Rubus (1885–1964) An American sculptor, born in Cleveland, Ohio, he was the son of an iron molder. He began as a painter, and, at age 35, turned to sculpture. His work consists of smoothly modified and rhythmic forms. It is said that Robus gave life to the mysteries of our innermost dreams and emotions in his sculptures.

Theodore Rousseau (1812–1867) A French landscape painter and friend of Millet and Diaz, who settled at Barbizon in 1844. He was influenced by the Barbizon School and also by the Dutch masters and by Japanese art.

Charles Marion Russell (1864–1926) An American painter, born in St. Louis Missouri, who recorded the Old West. He went to Montana in 1880 where he lived with a trapper for two years, then worked as a cowboy for some ten years, riding as a night herdsman. He was a keen observer and gifted story-teller. He settled in Great Falls, Montana, in 1897, where he built his studio and spent the rest of his career making a record of the West he had known as a youth.

Eero Saarimen (1910–1961) An American architect born in Finland. His first commission for the General Orators Technical Center (1948–1956) became a symbol of industrial success. His style dominated American architecture for several decades. Besides his many buildings and airport terminals, he designed modern furniture, specializing in the use of plastic materials.

August Sander (1876–1964) A German photographer, who bought his first camera at the age of sixteen, and began photographic studies while in the Army. He set up his own studio in Austria, then Cologne, Germany. He produced studies of German faces, resulting in his massive book, *Man of the 20th Century,* in which subjects emerged as universal characters.

August Sander, *Aperture History of Photography,* New York, 1977.

Karl Schrag (1912–) An American printmaker and painter, born in Karlsruhe, Germany. His line is both Oriental in its frugality and expressionist in its vigor. Together with brilliant color, his calligraphic line evokes a turbulent, yet exciting, view of nature.

Ben Shahn (1898–1969) An American painter, born in Lithuania, who received wide training as an artist and also as a biologist. He worked for the Public Arts project in New York and the Farm Security Administration in Washington. During the Great Depression he became leader of a school advocating social content in art. His most famous series are the Sacco and Vanzetti series, after the trial and imprisonment of the two revolutionaries. He excelled in many art media—prints, illustration, painting, photography—and as a teacher.

Charles Sheeler (1883–1965) An American photographer born in Pennsylvania, he traveled to Italy and became interested in architectural subjects, unadorned and examined in segments, as abstractions. He first became a photographer and then translated photos to canvas.

Shih-t'ao (1630–1717) A Chinese Oriental painter whose pseudonym was Tao-chi. He became a Buddhist monk at the age of fourteen on the date the Manchus overthrew the Ming dynasty. He loved the early masters of the northern and southern Song schools, but refused to follow the conventions of the day. He believed painting was a way of being in harmony with the world.

Osvald Sirén, *The Chinese on the Art of Painting,* New York, 1963.

David Alfaro Siqueiros (1898–1974) A Mexican painter who, with Diego Rivera and José Clemente Orozco, founded the modern school of mural painting. An ideological realism is present in his art. His mixture of form and movement has tremendous power and vitality.

John Sloan (1871–1951) An American artist who studied at the Pennsylvania Academy and then went to New York to join other students of Robert Henri of the Ash Can School of urban realists. He used sharp light effects and some of the abbreviated style of the Impressionists. He was also concerned with the life of the poor in the environment of the great New York melting pot. He was a contributing writer to The New Masses.

John Sloan, *The Gist of Art,* New York, 1939.

David Smith (1906–1965) An American sculptor who, after initial studies at Ohio University, worked in an automobile factory as a riveter on an assembly line. He went on to study at the Art Students League in New York and earned a living as taxi driver, salesman, carpenter, and seaman. Primarily, he was a Constructionist and a leading figure in welded metal sculpture.

Eugene W. Smith Born in 1919 in Wichita, Kansas, he became a photographer. His work has been reproduced in many popular magazines, including *Life, Collier's, Harper's Bazaar,* and *The New York Times.* His dedication to honest reporting and his concern that photojournalists develop a distinct viewpoint have greatly influenced many other photojournalists. Much of his work features moments of pathos and a dramatic use of light and dark.

Robert Smithson (1938–1973) An American artist, born in Passaic, New Jersey, he is considered one of the founders of the earthworks movement. Smithson's lack of concern for "quality" and "refinement" in the construction of his works demonstrates the emphasis placed by many artists in the late 1960s on conceptualization, rather than on the work of art itself.

Edward Steichen (1879–1973) An American photographer whose lifetime spanned the historical and technological development of photography. In 1902 he and Steiglitz formed the Photo-Secession Gallery, an effort to provide photographers with a place to be seen. During World War II he was in charge of Naval War Photography and, during his tenure as head of the photography department of the Museum of Modern Art, was responsible for organizing the international "Family of Man" Exhibition.

Joseph Stella (1877–1946) An American painter of Italian origin. During a trip to Europe in 1909–12 he met the Italian Futurists and was greatly influenced by their work. He later developed his Futurist style into a more personal one.

Sylvia Stone Born in Toronto, Canada, she is a sculptor who works primarily in Plexiglass, sometimes juxtaposed with planes of mirror or metal. Geometric forms joined together into sweeping structures reflecting layers of experience, shifting light, time, space, and fantasy are the motifs of her work.

Paul Strand (1890–1976) A photographer who is considered one of the heroes of modern American photography. The future of photography was contained in his early work (around 1917) of "street people," such as cab drivers and beggars, photographed from unusual angles. He is best known for his photographic portraits in which he stressed the unique qualities of every individual, whether famous or unknown.

Gilbert Stuart (1755–1828) An American portrait painter. He traveled to Scotland and England, and lived for six years in Dublin, Ireland. While in London, he studied with Benjamin West. When he returned to America he painted many portraits, including 124 of George Washington.

Thomas Sully (1783–1872) An American portrait painter born at Horncastle, Lincolnshire, England. He came to America with his parents when he was nine years old. In America he studied with John Trumbull and Gilbert Stuart. In 1809 he returned to England to work in the studio of Benjamin West. Back in America he set up his studio in Philadelphia. His subjects included Thomas Jefferson, Fanny Kemble, Lafayette, and Washington.

Graham Sutherland (1903–1980) A painter, born in London, of powerful psychologically revealing portraits, as well as highly imaginative landscapes. He worked as an Official War Artist in the Second World War and designed the great tapestry for Coventry Cathedral.

Tao-Chi: See Shih-t'ao

Toshiko Takaezu Born in 1911 in Pepeekeo, Hawaii, this American ceramist has become known for the quality of her thrown forms, her subtlety of brush decoration, and her range of coloration. She works with stoneware on the wheel and favors a closed, round form. Her typical colors are cobalt and copper blues, greens, and blacks.

William Henry Fox Talbot (1800–1871) An English photographer who first developed a practical method for producing photographic negatives on oiled paper. His process, known as the "calotype," was patented in 1841.

Henry Ossawa Tanner (1859–1937) An American painter of religious subjects and landscapes. His father was a distinguished African Methodist Episcopal bishop. Tanner studied under Thomas Eakins at the Pennsylvania Academy of Fine Arts and later at the Académie Julien in Paris. He received a number of major prizes between 1900 and 1915 and was elected to the National Academy.

Alma W. Thomas (1892–1978) An American painter, born in Columbus, Georgia. She spent 35 years teaching in the public school system of Washington, D.C. She found herself as a painter when she was in her seventies and, in 1972, at age 80, exhibited one-person shows at both the Corcoran Gallery and the Whitney Museum. She is known for her exuberant use of color.

Louis Comfort Tiffany (1848–1933) The son of the founder of Tiffany and Co., this artist was first a painter. He and John La Farge studied glassmaking in Brooklyn and, in 1880, applied for a patent on the iridescent glass process trademarked for him.

Titian (Tiziano Vecellio) (c. 1487–1576) born at Piene Di Cadore in the Venetian Alps, he worked in the studio of Giovanni Bellini and later Giorgione. A master of rich harmonies of color, his ideas and manner of working with color, light and shade influenced many other artists. His work was in demand throughout Europe by noblemen and kings. He prospered and lived in a palace, but died a victim of the plague.

Mark Tobey (1890–1976) An American artist, born in Wisconsin, who, after art school in Chicago, did advertising art work in New York. He then settled in Seattle and lived in the Pacific Northwest for most of his life. He was influenced by Japanese calligraphy and resided in a Japanese monastery. He began paintings called "white writing" upon his return to the United States.

George Tooker (1920–) An American painter born in Brooklyn, New York. He studied with Paul Cadmus, who taught him to use egg tempera. Tooker's style, in which realistically drawn scenes of figures are defined with polished and deliberate precision, has been termed Magic Realism. The contrast, between the careful execution and the unsettling psychological implications of his subject matter, sets up a particularly interesting tension.

Henri de Toulouse-Lantrec (1864–1901) An influential French Post-Impressionist painter and lithographer. At the age of fourteen he broke both thighbones and, as a result of a crippling disease, his legs were stunted. Lautrec became an observer of life, rather than a participant, and his paintings, lithographs and sketches are an important part of the history of the period.

J. M. W. Turner (1775–1851) An English artist who began to draw at an early age. He attended the Royal Academy where he exhibited and drew notice from the public. He traveled throughout England and portrayed historic landscapes and architecture. After a trip to the Continent his work became more mythological. He usually worked indoors from sketches and his well-developed memory. In his later works he became obsessed with the portrayal of pure light and the conflict of the elements.

John Gage, *Color in Turner: Poetry and Truth,* London and New York, 1967.

John Twachtman (1853–1902) An American Impressionist painter, He studied in Paris and returned to America in 1885. As he grew older, he became more spiritual and poetic in his pastel dreamlike landscapes.

Jorn Utzon Born in 1918 in Copenhagen, he studied at the Copenhagen School of Architecture. He later worked in Stockholm and in Finland with Alvar Aalto. He believed in using organic materials in accord with their own properties. The Sydney Opera House was his most famous project.

Vincent van Gogh See Gogh

Diego Velásquez (1599–1660) A painter who was born of noble Portuguese parents and later moved to Seville, Spain. He studied with a teacher who instilled in him a love for portraiture. Early influences were Caravaggio and the Seville School, which emphasized popular everyday subjects placed in architectural settings. He became a court official to Philip IV in Madrid, and his final paintings, such as the *Maids of Honor,* show a balance of complex elements in perfectly controlled composition.

Andrea del Verocchio (1435–1488) A Venetian who was truly a Renaissance man of Florence. Proficient as a sculptor, he was also a fine painter and a goldsmith. He executed monuments, public fountains, and sculptural façades of churches. The statue of Bartolommeo Colleoni was commissioned and produced to commemorate the condottiere after his death in Venice. He also directed an active workshop, which trained Leonardo, Perugion, and Botticini.

Vinci See Leonardo da Vinci

Antoine Watteau (1684–1721) A Frenchman who, at the age of 15, was apprenticed to Gé, a minor painter, and at 18 went to Paris, where he earned a living copying famous paintings. His first paintings were depictions of Italian comedy. He studied the work of Rubens and developed a talent for a supple line.

Max Weber (1881–1961) An American painter of Russian origin. Influenced at first by the Fauves and Cubists, he later worked in a more realistic, lyrical style.

Benjamin West (1738–1820) An American artist who painted portraits of cultured gentlemen and gained fame in London. In 1772 he was appointed historian painter to King George III. His subjects were portraits, the Bible, myths, and landscape. As a teacher in America he had many famous students: C.W. Peale, Gilbert Stuart, Samuel F.B. Morse, and John Singleton Copley.

Flexner, *America's Old Masters* (bibliography)

Edward Weston (1886–1958) An American artist who made some of photography's most famous images. The major themes of his work are portrayed in a world of heroic country people and in images of graceful forms and tones of the natural world. His work ranges from portraits of artists to bare sand dunes and the dried timbers of mountains.

Charles White (1918–1979) A painter whose works stressed the monumental dignity and timeless endurance reflected in pride and strength of character.

John White (active artist 1584–1593) An Englishman who sailed from England to America and was one of the first settlers in Raleigh's Virginia colony (1585). White made watercolor studies depicting the life and customs of the Indians and the flora and fauna of the New World.

Margaret Bourke-White (1904–1971) An American photographer, born in Connecticut, who studied photography with Clarence H. White and made industrial photos for *Fortune* magazine. A *Life* magazine photojournalist from 1936 to 1957, she provided *Life's* first cover photograph and sent in pictorial reports from travels in Europe, Asia, and America.

Grant Wood (1891–1942) An American painter born in Anamosa, Iowa. Wood was one of the regionalists. A form of realism common in America during the 1930s, regionalism was based on the desire of native artists to end America's cultural dependence on Europe by finding inspiration for art in everyday experiences. Wood's painting, however, remained strongly individual.

Frank Lloyd Wright (1867–1959) An American architect who was a disciple of the great architect Louis Sullivan. He extended the field to encompass Cubist theories in his early style of 1900–1910. The "prairie Houses" blended into the landscape, and Wright controlled the interior design of his houses, too, for he believed that buildings have a profound influence on those who use them.

Frank Lloyd Wright, *An Autobiography,* New York, 1943.

Andrew Wyeth Born in 1917, he was a Pennsylvanian and the son of illustrator and artist N.C. Wyeth, from whom he received his early training. Andrew felt no need to break with the family tradition of winters in Chadds Ford, Pennsylvania, and summers in Maine. These places provided the subject matter for his watercolors, temperas,and oils. He is rarely symbolic and his rural scenes often evoke a sense of longing or loss.

Mahonri Young (1877–1957) An American sculptor, and the grandson of the Mormon leader Brigham Young, was born in Salt Lake City, Utah. He was drawn to the theme of the working man throughout his life. Stylistically, Young's work had a powerful and rugged naturalism, yet it also possessed a sensitivity in its arrangement of masses.

BIBLIOGRAPHY

I. Understanding Art and Art History

Blandy, Doug, and Kristin G. Congdon. *Art in a Democracy.* New York: Teachers College Press, Columbia University, 1989.

Feldman, Edmund. *Thinking About Art.* Englewood Cliffs, NJ: Prentice-Hall, 1984.

Gardner, Howard, and David Perkins, eds. *Art, Mind and Education: Research from Project Zero.* Urban/Chicago, Illinois: University of Illinois Press, 1989.

Greer, Germaine. *The Obstacle Race: The Fortunes of Women Painters and Their Works.* New York: Farrar, Straus, Giroux, 1979.

Hauser, Arnold. *The Philosophy of Art History.* New York: World Publishing Co., 1963.

Lanier, Vincent. *The Arts We See: A Simplified Introduction to the Visual Arts.* New York: Teachers College Press, 1982.

Lucie-Smith, Edward. *The Story of Craft: Role of the Craftsman in Society.* New York: Van Nostrand Reinhold.

McCarter, William, and Rita Gilbert. *Living with Art.* New York: Alfred A. Knopf, Inc., 1985.

Rees, A.L. and F. Borzello, eds. *The New Art History.* Atlantic Highlands, NJ: Humanities Press International, Inc., 1988.

Richardson, John Adkins. Art: *The Way It Is.* 2d ed. Englewood Cliffs, NJ: Prentice-Hall, Inc., 1980.

Tafts, Eleanor. *American Women Artists* 1830–1930. Washington, D.C.: The National Museum of Women in the Arts, 1987.

II. Aesthetics, Art Criticism and Writing about Art

Barnet, Sylvan. *A Short Guide to Writing About Art.* Boston: Little, Brown & Co., 1985.

Berger, John. *Ways of Seeing.* New York: Viking Penguin International, Inc., 1977.

Carrier, David. *Artwriting.* Amherst, MA: University of Massachusetts Press, 1987.

Feldman, Edmund Burke. "The Critical Act." *The Journal of Aesthetic Education,* Vol 1
No. 2, Autumn 1966.

Greenberg, Clement. *Art and Culture: Critical Essays.* Boston: Beacon Press Paperback, 1965.

Taylor, Joshua C. *To See Is to Think: Looking at American Art.* Washington, D.C: Smithsonian Institution Press, 1975.

Wolff, Theodore F. *The Many Masks of Modern Art.* Boston: The Christian Science Publishing Society, 1989.

III. Artist and Art Careers

Brommer, Gerald F., and Joseph A. Gatto. *Careers in Art: An Illustrated Guide.* Worcester, MA: Davis Publications, Inc., 1984.

Cole, Bruce. *The Renaissance Artist at Work: From Pisano to Titian.* New York: Harper & Row, Inc., 1982.

Feldman, Edmund. *The Artist.* Englewood Cliffs, NJ: Prentice-Hall, Inc., 1984.

Holden, Donald. *Art Career Guide.* New York: Watson Guptill Co., 1973.

IV. Art Education

Chapman, Laura H. *Approaches to Art in Education.* New York: Harcourt Brace Jovanovich, 1978.

Chapman, Laura H. Instant *Art, Instant Culture: The Unspoken Policy for American Schools.* New York: Teachers College Press, 1982.

Eisner, Elliott. *Educating Artistic Vision.* New York: Macmillan, 1972.

Gardner, Howard. *The Arts & Human Development.* New York: John Wiley & Sons, 1973;

Gardner, Howard. *Art, Mind & Brain.* New York: Basic Books, Inc., 1982.

Lowenfeld, V., and W. L. Brittain. *Creative Mental Growth.* 7th ed. New York: Macmillan Co., 1983.

Michaels, John A. *Art and Adolescence.* New York: Teachers College Press, 1983.

Perr, Herb. *Making Art Together Step-by-Step.* San Jose, California: Resource Publications, Inc., 1988.

Wilson, Marjorie and Brent Wilson. *Teaching Children to Draw.* Englewood Cliffs, NJ: Prentice-Hall Inc., A Spectrum Book.

V. Lettering and Calligraphy

Cataldo, John. *Lettering.* Rev. ed. Worcester, MA: Davis Publications, Inc., 1983.

Cataldo, John. *Pen Calligraphy.* Worcester, MA: Davis Publications Inc., 1979.

Klager, Max. *Letters, Type and Pictures.* New York: Van Nostrand Reinhold, 1975.

VI. Color and Design

Albers, Jose. *Interaction of Color.* Rev. ed. New Haven, CT: Yale University Press 1975.

Anderson, Donald M. *Elements of Design.* New York: Holt Rinehart and Winston, 1961.

Benz, E., A. Portman, T. Izutu, et al. *Color Symbolism:* Dallas, TX: Spring Publications, Inc., 1967.

Cheatham, Frank and Jane Hart Cheatham. *Design Concepts and Application.* Baltimore, MD: University Park Press, 1983.

Ellinger, Richard G. *Color Structure and Design.* New York: Van Nostrand Reinhold Co., 1980.

Lidstone, John. *Design Activities in the Classroom.* Worcester, MA: Davis Publications, Inc., 1977.

Verity, Enid. *Color Observed.* New York: Van Nostrand Reinhold Co., 1980.

VII. Drawing and Painting

Brommer, Gerald F. *Drawing, Ideas, Materials and Techniques.* Worcester, MA: Davis Publications, Inc., 1978.

Couch, Tony. *Watercolor, You Can Do It.* Fairfield, CT: North Light Books, 1987.

Horn, George F. *Cartooning.* Worcester, MA: Davis Publications, Inc., 1965.

Nicolaides, Kimon. *The Natural Way to Draw.* Boston: Houghton Mifflin Co., 1941.

Purser, Stuart. *The Drawing Handbook.* Worcester, MA: Davis Publications, Inc., 1976.

Sheaks, Barclay. *Drawing and Painting the Natural Environment.* Worcester, MA: Davis Publications, Inc., 1974.

Timmons, Virginia G. *Painting, Ideas, Materials, Processes.* Worcester, MA: Davis Publications, Inc.

VIII. Architecture

Abramovitz, Anita. *People and Spaces: A View of History Through Architecture.* New York: Viking Press, 1979.

Bacon, Edmund N. *Design of Cities.* New York: Viking Press, 1967.

Barford, George. *Understanding Modern Architecture.* Worcester, MA: Davis Publications, Inc., 1986.

Brown, Frank E. *Roman Architecture.* New York: George Brazillier, 1961.

Bruno, Vincent, ed. *The Parthenon.* New York: W. W. Norton and Co., Inc., 1974.

Burchard, John and Albert Bush-Brown. *The Architecture of America.* Boston: Little Brown and Co., 1961.

Frankl, Paul. *Gothic Architecture.* Pelican History of Art Series. Baltimore, MD: Penguin Books, 1962.

Hitchcock, Henry Russel. *Architecture: Nineteenth and Twentieth Century.* Pelican History of Art Series. Baltimore, MD: Penguin Books, 1977.

Jenks, Charles, Baird, and George, eds. *Meaning in Architecture.* New York: George Brazillier, 1969.

Mumford, Lewis. *The City in History.* New York: Harcourt, Brace, 1961.

IX. Art Materials

Cooke, Hereward Lester. *Painting Lessons from the Great Masters.* New York: Watson Guptill Publications, 1967.

Mayer, Ralph. *The Artist's Handbook of Material and Techniques.* Rev. ed. New York: Viking Press, 1970.

Timmons, Virginia G. *Art Materials, Techniques, Ideas.* Worcester, MA: Davis Publications, Inc.

X. Art Room Health and Safety

Arts and Crafts Materials Institute: *Products Authorized to Bear the CP Products Seal of Approval.* Boston, MA: The Art and Craft Materials Institute, 715 Boyston St., Boston 02116. This list is updated annually.

National Art Education Association. *Art Safety Guidelines K–12.* Reston, VA: The National Art Education Association.

Qualley, Charles A. *Safety in the Classroom.* Worcester, MA: Davis Publishing, Inc., 1986.

XI. Sculpture

Boardman, John. *Greek Art, World of Art Series.* New York: Oxford University Press, 1973.

Hartt, Frederick. *History of Italian Renaissance Art: Painting, Sculpture, Architecture.* 2nd ed. New York: Harry N. Abrams, 1980.

Lidstone, John. *Building with Wire.* New York: Van Nostrand Reinhold, 1962.

Pope-Hennessy, John. *Italian Renaissance Sculpture.* New York: Phaidon, 1971.

Rasmussen, Henry and Art Grant. *Sculpture from Junk.* New York: Reinhold Publishing, 1967.

Ratcliff, Carter. *Red Grooms.* Abbeville Press, 1984.

Reed, Herbert and Burt Towne. *Sculpture from Found Objects.* Worcester, MA: Davis Publications, Inc., 1974.

Whitney Museum of American Art, New York. Intro. by Edward Albee. *Louise Nevelson: Atmospheres and Environments.* New York: Clarkson N. Potter Inc., 1980.

XII. Crafts

Bonestell, Georgia. *More Lap Quilting.* Birmingham, AL: Oxmoor House, Inc., 1985.

Bridgewater, Alan and Gill. *Decorative Kites.* Mineola, NY: Dover Publications, Inc., 1985.

Chamberlain, Marcia and Condall Crockett. *Beyond Weaving.* New York: Watson Guptill Co., 1974.

Enthoven, Jacquelin. *The Stitches of Creative Embroidery.* New York: Van Nostrand Reinhold, 1964.

Kenny, John B. and Carla. *The Art of Pâpier Maché.* Radnor, PA: Chilton Book Co., 1968.

Ketchum, William C. *All American Folk Arts and Crafts.* New York: Rizzoli International Publications, 1986.

Moseley, Spencer. *Crafts, Design, An Illustrated Guide.* Belmont, CA: Wadsworth Publishing, 1962.

McCreight, Tim. *The Complete Metalsmith, An Illustrated Handbook.* Worcester, MA: Davis Publications, Inc., 1984.

Nelson, G. C. *Ceramics: A Potter's Handbook.* 4th ed. New York: Holt, Rinehart and Winston, Inc., 1983.

Nigrosh, Leon I. *Claywork.* Worcester, MA: Davis Publications, Inc., 1975.

Norton, F. H. *Ceramics for the Artist Potter.* Reading, MA: Addison Wesley Publishing Co., 1955.

Rhodes, Daniel. *Clay and Glazes for the Potter.* Radnor, PA: Chilton Book Co., 1957.

XIII. Photography, Films, Video

Amphoto Editorial Board. *Night Photography Simplified.* New York: Amphoto, 1974.

Arnheim, Rudolph. *Film as Art.* Berkeley and Los Angeles: University of California Press, 1958.

Grill, Tom and Mark Scanlon. *The Essential Darkroom Book.* New York: American Photo Darkroom Book Publishers, 1981.

Halliwell, Leslie. *Halliwell's Filmgoers Companion.* New York: Charles Scribner's & Sons, 1984.

Holter, Patra. *Photography Without a Camera.* New York: Van Nostrand Reinhold, 1974.

Kodak, Inc. *Creative Darkroom Techniques.* Rochester, New York: Kodak, Inc., 1988.

Monaco, James. *How to Read a Film.* New York: Oxford University Press, 1977.

Nettles, Bea. *Breaking the Rules, A Photo Media Cookbook.* Rochester, New York: Light Impressions, 1977.

Pollack, Peter. *The Picture History of Photography.* New York: Abrams, 1969.

Staples, Terry. *Film and Video.* New York: Wanch Press, 1986.

Time Life Library of Photography. "Camera", "Light and Film," "Great Themes," "The Print," "Special Problems," "Art of Photography," "Photo Year, 1973". New York: Time Life Books, 1970.

Whitaker, Rod. *The Language of Film.* Englewood Cliffs, NJ: Prentice Hall, 1970.

Williams, Raymond. *Television: Technology and Cultural Form.* New York: Schocker Books, 1975.

XIV. Computer Art and Graphics

Flynn, Meredith and Steven L. Mandell. *Microcomputers: Concepts, Skills, and Applications.* St. Paul, MN: West Publishing Co., 1990.

Hubbard, Stuart W. *Computer Graphics Glossary.* New York: Van Nostrand Reinhold, 1984.

Lampton, Christopher. *Graphics and Animation on the Apple II, II+, IIE and IIC* and other titles in the Computer Literacy Skills series. New York, Franklin Watts, 1986.

Mandell, Colleen J. and Steven J. *Computers in Education Today.* St. Paul, MN: West Publishing Co., 1989.

XV. Special Education and Gifted and Talented

Bloom, Benjamin, Jr. *Developing Talent in Young People.* New York: Ballentine Books, 1985.

Clements, Claire B. and Robert D. *Art and Mainstreaming.* Springfield, IL: Charles C. Thomas Co., 1984.

Hurwitz, Al. *The Gifted and Talented in Art: A Guide to Program Planning.* Worcester, MA: Davis Publications, Inc., 1984.

Uhlin, Donald. and Edith de Chiara. *Art for Exceptional Children.* 3rd ed. Dubuque, IA: William C. Brown Publishing Company, 1984.

XVI. Museums and Art Collections

Hoving, Thomas. *King of the Confessors.* New York: Simon and Schuster, 1981.

Mason, Donald L. *The Fine Art of Security.* New York: Van Nostrand Reinhold, 1979.

O'Doherty, Brian. *Museums in Crisis.* New York: George Braziller, Inc., 1972.

Taylor, Francis Henry. *The Taste of Angels, A History of Art Collecting from Ramses to Napoleon.* Boston: Little, Brown and Company, 1948.

Tompkins, Calvin. *Merchants and Masterpieces: The Story of the Metropolitan Museum of Art.* New York: E. P. Dutton and Company, 1970.

XVII. Multicultural Arts

Arnold, Bruce. *A Concise History of Irish Art.* New York: Frederick A. Pralger Publishing, 1968.

Casteldo, Leopoldo. *A History of Latin American Art and Architecture, From Pre-Columbian Times to the Present.* New York: Frederick A. Pralger, 1969.

Chase, Judith Wragg. *Afro-American Art and Craft.* New York: Van Nostrand Reinhold, 1971.

Clifford, James. *The Predicament of Culture: Twentieth Century Ethnography, Literature and Art.* Cambridge, MA: Howard University Press, 1988.

Davidson, Basil. *African Kingdoms.* New York: Time Inc., 1966.

Glassie, Henry. *The Spirit of Folk Art: The Girard Collection at the Museum of International Folk Art.* New York: Harry N., Abrams, Inc., 1989.

Goldwater, Robert. *Primitivism in Modern Art.* Cambridge, MA: Belknap Press of Harvard University Press, 1986.

Gordon, Raoul, ed. *Puerto Rican Culture: An Introduction.* New York: Gordon Press, 1976.

Lee, Sherman E. *A History of Far Eastern Art.* 4th ed. New York: Harry N. Abrams, Inc., 1982.

Lewis, Samella. *Art: African American.* San Diego: Harcourt Brace Jovanovich, 1978.

Mai-Mai Sze. *The Way of Chinese Painting.* New York: Random House, Modern Library Paperback, 1959.

McClroy, Guc C., Richard J. Powell and Sharon F. Patton. *African-American Artists 1880–1987.* Seattle and London: University of Washington, Press, 1989.

Miller, Polly and Leon Goredon. *The Lost Heritage of Alaska.* Cleveland, OH: The World Publishing Co., 1967.

Reid, Dennis. *A Concise History of Canadian Painting.* New York: Oxford University Press, 1974.

Smith, Bradley. *Japan: A History in Art.* Garden City, NY: Doubleday and Co., 1964.

Smith, Bradley. *Mexico: A History in Art.* Garden City, NY: Doubleday and Co., 1966.

Smith, Bradley. *Mexico: A History in Art.* Garden City, NY: Doubleday and Co., 1968.

Sutton, Peter, ed. *Dreamings: The Art of Aboriginal Australia.* New York: The Asia Society Galleries, 1988.

Ungerleider-Mycrson, Joy. *Jewish Folk Art, From Biblical Days to Modern Times.* New York: Summit Books division of Simon and Schuster, 1986.

Willett, Frank. *African Art.* New York: Thomas and Hudson, Inc., 1988.

XVIII. The Artist and the West

American Heritage Editors. *The American Heritage Book of the Indians.* New York: American Heritage Publishing Co., Inc., 1961.

Armstrong, Virginia, comp. *I Have Spoken.* Athens, OH: Swallow Press, 1971.

Brody, J.J., Catherine Scott, and Steven A. Le Blanc. *Mimbres Pottery.* New York: Hudson Hills Press in association with the American Federation of Arts, 1983.

Brown, Dee. *The Westerners.* New York: Holt, Rinehart and Winston, Inc., 1974.

Conn, *Richard. Circles of the World, Traditional Art of the Plains Indians.* Denver, CO: Denver Art Museum, 1982.

Connell, Evan S. *Son of the Morning Star, Custer and the Little Bighorn.* San Francisco, CA: North Point Press, 1984.

Current, Karen and William R. *Photography and the Old West.* New York: Abradale Press/Harry N. Abrams, Inc., 1986.

Goetzmann, William H. and William N. *The West of the Imagination.* New York: W.W. Norton and Co., 1986.

Hassrick, Peter H. *Artists of the American Frontier.* New York: Promontory Press, 1988.

Hassrick, Peter. *Frederic Remington.* New York: Harry N. Abrams, Inc., 1973.

Jacka, Jerry and Lois Essary. *Beyond Traditions, Contemporary Indian Art and Its Evolution.* Flagstaff, AZ: Northland Publishing Co., 1988.

Marriott, Alice. *Maria: The Potter of San Ildefonso.* Norman, OK: The University of Oklahoma Press, 1948.

Renner, Frederick G. *Charles M. Russell.* New York: Abradale Press/Harry N. Abrams, Inc., 1974.

Rossi, Paul A. and David Hunt. *The Art of the Old West.* New York: Alfred A. Knopf, Inc., 1971.

Samuels, Peggy and Harold (eds.). *The Collected Writings of Frederic Remington.* Garden City, NY: Doubleday and Co., Inc., 1979.

Tillett, Leslie. *Wind on the Buffalo Grass, Native American Artists-Historians.* New York: Da Capo Press, Inc., 1976.

Wade, Edwin L. and Rennard Strickland. *Magic Images, Contemporary Native American Art.* Norman, OK: The University of Oklahoma Press, 1981.